High Speed Photography and Photonics

Cover photograph: A colour Schlieren photograph taken using a 700 ns spark source showing a flow at Mach 5.1 in a wind tunnel. A cylinder and wedge are 50 mm apart. The shockwaves interact and reflect from surfaces and each other. The colours indicate direction of density gradient.
Photograph courtesy of Dr. Harald Kleine.

The British Association for High Speed Photography

The Association is the focus for High Speed Photography and Photonics in the United Kingdom and represents the UK in the International High Speed Imaging Community.

The aims of the Association are to encourage the use and to spread the knowledge of High Speed Photography, High Speed Videography and Photonics, both amongst the scientific community and to all others interested in the subject.

Annual conferences are held, at which papers describing the latest developments and experimentation are given, and associated technical exhibitions allow an opportunity to view new equipment and discuss its merits with manufacturers.

Membership is open to all persons interested in the field, whether active photographers or not. Inter-member exchange of advice and information is strongly encouraged. Membership, which can be individual or corporate, entails a modest annual fee which is often recouped by membership discounts on conference registration fees.

To obtain further information, or apply for membership, please contact:

> The Hon Secretary
> Association for High Speed Photography
> PO Box 273
> Cambridge
> CB1 4ZR
> UK

> This volume is dedicated to the memory of
> John T. Rendell

High Speed Photography and Photonics

Edited by

Sidney F. Ray

BSc, MSc, ASIS, FBIPP, FMPA, FRPS

Principal Lecturer
University of Westminster
London

With 24 Contributors

Focal Press

Focal Press
An imprint of Butterworth-Heinemann
Linacre House, Jordan Hill, Oxford OX2 8DP
A division of Reed Educational and Professional Publishing Ltd

ℜ A member of the Reed Elsevier plc group

OXFORD BOSTON JOHANNESBURG
MELBOURNE NEW DELHI SINGAPORE

First published 1997

British Library Cataloguing in Publication Data
A catalogue record for this book is available from
the British Library

ISBN 0 2405 1479 3

Library of Congress Cataloguing in Publication Data
A catalogue record for this book is available from
the Library of Congress

Typeset in 9/10pt Times at The Spartan Press Ltd
Lymington, Hants
Printed by Martin's The Printers Ltd., Berwick on Tweed

Contents

Foreword

The development of a number of technologies in the fields of photonics, digital systems and computers has led in turn to various novel, useful and exciting developments in high speed photography and its industrial, commercial and military applications.

In Europe, the British Association for High Speed Photography (AHSP) (founded 1954) and the Swedish Association for High Speed Photography have established activities and hold annual conferences where members meet to hear papers and discuss the latest developments. They provide abstracts of their conference papers and some of these are published in full in the photographic press.

In the USA, the Society of Photo Instrumentation Engineers (SPIE) hold many conferences on photonic subjects and usually co-sponsor and publish the Proceedings of the International Congresses on High Speed Photography and Photonics every two years. These organizations, together with other general scientific sources in the public domain, provide a steady flow of published reports on photonics, including high speed applications. However, a readily accessible textbook specifically devoted to various aspects of high speed photography has not been published for many years.

This multi-authored work is an attempt to fill that gap in the scientific literature. Originated and sponsored by the Committee of the AHSP, a book on high speed photography was one of several ideas put forward as ways of making use of surplus funds from the 1990 International Conference hosted by the AHSP in Cambridge, UK. The aim was to use the funds to serve and further the interests of the general high speed photographic community.

The material in this book divides naturally into several sections and includes a useful amount of historical material. In turn, successive chapters deal with an introduction to and a description of the development of high speed photography, followed by details of illumination and the full range of image capture systems. Next there are details of data extraction and image processing to obtain experimental data in appropriate forms. A number of chapters then deal with what may be identified as the major applications of high speed photography, including ballistics, advertising photography, the natural world, detonics, the properties of materials and aircraft engineering. These are followed by other chapters on more specialist applications in fields such as combustion processes, motor vehicle safety and holography. A large number of diagrams and photographs illustrate and supplement the text, while tables of data provide numerical information.

The book is intended to be an introduction to high speed photography, principally to those who may wish to investigate its almost limitless potential as a tool for measurement and analysis in research and development work, but also to those who are interested mainly in standard photographic procedures but would also like to know more about the high speed areas.

As a university textbook, it is perhaps most suited to appropriate post-graduate research work, but undergraduates on courses with elective modules on topics such as film production, biomedical imaging, scientific photography and applied imaging should also find a range of useful introductory material.

As with most textbooks of this type, faced with the problem of selecting and documenting contemporary systems and applications, it is inevitable that gaps in coverage may be identified, some sooner than others. Likewise, established techniques may rapidly be made obsolescent by nascent technology. To address such omissions and developments, it is hoped that future editions of this book might appear at reasonable intervals, with appropriate updating of existing chapters and new material from additional contributors to reflect both progress and change in the subject.

As always, the editor must take ultimate responsibility for the coverage, accuracy and presentation of the contents. Where there are identifiable errors of fact or accuracy, or an inappropriate emphasis or the need for a new chapter, the editorial team welcomes constructive comment on these and other matters. In a multi-authored work such as this, it is inevitable that duplicate or even multiple coverage of a topic can occur. Where judged appropriate, some material has been retained which it is felt will benefit from differing treatments and so provide additional insight into features or applications.

It is hoped that this book fulfils its objectives as a textbook and provides suitable and adequate coverage of the field of high speed photography. Any serious omissions may be rectified in subsequent editions and there is always a need for authors on specialist and new topics to offer additional chapters for forthcoming editions and provide contemporary coverage.

It is appropriate here to register my thanks to the

large number of contributing authors, all of whom are eminent and expert in their fields and are people with great demands on their time. Brief details of each person are given in the accompanying list of contributors to show the vast pool of expertise underpinning the collective chapters. Almost everyone has had to deal with the full range of editorial requirements and guidance, often without the advantage of a complete overview of the whole project as granted to the editor, and this they have done patiently and courteously.

I would like to record my grateful thanks to Peter Fuller, who afforded me considerable assistance in some matters of editorial work and who used his extensive knowledge of the individual contributors worldwide and his own distinguished background in high speed photography to facilitate the collection of contributory chapters.

I would also like to record my thanks and those of the AHSP Committee to the many sustaining organizations and individuals who have freely given their permission to publish many of the photographs provided as illustrations

I would like to record also the unstinting and cheerful co-operation and assistance from Margaret Riley and Jennifer Welham of Focal Press who piloted this ambitious project through its many stages of production.

As always, I gratefully acknowledge the help and co-operation of my wife Anne and children Alexander and Christopher without whose tolerance and understanding I could never persevere productively to a successful outcome.

On a final note, it is fitting and auspicious that this textbook detailing some specialized applications of film cameras should be written in this, the centenary year of the first public showing in the UK of the Lumière Cinématographe on 20 February 1896 in the Great Hall of The Polytechnic, Regent Street, London. Apart from its role in making movies, cinematography has since developed as an important scientific tool for visualization and analysis.

Note

As with many other technological subjects, there are a large number of units, symbols and acronyms in use and a list of these has been provided for reference. There seems to be no standard unit for the number of images captured in one second by high speed photography, with claims for framing rate (s^{-1}), frequency (Hz), pictures per second (pps), [film] frames per second (fps), [video] frames per second, [video] fields per second, partial pictures per second (ppps), full frames per second (ffps), etc. After due consideration it was decided to use *pictures per second* (pps) as the standard unit in the text but, where judged appropriate, to use frames or fields per second in the appropriate context. Generally, video is correctly referred to in *fields per second*, while film uses frames per second, pictures per second, etc. Sometimes in a more loose sense, video is referred to in other terms, but due to the nature of the way in which the pictures are produced, i.e. in multiple tiny electronic elements through scanning, fields per second presents probably the truest scientific description.

Disclaimer

This book contains descriptions of the operation, use and applications of a range of equipment, materials and processes that readers may wish to investigate or use for their own purposes. In some instances and examples it has not been possible to give full operational details due to the limitations of space. In case of doubt, the user should obtain advice and assistance from a suitably qualified person before adopting any proposal made in this book. To the best of the Association's and the Publisher's knowledge the information in this book is accurate and up to date at the time of publication. However, neither the Editor, Association nor the Publisher can accept responsibility for any inaccuracy or error.

Sidney F. Ray

List of contributors

Kris Balch
Kris Balch is Technical Director of the Motion Analysis System Division of Eastman Kodak in San Diego, California.

John Brackenbury PhD
John Brackenbury is a zoologist and obtained a BSc in the Department of Zoology at Bristol University followed by a PhD in the Department of Anatomy of the University of Cambridge, where he now is a lecturer in Veterinary Anatomy. His research is in the fields of animal locomotion and vision and his chief interest at the moment is in the way animals target rapidly moving objects.

Claude Cavailler
Claude Cavailler works for the Commissariat à l'Energie Atomique (CEA) based in Moronvilliers, France, in the Dèpartment Dètonique.

Eric Clough
Eric Clough (co-author) is a Senior Experimental Officer and has managed the Internal Combustion Engine Laboratories in UMIST for 10 years. He has been instrumental in installing and commissioning computerized data processing equipment and emissions measuring equipment in the laboratories. He has published 12 papers on combustion in diesel engines, and was central in developing photography techniques and gas sampling valves used in UMIST over the last 15 years.

John M. Dewey
John Dewey retired from the Department of Physics and Astronomy, University of Victoria, British Columbia, Canada in July 1995 as Professor Emeritus of Physics. He has made extensive studies of the physics of shock waves using a range of visualization techniques, followed by photogrammetric analysis of results.

Christopher Edwards BSc, DipMgmt
Christopher Edwards was born in London in 1960 and educated at the North London Polytechnic and the Open University. His subjects were electronics and communications engineering, specializing in microwave engineering with a later job in industry as designer of waveguide components, followed by technical sales and management roles. This included time in the television and broadcast industry involved with delay lines, timing components and filters. Most recently, up to the amalgamation of the high speed imaging activities of Kodak and NAC, he was Product Manager for digital imaging products at NAC and involved in the introduction of Memrecam and Image Express motion analysis software to the European market. He has also worked at Imco Electro-optics on the sales and support of the Ultranac image converter camera and associated systems, together with its introduction to the European and North American markets.

Keith Errey
Keith Errey works for Oxford Lasers Ltd.

John E. Field FRS
Professor Field is Deputy Head of the Department of Physics, Cavendish Laboratory at Cambridge, and Head of the Physics and Chemistry of Solids (PCS) Section. He has been interested in high speed photography since his PhD studies (1958–1961) with the late Professor Bowden. Professor Field has built up what is now the best-equipped university facility in Europe. His research interests include fracture, impact, erosion, shock physics, high-rate of strain properties of materials, explosive initiation and diamond research. He has written two books, authored over 230 papers and supervised 52 students to PhDs. He was awarded the Duddell Medal by the Institute of Physics in 1990 and was made a Fellow of the Royal Society in 1994.

Peter W. W. Fuller BSc, MSc, MIEE, SMIEEE, CEng, ASIS, FRPS
Peter Fuller worked for the majority of his career in the Scientific Branch of the Ministry of Defence at RARDE, Fort Halstead. He was involved in Instrumentation and High Speed Photography in a wide variety of ballistic and aerospace applications and spent the last period of his career as head of Instrumentation and Ranges. He has been active in many international scientific organizations and has served in several capacities, including Chairman of the Aeroballistic Range Association and Chairman of the AESS (IEEE). He retired in 1989 and now works as an Independent Consultant in the same fields of instrumentation and photography. He has had a long involvement with the Association for High Speed Photography, including acting as Chairman and International Delegate. He acted as General Chairman for the International Conference on

High Speed Photography and Photonics held in Cambridge, England, in 1990. He is currently serving again as Chairman of the Association.

John Hadfield GBCT

John Hadfield graduated in 1970 with a Diploma in Photography, and in 1973 achieved Associateship of the Institute of Incorporated Photographers. His professional career has included working for: the Royal Aircraft Establishment, Bedford (1970–1972); Hunting Engineering Ltd, Ampthill, Bedford (1972–1982); I.I.M.C. Ltd Thame, Oxfordshire (1982–1990); and from 1990 to the present he has operated as a freelance cameraman specializing in 16 mm high speed filming. He is a committee member of the Association for High Speed Photography, an Associate Member of the International Association for Wildlife Filmakers, and a Member of the Guild of British Camera Technicians.

Manfred Held

Professor Dr Held was born in 1933 in Regensburg, Bavaria, and studied physics at Munich Technical University, being awarded a PhD in 1959. Professor Held started his career as a research scientist at the Max-Planck-Institute for Spectroscopy. He joined TDW at Schrobenhausen as early as 1960, where he pioneered research and development into shaped charges, self-forging fragments, fragmentation warheads, submunitions, passive and reactive armour as well as virtually all the diagnostic techniques needed in the analysis of detonations and other high speed phenomena. He headed the R&D department for many years and has become an internationally recognized authority in areas such as dynamic response of materials, detonics and high speed diagnostics, advanced armour and anti-armour systems. He has published more than 230 papers in the open literature and holds over 130 patents.

At present, he is Chief Scientist for new warhead studies and concepts, teaches terminal ballistics at Munich Military University and delivers guest lectures on detonics and related subjects all over the world. He is a member of the NATO Industrial Advisory Group (NIAG), Panel Subgroups 8, 9, 10, 12 and 17, and a sought-after expert in the forensic aspects of explosive events.

In 1989, his development of novel streak camera techniques was honoured with the British Coleman Award, and in 1986 he was awarded the German Diesel Medal for his numerous inventions. In 1991, Dr Held received the degree of Honorary Professor from Munich Military University.

Joseph Honour

Joseph Honour has worked in a small research group in a university investigating the characteristics of image tubes, particularly the types used in electronic cameras. This involved the manufacture and evaluation of photocathodes, phosphor screens and secondary emission from silicon. For the last 13 years has worked for Hadland Photonics Ltd in technical sales, which includes high speed photographic applications.

Conrad Kiel

Conrad Kiel (co-author) has worked for Photo-Sonics Inc. since 1973 in all phases of the camera manufacturing process. He started the Photo-Sonics rental department in 1980 and has served as a high speed camera technician on more than 400 television commercials and 50 feature films. Over the years he has designed reflex systems and video tapes for several of the Photo-Sonics cameras. He is currently the rental department manager.

Vance Parker

Vance Parker is principal of Parker Research and Publishing located in West Jordan, Utah. He is also a consultant to the Cordin Co., Salt Lake City, Utah.

Roberto G. Racca

Roberto Racca was born in Italy, from where he moved to Canada at the end of his secondary education. He received a PhD in Physics from the University of Victoria in 1990 with a dissertation entitled 'Time-Resolved Holography for the Study of Shock Waves'. Dr Racca has established a consulting firm in Victoria and has been active over the years in research ranging from acoustic oceanography to cardiovascular haemodynamics. For his work in high speed photography, particularly in the fields of holography and CCD video techniques, he was awarded in 1994 the Hubert Schardin Medal of the German Physical Society.

George Randall ABIPP

Following some years in industry, George Randall worked for 40 years in the Civil Service, of which 14 years were spent at the Royal Aircraft Establishment, Farnborough, and then 26 years at the Aircraft and Armament Experimental Establishment, Boscombe Down. The range of work included stills technical photography, visual aids, photographic instrumentation, fixed view camera installations in aircraft, military reconnaissance photography, high speed cine photography on ranges and airfields, air to air photography in many types of military aircraft and video recording applications. He retired from the Civil Service in 1991.

Sidney F. Ray BSc, MSc, ASIS, FBIPP, FMPA, FRPS

The editor, Sidney Ray, has worked for the University of Westminster (formerly The Polytechnic and then The Polytechnic of Central London) since 1966 and is currently Principal Lecturer in Photographic

and Electronic Imaging Sciences. He is responsible for teaching a wide range of topics in applied, biomedical and scientific photography as well as aspects of photographic optics and professional photographic practice. He has authored, contributed to and edited a large number of publications in these fields.

John T. Rendell

John Rendell joined the Royal Air Force in 1950 as a photographer, and on leaving in 1953 began work at the Royal Aircraft Establishment, Farnborough. He later worked at the Aeroplane and Armament Experimental Establishment, Boscombe Down, and later at the Proof and Experimental Establishment, Pendine, using and devising a wide range of high speed photography techniques. He then worked for John Hadland (P.I.) Ltd and later Gordon Audio Visuals Ltd, in both cases providing a high speed operator and consultancy service. In 1979 he formed his own High Speed Photography Consultancy business and provided a range of services to industrial, military and film/TV establishments or companies as well as supplying a range of equipment. He has a range of photographic qualifications and in 1988 was presented with the Coleman Award for services rendered to high speed photography applications. He was a member of the Association for High Speed Photography since the early 1960s.

Christine Roberts

Christine Roberts (co-author) is an associate of Vance Parker at Parker Research and Publishing.

Fred Schreppers

Since 1968, Fred Schreppers, Electrical Engineer, has been an employee of Weinberger AG, Switzerland, in the department for high speed photography. He is responsible for the design of high speed cameras and associated electronic control equipment. Since 1977 he has been the Director of Technology for this department.

Graham W. Smith

Graham Smith received his BSc in electronic engineering and PhD at UCNW, Bangor, North Wales, in 1967 and 1973, respectively. A member of the Institute of Electrical Engineers he received chartered status in 1977. Dr Smith has spent his career at AWE(A) in England and in recent years has pioneered specialist imaging systems. He is co-author of recent papers relating to radiation effects in solid-state imagers and is currently engaged upon further camera developments.

Hallock F. Swift

Hal Swift is Senior Research Scientist in the Impact Physics Group at the University of Dayton Research Institute (UDRI) where he combines the roles of scientific administrator, working scientist/engineer, technical consultant in several disciplines and teacher in various technical/scientific areas. He has a BS in physics from Cornell University, a MS, also in physics, from George Washington University and professional affiliations with the Society of Photo-Optical Instrumentation Engineers (SPIE), American Association for the Advancement of Science, Society of Motion Picture and Television Engineers, Aeroballistic Range Association (ARA) and Institute of Electrical and Electronic Engineers. He has developed a unique theoretical approach for evaluating effects of supervelocity impacts (above 50 km s^{-1} striking velocity); contributed significantly to light-gas gun technology and has other acknowledged contributions to the field of high speed photography, including cratering of geologic materials, shock physics and the ballistics of conventional and exotic guns. Recent work has been in studies of the laser shock preening of metals, developing a quantitative theory for predicting the intensity and duration of blows received by metallic specimens, leading to possible new alternative mechanisms to produce optimum results. He has co-authored three books, written 35 papers in refereed journals and prepared many technical reports, monographs, etc. Numerous honours received associated with high speed photography include the Schardin Medal from Germany, the Photonics Medal from the SPIE and the Ballistics Award from the ARA.

Jonathan Watts

Jonathan Watts was educated in Devon and at St Andrew's University, Scotland, followed by photographic employment until 1980 when he began work for London Scientific Films and Oxford Scientific Films as a wildlife and special effects cameraman. He has worked as a self-employed specialist wildlife cameraman since 1984 with his own company, British Technical Films. He has numerous film credits with the BBC Natural History Unit as well as other work in three-dimensional optical research and crewing on Imax films. His specialist areas are time-lapse, high speed photography, microscopy, photomacrography and three-dimensional recording, using equipment he has designed and built himself.

Desmond E. Winterbone FEng

After undertaking a student apprenticeship, Professor Winterbone was employed by the then English Electric Co. Ltd as a Design Engineer working on diesel engines until 1967 when he took up a Research Fellowship at the University of Bath (UK). He was awarded a PhD in 1970 for his thesis on the prediction of diesel engine performance. In 1970 he joined the Department of Mechanical Engineering at UMIST as a Lecturer and became a Professor in

the department in 1980. His research work has been in the field of prime movers, particularly diesel and petrol engines and automotive gas turbines, where he has made contributions to simulation, control and combustion in diesel engines. He is joint editor with Sir John Horlock of a book entitled *The Thermodynamics and Fluid Mechanics of Internal Combustion Engines*, Volumes I and II, and has published more than 100 papers in the general area of engineering thermodynamics. Professor Winterbone is currently a Pro-Vice-Chancellor of UMIST.

David A. Yates
On graduating from Imperial College in 1964, Dr Yates (co-author) joined the Marine and Industrial Gas Turbines Division of Bristol-Siddeley Engines Ltd (subsequently merged with Rolls-Royce) as a graduate apprentice. His first appointment was in the development of rocket engines, but when the UK rocket programme was abandoned he transferred to feasibility studies for advanced gas turbine projects, subsequently specifying in the combination of gas turbine plant with gas cooled nuclear reactors. He then spent a short time in the nuclear industry before joining Lanchester Polytechnic (now Coventry University) as a Lecturer in mechanical Engineering. During his time there he was seconded for 12 months to the Advanced Research and Emissions Laboratory of British Leyland, where he commenced research on internal combustion engine exhaust emissions. This work gained him his PhD. After Coventry he spent one year at the University of Limerick, Ireland, before joining UMIST as a Lecturer in Mechanical Engineering. While at UMIST his research has centred on diesel engine combustion and emissions.

Acknowledgements

Chapter 1

Figures 1.3(a), 1.3(b), 1.4, 1.5 and 1.8 reproduced courtesy of the Science and Society Picture Library, Science Museum, London.
Figure 1.12 courtesy of Kodak Ltd.
Figure 1.13 courtesy of Hadland Photonics.

Chapter 3

Figures 3.6, 3.7(a), 3.8 and 3.10 (see also Radio Shack leaflet 276–5010) by courtesy of Dr L. Winters, North Carolina School of Science and Mathematics, USA.
Figures 3.7(b, c), and Figure 3.9(a, b) are adapted from *Electronics and the Photographer*, T. D. Tower, Focal Press (1976).

Chapter 5

All the illustrations used are Crown Copyright and are reproduced by kind permission of the Controller of HMSO.

Chapter 13

Figure 13.3 reproduced courtesy of the Hewlett-Packard Co., USA.

Chapter 14

Figure 14.1 reproduced by permission of the Royal Astronomical Society, London.
Figure 14.2 reproduced by permission of the Science and Society Picture Library of the Science Museum, London.
Figures 14.3, 14.4, 14.5, 14.6, 14.8, 14.9, 14.11, 14.12, 14.13, 14.14, 14.16 and 14.17 are by the author.

Figure 14.7 reproduced by permission of the Visual Instrumentation Corporation, California, USA.
Figure 14.10 reproduced by permission of Dr M. Giraud, Institute Saint Louis, France.
Figure 14.15 reproduced by permission of L. Shaw, Lawrence Livermore National Laboratory, California, USA.

Chapter 17

Fig 17.1 Dr D. Warken FLG/EMI, Weil am Rhein, Germany and Dr A. Mikhalev, PI, St Petersburg, Russia.
Figure 17.2(a) is by the author.
Figure 17.2(b) is by the author.
Figure 17.3(a–e) are by the author.
Figure 17.5 E. Stilp, EMI.
Figure 17.6(a–d) are by the author.
Figure 17.7 as Fig 17.1.
Figure 17.8 P. Stubley, South Bank University, London.
Figure 17.9 Dr H. Kleine, Dr H. Gronig, Dr Jensen of RWTH, Aachen.
Figure 17.10 F. Frungel.
Figure 17.12 Mercedes Benz.

Chapter 22

All the illustrations used are Crown Copyright and are reproduced by kind permission of the Controller of HMSO.

Chapter 23

Figure 23.1 is reproduced by permission of Professor Nils Abramson, The Royal Institute of Technology, Stockholm, Sweden.

Abbreviations

μF	microfarad
μm	micrometre
μs	microsecond
°CA	degrees crankangle rotation
AAAS	American Association for the Advancement of Science
ABD	anti-blooming diode
ABG	anti-blooming gate
AC	alternating current
ACE	Advanced Combustion Engineering Institute
ADC	analogue to digital converter
ADPA	American Defense Preparedness Association
AHSP	Association for High Speed Photography
AIAA	American Institute of Aeronautics and Astronautics
ANFO	ammonium nitrate fuel oil
APS	Advanced Photo System
Ar	argon
ARA	Aeroballistic Range Association
ASA	American Standards Association
atdc	after top dead centre
AWE	Atomic Weapons Establishment
AWRE	Atomic Weapons Research Establishment
bit	binary digit
btdc	before top dead centre
°C	degree celcius;
C	diameter of the circle of confusion
CA	crank angle
CCD	charge coupled device
cd	candela
CD	compact disc
CDS	correlated double sampler
CEA	Commissariat à l'Energie Atomique
CFA	colour filter array
CFF	critical flicker frequency
CID	charge injection device
CPU	central processing unit
CSI	compact source iodide lamp
CT	colour temperature
CW	continuous wave
dB	decibel
DC	direct current
DLI	Doppler laser interferometry
DOF	depth of field
DQE	detective quantum efficiency
DRAM	dynamic random access memory
DTEO	Defence Test and Evaluation Organization
EFP	explosively formed projectile
EI	exposure index
EMC	electromagnetic compatability
EMR	electro-magnetic radiation
EPSRC	Engineering and Physical Sciences Research Council
ES	Edison screw
EV	exposure value
ffps	full frames per second
FOV	field of view
fps	frames per second; fields per second
fs	femtoseconds
FXR	flash X-ray
g	acceleration due to gravity
G I	generation one
G II	generation two
G III	generation three
GM	General Motors
H	horizontal
HeNe	helium neon
HIPI	high intensity photographic illuminator
HMI	hydragyrum (mercury) medium–arc iodide
HSP	high speed photography
Hz	hertz
IC	Integrated circuit
ICHSPP	International Congress on High Speed Photography and Photonics
ICIASF	International Congress on Instrumentation in Aerospace Simulation
IEEE	Institute of Electrical and Electronic Engineers
II	instantaneous image
IRIG	Inter-Range Instrumentation Group
IS	image server
IVF	instantaneous velocity field
J	joule
k	kilo – ($\times 10^3$)
K	degree kelvin
KDP	potassium dihydrogen phosphate

LASCR	light activated silicon controlled rectifier
LASCS	light activated silicon controlled switch
LASER	light amplification by stimulated emission of radiation
LCA	Laboratoire Central de l'Armement
LDA	laser Doppler anemometry
LED	light emitting diode
LIF	laser induced fluorescence
LII	laser induced incandescence
LLNL	Lawrence Livermore National Laboratory
lm	lumen
lx	lux
M	flash bulb synchronization coding; mega
MCP	microchannel plate
MIT	Massachussets Institute of Technology
mJ	millijoule
MOS	metal oxide semi-conductor
mR	milliradians
ms	milliseconds
mV	millivolts
MZI	Mach–Zehnder interferometer
NASA	National Aeronautics and Space Administration
N	newton
N	f-number
Nd:YAG	neodymium–yttrium–aluminium–garnet
NO_x	species of nitrogen oxide
ns	nanoseconds
NTP	normal temperature and pressure
OH	hydroxyl
OPD	optical path difference
Pa	pascal
PC	personal computer; printed circuit
PETN	pentaerythritol tetranitrate
PIV	particle image velocimetry
PMMA	polymethylmethacrylate
pps	pictures per second
ps	picoseconds
psi	pounds force per square inch
PT	phototransistor
Pt–Si	platinum silicide
PTV	particle tracking velocimetry
PVDF	polyvinylidene fluoride film
Q	resonance magnification; quality factor
QE	quantum efficiency

R&D	research and development
RAM	random access memory
RARDE	Royal Armaments Research and Development Establishment
RGB	red, green and blue
rms	root mean square
RO	record only
ROC	record on command (mode)
ROM	read only memory
rpm	revolutions per minute
rps	revolutions per second
s	second
SAE	Society of Automobile Engineers
SCR	silicon controlled rectifier
SCSI	small computers systems interface
SECAM	séquential avec mémoire
SHG	second harmonic generation
SMPTE	Society of Motion Picture and Television Engineers
SNR	signal to noise ratio
SPD	spectral power distribution
SPIE	Society of Photo-Optical Instrumentation Engineers
sr	steradian
SR	swirl ratio
SRL	super radiant light (sources)
STL	Space Technology Laboratories
SV	still video
SVC	still video camera
S-VHS	Super VHS
SW	swirl ratio
tdc	top dead centre
TIFF	tag image file format
TNT	trinitrotoluene
TTL	transistor–transistor logic
UHS	ultra-high speed
UMIST	University of Manchester Institute of Science and Technology
V	volt; vertical
VCR	video cassette recorder
VHS	video home system
W	watt
YAG	yttrium–aluminium–garnet
YOC	yaw observation camera

Introduction to high speed photography

Peter W. W. Fuller

1 Introduction

High speed photography, is now a long established, and well acknowledged, part of the scientific scene. More recently it has been increasingly employed across the communications, industrial and artistic fields as its unique capabilities and advantages have become apparent. The methods and apparatus involved are numerous and varied, and practitioners may spend many years in becoming expert in the techniques or in specializing in one particular area. Thus high speed photography is not mastered solely by technical studies but requires much applied practice as well. Those who have already become proficient in normal photographic practice are well equipped to move into the high speed region as many of the fundamental activities are the same.

The aim of this book is to describe and introduce some of the specific technical aspects of high speed photography to the photographer and also to provide an interesting general background in the subject for the layman.

1.1 Definitions

When writing about scientific subjects it is usual to begin with definitions and define terms. With high speed photography this is not a simple matter. If the question 'What constitutes high speed photography?' were to be put to a selection of experts in the field, they may well all give different answers. According to interpretation, all could be correct. The problem is that high speed photography uses the same basic principles as ordinary photography, but at some point, in the scale of increasing framing rate or decreasing exposure times, it slides into the province of high speed photography. The growth of electronic recording has led to the need to widen the description of high speed photography to include the term 'photonics'. The subject is now usually referred to as 'high speed photography and photonics' to enable it to include all possible systems. Photonics can be defined as 'the technology of generating and harnessing light and other forms of radiant energy whose quantum unit is the photon'. To be completely accurate, 'photonics' is not the sole province of high speed photography and can equally well be included in a description of modern slower speed photography.

In earlier times, to attempt a quantitative definition the American Society of Motion Picture and Television Engineers (SMPTE) suggested that high speed photography could be defined as 'exposures of one millisecond or less and framing rates of 250 frames per second or more'. Whilst this at least gave some precise numerical criteria, if one views it in the context of today's nanosecond exposures and 100 million pictures per second framing rates it does appear a little pedestrian.

A general definition could describe high speed photography as 'recording optical or electro-optical information fast enough for an event to be evaluated with a temporal resolution which satisfies the experimenter' (Paisley, 1993). Normally an experimenter would like a time resolution of, say, one to three orders of magnitude smaller than the event duration. Thus an event lasting one millisecond would be resolved by individual exposures of 100 down to 1 μs. For the results to be viewed as a smooth explicit sequence which would give a good impression of the process, cine photography would be employed and 30 to 100 frames or even more may be required. If only data on movement direction and velocity are needed, then as few as 5 to 10 frames may suffice.

However, it is not sufficient to include only temporal resolution in framing rates or by exposure duration, spatial resolution must also be considered. The two requirements have to be balanced against each other to give the best solution for each problem. Whilst cine photography usually springs to mind at the mention of high speed photography, the term can equally well be applied to single records or multiple records within one frame.

The general definition quoted earlier can thus be slightly modified to cover all aspects adequately: 'recording optical or electro-optical information with adequately short exposures and fast enough framing rates for an event to be evaluated with a temporal and dimensional resolution which satisfies the experimenter' (Fuller, 1994).

1.2 Purpose and advantages

What is the purpose of high speed photography and why is it required? In the study of the world around

them, humans have constantly been faced with the problem of events which are of short duration or in which things move so fast that they have been unable to observe them adequately with the naked eye. In early times most of these events were natural occurrences. As time went by and scientific studies began, man-made events and experiments produced the same kind of problems and the inability to observe fast movement limited scientific advance.

In order to understand an event or process thoroughly, a fundamental requirement has always been a need to measure, quantify and record it. The introduction of high speed photography began to offer a new and powerful means of making such measurements. High speed photography was thus initially developed and improved to serve primarily as a measurement tool. In modern times its use has been extended into the fields of art, communication and modern films, so that advertisement or drama make much use of high speed photography in order to produce 'slow motion' effects. In this case the scene is captured using a high framing rate to record motion normally too fast or complex for the eye to follow in real time. It is later replayed at a much reduced rate so that the time scale is stretched proportionally and the eye has time to observe the motion and refocus on various parts of the scene whilst it is taking place. The same process, often used in more extreme proportions, is one of the frequently used methods in scientific research involving high speed photography.

High speed photography provides two major benefits. Firstly, it enables the observation and recording of events in which the movement is normally too rapid to be followed by the naked eye. Secondly, it gives the power to manipulate time; events can be speeded up or slowed down from their natural occurrence rate when the record is reproduced. This is a major advantage as the event can be repeatedly played back at a rate which can be followed by the naked eye, until all the information required has been obtained either by simple observation or by detailed analysis. To the above advantages, we can add the ability to record images produced by otherwise invisible radiations such as ultraviolet or infrared and to make observations remotely or in areas where it would be unsafe or impossible for human observers to go.

2. Properties of the eye

The human eye, in conjunction with the brain, can perform astonishing feats of discrimination, adaptability and correlation and has a wide range and sensitivity to incoming images. In overall performance it far outstrips our other senses and also the best optical devices produced to date, although in specific aspects they may exceed its capabilities.

However, in the observation of rapidly changing phenomena it does have important limitations that can be considered as both advantages and disadvantages.

2.1 Persistence of vision

The eye–brain combination has the ability to retain the impression of a brief stimulus for a short time after it has gone. In early times a glowing stick whirled in a circle appeared to produce a continuous line and the phenomenon was known as *persistence of vision*. However, the effect was not studied in a scientific manner until 1765 when Chevalier d'Arcy, a French scientist, fixed a hot ember to a wheel and rotated it at an increasing rate until the glow appeared to form a complete circle. By measuring the rotation rate he was able to deduce that the persistence of vision lasted for about one-tenth of a second (0.1 s). He reported his findings to the French Academie des Sciences in the same year.

Later, in the early 1800s, scientists such as Murrey, Roget, Banks and Paris studied the optical effects produced when observing rotating objects at intermittent rates. In 1827, the Belgian physicist Joseph Antoine Ferdinand Plateau showed that at low illumination levels the persistence time was affected by object colour. He also made experiments with wheels which had vertical pegs fixed at equal intervals around their circumference. By observing the pegs on one wheel through those of another and varying the rate of rotation, he was able to make further observations on persistence time. Around the same time in England, the scientist Michael Faraday carried out similar experiments to determine critical flicker frequency. In modern times it is possible sometimes to observe similar phenomena to the experiments carried out above, when an old Western movie is viewed. At certain combinations of the actual speeds of the screen objects, and the filming and projection framing rates, things such as stagecoach wheels can appear to be turning backwards. Similar effects can be observed if a strobe light is used to make a cyclic motion, e.g. a rotating fan, appear stationary. Just above or below the critical frequency for a static appearance the fan may appear to change direction. Fox Talbot also became involved and in 1834 proposed his principle known as Talbot's law or the Talbot–Plateau law. This stated that 'if a point on the retina is excited by a light which undergoes regular and periodic variations and which has the duration of its period sufficiently short, it produces a continuous impression equal to that produced if the light emitted each period were distributed uniformly throughout the duration of the period'.

Whilst the eye does have severe disadvantages in its ability to follow fast changing images, in certain circumstances in combination with the brain it has a

significant retentive ability to hold an image in memory even if the exposure to the eye is very short. In order for this retention to be long enough to be registered unchanged by the brain there must not be another presented image or images directly following the first, or the brain will attempt to deal with the fresh information and the image will be lost. For example if an observer is in a dark room and an electronic flash is used to light the room, the scene will stay in the mind long enough for the brain to recall considerable detail. In early days, before photography was in regular use, this method using electrical spark illumination was often employed by scientists to study phenomena. After the event the observer would quickly make a sketch of the remembered image. This obviously had a high possibility for the introduction of errors and was a strong incentive for the development of an alternative process which would provide an accurate and permanent record. Photography was to provide such a process.

For repetitive or cyclic motion it is possible to illuminate the subject with a bright, short duration, pulsed light source or stroboscope. By adjustment of the source repetition rate a moving object can apparently be frozen in motion by ensuring that it is illuminated each time in precisely the same position in its cyclic motion. The eye, presented with the same image at a rate above the critical flicker rate, will then see an apparently stationary object.

2.2 Critical flicker frequency

The Talbot–Plateau law led to the idea of critical flicker frequency (CFF). If the eye is observing a source which is flashing above the critical flicker frequency, the source will appear continuous. For average lighting levels this will be about 16 flashes per second. As the source becomes brighter the critical flicker frequency will increase. This varies somewhat from person to person and with the image brightness and exposure time. We experience this every day when using filament lamps driven by the mains supply. Although the filament brightness is varying 50 times per second (Hz), this is above the critical flicker frequency and the light appears continuous to the eye. Conversely, most readers will have seen replays of early motion pictures in which the framing rate was relatively low and will recall the apparent extremely jerky movement of the subjects due to the framing rate falling below critical flicker frequency.

Films and television images are thus presented at above this critical rate. Films are usually shown at 16–24 frames per second (fps) and, to prevent critical flicker at low projection rates, individual frames may be projected several times in succession, the light is then cut off whilst the film moves on to the next frame and the sequence is repeated.

In the case of television the picture is made up of 625 horizontal lines (in the UK system). During transmission, every second line of the image is transmitted (first field) and then followed by the remaining lines (second field) forming an interlaced whole to create the picture. In this way 50 fields are projected per second to give 25 flicker free full pictures (frames) per second.

The film or television sequence is made up of still, discrete images each varying slightly from its predecessor. Providing the changes are presented to occur above the critical flicker frequency the eye and brain give us the illusion of continuous movement. Whilst this is a significant disadvantage in some respects, it is also a beneficial advantage in that it is the fundamental property which allows film projection and television to be viable processes.

2.3 Visual acuity

The acuteness of vision is not the same for all parts of the retina. Acuteness of vision is very high in the area known as the fovea, this is located in the lower middle of the retina, where the optic receptors are closely packed and the optic nerves exit to the brain. The diameter of the fovea is about 0.5 mm and the eye tends to try to orientate the eyeball so that the retinal image is focused on this spot. The small subtended angle of the fovea means that at 1.524 m (5 feet) distance the field of acute vision is less than 25 mm (1 inch) in diameter. This means that to observe an extended field the eye is constantly moving and trying to follow the area of interest. Thus when a moving object is observed which is moving faster than the eye muscles can rotate the eye to keep it focused on the fovea, the object becomes blurred.

Because of this problem, the persistence of vision and other limitations of the eye, the observation of fast changing phenomena must be made by special apparatus and processes which can act as enabling intermediaries between the event and our eyes. This is the role of high speed photography.

3. Image blur

To avoid image blur the main criterion is the time it takes for an object to move its own length. It is this time (T) which controls the maximum attainable resolution for a given exposure rather than the object's speed. In practice, many factors will be involved, including the camera, exposure time, recording medium response and resolution, the layout and geometry of the equipment and event, object size and object speed.

From this it is obvious that the worst subject to observe is one which is very small and travelling very fast, e.g. a micrometeorite. Some idea of suitable exposures to 'freeze' practical subjects is illustrated in Figure 1. This brings out the benefits

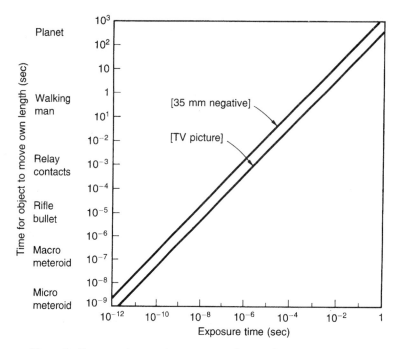

Figure 1 Exposure time requirements to produce two image quality levels for moving objects.

or disadvantages of subject size. Whilst a planet is moving very fast it is also very large, so T is relatively large; conversely, a walking man is not moving very fast but he is relatively small, so T is surprisingly short. At the furthest extreme the micrometeorite is both very fast and very small and exposure requirements become extremely demanding (Swift, 1992). In scientific or technical usage high speed photography is used primarily for subjects which are in very rapid motion. It allows observations and measurements to be made as though those subjects were stationary in one or more sequential positions.

The requirement to make clear observations and measurements presupposes high resolution, blur-free images. This is achieved by adequately short exposures rather than by the increase of framing rate. Increasing the framing rate allows the observation of the subject to extend for a longer percentage of the event duration, i.e. the intervals of time between images becomes shorter, so that for fast moving subjects the resolution of change rate becomes higher. If it is necessary that no part of the event time remains unobserved, then techniques such as *streak photography* (see Chapter 7) allow continuous observations. However, the subject then ceases to be recognizable as a whole and we can only observe the motion of selected edges, interfaces or changes in luminous intensity.

4. Information content of images

Most scientific endeavour is concerned with the gathering of information. For good scientific work the information must be accurate, it must be adequate to carry out the subsequent analysis which may be required, and it has to be acquired at a sufficiently high temporal rate and in a short enough exposure time to offer the resolution that the study requires. When searching for observation methods with the highest information recording rates, the engineer or scientist may be excused if their first thoughts centre on electronic and computing processes, since these now figure so prominently in the modern world. The computing 'byte' of information is made up of a varying number of 'bits' which define its resolution. The greater the number of bits the finer the gradations or resolution of the byte. Talk of megabytes (10^6 byte) or even tens of megabytes per second can appear most impressive in terms of information gathering capability. However, it still falls far short of the possibilities of the simple black and white film negative.

Consider such a negative made up of a pattern of adjacent dots each, say, 20 × 20 µm in size. A 20 × 20 mm square of negative will then contain one million (10^6) information elements. This is a relatively modest attainment for modern photographic processes. If each dot can assume a number of different density values, e.g. ten, then each

20×20 mm area of film can represent a choice from ten million (10^7) possible information elements. In reality the number of possible density values will be far higher than ten. In a typical snapshot type exposure of 1/250th of a second, 10^6 information elements will be recorded at a rate of 2.5×10^8 elements per second.

Using high speed photography, exposure times may easily go down to one microsecond or much less. Again considering the simple example above, the recording rate could rise to 10^{12} information elements per second instantly recorded in *parallel* without intermediate processing. Even the best electronic systems are still not currently attaining these levels in one-step recording. This represents the fundamental reason why video and electronic image recording still fall short of film standards at the present time.

However, these enormous amounts of information can give problems when we wish to analyse and make use of the records. It is unfortunate that information processing and retrieval of photonics images have not progressed at the same rate as improvements in reducing exposure times and increasing framing rates. These aspects are now receiving much more attention and, aided by the constant advances in electronic scanning and computer processing, the situation is steadily improving.

5. Applications

In more artistic applications of high speed photography, e.g. nature photography or advertising features, there is not so much concern about exploitation of measurement capability. However, picture quality and resolution are the paramount requirements and so the demand for technical expertise is on a par with that required for more conventional scientific applications.

Table 1 List of fields of application of high speed photography

Fluid flow and combustion research
Aero and armament research
Machining and tool design
Manufacturing processes
Physical and chemical processes
Sporting and physiological studies
Behaviour and movement of animals, birds and insects
Lighting and electrical engineering research
Medical research
Astrophysics research
Accident research
Racing timing
Transport and vehicle research
Materials research
Atomic energy research
Educational studies
Advertising and entertainment

The uses and applications of high speed photography are extremely wide and grow steadily as exposure times become shorter, framing rates become faster and resolution and image quality improve. Some of the areas in which high speed photography is used are listed in Table 1. This is not an exhaustive list and there are now very few areas in which high speed photography is not or could not be beneficially applied. Often the equipment is expensive to buy, but where only occasional use is needed, hiring can be a good alternative, together with the services of an expert consultant in high speed photography.

6. The future

The first high speed photographic experiments were conducted nearly 150 years ago. During that time light sources and cameras have developed through an amazing variety of systems, usually with the aim of providing higher and higher framing rates. Mechanical cameras have now reached a plateau of development and few really new mechanisms have appeared in recent years, so that new designs tend to be improvements on basic existing mechanisms.

As the subjects and events selected for study have grown more exotic and have tended towards shorter and shorter durations, mechanical cameras have reached their limits and electro-mechanical and purely electronic systems have evolved to cope with the extremely short exposures and high framing rates required. In fact, for some time it has been possible to proceed from image capture to hard copy printout via electronic cameras and computers without the use of film at all. In addition the steady increase in performance of video cameras and recording systems has opened up a new area of opportunity for photographers. In many instances they now have a viable alternative to the use of conventional cameras and film. In the case of still pictures the latest charge coupled device (CCD) chips are made with such high resolutions, i.e. several million pixel (picture elements) in a frame, that for many requirements they are valid substitutes for film. Video also provides an invaluable backup in the preliminary definition of what will be required if it is decided to use film and its special properties in the final recording.

A comparison of the major advantages and disadvantages of film and video is given in Table 2. This is not an exhaustive list and tends to change as new developments occur. At present the main advantages of film are resolution and full frame recording rates coupled with the number of frames recorded.

The growth in ability of electronic camera systems does not mean that film is becoming obsolete. This is far from the case and is likely to remain so for a very long time. It is expected that film and electronic

Table 2 The advantages and disadvantages of film and video systems for high speed photography.

Film	*Video*
Advantages	
Very wide range of framing rates	Instant replay
High spatial resolution	Reusable recording medium
Colour/black and white	Direct computer interfacing
Relatively low equipment cost relative to	Ease of use
exposure capability	Ease of multiple camera synchronization
Well established laboratory services	Colour/black and white
Storage depreciation characteristics well known	On screen photometric adjustment and analysis
Wide range of film speeds	Synchronized sound
Large format	Long recording times
Traditional technology	Lower running costs
	Fast information transfer
	Relatively easy to operate
	Low environmental impact
Disadvantages	
High running costs (film and chemicals)	High capital costs
Relatively difficult to operate	Lower resolution
Short recording times	Complex maintenance
Slow processing of results	Media storage characteristics not well known
Complex maintenance for high performance cameras	Smaller format of recording element
Relatively tedious analysis	Lower range of framing rates
Slow information transfer	Lower light sensitivity range, but this is constantly
Logarithmic recording of intensity	improving
Film processing and analysis equipment	
Additional requirement to camera	
Chemical handling involved in environmental impact	

recording will proceed not as rivals but as complementary systems, each with their own special merits.

The Kodak Advanced Photo System (APS) now has film which has a magnetic coating on one side capable of recording from 2000 to 8000 bytes of information. This may be used in a conventional way to record manufacturer, camera and possibly photographic data. However, it could also be used to record a brief description of the film subject and photographer's notes. The possibilities appear widespread – perhaps low resolution digital images for image editing, certainly information for subsequent digital processing of the image, and file and storage data. There is even the possibility that future computers might incorporate a film reading slot so that a film cassette can be passed as a storage medium much as a disc is passed at the present. The possibilities appear very exciting and there could arise a third composite medium of magnetic/film, combining the best features of both.

The modern experimenter using high speed photography must therefore have not only the long established knowledge of mechanical cameras and film, but also a working knowledge of electronics, computers, pixels and digital recording techniques. This is a formidable requirement.

Modern high speed photographic techniques are grossly underused in industry and scientific research.

One of the objectives of this book is to bring the advantages and practice of high speed photography to a wider audience, with the hope that it will encourage many more scientists and experimenters to make use of its many unique attributes.

References

Fuller, P. W. W. (1994) Aspects of high speed photography. *J. Photogr. Sci.* **42**, no. 1, 42–43

Paisley, D. L. (1993) What constitutes high speed photography? *OE Reports,* **Nov** 13

Swift, H. (1992) *Impact Dynamics*. Wiley, New York

Bibliography

Dubovik, A. S. (1968) *Photographic Recording of High-Speed Processes*. Pergamon Press, London

Hyzer, W. G. (1962) *Engineering and Scientific High Speed Photography*. Macmillan, New York

Jones, G. (1952) *High Speed Photography*. Chapman & Hall, London

Saxe, R. F. (1966) *High Speed Photography*. Focal Press, London

1 The development of high speed photography

Peter W. W. Fuller and John T. Rendell

1.1 Introduction

High speed photography is almost as old as photography itself, and closely involved with one of the leading pioneers, William Henry Fox Talbot. The 19th century saw the beginnings of both ordinary photography and high speed photography. By 1800 the fundamental basis of photochemistry had been established, and in the early 1800s many approaches to recording images using silver salts on various backing materials were pursued with slowly increasing success. As ordinary, still, pictorial photography slowly advanced, the inventions and improvements were taken and applied to the study of movement in many areas of science.

The way in which the fundamental processes of photography evolved are important to the study of the development of high speed photography. All such developments were dependent upon the current state of the art of image capture and the materials used. Many ideas and suggestions were put forward, and while many were feasible they were not able to be realized until photographic technology had advanced to a suitable point. For example, in 1864, Louis DuCos du Hauron applied for a patent for an idea for observing movement by recording photographs on a flexible band driven by a sprocketed drum and using a battery of lenses.

He was not able to make a working model as flexible film had not yet been invented; however, in 1867 the basic principle was proved by Humbert de Molard using stationary lenses. DuCos du Hauron had a remarkable grasp of the fundamental ideas behind many of the photographic developments which were to come and forecast many of them, including colour photography, which were later to be realized by others who came after him. Sadly, as with many other inventors both before and since, his ideas were not appreciated and he died in 1920, belatedly honoured, in extreme poverty.

1.2 Early photographic processes

During the first 40 years of photographic development there evolved four significant processes, together with many variants, for image recording.

These were the *daguerreotype*, the *calotype*, the *wet collodion plate* and, after two decades, the *dry plate process*. The broad principles were the same for all methods. The surface meant to receive the image was prepared on a backing of paper, glass, metal or more exotic materials such as thin leather, and then sensitized to produce a receptive area. The image was captured and then developed and fixed. If it was in negative form it might be made into a positive print. The actual practices were often very complex, subtle and intricate, and in early times possibly more art than science.

In the 18th century it had been discovered that silver salts were acted upon by exposure to light and darkened as metallic silver was formed. The discovery was not exploited to attempt proper photography although transient images were obtained. In 1802, Thomas Wedgwood, whose father Josiah has a lasting reputation in the field of pottery, experimented with paper soaked in silver nitrate solution. When objects were placed on the paper and it was exposed to light, white silhouettes on a black background were obtained as the salt was converted to black silver. The pictures were not fixed and did not last unless kept in the dark and could only be viewed by weak candlelight. Wedgwood collaborated with Sir Humphrey Davey who carried out similar experiments, but both failed to find a means to fix the images.

In 1813, Joseph-Nicéphore Niépce in retirement at Chalon-sur-Saone in France, began experiments to obtain images using photochemical methods. In 1816 he used a form of camera, the 'camera obscura' or pin-hole camera, to record an image. The picture was of the courtyard of his house and was recorded on paper sensitized with silver chloride and partially fixed with nitric acid. This was the first recorded use of a camera for such a purpose. He produced a negative picture and tried unsuccessfully to produce a positive from it.

Later he tried a different approach and turned to the use of 'bitumen of judea', a resinous substance which hardens on exposure to sunlight and then resists solvents. A thin film of the resin was placed on a polished pewter plate. After exposure, oil of lavender was used to dissolve the unhardened resin, leaving an image in the thin resin layer. The light

areas were resin and the dark areas bare pewter. Niépce called the process *heliography* (from the Greek words *helios* meaning sun and *graphein* meaning to draw). His first proper photograph using this system was taken in 1826, a view from his workroom window. He then moved to the use of silver plated copper sheets and improved the contrast of his pictures by blackening the remaining silver coating with iodine vapour. In 1829, Niépce signed an agreement with Daguerre to work together on the process. Unfortunately, Niépce died suddenly in 1833 leaving Daguerre to reap most of the fame and glory by using a modification of the original system.

1.2.1 The daguerreotype

The daguerreotype method was published in 1839 by Louis Jacques Mandé Daguerre, a French painter who collaborated with Joseph Niépce in its invention. Niépce's original method had required very long exposure times amounting to hours in sunlight. Daguerre's modifications allowed comparatively short exposures of minutes rather than hours. A film of silver iodide was formed on a polished silver plate and had to be exposed within an hour. Daguerre had discovered that very faint or latent images could be developed by exposing the plate to mercury vapour. It was this discovery which made such a difference to the required exposure time. In 1837 he discovered that the images could be fixed by using a solution of common salt and, later, hypo (sodium thiosulphate). Daguerreotypes were unique and could not be reproduced except by repeating the photograph. They could be viewed as positives or negatives depending on the viewing conditions and were also reversed images as would be seen in a mirror.

The publication of the daguerreotype process in 1839 caused many people to come forward with claims to have produced images by the action of light. Some had done valid work using various silver salts to coat glass, metal, leather or paper and fixing the images obtained with salt or hypo. Among them were people such as F. Gerber, J. B. Reade, J. Herschel and H. Bayard. Reade used an infusion of gallic acid as an accelerator, not realizing that it was developing a latent image. The knowledge of the use of gallic acid was later passed on to Talbot and assisted him in the invention of the calotype process. Sir John Herschel contributed a great deal to the development of photography including the first use of the words 'photograph' and 'photography' and introduced the terms *negative* and *positive* in 1840.

1.2.2 The calotype

The calotype method was evolved between 1835 and 1844 by William Henry Fox Talbot. It was the first two-stage photographic process, i.e. producing firstly a negative picture from which a positive could then be made, and could be carried out using a paper base instead of metal plates. He used paper coated with silver chloride and silver nitrate solutions and fixed them rather poorly with ammonia or potassium iodide solutions. The system was still slow and required exposures of half an hour or so and did not have the quality of the daguerreotype. Talbot struggled to improve the process and in 1840 discovered the ability to develop the latent image formed after a much shorter exposure time by using gallonitrate of silver. This was assisted by following the information on its use as an accelerator given to him by Reade. Good quality writing paper was coated with silver nitrate and potassium iodide to form silver iodide, and then further sensitized with gallic acid and silver nitrate. After exposure the negative image was developed using more gallonitrate of silver solution and was fixed using hypo and other salt solutions. The positive image could be printed by repeating the process, but this time sandwiching the negative with a fresh sensitized paper and exposing the combination to light. The positive was then developed and fixed in the same way to give a print. Whereas the daguerreotype was unique, each picture being a limited edition of one, Talbot's work represented a great advance, as a large number of copies could be obtained from a single negative.

1.2.3 The wet collodion plate

In 1848, Abel Niépce de Sainte-Victor, a cousin of Nicéphore Niépce, published a method of photography on glass. A glass plate was coated with white of egg sensitized with potassium iodide, washed with an acid solution of silver nitrate. After exposure it was developed with gallic acid and fixed. Exposures were still long, up to 15 minutes, but the clear plates were very good for magic lantern slides.

The wet collodion process was published in 1851 by Frederick Scott Archer in the March issue of *The Chemist*. Archer was a sculptor and experimented with calotyping because he wished to keep portraits of his sitters. Collodion, a mixture of gun cotton dissolved in alcohol and ether, was coated onto glass plates. The layer was sensitized by treating with ammonium iodide and bromine solution and then a silver nitrate bath. The plates were exposed immediately while still wet. Development was by pyrogallic acid and fixing with hypo. Although a very messy and complicated process, exposure times were only 2–3 s in bright sunlight compared to the previous long exposures, up to hours, required by earlier systems. The system required heavy equipment and a portable dark room for field use and was cumbersome and messy. Nevertheless it survived in use for many years due to lack of a better alternative.

1.2.4 The dry plate

The wet plate system fell from favour in 1871 when Dr Richard Leach Maddox published his dry plate process. The emulsion was now made with a coating of gelatin mixed with silver bromide. Development and fixing were similar to the wet plate system. However, plates could be stored in the dark and used when required and could also be stored after exposure and developed later. Initially exposure times were very much longer than the wet collodion process, but this was rapidly improved and the enormous benefits in convenience of handling won it immediate success. Exposure durations now came down to one twenty-fifth of a second allowing use in hand held cameras.

Plates were now made commercially for sale, and small easily portable cameras were designed to exploit the new development. Photography began to be more readily available for use by the general public, and of course its use in scientific photography was also facilitated. Dry glass plates were still heavy and prone to breakage and many attempts were made to improve the emulsion support. Some methods involved peeling the emulsion from a paper backing but these were not initially very suitable. In 1888, John Carbutt began to use very thin celluloid sheets, coated with gelatin emulsion. Celluloid had been invented in 1861 by Alexander Parkes but had previously been used in rather thick sheets. Greater success was obtained with nitrocellulose and later cellulose acetate as a backing material, allowing the development of the design of cine cameras to advance.

1.3 Early developments in still photography

Unfortunately, most of the results of early attempts at high speed photography are now lost and, although descriptions of work remain, very few prints or negatives survive. It took some time for the scientific community at large to realize the importance of photography in the study of moving subjects and the general making of records. The number of successful practitioners was also relatively few and when they died much valuable material was lost due to failure to realize its importance.

1.3.1 William Henry Fox Talbot

The first recorded usage of high speed photography was due to one of the early pioneers of photography, William Henry Fox Talbot and occurred in 1852 (Talbot, 1852). The slow shutters and small aperture lenses then available were satisfactory for pictorial photography of still subjects but still inhibited the study of moving subjects. Fox Talbot was keen to make photographs of objects in motion and searched for suitable alternative methods. The alternative to slow shutters and lenses was the use of a short duration, high intensity light with which the object could be illuminated. This would help to compensate for the then relatively slow speed of available emulsions. To produce such a photograph a camera with an open shutter would view the subject in a darkened room. It was known that the Leyden jar, the forerunner of our modern capacitor, could store high voltage energy which could be suddenly released to form a short intense spark.

In a demonstration to the Royal Society, Fox Talbot set up a page of *The Times* newspaper on a wheel or drum (accounts vary) which could be turned at high speed. Using a spark to illuminate the page surface briefly he photographed a small area of the fast moving print. On development of the negative, the print could be read clearly, the motion of the subject had been effectively frozen and high speed photography had been born (Talbot, 1852; Anon., 1864).

In 1852, Fox Talbot is quoted to have written

> . . . it is in our power to obtain the pictures of all moving objects, no matter in how rapid motion they may be, provided we have the means of sufficiently illuminating them with a sudden electric flash. But here we stand in need of the kind of assistance of scientific men who may be acquainted with methods of producing electric discharges more powerful than in ordinary use. What is required, is, vividly to light up a whole apartment with the discharge of a battery: the photographic art will then do the rest and depict whatever may be moving across the field of view.

Curiously, Fox Talbot moved on to take up other investigations and little use was made of this landmark experimental method for some 20 years. Once it was realized that short duration exposures could be used to study moving objects, many more photographers took up the challenge.

1.3.2 Thomas Skaife

In July 1858, an amateur photographer called Thomas Skaife took photographs of cannon balls in flight during mortar firings on Plumstead Marshes near Woolwich. Accounts were published in *The Times* in 1858. His simple camera used a pair of vulkanite shutters overlapping at the edges like a pair of double doors, following a design which he had patented in 1856. The wires which acted as shutter hinges projected through the camera case and were fitted with small reels. The reels were connected by silk threads and the shutters kept closed by an elastic band. A pull on another thread opened both shutters a quarter turn and upon

release they closed immediately. Using elastic bands to trigger the shutter opening, exposure times of about one-fiftieth of a second were estimated. The pictures were recorded on wet collodion plates. Viewers of the pictures obtained were reputed to have asked in some puzzlement 'How did you stop the cannon ball while you took the picture?'.

Skaife was very inventive and in his Pistolgraph camera, produced in 1859, using 25 mm (1 inch) square glass plates and a short focal length, wide aperture lens, he produced the forerunner of most modern miniature cameras. The camera did not resemble a pistol but was so called because of the release mechanism for the shutter which resembled the trigger of a pistol. Skaife is reported to have tried to take a picture of Queen Victoria and was detained until the police were assured that the camera was not an assassination weapon. Unfortunately, in the proving of his innocence the photograph was destroyed so no record remains. In 1860, Sir John Herschel may have had the Pistolgraph in mind, when likening the ease with which the small camera could be used to the actions in shotgun shooting, he wrote of the possibility of 'taking a

photograph as it were by a snap shot', the first record of the use of this term (Skaife, 1858, 1860, 1861).

1.3.3 Ernst Mach

The German Ernst Mach is well known for his work in aerodynamic science and his name is commemorated in *Mach number*, a term relating flight velocities to the speed of sound. However, he was an accomplished scientist in many other disciplines, including ballistics. By the early 1880s he had renewed the use of spark photography and was employing it, together with schlieren techniques, to photograph bullets and shells in flight. Later he collaborated with his son L. Mach, who also continued to carry out similar experiments following his father's lead.

Initially the sparks were triggered by allowing the projectile to short a simple wire switch to fire the spark discharge. These switches sometimes interfered with a clear view of the subject and L. Mach developed an ingenious way to produce a noncontacting switch (see Figure 1.1). The bullet passed

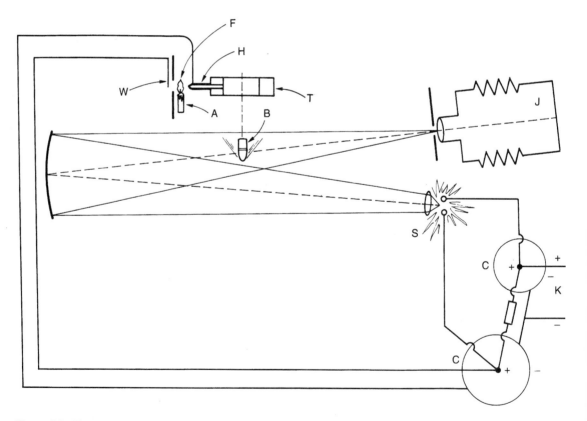

Figure 1.1 The apparatus used by L. Mach for taking schlieren photographs. K, Charging circuit; C, storage capacitors; S, photographic spark; B, bullet; J, camera; A, candle; T, trigger tube; H, side tube; F, blown flame; W, ionization switch.

through a short tube to which was connected a side tube at the end of which a candle flame was placed. Beside the candle flame was a series gap forming part of the spark producing circuit. The shock wave from the bullet passed down the side tube and blew the ionized gas in the candle flame into the switch gap and fired the spark. The resulting pictures shed new light on the differences in flow distribution and turbulence about bodies of different shapes and clearly demonstrated the effects of blunt or streamlined models (Mach and Mach, 1889).

1.3.4 Joseph Cranz

A little later, Joseph Cranz, an eminent Austrian ballistician, also used spark photography to study aerodynamic flow and shock waves. Together with Koch he also photographed the vibration modes of gun barrels and rifle recoil motion. For these experiments he used both continuous and spark sources. He was able to introduce a time element into his records by allowing the glass plates to slide vertically under gravity during the exposure time. The introduction of the shadow of a vibrating tuning fork into the field of view also gave a time calibration to the picture. While the images on the film were only points of light, the use of the moving plate changed the record into a continuous line so that the vibra-

tional movement could be traced with time, much as the image presented on a modern cathode ray oscilloscope screen would appear. Cranz used high speed photography extensively in all kinds of applications (Cranz and Glatzel, 1912).

1.3.5 Charles Boys

In England in 1892, Professor Charles Boys was also using spark photography to study flow about bullets. He made many discoveries regarding the properties of shock waves produced by the vibrations induced in impacted objects and also studied the interaction processes of multiple shock waves. He had realized that it was not necessary always to employ schlieren techniques to photograph fluid dynamic processes and much of his work was carried out using the relatively simple apparatus of the shadowgraph system. During the next few years he lectured extensively to the Royal Society describing the results of his spark photography (Boys, 1893).

1.3.6 A. Worthington

Around 1900, Professor A. M. Worthington of the Royal Naval Engineering College at Devonport was continuing the study of fluid dynamics and was following earlier work by Lord Raleigh on the

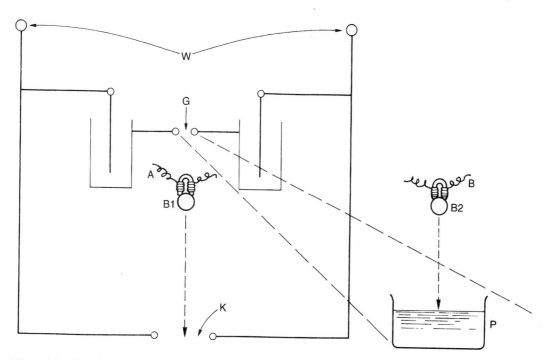

Figure 1.2 Worthington's circuit (simplified) for triggering a spark at a predetermined time. The two electromagnets (A and B) are in series and are switched off together, the two balls (B1 and B2) held by them drop simultaneously and the spark released by ball B1 photographs the splash caused by ball B2. W, Connection to Wimshurst machine; G, illuminating gap; K, gap shorted by falling ball; P, pan of water.

behaviour of liquid splashes. In his early experiments he used a spark to illuminate the experiment and then drew the result from the image retained in memory, a practical example of the use of the persistence of vision phenomenon. This was not a very satisfactory method and he later moved on to the use of photographic records. Like Mach he invented clever devices to trigger his sparks. A particularly effective arrangement acted as both a trigger and a variable delay system (see Figure 1.2). He used a series electrical circuit which was common to two electromagnets. When the current was broken, it operated a mechanism to release a drop of liquid which was synchronized with the release of a steel ball. The ball was arranged to fall through a series gap to trigger the spark. By varying the height of the ball release above the gap, he was able to adjust the spark instant to obtain a series of images of splash development with time. In 1908, he published the book *A Study of Splashes*, containing hundreds of pictures of splash interactions. Like Talbot before him, he was very aware of the potential of photography for scientific observation and in 1908 wrote:

> It would be an immense convenience if we could use a kinematograph and watch a splash in broad daylight, without the troublesome necessity of providing darkness and an electric spark. But the difficulties of contriving an exposure of the whole lens short enough to prevent blurring, either from the motion of the object, or from that of the rapidly shifting sensitive film, are very great, and anyone who may be able to overcome them satisfactorily, will find a multitude of applications awaiting his invention.

Luckily his hopes were to be realized within the next decade (Worthington, 1908; Worthington and Cole, 1897, 1900).

Spark photography has been mentioned many times so far and it may appear that spark photography was the primary method employed in early high speed photography. This was true because at that time no other methods had yet been developed for providing such short exposure times. Initially spark photographs were obtained as individual images, but the urge to provide a visual history of short duration events led to the use of multiple sequential sparks and the search for improved shutters with faster operating times which could be used with continuous light sources.

1.4 Early developments in multiple-still and cine photography

The urge to recreate images of life and movement has existed since man's earliest times and is manifested in the production of cave paintings, shadow plays and puppets. In more modern times the task has been taken over by cine film and video recording and has gained a valuable dimension in the addition of sound. From the earliest beginnings of photography the new medium was seen to open up a new era of image recording. Long before it became a practical possibility there was speculation on the advantages of being able to recreate previously photographed events in a continuous display at a later time. Not only would records be possible of important events and artistic occasions in every day life, but scientists could see the advantages of being able to use the system to analyse motion and make visible events hitherto unseen by the naked eye.

1.4.1 Multiple sparks

Following the single spark photograph experiments already described, it was required to introduce a time factor and event history by producing a series of sequential sparks. This could be achieved by two methods: either using a series of sparks fired in one spark gap, or by multiple spark gaps fired in sequence. With a single gap the rate of firing may be limited by residual ionization, whilst multiple gaps may give many differing locations for the light source or problems with sympathetic triggering.

In 1904, Lucien Bull of the Marey Institute in France, constructed a spark system and associated drum camera both driven by an electric motor. The spindle operated an electrical switch connected to an inductor which produced up to 2000 sparks per second. The drum camera could give 50 full size frames or many more smaller frames. A capping shutter operated by the experiment prevented dual exposures. Bull was able to obtain the first photographs of insects in flight and covered ballistic subjects such as flying bullets (see Figure 1.3) (Anon., 1920). The system was later improved by the use of a free running circuit in which a large capacitor fed a small capacitor connected directly across the spark gap. As the gap reached breakdown voltage the small capacitor discharged and immediately began to recharge fed by the large capacitor. Framing rates up to 15 000 pps could be obtained. In 1905, Kranzfelder and Schwinning successfully discharged 10 capacitors through one gap using a rotating switch. By 1909, Cranz had built a Ballistics Cinematograph somewhat similar to Bull's design, using sparks produced by an oscillator feeding a pulse network. Framing rates up to 10 000 pps were obtained. By 1912, Schatte and Glatzel had managed 50 000 and 100 000 sparks per second, respectively. Multiple separate spark cameras reached a peak of design in the Cranz–Schardin system of 1912, in which multiple sparks arranged in a circle were focused via a common lens onto multiple

Figure 1.3 The high speed photography of Lucien Bull at the Marey Institute, Paris. (a) Lucien Bull with his high speed camera (1904). (b) High speed photography sequence of a house fly taken by Bull (1907). Source: Science & Society Picture Library

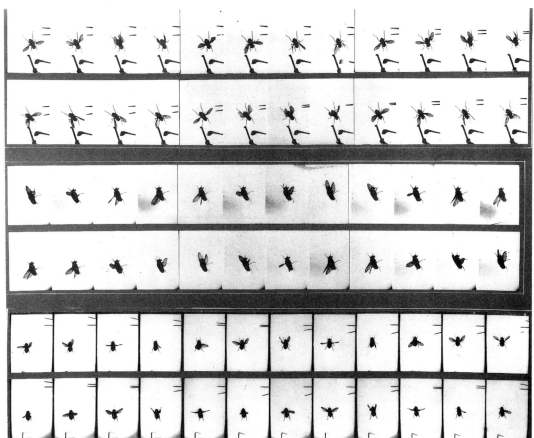

object lenses to produce a ring of pictures on a common plate.

1.4.2 Multiple images/time history

Around 1800, scientists investigated the phenomenon of the *persistence of vision*. In this natural attribute of the eye separate images presented to the eye at a rate of more than about 12–15 per second appear to blend smoothly into a continuous scene of movement. It is this attribute which makes possible the enjoyment of television and the cinema. The discovery of persistence of vision was soon followed by attempts to harness it to view motion synthesis.

At first the effects were achieved by taking a series of drawn images and mounting them in various devices intended to project or present them in rapid sequence to the viewer. Amongst these devices were machines such as the Praxinoscope, Zoetrope, Phenakistiscope and others.

In photographic processes and the majority of cameras, exposures were still quite long. Exceptions to the long exposure rule were cameras such as Skaife's pistolgraph which overcame some of the problems of slow emulsion speed by using small plates and very wide aperture, short focal length lenses. Another method was the use of intense light sources such as the electric spark. Thus, by about 1860, if an action could be controlled to occur within restraints defined by the photographer, a series of consecutive still photographs could be obtained and shown in a Zoetrope or similar device. Objects had to be limited in speed of movement but the first steps had been taken towards introducing a time history into photography.

The scene was thus set in the late 1800s to employ the images obtained by the new science of photography in similar machines to bring about the introduction of cinematography. However, there were two major obstacles: firstly, the best available photographic processes still required exposures of about one twenty-fifth of a second, making sharp pictures of moving objects difficult to obtain; and secondly, the backing materials upon which the emulsions were placed were mostly rigid or, if flexible, did not readily lend themselves to successive projection or movement through a projection device. What was needed was a flexible tough backing for the emulsions which could be manufactured in long strips.

1.4.3 Work of Eadweard Muybridge

In 1830, Edward Muggeridge was born in Kingston on Thames, England. He was destined to have a profound influence on the analysis of movement

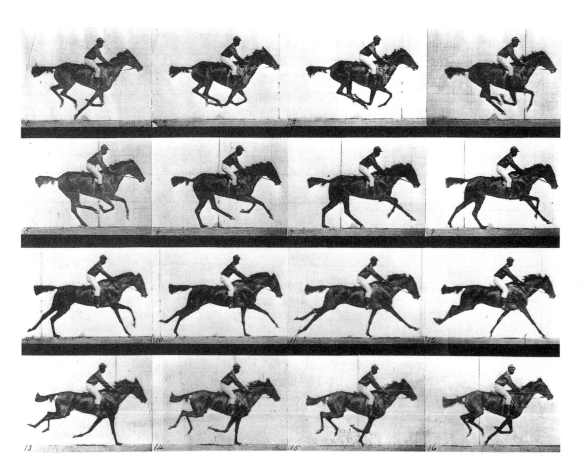

Figure 1.4 Muybridge's pictures of a galloping horse. Note that in frames 2 and 3, all four feet are off the ground at the same time. Source: Science & Society Picture Library

using sequence photography. In 1851, having changed his name to Eadweard Muybridge, he emigrated to America and after an initial period in bookselling he began to study photography. In 1860 he returned to England and learnt the wet collodion process and pursued his interest in photography. He returned to California in 1867 and undertook several assignments in pictorial photography and established a reputation as a photographer of note.

In 1872, Muybridge was asked by Leland Stanford, a former Governor of California, to help settle a controversy. Stanford was interested in horses and the controversy concerned the question as to whether a trotting horse had all four feet off the ground at any one time. Stanford believed that it did and thought it might be confirmed by photography. In 1872 Muybridge made some studies of a horse at Sacramento racetrack, but due to the slowness of the wet collodion process the blurred hooves gave inconclusive evidence. However, Muybridge persevered and in 1873 obtained some sharper silhouette pictures which were adequate to settle the

question, showing that indeed at some point all four hooves were off the ground simultaneously (see Figure 1.4). The improvement in sharpness was brought about by using shorter exposure times, which were possible because the use of silhouette photography required less light than front lit photographs. Muybridge was to make much use of silhouette photography in his subsequent studies.

There followed an interval of several years and then in 1877 Stanford again asked Muybridge to carry out more action photography. During the interim period Muybridge had developed an improved shutter giving a one-thousandth of a second exposure, and using this and better plates he was able to produce much more detailed pictures of horse locomotion. These pictures caused considerable upset when published as they showed motion considerably different from the conventional artistic representations then accepted.

In 1878, Stanford sponsored further work and Muybridge built a special layout to undertake the production of sequential pictures of animals in

Figure 1.5 Muybridge's photographic track. Source: Science & Society Picture Library

motion. A long shed housing a row of 12 cameras was built alongside a track. On the other side of the track a white background was placed on which calibration marks were printed. The shutters designed by Muybridge had two plates, each containing a horizontal slit. The plates were held at the top and bottom of a frame under elastic tension. On release of the shutter the plates and slits moved in opposite directions sliding across each other, the passing slits providing a short duration exposure. The cameras were triggered by threads stretched across the track, contacted in turn by the moving subject the threads made contacts which operated the shutters. With time, the process and layout were improved and hundreds of studies were made (see Figure 1.5). Muybridge designed a projector called the *Zoopraxiscope* which projected moving images made from the photographs onto a screen. The images were reproduced around the circumference of a glass disc which turned in front of the projection lens.

In 1883, having parted from Stanford, Muybridge built a new open air studio at the University of Pennsylvania, and redesigned the system. He now changed to having cameras with multiple lenses using dry plates and a tuning fork recording system to provide a time scale. Shutter control was by electrical signals. His subjects ranged from animals of all kinds to human beings. In 1884 and 1885 he produced over 100 000 photographs. His combined output of photographs represents probably the largest study of animal and human locomotion ever undertaken and selected sets of pictures remain a valuable asset to artists and physiologists worldwide. Muybridge continued to take photographs and conduct lecture tours for many years, finally returning to live in England where he died in 1904 (Muybridge, 1899, 1901).

1.4.4 Étienne-Jules Marey

Whilst Muybridge worked in America, a Frenchman, Étienne-Jules Marey, was working along similar lines in France to study animal motion. Initially he devised mechanical and pneumatic devices to record the movements, the signals were recorded on smoked paper revolving on a drum. The mechanisms, which required attachment to the animal under study, were cumbersome and in some subjects, such as birds, in which he was particularly interested, interfered with the subject's movement. Having heard of the Muybridge work, in 1851 Marey asked him to take some pictures of birds in flight. The results were not very good, Muybridge's cameras being ill adapted for small subjects in vertical movement.

In 1881, inspired by Muybridge and the design of a multi-image camera made in 1874 by Pierre Janseen, an astronomer, Marey built a 'photographic gun'. His idea was to produce a camera capable of taking multiple images and light enough to handle such that it would allow a moving subject, such as a bird, to be followed with ease. The camera had the appearance of a large barrelled rifle with the lens contained in the barrel. The large 'breech' of the gun contained a clockwork mechanism which turned two discs. The metal disc nearest to the lens turned steadily at 12 rps and contained a narrow slit shutter which aligned itself across the barrel 12 times a second. At each alignment the image projected down the barrel was allowed through the slit for 1.39 ms (1/720 s). Immediately behind the first disc another disc containing 12 windows and driven by a cam rotated intermittently, it stopped 12 times a second in line with the image coming down the barrel. A circular or octagonal glass film plate was fitted behind the second disc and revolved with it. With this camera Marey was able to record bird flight at a rate of 12 pps (see Figure 1.6). Following this success Marey built a much larger camera with one fixed plate and a large diameter rotating shutter with very narrow slots. The whole system was housed in a wheeled cabin mounted on a stretch of railway track. The camera was operated by a weight falling under gravity and exposed at a rate of 10 pps with an exposure duration of about 1 ms. The images on the plate overlapped more or less according to the rate of movement. A timing clock was

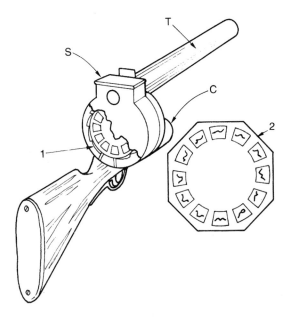

Figure 1.6 Marey's photographic gun (1882). S, Rotating slit shutter and framing discs; T, lens tube; C, clockwork drive mechanism; 1, Ratchet for positioning areas of sensitized plate in turn behind aperture on release of trigger; 2, sensitized glass plate showing 12 successive exposures of a bird in flight, taken at a framing rate of 12 pps.

included in the camera field of view. The whole system was contained within the cabin and moved along the track so that it could be placed in the best position to view the moving subject. With this camera he made many studies of human locomotion. In some cases to make the movement more clear for analysis, subjects were clothed in black and their limbs or important reference points marked with white lines or bright patches. The use of timing marks recorded on the same film as the picture frames has continued into modern usage.

As is always the case, multiple images on one plate become very confused if the subject does not move far enough between exposures. Another drawback is the limitation in the total number of images which can be recorded. With these realizations in mind, Marey began to look for alternative types of film stock that might permit advances in camera design.

1.4.5 George Eastman and the development of cine film

George Eastman was born in 1854 and while working as a bank clerk he became interested in photography and started experimenting with gelatin emulsions. Having achieved some success, in 1879 he went to England, which at the time was the world centre for photography, to take out his first patent. In 1881 he went into partnership to form the Eastman Dry Plate Co. and began making dry plates commercially. In company with others he also experimented to make emulsions that would be light and flexible. He made a base of paper which was coated with collodion and then with the emulsion. After the film was exposed, developed and fixed, the paper was peeled away leaving the negative on the collodion base. The Company made the new 'stripping film' in rolls, but professional photographers were not quick to take up the idea and to reach a new market Eastman made a new camera, the 'No. 1 Kodak' for sale to the general public. The camera came ready loaded and when used was sent back to the factory for processing, much in the same way as today's disposable holiday cameras. Soon he employed a chemist to experiment further with the film base and they developed a nitrocellulose based film which stemmed from the celluloid invented in 1861 by Alexander Parkes. In 1888, John Carbutt, an Englishman who had emigrated to the USA, persuaded a manufacturer to make much thinner sheets than was normally the case. The new film was used as cut sheets and could support the emulsion without a paper backing. This film could also be made into long rolls and the scene was set for the development of cine filming. By 1902 Eastman was producing nearly 90% of the world's output of film. The nitrocellulose film, which was highly inflammable, was

replaced around 1930 by non-flammable cellulose acetate film. Nitrocellulose film had been independently invented and a patent applied for in 1887 by the Reverend Hannibal Goodwin. After a 12 year battle against Eastman in the courts his successors were awarded five million dollars.

1.5 The development of cine cameras

The development of flexible film gave Marey, working in France, the new materials which he had been looking for and he quickly designed a new camera. This used a rotating disc shutter and an elementary form of intermittent movement for the film. Up to 40 pps could be obtained, although the interframe time was not always even (see Figure 1.7). By 1890 he had produced an improved version with a star wheel clamp to give intermittent motion. Following Eastman's production of the new film using celluloid as a backing, which was tough, flexible and transparent, Marey was able to use a version of this in his new camera and was able to run it at up to 100 pps. The Eastman development of celluloid backed film was really the turning point for the development of cine photography and the beginnings of the cinema industry of today.

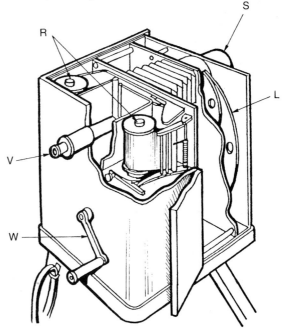

Figure 1.7 Marey's first film camera (1887–1890). Unperforated film is drawn horizontally across the aperture, guided by spring loaded rollers. Very brief exposure is given through the holes in contra-rotating shutters. Viewfinding is through the back of the film. R, Film reels; V, viewfinder; W, operating winder; L, lens; S, contra-rotating disc shutters.

Marey's prime objective was *chronophotography*, or the analysis of movement through a single sequence camera; thus he was not primarily concerned with projection. Whilst he carried out valuable pioneer work in this area, others were to bring cinematography projection to fruition.

In January 1888, Louis-Aime Augustine Le Prince, born in Metz but working in England, patented a design for a new cine camera. Le Prince was the first to try to explore the possibilities of Eastman's new paper roll film for cine purposes. The camera contained 16 lenses and recorded on two rolls of film which were exposed in turn with a sequence of eight pictures at a time. He also described a single lens version which contained in its specification most of the design features of the intermittent action cine cameras that were to come later. Although the design had minor drawbacks it did work, as a surviving film well demonstrates. The pioneering work of Le Prince came to a sudden mysterious end when in 1890 he boarded a train at Dijon in France and disappeared, never to be seen again.

Ottoman Anschütz was working in Prussia during the 1800s, and in 1885 he also began taking sequence photographs with multiple cameras using roller blind shutters. By 1887 he had created the *Electrotachyscope* to project his pictures using a pulsed Geissler tube as a projection light source. Another sequence photographer, a French medical researcher Albert Londe, used multi-lens cameras recording on a single plate with electrically operated shutters. Another Frenchman, General Sebert, collaborated with Londe to produce a device for ballistic studies using six small cameras arranged in a circle. With this he made studies such as the launching process of torpedoes. As the 1800s drew to a close, more and more experimenters produced new designs for cameras using roll film with various intermittent mechanisms for halting the film in the gate while the exposure was made. These included Le Prince, Rigas, William Friese Green, Donisthorpe and Varley.

By 1893, Thomas Alva Edison, an American famous for his many inventions, including the phonograph and electric lighting, met with Muybridge and became interested in photography and in particular the possibilities of moving pictures. At the time he had a young Scotsman, W. K. L. Dickson, working for him and together they designed and patented a camera which was based on many of the ideas put to him by the Englishman, William Friese Green. The camera, which was of the intermittent type, used the new celluloid film cut to a width of 35 mm with four rectangular perforations per frame. The perforations enabled the film to be drawn accurately through the camera by sprocket wheels and framing rates up to 46 pps were possible. The films produced by this camera were used in the *Kinetoscope*, also designed by Edison, which was first displayed at the World's Fair in Chicago in 1893. The kinetoscope was a coin operated 'peep show' machine which could be viewed by only one person at a time. The viewer looked down through a framed aperture onto the film image. About 15 m (50 feet) of film in a continuous loop and driven by an electric motor passed under a magnifier, and each frame was briefly illuminated by a light source via a revolving disc with a perforated rim. This was the first commercially successful motion picture machine but had the drawback of not being suitable for multiple viewing. Large audience viewing was to come in 1896 with a projector built by Robert Paul in London and demonstrated to the members of the Royal Institution early that year.

Robert Paul had originally made versions of the Kinetoscope which he sold in England. He collaborated with Birt Acres who had built a camera with intermittent film movement. Having developed his projector from the Kinetoscope, in 1896 Paul was using the combination to produce and show newsreel type films, giving the first Command Performance in 1896 before the Prince of Wales. Also in that year he filmed the Derby horse race and showed the film the same evening at the Alhambra Theatre in London. Around 1900, a large number of arbitrary film sizes and widths were in use and, eventually, in 1909 following an international conference, Edison's 35 mm width and perforation disposition was adopted as a general standard.

J. N. Maskelyne, famous for his stage illusions, produced a camera with constantly moving film with motion compensation provided by a ring of lenses rotating in a circle (see Figure 1.8). This was a very

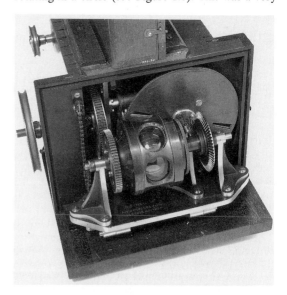

Figure 1.8 Maskelyne's Photo Chronograph of 1903. Close-up of lens and shutter mechanism.

novel concept for the time and the idea was to surface again in the 1920–1930s before being ousted by the rotating prism system.

In France, the Lumière brothers, Auguste and Louis, developed a camera with an intermittent movement using a claw mechanism which entered the film perforations and moved it down one frame at a time. Again a pioneering design, this mechanism was to become widely used up to the present day. The machine could be used as camera, printer and projector and was called the *Cinematographe*. It was publicly demonstrated in 1895. Around this period many designs were produced with multi-function abilities. From around the 1900s cine photography became more and more involved as an entertainment, and the monetary backing gave the possibility of more research and design improvements. These in turn were a help to further applications in the scientific field.

With the development of a flexible celluloid film base, many sequenced photographs could be recorded on a single roll of film. This overcame the problems caused by the inflexibility and limited storage capacity of glass plates. In a typical film camera of the early 1900s of the intermittent type, the sensitized reels of film were perforated with at least one hole on each edge for each picture and placed into a darkened chamber containing a feed and take-up spindle. Film from the feed spindle was laced through an aperture, or *gate*, to a take-up spool on the spindle. This gate was positioned at the focal plane of the camera lens, together with a single cut-out *sector disc shutter*, between the lens and film. A cyclic action of the claw and shutter alternately exposed one picture position in the gate. This continued until the end of the reel was reached. As has been mentioned earlier, at least 15–18 pictures, or frames per second (fps), were needed to give smooth, jerk free animated motions when re-projected.

In the film projector, it was found necessary to fit a three-bladed sector shutter to flash each picture three times, to give 50 flashes per second illumination at a projection rate of 16 fps or more and eliminate picture 'flicker'. So 16 fps was selected as the international 'record' and 'project' rate for silent films. When sound films arrived in the late 1920s, adequate sound reproduction was only possible with a sound track velocity exceeding 400 mm s^{-1}. The international record and playback standard was raised to 24 fps. A two-bladed projection shutter maintained 'flicker-free' standards whilst increasing projector light transmission.

Occasionally cameras were undercranked or overcranked to speed up or slow down, respectively, the subject movement to provide artistic effects in feature film making. Filming rates up to four times the normal could be achieved, but generally camera speeds were limited to 100 pps, to avoid camera and film problems which appeared at higher rates.

1.5.1 Lighting developments

Over the first 30 years of the 20th century, few changes were made in high speed still photography. High voltage air sparks were the main light source being used prior to the invention of the gas discharge tube. Whilst spark sources were very useful, they had not yet been refined to produce a well shaped pulse of light without a 'tail decay', but this was to come over the next decade. Unfortunately, they were limited in light output for large area illumination unless built on a very large scale which then made them rather unwieldy.

Dr Harold Edgerton developed his electronic flash in 1931. With this an electrical discharge took place within a sealed tube in an atmosphere of krypton, argon or xenon gas to improve the luminous efficiency of the source.

It was not until 1942 that the first commercial lamp of this type – the American Kodatron Speed lamp – was introduced under licence from Dr Edgerton's company (E. G. & G.) for general portrait, commercial and industrial photography. This was meant to replace the older tungsten lamps, or expendable flash bulbs. With flash exposures down to only 100–500 μs and high power outputs of 200–1000 J, this gave photographers greater working flexibility and, for the first time, an ability to 'freeze' action without difficulty. Soon, lower power portable 'speed flash' outfits appeared, at first weighing as much as 15 kg, but soon to be 'miniaturized' to 3 kg, and these attracted press photographers, who found that the 100–200 μs flash could freeze the fastest actions.

Dr Edgerton developed electronic flash systems for true high speed photography by using higher voltages (20 kV), low capacity condensers and shortened leads to reduce flash durations to as low as 1–10 μs. The flash units were triggered by trip circuits using thyratrons. These in turn were operated by trigger pulses from photoelectric cells, microphones or pressure switches – essential in high speed work. The E. G. & G. flash was powerful and ideal for front lit high velocity projectile work. Soon E. G. & G. began to build powerful xenon strobes suitable for multi-image 'stills' and synchronized high speed cine work using rotating prism cameras.

Throughout the 1950s and 1960s, several types of powerful single flash and multi-strobe lamps were built in Europe, notably by Dawes and Turner in the UK and Frungel in Germany.

1.5.2 Beginnings of high speed cine and still photography

The first major high speed cine breakthrough came in the early 1930s when F. J. Tuttle designed the rotating prism, continuously moving film system, using an *image compensation* principle similar in

concept to Maskelyne's invention almost a half a century earlier. The principle used a rotating prism placed between the incoming image and the continuously moving film. The prism, the rotation rate of which was synchronized with shutter and rate of film movement, moved the focused image onto the film so that they were stationary relative to each other. This gave a still image on the film, even though it moved continuously through the camera (Figure 1.9). The new cameras were made by the Eastman Kodak Company, who firstly introduced cameras which ran to 250 pps, followed by the Eastman 2 with its maximum speed of 2500 pps. In two steps, maximum recording rates were raised from 100 to 2500 pps using the recently introduced 16 mm film stock. Soon the EK Model 3 camera was introduced with improved speed controlling and the maximum rate increased yet again to 3000 pps. Within 2 years, another American company, Westrex, launched the now well known Fastax range of cameras which, using more powerful twin motors, reached 4000 pps.

Scientific applications such as animal locomotion, flow visualization and ballistic events had, up to 1930, monopolized the high speed photography scene. The combination of the Tuttle system and 16 mm film opened up new prospects and for the first time high speed photography was used in industry. Probably the best known application in the 1930s

was at the Bell Telephone Laboratories in the USA to study premature electrical relay failure. The resulting film records gave Bell a startling insight into the causes of relay failure, by simply observing and analysing relay contact behaviour in detailed slow motion. The use of the high speed camera as a fault finding tool resulted in a full scale R&D programme to modify and improve the design of switch mechanisms. In the USA, industrial engineers were quick to recognize this trouble shooting and R&D potential in a number of industrial processes. It helped manufacturers to reduce faults, improve output and lower costs.

At this time, air sparks were capable of 100 ns minimum but with low luminosity, and the best high speed xenon tubes were unable to flash for shorter times than 1 µs. Alternative means of shuttering or lighting were needed for ultra-rapid events. Two methods were discussed in the mid-1930s but were not used until World War II.

Firstly, an electro-optical device known as a *Kerr cell shutter* was used. The cell had transparent windows at each end and contained parallel plate electrodes between which the beam was passed. The cell was filled with an isotropic liquid which became birefringent on application of a high voltage pulse. This caused rotation of the plane of polarization of the beam passing through the cell. Initially the beam was cut off by placing crossed polarizers at each end of the cell. On application of the pulse, the cell allowed the beam to be transmitted for the duration of the pulse. Typically, this was 100 ns or less. Transmission however was poor; only 10% of the original light was passed to the film, so very high light intensities were required. Nevertheless, superb photographs were produced of subjects such as the early stages of explosive detonations. At Aldermaston, the Atomic Weapons Research Establishment (AWRE) produced a system which had eight cameras and shutters in a circle. Among other applications, they were used to produce sequences of eight large sharp photographs of the early stages of the fireball of atomic bomb explosions.

The other ultra-short duration 'shutter' or light source was the *argon flash bomb*, for stills and motion picture sequences of rapid events. This system used an explosive shock wave which passed through an atmosphere of argon gas. An intense flash was produced as the gas became ionized and exposure time was a function of the length of the gas column through which the shock wave passed. Typical times ranged from a few microseconds down to tens of nanoseconds and were suitable to light large areas for still photographs of ultra-high speed events. For cine sequences, the duration could be extended to tens of microseconds by increasing the explosive charge and length of the argon gas container. Needless to say, these sources could only be used for explosive events, where both subject and

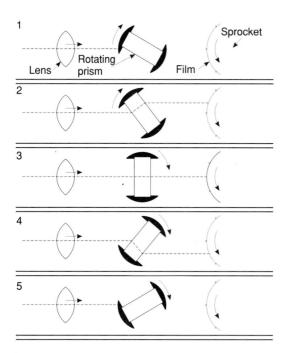

Figure 1.9 · Principle of the Tuttle system using a two-sided rotating prism. This was used in Eastman 3, Fastax T and Stalex WS3 cameras.

light source would be totally destroyed (see Chapter 2).

By the end of the 1930s, both 8 mm and 35 mm gauge versions of the Fastax camera had been developed. Varying the picture height from full to half formats doubled the framing rate potential, without the need to further increase the film velocities.

1.6 1939–1945: World War II developments

The outbreak of World War II in 1939 created a rapid growth in systems for military research purposes. Several continuously moving film/image compensation cameras were developed in the USA, Great Britain, France and Germany. Surprisingly, Maskelyne's rotating lens disc method was taken up by at least four manufacturers, i.e. Jenkins in America, AEG and Thun in Germany, Merlin and Gerin in France, and Vinten in Britain. Also from Germany an unorthodox spinning mirror and moving film was used in Zeiss Ikon 16 mm and 35 mm cameras. Wartime conditions found high speed cameras in all theatres of military experimental research and development, but the leaders in the field were unmistakably Fastax and Eastman designs. Further improvements in the control of Fastax cameras raised maximum speeds to 8000 pps (16 000 pps for half height) and careful prism masking improved image resolution and contrast. In Europe, several new intermittent action cameras were built to satisfy the ever increasing need for highest quality recordings at the moderate camera speeds needed to record bomb/store releases, parachute deployment, projectile flight and impact, etc., from ground based cameras. Debrie (France) and Zeiss (Germany) 35 mm cameras could reach 250 pps. The best known, and probably the fastest, came from the North London factory of Vinten Ltd, the Model HS300, capable of 275 pps. With a full register pin/intermittent action transport system, very high quality, high resolution results were possible. A parallax corrected, interchangeable twin lens optical system permitted the focusing of viewing and taking lenses simultaneously at any time before or during filming. Lens arrays from 25 mm (1 inch) to 300 mm (12 inch) were standard. Soon, longer lenses up to 2000 mm with matching binocular sights were made to meet the ever increasing demands of war. Also, the variable shutter could permit exposure times from 100 μs to 2 ms at full speed. For accurate timing a 50 Hz tuning fork and coil allowed a high voltage spark to be imaged on to the film edge. For over 50 years the HS300 has given yeoman service on British R&D testing ranges in all conditions and several are still in daily use.

Less successful was the sister camera, the 35 mm Vinten HS3000, which used Maskelyne's rotating lens disc principle and was capable of reaching speeds approaching 3000 pps. The camera used a very carefully balanced duralumin disc with 48 matched 50 mm lenses mounted on its periphery: this disc was rotated at high speed. The film was driven around a revolving gate so that it moved at the same speed and direction as the lenses, to produce a stationary image on the film. A powerful three-phase electric motor drove a heavy flywheel mounted at the back of the camera. Power from this flywheel was transmitted through a friction clutch and three-speed gear box from an Austin car to the lens ring and film drive sprocket. The inflammable nitrate base film stock in use at the time presented a serious fire risk. To reduce this, the film chamber was filled with nitrogen gas prior to the film run. The sheer size, weight and power of the camera necessitated setting it up on a cast iron bed plate, mounted on an adjustable stand. An HS3000 running at full speed must qualify as one of the most dramatic spectacles of high speed photography ever! Image resolution, although acceptable, fell short of the slower HS300 standards, and only a few were built. Most of the higher speed work was performed with the simpler and more efficient 16 mm/35 mm Fastax and Eastman cameras.

Several novel, purpose built cameras appeared during the war, using unusual film sizes and capable of multi-framing records. Designed to observe the early stages of mortar shell firings, the Bowen Ribbon Frame Camera used one of the larger amateur paper backed roll films still being manufactured at the outbreak of war – the Kodak VP 122 postcard roll film. Large 95 × 6.35 mm (3.75 × 0.25 inch) format pictures could be run at speeds up to 100 pps. A large rotating prism produced the 'ribbon frame' format and with a variable slit shutter provided exposure times from 1 ms to 100 μs at full speed. Mounted on a special tripod with rapid levelling facilities, a finely adjustable head accurately tilted the camera from 0° to 90° to align the camera with the expected projectile trajectories. It was ideal to study mortar shell and aircraft rocket behaviour over the first few metres of flight. Resolution was excellent and, by using conventional developing, printing and enlarging facilities, early inspection was possible, with large paper records being produced on location in a mobile darkroom.

Another high resolution camera for observing single picture records was the so called yaw observation camera (YOC). Using the readily available paper backed Kodak VP116 roll films, the film (with paper backing) was transported at high speed past a static focal plane slit. It was powered by a wind-up clockwork motor which enabled flexible operation in the field, independent of electrical mains or batteries. A special stand permitted the camera to be rotated through 90° to align a focal plane slit at

right angles to the projectile trajectory. The recording technique was similar (but faster) to that used in 'photo-finish' race course cameras. In these, the forward speed of the film was arranged to match the horses' image velocity to record a 'bit by bit' image of the animals as they passed the focal plane slit. These cameras were located at the winning post. When used for ballistic purposes, the camera 'stand-off' (distance) from the projectile trajectory was arranged to suit (a) the estimated projectile velocity, (b) the velocity of the film at the focal plane slit and (c) the focal length of the camera lens.

The YOC camera was the forerunner of several later 16, 35, and 70 mm 'smear', or 'ballistic-synchro' cameras, as they later came to be known. This technique is still in use worldwide, to provide not only extremely detailed records of high velocity projectiles, but also to provide data on velocity, spin rate and attitude. YOCs were still in use on British ranges until the early 1960s (see Chapter 14).

Armament research demanded increasingly higher picture sampling rates to record and analyse microsecond and nanosecond events occurring in ballistics, detonics and plasma physics. Moving film conventional cine cameras did not have short enough exposures or fast enough framing rates and their long recording periods were not necessary for these applications. An alternative form of camera using a shorter length of film attached to the periphery of a rapidly rotating drum was employed. Discrete successive images were recorded on this film for a single rotation of the drum via a static framing lens array, or by using a short duration pulsing light source and a camera in streak mode. Framing rates up to 250 000 pps were possible for a period of 250 μs, ideal for short duration events, e.g. ballistic flight/impact/detonation, fracture tests, etc. Using a principle first used by Boys in 1893, a wide variety of drum cameras were custom built for specific applications. These were divided into two main groups, i.e. large diameter drums running at low speeds, or small diameter drums at high speed to take advantage of longer recording times or maximum portability, respectively.

The high speed *drum camera* continues its popularity, satisfying the needs of those requiring an intermediate range high speed camera capable of superb image quality, with low running costs. Nowadays, however, they are only manufactured by Cordin Inc., Salt Lake City, USA.

Another simple technique conceived during World War II used the 'image dissection' principle. Here, either the lens or the film was moved in a direction parallel to its own plane and that of a lenticular plate consisting of minute, optically refracting, parallel cylindrical elements of equal width, placed in contact with and extending across the film area. Thus many pictures were exposed made up of separate elements side by side but only viewable as complete images when decoded by the special taking lens. The advantage of this system was that, instead of having to move the film or lens one complete frame width before a second image could be exposed, the film or lens only needed to be moved a distance equal to the width of one element between exposures. Thus, for a given speed limit of film or lens movement, many more pictures could be exposed per second, giving greatly increased framing rates. After processing, the lenticular plate was placed over the developed image so that only one 'line width' was viewed at any one time. Moving the plate across the image would expose each of the 100 (approximately) images recorded, for subsequent rerecording and animating with a conventional camera.

Poor light sensitivity was the main drawback of this technique, necessitated by the need for very high resolution, fine grain, slow plates. Another problem was that, due to the imaging method, each image could only be of small area. Courtney Pratt built the most successful camera and this was marketed until the mid-1960s as a simple to use and economical to run system, for ballistics research.

The rotating mirror/fixed film system of ultra-high speed photography was infinitely better. In the UK this was developed by the AWRE, Aldermaston, between 1940 and 1945 to study the initial stages of conventional and nuclear explosions. Both streak and framing cameras (Miller systems) were built. Both systems used a rotating stainless steel mirror driven by an air turbine at 3500–6000 rps. In the streak camera, light from the event was focused by the main lens on to a slit. From the slit the diverging light passed through a second lens to form a focus on an arc of film at 60–90° to the lens axis, via the rotating mirror. The framing camera differed by focusing light from the main lens on to the rotating mirror. Diverging light from the mirror was scanned across an array of 'framing' lenses to form a sequential set of pictures on the film. Extremely high rates were possible with the range of lens arrays, which provided large 20 mm diameter pictures at 2 million pps, or 8 mm images at 8 million pps. In streak mode, time resolution was 1×10^{-8} s at 22 mm μs⁻¹ writing speed.

Similar Miller cameras were produced in the USA by Beckman Whitley and later by Cordin Inc. Currently, Cordin still build a wide range of 35 mm and 70 mm drum and rotating mirror cameras capable of recording high quality black and white and colour images from 8 mm to 80 mm diameter, at speeds from 1000 to 20 million pps.

1.7 1945–1955: The post-War years

Following the spate of intense activity from 1939 to 1945, few changes in technique or equipment

occurred until the mid-1950s. In Europe, Wollensak Fastax cameras were imported from the USA, initially for defence experimental ranges, but later for industrial applications, mainly due to the representation by John Hadland, who operated a High Speed Service on a contract hire with operator basis in the early 1950s with Eastman Type 3 cameras. By 1957 he had become UK distributor for Wollensak Fastax and the interest in high speed photography as a research and development tool developed in the UK in a similar manner to the USA in the late 1930s. Vinten Ltd continued producing their HS300 cameras, and Acmade Limited of Denham, better known for film editing equipment, built an unusual 35 mm rotating prism camera. With three interchangeable rotating prism assemblies, speeds up to 2000 full height, 4000 quarter height, or 8000 quarter height pictures per second were possible. A static prism and slit mask also enabled streak recordings to be made. Extremely powerful motors and supplies were needed for fast running: one 15 kV·A diesel generator was used with a single camera and two cameras could stall the generator! Picture quality varied from poor (full height) to excellent (quarter height). An accompanying 35 mm *analysing projector* used the camera rotating prisms to project any of the three formats in cine, or stop frame mode. At least two defence ranges in the UK used these cameras until the mid-1960s. One still survives at the Science Museum, South Kensington.

1.8 1955–1975: High speed photography in space research

Seemingly unlimited funds were made available for civil and military space research in the USA at NASA. New medium speed cameras were designed to a National Aeronautics and Space Administration (NASA) specification to record space vehicle behaviour, from lift-off to motor separation and its return to Earth. Framing rates of up to 500 pps permitted the design and production of a new generation of intermittent action/pin register cameras, capable of working under the harshest environments, both on board and in closely sited observation sites around the launcher. Four high speed camera manufacturers were contracted to produce 16 mm cameras, these were DB Milliken, Mitchell, Photosonics and Red Lake, all based in California. Photosonics also developed a new range of 35 mm and 70 mm cameras together with sophisticated semi-automatic and fully automatic trackers for these cameras. Throughout the 1960s and 1970s, hundreds of these cameras were built to satisfy NASA needs. They quickly earned the reputation for extreme reliability and became popular in the motion picture world for their superb picture quality

at speeds 20 times faster than the standard projection rate, unheard of within the film industry prior to their introduction.

1.9 The improvement of rotating prism film cameras

Following Tuttle's development of his image compensation system in 1932, camera design remained largely unchanged over the next 25 years. Higher maximum speeds were reached with higher power motors, but image quality, resolution and steadiness fell short of the slower intermittent cameras, in full frame format.

First steps to improve matters occurred in 1960 with the introduction of a high definition Fastax camera known as the T Series. Two-sided rotating prisms replaced the usual four-sided glass prisms. This improved image compensation and shuttering, but necessitated doubling the rotational speed of the prism, which limited maximum framing rates to 6000 pps. As a result, optical resolution improved across the frame area and exposure was almost halved. Despite the lower speed reached, the cameras were popular.

In a further attempt to improve rotating prism camera performance, Bob Shoberg's new Red Lake Camera Company based in Santa Clara, California, developed the revolutionary 'Hycam' optically relayed cameras. In an attempt to reduce the customary image 'weave and bounce' of rotating prism cameras, the rotating prism and film sprocket shared a common drive spindle (Figure 1.10). Using C mount lenses for the first time with rotating prism cameras, through an optical relay system, very clear sharp pictures of 68 lp mm^{-1} were possible. One could almost mistake Hycam pictures for slower conventional camera records. There was a penalty, however; the optical relay arrangement lowered the effective aperture of the system to two stops less (–2 EV) than the Fastax. This was generally unacceptable for military range trials, where much of the work was carried out using daylight alone. In industry this presented few problems, as they had the choice of high intensity light sources and mainly close-up recording.

Less than a decade later, a third-generation rotating prism camera was launched, hoping to embody the wide aperture optics of the Tuttle system with the high quality images of the Hycam, it was known as the Photec, also designed by Shoberg. In this camera, further redesign allowed a reduction of the number of relay prisms and lenses in the light path and regained the lost image intensity of the Hycam (Figure 1.11). Both Hycam and Photec cameras are still produced by Visual Instrumentation, California, and Photographic Analysis Company,

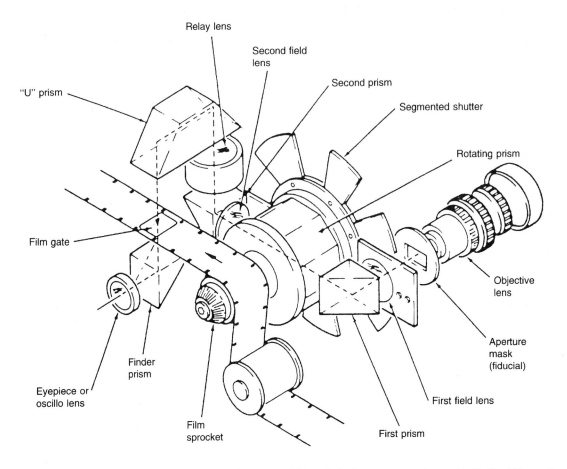

Figure 1.10 Principle of the Hycam rotating prism camera. This optical relay system was also used in Hadland Hyspeed cameras.

Florida, and are considered to be the 'workhorses' of high speed photography.

Improvements in high speed film materials since the 1950s has raised sensitivity and image quality to very high levels. A rating of 400 ISO with black and white films was barely possible in the mid-1950s, whilst the fastest colour material was 100 ISO, which was very grainy and with poor image resolution. Today, black and white film ratings go up to 30 000 ISO equivalent using extended development, whilst 500 ISO colour negative film is fast, tolerant to under- and overexposure, with superb sharp colour and is perfect for high speed photography.

During 1980, film made a 'last ditch' stand to compete with the newly arrived video technology in terms of speed of availability of results. Polaroid introduced their Polavision Super 8 Cassette films rated at 25 ISO colour and 320 ISO black and white. Intended for the amateur film market, it was soon eclipsed by the vast numbers of popular VHS and Video 8 cameras reaching the market by 1985.

Nevertheless, MA Systems, USA, produced their Mekel 300 Polavision high speed camera (Figure 1.12). The outfit consisted of an intermittent action/pin registered camera, capable of recording at 6–300 pps, plus a self-contained processor/analyser projector. After exposure, the snap-in Polavision cassette was immediately transferred to the processor, where it was automatically processed for 90 s. It then ran through the projector at 16 fps for one complete run to promote drying. Thereafter, it could be re-projected at variable speeds and stop frame, for detailed analysis. At least 60 of these ingenious systems were in daily use in the UK during the mid-1980s and, despite the eventual demise of the Polaroid film, supplies were available for well over 10 years.

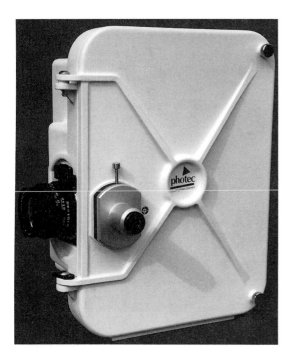

Figure 1.11 The Photec high speed camera. Using 16 mm film in 400 foot magazines, framing rates of 100–10 000 pps were available.

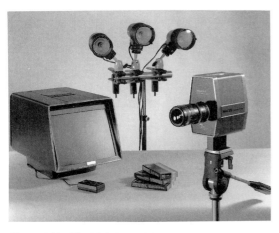

Figure 1.12 The Mekel 300 high speed camera/processor system using 8 mm Polaroid material, complete with projector and lighting.

1.10 From film to electronic imaging

Up to the 1960s, film recording still dominated the ultra-high speed photography scene, with the range of AWRE, Barr and Stroud and Beckman Whitley rotating mirror cameras. Providing 'event' light intensities were sufficiently high, superb recordings

could be made. However, failures occurred with low luminosity, ultra-high speed events, e.g. low energy electrical discharge phenomena. Even with the fastest film materials available and forced developing, worthwhile recordings could not be obtained.

The development of the electronic *image tube*, capable of recording a single shot, high quality picture, in relatively poor light proceeded during the early 1950s through to the late 1950s. This eventually led to the production in 1960 of the STL three picture image converter tube camera by Space Technology Laboratories, USA. This image tube consisted of a photocathode, an electronic lens and a fluorescent screen. Light from the event was focused on the photocathode where the light image was transformed into an electron beam. This beam was electronically shuttered and/or intensified within the electronic lens and the image translated back into light on the fluorescent screen. It could then be photographed either with a 4 × 5 inch Polaroid or a conventional sheet film camera. Looking remarkably like a broadcast television camera, the STL produced three sequential images each measuring 17 mm × 25 mm with a resolution of 12 lp mm^{-1}, capable of recording at 2000 to 20 million pps, and having variable exposures from 10 μs down to 5 ns by using alternative plug-in printed circuit (PC) boards. It could also be converted to a streak camera with a 50 ns streak time and time resolution down to 0.5 ns. Image intensification enabled previously elusive low luminosity/ultra-high speed events to be recorded. The delay time after triggering to first picture was only 12 ns.

John Hadland (P.I.) Ltd introduced the STL system to Europe in 1961, but in the late 1960s this company started to design its own image converter camera, based on an AWRE design. Alex Huston (ex AWRE) headed this project and, by 1969, the *Imacon camera* was launched. Hadland Photonics Ltd and Imco Electro-Optics Ltd have since earned the reputation as European leaders in the field of image converter development, producing a wide range of standard model and custom built cameras with framing rates of 10 000 to 600 million pps, or a streak time resolution of only 2 ps. Images can still be recorded on conventional or Polaroid film, but today the preference is to store data in an electronic memory for subsequent analysis, animation or enhancement.

1.11 1976–1996: From film to video motion analysis

Success with image converters in ultra-high speed photography led to attempts to overcome the limitations of film in the intermediate high speed range. Video technology was the obvious alternative, with the benefits of:

- Instant replay of records.
- Simple operation.
- Extremely low running costs.
- Long play capability.

First attempts were made with modifications of existing cameras. Recordings were shot at normal rates of 25–30 pps, with either mechanical shutters or strobe flash sources being used to shorten exposure times.

From 1970, a number of these cameras were made in the USA, providing normal rate, high quality colour/monochrome records with 100 μs exposure times. Initially used for military applications, e.g. aircraft store releases, gun cartridge ejections and parachute development, they had a number of industrial applications, e.g. to spot check production line processes, or for quality control purposes. The slow sampling rates, however, severely restricted their use for full analysis.

Two truly *slow motion analysis systems* were built in the USA and Japan, capable of recording at up to 200 pps and replaying in slow motion. They were both based upon modifications of conventional video recording systems using normal imaging tubes and rotating head recorders. The NAC SAV 200 from Japan, for example, used standard VHS tape cassettes and produced colour records at 200 pps, with analysis replay at 0–15 pps in forwards or reverse mode. Exposure control was either by variable shutter or synchronized strobe flash. Twin cameras permitted two-dimensional viewing. The other was the Instar camera made by Video Logic of San Jose, USA. It was based on a modified version of the NTSC system and was capable of 120 pps.

In December 1980, an Eastman Kodak Company called Spin Physics from San Diego, USA, introduced the revolutionary SP2000 *video motion analysis system* (Figure 1.13). It combined state-of-the-art advances in electronic imaging and video recording technology. The result was an instant playback system capable of recording at 2000 pps (full frame), or 12 000 split frames per second. It raised video recording rates to the level of many rotating prism film cameras, with the added advantage of instant 'on site' analysis of records. This was achieved by using 12.5 mm (0.5 inch) magnetic tape and recording 32 tracks of information in parallel. This allowed much faster dumping of the information from the 240 × 192 pixel imaging chip and thus raised the permissible framing rate. The signals were frequency modulated for recording and a special timing track was included to allow full synchronization of all the tracks. Today, NAC in Japan and Eastman Kodak in the USA lead the field in high speed video technology. The latest NAC HSV-500 and HSV-1000 systems have continued NAC's colour video tradition, recording at rates up to 1000 pps.

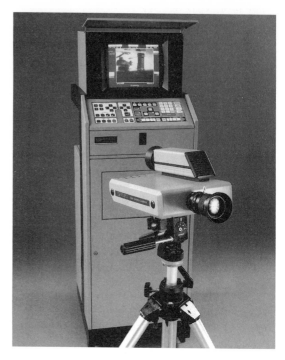

Figure 1.13 The Kodak SP 2000 High Speed Motion Analysis system.

The Ektapro Series 1000 using microprocessor controlled tape recorders replaced the SP2000 in 1986. With a speed range of 25–1000 full pps, or split frames to 6000 pps, the Ektapro 1000, whilst not having the equivalent performance of the SP2000, had a price which had been reduced to less than half that of the SP2000.

Digital storage motion analysis systems, such as the Phantom V2.0 made by Vision Research USA, have many advantages over systems using tape storage. Operating on a similar principle to transient recorders, the systems normally store incoming images continuously, and as the store becomes full the longest held images are dumped to allow storage to continue. This process can be controlled in different ways. The images can be stored or dumped during the event sequence so that only selected sections of the record are retained. This maximizes the use of the data store capacity. In addition, the chosen sections can be pre-set to run at varying framing rates, so that a variable speed event can be recorded at the best rate for each part. Unpredictable events can also be recorded by programming the store to retain images taken and held in the store prior to the arrival of the triggering pulse. The amount of pre-trigger store retained can be set to suit the application. Normal full resolution pictures are available up to 500 pps, and with special formats rates up to 3000 pps when required.

The latest Ektapro 1000 EM was introduced in 1989. It was a solid state electronic memory system capable of storing up to 1200 full frames at 1000 pps, or 7200 split frames at 6000 pps. Recording continuously for 1.2 s at full speed, it could be stopped manually, or remotely, thereby storing the previous 1.2 s of recordings for analysis and/or VCR downloading.

Sensitivity was double that of the early SP2000 system, but resolution with the 240 × 192 pixel sensor was the same. An image intensifier system was available to increase the light sensitivity by up to 12 lens stops (+12 EV). The intensifier could also electronically gate the shuttering down to 10 μs per picture at all recording speeds.

Introduced in 1993, the latest Ektapro HS Motion Analyser Model 4540 further raised framing rates to 4500 full pps (or 40 500 split pps), enabling this system to be used for military and industrial applications hitherto only possible with 16 mm film cameras. Operating as a digital image recorder, the system could store up to 5120 full frames (or up to 81 900 split pictures), in the electronic memory. These digital images could be replayed instantly from the memory. Optical resolution had been raised to 256 × 256 pixels and sensor light sensitivity increased to 3000 ISO equivalent. Like earlier Ektapro systems, the video output signal was available for immediate computer acquisition via the RS232/IEE serial interface cards and the VCR storage of images.

1.12 Lighting

Since the first Leyden Jar air spark photographs taken by Fox Talbot in 1851, high speed photography has been carried out over a wide range of observations – from microscopic living organisms to industrial processes and hazardous military applications. In all cases, the event has had to be sufficiently brightly lit to make short exposure recordings at hundreds, thousands or millions of pictures per second possible. Lighting is probably more critical in high speed photography than in any other branch of photography.

Many methods have been used, including air sparks, pulsed gas tubes, conventional overrun photofloods, expendable flash bulbs, pulsed lasers and even lighting 'bombs'. These are discussed in Chapter 2.

1.13 Processing and analysis

The treatment of high speed film records after exposure varies enormously. For best results they are given full professional laboratory services. Usually, however, the early results of a series are required soon after exposure, and film processing can vary from 'bucket' developing in a makeshift darkroom, to more delicate handling in a purpose built, portable, black and white negative film processor.

Master negative inspection is normal to obtain qualitative and quantitative data, but to avoid damage to the master a copy print should be made for initial checking to decide on the final measurements required.

Any film projector may be used to inspect the records, but for data extraction it is necessary to use specially constructed film analysers capable of slow motion, 'freeze' frame and forward/reverse projection.

Since 1932, *analysis projectors* have mostly been made by modifications to existing film projectors. In the UK, Specto Ltd included an analysis version of its standard 16 mm projectors during the 1950s. Film could be run either at 16 or 2 fps and frame by frame without damaging the film. From the USA, Eastman Kodak and Bell and Howell Analyst projectors with a wide speed range, stop frame and forward/reverse running were introduced. Eventually, specialist small companies like LW International and Lafayette further developed the Kodak Analyst for pulse variable speed running and remote control. Forced air cooling on the light unit and gate enabled unlimited stop frame projection. Unusual machines like the 35 mm Acmade Analyser mentioned earlier were built (see Section 1.7).

To extract and process quantitative data from film in the fastest possible time, requires a motion analyser data reduction system comprising:

- A projection head to transport film in a similar manner to those already discussed.
- A projection case with a front or rear projection facility fitted with precise *xy* image measuring devices.
- A suitable external computer and cathode ray tube (CRT) monitor.

Today, three systems are produced by NAC in Japan, and the Vanguard and Visual Instrumentation Corporations in the USA. They use interchangeable 16 mm, 35 mm or 70 mm projection heads mounted on a projection case with *xy* cross hairs containing either linear encoders, or, in later systems, inductive loop digitizers. They enable extremely high resolution measurement down to 0.03 mm from any point on the projected image, including film edges with timing data. Readout information is passed to the computer via an RS232 interface. Simultaneously, the computer can transmit messages back to the film analyser to permit interaction between the operator and the data gathering procedure, by means of instructions and operational menu choices displayed on the accompanying CRT monitor.

Unlike high speed film equipment where cameras, film processing and motion analysis equipment operate independently of each other, high speed video motion analyser systems are able to record, playback and quantitatively analyse resulting records in a single machine. Additionally, computer acquisition is, in most cases, provided via built-in RS232/IEE serial cards. Immediate data processing is therefore possible, albeit with the lower resolution potential of the video image, but in many cases the ultra-high resolution of film is unnecessary.

1.14 The future

Film cameras, materials and analysers have now nearly reached their ultimate performance and further improvements will occur in control systems using new microprocessor technology. The capability of modern rotating prism and drum cameras has closed the performance gaps between the extremes of the intermittent action cine and the Miller type rotating mirror systems, so that today it is difficult to know which camera has recorded film taken at hundreds, thousands or millions of pictures per second.

Video technology, however, is rapidly developing. In 1980, the highest video recording speed was 120 pps. Today 4500 full pps and over 40 000 split pps are possible. In the Battelle Institute in the USA, 10 000 full pps have been achieved, but with a limited number of pixels in the array.

For the foreseeable future, it is unlikely that electronic imaging technology will be able to match the high speed recording capabilities of film in terms of resolution. Computer assisted video technology, however, is ideal for the quick extraction and processing of data from both film and video sources. Film and video systems will complement, rather than compete, with each other.

The choice of high speed motion analysis systems, whether film or video, has never been so great, and it can confidently be said that there are now very few events which are so fast that they cannot be observed and analysed by high speed photography.

References

Anon. (1864) Sketches of eminent photographers; William Henry Fox Talbot. *Br. J. Photogr.* **11**, 340–341

Anon. (1920) Photographing a bullet in flight. *Conquest Magazine,* **Sep.** 510–515

Boys, C. V. (1893) On electric spark photographs or photography of flying bullets. *Nature* **47**, 413–421; 440–446

Cranz, C. and Glatzel, B. (1912) Photographic recording of ballistic and other rapid phenomena with the aid of the quenched spark. *Phys. Gesell.* **14**, May, 525–535

Mach, E. and Mach, L. (1889) Weitere ballistisch – photographische Versuche. *Setzungsber. Kaiserlichen Akad. Wissenschaft. Mathematisch-Naturwissenschaft. Classe* **98**, 1310–1332

Marey, E. J. (1883a) *Le Vol des Oiseaux.* Masson, Paris

Marey, E. J. (1883b) Emploi des photographies partielles pour etudier la locomotion de l'homme et des animaux. *Compte Rendus Acad. Sci. Paris* **96**, 1827–1831

Marey, E. J. (1894) *Le Mouvement.* Masson, Paris [Pritchard (trans) (1895) *Movement.* Heinemann, London]

Muybridge, E. (1899) *Animals in Motion.* Chapman & Hall, London

Muybridge, E. (1901) *The Human Figure in Motion.* Chapman & Hall, London

Skaife, T. (1858) Letters. *The Times (London)* 29 May, 14 July, 5 August

Skaife, T. (1860) *Instantaneous Photography.* H. S. Richardson, Greenwich

Skaife, T. (1861) *Instantaneous Photography,* 2nd edn. J. Hogarth, London

Talbot, W. H. F. (1852) On the production of instantaneous photographic images. *Phil. Mag. (4th series),* January, 73–77

Worthington, A. M. (1908) *A Study of Splashes.* Longmans, Green and Co., London

Worthington, A. M. and Cole, R. S. (1897) Impact with a liquid surface studied by the aid of instantaneous photography. *Phil. Trans. R. Soc., London, Ser. A* **189**, 137–148

Worthington, A. M. and Cole, R. S. (1900) Impact with a liquid surface studied by the aid of instantaneous photography; Paper II. *Phil. Trans. R. Soc., London, Ser. A* **194**, 175–200

Bibliography

Chesterman, D. K. (1951) *The Photographic Study of Rapid Events.* Oxford University Press, London

Courtney-Pratt, J. (1957) A review of the methods of high-speed photography. *Rep. Prog. Phys.* **20**, 379–432

Courtney-Pratt, J. (1968) Some aspects of miniaturisation in high-speed photography. *J. SMPTE* **77**, 1171–1176

Courtney-Pratt, J. (1972) Advances in high speed photography 1957–72. *J. SMPTE* **82**, 167

Courtney-Pratt, J. (1983) Advances in high speed photography 1972–82. *High Speed Photogr. Photon. Newsl.* **3**, 19

Courtney-Pratt, J. (1986) The future of high speed photography. *Proc. SPIE* **674**, 319–328

Jones, G. A. (1952) *High Speed Photography.* Chapman & Hall Limited, London

Saxe, R. F. (1966) *High Speed Photography.* Focal Press, London.

2 Lighting for cine and high speed photography

Peter W. W. Fuller

2.1 Introduction

Photography has been described as 'painting with light', and the provision of suitable light sources is a fundamental requirement for all photography. It assumes particular importance in high speed photography due to the high framing rates and short exposure times required. These in turn demand very high light intensities to achieve good exposures. The requirements vary over a wide range, extending from large area, long duration lighting, such as might be employed for large outdoor events, to small area, short duration lighting, which might be used for the study of insect flight. This wide range of requirements can be accommodated by an equally large selection of lighting methods and equipment. Another extremely important function for lighting in high speed photography is to form a very useful alternative to mechanical or electrical shuttering of cameras. Excellent results can be obtained by using an open shutter in darkened ambient conditions and exposing the image by single or multiple short duration light flashes.

In the early days of still photography, and then later when cine photography began, sunlight was a vital ingredient for picture making. It was no accident that the early cine pioneers chose southern California as one of their bases of operation, or that Hollywood became a centre for the motion picture industry. With time, development of both the filament and arc lamps gave the possibility of filming indoors, and increased both the available time for filming and extended the range of possible locations. In the high speed still photography field, the discovery and steady improvement of optical sparks, flash bulbs and flash tubes provided shorter and shorter duration sources, culminating in the current ultra-short pulses provided by lasers. In the high speed cine field, intense continuous sources increased in type and number to provide the high illumination levels required as cameras were developed to give higher and higher framing rates.

2.2 General requirements

In general, light sources fall into two main categories: continuous and transient types. In addition, transient types may be singly or repetitively fired in production of cine or 'quasi-cine' records.

For all sources, portability is a major attribute, as many high speed projects will involve going to the work site and operating without the benefits of a studio environment. Sources, or at least the output head, should be compact so that they can be easily positioned close to subject and/or camera if required. It is very useful if light sources can be run from both AC mains supplies and DC current, so that in remote locations power can be supplied from batteries. Reliability is also of prime importance, coupled with minimum maintenance needs. Replacement of items such as filament lamps or tubes, which may have a relatively short working life, should be simple and not involve complex dismantling of the device. Sources should, if possible, be efficient in the way in which they convert energy into light output so that their local environment does not become unreasonably hot. It is often necessary to choose a source with low heat emission in its illumination to avoid damage to delicate subjects, e.g. in the high speed photography of insects.

Sources can be described by several parameters, including duration, intensity, repetition rate, spectral power distribution, efficiency, size and shape of the output volume, colour temperature, triggering requirements and other aspects such as power requirements and portability.

2.2.1 Lighting combinations

Cine filming will usually require continuous lighting. However, there are some techniques in which pulsed light sources may also be used in synchronism with the opening of the cine camera shutter, or with an open shutter in a dark environment. For some high speed camera applications, longer duration transient devices such as flash bulbs may be more efficient than continuous lighting. Still or multiple still photography will use various types of transient sources according to the exposure times required. In instances where longer duration exposures will suffice, such as can be obtained by the use of mechanical shutters, continuous lighting may also be employed.

2.3 Definitions

At this point it is convenient to define some of the terms which are associated with the description of light sources and the determination of exposures.

2.3.1 Candelas

The photographer will be very interested in the light output capability of a source. This is usually given in candelas (cd). A candela is equal to the intensity in a given direction, of a source of light with frequency 540×10^{12} Hz which has a radiant intensity in that direction of 1/683 watts per steradian (W sr^{-1}).

2.3.2 Lumens

At some point away from the source the light level will be expressed as luminous flux or lumens (lm). A point source of one candela radiates one lumen into a unit solid angle of one steradian. If we consider a sphere of unit radius, one steradian or unit solid angle is subtended at the centre of the sphere by a surface of unit area. For example, an area of 1 m^2 on a sphere of 1 m radius subtends a unit solid angle at the sphere centre of 1 sr (see Figure 2.1).

2.3.3 Lux

The intensity of light falling on the subject is decided by the lumens per unit area, or illuminance. Sometimes referred to in old units as foot-candles or one lumen per square foot. The preferred SI unit is the lux (lx), which is an illumination of 1 lumen per square metre (lm m^{-2}). One lux is approximately equal to 10 foot-candles.

2.3.4 Lumens/watt

Source luminous efficiency or efficacy will be given as lumens per watt (lm W^{-1}). It is a measure of the efficiency with which electrical input, in watts, is converted into light output, in lumens.

2.3.5 Lumen-second

Total light over a period of time coming from a source is usually expressed as lumen-seconds (lm-s). A lumen-second is the light given out in one second by a one lumen source.

2.3.6 Lux-second

For photographic exposure onto an emulsion, where an area is involved, a more convenient measurement is the lux-second (lx-s) or one lumen-second per square metre (lm-s m^{-2}).

2.3.7 Inverse square law

The illumination from a point source, or a source which can be considered as small in relation to the distance from which it is illuminating the subject, will obey the inverse square law of illumination. Consider the light from a small source, falling on a surface a certain distance away. The radiating energy will be spread over the surface area within the confines of the beam. If the surface is now moved to be twice the original distance away, the total radiated energy will remain the same, but it will now be spread over a surface which is four times the original area. Thus the average illumination per unit area will fall to a value proportional to the reciprocal of the distance squared (Figure 2.2(a)).

The illumination of a surface in lux can be calculated by dividing the luminous intensity of the source by the square of its distance normal to the surface in metres. Strictly speaking, if small parts of the illuminated area are considered, the direct inverse square law will only apply to an area on the surface which receives illumination at 90° to the surface. If the rays strike the surface at an angle of less than 90°, then Lambert's cosine law will apply.

2.3.8 Lambert's cosine law

This law states that the illumination on an elementary surface due to a point source of light is proportional to the luminous intensity of the source normal to the surface multiplied by the cosine of the angle between the normal and the location of the elementary surface, and is inversely proportional to the square of the distance between the elemental surface and the source. The two basic laws of illumination are illustrated in Figure 2.2(b).

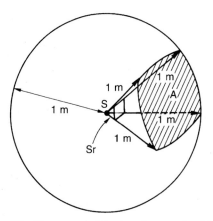

Figure 2.1 The concept of the steradian or unit solid angle. S, Source at centre of hollow sphere of diameter 1 m; A, surface area of 1 m^2; Sr, steradian as a unit solid angle.

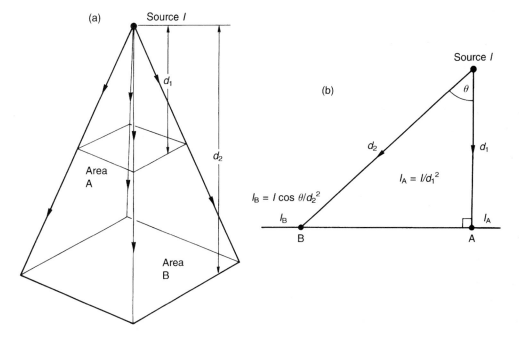

Figure 2.2 Illumination from a source. (a) The inverse square law of illumination. Source emitting I lumen provides illumination I_1 on area A at distance d_1, and I_2 on area B at distance d_2. The relationship is $I_1/I_2 = d_2{}^2/d_1{}^2$. (b) Illustration of Lambert's cosine law of illumination. Illumination at point A on a surface normal to the source is given by $I_A = I/d_1{}^2$; at point B with inclination angle θ, $I_B = I\cos\theta/d_2{}^2$.

2.4 Source spectra

2.4.1 Spectral power distribution

Sources will emit energy in a wide band of the radiation spectrum, ranging from the infrared to the ultraviolet. Most applications of high speed photography will use sources covering the visible band of the spectrum, which extends between wavelengths of 400 and 700 nm. The distribution of the various radiation wavelength intensities or *spectral quality* will vary with the source. For example, incandescent sources which operate by heating material to a point where it emits radiation, e.g. a simple tungsten filament bulb, will have a high output in the infrared region as well as a visible output.

2.4.2 Colour temperature

The colour quality of each source may be defined by the *spectral power distribution* (SPD) curve. These curves show graphically how sources which may be loosely described as producing 'white light' actually differ quite substantially in terms of their spectral distribution. The spectra appear in three main forms: continuous spectra having output at steadily varying levels throughout the wavelength range, continuous spectra with a varying background with broad bands of higher level output, and discontinuous or line spectra which have high output over narrow bands but otherwise a very low background level.

Whilst of considerable scientific interest, the SPD curves are a rather complex way of describing the radiation characteristics of a source. For everyday use it is more convenient to describe them as having a particular *colour temperature* (CT).

Apart from the use of lasers, single colours are not usually found in photographic light sources. Most sources will give 'near-white' light. A system of colour temperature is used to specify the characteristics of each source. Colour temperature is most important in colour photography where appropriate filters, sources and film are used to obtain a correct colour balance in the image.

If a *black body* or total source radiator is at a specific temperature, within the correct range it will emit radiation of a certain spectral distribution in the visible region. The *black body temperature* is usually described in the absolute temperature scale of degrees kelvin (K). This has the same scale interval as degrees celsius (C) but has its zero at absolute zero ($-273.15°$C). If a light source emits a spectral distribution which effectively matches that from a black body at a certain temperature, it will be described as having a colour temperature equal to the black body temperature in degrees kelvin. The colour of a heated body will normally change with

temperature rise through pale red, bright red, orange to white, with a high blue content at the upper temperatures. The output spectrum of a black body lies on a curve representing output at different temperatures, this curve is called the *black body locus*. Unless the output from a source lies on or near the black body locus the use of colour temperature to describe the source characteristics is open to dispute. It is truly applicable only to sources whose SPDs are close to that of the black body and thus tends to be most applicable to incandescent sources. However, it can act as a useful guide for a variety of sources.

In black and white photography the colour temperature is not so very important. In the past, high speed photography has been mainly carried out using black and white film. As the speed rating and quality of colour films has improved, the use of colour has become quite common in some high speed applications. In many scientific experiments, black and white pictures are quite adequate for measurement purposes. However, in the study of certain processes, e.g. combustion or flow visualization, the use of colour provides much additional information. Exact colour rendering is perhaps not so necessary in high speed photography as in lower speed pictorial photography. Most high speed photography is applied to measurement or observation purposes and the aesthetic qualities of the images produced are often not given much importance. However, high speed photography has become more and more important in advertising and in the observation of the natural world and in these areas correct colour rendering is very necessary. Tables of colour temperature for various light sources are available as a guide to film choice. Due to *reciprocity failure* when very short exposures or short intense light levels are used, the possible need for forced development and larger stops to allow for these problems may require some experimentation. When a particular source has to be employed to achieve a required result, careful notes of film type, filters used, camera settings and development procedure will be invaluable in building up a data bank for future work. Colour temperature meters are available to measure the source output to assist the choice of film and settings, but, ultimately, experimental verification will be the true test.

If high speed videography is employed the adjustment of colour rendering will be considerably easier and quicker by direct reference to the monitor screen.

2.4.3 Reflectors

Most sources, apart from lasers, will employ reflectors to direct as much of the available output as possible towards the subject. Many lamps have a reflecting surface deposited inside the envelope to assist in this objective. Some will also have specially shaped envelopes to focus the emitted light. Reflectors can also be used to spread the light over a wide area or concentrate it into a small intense beam. By allowing the source to move relative to a curved reflector the beam dispersion can be varied over a chosen area. If the source is placed at the centre of curvature of the reflector, a near-collimated beam can be produced. Reflectors can thus affect the way in which the light from a source is distributed and can also modify its colour by having a surface coating. The effect on illuminance can be quantified by the *reflector factor* which is the ratio of subject illuminance of a source with and without a reflector. It varies between 2 and 6.

Beam shape and intensity can also be varied by the use of lenses, these are often of the Fresnel type which are usually thinner and lighter than their normal lens counterparts. As with reflectors they will usually be built into the lamp housing and will sometimes be movable in order to spread or concentrate the beam as required.

2.5 Types of lighting

Light sources have developed in a complementary manner with high speed cameras and it is convenient to classify them in decreasing order of exposure time (see Table 2.1).

Table 2.1 Types of lighting used for high speed photography

Source	Typical duration (s)
Sunlight	Continuous
Tungsten filament lamps of various types	Continuous
Arc sources	Continuous
Flash bulbs	$0.5 - 5 \times 10^{-3}$
Electronic flash	$10^{-3} - 10^{-6}$
Argon bomb	$10^{-6} - 10^{-7}$
Electric spark	$10^{-6} - 10^{-9}$
X-ray flash	$10^{-7} - 10^{-9}$
Pulsed laser	$10^{-6} - 10^{-12}$
Super radiant light sources	10^{-9}

2.5.1 Sunlight/daylight

Sunlight/daylight is used as much as possible for external work and in some cases it may be the only illumination available. Unfortunately, it has the disadvantage of not being fully under the control of the photographer. Normal daylight will be a mixture of light from direct sunlight, and light reflected from the sky and clouds. It has a continuous spectrum, but in the visible region it can be represented reasonably closely by colour temperature values. These will vary with the time of day and weather conditions to give

colour values ranging between about 2000 and 15 000 K.

Sunlight rather than just daylight can be used for high speed photography and often in ballistic trials or natural history subjects it may be the only lighting available. Framing speeds are limited, but in bright sunlight and using wide aperture, rotating prism cameras, rates up to 10 000–20 000 pps are possible using fast film. Forced processing may also be necessary to achieve satisfactory density. Daylight in the UK has a colour temperature of about 6000 K, and an illuminance around 100 000 lx on a clear day in the open. Due to the very high illumination levels demanded by high speed photography, the sunlight/daylight will often have to be complemented by artificial lighting.

2.5.2 Tungsten filament lamps

These have a relatively low efficacy of around 20–25 lmW^{-1} and photographic types have a colour temperature around 3200 K. This is obtained by operating at above normal filament temperatures and results in reduced life. This 'overrunning' method is applied even more strongly to Photoflood lamps which have a temperature of 3400 K and a higher output with a slightly higher efficiency of about 30 lm W^{-1}, but only a short life of the order of 2–20 hours. Ordinary tungsten filament lamps tend to become blackened inside the envelope due to deposited tungsten, and their output characteristics tend to change during their lifespan. Tungsten lamps have been improved upon by tungsten halogen and arc sources, but provide a relatively cheap light source for large areas.

2.5.3 Tungsten halogen lamps

In high speed photography, overrun lamps tend to be replaced by *tungsten halogen lamps* which are used for general lighting purposes including studio type photography of static or slow moving subjects. Tungsten halogen lamps have a small amount of a halogen vapour in the envelope to improve their performance. The lamp is designed to allow the envelope to run very hot. The tungsten vapour which settles on the envelope combines with the halogen and is disassociated again at the filament redepositing the tungsten back onto the filament. This continuous cycle preserves output and the colour temperature constant at around 3400 K, which considerably improves the life time over ordinary tungsten up to about 200 h. They are consequently widely used for continuous lighting. Luminous efficacy is around 25–30 lm W^{-1}. The regeneration cycle relies on a very high envelope temperature, which requires small dimensions and the use of high temperature glass or quartz. The extra strength provided allows a higher filling pressure and contributes significantly to the improved performance.

Because of the very high envelope temperatures at which lamps operate, it is necessary to handle them with care and use gloves to avoid depositing grease or other contaminants onto the surface. Once the lamp is switched on contaminants will be fused into the surface and become immovable. Tungsten halogen lamps meant for projectors incorporate a reflector and are often used where general lighting is required. Low voltage types such as those which operate on 6 or 12 V are particularly useful in external trials, where it may be difficult to have mains AC supplies available.

Very efficient light sources are available that provide a ring of tungsten halogen bulbs with space in the centre to allow positioning around the camera lens. The light is concentrated into a small area without shadows. By the use of lamps with integral dichroic reflectors, which reflect visible light but transmit infrared, the forward emission of heat is kept to a low level. These systems are relatively portable and easy to set up, and are particularly important for the photography of delicate subjects such as small animals or insects.

2.5.4 Arc sources – gas discharge lamps

Developments over the last decade have led to the production of arc sources with extremely high output levels. High pressure, vortex stabilized argon arcs are the most powerful sources made to date (Camm, 1992).

2.5.4.1 Vortex stabilized argon arcs

The lamps use a quartz tube in which a current is passed through a central column of flowing argon gas. On the inside of the tube walls, a swirling layer of flowing water provides a barrier between the gas column and the tube. This barrier allows the ionized gas to carry a very large current which heats it to 12 000°C without damage to the containing tube. The output spectrum is continuous with peaks at argon lines. The colour temperature is 6500 K, with an overall spectrum similar to that of sunlight. The level of the gas arc output follows current density with only microseconds delay, so that millisecond pulses or continuous running are easily achievable. The 300 kW version using a 6 m parabolic reflector can produce a 6 m diameter beam with a divergence of 2°. This will provide a peak irradiance of 400 000 lx at 100 m. This offers a very useful ability where high illumination levels are required in areas such as ballistic type applications. In this case, low power sources would need to be placed close to the event and might be in grave danger of being severely damaged.

2.5.4.2 Xenon gas discharge lamps

Xenon gas discharge lamps are suitable for many applications and the short arc, high intensity, point

source types are very useful where intense collimated beams are required, for example in illuminating down tubes or other long narrow apertures. These sources discharge at twice the applied mains frequency, giving an almost continuous spectral emission, and have a colour temperature of around 5600 K. Xenon gas discharge lamps have relatively high efficiency of up to 70 lm W⁻¹. They are relatively expensive and the higher power, long arc type lamps (several kilowatts) are bulky and heavy, but very worthwhile if affordable. Short arc xenon lamps give very high luminance point sources; efficacy, however, is relatively low at 25–35 lm W⁻¹.

A high output xenon discharge lamp was described by Beeson (1960). The lamp system comprised the lamp in its housing with reflector, a set of secondary cells and a control unit. The lamp ran on 36–42 V and was initiated by applying a short 10–15 kV pulse between the probe and the cathode. The current and thus light output were controlled by a ballast resistor. The lamp, known in the UK as the Hadland MR 456, could be run continuously at 2 kW. It could also be run at 2.5 kW for 10 s, 5 kW for 5 s and 7.5 kW for 2 s. The arc discharge was cut by the application of a strong magnetic field, which was applied from the side and stretched the arc to the point where the voltage could no longer sustain it and so it was extinguished.

2.5.4.3 HIPI

The more modern version of the xenon gas discharge lamp is the *high intensity photographic illuminator* or HIPI made by VIC in the USA. It is a continuous xenon source designed to give very high illumination levels, particularly for synchroballistic photography of projectiles in flight. The lamp operates in two modes, namely 'normal' and 'boost', with boost mode being limited to 5 s. The high pressure, xenon, short arc, DC lamp has a parabolic reflector and an area of coverage of a maximum of some 864 mm (34 inch). The colour temperature is 5900 K and normal output is some 377 000 lx (35 000 lm ft⁻²) at some 23 m (75 feet), rising to 754 000 lx during boost mode. The lamp and power supply are made very robust to withstand gun blast pressures. An example of the use of this lamp for synchroballistic photography is shown in Figure 14.7.

2.5.4.4 Metal halide discharge lamps

These have a high efficacy but also have a particularly high fluctuation level when used on AC mains. They employ a quartz envelope and are filled with various combinations of metal halides giving rise to their name of *compact source iodide lamps*, or CSI lamps. They have an almost continuous spectrum and a high efficiency of 85–100 lm W⁻¹. Modern developments in ballast resistors have vastly improved the fluctuation problems but, as always, an actual check test under the planned conditions of use will be very worthwhile.

In general, mains operated continuous lighting lamps of the filament or discharge type should be used with caution as the light often fluctuates at rates of 50 or 100 Hz. Whilst appearing continuous to the naked eye, the fluctuations may cause problems when short duration exposures are used such as are common in high speed photography.

2.5.5 Expendable flash bulbs

Flash bulbs have a very long history in both conventional and high speed photography. They also hold an unusual position in that their useful operating time of about 20 ms allows them to be used for both cine and single flash photography. The bulbs contain a fine metal wool of aluminium–magnesium alloy or a similar combustible metal and are filled with oxygen at low pressure to assist good combustion. Application of voltage fires a small igniter which starts the burning of the main metallic contents. They have the advantage that their ignition can be achieved with a small DC voltage, and the most simple circuits will operate from small dry batteries. More elaborate circuits may use higher voltages and incorporate test circuitry to check that the bulb is good. The main disadvantage is that they are a once-off item and must be replaced after each usage. When large arrays are employed this can be a time consuming task and strong precautions should be taken to avoid accidental pre-firing. Because of their relatively long burn up time, accurate timing and synchronization is essential when using flash bulbs. Bulbs are available in a wide range of outputs, from about 5000 to 100 000 lm s⁻¹, and in a variety of burn up times to peak output. Delays vary from 5 to 35 ms, with higher powers having the longest delays. Colour temperatures fall into two bands (3500 and 5500 K), the higher value being achieved by coating the bulbs with a transparent blue lacquer. The spectrum is virtually continuous.

The light output in relation to weight, size and extreme portability make flash blubs very efficient sources. The total light output of a flash bulb is roughly equal to a 1000 J electronic flash tube. Additionally, their relative cheapness and expendability make them ideal for photographic situations where the light source may suffer damage or destruction. As a consequence they are much used in ballistics high speed photography. By simultaneous firing of large numbers of bulbs, large areas can be lit to a level equivalent to many kilowatts of light output from other sources. For the normally short event time involved with most high speed subjects their useful short output time is no disadvantage.

2.5.5.1 Programmed firing of flash blubs

With modern developments in control systems it is

possible to *ripple fire* many bulbs in quick succession, giving an almost steady light output over a period of half a second or longer. Alternatively, they made be fired in timed groups or a large number may be fired simultaneously to provide a very high output level. Commercial equipments are made by Bowen Electronics UK, and their Rippleflash 20 system uses standard Edison screw (ES) flash bulbs (Figure 2.3). Ripple firing using eight bulbs gives an overlap sequence for about 0.5 s, or up to 160 bulbs can be fired simultaneously.

Figure 2.3 Bowen Electronics Flashbar 5 + 5 Rippleflash system.

2.5.5.2 *Use with cine*

Guidance on the use of flash bulbs when employed as illumination for a high speed camera such as the Fastax type is given by Hyzer (1962). He quotes the approximate *guide number* (Gn), in feet, as:

$$\text{Gn} = dA = \left(\frac{C}{m+1}\right)\left(\frac{ISpN}{F}\right)^{1/2} \tag{2.1}$$

where d is the lamp to subject distance (in feet), A is the *f*-number of the camera lens or system, m is the image magnification, I is the average light intensity (in lumens), S is the film speed (in ISO), p is the shutter exposure constant ($1/3$ for Fastax), N is the number of lamps fired simultaneously, and F is the picture frequency (pps). C is a constant depending on reflector efficiency and reciprocity law failure; it is equal to 0.15–0.2 for an average reflector and 0.2–0.25 for a large studio reflector. Note that C is a function of the reflector efficiency factor (R), where $C = 0.7(\sqrt{R})$. The parameter R is the ratio of luminous intensity with and without a reflector.

2.5.6 Electronic flash

With the consideration of electronic flash tubes, the continuous or long term transient sources used with cine photography are set aside so as to move into the region of still high speed photography. However, sequential framing photography need not be abandoned, as multiple flash exposures on single or multiple plates and multi-flash assisted cine photography can still supply the valuable time history aspect to our photography.

Most transient sources will perform the 'shuttering' function in their particular photographic applications with the normal shutters of the associated cameras either removed or left open for the event duration.

A large percentage of current short duration still high speed photography is taken using electronic flash. Indeed this type of photography is often referred to as 'flash photography' even if taken with some other short duration light source.

2.5.6.1 *Electronic flash development*

There are now many types of electronic flash tube but they all had their origin in the pioneer work of Harold Edgerton in the USA. In the early 1930s, whilst working on mercury arc rectifiers, he observed the high light outputs which were produced from the discharge and considered that they could be harnessed for photographic purposes. He experimented by making special tubes in which he enclosed a spark gap surrounded by mercury vapour. When subjected to a high voltage pulse the tubes produced a bright light flash and the electronic flash tube was born. Edgerton developed these devices extensively and experimented with other filling gases. Unlike flash bulbs the tubes could be flashed repetitively to produce a stroboscopic source. Modern tubes use xenon, krypton or argon mixtures. The tube is fired by the application of a pulse of several hundred volts across its electrodes. A trigger pulse of several thousand volts allows the tube to be flashed at any desired instant. Flash units are often run from low voltage battery supplies which are converted to high voltage by a small oscillator. Flash tubes can be made for a wide range of output levels, from small units attached to cameras, to large studio units providing several thousand joules of output. Flash duration of the tubes may vary from a few milliseconds down to a microsecond, but output drops with reduced duration. The SPD of the discharge has a high continuous background with a line spectrum of xenon as would be expected. Colour temperature is around 6000 K and the output is high in the blue region, which, if necessary, can be corrected with appropriate filters or reflectors. Efficacy is of the order of 30–50 lm W^{-1}. Synchronization is relatively easy due to the almost instantaneous response to a trigger pulse (see Chapter 3). For still photography, several sources can be fired simultaneously from a common trigger or can be fired from built-in triggers which detect the light from another flash unit.

2.5.6.2 Edgerton aerial flash

During World War II extremely large Edgerton flash units were installed on reconnaissance aeroplanes and used at night to take pictures of the results of bombing raids. The tubes were extremely powerful giving outputs of 60 000 J, and pictures were successfully taken from heights of some 2150 m (7000 feet).

2.5.6.3 The Arditron

Also during World War II, a discharge tube was developed which allowed significant advances in high speed photography, particularly in the ballistics field. It was developed at the Armament Research Department at Fort Halstead in England, and hence came to be known as the Arditron. The unit including mains power supply, the flash tube mounted in a hemispherical reflector and associated controls was built into a portable metal box some $0.7 \times 0.7 \times 0.9$ m (2 feet square and 3 feet high), (Anon., 1946; Mitchell, 1948). It was later further refined and developed by several commercial firms. The Arditron tube used argon at a pressure of 75 cm and the tube was pulsed by a 2 µF capacitor charged to 7500 V. A 5000 V trigger pulse was used to fire the tube. Peak flash duration was of the order of 1–2 µs.

2.5.6.4 Strobe flash

At the instant of peak light output, flash tubes may be operating at megawatt discharge levels for a short time. They must therefore be very strongly constructed to withstand the very high impulse energy involved. This also means that they must not be grossly overdriven to avoid any possibility of tube breakage or explosion. When used in a stroboscopic mode the output is limited to prevent the discharge energy in the gas building to destructive levels. Chesterman has made a detailed study of several flash tubes under various operating conditions (Chesterman and Glegg, 1954).

Many modern flash-guns incorporate a photocell to integrate the light reflected from the subject. This is used to operate a thyristor switch which will cut off the tube discharge to allow automatic exposure duration. By incorporating a background of high reflectance behind the subject, the flash-gun can be forced to give a very short flash duration, but it will be at reduced intensity. Some flash-guns have a removable photocell which can be taken from the flash-gun, though still connected by a flying lead, and placed close to the subject to assist in duration reduction.

The electronic flash tube can be made to produce a series of flashes at various rates, when it is often called a *stroboscope*. By synchronizing the flashes to appear at the same instant in each cycle, this can be used to apparently bring cyclic movements to rest, to allow the study of revolving or oscillating machinery, e.g. rotating fan blades. It can also be used to produce multiple high speed exposures on a single film frame to study human or other subjects in motion, e.g. analysis of a golf swing or assistance with the perfecting of an athletic performance. These multiple exposures on a single picture are full of information as the movement between exposures can be used to obtain the velocity and acceleration of the moving object.

2.5.6.5 Cine sychronization

A stroboscope can also be employed very effectively to 'shutter' cameras running in continuous mode with open shutters and the movement compensation mechanism temporarily removed. Used in this way it is often possible to obtain a cine recording with exposure times much shorter than would have been possible with the normal camera mechanism (see laser sources also). Alternatively, the flash can be synchronized to occur when the cine camera shutter is in its fully open position. In this way the normal cine action is used but the exposure time for each frame can be much shorter than that available from the built-in camera shutter.

2.5.7 Argon bombs

Light sources called *argon bombs* are reserved almost exclusively for ballistics photography. The argon bomb is not to be found in every photographer's kit as it is literally an explosive light source. In field experiments, particularly where high speed photography of explosions is concerned, the event itself can produce very high intrinsic light levels. To allow short duration photography of such subjects a very high intensity source is required. The high intensity of the argon light allows the camera lens to be stopped down to a point where the light from the explosion under study can be ignored.

The use of conventional equipment would involve placing a large and expensive piece of equipment at risk and the argon bomb is a viable alternative. Because of its explosive nature and the attached damage potential, such devices are normally only used by government or military establishments.

The device is extremely simple. A cardboard or plastic tube is closed at one end with a clear plastic window. At the other end of the tube a small pad of explosive is placed on the inside of a solid end plug. The tube is filled with argon or xenon gas and placed with the clear end facing the event (Figure 2.4). When the explosive is detonated a shock wave travels through the gas which becomes ionized and produces an intense light flash. The intensity is governed by the shock wave strength and tube length. A typical device would produce a 380 mm (15 inch) field at 1.22 m (4 feet) distance with an illumination of 100 000 lm cm^{-2} for 100 µs.

Typical duration times for these sources are of the order of 100 µs or less and they are suitable for use

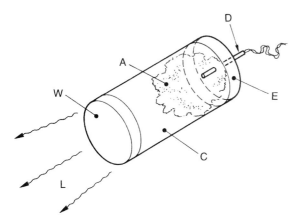

Figure 2.4 The argon bomb light source. C, Cardboard tube; A, argon gas filling; E, explosive; D, detonator; W, window; L, light output.

with high speed rotating mirror cameras, which provide the necessary short duration shuttering required. It was shown by Winning and Edgerton that the flash duration is equal to about 2 µs for each 10 mm of the argon path through which the shock travels. Many types of argon explosion driven sources have been made (Michel-Levy and Muraour, 1937; Sewell *et al.*, 1957). An argon source was produced by Bagley (1959), which was carefully designed so that the gas layer was very thin and the shock wave travelled through it precisely parallel to the output window. In this way the exposure time was reduced to the order of 0.1 µs. The source could also be enclosed in a 6.25 mm (0.25 inch) thick steel box which contained the explosion and allowed personnel to remain close by during its use.

2.5.8 Spark light sources

2.5.8.1 Spark development and operation

Spark light sources have an important place in the history of high speed photography. What could be considered as the first true high speed photographs were made in 1851 by William Henry Fox Talbot using an electric spark. He took a picture of a sheet of newspaper revolving at high speed on a spinning disc. The subsequent image showed that the print was clearly legible and the movement had been effectively frozen. More than 50 years was to pass before any other form of photographic device began to even approach a millisecond exposure capability let alone the microsecond ability of the spark. The spark source has continued to be used most successfully in all manner of photographic applications up to the present day. The basic principle is very simple, but a great deal of work has gone into attempting to perfect and improve the operation and light output quality.

A basic circuit is shown in Figure 2.5(a). A high voltage source is used to charge a capacitor to high voltage through a charging resistor. Once charged the energy can be discharged through a spark gap, ionizing the air in the gap and producing a bright flash. The brilliance of this kind of spark will have been appreciated by most readers when near a passing electric train the contact shoes of which momentarily lose connection with the rails. The triggering of the spark is achieved by closing a trigger gap (Figure 2.5(b)), or more efficiently by using a trigger electrode included in the main light producing gap. In this case a small trigger spark can be employed to ionize and break down the main gap (Figure 2.5(c)).

Spark sources will typically have durations of 1 µs or less and are thus extremely suitable for short exposure photography. One drawback is that, although the main light pulse is very short, the ionization may persist as a slowly fading light source after the main pulse. This is often bright enough to give a blurred outline on the rear of a moving subject. The problem can be reduced by using a series fuse link or quenching circuit, which prevents the current from developing into a ringing oscillation which prolongs the emission.

2.5.8.2 Spark gap types

The simple spark gap will tend to have an elongated source shape (Figure 2.5(d)). This is suitable where a slit source is required, e.g. in schlieren photography. However, the spark path tends to wander in its passage across the gap in consecutive discharges. This makes it difficult to produce a constant source position. The light output and spark path regularity can be greatly improved by the use of a fine guiding gas jet between the electrodes. This gives a preferential path to the ionization from spark to spark. Argon gas can be used successfully for this purpose with the gas passing down a fine hole in the centre of one electrode. A small circular source is preferable for shadowgraph photography purposes. This is often achieved by using a gap in the form shown in Figure 2.5(e). This is often called a *Libessart gap* after its inventor. Whatever the spark path within the gap the actual light output is constrained to exit from the small hole in the electrode, thus ensuring that it will always be a point source. To achieve best results the system inductance must be kept low and circuits are often designed where the spark gap is connected directly to a capacitance to eliminate long leads. Specially designed spark heads have durations of the order of 10 ns. It can easily be seen how the spark gap developed into the flash tube by simply enclosing both gap and gas in a glass or quartz envelope.

2.5.8.3 Multiple sparks

Spark gaps can be pulsed repetitively to give multiple sparks from the same source. However,

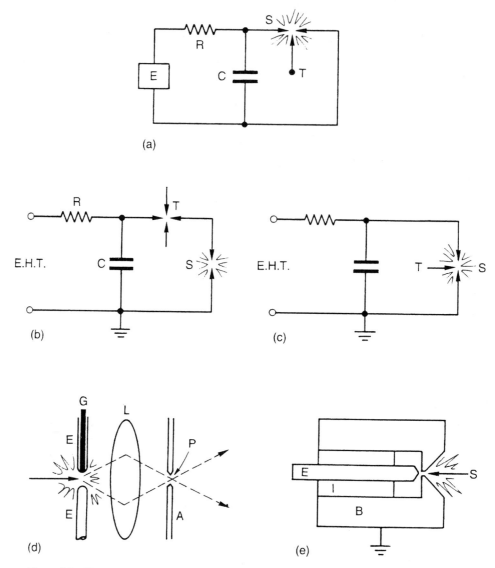

Figure 2.5 The spark source. (a) Basic spark source circuit. E, EHT power supply; R, charging resistance; C, storage capacitor; T, trigger electrode; S, spark gap light source. (b) Separate series trigger T. (c) Trigger T on light gap. (d) Long or open gap type of spark. E, electrodes; L, lens; P, point source; A, aperture plate; G, sometimes gas flows through the centre, e.g. argon. (e) The Libessart or end fire gap. E, electrode; I, insulation; B, body; S, light emitting spark gap, i.e. point source.

repetition rate is governed by the ability of the feed circuit to prevent 'ringing' and for the ionization in the gap to be removed ready for the next pulse. Alternatively, a number of gaps can be sequentially triggered as in the Cranz–Schardin system, or as a series of cascading gaps arranged with intermediate lenses so that the light always issues from the same point (Figure 2.6). Much fine adjustment is often necessary in these set-ups to prevent simultaneous sparking or out of sequence firing (Fuller and Wlatnig, 1975).

Because of their construction complexities and a multiplicity of types, a large percentage of spark light sources have been and are made 'in-house' by research establishment and university staff. However, in the UK, Pulse Photonics Ltd began making commercial spark gap light sources in 1987 and still produce one-, two- and four-spark source units which can be controlled via a multi-channel sequencer.

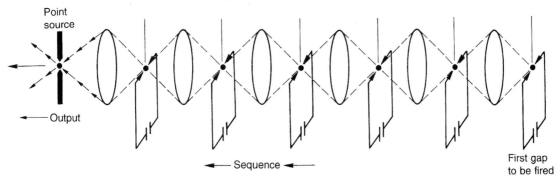

Figure 2.6 A cascade of sparks. The series of flashes appears as a single point light source through a series of consecutive focusing lenses. As many as six spark gaps can be used without noticeable deterioration of light intensity.

2.5.8.4 *Cranz–Schardin system*

A very effective system was developed by Cranz–Schardin (ISL France/Germany) in which multiple gaps are used to give multiple pictures usually on a single plate in a circular format (Figure 2.7). These are very effective but have the drawback that each picture is taken from a slightly different viewpoint, which complicates detailed analysis of the picture series produced.

An interesting feature of spark light sources is that they can be used, without a camera, to produce very acceptable pictures. Providing the output is a point source they can be set up to take a shadowgraph record of an event using just the source and a sheet of film. The event is arranged to occur between spark and film and of course must be conducted in darkness during the event and whilst the film is uncovered. A very important application is in aeroballistic ranges where multiple orthogonal spark pictures are taken and analysed to reconstruct projectile trajectories.

2.5.8.5 *Stroboscopic spark sources*

Special stroboscopic type sources have been developed for high speed photography in which the largest sources can produce 1 μs pulses at up to 100 000 Hz with megawatt light outputs. Alternatively, smaller units can give 10 ns flashes at up to 20 000 Hz with 10 mJ outputs.

2.5.9 X-ray sources

Whilst it could be argued that X-rays are not strictly 'light' sources in that their output is not in the visible region, they can be used to expose film and so it is thought reasonable to include them here. In fact their wavelengths begin beyond the end of the

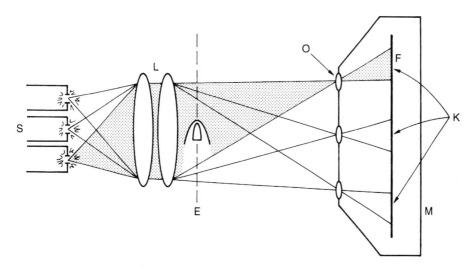

Figure 2.7 The Cranz–Schardin camera system using multiple spark sources. The spark light sources are fired in a chosen sequence with selected delays. S, spark source; L, condensing lens; E, observed event; O, objective lens; M, multi-lens camera; F, film surface; K, shadowgraph images.

ultraviolet section of the spectrum and the region normally used for X-ray photography is in the range 10^{-4} to 10^{-1} nm. For self-luminous subjects where ordinary filming is difficult, or where smoke, dust or debris obscure the event, X-rays provide an excellent observation method. Their most attractive quality of course is their ability to penetrate otherwise opaque objects to reveal what is happening inside. Flash X-rays can have durations of 1 µs or less and so can be counted as very short duration sources and very suitable for high speed photography.

For a parallel beam of X-rays, the intensity of the beam passing through a surface perpendicular to the beam is expressed in watts per square metre (W m^{-2}). For the radiation emitted from a point source, which is the more practical situation, the intensity per unit time, per unit solid angle in a specified direction will be I_o. At a distance d, the intensity I will be

$$I = \frac{I_o}{d^2} \tag{2.2}$$

The X-ray beam is usually described in terms of its 'dose' D, expressed in roentgen, which represents an amount of ionization. The roentgen (R) is defined as 'the quantity of X or gamma (γ) radiation such that the associated corpuscular emission due to ionization per 0.001293 g of air, produces in air, ions carrying 1 esu of electricity of either sign'. The energy needed to ionize one air molecule is 52×10^{-19} J, so the absorbed energy corresponding to 1 R is 0.109×10^{-7} J cm^{-3} of air at NTP $(0.84 \times 10^{-5}$ J $g^{-1})$. The corresponding intensity I_d is the dose per unit of time and is given (in R s^{-1}) by

$$I_d = \frac{dD}{dt} \tag{2.3}$$

An *absorbed dose* is defined as the 'amount of energy imparted to matter by ionizing particles per unit mass of irradiated material'. This is expressed in rads. A *rad* is the unit of absorbed dose and is equal to 10^{-5} J g^{-1}.

The X-ray spectrum is a continuous one which varies with applied voltage and upon which are superimposed line spectra determined by the anode material in use. As has been seen above, X-rays will fall in intensity per unit area as the beam spreads out with distance or passes through absorbing media. Thus the stand-off distance of the source from subject and film will be important.

2.5.9.1 *Construction and operation of flash X-ray tubes*

In 1895, Roentgen discovered that when matter is bombarded with cathode rays, i.e. electrons, it results in the generation of electromagnetic radiation (EMR) called X-rays. The X-ray tube system

will include the cathode, which is the source of electrons, the anode, which is the target for the emitted electrons, and a high voltage, which is applied across the anode and cathode to accelerate the electrons. The X-ray tube is usually made of glass and contains the central anode and the cathode, both of which may take a variety of forms. The tubes may be gas discharge, vacuum discharge or field (cold) emission types. The use of gas discharge types has been abandoned due to their low efficiency. The typical flash X-ray tube will have its internal pressure maintained at less than some 1300 N m^{-2} (some 10 T). Originally used with a third trigger electrode, they are mostly now simple diode tubes designed for operation between 400 and 800 kV. The output window will be glass or metal. The basic circuit of a typical flash X-ray system for low voltage (<100 kV) soft radiation, is similar to that used to produce the electric spark (Figure 2.8). A capacitor is charged from a high voltage source and then discharged through the flash head. Instead of producing light the resulting electron bombardment of the anode produces X-rays which fan out in

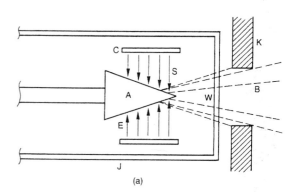

(a)

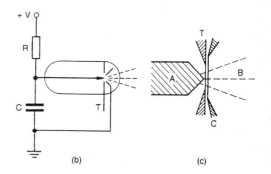

(b) (c)

Figure 2.8 Circuit for flash radiography. (a) Typical diode tube detail. A, X-ray target anode; E, electron beam; J, X-ray tube; C, cathode; S, X-ray source; W, window; K, collimator; B, X-ray beam. (b) Basic circuit of a simple X-ray flash system. T, trigger; V, charging voltage; R, charge limiting resistor; C, capacitor. (c) Triode tube detail. A, anode; T, trigger electrode; C, cathode; B, X-ray beam.

a conical beam. Generally the higher the voltage the 'harder' or more penetrating the subsequent X-rays will become, and the greater their penetration will be through a given material. Typical voltages range from tens of kilovolts up to megavolts for the largest and most powerful sources. For higher voltage, i.e. harder X-rays, the high voltage pulse will be supplied by means of a transformer or a *Marx surge generator*. These devices will also allow the production of shorter length pulses ranging from 0.1 μs down to tens of nanoseconds.

The radiation spectrum will vary with the anode material, the tube window and the electron accelerating voltage. The various classes of output can be listed as:

- 'Hard' output (greater than 50 keV) suitable for penetration of thick objects. Voltages up to several mega electron-volts. Usually uses a tungsten anode.
- 'Medium' output (20–50 keV) using a beryllium tube window and tungsten anode.

- 'Soft' output (10–20 keV) using a molybdenum anode, giving output which is nearly monochromatic.
- 'Very soft' output (less than 10 keV) using a tungsten anode. Gives thin layer detail in low density media.

During interaction with the object the beam will be both scattered and absorbed. These processes are governed by the energy of the beam, the density of the object and its atomic structure. The beam which passes on to the detector is modulated in intensity and spectrum and now contains primary and scattered rays. Scattered rays are not desirable as they have no image information and only reduce image contrast by creating background exposure. They tend to worsen with increasing X-ray energy.

To allow *X-ray cinematography*, the tube can be pulsed sequentially and the pictures can be superimposed on a single frame. This is not a very effective method, being limited to about five exposures or less. To avoid the superimposition of images,

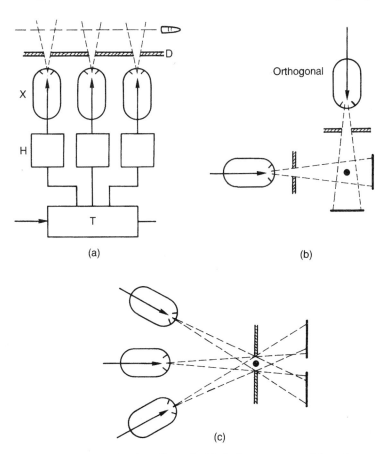

Figure 2.9 Multiple tube cineradiography. Typical arrangements of three alternative systems. (a) In-line. T, trigger; H, high voltage pulse; X, X-ray tube; D, collimating apertures. (b) Orthogonal. (c) Diagonal.

Figure 2.10 Multi-pulse X-ray flash system. T, High voltage pulser and trigger; X, X-ray tube; F, fluorescent screen; I, image intensifier; C, cine camera.

multiple tubes can be used observing from several angles and each recording on a separate film (Figure 2.9).

For conventional cine photographic sequences a cine camera can be used in conjunction with an image intensifier tube and a fluorescent screen (Figure 2.10). The pulsed X-ray system will be triggered by the camera, in synchronism with the camera framing rate. Alternatively, a long duration X-ray pulse may be produced, long enough to cover the event duration (Figure 2.11). The pictures will be sequenced by the use of an image converter tube as a shuttering device. The final image record will be captured by an image converter or ordinary cine camera or drum camera running in open shutter mode.

Early framing rates were in the 150–200 pps range, but rates up to 10^6 have been achieved. A typical median performance might be 50 frames at 10^3 or 10^4 pps. The number of frames will be limited due to the limitations on repetitive pulsing of the X-ray tubes. High pulsing rates create high heat levels and increased erosion of the anodes. Pulse rates will thus tend to decrease with increasing operating voltage.

2.5.9.2 Intensifying screens

All materials absorb X-rays to varying degrees and this absorption produces variations in the amount of X-rays transmitted through the various parts of the object according to the absorption factor and thickness of each part. X-rays thus produce *shadowgraphs* of the subject on the film. Radiographs taken using soft X-rays are mostly made using special radiographic film without intensifying screens.

In flash radiography, fluorescent intensifying screens are usually required. Intensifying screens convert the X-ray photons into visible light which assists the formation of the image on the film emulsion. Substances used for intensifying screens include calcium tungstate with an emission spectrum between 350 and 550 nm, zinc sulphide (390–550 nm), or sulphates of lead and barium (300–450 nm). The use of screens reduces the film definition somewhat due to multiple reflections. The choice of film and intensifying screen is a complex decision. It involves beam energy, object material and stand-off distance amongst other considerations.

The screens are placed in close contact with the film and usually in pairs, one each side of the film. X-ray films are subject to *image blur* which will be a combination of blur due to subject movement, blur

Figure 2.11 Long-pulse X-ray flash system. Single tube radiography. T, trigger; V, power supply; X, long duration X-ray pulse; J, event, e.g. a bullet; S, scintillator; K, photocathode; I, image intensifier; P, phosphor; M, image converter; C, camera.

due to the presence of intensifying screens and blur due to the beam geometry. The latter is due to X-ray sources not being proper point sources, i.e. they have areas which are of significant size. This produces a *penumbra* surrounding the image, according to the ratio of object to film and source to object distances (Figure 2.12). Contrast, or the ability to show thickness differences will decrease with increasing system voltage.

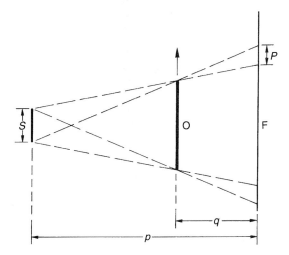

Figure 2.12 Effect of X-ray source size on penumbra. *S*, X-ray source size; O, object; F, film; *p*, source to film distance; *q*, object to film distance; *PF&*, *penumbra*. *Geometry of system gives* $P = S[q/(p - q)]$.

2.5.9.3 Cassettes

As the X-rays will pass through thin materials the film can be enclosed in a protective *cassette* to shield it from normal light. In the most simple system, normal cameras are not required and, in a similar way to simple spark shadowgraphs, all that is needed to make a picture is the film and an X-ray source. In some cases image intensifying screens will also be included in the cassette to enhance image brightness by conversion of X-rays to light photons.

The type of film cassette will be chosen according to intended use. For normal purposes the cassette will be in the form of a thin light-tight 'book' usually made of aluminium with a hinge along one edge and a catch on the opposite side. The film and screen(s) are placed inside and the cassette locked shut before being placed in position. For more robust environments such as may be found in situations where the cassettes may be dislodged from position or struck by flying debris during the event, e.g. ballistic type events, special cassettes will be used. These will be of more sturdy build and may incorporate foam sheets to protect the film from impact vibration and may also have external sheets of plywood or polythene to give further protection. Cassettes placed

near explosions will usually be left free to move with the blast, as this will probably produce less damage than if they are rigidly fixed. For extremely powerful explosions, a fluorescent screen has been placed close to the explosion area and viewed via mirrors. The image is transmitted to the recording system which is housed safely in an emplacement nearby. The screen is destroyed at each firing, but by that time the image has been captured (Bergon and Constant, 1970).

For some work it may be necessary to limit the area of the exposure to the X-ray beam. Lead is a good absorber of X-rays and lead sheet or lead blocks can be placed to shield areas which require protection. If *fiduciary marks* are required to give reference points on the recorded pictures, wires or other metallic objects can be placed to give horizontal and vertical references. In some instances, absorption levels may be measured from the exposure density on the pictures. In this case *calibrated step wedges* of known thickness and properties will be included in the picture as references.

2.5.9.4 Care in selection and use

X-ray photography is a highly specialized and complex form of photography, and consequently photographers who practice it will often make it their speciality subject area. The use of X-rays constitutes a potential hazard to the user and those in the vicinity of the apparatus. *No one should attempt or be allowed to use X-ray equipment without supervised training and successful examination in the subject.*

Because of the ability of X-rays to penetrate solid objects, personnel behind apparently adequate barriers, e.g. a brick wall, against which the beam is directed, may still be in an area of hazardous radiation levels. Thus it is vital that whenever an X-ray system is set up the surrounding area, and particularly the area within the beam direction, is carefully monitored, even though the site is bounded by apparently solid walls or objects. If there is some doubt, experiments can be conducted using radiation monitors to check the exposure levels at the area in question. As a general rule, all personnel should be cleared from the area during filming and during preliminary testing. All personnel directly involved with X-ray photography, and others in the vicinity, must wear badge monitors which will be checked at intervals to see whether they have exceeded safe exposure levels. A code of safe conduct will be enforced by the local administration. As with many electrical devices involving high voltage, X-ray equipment should only be maintained or repaired by skilled and fully trained staff. Special care should be taken in the use of X-rays because of the nature of the radiation involved. A dangerous dose can be received without the recipient being aware of the fact, so responsibility and

care on the part of X-ray operators is of paramount importance.

X-ray apparatus needs to be matched to the subject in terms of power and exposure durations. Due to the wide variations in absorption levels, 'soft' (i.e. low voltage) X-rays may not penetrate more dense or thicker objects and information will be lost. Alternatively, if 'hard' (i.e. high voltage) X-rays are used, the radiation may pass through some parts of the subject with negligible attenuation and they will apparently disappear. Again information on their status will be lost. Thus it is necessary to choose the radiation level with care to obtain the best results for a given subject. By the use of a suitable choice of films and intensifying screens both 'hard' and 'soft' images can be obtained simultaneously. The soft image using one kind of film is exposed directly and the hard image by using another kind of film is exposed between intensifying screens. An example of this is given in Chapter 13 on project design and planning.

2.5.10 Lasers

Lasers, an acronym of 'light amplification by stimulated emission of radiation', produce a unique type of light with characteristics unobtainable from any other type of source. Whilst lasers of various kinds have been available for several decades now, their use in general high speed photography, apart from holography, has been relatively little. However, in scientific research photography it has long been realized that the special properties of lasers would be extremely valuable and that they would allow previously unobtainable experimental observations to be made.

According to type, the laser can be run to give a *continuous* or *pulsed* output, which is convenient for photography. Some types can be run in only one or other of the output forms, whilst others can be operated in either. For ultra-short illuminating sources the laser is in a class of its own. Durations of a few picoseconds (ps) are possible and, according to type, the laser can be exposed in single or multiple flash mode to produce sequential frames on cine film or single film frames. In addition, lasers can be synchronized with cine cameras so that shutter opening and flash can be coincident.

Particularly valuable attributes of laser light are:

- Low dispersion angle of the beams.
- Very high intensity light output.
- Very short duration, modulated or continuous beam output choice.
- Well defined monochromaticity.
- Coherent light output (essential for use in holography).
- Wide choice of output wavelength.

2.5.10.1 *Basis of operation*

The laser has been steadily developed since its invention in the early 1960s and new types are still being produced at intervals. Lasers are of three main forms: solid state, gas or vapour and, the most recently developed, semiconductor. The first two types are most important for high speed photography purposes as semiconductor lasers do not as yet have adequate output except for restricted size events which only require very small light sources.

The actual lasing action of materials is very complex and cannot be covered in detail here, but a simplistic explanation follows. Whatever the material, the working principle is basically the same. The requirements are an active medium, a feedback mechanism or resonant cavity forming a Fabry–Perot system, and a source of excitation energy (Figure 2.13(a)). Energy, in the form of light or electricity, is supplied to raise the atoms of the active medium to a higher energy or 'excited' state. The mechanism for achieving this is by the addition of photons, i.e. a quantum or discrete amount of electromagnetic energy, which is exactly the amount required to raise each electron to the next energy level. This action is called *transition*. The atoms quickly return to their lower energy state, but in the downward transition they emit a photon of energy with a characteristic wavelength. For laser physics the transitions involve electrons in the valence shells of atoms or molecules. Transitions are very complex and can take place in many forms and are not all equally likely to occur. In general, more atoms are in a lower ground state than in excited levels and quantum mechanical rules make some transitions more likely than others. Thus atoms and molecules make transitions to higher energy levels when they absorb light (photons) and return to lower energy levels when they emit photons. Emission can be *spontaneous*, i.e. it occurs by itself (most natural light is produced in this way), or *stimulated*, when a photon of the correct wavelength and energy stimulates an excited atom in the correct energy state to release energy at the same wavelength, i.e. the photon is absorbed. The simple equilibrium emission and absorption of atoms and photons does not achieve very much. To produce a lasing action we must produce conditions where the population of the upper layers (i.e. higher energy) potential emitters is higher than the population of the lower levels (i.e. low energy) potential absorbers, a condition known as *population inversion*. To produce this state, the lasing medium must be selectively excited by the addition of light or electrical energy, so that the chances of an interaction occurring under the correct conditions become much greater. When this can be achieved, the medium is arranged in a resonant cavity so that those photons which are emitted parallel to the axis of the resonating system, instead of being lost outside, will be reflected back

to pass again through the lasing medium. This will assist in producing further interactions and, under the correct conditions, the production of photons will turn into an *avalanche* process where multiple interactions produce more and more transitions and photons and lasing is sustained.

In practical lasers, in order for the population inversion to be maintained, the transition process is a cyclic one, which is achieved by appropriate design and use of materials. It involves the atoms stopping for a time in intermediate energy levels in their downward fall. Once raised to the higher energy level from the ground state the atoms quickly drop to a slightly lower level (metastable), where they stay for a longer period. They then fall to a lower energy level which has a shorter life time than the metastable level and then drop to ground level by spontaneous emission. Population inversion and lasing emission occurs between the metastable and lower energy level states (Figure 2.13(b)) where the photon production will be amplified and the material will 'lase' and give out a beam of characteristic radiation. The objective of this four stage arrangement is to keep the highest energy and ground states relatively low in numbers so that they are free to emit and receive atoms in the cyclic flow. Thus, while external energy is supplied to the material and the conditions are suitable, the lasing action will continue and the laser beam will be sent out. Sometimes the lasing occurs in discrete bursts, as in the *ruby laser* which emits each time the exciting flash lamp is fired, or sometimes the lasing action will be continuous and the beam will be also continuous or shuttered externally, as in an *argon laser*. In order to control the instant at which the laser will emit a large light pulse, the *Q-switched laser* can be used. In this system the laser is being pumped or fed with energy but the Q or resonance magnification is kept low so that, even though the population inversion is being raised to high levels, stimulated emission remains low and no lasing occurs. When the system is suddenly brought into a resonance state by introduction of a reflecting surface to create a state of high Q or resonance in the cavity, the large population inversion is suddenly reduced and a giant laser pulse is emitted. Pulse powers of 5×10^{10} W and above can be produced with durations of 20 ns.

For the majority of high speed photographers the use of most lasers will be simply a matter of switching on, bearing in mind the safety requirements which must be observed. A knowledge of the internal working processes are thus not essential; however, it is sensible to try to understand the basic operating principles of the types used in order to operate them in the best way and avoid premature failure due to bad procedures. This is particularly vital if triggering of the laser system is involved. The assistance of a skilled laser operator is to be recommended when ever possible.

2.5.10.2 *General attributes*

Lasers are usually of low efficiency, ranging between 1% and 20%, i.e. of the energy supplied to the laser not more than 20% will be converted into laser radiation. Lasers produce light in the visible waveband but will also operate in the ultraviolet and infrared regions.

When lasing occurs the laser produces light characteristic of the lasing material. This will give each laser a specific wavelength and colour. Some lasers can give combined outputs at different wavelengths which can be separated optically if required. This property is called *multi-line operation* and in some lasers, such as argon, the wavelengths are close together, between 450 and 530 nm. In others, such as the carbon dioxide laser, the wavelengths, amounting to dozens in number, may be spread over a large range from 9 to 11 µm (Fuller and O'Conner, 1995). Generally useful levels of output are restricted to a relatively low number of wavelengths. Some lasers such as those which use organic dyes in solution, can be 'tuned' over quite a wide range by adjusting the laser dye and the optical resonator. As laser pulses can be so short, there are effectively few objects that cannot be frozen in motion, even including light itself (Abramson, 1980). In 1971, Michel Duguay and his colleagues at Bell Telephone Laboratories in the USA, were able to capture a 10 ps laser pulse made visible by its passage through a glass cell containing milk solution. The ultra-fast shuttering was achieved by the use of a *Kerr cell*. Later, in 1980, at the Spectra-Physics Facility Laboratory in California, Dr N. Abramson used a Spectra-Physics dye laser to produce a string of 10 ps pulses. Using a holographic set-up he was able to record the passage of the individual pulsed wavefronts through a convex lens and show the wavefronts being focused down to a point, thus

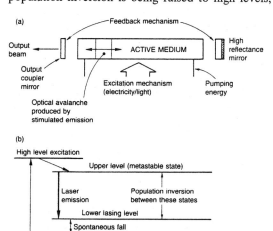

Figure 2.13 The laser. (a) Basic operating elements required for all lasers. (b) Four level laser operation.

graphically illustrating the actual process which we usually have to take for granted (see Chapter 23).

If required, laser light can easily be passed into optical fibre bundles and conveyed to a point where the light source will be most effective, often into areas which would otherwise be inaccessible to an illuminating beam. For subjects which have very high inherent luminance, e.g. burning propellant, where the light output would effectively preclude photography, lasers can still be used. Advantage can be taken of the very narrow wave band property of the laser light so that it can be used with a very sharp cut-off filter which allows only the laser light to reach the camera, all extraneous background light being cut out.

2.5.10.3 Metal vapour lasers and cine synchronization

Over the last few years, metal vapour lasers have been steadily improved and these can be used very effectively in high speed photography. The lasing cycle is controlled by the application of external electrical pulses. The lasers can produce visible light pulses down to tens of nanoseconds duration. Output of a *copper vapour laser* (for example, such as those made by Oxford Lasers Ltd, UK) is in the green and yellow bands (511 and 578 nm). In this company's 'Laserstrobe' system, by combining a laser and a continuous motion film camera, the laser can be triggered from the camera to produce a pulse at the optimum point in each frame. In this way, the maximum framing rate of the camera can be combined with the exposure time of the shuttering laser to produce a formidable combination and a performance far above that of the camera alone. The Laserstrobe can run up to 50 000 flashes per second with durations between 10 and 35 ns. For subject situations of low subject to background contrast, a narrow band green transmitting filter can greatly increase the contrast. One company, Berelk Ltd, has developed a special '*N* shot counter' system to allow easy control of the laser and associated camera.

The combination of camera and metal vapour laser enables the effective exposure time of the camera to be reduced to that of the laser. It improves the optical resolution by up to 50% and, because of the increased illumination intensity, larger effective lens apertures can be used. It also enables cameras normally used in the *streak mode* with no built-in shutter, to be used to produce sharp discrete framed images. In the latter case, the laser pulse rate and film movement rate must be adjusted so that *overwriting* between adjacent frames does not occur, and in drum type cameras provision must be made to prevent general overwriting by the use of a separate shutter which controls the start and finish of the recording.

2.5.11 Super radiant light sources

Super radiant light (SRL) sources represent an alternative to argon bombs or lasers as intense short duration light sources. Such SRLs are obtained by applying a short intense burst of electrons to certain special crystals. A typical source might be a plate of cadmium sulphide (CdS), backed by a thin aluminium grounding foil. The crystal plate is stimulated much in the same way as a crystal laser, the individual crystals lase to produce an intense light output during the duration of the electron burst.

The SRL sources are not widely known or used as they require an electron beam tube for operation and dedicated tubes are not available in many laboratories. However, many flash X-ray systems can be used in a dual role as electron beam sources and can be modified for SRL work. Exposure durations down to a few nanoseconds ensure that very fast moving objects can be imaged without blur. For specific applications on self-luminous events or where very fast objects must be frozen in motion a SRL is very appropriate.

2.6 Light source safety considerations

All light sources should be seen as possible sources of danger, and treated with care. There is danger from intense light beams being directed into the eyes, and in particular those which have a high ultraviolet content. Exposure to these beams for even a short length of time will produce irritation and conjunctivitis in the eyes. Reflected light as well as direct exposure can be dangerous. Apart from light output, high voltages and currents may be in use to supply the sources. Very high voltages may be present, a particular case being that of optical sparks, where 10–15 kV or even greater voltages are not uncommon. Lamp surfaces and lamp housings can also get extremely hot and there is the possibility of burns.

If lasers are used there is a high risk of eye damage from the higher powered class 3b and 4 types, even from reflected light. Great care must be taken to avoid reflecting surfaces in the beam path, and to see that collimated beams do not escape from the immediate monitored surroundings of the area in use. Appropriate eye protection should be worn whenever possible. There is particular danger when lining up a system, especially when looking through viewfinders, which may contain magnifying elements. In this case, sources which by may be classed as safe when the beam is viewed in its normal state by the unaided eye, may become dangerous if the energy is concentrated into the eye by the use of element objectives which greatly increase the gathering cross-section, e.g. binoculars. When using

lasers, operating crews should be kept to a minimum and if visitors or other people must be present who are untrained in the use and dangers of lasers, it is necessary to ensure they are briefed on safety procedures and issued with the appropriate protective gear.

When lasers are directed at a particular area in which the objects illuminated may become displaced or destroyed, it is essential that a *backstop screen* is provided beyond the objects to avoid the propagation of the beam beyond the controlled area. It is also sensible to try to arrange for beams parallel to the ground to be projected either well above or below normal eye levels to minimize unwanted reflections or direct interaction with the faces of operating personnel when they are moving around in the area.

Acknowledgements

The assistance of Mr J. Rendell in the provision of Figures 2.2 and 2.3 and in technical discussion is gratefully acknowledged.

Figure 2.5 is modified from a diagram by F. Fründel.

References

Abramson, N. (1980) Holography records picosecond light pulses in flight. *Spectra-Phys. Laser Rev.* **6**, no. 2, 1–2

Anon. (1946) The Arditron. *Discovery* **7**, 825–827

Bagley, C. H. (1959) Enclosed argon explosive light source. *Rev. Sci. Instrum.* **30**, no. 2, 103–104

Beeson, E. J. G. (1960) A high power Xenon discharge lamp system. In *Proceedings 5th International Congress on High Speed Photography*, pp. 6–10, SMPTE, New York

Bergon, J. C. and Constant, J. (1970) Special protection boxes for radiographic film. In *Proceedings 9th International Congress on High Speed Photography*, pp. 277–280, SMPTE New York

Camm, D. M. (1992) The world's most powerful lamp for high speed photography. *Proc. SPIE* **1801**, 184–189

Chesterman, W. D. and Glegg, D. R. (1954) Short duration spark discharges in Xenon. In *Proceedings 2nd International Congress on High Speed Photography* (P. Nashin and J. Vivie, eds), pp. 8–18. Durand, Paris

Fuller, P. W. W. and O'Conner, J. (1995) A Michelson Interferometer for high resolution of shot start movement using a CO_2 laser. In *Selected Papers on Scientific and Engineering High-Speed Photography*, pp. 297–305 (SPIE Milestone series MS 109). SPIE, Bellingham

Fuller, P. W. W. and Wlatnig, E. J. M., (1975) A multiple spark system incorporating fibre optics and an electronic timer for projectile photography. In *Proceedings 11th International Congress on High Speed Photography*. SPIE, Bellingham

Hyzer (1962) *Engineering and Scientific High-Speed Photography*. MacMillan, New York.

Michel-Levy, A. and Muraour, H. (1937) Photographs of phenomena accompanying explosions of brisant explosive. *Comp. Rend.* **204**, 576–579

Mitchell, J. W. (1948) The Arditron. *J. Illum. Eng. Sci.* **41**, 261–262

Sewell, J. *et al.* (1957) High speed explosive argon flash photography system. *J. Soc. Motion Picture Television Engrs* **66**.

Bibliography

Jamet, F. and Thomer, G. (1976) *Flash Radiography*. Elsevier, Amsterdam

3 Synchronization and triggering

Peter W. W. Fuller

3.1 Introduction

The instant of image capture has always been a major factor in pictorial photography. Indeed, most of the great names in this field have made their reputations by being able to capture the split second in which an otherwise mundane scene momentarily transforms into an arresting image.

Whilst timing is important in pictorial photography, it becomes crucial in high speed photography where subjects are fast moving, framing rates are high and exposures very short. Synchronization of the event and image capture becomes the link which determines success or failure in the project. To achieve synchronization between event and image capture, some form of *triggering* and *time linkage* must be employed. As well as controlling the shutter, it may be necessary to produce additional light on the subject at the correct moment to enable the image to be adequately exposed. In some situations, short duration light sources may be used in the dark with an open shutter to produce the short exposures required. In this case only the light may need to be synchronized with high resolution, whilst shutter opening and closing time can be of relatively low resolution.

The diagram in Figure 3.1 shows the stages in the triggering and synchronization process. It does not cover all possible scenarios, but shows the major elements involved and the way in which the variations in sequence occur and how they are interconnected.

In many instances the event may be externally controllable, in this case a *pre-trigger* will start the event and prepare lighting and camera for action. The event then proceeds and lighting and image capture operate after predetermined *delays* to complete the process.

If the event is not externally controllable, then the beginning of the event will trigger lighting and image capture with appropriate delays. In some cases the delays required may be zero. If the recording system has a long duration (running time), and it is known that the event will occur within a certain time period less than the recording time available, then it may be possible to begin the recording at the beginning of the unknown delay period and still obtain an image.

This method will be necessary if it is vital to capture the beginning of the event. This will not be a favoured method as it will probably be extremely wasteful in terms of film. If the final result required is compatible with video capabilities then this will be an excellent method due to the very long recording times available.

The choice of synchronization, delay and trigger mechanism will of course be governed by the event characteristics, recording method used and requirements for final analysis. Systems vary from extremely simple to highly complex. All systems, however, require an event detector(s), a trigger mechanism producer, a variable delay and an outlet to the camera/recording system. Further outlets can be added to operate lighting or other devices, whilst

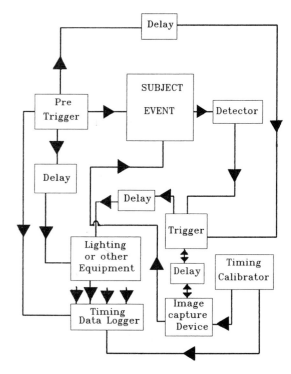

Figure 3.1 Sequence and interactions in a typical high speed event.

for serious scientific studies the recording device will be *time calibrated* and an overall record of all signal occurrences may be recorded on an appropriate *data acquisition* system.

The interactions can be described by considering a relatively slow speed event being photographed using a conventional camera equipped with flash. Take, for example, a photographer covering a diving exhibition. Initially we will assume that there is no chance to employ external assistance in triggering or synchronization and all depends upon the photographer and camera combination. The image is required at the instant at which the diver's outstretched hands touch the water surface.

In this case the photographer may *pre-trigger* the event by indicating to the diver that he is ready. His eyes will act as the motion monitor as the diver falls. After a short delay, the eye and brain interaction will decide the appropriate moment at which the brain will tell the finger to synchronize the record by tripping the camera shutter and flash. The photographer's eye and brain will form a sophisticated delay system as they estimate speed of fall, time of arrival of the fingertips at the water surface and a small fractional pre–trigger to allow for the photographer's finger movement and shutter mechanism delay.

A successful result may require several attempts, as we are dealing with human reactions and errors and exact repetition will be difficult. As a rule of thumb, events requiring synchronization to within less than half a second are probably best triggered automatically rather than by hand.

An alternative, more scientific, approach might eliminate the photographer altogether from the timing and synchronizing chain. The camera and flash would be set up to view the water surface at the appropriate location. A *light beam trigger* located just above the surface, could be operated by the diver's fingertips breaking the beam. This would trigger camera and flash via a variable delay selected by considering beforehand the calculated speed of fall and the beam to water distance. In this method precise changes based on indications from the first result will probably produce the desired effect in one or two shots. Using this automatic system, many of the timing variables can effectively be eliminated and the system will operate consistently shot after shot.

As high speed photography is principally used to study fast moving objects, synchronization is very important and may be employed for a variety of purposes. The coincidence of event, shutter opening or exposure and switching on of auxiliary lighting are the more obvious aspects. However, in some film cameras, such as rotating mirror or prism types, it may also be necessary to ensure that the image transmission path via the rotating mirror reaches the beginning of its recording position at the start of the

event, also that the opening and closing of the *capping shutter* coincides with the correct mirror position so that it is arranged to prevent *overwriting* on the film. In other cameras it may be necessary to synchronize the event with the time when the film camera has reached its correct operating speed or film velocity or when a certain length of film has moved through the camera.

To achieve correct synchronization it is necessary to have some means of detecting object presence or event occurrence in order to provide a suitable signal to operate other equipment. The most appropriate detector will be used in each case. If the detector itself does not provide a suitable output signal it may be necessary to transform its output into another more useful form of signal. It may also be required to have some means of varying the time at which the signal reaches its destination and for this some form of *delay* will be incorporated.

Triggers are involved in detecting a variety of forms of motion and have to be chosen to suit. The *object motion* may be in a straight line, curvilinear, rotational, steady state, transient or periodic. The first three define the main directional form of the motion, whilst the last three are more concerned with the motion characteristics in terms of speed and acceleration.

3.2 Timing

3.2.1 Timing requirements

In terms of criticality of timing, the highest timing definition will be required by still/single frame photography. Using a single exposure, the timing must be very accurate or it is likely that no image will be recorded at all, or the image may be taken at the wrong moment in the event history. The same problems will apply if a series of single exposures are made, unless triggering and timing are correct.

For *still video* and *electronic cameras*, timing will be crucial as they will usually be employed for fast acting subjects. As the available number of frames is likely to be fairly small, these cameras are in a similar class to single or multiple still photography.

For *streak* or *smear photography* timing is still very important, as subjects will generally be transient and very fast moving. However, providing image recording is begun before the subject moves into the camera view or before the changes of an already in-view subject begin, the continuous recording mode involved will ensure that no action is lost.

For cine or video photography, requirements are probably the least arduous. Subjects will generally be slower moving and of longer duration, although there will be exceptions such as rotating mirror photography of explosive events or similar situations. As with smear and streak photography, as

long as recording begins even a few frames before event action, the large number of frames will ensure adequate coverage to give a good event history. Even if the action start is missed, some information will be derived from the experiment.

3.2.2 Jitter

Jitter represents the overall allowable *time variations* in the action time of a triggering sequence. This will include trigger response time, any inherent interface delays and the response delay of the recording system between initiating the signal and the beginning of exposure. There will be as many specific instances as there are experimental situations and each will have to be assessed individually. However, there are some particular situations for which examples can be offered to give a guide to the method of approach.

Example 1. Consider a simple situation where a small object will be photographed by a single exposure whilst moving perpendicular to the viewing direction of the camera (Figure 3.2(a)). The object is moving at a velocity V. The field of view of the camera covers a distance X along the movement path of the object. Exposure duration is sufficiently short to freeze the image with acceptable blur. If the exposure is triggered as the object passes point A the exposure must take place whilst the object remains in the field of view A–B. Thus maximum permissible jitter time t will be equal to:

$$t = \frac{x}{v} \qquad (3.1)$$

otherwise the object will have moved outside the field of view.

Example 2. If the object of length L occupies a large proportion of the field of view then available time for recording will become more critical and of shorter duration (Figure 3.2(b)). If the exposure sequence is again triggered when the front face passes point A a deliberate delay must be introduced to allow the rear face of the object to reach A before recording begins. The exposure will then need to occur after the rear face of the object reaches A and before the front face reaches B. Delay time will need to be at least L/V. Delay jitter should not be more than, say, Y/V. If trigger and delay jitter is a maximum time of Y/V, then the object must be exposed in the time it takes to travel distance Z, i.e. Z/V. The jitter of the interface from the delay output response at the camera plus the camera jitter must be less than Z/V. Thus total jitter of trigger system, delay, interface and camera response must be less than $(Y+Z)/V$. This will obviously be much less than X/V in Example 1.

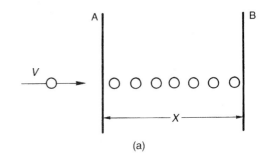

(a)

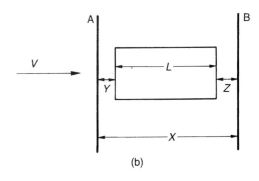

(b)

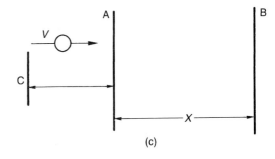

(c)

Figure 3.2 Examples of trigger jitter requirements.

In most instances it will be possible to find a trigger chain and camera response which will easily meet the requirements. Allowable jitter obviously becomes more critical with increase in object velocity and lower *object/field view ratios*. If velocities become very high it may be necessary to start the triggering sequence at some point before the object reaches A. Thus for higher speed objects it is worth checking the system operational requirements carefully and, if uncertain, carrying out some re-

sponse time checks before committing the experiment to the chosen method.

Example 3. For cine sequences it is usual to try to ensure that a certain minimum number of frames are recorded during the event, particularly if analysis will be by post-projection and visual observation of the sequence at a slower framing rate. For cine sequences the event will often be triggered by the camera reaching full operating speed. In this case the allowable jitter in the event triggering can be investigated. Given that, at full framing rate, the number of frames available will be N according to the length of film which is being used. Let the minimum number of frames required for the sequence be n and the interframe time, at the framing rate chosen be T. For an object which will remain within the camera field of view throughout its required time history a record is needed for a time Tn out of an available recording time of TN. Thus the event must be triggered and run its full course within a period of time of $(N - n)T$ from the moment the camera reaches operating speed or the sequence will be lost. If the event duration time is E, and its triggering delay time is e, then $(E + e)$ must be less than $(N - n)T$ and the allowable jitter must be less than $(N - n)T - (E + e)$.

Example 4. If, however, the object enters and leaves the field of view during the event time new complications arise. Let us consider the same situation as Example 1, but using a cine camera for the record (Figure 3.2(c)). If a minimum number of frames of the subject must be captured for analysis, these frames must be obtained whilst the object is in the field of view. Framing rate must then be adjusted to allow the chosen number of frames to be exposed in the time it takes for the subject to cross the field of view. If the object has velocity V, the time for the required number of frames to be exposed will be V/X. Then $(N - n)T$ must be equal to or less than V/X.

The camera must have achieved its necessary framing rate by the time the object enters the field of view and there is a certain delay time before full framing rate is reached. The camera will thus need to be triggered when the object reaches point C, say, so that CA/V is equal to or slightly longer than the camera run-up time. If the camera run-up time is r and the trigger jitter is J, then $(r + J)$ must be less than CA/V, and jitter must be less than $(CA/V) - r$. In this case adjustment is relatively easy as small required variations in CA/V can be accommodated by moving point C nearer or further from A.

So far calculations have assumed a pre-knowledge of V and this is acceptable if V stays constant and very high velocities are not considered. However, V may be variable within limits which, if high velocities are involved, may mean quite large variations in

the relatively short time periods involved. To achieve a low field of view to image size ratio, the time jitter may make it very difficult to capture the object as it passes the field of view. In this case the problem can be overcome by the use of an *'up–down' counter system* (see Section 3.8.7).

3.3 Synchronization requirements for various situations

The requirements for synchronizing cameras, lighting and events vary widely in timing resolution and complexity of operation. At the least demanding level, the photographer can act as detector, trigger delay and switch operator for cameras and lighting. For the most demanding projects the photographer will set up the apparatus, triggers and delays, but the event operation and actual capture of the image will be entirely automatic. If necessary, automation will allow the photographer to be quite some distance from the event when it occurs and the pictures are taken.

3.3.1 Manual sychronization

The ability to manually synchronize camera operation and lighting will vary among individuals and depends upon their inherent reaction time, the nature of the event and the environmental conditions under which the event is taking place. Operator performance can be improved by experience and practice. In one instance it may be required to start the camera or fire a flash at a particular point in the event sequence. The stimulus to react may be aural or visual and this presupposes fairly close proximity to the event. Alternatively, the camera and lighting may be switched on and then the event triggered when the camera is up to speed. With experience the operator can tell from the motor sound the approximate instant at which the camera reaches operating speed.

The *environment* will have considerable effect on performance. Exposure to noise, excessive heat or cold, wind and rain, tiredness or mental stress will tend to reduce concentration and cause slow reaction times. Close repetition of sequences may also induce an automatic response which may go out of sequence if concentration slips.

Experiments have shown that a *typical reaction time* between eye and muscle coordination is of the order of 0.2 s. Thus for sequences where reaction time or jitter for an event must be less than 0.5 s, say, it is probably better to use automatic synchronization.

If *automatic synchronization* is not practicable then the manual method can be successful if careful planning is applied to procedure, signals and count-

down. The best situation is for one operator to control both camera and event. A stopwatch can be used to assist timing. If more than one person must be involved to operate various pieces of equipment, a visual or oral *countdown* is advisable. If some distance separates the operators, telephonic or radio communication can be used to avoid sound transmission delays. Alternatively, clearly defined hand signals or signal lamps, visible to all positions, can be operated by the controller. *Manual synchronization* can be impressively effective given practice and experience. More film may be used because overlap and delay timing may be less well resolved, and this may be quite important if costing is critical. However, this may be offset in situations where automatic synchronization is not readily available and where its provision may involve high cost and complexity.

Up to the limits of the criterion for permissible jitter times, the combination of the human eye, brain and manual dexterity can provide excellent control at relatively low cost. In general, manual operation and synchronization are quite feasible, but for critical timing automatic methods should be used.

3.3.2 Automatic synchronization

Automatic synchronization relies heavily on effective and reliable *triggering systems*. The type and timing of the synchronization varies with the kind of image recording system in use, and whether the event is triggered by the camera, or vice versa. In some situations, event occurrence time may be unpredictable and special precautions are be needed to ensure the event is captured.

Synchronizing signals will be needed to:

- Operate short duration lighting of the spark or flash type in single, multiple or stroboscopic mode.
- Switch on long duration flash or continuous lighting and possibly also switch it off after the event.
- Operate camera shutters of various kinds.
- Ensure that, where the incoming image is reflected, refracted or moved by intermediary elements before reaching the recording medium all elements are in their correct relative positions to allow the image clear access to the medium during the exposure time.
- Ensure that the camera is brought to rest or switched off following the end of the event, either to prevent the use of the remaining recording medium, or, in some special cases, to avoid the *overwriting* of previous exposed medium.
- Start and/or stop events.
- Operate auxiliary devices such as event timers, timing reference marks, sequence indicators, and recording instruments other than purely pictorial devices, e.g. recording oscilloscopes.

3.4 Light source synchronization

3.4.1 Spark or flash photography

For single or multiple flash photography with visible light the event will probably take place in darkened conditions with the camera shutter open. The shutter can be manually operated and its opening and closing time will not be critical. Synchronization of the flash is arranged so that the subject is comfortably within the field of view when the exposure is made. Synchronization is only involved in ensuring flash coincidence with a chosen subject position or a chosen time in the development of an event. An appropriate *trigger device* is chosen with operating rate and delay resolution consistent with subject velocity.

3.4.2 Flash or cine X-ray

For *flash X-ray techniques* the conditions will be similar to those with visible light flash, except that when used with film cassettes the film will be sealed from visible light. No shuttering is required and the ambient light level does not matter. The X-ray pulse will act as the determinant of exposure instant and duration. Synchronization requirements are similar to those required for visible flash.

For *cine X-ray techniques* the set-up is more complex and one of two types of system is used. The first uses a *long pulse X-ray source* with an *image intensifier* screen and *image converter* to produce a series of images which can be recorded from the image converter screen by a film camera. Synchronization signals will be needed to start the long pulse X-ray source at the correct time and also to begin the shuttering sequence of the image converter. In the second system, a *high voltage pulser* operates the X-ray source and the pictures will be recorded using an image intensifier and cine camera. In this arrangement the pulser will be driven by signals from the cine camera arranged to coincide with the time of its shutter opening, i.e. stroboscopic mode. Synchronization signals are needed to start the camera in time to allow it to reach operating speed before the event occurs and the subject is in the field of view, and also to start the pulser sequence once the camera is up to speed and the event is underway. In some instances the camera may trigger the event and the pulser via suitable delays once it reaches operating speed.

3.4.3 Stroboscopic flash

An event can be recorded in two ways using a *stroboscopic flash mode*. First, the subject is in a dark environment and is illuminated by a series of timed interval flashes of light from flash tubes, sparks or laser illumination. During this period the shutter of a still camera remains open and all images

are recorded on the same frame. A slight variation on this is represented by the *Cranz–Schardin* type apparatus, which employs multiple separately positioned flash sources that use a common objective lens to produce multiple separate images on a single frame or in separate cameras. The flash sources and cameras are usually arranged in a complementary circular formation. Synchronization is required to start the flash sequence and to ensure that each flash occurs at a series of pre-set intervals after the initial start pulse. Again the shutter must be opened before the sequence begins.

In the second system, the images are recorded by a cine camera which triggers the flashes that are arranged to occur when the shutter is fully open. The light flashes originate from a common source and occur at the cine framing rate. They may be from flash tube, spark or laser. In this case synchronization is needed to provide a starting pulse at an appropriate time to allow the camera to reach operating speed and start the strobing sequence when the subject has reached the camera field of view. Alternatively, the camera may be started and allowed to trigger the event and strobe lights once it is up to speed.

3.4.4 Long duration flash or continuous lighting

Expendable *flash bulbs* are used extensively in high speed photographic applications and because of their operating characteristics they occupy a special area between short duration flash sources and continuous lighting. Flash bulbs have an overall operating time of tens of milliseconds according to type. The light output intensity varies with time in a rounded sawtooth form and peak output does not occur until some time after initiation. Bulbs are classified by *peak flux*, overall duration time to *half peak* and *time to peak*. Thus, when considering synchronization, allowance must be made for bulb burn-up time and the rise time to peak or half peak must be known.

In conventional still cameras for pictorial use it was the custom to incorporate separate trigger sockets for flash bulbs and electronic flash, with an appropriate mechanical or electrical delay built into the flash bulb circuit, coded as type M synchronization. The latter feature is now rare in contemporary cameras. For high speed photography work, the long burn time of flash bulbs makes them unsuitable for open shutter use unless the event movement rate is very low. However, with separate shuttering they are very efficient light sources for still or cine pictures at short exposure times. In some cases, several pictures may be exposed during the peak light output period. Synchronization using flash bulbs must allow a delay for burn-up time, after which the camera shutter will be operated.

Because of their high light output, simple circuitry and light weight, flash bulbs are much valued for high speed use particularly in outdoor situations. For cine use, their relatively short peak duration has been a problem. However, modern systems allow flash bulbs to be fired singly, in groups or in a *ripple mode*, which can give an almost constant light output over long periods. For example, using say 30 bulbs, a continuous ripple flash output of about 0.6 s can be obtained. For cine applications triggering to both camera and flash bulb sequence units will need to allow for both the camera to reach required framing rate and burn-up time of the first bulb. The bulb firing sequence and intervals are accomplished internally by the *flash control unit*.

Continuous lighting does not require close synchronization with event timing and manual control is normally adequate. For close-up filming of delicate, heat sensitive subjects, it may be necessary to have a timing control for continuous lighting to prevent undue heat build-up on the subject. In some lamps, *dichroic reflectors* are used. These reflect visible light but transmit infrared, so that the forward heat emission is kept to a low level and the problem of overheating the subject may be avoided over reasonably long periods of filming.

3.5 Camera synchronization
3.5.1 Mechanical cameras

When used with light sources which control exposure times, e.g. short duration flash, still camera synchronization is not so important as long as the shutter is open when the flash occurs. When lighting is either of long duration, or continuous, and still, streak or framing cameras are used, then synchronization assumes primary importance.

Note that, in this section, in order to simplify description the term 'event' is used in a specific sense to describe the period during which the subject actually goes through whatever motion or process is under study and will apply either to a subject which remains within the camera field of view during the recording period, or which moves into and through the field of view during the recording period.

For streak and framing film cameras, the camera must reach the selected *operating speed* (framing rate) before recording commences. This is achieved by accelerating the camera to operating speed so that it is ready to record as the event commences or by bringing the camera up to speed and then triggering the event from the camera. For cameras using spooled film, i.e. with the possibility of fairly long recording times, the event time can occur in a relatively long time slot, governed by framing rate and spool capacity. There is no danger of *overwrit-*

ing exposed film and so post-event shuttering is not essential.

For 'medium speed' cameras using rotating prism motion compensation (such as the Fastax type made by the Wollensak Optical Company), synchronization and speed control in early models was achieved by physically separate control units such as the 'Goose', also made by Wollensak. In similar modern cameras, the control systems are usually integral, to give a completely self-contained unit, and the triggering signals are fed directly into the camera.

For cameras of either the *drum* or *rotating mirror* type, which use a fixed length of film, the situation is more complex. Two new requirements arise: first, the camera must be ready to record as the event commences, i.e. it must be up to speed and in a state to convey the image to the film; and, secondly, suitable shutter control must be applied to prevent overwriting of the exposed record. These cameras operate in either continuous access or synchronous access modes. In continuous mode, once the capping shutter is open the camera is ready to record whenever the event occurs. No synchronizing is required between event and camera apart from the low time resolution opening of the capping shutter, which can be done by other means. Once the event is in progress, only one complete writing sequence can be allowed before the capping shutter must again be operated. This means that this shutter must be actuated by a delayed signal which is initiated by the event start and whose delay is equal to the time of one full revolution of the camera sweep. If the event takes place in the dark the 'capping' of the camera can be carried out by using an open shutter and flash illumination timed to last one sweep of the camera. Event duration must, of course, always be shorter than the time for one camera sweep at the framing rate selected, otherwise data will be lost.

For synchronous access, the film length in the camera is even shorter as it will probably only span a 90° arc in the camera's circular housing. Such cameras can only be used for events which can be initiated by *camera control,* e.g. explosions or similar events, as the internal mirror or prism must be in the correct position to begin writing on the film at the instant the event begins. The capping shutter must be operated as soon as the sweep reaches the end of the film strip, as controlled by an internal monitoring device within the camera.

The spool type of medium speed camera can be expensive to run if the total film footage is used each time, and only a small section of footage contains useful data. Some of this length must of course be used to get the camera up to speed, but this percentage is minimized with modern methods of camera speed control.

In terms of synchronization requirements some cameras offer considerable advantages. The Lex-

ander camera is a good example. It uses a principle similar to that adopted by the Eichner camera in the late 1950s. The camera has a rotating prism for image motion compensation. A pre-determined length of film is retained in loose folds in a magazine and is driven through the camera by pinch rollers which remain open until triggered. The camera is run up to speed and can remain at speed for some time. When the synchronizing pulse arrives at the camera the drive rollers close and send the film through the gate with very high acceleration. This acceleration is made possible by the very low mass of the film. The camera allows image capture at the selected framing rate after only 20 ms from triggering. The camera is excellent for medium rate events with unpredictable starting times as synchronization can be achieved by a signal from the event rather than the camera. Saving on film is also impressive as only a few metres are used each time.

3.5.2 Electronic and video cameras

Synchronization of *electronic cameras* of the image converter type is relatively easy as no film has to be accelerated to speed and response is almost instantaneous. However, in the earlier models, the number of frames available is quite low, so synchronization timing must be of high resolution. Event duration, framing rate, framing interval and trigger delay will need to be carefully manipulated to fully cover the event. The latest electronic cameras are based on advanced charge coupled device (CCD) and gated microchannel plate intensifier technology and may have as many as eight individual channels. Each channel can store single or multiple exposures and provides independent exposure time, interframe time, gain and trigger delay. They are fitted with *CCD cameras* in place of the film cameras formerly used to obtain a permanent record once it had been electronically captured by the primary camera. Triggering is still reasonably critical, but the enhanced versatility of the exposures following triggering make accurate timing much easier. Electronic cameras will have all the necessary operational and timing controls built into the main camera body or, in some instances, they may be controlled from an external computer.

Video cameras have a low level of synchronization requirement as the recording time available is so long that continuous running can be employed, even for events with unpredictable occurrence times. In the case of very high framing rate video cameras, the total recording time may be limited to tens of seconds only. However, apart from events of unpredictable occurrence, the overall duration required for most high speed photography applications will be still well within the recording time range. For still video, where multiple superimposed exposures are made within the area of one frame,

the synchronization requirements are similar to those of image converter cameras.

Triggering problems have been eased with the arrival of digital solid state recording on video cameras. Even with high framing rates and relatively low recording times due to limited memory, synchronization presents no problems. This is because the camera can be set to record continuously working on the 'bucket brigade' principle. In this mode the camera records continuously into the memory in sequence of arrival. As the memory becomes full, the longest held record is dumped to make way for the next datum arriving at the memory. The recorded data thus progress through the memory in a 'bucket chain'. The memory can be frozen at any time by a trigger signal and this can be set to include a chosen amount of data arriving before the trigger signal. The memory can also be set to store chosen periods of data in timed burst sequence so that the available memory can be used to best advantage and is not wasted on unwanted records. Images can also be stored by using a strobe mode from a trigger signal arriving at a specified point during a cyclic event, e.g. recording a rotating mechanism.

3.6 Shutter synchronization

3.6.1 Capping shutters and external shutters

Capping shutters provide a primary shutter or capping mechanism for cameras. They are used to provide a period during which incoming light is allowed access to the camera, but actual exposure of the recording medium will be by a secondary internal shuttering mechanism or by application of single or multiple flash illumination of the subject. Capping shutters can be very simple mechanisms and manually controlled for situations where synchronization timing can be non-critical. For medium resolution timing, capping can be carried out using a conventional *leaf shutter* set for a long exposure time to cover event duration.

For ultra-high speed cameras where framing rates are extremely high and the number of exposures is strictly limited due to film length considerations, capping shutters may have very stringent operating time requirements. In this usage they will only be required to cut off incoming light when all available frames have been exposed. To achieve the very short operation times required (of the order of microseconds) ordinary mechanical movement is too slow and special systems have been developed. One kind uses a glass plate sandwiched between clear plastic sheets, which has an *electrical detonator* fixed to its edge. When the detonator is fired the glass is shattered into small fragments which are retained between the sheets forming an opaque shutter. A second type consists of a parallel sided

glass chamber in which a wire is placed. When a large current is pulsed through the wire the combustion products are deposited as an opaque soot onto the glass walls. A third type again uses a glass cell. It has a store of carbon powder in a side chamber, either alone or mixed with grease. This is blown between the glass walls by a small squib operated by an electrical pulse. Yet another type uses a thin aluminium foil tube inside a magnetic coil. When shutter closure is required a large current pulse is sent through the coil. The interaction between the field from the coil and that induced in the tube, collapses the foil tube and shuts off image transmission. This capping system is particularly useful where a glass interface is undesirable in the image path.

Time synchronization of these shutters must be to fine limits, and this is assisted by their inherent low jitter times of the order of one or two microseconds. A slower but more simple shutter can be made by placing a small mirror in the image path, placed to reflect the image into the camera. When shuttering is required the mirror is shattered or moved from the beam path by explosive means, interrupting the path to the camera. For fast opening capping shutters, an opaque block can be explosively removed from the beam path just before recording is to commence. Other types of shutter employ a *sliding plate* which has a hole cut in it to coincide with the camera lens position. Before operation the plate blocks access to the camera lens. When the shutter is required to be opened, the plate which is constrained to move in slots, is fired sideways by a small squib or compressed air charge opening the path to the camera.

3.6.2 Ultra-fast shutters

When film cameras are used for self–luminous subjects, with or without extra additional lighting, it is often necessary to supply another external shutter which has a faster operating time than the integral shutter of the camera. This can be done using magneto-optic or electro-optic shutters, which have much faster response than mechanical shutters.

3.6.3 The magneto-optic or Faraday shutter

In 1845, Faraday noted that if a strong magnetic field is applied to a glass block, the block displays a rotational effect on plane polarized light transmitted through the block. This effect is apparent when the light beam is parallel to the magnetic lines of force. If crossed polarizers are placed each side of the block only a very small amount of light passes through the system. When the magnetic field is applied the block rotates the plane of polarization of the incoming beam from the first polarizer to

coincide with the plane of the second polarizer or analyser, thus allowing light through the system. Exposure times are of the order of a microsecond.

3.6.4 Electro-optic cell or Kerr cell

The electro-optic cell principle was discovered in 1875 by Kerr. In certain isotropic liquids, e.g. nitrobenzene, application of a strong electric field causes them to become anisotropic and to rotate the plane-polarized light being transmitted through them. If such a cell is placed between crossed polarizers the sequence of events is similar to that which occurs with the magneto-optic shutter, and light is transmitted when a high voltage pulse is applied across the cell. Exposure times can be in the nanosecond range.

Both cells require the application of short, high voltage pulses, the Faraday cell requiring high current to produce the magnetic field for operation. Both cells have a low transmission efficiency of 10–15%, and so are only suitable for very brightly illuminated subjects. Synchronization resolution has to be very high and the switching power supplies for these cells are complex, particularly if a string of pulses is required.

Both Faraday and Kerr cells found regular usage in the mid-1900s. Kerr cells were used extensively in the experimental studies of atomic bombs, as their very short exposure capabilities were unique at that time. In contemporary general high high speed photography, the provision of short duration exposures is by short pulse lasers, image converter tubes, gated image intensifiers or other means. Faraday cells have now gone out of general use, but Kerr cells are still being used for very specialized laboratory research projects requiring exposures into the subnanosecond region.

3.7 Triggering and detection methods

The triggering of recording devices is a common requirement in all scientific experiments and can range from a simple manual action to a very complex detection, delay and operating sequence. Complexity increases as event duration or desired sampling rate interval decreases, or the average human response time capabilities are exceeded in terms of aural, visual or muscular movement. For some observations, the detection capabilities required, the existing environment, inaccessibility, and danger levels are such that there is no possibility of human involvement.

3.7.1 Historic triggering systems

Triggering systems have been required since the earliest use of high speed photography in the mid-1800s. In these early times, technology was in a relatively primitive state in terms of detection devices and much ingenuity was required in order to compensate. During this period the primary source for short duration exposures was the electric spark, used with open shutters in a dark environment. The sparks required fast acting triggers synchronized with the event and these were usually provided as series switches in the spark circuitry.

Scientists such as Mach, Boys, Worthington and Cranz all used simple *wire switches*, which were shorted by the direct movement of the subject. The work of Mach, Cranz and Boys was primarily involved with study of the motion of projectiles and these triggered their own photographs by striking simple wire make-switches. Whilst effective, this method had the disadvantage that the switches appeared in the photographs, and sometimes debris from the switch/projectile impact tended to confuse the interpretation of the pictures. This was solved by Mach by using an alternative system. The bullets were fired through a tube which had another tube joined as a T junction in its centre. As the bullet passed through the tube, its associated shock wave passed down the side tube and blew a candle flame into a series switch gap. The ionized gas in the flame completed the circuit and fired the spark. This left the picture area quite free of extraneous objects.

Worthington studied *liquid splash formations* and produced a very clever combined spark trigger and delay. He used balls dropped into the liquids to form the splashes. He constructed a system using two electromagnets in series to suspend two steel balls (Worthington, 1963). One, when dropped, fell into the liquid to produce a splash, the other fell through a gap which formed part of the spark circuit, closing it and firing the spark. As the balls were released simultaneously, various relative delays could be introduced by varying the distance between the spark circuit gap and the release point of the trigger ball. This allowed him to produce a series of separate photographs at chosen times in the development of the splash.

The clever improvisations of these early pioneers sets a good example for current practice. Triggering problems can often be solved using simple devices and ingenuity, where complex and expensive solutions are not feasible or available.

3.7.2 The trigger sequence

As in other experimental work, the triggering of photographic sequences consists of a chain of events leading to the final required action and includes:

- A *detector mechanism*, to detect the movement or change in the object or event under study.
- A suitable *delay mechanism*, if necessary, to

ensure that the triggering signal is passed on to operate the photographic system at the correct instance.

- A *transforming mechanism*, by which the output of the detecting mechanism is changed into the correct form to operate cameras, lighting, auxiliary equipment, etc., as needed.

The transforming mechanism may occur directly after the detector output or may not be required at all, if the detector output and photographic system input are directly suited, e.g. a compatible electrical pulse for output and input.

3.7.3. Detection methods

In principle, anything capable of responding to some phenomenon associated with the object can be classed as a detector/sensor. The *ideal detector* would:

- Produce no damage or interference with the object detected or its natural movement or properties.
- Have high spatial resolution and very short response time.
- Be able to cover a variable detection area and object size.
- Be immune to interference or disturbance other than from the chosen mode of operation.
- Be easy to set up and align.
- Be easily reset after operation.
- Require little maintenance or adjustment.
- Be reusable many times.
- Be usable in or outdoors in a variety of conditions.
- Be cheap and easy to operate.
- Have adjustable sensitivity.
- Be reliable.

These ideal properties are unlikely to be all present simultaneously in a single device, but most usable detectors will incorporate several of them.

There are many possible variations on detection devices. They can be divided into two classes: those having *direct* or *indirect* operation, depending on whether or not the object makes physical contact with the detector. In turn, the detection methods can be described under the headings of:

- Simple make or break switches or contacts.
- Detection of radiation emitted by or reflected from the object.
- Detection of the interruption of an external radiation source by the interposition of the object.
- Detection of sound emitted by the object or caused by object movement.

- Detection of local pressure changes or shock waves produced by the object.
- Detection of changes in electric or magnetic fields caused by the presence of the object.

3.7.4 Make or break switches

Such switches, as the name implies, will make or break a simple contact and be operated by object movement. Some possible examples are:

- Two wires or metal strips which are moved together or apart. These may either be operated directly by the object, or may be moved under the influence of a magnet carried by the object.
- A *microswitch*, the operating lever of which is moved.
- A thin *insulated foil sandwich*, which is pierced by the object thus connecting the two sides,
- A thin *metallic strip conductor* supported by a thin insulated backing sheet. This is configured as a pattern of parallel lines joined into a continuous strip which when broken gives a 'break' signal. An alternative pattern uses two sets of interlacing parallel fingers which are joined across their opposite ends. When shorted between lines the pattern acts as a *make switch*. The devices operate to make or break contact when pierced by the object.
- A simple *vibration switch* operated by object movement.

Simple switches are probably the easiest triggering devices to construct and set up while offering much scope for inventiveness. Some will only provide a single operation, whilst others will be reusable many times. In the former case, of course, they will require replacement after each event.

3.7.5 Detection of increased object radiation

The necessary radiation can come from the object, e.g. self-luminous, or it may be radiated from the object by reflection of some external source. The radiation will usually be visible light. It may also be in the infrared if a non-visible beam is required, e.g. where uncovered photographic materials are in the vicinity. Alternatively, the object may be just very hot but not incandescent. In special situations the irradiating beam may use microwave radiation. Detectors will be chosen to suit the wavelength involved.

If the radiation is inherent in the object, detector position and angle of view may not be critical as the radiation will be omnidirectional. However, if detection is by reflected radiation, e.g. it occurs as the object passes through a light sheet or beam, care will be needed to see that the detector is suitably

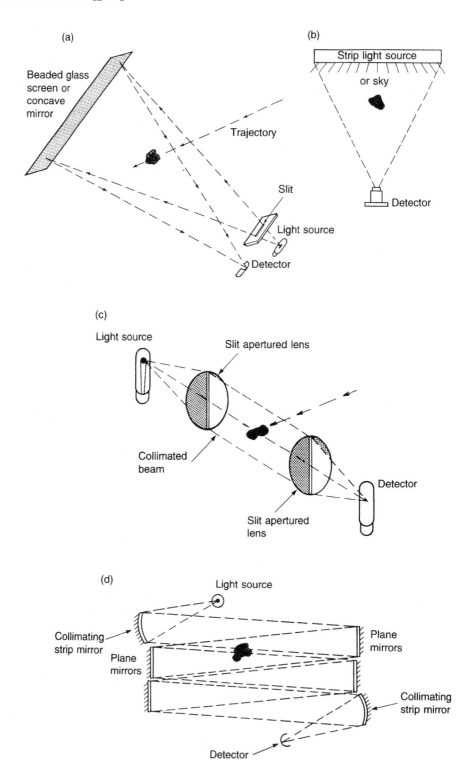

Figure 3.3 Light beam detectors.

placed to receive the reflected radiation. This will be a function of the source beam direction and object reflecting surface shape, orientation angle and reflectivity when it enters the beam. This is known as *backscatter detection* and it depends heavily for success upon the object having a high reflectance value.

Radiation can also be detected in a *forward scatter mode*. In this case radiation must be scattered in a direction away from the source and to operate successfully it needs a special optical set-up and an object which is relatively small compared with the beam focusing element.

3.7.6 Beam decrease detection

In the beam decrease detection method, the object passes through a collimated or uncollimated radiation beam. Detectors behind the object path experience a partial or complete reduction of incident radiation when this is cut off by the object. When using uncollimated beams, the detector may be placed near the beam source i.e. with both on the same side of the object path. In this case a *retro-reflective screen* or mirror is placed behind the object path to reflect the change in incident radiation back to the detector.

For uncollimated beams, the intensity of light reaching the detector will be inversely proportional to the square of its distance from the source, so the system must be more sensitive than for collimated beams. Beams may have to be uncollimated if the path of the object is not well predictable and a large area needs to be covered. A particular case of the uncollimated beam method is where the light source is the open sky and the detector views a thin fan of light coming from behind the path of the object (Figure 3.3(a, b)).

Collimated beams are formed by using a *collimator* at the source and refocusing the beam into the detector on the far side of the object path. Collimated beams will be effective over a much longer distance, as the beam intensity will remain higher for a given distance and the detector will see a bigger percentage of source radiation cut off for a given sized object. Collimated beams require the object path to be predictable (Figure 3.3(c)).

The coverage of a collimated beam can be enlarged by arranging it to pass with multiple reflections between two mirrors set at a slight angle to each other. This increases the coverage but also loses considerable beam intensity during the multiple reflections. This seriously lowers the sensitivity at the detector if multiple reflections are used (Figure 3.3(d)).

Infrared radiation can be used for interrupted beams where uncovered photographic materials or open shutters are in use in the event area under darkened conditions. Use of infrared will prevent interference with the photographic system and unwanted fogging. In the study of birds or animals the invisible infrared detection beam will allow the subject to move freely into the filming area without being disturbed by the presence of unusual light sources.

3.7.7 Sound detectors

Sound detectors are simple to use and set up compared to other detector types. Because of the relatively slow speed of sound in air, the detector's position relative to the source can be adjusted to provide a built-in delay system. Speed of sound at sea level is some 332 m s^{-1} (1100 ft s^{-1}), so each 332 mm (approximately 1 foot) of separation between source and detector will give about 1 ms delay.

For sounds with a relatively slow rise time, conventional audio microphones with a wide frequency response are suitable. To sharpen the response for trigger pulse production, it may be necessary to use a *Schmitt trigger* or similar circuit to transform the relatively slowly rising front of the microphone output signal into a square shaped pulse. Care should be taken not to subject simple microphones to high *overpressures*, as they are easily damaged.

If the sound has a fast rise time and fairly high level, then *piezo-electric film* or *piezo-electric crystal* detectors can be used. These give a fast rise output pulse and are resistant to high overpressures. Whatever type of sound detector is used, an amplifier and pulse shaping stage are desirable to produce a versatile trigger output. The output stage will often be a *silicon controlled rectifier* (SCR), which acts as a high duty electronic switch for further mechanical or electrical stages.

3.7.8 Pressure switches

Pressure switches may be simple mechanical devices responding to direct pressure exerted by a moving object, or they may be operated by a flap moved by a pressure wave which in turn operates a simple switch. These can be made fairly easily; two examples are shown in Figure 3.4. The *diaphragm switch* can be set to respond to very low level pressure changes.

Very lightweight *flap switches* were used by Dr Bull in the early 1900s when photographing insect movement. When emerging into the camera field of view, the insects operated tiny flap switches, which in turn made electrical contacts that triggered the illuminating sparks.

Electrical *transducers* in the form of piezo-electric foils or piezo-electric crystals can be used in a similar way to their use in sound detectors. Polymer forms of piezo-electric materials have been studied for some 60 years. In the 1970s, *polyvinylidene fluoride*

(a)

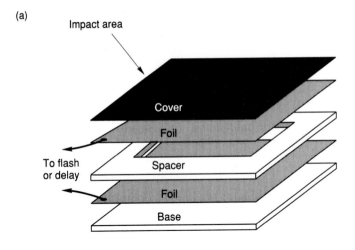

(b)

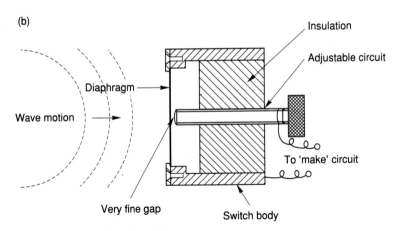

Figure 3.4 Simple triggering switches.

film (PVDF) was developed. After being stretched and polarized this was found to have high charge production potential when subjected to pressure. The film is translucent, tough, pliant and inexpensive and gives high output with broad band electro-acoustical characteristics. It has been employed in microphones, pressure switches, touch sensors and a huge range of other applications. It is an extremely useful material for triggering applications and lends itself readily to the varied needs of the photographer. The charge output from the foil must be changed into a useful signal via a charge amplifier, but the foil itself requires no power supply.

If the pressure waves brought about by the event are of high enough velocity they will produce shock waves, e.g. the pressure waves from explosions or supersonic projectiles in ballistics research. These can again be detected by suitable robust microphones or piezo-electric transducers and will provide very fast rising trigger pulses. Shock waves will also introduce travelling waves in solid objects which they strike. These in turn can be detected by a piezo-electric detector connected to the object to provide a trigger signal. Thus in areas where risk to equipment is very high, e.g. near explosions or near gun muzzles, a metal bar can be placed where it will be struck by the expanding shock wave and a trigger signal can be obtained from a sensor placed in a safe environment at the end furthest from the shock. Whilst some delay will be involved for shock transmission along the bar, the speed of sound in solids is

higher than in air, so delays will probably be negligible and certainly lower than for direct airborne shock waves.

3.7.9 Electric or magnetic field detectors

In some instances object movement can be used to operate capacitive or magnetic field sensors. Magnetic field sensors may be triggered by: either by the movement of a magnet attached to the object, or by the object presence altering a magnetic field produced by the sensor, e.g. either by the movement of the object through a current-carrying coil; or by production of a magnetic field produced by a current caused to flow by the object, e.g. movement of a magnetized object through an inert coil. Because of inductive delays the signals may need to be sharpened by using either detection of zero crossing points on the waveform produced, or by use of *Schmitt trigger* circuits.

Capacitance sensors can be very useful in instances where the subject is delicate, or where no additional triggering aids can be attached to it. Capacitance switches will be operated purely by the presence of the object changing the electric field surrounding the sensor. For example, the object may be made to pass between two parallel plates between which an electric field has been generated. The object presence will change the interplate capacitance and this change is detected to provide a trigger output.

In some special circumstances associated with *combustion*, such as gun muzzle blast, a jet engine or rocket jets, burning gas or flames; the ionization present in the gas will be sufficient either to provide a conducting path across a switch (see Mach candle flame switch) or to provide an electric charge on a nearby conducting surface. This charge can then be used as a trigger signal.

A special *ionization trigger* can be used with flash X-ray sources to give a trigger pulse to associated photographic equipment. Two very thin aluminium foil discs separated by a small gap are placed in the path of the X-ray beam and normal to its direction. The discs each have a central hole which allows free passage of the beam except for a very small interference around the hole periphery. A high voltage (10 kV) is set up across the two discs but no current flows until the beam radiation momentarily strikes the foils. Sufficient electrons are produced to provide a high voltage trigger pulse with only a few nanoseconds delay (Swift and Strader, 1968).

3.8 Trigger signal transmission and delay methods

3.8.1 Transmission methods

The detector which operates a photographic device, directly or indirectly, may not necessarily be within the field of view of the camera and may be operated at some distance from the photographed event. The trigger signals will usually be carried electrically, as this is a convenient communication means with very low inherent delay times. It also lends itself to manipulation in the form of amplification, attenuation, change of waveform shape and controllable delay of transmission. At the imaging point it can also be easily turned back into mechanical energy to operate further equipment.

In early photography, *pneumatic signals* were used for triggering pulses. Simple shutters were often remotely operated by squeezing a rubber bulb and passing a pressure pulse along a tube. At the other end of the tube a small piston was moved by the pressure and this operated the shutter. This was a simple and effective system but it suffered from inherent delay. It is not suitable for anything but relatively slow rate events, but has the advantage of requiring no electrical supply and could be applicable in some cases for capping shutters.

For triggering over long distances in outdoor locations, trigger pulses can be sent over a radio link. This avoids the laying of long lengths of signal cable and is particularly helpful if the trigger site and photographic site are separated by difficult country or by a stretch of water. The best systems will be those using focused antennas and receiver dishes. This usually requires a clear line of sight between the locations. The focused beam system has the advantage of low loss and efficient transmission and a minimum chance to cause or receive interference to or from other local systems. Security and avoidance of false triggers can be enhanced by using pulse coded signals for transmitters and receivers.

Light flashes are often used for triggering of slave flashes from a master flash. The slave flash heads have small light detectors which switch on the slave flashes when a change in ambient light is detected. When using this method for very high speed motion the response times of the slave flash units should be checked to ensure that jitter time is not significant, i.e. to ensure that flashes are simultaneous.

3.8.2 Interference with trigger signals

In areas of high electrical interference where high voltage or current pulses are present, trigger signals may be distorted or false signals may be produced with the production of unwanted pre-triggers. The problem can often be alleviated by the use of electromagnetic *interference shielding* or by rearrangement of cable runs to remove them from the source of interference. Sometimes elimination of parallel runs of signal cables and any cables producing interference may be sufficient or they can be arranged to cross at right angles. This reduces the coupling field to a minimum.

In very difficult circumstances it may be necessary

to transform the trigger signals into light pulses and send them down *fibre optic cables* to the receiving point. Here they can be retransformed into electrical signals free of interference. Whilst appearing a complicated solution, this may be the only practical alternative. Modern commercial units for such signal transformation are readily available in the form of transmitters and receivers, which can be placed at each end of the optical cable.

3.8.3 Triggering delay methods

Accurate event and exposure triggering can pose problems, particularly with subjects that move very fast or where the time for various pieces of equipment to reach operating readiness differs widely. Thus in most triggering systems provision is usually made for a variable delay of some kind to be incorporated into the signal path. Delay circuits can be constructed in-house or use made of available commercial types. Delays are based on either mechanical or electrical principles. Mechanical types are usually more simple in concept but do not have the time resolution or versatility of electrical types.

In early photography much ingenuity was employed to provide variable delays. Two examples, those of Mach and Worthington, have already been described. The principle of shorting a gap with a puff of ionized gas (Mach) was also employed by Libessart. He provided a central ionized gas producer in the form of a high voltage spark gap in a tube. The tube had a number of tubes of various lengths radiating from its sides at right angles, all level with the central spark gap. At the ends of the tubes ionization gaps were arranged to fire a series of sparks. Following firing of the main spark the expanding cloud of ionized gas took different times to traverse the tubes to fire the secondary gaps.

3.8.4 Mechanical delays

For delays using simple switches, the switch unit can be moved relative to the moving object to allow more or less movement before operation occurs. Weights falling under gravity can be used to operate switches directly or they can turn geared mechanisms via drums and ropes. Gravity can also be employed using balls rolling down inclined planes of various lengths or pendulums falling through various arc lengths. These in turn will operate electrical contacts. The use of sound switches will allow variable delays by varying the distance between the microphone and the sound source. For low time resolution requirements such as capping shutters, clockwork mechanisms can also be employed.

3.8.5 Electrical/electronic delays

Electronic delay units are extensively used and are available in varying degrees of complexity and with single or multiple operating channels. A comprehensive delay unit can be battery or mains operated. For general use it should ideally have the following features:

- A variety of possible triggering inputs including those from make contacts and break contacts, as well as transistor–transistor logic (TTL) compatible, high voltage and polarity inversion types.
- Easily programmed delays for each channel, with clear analogue or digital displays to show the settings.
- Facilities for chaining delays if needed.
- Manual test buttons for checking operation when trigger pulses are not available during the set-up period.
- A variety of outputs similar to inputs, including in addition high current outputs that may be needed to operate a final mechanical stage, e.g. solenoid coils.
- Provision for varying output pulse length.
- Indicator lamps to show 'power on', 'delay ready' and 'delay fired' states.

A comprehensive delay system having many of the above features will be expensive, but invaluable to the photographer faced with a continually changing demand in system requirements.

3.8.6 Delays for straight line movement

Consider the situation where an object moves in a straight line to cross the camera field of view. It is required to open the camera shutter or fire a flash when the object is in the camera view. We can place a detector at a point along the object's path and, if we know the object velocity, the required delay from detector trigger to camera trigger can be calculated (Figure 3.5(a)). A detector is placed at P and the distance to the edge of the field of view is D. The object velocity is V. If the field of view has a width d, the required delay time T to allow a picture to be exposed when the object is in the middle of the field of view is given by

$$T = \frac{D + \frac{d}{2}}{V} \tag{3.2}$$

Maximum allowable jitter for a small object will be

$$t = \frac{d}{V} \tag{3.3}$$

where t is the combined delays involved. Object velocity will need to be known to a reasonable accuracy beforehand in order to set the correct delays to capture the object. If the velocity varies at each event it will be extremely difficult to obtain a successful picture.

(a)

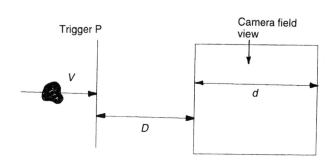

(b)

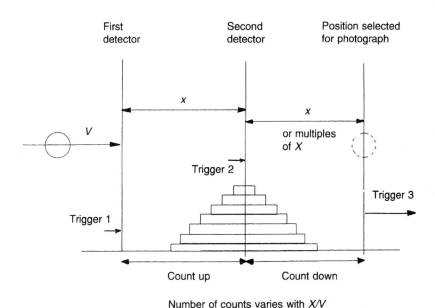

Number of counts varies with *X/V*

Figure 3.5 (a) Simple trigger delay system and (b) an up-down counter unit.

3.8.7 The up–down counter delay

For events where velocity is very difficult to predict with sufficient accuracy an *up–down counter delay* can be used. This delay unit uses a two stage system (Figure 3.5(b)). The counter is started by the first detector, and stopped by the second detector. The counter then reverses and counts back to zero. When zero is reached a trigger pulse is sent out. Thus if the distance from the first to the second detector is *X*, and the distance from the second detector to the camera position is also made equal to *X*, it is known that the object will be opposite the camera position when the trigger pulse occurs, irres-

pective of object velocity. By using digital techniques the counters can be made very precise. Some advanced systems allow multiples of the first count-up delay to be selected for the second count-down delay, where it is not possible to make both distances equal to '*X*'. In this case the distance between the second detector and the camera position must also be set to the multiple value used for the time. The positioning of the detectors and camera must be done with care, using tape measures to ensure accurate results.

3.9 Triggering on a budget

Correct triggering and synchronization are essential if fast moving subjects are to be recorded. In many high technology research areas the necessary equipment, in the form of various types of detectors, pulse shaping and delay systems, will be available as items from the in-house technical stores or from the photographic department inventory. In the case of small groups, such as the single freelance or physics departments in educational establishments, equipment stocks may be low and purchase budgets sparse. In these cases much can still be achieved by the exercise of ingenuity and the use of simple apparatus, including the building of relatively cheap electrical circuits.

For anyone who wishes to venture into the high speed photography area, dedicated high speed cine cameras or high speed video systems may be too expensive to acquire and run. However, a great deal can be achieved using flash photography with flash units and cameras intended for the domestic market. Using commercial flash units which have *self-quenching* circuitry to control exposure levels and, consequently, exposure durations, exposures down to tens of microseconds can be achieved, with the penalty of reduced light output.

3.9.1 Simple mechanical switches and actuators

Two examples of simple mechanical switches are shown in Figure 3.4. Figure 3.4(a) shows a simple *impact switch* which can be made very cheaply using card and thin aluminium foil sheets. It is operated by a falling object and can be used to form part of a simple delay system. For example, a steel ball suspended from an electromagnet operated by a break circuit can be released at varying heights above the switch to introduce a variable delay.

In Figure 3.4(b), the switch is operated by external pressure waves, and with careful adjustment it can be made very sensitive. The diaphragm can be made using metallized plastic film stretched taut across the housing. Again all parts can be improvised from simple, cheap materials.

Actuators are often required to exert quite large forces for the operation of some system in the trigger chain. It is often convenient to operate these actuators by some relatively low force device such as a small solenoid which can be activated by a small current passed over an electrical link. Typical examples might be: a remotely switched solenoid which releases a spring operated cable control for a shutter release, or a strong spring motor with a solenoid controlled escapement.

A simple and quick acting actuator can be assembled using a spring under pressure, such as a mouse trap. The spring is constrained by a fusible wire which is broken by application of a high current. This in turn can be triggered by a simple make switch which applies the current. The stored spring energy can be used to operate mechanical devices, e.g. a fast opening or closing shutter.

The final stage in many trigger units is a silicon controlled rectifier (SCR) which will act as a switch to further stages. The SCR will handle voltages of several hundred volts according to the type chosen and can also pass currents high enough to actuate solenoids, or relays to produce mechanical actuation. Another benefit is that the SCR effectively isolates the preceding amplifier from whatever is connected across its output. Another important factor is that the SCR will remain switched on until its supply voltage is removed or reversed, even if the trigger pulse is only transient. To avoid overheating of components a switch should be included to cut the supply to the anode, and can also be used to allow resetting.

3.9.2 Sound triggers

Figure 3.6 shows a circuit for an electrical sound trigger that is operated by a *piezo-disc* or microphone that respond to fast rising sound pulses. The signal from the pickup is amplified by a simple transistor circuit and applied to the SCR switch (Winters, 1990). The SCR output can be connected directly across a flash trigger input or can be made part of a series circuit to operate a solenoid or relay (see also Figure 3.8).

3.9.3 Light triggers

Light triggers can be made to respond to light arrival or light cut-off conditions. The light falls either on a light sensitive *phototransistor*, *light dependent resistor* or *photocell* and the output produced can be amplified to drive an SCR switch. The detecting

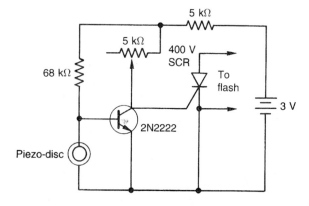

Figure 3.6 Electrical sound trigger circuit.

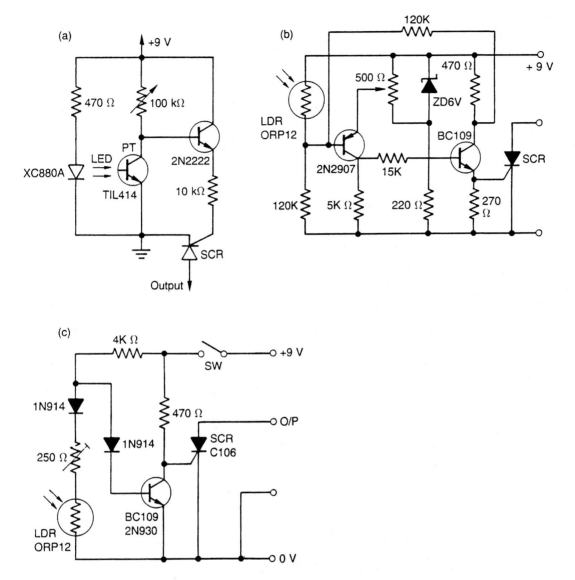

Figure 3.7 Light actuated circuits.

light beam can be incorporated into a common circuit or be made completely independent.

If the system is incorporated as in Figure 3.7(a), then the light emitting diode (LED) and phototransistor (PT) will form the detecting unit. If the object passing between them is small and fast moving or the two elements are well separated, sensitivity can be controlled by a 100 KΩ variable resistor. This system responds to light cut-off (Winters, 1991). The circuit shown in Figure 3.7(b) is also a light cutoff trigger but uses an externally controlled beam focused onto the light dependent resistor (LDR). Light falling on the LDR keeps its resistance low and the two stage transistor amplifier holds the SCR in the off state. When the light is interrupted, the LDR resistance rises and a positive voltage is applied to the SCR gate turning it on. Sensitivity can be adjusted by the 500 ohm variable resistor (Tower, 1976).

Figure 3.7(c) shows a circuit which responds to an increase in light level. It will respond either to a brief flash or a slowly increasing or decreasing light level, as the switching point can be set using the 250 Ω variable resistor. When light on the LDR is low the LDR resistance is high, the BC109 transistor is switched on, and the SCR is kept switched off. When light falls on the LDR its resistance falls allowing the BC109 to switch off and switch on the SCR to send out the signal (Tower, 1976).

3.9.4. Opto-couplers

In some situations it may be required to operate a solenoid or relay using a high working voltage. If this is controlled by a signal from a low voltage system, such as a switched input from a controlling computer, it may be necessary to electrically isolate the circuits to prevent damage to the controlling computer. Figure 3.8 shows such a circuit. A +5 V trigger signal from a detector is fed into the AN input and switches on the *infrared opto-coupler*. The signal is fed onto the SCR gate which switches it on and allows current to flow through the solenoid. When open, the safety/reset switch prevents unwanted firing of the circuit and can also be used to reset the SCR by interrupting solenoid current (Winters, 1991).

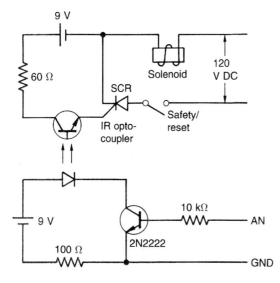

Figure 3.8 Opto-coupler and actuator circuit.

3.9.5 LASCRs

The *light activated silicon controlled rectifier* (LASCR) is a similar device to the SCR but will only handle more modest powers. However, it is suitable for many applications and has the advantage that it is operated by a light flash directly. When using multiple light sources, it is often required to operate several slave flashes from a master flash. Figure 3.9(a) shows a very simple circuit using an LASCR which requires no power. The circuit can be made very small and connected directly to a co-axial plug to fit into the co-axial trigger socket of the slave flash unit (Tower, 1976).

If a *light operated actuator* is required, the mains driven circuit shown in Figure 3.9(b) can be used.

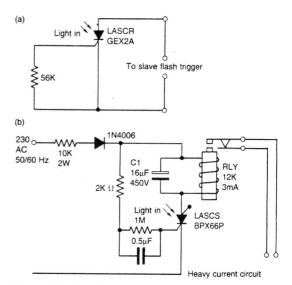

Figure 3.9 Slave flash trigger and a mains driven actuator.

The switching device is a *light activated silicon-controlled switch* (LASCS) with one connection left blank. The capacitor C1 is designed to prevent relay chatter for slowly changing light intensity and can be replaced by an IN4004 rectifier diode with its cathode to the positive supply if the light is switched on and off in a positive fashion (Tower, 1976).

3.9.6 Electronic delays

Many set-ups will require a controllable delay unit. A simple system is shown in Figure 3.10. The system uses a type 556 timer integrated circuit which incorporates two type 555 timers in one package. When the input is switched to ground the first timer starts and gives out a square pulse at output 1 (pin 5). The pulse width is controlled by the capacitance *C* and the variable potentiometer *R*. This pulse width is the unit delay time. The output from output 1 is coupled to pin 8 of the second timer. When the output pulse from 1 falls to zero the second timer starts producing a 10 ms pulse at pin 9.

This pulse gates the SCR and gives a switch-on to control a subsequent circuit or actuator. Output 1 can be used to indicate the start of the delay time, or by connection to an SCR circuit, it can be used to fire a flash or actuator. By using a 1 MΩ potentiometer for R and a 0.5 μF capacitor for *C* a selection of delays up to 0.5 s can be obtained. The values of *C* and *R* can be varied to give different delay ranges. The smallest delay is about 200 μs. The output from 1 does not have to be connected to an external stage, but if used to drive a flash unit it could provide a double flash system with a controlled interval. The delay unit can be used

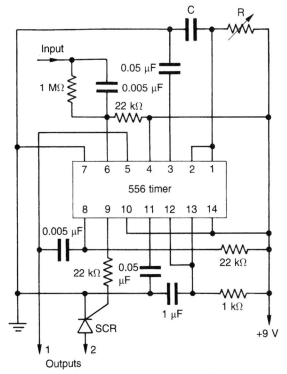

Figure 3.10 Simple delay unit.

with sound trigger (Figure 3.6) and/or light gate systems (Figure 3.7) as trigger inputs to make a complete unit (Winters, 1991).

3.9.7 Safety

All the circuits shown in this section are offered as guide examples only. As far as is known they have been used successfully in the referenced applications. No detailed construction guidance is given, this being left open to choice, but construction should only be carried out by those adequately qualified in electronic and electrical systems. It must be emphasized, that any electrical circuits using mains power supplies or high voltage batteries and capacitors or very high voltage circuits, such as are found in flash units, should be treated with great care. In-house construction of such systems is quite feasible, but should only be carried out by electrical/electronic experts or under their direct guidance.

3.10 Summary

Synchronization and triggering in simple or complex forms are an inherent part of the image capture process in pictorial or high speed photography. The number and variety of possible systems and methods are endless and must be chosen by the photographer to fit the particular circumstance for each project. The topic requires the photographer to learn a little of the rudiments of electronics and mechanics in order to provide solutions for the problems that arise. It is good practice to endeavour to accumulate a collection of detecting devices, trigger systems, delays, actuators and pulse shaping circuitry, either commercial or built in-house. These can form the basis for future problem solving systems. Most modern cameras have many of the required devices built in as part of their basic construction and the photographer will often only need to provide a suitable trigger pulse from the event.

It is well worth keeping a notebook of triggering and synchronizing systems and circuits with copious notes on the way in which parts of the system were interconnected and how a particular requirement was achieved. In particular, notes on settings to give specific delay times or the order in which a series of devices was connected will save hours of experimentation when a similar situation arises again. It is very useful to make a copy of the triggering input connections for each camera and paste them into the carrying case so that they are readily available at all times.

As will have been seen from the descriptions of the methods devised by the pioneer photographers in the early part of this chapter, the main requirements for success in triggering and synchronization are still ingenuity and the ability to adapt and improvise.

References

Gibb, A. (1982) Application of an exploding wire capping shutter to the study of solid high explosive charges using an ultra-high speed rotating mirror camera. *Proc. SPIE* **348**, 446–453

Swift, H. F. and Strader, E. (1968) Flash X-ray actuated trigger switch. *Rev. Sci. Instrum.* **39**, no. 5, 728–730

Tower, T. D. (1976) *Electronics and the Photographer.* Focal Press, London

Winters, L. M. (1990) High speed photography with sound triggers. *Phys. Teach. (USA)* **28**, 12

Winters, L. M. (1991) High speed photography with computer control. *Phys. Teach. (USA)* **29**, 356

Worthington, A. M. (1963) *A Study of Splashes.* Macmillan, London

4 High speed cine systems

John Rendell and Joseph Honour

4.1 Introduction

High speed cinematography is an extension of high speed still photography, in that the end result consists of a series of high speed still photographs separated by equally spaced, short duration time intervals, which, when projected in the same order provide the illusion of animated movement.

With high speed still photography it is essential to restrict exposure to a point where the 'event' movement is sufficiently arrested to be recognizable by either mechanical shuttering, or by lighting the subject with a short duration flash of light from either spark or electronic flash sources.

4.2 Single pictures

Single pictures of events are limited (Figure 4.1). They can only show the subject at a single point in time. Using a series of flashes from air or argon sparks, xenon or laser strobes, a subject can be observed for a measured time period, on a single photograph. The approach and impact of a bullet striking a target, or the swing of a golf club, are examples of subjects suitable for this treatment. The resulting 'multiple flash' photograph provides a perfect history of the event, permitting extra information to be obtained that is impossible with a single picture. With the bullet, for example, it is possible to study the attitude before impact (i.e. the pitch and yaw, etc.), measure velocities from the known flash repetition rate and observe the impact. As an alternative to film, modern charge coupled device (CCD) video cameras fitted with a suitable frame store facility, provide immediate analysis of records.

The multiple flash record is half way to becoming a cine record. Using a synchronized strobe with a cine camera provides ultra-short exposures and cool lighting if xenon and laser strobes are used. The introduction of electronically gated CCD video sensors can produce short exposure either 'still' or multiple images held in a single frame store. The Hadland Photonics Ballistic Range and Model 468 cameras as described elsewhere permit exposure times from 200 ns to 1 µs with still or multiple exposures, with independently selectable exposure times.

Figure 4.1 Photograph of a violent balloon burst due to overinflation. Taken using an open flash technique and a Hadland xenon microflash with a LSD2 tube giving a 2 µs exposure duration. A microphone trigger was used. (Picture courtesy of Hadland Photonics.)

4.3 High speed cine systems
4.3.1 Intermittent action type (25–500 pps)

The normal motion picture camera uses an intermittent action film transport system. It produces the very best results in terms of spatial resolution and picture steadiness because the film frame is held stationary when an image is exposed. Register pins adjacent to the film gate ensure that each frame is correctly positioned just prior to and during the exposure of each frame. However, this 'stop and start' movement limits the maximum speed to 500 pps with 16 mm and 360 pps with 35 mm gauge film.

Based in Munich, the Arriflex company manufactures cameras for the film industry and also produces a range of slow motion 16 mm, 35 mm and 65 mm Panavision cameras able to operate from normal

Table 4.1 Properties of high speed camera systems

High speed recording camera or system	Recording medium and length[a]	Image size (mm) at film or sensor [No. of images]	Recording speed/rate range (fps, pps)	Exposure per picture (continuous lighting)	Quoted resolving power[b] ($1p\ mm^{-1}$)	Potential data content	
						Points of information per picture (millions of points)	With copper vapour laser (millions of points)
Intermittent action pin-registered film cameras							
*Photosonics Series IP, IPL, IVN Actionmaster	16 mm film 60 m/400 m (200'/1300') DS	7.5 × 10 [8000/48 000]	10–500	0.25 s–42 μs	90–120	0.6–1.07	n/a
*Photosonics 1W	16 mm film 60 m/120 m (200'/400')	7.5 × 10 [8000/16 000]	25–1000	0.09 s–21 μs	70–100	0.37–0.75	n/a
Photosonics Series 4E, 4EL, 4ER, 4ML 6E, 6EL*	35 mm film 60 m/300 m (400'/1000') ML	18 × 24 (6E/EL only) [3200/16 000] 24 × 24 [2500/10 500]	6–360 (*6–250)	55 ms–39 μs	90–120	3.5–6.22 (*4.67–8.3)	n/a
*Photosonics Series 10R, 10RL	70 mm film 300 m (1000') ML	56 × 56 [500]	6–125	42 ms–111 μs	90/120	25–45	n/a
*Visual Instrumentation Locam Series 11	16 mm film 60 m/120 m (200–400') DS	7.5 × 10 [8000/16 000]	2–500	0.89 s–42 μs	90/120	0.6–1.07	n/a
Rotating prism film cameras							
*Hadland Hyspeed Series S2	16 mm film 30–120 m (100–400') DL	7.5 × 10 [4000/16 000]	10–10 000	40 ms–2 μs	68 (centre)	0.306	0.6
*Hadland Hyspeed S2 Half Height	16 mm film 30–120 m (100–400') DL	3.7 × 10 [8000/32 000]	20–20 000	20 ms–1 μs	80	0.21	0.35
*Hadland Hyspeed S2 Qtr Height	16 mm film 30–120 m (100–400') DL	1.85 × 10 [16 000/64 000]	40–40 000	10 ms–1 μs	80	0.115	0.18
*NAC E10 Full Frame	16 mm film 30–120 m (100–400') DS	7.5 × 10	100–10 000	2 ms–2 μs	68 (centre)	0.306	0.6
*NAC E10 Half Frame	16 mm film 30–120 m (100–400') DS	3.7 × 10	200–20 000	1 ms–1 μs	80	0.21	0.35
*NAC E10 Qtr Frame	16 mm film 30–120 m (100–400') DS	1.85 × 10	400–40 000	0.5 ms–1 μs	80	0.115	0.18
*Photec Full Height	16 mm film 30–120 m (100–400') DS	7.5 × 10 [4000/16 000]	100–10 000	2 ms–2 μs	68 (centre)	0.33	0.64
*Photec Half Height	16 mm film 30–120 m (100–400') DS	3.7 × 10 [8000/32 000]	200–20 000	3.33 ms–1 μs	80	0.22	0.37
*Photec Qtr Height	16 mm film 30–120 m (100–400') DS	1.8 × 10 [16000/64 000]	400–40 000	1.67 ms–1 μs	80	0.115	0.18

High speed recording camera or system	Recording medium and length[a]	Image size (mm) at film or sensor [No. of images]	Recording speed/rate range (fps, pps)	Exposure per picture (continuous lighting)	Quoted resolving power[b] (lp mm^{-1})	Potential data content	
						Points of information per picture (millions of points)	With copper vapour laser (millions of points)
*Photosonics Series 1B, 1C, 1FA, 1E High *g*	16 mm film 15–120 m (50–400') DL/ML	7.5 × 10	100–1000	2.5 ms–30 µs	56 (centre)	0.189	n/a
*Photosonics 35 mm Series 4B, 4BL, 4C, 4CL	35 mm film 150–300 m (500–1000') ML	18 × 24 [8000/16 000]	90–3250	2.78 ms–80 µs	56 (centre)	1.21	n/a
Photosonics 70 mm Series 10B	70 mm film 300 m (1000') ML	56 × 56 [5250]	90–360	2.78 ms–694 µs	56 (centre)	8.0	n/a
*Visual Instrumentation Hycam 11 Series 40–42 Full Height	16 mm film 30–600 m (100–2000') DS	7.5 × 10 [4000/80 000]	10–11 000	40 ms–1.82 µs	68 (centre)	0.306	0.6
*Visual Instrumentation Hycam 11 Series 40–42 Half Height	16 mm film 30–600 m (100–2000') DS	3.7 × 10 [8000/160 000]	20–22 000	20 ms–0.91 µs	80	0.21	0.35
*V.I. Hycam 11 Series 40–42 Qtr Height	16 mm film 30–120 m (100–2000') DS	1.8 × 10 [16 000/320 000]	40–44 000	10 ms–0.91 µs	80	0.115	0.18
*V.I. Fastax Series 2/46 + 48 Full Height	16 mm film 30–120 m (100–400') DS	7.5 × 10 [4000/16 000]	100–10 000	4 ms–2 µs	56 (centre)	0.2	0.6
*V.I. Fastax Series 2/46 + 48 Half Height	16 mm film 30–120 m (100–400') DS	3.7 × 10 [8000/32 000]	200–20 000	2 ms–1 µs	56	0.115	0.37
*Weinberger Stalex High *g*	16 mm film 30 m (100') DS	7.5 × 10 [4000]	50–3000	4 ms–67 µs	56 (centre)	0.25	n/a
*Weinberger Stalex 70 Ribbon Loading Frame in loop form	16 mm film Magazine	10 × 65 [500]	50–1000	4 ms–10 µs	56	2.0	n/a
Drum film cameras							
*Cordin Model 317 Framing Camera A	35 mm film in 1 m DC	7 × 10 [100]	10 000–100 000	20–2 µs	48 H 30 V	0.101	n/a
*Cordin Model 317 Framing Camera B	35 mm film in 1 m DC	18 × 10 [46]	500–16 100	400–12 µs	28 H 20 V	0.101	n/a
*Cordin Model 350 Framing Camera	35 mm film in 875 mm DC	7.5 × 10 [224]	260–35 000	800–6 µs	56 H 40 V	0.168	n/a
*Cordin Model 318 or 'Laserdrum' Streak Camera	35 mm film in 875 mm DC	With Laserstrobe 6 × 25 25 mm diam [140]	With Laserstrobe 2000–50 000 @ 12–306 m s^{-1} drum speed	With Laserstrobe 10–35 ns	With Laserstrobe 50 H 48 V	See next column	0.36–1.18
*Cordin Model 370 Streak Camera	70 mm film in 875 mm DC	With Laserstrobe 6 × 60 60 diam. [140]	With Laserstrobe 2000–50 000 @ 12–30 m s^{-1} drum speed	With Laserstrobe 10–35 ns	With Laserstrobe 50 H 45 V	See next column	3.25–25 approx.
*Cordin Model 377 Framing Camera	70 mm film in 1 m DC	7.5 × 10 [500]	20 000–200 000	10 s–1 µs	48 H 40 V	0.144	n/a
Rotating mirror film cameras							
*Cordin Model 119 Framing Camera DC	35 mm film in 875 mm DC	8 × 14 [130]	Up to 25 million	n/a	68H 28V	0.213	n/a

High speed recording camera or system	Recording medium and length[a]	Image size (mm) at film or sensor [No. of images]	Recording speed/rate range (fps, pps)	Exposure per picture (continuous lighting)	Quoted resolving power[b] (1p mm[-1])	Potential data content	
						Points of information per picture (millions of points)	With copper vapour laser (millions of points)
*Cordin Model 126 Framing or Streak Camera	35 mm film framing or 70 mm Streak in 1 m DC	Framing only: 2 × 25 [104] to 16 × 25 [26]	25 000–20 million	n/a	68 H 40 V	0.136–1.088	n/a
*Cordin Model 330A simultaneous Streak/Framing Camera	2 × 35 mm films in 1 m DC	Simultaneous 5 × 25 framing and 430 × 25 Streak	Framing: 24 000–2 million Streak: 10.6 mm μs[-1]	n/a	28 H 20 V	0.07	n/a
*Cordin Model 121 Framing Camera	70 mm film in 1 m DC	38 × 60 [25]	2000–2.5 million	n/a	40 H 24 V	2.189	n/a
Electronic imaging, including video and image convertor systems							
*Cordin Model 288 Electronic Imaging System	Cranz–Schardin CCD 8 frame storage	n/a	Frontlit 100 000 Backlit 10 million [8]	n/a	512 × 512 pixels	0.262	n/a
*Hadland SVR Electronic Ballistic Range Camera	Single 1 CCD frame transfer	6.6 × 8.8 CCD sensor	1–16 multi-images on single still frame from 200 ns separations	1 ms–200 ns in 1000 increments	486 × 1134 pixels	0.551	n/a
*Hadland SVRC Colour Electronic Ballistic Range Camera	Single colour 3 frame transfer (1 CCD's or 3 separate B/W images)	6.6 × 8.8 CCD sensor	1–16 multi-images on single still frame from 200 ns separations	1 ms to 200 ns in 100 increments	486 × 1134 pixels	0.551	n/a
*Hadland Imacon Model 468 Image Converter Camera	8 independent intensified CCD sensors through one optical lens axis	8.47 × 12.67 CCD sensor	10–100 million [4–8]	10 ns–1 ms	385 × 576 pixels	0.22	n/a
*Kodak Ektapro 1000 EM Motion Analysis System	Dynamic random access memory (DRAM) Digital	9.6 × 7.2 to 12.5 × 10.1 [1000/6500]	50–1000 full and 600–12 000 split frames	20–1 ms	192 × 239 pixels (full frame)	0.046 (full) to 0.0038 (1/12 frame)	Same with CVL but with ultra-short exposures
*Kodak Ektapro HS 4540	DRAM digital	10.24 × 10.24 [1000–50 000]	30–4500 full and 9000–40 500 split frames	33 ms–25 μs	256 × 256 pixels [full frame]	0.066 full to 0.0009 split	Same with CVL but with ultra-short exposures
*Kodak Ektapro HRC 1000 & RO colour	DRAM digital	6.5 × 8.7 [680–4500]	250–1000	4 ms–250 μs	384 × 512 pixels	0.197	Same with CVL but with ultra-short exposures (1000 pps only)
*NAC HVS 500 H/S Colour Video	SVHS Video cassette	10 × 13 (64 500)	250 full and 500 half frames	Shutter: 400–100 μs Xenon strobe: 20 μs	350 TV lines (SVHS) 240 TV lines (VHS) horizontal full frame	0.046 (full) 0.023 (half)	n/a

High speed recording camera or system	Recording medium and length[a]	Image size (mm) at film or sensor [No. of images]	Recording speed/rate range (fps, pps)	Exposure per picture (continuous lighting)	Quoted resolving power[b] (1p mm^{-1})	Potential data content	
						Points of information per picture (millions of points)	With copper vapour laser (millions of points)
*NAC Memrecam C1S Colour	DRAM digital	4.2 × 5.6 to 1.8 × 2.4 [500–6400]	100–2000 half height	10 ms–42 μs	434 × 580 to 260 × 234 pixels	0.25–0.061	Same with CVL but with ultra-short exposures (above 1000 pps)
*NAC Memrecam C2S Colour	DRAM digital	3.63 × 4.84 to 1.67 × 4.84 [260–3200]	200, 300, 400	10 μs	242 × 504 to 111 × 504 pixels	0.122–0.056	n/a
*NAC HVS 1000 H/S Colour Video	SVHS video cassette	10 × 13 [64 500]	500 full and 1000 half frames	Shutter: 400–100 μs Xenon strobe: 10 μs	350 TV lines (SVHS) 240 TV lines (VHS) H full frame	0.046 (full) 0.023 (half)	n/a
*IMCO Ultranac Image Converter Camera	CCD sensor 770 × 1152 pixels	15 × 18 to 8 × 14	2000 to 20 million	320 ms–10 ns	450 × 580 pixels	0.14 to 0.35 at image tube	n/a
*Red Lake Motion-scope	CCD frame storage	n/a [2048]	60–500 (single full frame)	Variable, independent of rate	336 × 243 pixels	0.082–0.02	n/a
*Vision Research Phantom v2.0	CCD frame storage	n/a	1–500 (single full frame 2–3000 allocated formats)	Variable, independent of rate	512 × 512 pixels (full frame)	0.26–0.044	Same with CVL but with ultra-short exposures (above 1000 pps)
*Weinberger Speedcam +500	CCD frame storage	4096 × 4096 [250–4000]	20–3000	50 ms–200 μs	256 × 256 to 42 × 256 pixels	0.66–0.0164	Same with CVL but with ultra-short exposures (above 1000 pps)
*Weinberger Speedcam +2000	CCD frame storage	2048 × 2048 [1000–16 000]	80–5000	12 ms–200 μs	128 × 128 to 50 × 128 pixels	0.016–0.006	Same with CVL but with ultra-short exposures (above 1000 pps)
*Weinberger Speedcam 512	CCD frame storage	4096 × 4096 [250–800]	20–3200	50 ms–200 μs	512 × 512 to 128 × 512 pixels	0.26–0.066	Same with CVL but with ultra-short exposures (above 1000 pps)

n/a Not available.

The above data are quoted for perfectly exposed images and subjects having high contrast ratios of 1000 : 1. As contrast is reduced and/or images are overexposed, resolution levels become progressively lower, particularly with film images. For example, with some film materials, resolution can be reduced to a third of the amounts quoted, when the subject (and therefore image) contrast ratio is reduced to 1.5 : 1. With film cameras, it is recommended that tests be carried out when film material changes are made.

Lenses should always be well shielded from strong specular front light sources, to avoid internal light scatter, which could degrade image contrast/resolution. This is particularly important with rotating prism cameras and/or zoom lenses, due to their increased number of air/glass surfaces.

[a] DC, daylight cassette; DS, daylight spool; ML, magazine loading.
[b] Pixels, TV lines. H, horizontal; V, vertical.

Figure 4.2 Photo-Sonics 16 mm camera model 1–VN with pin registered intermittent action up to 1000 pps, the fastest pin register camera produced. (Picture courtesy of Photo-Sonics International Ltd.)

speeds to 150 and 100 pps respectively. For film studio applications they can also be run in reverse. In the USA, since the late 1950s, Photo-sonics Inc. have built 16 mm, 35 mm and 70 mm intermittent

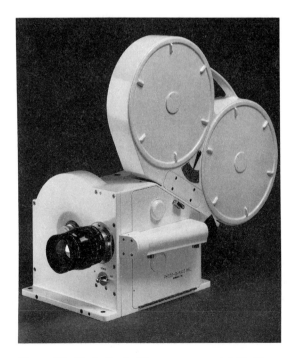

Figure 4.3 Photo–Sonics 35 mm camera model 4E with pin registered intermittent action up to 360 pps. (Picture courtesy of Photo-Sonics International Ltd.)

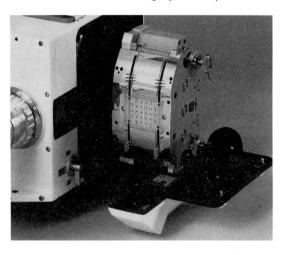

Figure 4.4 Photo-Sonics 70 mm camera model 10R with pin registered intermittent action up to 120 pps. The transport mechanism is shown, including the 12 pulldown arms, four register pins and vacuum pressure plate. (Picture courtesy of Photo-Sonics International Ltd.)

action, pin-registered cameras for the National Aeronautics and Space Administration (NASA) (Figures 4.2–4.4). Here, once again, they are frequently required for film making purposes. The 16 mm and 35 mm cameras can be run at 500 pps and 360 pps, respectively, whilst 70 mm instrumentation cameras can record ultra-high quality records at up to 150 pps. The Visual Instrumentation Company of California now build the pin-registered 500 pps Locam Camera originally introduced by the Red Lake Company. This design is also popular with film makers.

4.3.2 Rotating prism systems (100–40 000 pps)

First manufactured by Kodak Limited in 1932, there are now five manufacturers producing rotating prism cameras in Europe, Japan and the USA. The original Tuttle System is capable of a 'speed' (framing rate) range of 100–10 000 full frames per second (pps) on 16 mm film. By doubling or quadrupling the number of prism facets used, maximum framing speeds can be increased to 20 000 'half height' or 40 000 'quarter height' split frames per second (pps). Resolution is usually limited to 50 lp mm^{-1} due to slight variations in image compensation for motion at the film plane. The best known manufacturers were Wollensak (Fastax designs, see Figure 4.5) and Hitachi from the USA and Japan, respectively. Note that Wollensak once manufactured a high resolution relay type camera, the WF32, with a maximum rate of 3000 pps but superb resolution. Only a few were ever made. Also, Hitachi made a model 16 HD, now known as the NAC E10. All

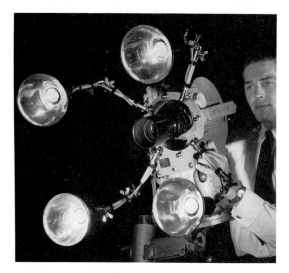

Figure 4.5 A publicity photograph dating from 1961 showing the Wollensak Fastax rotating prism camera with operator. The heavy duty stand and lighting rig for four reflector floodlights are also shown. (Picture courtesy of John Rendell.)

other Fastax and Hitachi cameras used the Tuttle system.

Soon after World War II came the necessity for a small camera for mounting on an aircraft or missile mounted and capable of withstanding high acceleration, deceleration and extreme vibration conditions. As a result, a modified version of the Wollensak Fastax, known as the Fastair, was developed. It could withstand accelerations of 980.665 m s^{-2} (100g) along the optical axis and 490.33 m s^{-2} (50g) perpendicular to it. In addition, it could continue to perform satisfactorily under 98.07 m s^{-2} (10g) within a vibration frequency range of 20 to 2000 Hz. As its name implies, the Fastair was built to withstand mounting to aircraft, airborne or ground rocket propelled vehicles in order to record 'on board' events. With its 16 mm × 30 m (100 feet) magazine, the camera weighed less than 4 kg. Its frame speed was 12–680 pps, which is moderate for a rotating prism camera, but it earned a reputation for rugged reliability and many are still in use today. The USA Fairchild company also introduced a similar 'projectile' camera in the mid-1950s, but it did not meet with the same success as the Fastair.

By 1960, the Swedish company Stalex had introduced an even smaller and faster camera, the Stalex MS16A, built to a similar operational specification as the American cameras. Using a powerful miniature 10–60 V DC motor and three interchangeable gearboxes, it could cover a framing rate range of 30–3000 pps and withstand accelerations of 392 m s^{-2} (40g). This was later raised to 980.665 m s^{-2} (100g) with a special 'high g' kit and lens mount. It was

fitted with a two-faced rotating prism providing excellent shuttering and image resolution and weighed a little under 2.5 kg. Since 1960, several improvements have been made to improve speed regulation and handling. Many cameras are in use worldwide, particularly in road vehicle crash testing programmes, where their size and performance is ideal for all 'on board' and external applications.

With all film cameras there is a time delay required between starting the camera and triggering the event to allow the camera to reach the desired framing rate, and to run off the fogged film leader before the unexposed film is reached. On a 30 m spool of film set for 5000 pps, this framing rate is not reached until at least half of the film has run through and this can take at least half a second, by which time the event may have occurred and the recording missed.

During the 1960s several attempts were made to improve matters and capture non-triggerable events. The John Hadland Limited organization achieved both conditions in a modified Fastax control, where 1000 pps within 5–10 ms were requested. It was achieved by switching a high voltage charge from a large capacitor through the camera motors to initiate the recording and followed up by a sustained lower voltage to maintain 1000 pps throughout the remaining film run.

From Weinberger AG (of Switzerland and Sweden), comes an unusual 70 mm 'cine' film camera with special running characteristics. In this

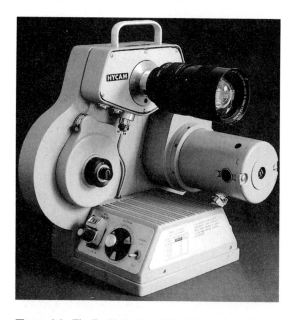

Figure 4.6 The Red Lake (now Visual Instrumentation) Hycam 16 mm rotating prism camera. Up to 120 m (400 feet) of film could be exposed at 10–11 000 pps. (Picture courtesy of John Rendell.)

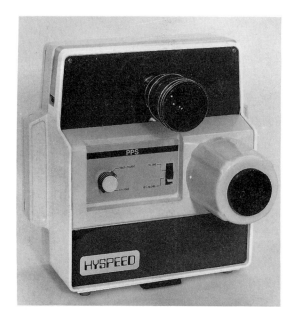

Figure 4.7 The Hadland Hyspeed 16 mm rotating prism camera providing 10–10 000 pps with a 120 m (400 feet) load.

camera a 5 m length of film is wound from cassettes into a large, light-tight film chamber. It is held in loose loops before passing through the film gate and rollers. A large single-faced rotating prism produces large sharp images of size 55 × 10 mm on the 70 mm film. In stand-by condition, the drive rollers are separated but are moved together to clamp and drive the film when required. Up to 1000 pps can be reached within 2–3 frames and recording can continue for a further half a second. A variable shutter permits wide exposure control. In many ways this camera has many of the characteristics of the World War II Bowen Ribbon Frame Camera, but is 10 times faster!

In 1960, Bob Shoberg, then President of Red Lake Laboratories in the USA, produced the Hycam camera (Figure 4.6) using a revolutionary optically relayed rotating prism system, which greatly improved image resolution and stability, by placing the prism on the camera film sprocket shaft. However, the long optical path from prime camera lens to the film path caused a reduction in the effective aperture of the system equivalent to the loss of two 'stops' of light (−2 EV), due to the limits in the dimensions of the relay lens. The Hadland Hyspeed camera (Figure 4.7), introduced in 1970,

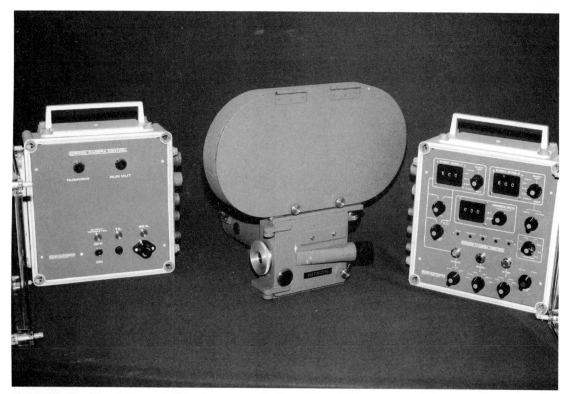

Figure 4.8 The Hitachi 16 mm rotating prism camera with Bowen Electronics Advanced Camera Control of 1975. (Picture courtesy of John Rendell.)

used a similar optical path. However, both these systems have been popular for industrial high speed photography in research and development applications.

Hitachi, the Japanese high speed camera manufacturer, in 1970 introduced a similar camera (Figure 4.8), the Model 16HD, and apart from adding improved electronic control systems, this has been continued ever since by NAC of Japan, who took over production in the late 1970s and redesignated it the Model E10. Light transmission was improved, with a loss of only 1 stop (-1 EV) compared to the standard Tuttle design, and image quality is high.

At about the same time, Shoberg developed the Photec camera (Figure 4.9). In this, the optical relay system was removed and replaced with a single U-shaped prism and lenses of long back register, to improve the light transmission and closely match that of the original Fastax cameras. The single shaft film sprocket and rotating prism arrangement was retained and this feature has resulted in high resolution images of exceptional clarity and steadiness.

The rotating prism camera has for 60 years been considered as the workhorse industrial high speed camera and can be found worldwide in all industrial

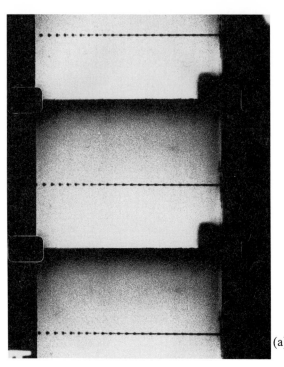

(a)

Figure 4.10 Behaviour of a pulsing ink marker recorded at 5000 pps with 35 ns exposure per frame by Laserstrobe illumination: (a) a perfect ink jet; (b) break up of jet during the onset of a fault. (Picture courtesy of Oxford Lasers and John Rendell.)

(b)

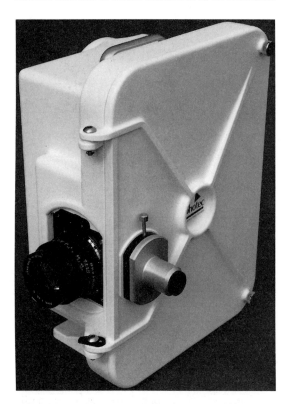

Figure 4.9 The Photographic Analysis (USA) 16 mm Photec rotating prism camera. (Picture courtesy of John Rendell.)

Figure 4.11 Cordin 70 mm ultra-high speed framing camera using the Miller principle. (a) Camera body and lens assembly. (b) Camera interior showing imaging and relay lens assembly. (c) Camera interior showing mirror assembly, relay lenses array and curved film track. (d) Detail of film track and framing lenses. (Photographs courtesy of the Fast Event Facility, Royal Ordnance Division, Chorley.)

a

c

b

d

and military applications, from biscuit making to ballistics. Figure 4.10 shows two sequences of pictures of the ejected ink stream behaviour of a pulsing ink marker, as used for can and bottle marking, photographed using a Hadland Hyspeed 16 mm camera running at 5000 pps. An Oxford Lasers Laserstrobe was used in diffused backlit mode for illumination. This pulsed copper vapour laser is synchronized with the framing rate and gives a 35 ns exposure per picture.

4.4 Drum and rotating mirror cameras (10 000 to 25 million pps)

At about 40 000 quarter pps, conventional film transport systems and materials have reached their limits in strength and operational reliability. To overcome this, it is necessary to attach the film (usually 35 or 70 mm gauge) to a rotating drum operating inside a light-tight chamber. Known as a *drum camera,* separate images are formed by static 'framing' lenses arranged within the chamber, to break up the 'streak' image on the drum into discrete pictures, for one complete drum rotation only. Alternatively, a high speed xenon, or copper vapour laser strobe with ultra-short light pulses, can form the sharp images on the rapidly moving film. The 'Laserstrobe' made by Oxford Lasers is described in Chapter 9. The former technique offers up to 100 000 pps and the latter up to 40 000 pps.

To achieve framing rates above 100 000 pps a *rotating mirror camera* is required. Light from the primary lens is relayed to a spinning mirror of stainless steel or beryllium, rotating at up to 10 000 rps. Reflected light from the rotating mirror passes through a bank of 20–120 'framing' lenses on to a static arc of 35 mm film.

Using this 'Miller System', framing rates up to 25×10^6 pps are possible. Originally designed to observe high explosive detonation phenomena, these cameras are still widely used in electrical plasma research, crack propagation and shock tube studies, where ultra-high speed phenomena are required to be studied in great detail.

They are now only manufactured by Cordin Inc., USA, see Figure 4.11, but the range of 35 and 70 mm 'Miller' cameras operate at recording rates from 2000 to 25×10^6 pps, on colour or monochrome film. Interchangeable arrays of framing lenses permit recording of a smaller number of large pictures (60×38 mm in size) at 2.5×10^6 pps, or large numbers of small frames at the higher rates. Figure 4.12 shows the progress of an explosively formed projectile recorded using a Cordin 318 35 mm drum camera with Laserstrobe at 22 000 pps. The 2.5 m^2 area was illuminated using retroreflective material to give a bright field with a 10 W pulsed laser.

Unlike conventional intermittent and rotating prism film cameras, the images recorded on drum or rotating mirror cameras are not accurately registered to the film sprocket holes. Consequently, to animate such a series of sequential images requires frame by frame copying with a cine camera, or rostrum camera as it is sometimes called, in a similar manner to the cartoon animation of drawings. In this, it is essential accurately to align each image to screen reference points to produce accurately regis-tered images. Alternatively, a telecine film to video projector with a continuous film transport facility (streak) plus a video editor capable of single or fixed multi-frame recording, are used to produce the same result, which, although tedious, is capable of bringing to life a series of still photographs.

4.5 Electronic cine camera systems

4.5.1 Introduction

Compared to a conventional mechanical cine camera, the electronic counterpart offers a very limited number of frames, i.e. 'time window'. However, the features that make the electronic camera more versatile can more than offset this limited recording time window. For many applications mechanical cameras cannot operate at framing speeds that would allow detailed analysis. This is particularly relevant when recording very fast phenomena. Miller system cameras (Section 4.4) can achieve microsecond exposures at high framing rates but require high light levels for good quality pictures.

The *image converter camera* was developed to complement the mechanical camera so that the lower recording rates of this type of system started where the ubiquitous rotating prism camera reached its maximum rate when operating at full frame height. However, the operating principles of the electronic image converter camera restrict the number of full frame images to only eight compared to considerably higher numbers available from a prism camera. Image quality also falls short of that produced by a mechanical camera. Consequently, some potential users have shunned image converter cameras, regarding the results inferior to those available with conventional film. However, history will no doubt detail the success story of electronic cameras with rather more tolerance.

4.5.2 Image converter systems

In the years immediately after World War II, cameras were developed that could have been used for nuclear research purposes. At that time, researchers wanted to be able visually to record ultra-fast phenomena without the restrictions imposed by the need to run mechanical cameras up to full speed. In particular, the ability more readily to synchronize the camera to the event. The first image converter camera was developed by the American company TRW using an *image tube* manufactured by RCA. This camera produced only three sequential images, the quality of which did not compare to those from present day devices. However, this camera offered advantages over other electron optical devices in use at that time. Further development resulted from proposals made by the Russian

Figure 4.12 Film sequence showing an explosively formed projectile. taken at 22 000 pps using a Cordin 318 35 mm drum camera and pulsed laser. (Picture courtesy of AWE, Foulness.)

M. Butslov, who suggested that the beam of photo-electrons generated at the photo cathode could be *shuttered* to give a sequential series of discrete images. This concept was further developed at the Atomic Weapons Establishment in the UK, then commercialized in a camera by John Hadland PI to be sold under the trade name of Imacon, of which there have now been over 500 such cameras sold worldwide.

Other manufacturers have produced image converter cameras, which in some instances offered features that the Imacon design lacked, but they failed to capitalize on them simply because they were not prepared to systematize their products for specific applications. Hadland Photonics proved that their cameras' systems could be configured to satisfy individual requirements and extend recording capabilities to capture images from virtually all aspects of research and development. More recently, an image converter camera incorporating many design suggestions made by A. Huston (1983) has been marketed by the Japanese NAC company. This camera offers both variable exposure and inter-frame times, so making it possible to utilize more usefully the limited recording window.

For many years the image sequences from image converter tubes were recorded directly onto Polaroid film, thereby facilitating visual assessment of the process under investigation within 30 s of the event being recorded. However, to quantify the information that had been recorded was quite an involved process and often resulted in the need for additional verification from other data gathering instrumentation. The introduction of silicon based sensors has made it possible to digitize image sequences captured by image converter cameras, significantly extending the potential for critical analysis by use of a personal computer. Whereas in the past a steel ruler pressed against the print surface could only approximate distances to the nearest millimetre, it is now possible accurately to interrogate the dynamic sequence down to pixel level. Furthermore, it is possible to enhance and modify either the complete image sequence or just selected sections of the record that extends data collection.

4.5.3 X-ray imaging systems

Image converter cameras have also been engineered into specialized data collecting systems. When used with short duration pulsed X-ray sources they allow the recording of events that are obscured with smoke, dust and plasma thereby excluding normal photographic methods. To maintain the high sensitivity of the system, as necessary for recording ultra-fast phenomena, an *X-ray intensifier* is used to convert the radiation to visible wavelengths for normal image acquisition. A submicrosecond decay phosphor is used on the output window of the X-ray intensifier to reduce degradation resulting from image retention. This is a phenomenon whereby the images recorded at the beginning of the sequence can reduce contrast and cause unsharpness of images recorded at the later stages of the sequence. However, even with this extremely short decay phosphor a million pictures per second is the upper limit before loss of quality becomes apparent.

A novel concept was developed which incorporated a multi-anode flash X-ray source that allowed greater stand-off distances and better penetration. However, the most significant advantage offered by this system was the very short duration of the individual X-ray pulses, which arrested image movement of events with velocities up to 8 km s^{-1}. Used with the ubiquitous Imacon 792 camera this system has produced detailed image sequences that otherwise could not have been recorded.

4.5.4 Recent developments

The latest electronic framing camera incorporates technology based on intensified CCDs and produces digital images as output at framing rates up to 100×10^6 pps. This concept has been made possible by the computer aided design of a pyramidal beam splitter, which was a long established optical system that suffered from major operating problems. These shortcomings have been overcome by incorporating an iris diaphragm in the optical relay system used. This facilitates control of depth of field and the amount of light reaching the sensors without vignetting.

This camera is totally controlled by a personal computer which can display the high resolution images within less than half a second after they are recorded. Features of variable exposure duration, interframe interval and sensitivity make this camera a comprehensive recording system that is supported by a wide range of software features for rapid analysis of the recorded sequence. Another feature of this camera, and the first time this facility has been incorporated in an electronic camera, is the ability to record simultaneously in both framing and streak modes. This offers scientists and engineers the possibility of acquiring the maximum visual data from an event. This information can be evaluated either in the 'raw' state or downloaded to a hard disc in the control computer, allowing rapid retrieval for future discussion or quantitative measurement. This type of digital data can then of course be readily transmitted by modem to any country in the world, thereby making co-operation between distant research groups a formality.

References

Huston, A. E. (1983) *U K Patent GB 2 109 659*

5 High speed CCD camera technology

Graham W. Smith

5.1 Introduction

Charge coupled device (CCD) imaging technology has caught the imagination of scientific and, more recently, domestic users since its conception. Image sensors have emerged from research centres since the early 1970s. A leading UK research institute (HIRST) at Wembley pioneered devices for the General Electric Company (GEC) and more recently for the English Electric Valve Company (EEV). Many new devices have emerged with the growing advances in CCD technology. Many of the established 'tubed type' cameras have been replaced by CCD imaging counterparts. New ideas are being continually contemplated especially in the field of high resolution imaging and fast readout and framing devices. The trend has been in the professional and scientific arena to link specialist imagers to computer based data capture and dedicated frame grabber and computer memory systems. These systems provide a powerful analysis tool for the professional user.

The CCD imaging sensor provides the heart of any imaging system. Hitherto many users have concentrated on the availability of standard broadcast cameras based on CCD structures to provide them with their imaging requirements. This chapter concentrates on the requirements of specialist

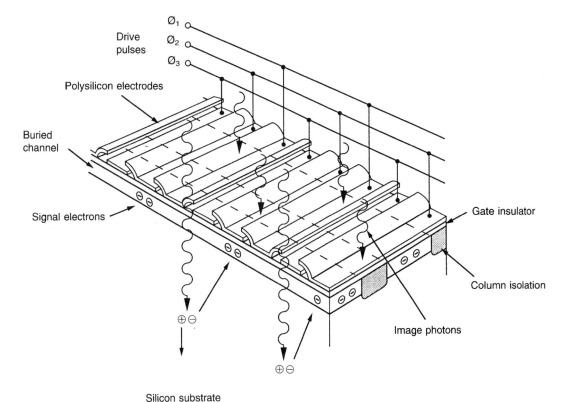

Figure 5.1 Section of a CCD image sensor.

cameras and associated technology involving the capture of high speed imaging events based upon CCD technology with which the author has been involved at the Atomic Weapons Establishment (AWE) Aldermaston. It gives an appreciation of key technical issues and parameters of importance in such activities and some of the problem areas that can be experienced or encountered.

5.2 Basic structure of a CCD

The CCD is essentially a silicon integrated circuit of the *metal oxide semi-conductor* (MOS) type. The basic structure is illustrated in Figure 5.1. The device comprises an oxide covered silicon substrate upon which is formed an array of closely spaced electrodes. Each electrode is equivalent to the gate of an MOS transistor. Signal information is carried in the form of a quantity of electric charge, usually electrons (although opposite polarity devices are also possible). The charge is localized beneath the electrodes with the highest applied potentials because the positive potential on an electrode causes the underlying silicon to be in depletion and thus assume a positive potential which attracts the negatively charged electrons. It is therefore common to say that the electrons are being stored in a *potential well*, as is apparent from the shape of the potential distribution beneath the electrodes. The active part of the device in which the charges are located is called the *channel* and this region is bounded by electrically inactive p-type channel-stop regions. *Charge coupling* is the technique by which signal charge can be transferred from under one electrode to the next. This is achieved by taking the voltage on the second electrode also to a high level, then reducing the voltage on the first electrode, as illustrated in Figure 5.2. Hence, by sequentially pulsing the voltages on the electrodes between high and low levels, charge signals can be made to pass down an array of very many electrodes with hardly any loss and very little noise. To achieve this, the electrodes are driven in sequence by a set of three-phase drive pulses; ϕ_1, ϕ_2 and ϕ_3, as illustrated. Charge signals can then be stored under every third electrode in the array and will be transferred together along the array under control of the drive pulses.

5.2.1 The CCD imager

To explore the concept of utilizing a classical CCD device in the *true imaging scenario*, the basic organization of an area imaging device is shown in Figure 5.3, which depicts the industry standard *frame transfer mode* of operation. The device comprises an array of horizontal electrodes above a number

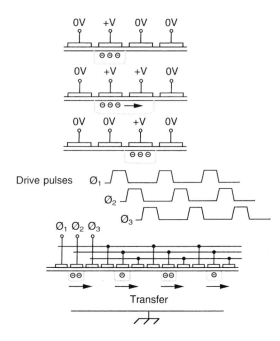

Figure 5.2 Charge transfer.

of vertical charge transfer channels (or columns) defined by channel-stop regions. The horizontal electrodes are grouped into two sections: an upper image section and a lower storage section. In the example shown, there are 12 electrodes in each of the image and store sections, and five columns. A further line readout section below the store is employed to transfer the charges in each TV line to the on-chip charge detection amplifier for video output.

The drive pulses applied to the image, store and line readout sections for device operation are designated Iϕ, Sϕ and Rϕ respectively. The direction of charge transfer under such operation is shown by arrows. Both store and line readout sections must be shielded from incident illumination by external opaque masking. The array operates as follows. The electrodes are fabricated from a material that is semi-transparent to light (polycrystalline silicon, or polysilicon as it is commonly called), if an optical image is focused on the image section then photons will penetrate the electrode structure and generate electron–hole pairs in the underlying silicon substrate. The electrons will diffuse to the nearest biased electrode where they are collected as signal. The holes diffuse down into the substrate where they are effectively lost (Figure 5.1). The overlapping electrode structure normally employed in practical devices and the *buried channel mode* of charge storage ensure high efficiency charge transfer without bias light or bias charge.

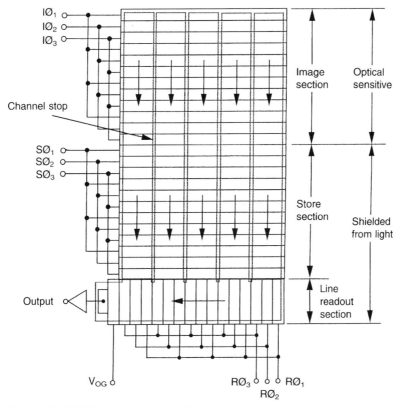

Figure 5.3 CCD frame transfer array schematic.

A single *photosensitive element* is thus an area bounded by the column isolation (channel-stop) regions and the triplet of electrodes centred on the biased electrode. Inspection of Figure 5.3 will therefore show that the array used as an example provides a matrix of five horizontal (H) by four vertical (V) independent photosensitive elements. The quantity of charge collected is proportional to the local light intensity and the time allowed for collection. At the end of the time allowed for collection (integration time) the whole pattern of charges that has collected in the image section is transferred into the store. This is achieved by applying drive pulses simultaneously to electrodes of both image and store sections; exactly four pulses in each phase are required for the example shown. Light is, of course, still incident on the image section and fastest possible transfer is desirable to minimize the pick-up of spurious signal as the charges are moving from one section to the other. Then, by applying appropriate pulses to the electrodes of store and line readout sections, all the photogenerated charge is moved as a block one element at a time down the store section, the lowest line of charges being transferred in parallel to the lower line readout section. Then, by application of $R\phi$ pulses, the line of

charges is sequentially transferred to the on-chip *charge detection amplifier* which converts the charge signals into a voltage modulated video output. The next line of signals is then transferred down from store to line readout section and read out in the same way. A second pattern of charge is being collected in the image section whilst the first is being read out. Once readout of the first charge pattern is complete, the second pattern is transferred to the store for readout, and so on through further cycles of the array. Thus the classic CCD imager is really the combination of the imaging photo-MOS structure with defining array clocking electrodes and an output amplifier port.

5.2.2 Basic array types

The most commonly used area array types of CCD imager are shown in Figure 5.4. These are the *frame transfer* (as previously described), the *interline transfer* and *X–Y addressable* arrays. The basic operation of the interline transfer device depends on the transfer of photogenerated charge in the imaging pixels along shielded columns (spaced between the vertical photosites) to a horizontal register that reads out at typically TV line rates. The X–Y

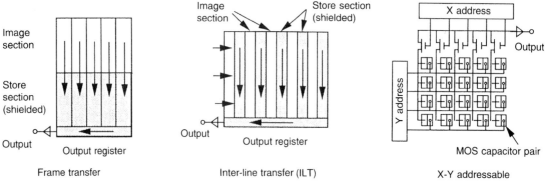

Figure 5.4 Common types of CCD area array imagers.

addressable arrays usually use MOS capacitor pairs to store photogenerated charge. The signal is read out sequentially by detecting voltage changes on the capacitance utilizing the address matrix of the X and Y registers. Variants of the X–Y addressed arrays can also use a photodiode as the pixel photosite.

The relative merits of these types of array have been widely reported (Homes and Morgan, 1979). However, it is important to recognize a key factor in the application of high speed transient light capture, i.e. that there exists a very fundamental difference in the image acquisition *resolution* between frame transfer and interline structures. This is associated with the *interlaced* function of these arrays.

5.2.3 Interlacing factors

Interlacing as required by conventional TV (i.e. scanning of alternate lines in sequential fields) cannot be achieved directly with frame transfer arrays. This is because the entire field of photogenerated charge is completely read out during each field with the rows of photosites (pixels) remaining fixed in the spatial axes. The second field of readout would therefore be a replica of the first field, i.e. *non-interlaced scanning* with vertical resolution equivalent to the number of CCD pixel elements in the vertical image section. To achieve interlace scanning, frame transfer devices utilize a mode of operation that gives rise to *pseudo-interlace*, which effectively doubles the number of pixels in the vertical direction and hence the vertical spatial resolution. This mode of operation is illustrated in Figure 5.5. The first field (A) is obtained by collecting charge under the electrodes of one phase in the image section ($I\phi_1$). These signals are read out and the drive pulse sequence to the image section is modified such that the next field (B) is collected under the electrodes of the other two phases ($I\phi_2$ and $I\phi_3$) and then read out (after amalgamation of charges under one of these electrodes) as before. In this way, although charge is picked up from the whole of the image section in each

field, the centres of charge collection are shifted back and forth by half the vertical width of the element to give in effect a 2 : 1 interlace in the vertical direction. Each CCD element (i.e. electrode triplet) thus behaves as though it were two overlapping photosensitive elements, and the number of TV lines is effectively *double* the number of vertical CCD elements in the image section of the array.

Interline devices are structured with the full vertical CCD pixel count equivalent to the complete FRAME vertical resolution required. Odd/even photosites share a common transfer vertical shift register element (Figure 5.6). On the first field (odd) all the odd photosites are transferred into the vert-

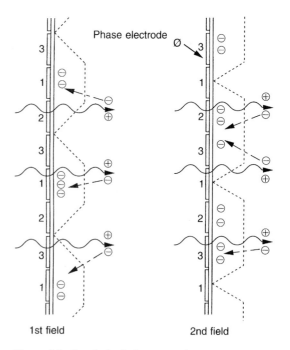

Figure 5.5 Interlacing in frame transfer arrays.

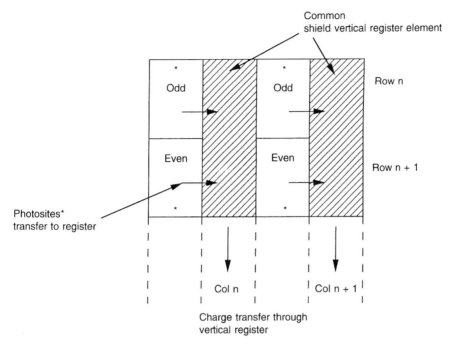

Figure 5.6 Interline pixel elements.

ical shift register for subsequent field readout, and then on the second (even) field all the even photosites are subsequently transferred for the second field readout. Thus true interlaced scanning can be attained.

Under synchronized transient light capture a frame transfer array will only give rise to *half* the vertical resolution of what is quoted for the vertical frame resolution, i.e. resolution only equivalent to the actual number of vertical CCD elements on the silicon wafer in the image section. (The resultant photogenerated charge from the transient event is removed completely from the imager under readout in the *first* field.) The resolution for transient light would therefore be only *half* that of an equivalent interline device achieving the same frame resolution. The interline device under a transient light event would achieve full vertical resolution but would take *two* fields to read the video signal out as both odd and even photosites receive incident light illumination at the same time but are read out on subsequent fields. Data sheets can be misleading in quoting vertical resolution; therefore, it is necessary to establish the format of the CCD sensor before experimentation with single shot or transient studies.

5.3 High speed readout three-phase frame transfer array CCDs

In the design of fast readout CCDs there are three main areas where the speed performance of the CCD can be limited. These are the transfer through the image section, transfer along the horizontal readout register and the dynamic performance of the output amplifier. A theoretical appraisal of these parameters is now presented.

5.3.1 Parallel transfer through the image system

The speed of parallel transfer is largely determined by the *time constant* of the electrodes.

If an electrode, of width W across the device and length L in the transfer direction, has resistance R_0 and capacitance C_0 per unit area, then its effective resistance R and capacitance C will be:

$$R = \frac{WR_0}{L} \quad C = WLC_0 \qquad (5.1)$$

If this electrode is driven from both ends as is normal then its time constant t_p will be:

$$t_p = \frac{W^2RC}{12} \qquad (5.2)$$

The factor 12 arises from a factor 4 for the drive from both ends, and a factor of approximately 3 for the distributed nature of the resistance and capacitance of the electrode. The rise and fall times of the pulse should be approximately $3t_p$ to allow full amplitude at the centre of the array. This and the three overlap periods required per pixel leads to a minimum cycle time of $9t_p$. Substituting typical values into Equation (5.2) and converting to a frequency f_0 gives:

$$f_0 \text{ (max)} = \frac{1}{W^2} \text{ (in MHz)} \qquad (5.3)$$

if W is the width of the polysilicon electrodes (in centimetres).

Experience with practical devices suggests that the predicted performance is somewhat conservative and up to a factor of 2 faster operation is possible. About 2 MHz may therefore be possible for the vertical transfer rate for devices with an electrode width of 1 cm.

5.3.2 Serial transfer

The on-chip limitations of serial transfer are set by the speed with which charge can be transferred between electrodes. The transfer of charge is governed by three processes (Homes and Morgan, 1979). Initially, the electrons flow under the influence of a *self-induced field* caused by the uneven distribution of electrons during the transfer process. This field is responsible for most of the actual charge transfer. After most charge has been transferred, however, the self-induced field becomes small and is no longer important in the transfer of the remaining charge. For high transfer efficiency it is the transfer of this remaining charge that determines the limiting serial transfer speed. The situation in a buried channel device is shown in Figure 5.7. The close electrode spacing and charge location in the semiconductor give rise to an electrostatic coupling of the bulk potentials.

This coupling leads to a *fringing field* between the electrodes, even in the absence of any signal. It is this field which governs the transfer of the last fraction of any signal charge between electrodes.

An approximate equation for the amount of charge $N(t)$ remaining at a time t after transfer has started due to such a field (Barbe, 1975) is:

$$\frac{N(t)}{N_0} = \exp\left(\frac{-t}{T_f}\right) \qquad (5.4)$$

where N_0 is the number of electrons at the start of transfer, and T_f is a constant related to the strength of the fringing field E_f.

As the fringing field strength is a two-dimensional effect (Barbe, 1975) it is not easily calculated, but an approximate value of T_f using the parameters shown in Figure 5.7 can be taken as:

$$T_f = \frac{L^3}{\mu 2V(3s + d)} \qquad (5.5)$$

where L is the electrode centre to centre spacing, μ is the bulk electron mobility, V is the voltage difference between electrodes, s is the oxide thickness and d is the channel depth.

Evaluating this expression for $N(t)/N_0 = 10^{-5}$ gives:

$$T = 50 \, L^3 \text{ (in ps)} \qquad (5.6)$$

where T is the transfer time across one three-phase cell comprising three electrodes of length L micrometres. For a typical device of register element length 21 μm, a horizontal output frequency of 50 MHz is feasible.

5.3.3 Output amplifier dynamics

The design of a typical high speed charge detection amplifier is shown in Figure 5.8. In operation, charge is detected as the voltage change on the output node capacitance C_0. This voltage change is the input voltage to the two-stage source follower circuit. After detection of the signal charge from a pixel the node is reset by pulsing OR high and removing charge through the reset drain VRD.

The amplifier is designed so that the first stage uses a small transistor to give low output node capacitance and thus high sensitivity (in volts per electron). The second stage is much larger to increase the drive capability of the output.

The intrinsic time constant of a MOS transistor is given by:

$$t_0 = \frac{C_g}{g_m} \qquad (5.7)$$

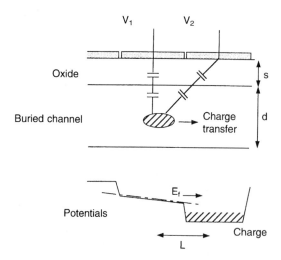

Figure 5.7 Fringing fields in interelectrode transfer.

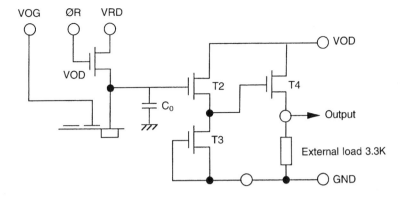

Figure 5.8 High speed output circuit.

where C_g is the gate capacitance and g_m is the mutual conductance. This will have a minimum value set by:

$$t_{min} = \frac{L}{V_s} \qquad (5.8)$$

where L is the channel length of the MOS field effect transistor (MOSFET) and V_s is the saturated carrier velocity. This minimum is, however, usually increased greatly by parasitic capacitance. For two stages the bandwidth determining time constant t_b will be:

$$t_b = nt_0 \qquad (5.9)$$

where n is the ratio of transistor sizes between the second and first stages.

The most important consequence of these time constants on the performance of the output circuit is in their influence on the output *settling time*. The settling time of the amplifier has to be less than the time taken to transfer two-thirds of a readout register pixel or the output will not have fully risen before the next reset pulse.

Considering a general amplifier designed to the format shown in Figure 5.8, then a settling time of 10 ns, which is sufficient for operating an output reset frequency of up to 40 MHz is achievable. The fast rise time that is needed to operate at elevated clocking speeds implies that the slew rate of the output should also be high. In the two-stage circuit shown in Figure 5.8, therefore, sensitivities of 2–3 µV per electron of signal charge are normally achievable, which would represent an output voltage swing of 1.5 V for a typically full well capacity of 500 000 electrons.

5.3.4 Power dissipation

A further consideration in the design of fast readout CCD devices is *power dissipation* on the silicon CCD chip. Power is dissipated in the output amplifier, the parallel image transfer and the horizontal readout register polysilicon electrode structures. The horizontal readout register frequency is by far the dominant component in achieving fast readout. However, increasing register frequency (f) also increases power dissipation by a factor related to f^2 (Ball *et al.*, 1990). Power dissipation in the output amplifier can also be a problem. The greatest dissipation occurs in the final output transistor T4 (Figure 5.8). Fast operation requires high quiescent current. For optimum performance of the amplifier the quiescent current needs to be sufficiently high not to leave the transistor operating in low gain areas when the signal is applied. For lowest distortion and highest gain, the transistor must also be operating in saturation. This means that the drain-source voltage must be appreciable, and this combined with the high current can lead to significant on-chip dissipation.

Another consideration associated with dissipation is the subsequent temperature rise of the device. An increase of 8°C will double dark current build up. In professional imaging systems, where dynamic range is of key importance, the photon statistics of *dark current* become a significant factor. Fortunately, in high speed readout devices (with field times of milliseconds) dark current effects are usually not significant, unlike the CCDs deployed in slow scan systems.

5.3.5 Practical TV device parameters

A typical broadcast standard 625 line TV imager operating in the frame transfer mode with, say, 578 horizontal pixel elements and 288 vertical elements (interlaced scan) utilizing a 225 × 15 µm pixel size would require an output horizontal register operating at about 11 MHz and a vertical transfer rate of about 0.4 MHz. Such operating speeds are conservative within the limits set by Equations (5.3) and (5.6). Device designs are a compromise between equal spatial sampling in the horizontal and vertical

directions of the array. For higher definition TV the readout rate of the horizontal register needs to be much higher. This can be achieved by either smaller pixel elements, which affect dynamic range due to reduced well capacity, or by split horizontal register outputs, which reduce clocking rates by virtue of parallel readout amplifier ports (Burt, 1991). The concept of a *split register output* led the AWE to the development of a specialized multiport 512 × 512 fast readout full frame CCD imager which was fabricated by EEV Ltd (Ball *et al.*, 1990).

5.3.6 Specialized fast readout full frame 512 × 512 CCD imager

The primary design requirements for the fast readout sensor were:

- Full frame device.
- Single luminous event capture.
- Spectral response of 400–1000 nm.
- Saturation energy density of 1.5 erg cm^{-2} at 570 nm.
- 512 × 512 active pixels.
- Pixel size 21 μm × 21 μm.
- Dynamic Range ›1000 : 1 (single shot).
- Vertical and horizontal clocking rates (0.5 MHz and 20–30 megapixels per second, respectively).
- Dark reference sensing elements.
- Binning capability.
- Multi-port output structure.
- Full frame readout in ‹2 ms.
- Incorporation of gated anti-blooming structure.

To meet the requirement of reading out a full frame imager of 512 × 512 elements in 2 ms an output horizontal register operating frequency of at least 131 MHz would be required, assuming a vertical transfer rate of about 1 MHz. This is clearly beyond the capabilities of a single register stage, as discussed in Section 5.3.2. Therefore, the device architecture adopted for the array is as shown schematically in Figure 5.9. The image section is split into two halves each transferring charge to a sectionalized readout register giving eight parallel readout ports in total. This configuration reduces the output data rate per port to a more manageable frequency of about 23 MHz for a frame readout of 2 ms.

Adopting the multi-port design approach of Ball *et al.* (1990) with this imager means that all the classical electro-optic performance parameters of the CCD imager are not compromised under fast readout conditions. In fact some parameters, such as charge transfer array efficiencies, are improved because of reduced register pixel elements.

5.3.6.1 *Array format details*

A few extra non-illuminated lines of CCD elements at the top and bottom of the device, between the

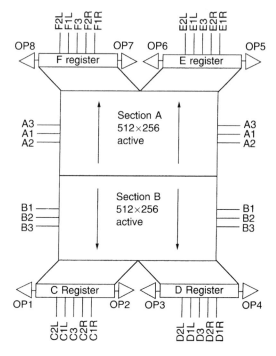

Figure 5.9 Schematic drawing of a fast readout 512 × 512 CCD.

active image array and the readout register sections are incorporated to offset the register halves and give the space necessary for the centrally located output amplifier. Also included on both sides of the array are some additional shielded columns for dark current reference compensation of the active image pixels. As an option at fabrication a *gated anti-blooming structure* (more fully described in Section 5.4.5.1) can be incorporated in the pixel structure. The gated anti-blooming function enables microsecond removal of any spurious signal build up within the array, normal *anti-blooming* in the event of optical overload of the imager and the ability instantly to reset the imager for transient light capture. The choice of pixel size was determined by the required peak signal (electron well capacity is a factor influencing this parameter) and the requirement to incorporate the gated anti-blooming structure.

5.3.6.2 *Readout procedure*

Referring to Figure 5.9, the bus structure of the image transfer is arranged so that in the normal mode of operation the A clocks transfer half of the image scene to the E and F registers, and the B clocks transfer the other half to the C and D registers. The readout registers are also split (electronically) in their normal mode of operation. Each register transfers half a line of active signal to

the left and the other half to the right. For example, considering a line of signals that are read into registers C and D, the left-most quarter is read out through output port 1, the right-most through output port 4 and the inner left and right quarters through output ports 2 and 3, respectively. If maximum speed readout is not required, the device has the option of readout through only two or four of the registers. This is achieved by merely transposing the drive pulse waveforms to the left and right phase 1 and 2 electrodes and/or the A and B sections. The design of the horizontal readout registers also includes enough register element capacity for *binning* (amalgamation of signal charge in the vertical direction) of up to four active rows of pixels for even further flexibility of readout.

The use of a large number of outputs does increase power dissipation compared to a standard device operating at normal TV scanning rates. Each output dissipates 60 mW if run continuously at 23 MHz. A total chip dissipation of about 0.9 W has been observed, approximately half the dissipation is in the image/horizontal register sections with the remaining half within the output amplifier ports. This dissipation leads to approximately 15°C in chip temperature rise from ambient. The corresponding increase in dark current build up is not a problem at these operating speeds providing a short exposure (integration period prior to readout) is used.

5.3.6.3 Output amplifier

A similar two-stage output amplifier configuration as described in Section 5.3.3 was utilized for each output port. Operation at a reset frequency of 2.3 megapixels per second yielded 1.3 V output for peak signal and a corresponding dynamic range of approximately 3000 : 1 (peak signal to root mean square (rms) noise). The fabricated device was encapsulated in a 72 pin package and is illustrated in Figure 5.10.

5.4 Classical CCD cameras

Classical CCD cameras derive their roots from the replacement of broadcast standard cathode ray tubes with their associated technology and combine all the advantages of solid state imaging, i.e. geometric fidelity, uniform flat field response, linear optical transfer characteristic, high dynamic range and freedom from photoconductive lag and shading effects. However, classical CCD cameras have one drawback which they share with their TV tube counterparts and that is the exposure time is equivalent to a complete field interval. This would be typically 20 ms for CCIR and 16.6 ms for RS170 standards. Given this relatively long *effective exposure time*, some degree of *image blur* is inevitable in any application involving the imaging of moving

Figure 5.10 AWE/EEV 512 × 512 fast readout CCD imager.

objects. The faster the moving scene the greater the resultant image blur. It is also important to realize that an imaging CCD based on a photo-MOS structure, as with any solid state imager, is always transparent to incident light but it is the rapid movement of charge from the photosites into the opaque storage regions, or directly to off-chip storage, that can further minimize potential image blur. Differing CCD array architectures have different characteristics, with interline structures generally performing better in this respect.

5.4.1 Solutions to image blur

There are several established solutions to the problem of image blur, but all tend to make systems more complex or more expensive, and often both. A *mechanical shutter* synchronized with the CCD field rate can be used to restrict exposure (or integration) time and thus stop motion blur. Unfortunately, mechanical shutters are usually bulky and, compared with the cameras, relatively prone to failure.

An alternative is *strobe lighting*, and in some situations this can be a very effective means of dealing with subject movement. On the other hand, it can also present problems. The ratio between strobed and background illumination of the subject must be high to make any image collected outside the strobe period insignificant. This means using very powerful strobes, or screening the image area from ambient light, both of which may be unacceptable on the grounds of cost or practicality. Screening may simply not be possible due to lack of space, or the need to retain visual or physical access to the subject.

Even where this is not a constraint, screening

inevitably adds cost and complexity to the installation. Where human operators are involved, screening may be essential, as some strobe frequencies are known to cause harmful effects, even as serious as triggering epileptic attacks in susceptible individuals. In addition, the very nature of strobe light can be troublesome because the hard shadows it produces are often perceived by machine vision systems as part of the image.

A synchronized gated image intensifier placed in front of the CCD imaging area is one way of obtaining a short integration time without necessarily adding additional external lighting.

5.4.2 Electronic shuttering

Pseudo-electronic shuttering, achieved by reducing the camera's internal electronic integration time, has, for many applications, eliminated the need for external measures for overcoming image blur. Techniques for electronic shuttering are based around the concept of removing photogenerated charge within the CCD structure for most of the field and then allowing exposure of typically microseconds or greater immediately prior to the field synchronizing pulse. Image blur in all but very fast moving subjects is eliminated. This type of shuttering is very common and was pioneered for the classical domestic camcorder with non-synchronized continuous event recording, the reduced exposure giving rise to the potential of *fast freeze frame information*. However, in transient light events, because camera exposure takes place at the same time in every TV field, the transient event being imaged must be accurately synchronized to the exposure interval, otherwise if the event of interest is not in the field of view during the defined integration (exposure period) it will not be correctly imaged or imaged at all. It is important to realize that with this style of on-chip pseudo-electronic shuttering there is a *pro rata* reduction in video signal output amplitude with reducing exposure times for a given continuous scene illumination because of the electronic removal of photogenerated charge from the CCD prior to video signal processing. The optical exposure to the sensor remains the same, whereas with classical external shuttering the true incident light impinging on the sensor is reduced which then gives rise to a reduced video signal. (Microchannel plate intensification can be used to compensate for the reduction in optical exposure.)

5.4.3 Specialized CCD cameras

The problems of image blur, transient and temporal light capture manifest themselves in a plethora of research and development environments. This has led to the development of specialized CCD based cameras in industry (Morcom and

Burt, 1987) and at the AWE, Aldermaston (Smith *et al.*, 1994). These solid state cameras are triggerable, instantly resettable and have the ability of capturing fast moving phenomenon, transient or temporal light events of short duration typically within the nanosecond to millisecond time regime.

5.4.4 The asynchronous camera

In many situations, the timing of a transient event to be imaged can be defined by a system fiducial marker but this timing function is usually random to the camera synchronization field pulses. The *asynchronous capture camera* directly overcomes the problems of random image capture. This camera still retains pseudo-electronic shutter ability but, unlike synchronous types, it may be randomly triggered at any time during line or field sync periods. Yet the resultant picture is read out in standard RS170 or CCIR video format and fully synchronized with video timing system. Consequently, the camera can image events whenever they occur with respect to video timing, whilst providing an unconditional stable output.

Operation of the asynchronous camera can best be appreciated by comparison both with conventional and synchronous electronically shuttered cameras at the level of the CCD itself. Conventional cameras, such as the EEV Photon series, use a CCD of the frame transfer type, as illustrated in Figure 5.3.

The optically exposed image section consists of an array of charge-collecting electrodes on which a pattern of charge corresponding to the imaged scene, and proportional to the incident light intensity, is gathered. At the end of the time allowed for charge collection (integration time), the whole charge pattern is transferred rapidly to a similar sized, but optically shielded array on the same chip acting as a store. This is achieved by applying drive pulses simultaneously to both sections, normally during the field sync period. On completion of the transfer, the image section returns to charge collection, while the stored field is transferred, one line of charges at a time, to the line readout section. From here they are clocked out serially to form the basis of a voltage-modulated video signal. Since the readout rate is normally set to produce an output compatible with a standard 525 or 625 line TV system, it follows that the image integration time is fixed at around 20 ms, which is too long to allow blur-free imaging of moving objects without the use of strobe lighting, mechanical shuttering or fast-gating optics. Figure 5.11 illustrates the way in which a shutter or strobe, synchronized with the video timing, gives reduced integration time.

Electronically shuttered cameras can achieve internal control of integration time by a process

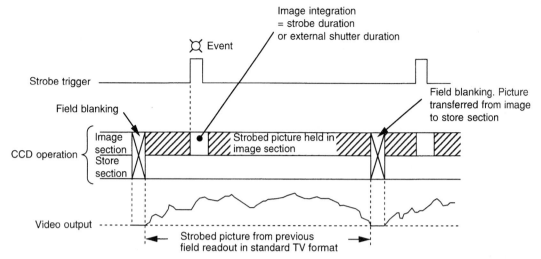

Figure 5.11 Strobe or shutter control of integration.

known as *reverse clocking*, applied to the slightly different CCD structure illustrated in Figure 5.12.

Essentially, what happens is that the image section is cleared throughout most of the field by clocking the elements in reverse sequence in order to dump any photogenerated charge into the diode drain. Immediately prior to the field sync period, reverse clocking is stopped and charge is allowed to collect in the normal manner for the remaining period of the field. This is then transferred to the store in the normal way during field sync, and read out in the next field. Integration time can be reduced by a factor of 100, but image capture is restricted to the same period in each field, as shown in Figure 5.13. Therefore, any event must occur in this period to be imaged at all.

The asynchronous camera overcomes this limitation not so much by a difference in the design of the CCD itself, but in the circuitry used to control it. Instead of being fixed, the timing of image integration and frame transfer may be determined by an external trigger pulse which can arrive at

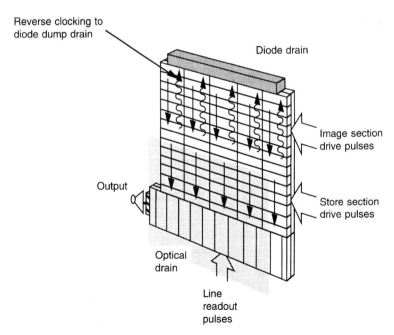

Figure 5.12 CCD with diode dump drain.

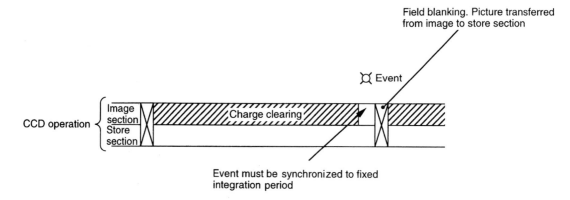

Figure 5.13 CCD electronic shutter timing.

any time, even during the field sync period. Nevertheless, the readout remains field synchronous. Figure 5.14 illustrates the operation of the CCD sections.

The image section is continually reverse clocked until a trigger pulse is received. When this happens, a final fast sweep of the image area can be performed to clear any residual charge, followed by the exposure period in which photogenerated charge is collected for a time determined either by the setting of a system control, or by the width of the trigger pulse, depending on the mode of operation selected.

During the waiting period, the store section and readout register are clocked continuously to prevent the accumulation of dark current.

Immediately image integration ends, the acquired frame of charge is transferred rapidly into the store section. This happens regardless of what point has

been reached in the TV field, unlike the process of frame transfer in an ordinary CCD camera, which must take place during the TV field blanking period. On completion of frame transfer, the image section returns to charge clearing, but further clocking of the store is inhibited. The stored picture information is held until the beginning of the next active TV field, during which it is read out in the normal way, fully synchronized with the video timing. A pulse is issued by the camera to act as a frame store TV field-grab signal. After the TV field is read out, the camera is ready to receive another trigger pulse.

As read-out occurs on the TV field immediately following the one during which the camera is triggered, the delay between image capture and read out is always less than one TV field duration. However, because two TV field periods are required

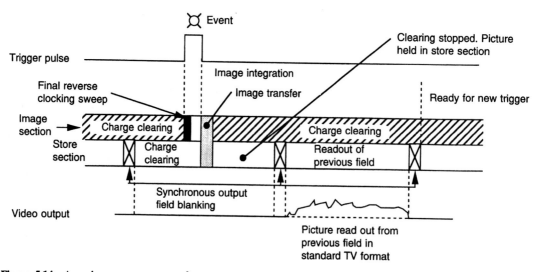

Figure 5.14 Asynchronous camera waveforms.

for each image integration/readout cycle, the asynchronous camera generates a maximum of 25 or 30 TV fields per second (according to the video standard), unlike the synchronous units which integrate one frame of charge while the previous one is read out, and can thus produce 50 or 60 fields per second.

In the strobed mode of operation, where integration time is set by the width of the trigger pulse, an effective increase in sensitivity can be gained by lengthening the trigger pulse to extend exposure beyond the duration of a single TV field.

The combined effect of clearing the store area until arrival of a trigger pulse, making frame transfer timing independent of the TV field blanking period, and inhibiting store section readout until the next active TV field, is to allow true asynchronous image capture without loss of synchronism at the output. As a result, the camera places no special requirements on the video system.

5.4.5 The immediate readout camera

The immediate readout camera concept, pioneered at AWE and developed in conjunction with EEV, was a natural follow on from the asynchronous camera type. The immediate readout camera was developed as a truly resettable camera, i.e. the charge contained within the photosites can be instantly removed by pulsing a specialized gated anti-blooming structure within the array rather than by reverse clocking to a dump drain as in the asynchronous camera. Figure 5.15 shows a schematic drawing of the gated anti-blooming structure.

5.4.5.1 Gated anti-blooming operation
In normal operation, fixed static potentials exist on the anti-blooming gate (ABG) and anti-blooming diode (ABD) such that control of saturation levels and subsequent anti-blooming, i.e. removal of excess charge above saturation, is implemented. By pulsing the ABG in a negative direction it is possible to remove all the pixel well charge into the ABD with very high efficiency, and of that approaching the normal charge transfer efficiency of the array. Furthermore, the time taken to dump or remove photogenerated charge is only about 1 μs. (Reverse clocking techniques as used in the asynchronous camera can take as long as 250 μs for complete irradiation of charge under some conditions.)

5.4.5.2 Immediate readout timing
The immediate readout camera timing (depicted in Figure 5.16) is similar in format to the asynchronous camera (described in Section 5.4.4), but the video field of interest immediately follows the frame transfer period, i.e. there is no variable delay from the frame transfer period to the field readout. The vertical sync period upon receiving a trigger pulse to

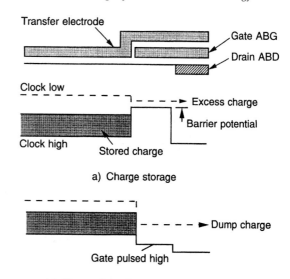

a) Charge storage

b) Charge dump for exposure control

Figure 5.15 Schematic illustration of gated anti-blooming.

the camera for transient light capture effectively aberrates during image integration and then re-initializes after frame transfer. It is important to realize that it is the first field of readout that contains true video information (light) and all subsequent fields should contain dark current information only. A dedicated personal computer (PC) based *field grabber* is normally used with this type of camera for capture and display purposes.

The ability to charge dump in 1 μs via the gated anti-blooming structure makes the camera an extremely versatile tool in transient light capture, as previous scene illumination can be removed on a temporal basis. The dump capability also means that one can instantly reset the camera even during scene illumination for a successive capture following an aberrated light event. Figure 5.16 also illustrates the charge dumping timing functions. A further advantage of the immediate readout camera is the minimal time from trigger to the field readout period.

Figure 5.17 shows the asynchronous camera mated to a generation II gated microchannel plate intensifier. This combination provides a very powerful tool with the ability to capture transient events with temporal resolutions approaching 5 ns against a background of scene illumination. The spatial resolution of the EEV sensor incorporated within this particular camera is 1032 (H) by 244 (V). The camera may simply be re-configured to run as a conventional interlaced camera with image resolution of 1032 (H) by 488 (V) RS170 format, which is ideal for focusing operations prior to transient studies. Figure 5.18 shows a photograph of image capture taken with this camera of an explosive mine

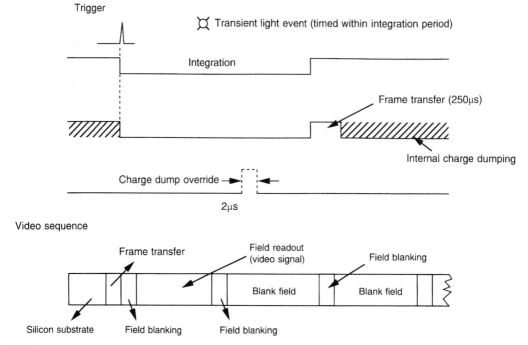

Figure 5.16 Immediate readout camera timing waveforms.

detonation. The high spatial resolution and contrast are pertinent factors that contribute to the quality and fine detail of the image.

5.4.6 Specialized high speed CCD readout camera system

A unique high speed CCD readout camera system developed for an in-house technical programme at the AWE is illustrated in Fig 5.19. The camera and capture system were developed around the special-ized AWE/EEV 512 × 512 pixel full frame multi-port sensor (more fully described in Section 5.3.6). This image system has high spatial resolution, fast readout and wide dynamic range, and was designed for single shot transient light studies (Smith *et al.*, 1994). The video from the camera head is digitized and downloaded into a non-volatile memory. This can be interrogated by computer for instant image analysis. An optional electronic shutter (large

Figure 5.17 Immediate readout camera.

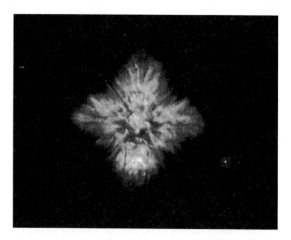

Figure 5.18 Explosive event (mine detonation).

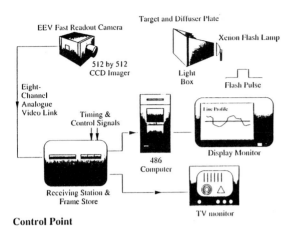

Figure 5.19 Fast readout image capture and analysis system. System features: fast frame transfer of 10 bit image data; battery backed non-volatile memory storage; flexible timing and control; fast access to data for signal processing and monitoring; TV compatible output.

Figure 5.20 Fast readout camera and receiving station.

format 40 mm diameter microchannel plate) mated to the camera's sensor front end can extend performance such that high resolution, low light level events with temporal information may be captured in the presence of scene illumination.

Figure 5.20 depicts the camera head, receiving station and display monitor in a laboratory environment. This system has the ability to capture a transient light event of nanosecond duration and read out its associated image in less than 1.7 ms with an optical dynamic range (grey scale) approaching 1000 : 1 with a spatial resolution of 512 × 512 pixels. The camera is truly instantly resettable and can be remotely driven to capture a timed transient event.

5.4.6.1 *System description*

The camera head generates all the signals necessary to drive the multiple output registers of the specialized sensor at a pixel clock frequency of 25 MHz and to process the resulting outputs to provide eight synchronized parallel video analogue signals. The camera head can be instantly reset for image integration similarly in concept as the immediate readout camera (see Section 5.4.5) by pulsing the incorporated gated anti-blooming structure within the sensor. Resetting can be achieved in approximately 0.3 μs by this method. Image integration is user defined can be set effectively from zero (after reset) to a period just exceeding the duration of the transient light duration of interest.

The anti-blooming structure gives blooming control as well as the facility to remove unwanted charge within the sensor in a precise manner. Other

features of the camera head include trigger lockout preventing erroneous trigger pulses from re-triggering the camera and the selectable electronic defined integration period. A technique known as *binning* is also incorporated in the camera head. Adjacent pairs, triplets, or quadruplets of lines may be amalgamated in the vertical transfer direction, prior to horizontal readout. This technique can be used to improve low light level capture and/or improve speed of readout. Under four times binning, 0.6 ms readout of an entire frame is possible, albeit at the expense of reduced vertical resolution. Another electronic feature designed into the head is automatic dark reference signal correction of the active pixels by use of the dark reference sensing elements fabricated on the CCD imager. Furthermore, flexibility in the clocking arrangements to the sensor and the design of the horizontal readout registers mean that a reduced number of parallel video output ports can be used if a slower field readout time is requested, thereby reducing the complexity of the system.

The synchronized eight parallel video outputs are connected directly to the receiving station together with control signal lines either by co-axial cables or analogue modulated fibre-optic links.

The receiving station (Figure 5.20) provides the functions of digitization, image storage with video display or computer readout for scientific analysis. Digitization modules digitize the incoming video signals in real time to 10 bit parallel data with appropriate parity and overflow bits.

Digitized data are bussed to complementary field store modules based upon CMOS devices (which are protected by battery back-up in the event of power failure) for image retention. Each module contains enough memory capacity for two images. Data may be read from the field store modules, either by a scan converter which displays the capture image with full 512 × 512 resolution on a normal 625 line TV monitor, or by a customized PC interface which enables transfer to a computer file for subsequent display or analysis. A control module defines the system trigger, capture, lockout and display ergonomic functions.

The ability to store two high resolution images means that one can configure the camera system to capture a true *background image* by triggering the camera a few fields before the *real* event of interest. Background subtraction of these two images by computer analysis will then remove any unwanted systematic noise component contained within the two images. (Systematic noise within the camera system has been found to be negligible.)

Memory extension of the receiving station is entirely feasible, thereby extending the capabilities of the system for multi-pulse transient capture, e.g. pulsed laser studies or pseudo-framing applications either with the use of an external strobe light or an external gated microchannel plate shutter.

5.5 Radiation factors relating to CCD structures

In certain applications CCD cameras need to be deployed in radiation environments. There are two aspects to the effect of radiation upon silicon semiconductor-based optical imaging devices: spurious signal generation when operating in a radiation field, and permanent damage. High-energy photons (ionizing radiation), e.g. γ-rays, X-rays and cosmic rays, cause the generation of electron–hole pairs. Such generation within the bulk silicon causes spurious signals in the form of photo-charge but no permanent damage. Within an oxide layer, however, the holes remain trapped and with increasing dose can lead to a significant shift in the flat band voltage (causing a change in the optimum dark current bias) (Janesick *et al.*, 1988; Roy *et al.*, 1989) and an increase in surface generation rate (i.e. background build-up or dark current) (Yates *et al.*, 1986).

High-energy particles, e.g. neutrons and protons, can cause lattice displacement, giving rise not only to large transient signals upon impact causing localized dark current *spikes* (Janesick *et al.*, 1988) or *stars* (Yates *et al.*, 1986; Yates and Turko, 1989a, b), as they are often referred to, but also the possibility of permanent damage in either the silicon or oxide

interface. Several reactions of neutrons with silicon nuclei that produce ionizing particles include elastic and inelastic scattering, (n, p) and (n, α). The particles create electron–hole pairs as they pass through the silicon substrate. Carriers produced in device depletion regions, or within a diffusion length of these regions, are stored as photo-charge, which is read out later as video signal from the CCD. Because of the short range of scattering recoils and charged secondary particles, most of the energy deposited as ionization occurs within the material where the reaction occurs. Consequently, a single reaction can show up as a local effect or a star in one or a few contiguous pixels on the CCD.

Figure 5.21 Neutron star effects superimposed on a test image (immediate readout camera).

Figure 5.21 illustrates a test image taken with the immediate readout camera (see Section 5.4.5) with 14 MeV pulsed neutrons superimposed on the CCD imager under transient light conditions. The neutron star effects can be clearly seen. Figure 5.22 shows an example of distinguishing signal change resulting from simultaneous irradiation with pulsed neutrons (14 Mev) and γ-rays (bremsstrahlung spectra endpoint energy of 16 MeV) on the same camera. The γ-ray induced signal is derived by subtracting the video scan line pedestal level of a background (unirradiated) field from the increased pedestal level after irradiation.

Experiments have shown (Yates *et al.*, 1992) that pulsed neutron irradiations of typically 10^7 neutrons cm^{-2} do not tend to cause permanent damage effects.

5.5.1 CCD radiation susceptibility parameters

In a conventional CCD, light absorbed by the silicon gives rise to an electron–hole pair, of which the electron is subsequently collected by the polysilicon

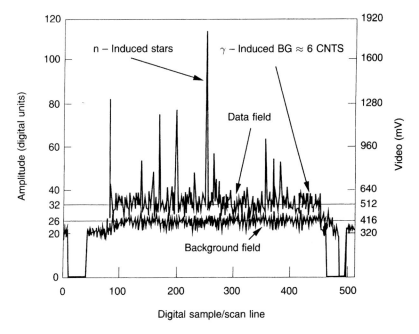

Figure 5.22 Video line scans from a CCD camera under simultaneous irradiation by pulsed γ-rays and neutron sources.

electrode structure within the device and generates a signal. The depth at which the carriers are generated is dependent on the wavelength of light, but 90% of all light at 400 nm is absorbed within the first 0.4 μm of silicon and 90% of all light at 900 nm is absorbed within the first 60 μm of silicon. It can thus be seen that only a thin silicon layer is required to absorb and detect the visible illumination.

With regard to *radiation sensitivity*, the magnitude of the transient pickup depends essentially on the active volume of the semiconductor associated with each element. The relative magnitude then depends on the active volume and the absolute magnitude of the readout noise. Because these factors also influence optical sensitivities and dynamic range, it is an inevitable trade-off that as optical sensitivity increases so does the apparent sensitivity to radiation induced pickup.

The key point is that the capture cross-section of silicon for ionizing radiation detection is much lower (when compared with the visible spectrum) and electron–hole pairs are generated throughout the whole of the silicon wafer. The question then arises whether these carriers are collected by the classical CCD polysilicon/depletion electrode CCD structure.

Mobility of these carriers is determined by equivalent diffusion lengths or carrier lifetimes. Diffusion length is dependent upon many parameters, but is dominated by the doping concentration of the silicon (Willander and Grivikas, 1987a–c).

In some commercial devices the base silicon or substrate on which the epitaxial silicon is grown is very highly doped (*low resistivity*), giving a low carrier lifetime, so that most carriers generated within the substrate will be lost before they reach the classical CCD structure within the epitaxial layer. These designs provide *high resistivity* appropriate for storage requirements only in the epitaxial layer. As a comparison, CCD devices formed on bulk silicon of appropriate resistivity (to provide storage for typical field times of tens of milliseconds) would be of *high resistivity* throughout the entire wafer, and carriers generated deep within the wafer would be collected by the CCD structure. Comparative measurements (Yates *et al.*, 1992) indicate a much higher susceptibility to ionizing radiation from bulk devices when compared with epitaxial grown devices. Also, measurements taken on *charge injection devices* (CIDs), which are also of epitaxial structure, indicate even higher radiation immunity than an equivalent specification CCD due to their generally thinner epitaxial layers. This supports the view that one of the major keys to good *radiation hardness* is the epitaxial approach with attendant resistivity and thickness parameters of the silicon appropriately defined.

CCD structures can be optimized with respect to minimizing the ratio of radiation to optical sensitivity. In theory, the susceptibility of any silicon device to radiation noise should be independent of type, i.e. interline transfer, full frame and photo-

diode, provided the ratio of volume of silicon available for radiation detection (within carrier diffusion lengths of collection) to volume of silicon available for photon detection is the same. Frame transfer devices utilize pixel structures that virtually cover the entire image area without loss of detection area between pixels and thus optimizes the above ratio. However, interline transfer devices necessarily lose some image area (due to vertical registers). Thus only a percentage of the image area is available for photon detection, whereas all the image (wafer) area is available for radiation detection.

5.6 Future aspirations of CCD technology in the high speed camera arena

CCD camera and sensor technology is far reaching. Potentially, the solid state sensor will offer true framing capability in excess of 10–100 000 fps with broadcast standard quality and replace the plethora of film framing cameras that operate in this recording window. To date, the specialist high speed pseudo-framing camera systems operating in excess of 1 million frames per second are based on cathode ray tube technology coupled to scientific grade readout CCD sensors. Transient and temporal light capture of transient events can be accomplished by the cameras as described. For the future, specialized CCD systems are currently being considered which focus on direct electron bombardment of the pixel well CCD structure within vacuum enclosures. These systems will open up further avenues in the development of hybridized cameras operating with shuttering performance in the picosecond time domain. Such cameras will have much higher operation efficiencies compared to conventional phosphor configured microchannel plate or cathode ray tube types.

To the researcher, the CCD imager in its wider scenario offers unrivalled ability to respond to light stimulus. The potential configuration and architecture of such sensors and camera systems are only limited by the imagination and ingenuity of the scientists, engineers and users involved in the high speed imaging fraternity.

Acknowledgements

The author wishes to thank the Atomic Weapons Establishment at Aldermaston for permission to publish a record of an explosive mine detonation taken with an immediate readout camera and also to thank EEV Ltd, Chelmsford, UK, for permission to use extracts from their technical publications upon CCD imaging and camera technical bulletins.

References

Ball, K., Burt, D. J. and Smith, G. W. (1990) High speed readout CCDs. *Proc. SPIE* **1358**, 409–420

Barbe, D. F. (1975) Imaging devices using the charge-coupled concept. *Proc. IEEE* **63**, no. 1, 38–67

Burt, D. J. (1991) CCD performance and limitations: theory and practice. *Nucl. Instrum. Methods Phys. Res.* **A305**, 564–573

Homes, M. J. and Morgan, D. V. (1979) *Charge-Coupled Devices and Systems*, pp. 24–33. Wiley, Chichester

Janesick, J., Elliot, T. and Pool, F. (1988) Radiation damage in scientific charge-coupled device. *Proc. IEEE Nuc. Sci. Symp.*

Morlom, J. and Burt, D. J. (1987) *CCD Imaging III*. EEV Technical Publications, EEV Ltd, Chelmsford, Essex, UK

Roy, T., Watts, S. J. and Wright, D. (1989) Radiation damage effects on imaging charge-coupled devices. *Nucl. Instrum. Methods Phys. Res.* **A275**

Smith, G. W., *et al.* (1994) High speed readout camera system. *Proc. SPIE* **2273**, 61–70

Willander M. and Grivickas, V. (1987a) Lifetimes of photogenerated carriers in doped Si. *Properties of Silicon*, pp. 198–199. INSPEC

Willander, M. and Grivickas, V. (1987b) Diffusion and mobility of photogenerated carriers in undoped Si. *Properties of Silicon*, pp. 200–201. INSPEC

Willander, M. and Grivickas, V. (1987c) Diffusion and mobility of photogenerated carriers in doped Si. *Properties of Silicon*, pp. 202–203. INSPEC

Yates, G. J., Bujnosek, J. J., Jaramillo, S. A., Walton, R. B., Martinez, T. M. and Black, J. P. (1986) Radiation effects on video imagers. *IEEE Trans. Nucl. Sci.* **33**, no. 1

Yates, G. J., Smith, G. W., Zagarino, P. and Thomas, M. C. (1992) Measuring neutron fluences and gamma/X-ray fluxes with CCD cameras. *IEEE Trans. Nucl. Sci.* **39**, no. 5.

Yates, G. J. and Turko, B. T. (1989a) Circumvention of radiation-induced noise in CCD and CID imagers. *IEEE Trans. Nucl. Sci.* **36**, no. 6, part I, 2214–2221

Yates, G. J. and Turko, B. T. (1989b) *Radiation-Induced Noise in CCD and CID Imagers* (Los Alamos National Laboratory Report LA-11706–MS). Los Alamos, NM

6 High speed videography

Kris Balch

6.1 History of videography

6.1.1 Introduction

From the time English photographer Eadweard Muybridge used a sequence of still cameras in the 1870s to photograph moving horses to the use of high speed cameras in the early 1960s, film was the only medium available to record motion that was faster than the eye could perceive. The development of reliable video technology gave researchers and engineers another tool for motion analysis and the benefit of immediate review of the recorded event.

Up to that time, film processing had changed little over the previous century. It was more automated, the chemical solutions were more balanced, and the processing time had been somewhat reduced. But special developing facilities were still required. So was time. Video changed that. High speed events that are random in nature, extreme in size or speed, or have other challenging characteristics can be difficult or impossible to study using conventional video (camcorder) imaging techniques. New video technology was required to capture images of such demanding applications. The combinations of these new video technologies into a recording system are commonly referred to as a *high speed video system* or a *motion analyser*. Since the 1970s, when the first electronic motion analysers became commercially available, the cost, capabilities and useability of high speed video and electronic cameras have improved dramatically. Today's high speed video cameras offer far more capabilities and advantages than their forerunners. And, while film certainly continues to have important applications in high speed photography, the increased sophistication of electronic motion analysers assures its place in future image data acquisition requirements.

This chapter covers the history of videography and its fundamental technology. It details the equipment that is available now and will be in the future and how to determine imaging requirements for particular applications. It also describes how a typical motion analysis test is set up and the test results analysed. Finally, the chapter outlines a view of where this technology will go in the next 10 years and how industry standardization will aid in enhancing its future.

6.1.2 Origins and classification

The evolution of motion analyser technology can be delineated by frame rate and the sophistication of features. The first motion analysers were an outgrowth of magnetic recording technology in the early 1960s, with the *first-generation* motion analyser commercially available in the 1970s. These devices were limited by the era's technology, and could capture only 120 full frames per second (ffps). The *second-generation* motion analyser was introduced by NAC Inc. in 1979 and could capture 200 ffps. This was a great step forward in technology, since the HSV-200 captured images in colour and could record for long duration. In 1980, Kodak introduced a *third-generation* motion analyser, the SP2000 motion analysis system. This revolutionary high speed video device recorded monochrome images at 2000 ffps or 12 000 partial frames per second (pfps) onto 12.7 mm (0.5 inch) instrumentation tape. Although the frame rate was unsurpassed for many years, the handling of images on magnetic tape was cumbersome.

The next significant technology advancement in motion analysers came in 1986 with the launch of the Kodak EktaPro 1000 motion analyser, which operated at 1000 ffps and 6000 pfps. Although it operated at a lower frame rate than the SP2000 motion analysis system, the EktaPro 1000 motion analyser had many advanced features. These included a low cost, high performance tape transport system, dual camera operation, GPIB control interface and inter-range instrumentation group (IRIG) time code synchronization. The tape transport moved 12.7 mm (0.5 inch) tape at 7.62 m s^{-1} (300 inches per second) while the heads recorded 16 channels of image data. The dual camera operation allowed images from either camera or displayed them both in a *split screen*. The cameras could even operate at different frame rates. The two camera images could also be interleaved so that two 500 ffps cameras provided 1000 ffps. Magnetic recording technology has been used in the last three generations of motion analysers. But the technology suffered from the recording limitations inherent in magnetic tape based motion analysers. Such motion analysers were limited not only by the amount of record time, but also, during

a rewind cycle, the magnetic tape was not positioned for recording and an intermittent event at this time could not be captured.

Since these recorders were electromechanically intensive, there was a lag in response time from the moment a recording was initiated to the actual recording of an image. This lag time was also present in their ability to stop. The time required to start and stop made these motion analysers inefficient for short recordings. Some applications require only a few images at any given time to be captured at a high frame rate. There may be long periods of time between capture. A magnetic tape based motion analyser would waste most of its recording media with start–stop sequences. These were but a few of the limitations, and, with complex applications, the difficulties multiplied.

The *fourth-generation* motion analyser was an entirely new approach to high speed image capture, using solid state memory as the recording media. In 1990, Kodak introduced the EktaPro EM motion analyser, which stored digital images in dynamic random access memory (DRAM). This was a departure from conventional wisdom that insisted an event must be captured by recording minutes of image data. However, the DRAM technology demonstrated that long record times were not necessary for most applications. Manipulating images with DRAM technology allows unique image capturing techniques, improves image quality and provides for continuous image recording. Over the last two decades, DRAMs have been increasing in storage density and decreasing in storage cost per frame. Recently, DRAM architectures have been pushing the memory densities to a level where their use in high speed motion analysers is cost effective. Even higher densities are expected in the future.

The *fifth-generation* motion analyser advances the technology with higher resolution, faster frame rates and improved image quality for colour and monochrome images. Three motion analysers qualify as fifth-generation machines: the Kodak EktaPro HS motion analyser, model 4540; the Kodak EktaPro Hi-Spec motion analyser; and the Kodak EktaPro motion analyser, model 1000HRC. The HS 4540 records at 4500 ffps to 40 500 pictures per second (pps). The HS4550 has four times the record rate over older motion analysers at similar resolutions. The Hi-Spec is a more compact analyser that records 1000 ffps in rugged environments. The imager can withstand shock loading up to 40*g*. The HRC records up to 1000 colour or monochrome images per second at a resolution of 512×384 pixels, this is four times the resolution over older motion analysers.

The *sixth-generation* motion analysers are self-contained and offer users increased flexibility and durability. The Kodak EktaPro RO imager, the

NAC Memrecam Ci motion analyser, the NAC Memrecam CCS motion analyser, the Redlake MotionScope 500 and the Kodak EktaPro Motion-Corder all qualify as sixth-generation analysers.

The Kodak EktaPro RO imager is a stand-alone, self-contained camera specifically designed to replace film cameras in extreme environments. The RO is small in size and lightweight. The imager accepts a removable PCMCIA hard drive or *flash memory drive* for archiving images from DRAM memory to these drives. The images are held until downloaded to a desktop computer. Previous motion analysers were tethered to an image processor. The RO (record only) camera requires no such processor or tethering. Instead, any computer with appropriate software can convert the data to tag image file format (TIFF). The data can then be analysed.

The Memrecam provides similar stand-alone capabilities. It can deliver 500 colour ffps at a resolution of 580×434 pixels. By reducing the resolution, it can record up to 2000 pps in colour. The Memrecam Ci has a built-in control panel that is easy to use and simple. NTSC/PAL images can be viewed on a standard monitor as the user manipulates video cassette recorder (VCR) like controls on the rear panel.

The Redlake MotionScope 500 is a self-contained monochrome camera that has a built-in monitor. The MotionScope can record 250 full frames and 500 partial frames. It has simple controls on the rear panel. This analyser has a removable camera head that makes it ideal for use in production manufacturing. The size of the camera head allows imaging into restricted space, and its cable disconnects and the head attaches to the processor.

The Kodak EktaPro MotionCorder is a highly portable analyser designed specifically for the production manufacturing environment. It is has a very small and highly sensitive camera head for imaging in tight areas. It has an International Standards Organization (ISO) (formerly American Standards Association (ASA)) or *exposure index* (EI) equivalent of approximately 1600. It is a monochrome camera with a resolution of 640×240 pixels. Combining the high sensitivity (extended depth of field) with this resolution, the MotionCorder produces superb images. The MotionCorder can image at 240–600 ffps. It has different frame formats that provide more options for longer record time. It can record from a few seconds to over 40 s depending on the frame format.

The sixth-generation motion analyser's main advantages are size, cost, portability, ruggedness and ease of use. The RO is designed to capture images and have a limited playback. Images are intended to be played back on a computer. Since most companies already have a computer, and since most use specific analysis software anyway, the only

additional cost is the camera. This kind of 'stand-alone' image capture system is expected to represent the way in which future motion analysis systems will be developed and sold. It can be compared to how personal computers are now sold, where customers combine different vendors' hardware and software to configure their machine to their specific applications.

6.1.3 Why use high speed video?

High speed video cameras offer the advantages of ease of use, live picture set-up, reusable recording media and, most importantly, immediate playback capabilities. The technology also offers specific cost benefits. There are no chemicals or film to buy. The high speed electronic camera can be used repeatedly without concern of the cost of disposable material.

There are two disadvantages: speed and resolution. Film still offers greater framing rates and image resolution. Figure 6.1 shows a plot of electronic resolution in pixels versus film types.

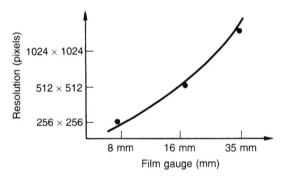

Figure 6.1 Comparison of sensor resolution and film gauge.

Other applications currently using high speed motion analysis include: production line trouble shooting, machine diagnostics, destructive testing, automated assembly, packaging, paper manufacturing and converting, and a variety of impact, shock and drop tests. Some research groups use the technology to study combustion, ballistics, aerodynamics, flow visualization and human performance.

Because film cameras require a 'run-up' or 'wind-up' time to get up to full speed, electronic imaging has distinct advantages when events are unpredictable or intermittent. Some examples include: lightning strikes, a jam in a production line, a blade failure in a turbine engine, or a vessel subjected to increasing pressure until it ruptures. Due to the unpredictable nature of such events it is hard to know in advance when to start the camera. Electronic cameras, on the other hand, can be triggered automatically by a variety of means, or

they can record continuously in a loop until triggered to stop.

For example, in a canning operation, one out of every 1000 cans jams up the production line. But because the jam is completely unpredictable, there is no indication when a problem may occur. By the time an event occurs, recording is too late. To keep the camera running at high speed while waiting for an event is extremely costly and impractical. Table 6.1 gives data for various record lengths, record framing rate and playback times.

Electronic cameras offer another distinct advantage: synchronization. Multiple electronic cameras can be set up at different angles to record an event or series of events. The cameras can be triggered together or in any particular sequence. Most importantly, when any cameras are running at the same time, they capture data at exactly the same moment. This allows for more complete data, better quantitative measurements and greater analysis. Such precise synchronization is not possible with high speed film cameras.

In an airbag deployment, for example, engineers would want to see a test from a variety of angles. The information is far more valuable if an exact moment can be viewed from different angles. Because such events are of extremely short duration, having cameras even slightly out of synchronization reduces enormously their information value for three-dimensional analysis.

The electronic camera's immediate playback capabilities may be its greatest asset. The cost of film is minuscule when compared to the cost of an engineer's time. If a test can be reviewed immediately, engineers will know if they need to plan another test. It also speeds up the entire process of finding a problem and then correcting it. The lengthy delays between tests and the expensive set-up and tear-down of test equipment are things of the past.

6.2 Fundamental technology

6.2.1 Imaging devices

Imaging devices are the detectors that convert light from photons to electrons. Typically, this is a sensor that has a structure using metal oxide semi-conductor (MOS) or charge coupled device (CCD) technology. The sensor captures the optical image by *tessellating* the incident light into a two-dimensional array of the picture. A single photosite is called a *pixel*. The light energy is converted into an electrical charge. Depending on the architecture of the sensor, these pixels are 'addressed' to read the converted charge out of the sensor. Some sensors use a photocapacitor or a photodiode as the photosensitive element in the sensor. After conversion, some offsets and parasitics must be removed from

Table 6.1 Playback time at different record framing rates for 0.5, 5 and 60 s recording durations, and playback rates of 1, 5, 10, 15 and 30 pps

Framing/ playback (pps)	250	500	1000	2000	3000	4500
Playback time (s) versus record framing rate for 0.5 s of recording						
1	125	250	500	1000	1500	2250
5	25	50	100	200	300	450
10	12.5	25	50	100	150	225
15	8.33	16.67	33.33	66.67	100	150
30	4.17	8.33	16.67	33.33	50	75
Playback time (min) versus record framing rate for 5 s of recording						
1	20.83	41.67	83.33	166.67	250	375
5	4.17	8.33	16.67	33.33	50	75
10	2.08	4.17	8.33	16.67	25	37.50
15	1.39	2.78	5.56	11.11	16.67	25
30	0.69	1.39	2.78	5.56	8.33	12.50
Playback time (h) versus record framing rate for 60 s of recording						
1	4.17	8.33	16.67	33.33	50	75
5	0.83	1.67	3.33	6.67	10	15
10	0.42	0.83	1.67	3.33	5	7.50
15	0.28	0.56	1.11	2.22	3.33	5.00
30	0.14	0.28	0.56	1.11	1.67	2.50

the signal. This is the process for converting light into an electrical charge.

Most imaging devices used in today's motion analysers are solid state sensors. There are a few motion analysers still using image tubes (i.e. vidicon and plumbicon types). The main advantage of using these tubes is the relatively low cost. However, tubes will deteriorate over time, exhibit *image lag* from fast moving objects, are subject to damage easily and are non-linear in their photoelectric response. In contrast, the solid-state sensors' characteristics include no deterioration over time, no image lag and they are very linear. Some sensors are coupled with image intensifiers. An image intensifier is used to amplify light. Intensifiers may also have a shuttering capability. Some solid-state sensors have electronic shuttering that can be precisely controlled. Today, tubes are not used for imaging but rather for light amplification.

Electronic sensors that operate at frame rates above 200 ffps are *multi-channel devices*. 'Multi- channel' means that the sensors read the imaging data out in parallel over multiple readout channels. The fundamental sensor architectures include: interline, interline transfer, block and frame transfer. The *interline* architecture is good for very fast frame rates but is limited in resolution due to the charge transfer over long buses. The *interline transfer* is usually made with a combination of a photodetector that transfers its charge to a CCD shift register. These sensors are good for higher resolution, but typically have a limited frame rate not much over 1000 ffps. The *block* type architecture divides the sensor into subblocks. These blocks

are read out in a pre-determined order. This allows a very high readout rate (ffps), but the resolution is limited due to the bus structure. The *frame transfer* type sensors have to move all pixel data to a shielded area on the sensor. From the shielded area, the pixels are read out of the sensor. This type of sensor is limited in the frame time but typically has higher resolutions than MOS devices (interline). The block, interline transfer and frame transfer architectures are shown in Figure 6.2.

6.2.2 Signal processing

The *signal processing channel* is very important for producing high-quality images from a motion analyser that uses multi-channel sensors. The 'noise' associated with one channel may be small when viewed as a single element. However, when multiplied by several adjacent signal processing channels, the noise is very noticeable. This is why it is important for any multi-channel motion analyser to have very low noise channels.

A typical signal processing channel is shown in Figure 6.3. First, the video signal output from the sensor is amplified by a pre-amp. Next, the video signal passes through a sample-and-hold circuit. The purpose of the sample and hold is to capture the video signal and hold it for conversion. There are many forms of sample-and-hold circuits. One of the commonly used designs is a *correlated double sampler* (CDS). This circuit, in addition to the sample-and-hold function, eliminates reset noise

(a)	(b)	(c)

Figure 6.2 Sensor architectures: (a) block transfer; (b) interline transfer; (c) frame transfer.

associated with the charge-to-voltage output structure of the CCD imager. The next step is to convert the analogue video signal to a digital value. The analogue-to-digital converter (ADC) transforms a given voltage level to a digital code value. This code value will be as wide as the analogue-to-digital converter's precision. Most high speed video systems convert the pixel values to a depth of 8 bits.

One way to determine the performance of a video signal processing channel is with an assessment of sources of noise within the channel as compared to the actual video level. This is called the *signal to noise ratio* (SNR). The SNR is a common figure of merit used in video specifications and is given as follows:

Channel SNR in decibels (dB) is defined as:

$$\text{SNR (dB)} = 20 \log_{10} (\text{Channel signal}_{max}/\text{Channel noise}_{sum}) \tag{6.1}$$

where Channel signal$_{max}$ is the full scale video level measured in millivolts (mV), and the Channel noise$_{sum}$ is the square root of the sum of the squares of pre-amp, sample-and-hold noise and analogue-to-digital noise sources.

The sensor SNR is defined as:

$$\text{SNR (dB)} = 20 \log_{10} (\text{S electrons}_{(full\ well)}/\text{N electrons}_{(noise)}) \tag{6.2}$$

where S electrons$_{(full\ well)}$ is the signal charge in electrons rms (root mean square) stored in the fully saturated well, and N electrons$_{(noise)}$ is the standard deviation of noise in electron rms.

Summing the noise for each element in the signal processing channel described in Figure 6.3 gives an accurate measurement of its performance as given in Equation (6.1). Noise from the sensor must also be added to obtain the complete estimate of channel noise.

When a specification sheet describes the digitization of an image as being to 8 or 10 bits, the true SNR should be examined. The SNR value for a true 8-bit video signal is 48 dB and for a 10-bit video signal it is 60 dB. If the specification sheet claims a 10-bit pixel, the SNR must then be 60 dB to have 10 bits. Simply using a 10-bit ADC on a signal that has an SNR of 8 bits will not give the expected dynamic range or image quality.

6.2.3 Digital image storage

There are two types of image storage for a motion analyser. The first type captures images at the framing rate of the camera. The second type archives images onto magnetic media after the images have been captured. The difference between the two types of storage is not only the rate at which images can be written, but also their permanence.

6.2.3.1 Image capture and storage

Motion analysers have used various types of electronic media to store images during capture. These include magnetic longitudinal recording, helical scan recording, solid-state memory (dynamic random access memory (DRAM)), magnetic disc, optical disc and magneto-optical disc.

Magnetic media have been used because of a long history of storing recorded information. The first demonstration of magnetic recording for reproduction of information was by Valdemar Poulsen in 1898 (telegraphone). In 1920, the development of the vacuum tube amplifier made possible the reproduction of sound at a specified level from a steel wire. In 1947, the introduction of magnetic recording to radio broadcasting started with The Bing Crosby Show. The art and science of magnetic recording have advanced significantly since that time.

Sensor

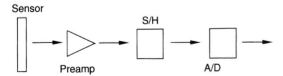

Figure 6.3 Sensor signal processing channel.

A simplified process of magnetic recording is illustrated in Figure 6.4. An incoming electronic signal is amplified through the write amplifier, which excites the record head with a current. The record head produces a magnetic field. This field is contained within the head except at the point where the tape makes contact with the head. At this point, the head has a separation called the 'head gap'. The magnetic field diverges from the head and penetrates the magnetic tape, which 'copies' the information onto the tape. The tape moves by the transport at a constant velocity while the field of the magnetic head changes according to the next signal to be recorded.

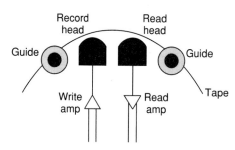

Figure 6.4 Magnetic recording.

The reproduction of the original information requires rewinding the tape and passing the area that was recorded over the reproduce heads. The magnetized area on the tape induces a magnetic field onto these heads. This field is converted into a current by the heads and is then amplified and restored. Restoring the signal means that it must be corrected for distortions introduced by the magnetic recording/reproduction process. This is the basic record and reproduce process.

There are several recording limitations inherent with magnetic tape based motion analysers. One of its biggest handicaps is handling the complexities surrounding record time. During a rewind cycle, the magnetic tape is not positioned for recording and an intermittent event at this time cannot be captured. Since these recorders are electromechanically intensive, there is a lag in response time from the moment a recording is initiated to the actual recording of an image. This lag time is also present in their ability to stop. The time required to start and stop makes these motion analysers inefficient for short recordings. Some applications require only a few images at any given time to be captured at a high framing rate. There may be long periods of time between capture. A magnetic tape based motion analyser would waste most of its recording media with start-and-stop sequences. Most modern motion analysers use solid-state memory (DRAM) storage for image capture. The advantage of manipulating images with DRAM

technology allows for unique image capturing techniques. In addition, storing digital images in DRAM provides substantially better image quality. Images can be continuously recorded, like an endless loop tape recorder, which helps in capturing elusive intermittent events. Images can be recorded instantly on command, which allows users to capture a multiple series of 'snap shots'. Playback rates can be adjusted in a variety of speeds both forward and reverse for in-depth analysis. Undoubtedly, it is DRAM based memory that has increased the popularity of motion analysers as problem-solving devices.

Table 6.2 Bandwidth requirements (Mbit s⁻¹) for different sensor resolutions and framing rates

Sensor resolution (pixels)	Framing rate (fps)			
	3000	1000	500	30
256 × 256	197	66	33	2
512 × 512	786	262	131	8
1024 × 1024	3200	1000	524	32

Writing into multiple DRAM memories in a highly parallel architecture allows for extremely high frame rate capture. Table 6.2 illustrates the bandwidth requirements for different sensor resolutions. For example, to capture images that have a 512 × 512-pixel resolution at 1000 fps, requires a DRAM bus width of 128 bits. DRAMs can be adapted to match the capture bandwidth by simply changing the width of their bus. This flexibility is one of the attributes that makes DRAMs widely used in motion analysers.

6.2.3.2 Image storage and archiving

The next stage of image storage calls for downloading the DRAM data to a more permanent archival source. In most instances the medium of choice is magnetic tape, the capture medium is the same as the archiving medium. However, with DRAM base storage, images must be saved since the DRAM is 'volatile'. If power is removed, the images are erased. Both magnetic and optical storage are used to archive images. The choice is usually dependent on the capacity required and the transfer rate. The trade-offs are cost of the media, the transfer rate, the access time to images and the storage capacity. An additional factor may be the method of image distribution once they are stored. Each of these factors needs to be weighted by the user to select the archiving media that suits the application. Table 6.3 gives the details of a variety of archiving devices. Most of these storage devices are those widely used in the computer industry.

Table 6.3 Storage devices and capacities for a 512 × 384 pixel image

Type of storage	Capacity (Mbyte, frames)	Transfer rate (Mbit s⁻¹, frames)	Media cost (currency unit)	Hardware cost (currency unit)	Size
8 mm drive	40×10^3, 200 k	6, 30	25	3000	5.25 hh
8 mm library	400×10^3, 2 M	2, 10	25	50 000–100 000	7.6 ft³
CDR write	680, 3.4 k	0.6, 3	5	5000	5.25 hh
CDR jukebox	62.5×10^3, 310 k	0.2, 1	5	14 000	1.3 ft³
5.25 optical	1.2×10^3, 6 k	0.5, 2.5	110	3000	5.25 fh
5.25 optical jukebox	18×10^3, 90 k	0.4, 2	110	13 000	3.1 ft³
Disc RAID–5	30×10^3, 150 k	20, 100	2500	25 000	1.8 ft³
D1 video	152×10^3, 762 k	27, 1350	468	138 000	2 ft³
Composite digital video	201×10^3, 1 M	27, 1350	248	46 000	1.8 ft³
PCMCIA	340, 1700	0.75, 3.75	700	125	2.5 ff

The 8 mm tape drives are slow for archiving. However, they are cost effective and have a large storage capacity. The compact disc (CD) writer discs are improving with respect to their write times, and do have the advantage that their storage life is over 100 years. This medium is relatively inexpensive. Their access times are also improving. Also, such CDs can be put into an 'optical jukebox', which is particularly advantageous for libraries where cost is a factor. Optical drives are somewhat better than CDs for archiving. Their transfer rates are higher and the capacity per disc is slightly higher. Multiple hard drives (RAID) are good for fast archiving and are in the medium cost range, but have a limited capacity. Digital video tape transports offer very good transfer rates, very large storage capacity but suffer in access time. Also, these tape units do need an extensive library jukebox for multiple tape access. The PCMCIA drives are not very good for archiving due to their limited storage capacity. However, they are a very good medium for intermediate storage of images before archiving. This is because of their rugged design, which can withstand the tough environments that motion analysers have to endure. Ranking by capacity, performance and cost, tape has the advantage for archiving images.

6.2.4 Display and playback

Traditionally, the displays used for motion analysers are video monitors that conform to NTSC, PAL and SECAM standards. NTSC is widely used in the United States, Canada and Japan. PAL is used mostly in Europe. SECAM is the standard used in France. Some of the newer motion analysers use computer monitors (SVGA). Some video monitors have an RGB (red, green and blue) input; however, most of these are at a low bandwidth (CGA resolution). The display performance of each standard is listed in Table 6.4

Table 6.4 Display performance of video monitor standards

Display type	Lines per frame	Pixels per frame	Field rate (Hz)
NTSC	525	–	60
PAL	625	–	50
SECAM	625	–	50
HDTV	≥1000	–	60
VGA	–	640 × 480	72
SVGA	–	1024 × 768	75
XVGA	–	1280 × 1024	86

Although video monitors are widely used, in the future these monitors will limit the performance of the higher resolution motion analysers. Note that RGB monitors are used in some motion analysers. These monitors do not limit the resolution as compared to video monitors. Also, they are better suited for non-interlaced CCD sensor formats.

6.2.5 Analysis

After the images have been captured and then displayed for a quick look at the motion, the user may need to make some measurements. Measurements can be made using a variety of methods. The simplest method involves laying a ruler on the video monitor, marking points with a grease pencil and measuring the movement of an object from frame to frame. Often, a reference object of known dimensions is placed in the plane of view. Then the object is measured and a *conversion factor* is determined for correcting any magnification due to the lens. Velocities may be calculated by determining the distance an object moves between a frame interval and multiplying the time interval between the measured frames. This is a fundamental approach for carrying out simple measurements.

The latest *digital motion analysers* make measure-

ments easier for the user. Most of these analysers have an X–Y reticle. The reticle can be moved in increments of pixels. Therefore, the actual distance can be measured in a given image plane by simply noting the initial X–Y pixel co-ordinates to the ending X–Y pixel co-ordinates. The accuracy is much higher due to the exactness of pixel position as compared to resampled video that may have less predictable boundaries.

A more sophisticated method of analysing motion is using a dedicated workstation or software program designed for this purpose. Motion analysis workstations are used to read an analyser's images, play back the images, provide software tools for marking objects, track the marked objects from frame to frame and store the data in files. There are different levels of sophistication in these workstations. Some measure motion through manual tracking methods while others are automatic. The manual tracking analysers are simple to use but are labour intensive. The automatic analysers require some operator set-up and monitoring; however, the level of involvement is far less.

The feature of *autotracking* is very important when many images are being analysed. Autotracking removes the tedium and errors that happen when operator fatigue sets in. It also reduces the processing time compared to manually moving markers, stepping to the next frame and moving the markers again. An autotracking algorithm is designed to locate the centroid (centre) of an object. This may be accomplished using a computer algorithm by looking for image threshold boundaries within a given search area, pattern recognition, or with some other type of predictor. The operator usually needs to monitor or check the tracking process occasionally. Most analysers will stop on the frame in which an object is lost. There may have been some obscuring or erratic movement that exceed the tracking boundaries of the predictor. When this happens, the operator edits the marker's position and re-starts the tracker. All the previous data are still valid. The automatic tracking capability of a motion analyser is important when thousands of images need to be analysed.

The images of motion are often captured in less than ideal conditions. The images may be darker than desired or in need of some modification, so motion analysis workstations usually have the capability to adjust brightness.

6.3 Determining what is required

To obtain satisfactory motion analysis results from a high speed video camera, a number of factors have to be resolved. Issues such as framing rate, image resolution and methods of recording determine the imagery that will result from a given test. How much light is available? How much light is needed? What are the sensitivity and resolution capabilities of the imager? The answers to these questions determine not only the equipment requirements for the test, but also obviously influence the test results.

The first question that must be asked is: 'What needs to be seen and/or measured from the motion analysis test?'. That answer determines everything else. But because of the technology's flexibility, the questions do not have to be answered perfectly. One of high speed videography's greatest assets is immediate playback. If in the first test the frame rate is too slow, the rate is simply increased. If more light is needed to get a sharper image, another lamp can be added, the lens aperture may be opened or a light amplifier (intensifier) could be used. Engineers can also experiment with various settings to find the optimal parameters.

The following section describes the various parameters that determine the end result. In any motion analysis test, all these factors must be determined to some degree, even if the experimenter must guess through trial and error.

6.3.1 Framing rate

Framing rate, frame rate, sample rate, capture rate and imager (or camera) speed are interchangeable terms. Measured in frames or pictures per second, the imager's speed is one of the most important considerations in motion analysis. The framing rate is determined after considering the event's speed, the size of the area under study, the number of images needed to obtain all the event's essential information and the framing rates available from the particular motion analyser. For example, at 1000 fps a picture is taken once every millisecond. If an event takes place in 15 ms, the imager will capture 15 frames of that event. If the frame rate is set too low, the imager will not capture enough images. If the frame rate is set higher than necessary, the analyser's limited storage may not be able to store all the necessary frames. In other instances, too high a framing rate sacrifices the area of coverage. This happens when an imager's frame rate is set higher than its ability to provide a full-frame coverage. In most of the new generation of motion analysers, the imagers have an option that provides 'partial frames per second' (pfps). At this rate, the height of the image is sacrificed but in return, the frame rate can be as much as 12 times the imager's full-frames per second (ffps) rate. The performances of the lower framing rate motion analysers are enhanced to increase their framing rate by recording partial frames but then using *line doubling* during display. Line doubling is a technique for restoring the partial frame image to a full frame image. Currently, the fastest motion analyser provides 4500 ffps and up to 40 500 pfps. When considering the framing rate

performance of a motion analyser the requirements must be specific. The manufacturer's specification sheet must be closely studied to see what the true resolution is at any given framing rate, particularly for lower frame rate motion analysers using the technique of line doubling to increase their full framing rate performance. However, the true resolution at the stated frame rate is actually lower than stated and upon display the lines are doubled to fill out the image (4 : 3 aspect ratio). If no analysis is intended for the images this presents no problems. However, if measurements are to be made, it is important to know the true frame size (resolution) during recording so that measurements in the direction that lines are doubled can be corrected for in the calculations. Typically, for this type of motion analyser the imaging sensor was designed for standard video rates. By using this type of sensor the cost is less than a sensor designed for high framing rates. The sensor is being pushed to a higher framing rate. To achieve a higher framing rate beyond its original specification, the amount of image data read out of the sensor must be reduced (lower resolution). Therefore, it is necessary to make sure the framing rate performance matches the motion analyser's capability.

6.3.2 Recording time

The recording time (duration) of a high speed video system is dependent on the frame rate selected and the amount of storage medium available. The continuing technological advances in DRAM cards make higher storage levels affordable, but DRAM is still a limiting factor. However, as Table 6.5 shows, most high speed events occur in such short duration that a 1600-frame DRAM card is usually more than enough to capture the event. Those seeking higher storage capacity can get at least 19.7 s of recording

time on the Kodak EktaPro EM motion analyser running at 1000 fps. Another choice would be the NAC Memrecam C2S that has 24 s of record time at 200 fps. This motion analyser makes use of image compression technology to gain a longer recording time with limited DRAM memory. As memory chips get denser, that capacity will increase, as it will for similar motion analysers. Table 6.5 provides data on average event times for various applications; event times were measured from actual imaging data. The definition of an event time is the duration of an event that produced significant information for motion analysis.

6.3.3 Time magnification

The goal in using a high speed camera is to obtain a slow motion display of a high speed event. Time magnification describes the degree of 'slowing down' of motion that occurs during the playback of an event. To determine the amount of time magnification, divide the recording rate by the replay rate. For example, a recording made at 1000 fps and replayed at 30 fps will show a time magnification of 33 : 1. One second of real time will last for 30 s on the television or computer monitor. If the same recording was replayed at only 1 fps, that 1 s event would take more than 16 min to play back. Most systems allow replay in forward or reverse with variable playback speeds. Therefore, it is important to capture only the information that is necessary. Otherwise, long recordings can take hours to playback. Some examples are shown in Table 6.6.

6.3.4 Exposure

Many factors influence the amount of light required to produce the best image possible. Without sufficient light, the image may be:

Table 6.5 Average duration of a range of events and applications and the number of frames obtained for analysis

Subject or event	Event duration (s)	Frames recorded (1000 fps rate)
Money sorting machine (single bill time)	1.2	1200
Flame pattern test (fuel combustion)	0.7	700
Wire bonding (one cycle)	0.8	800
Surface mount (one placement cycle, no pickup)	0.3	300
Food-crackers on process line (three samples)	0.3	300
Potato chips being bagged (one cycle)	1.1	1100
Tyre testing, front and rear over glass plate	0.4	400
Hot glue applied to film box flap	0.2	200
Blood stream (one cell motion across screen)	0.8	800
High voltage circuit breaker (one cycle)	0.2	200
Label pickup (one label)	0.6	600
Golf ball impact and flight (club)	0.6	600
Composite material fracture	0.1	100
Car crash test (impact)	0.3	300
Airbag inflation	0.035	35

Table 6.6 Time magnification in high speed video recordings

Recording rate (fps)	Recording time (s)	Frames recorded	Playback time @ 30 fps (s)	Playback time @1 fps (min)
250	20	5000	167	83
500	50	30 000	1000	500
1000	2	1500	50	25
4500	0.11	500	17	8

- Underexposed, so that detail is lost in dark regions.
- Unbalanced, hence poor colour reproduction.
- Blurred, due to the lack of depth of field at large aperture.

The length of time for which the imaging sensor is exposed to light depends on several factors. These factors include: lens *f*-number, framing rate, shutter time, light levels, reflectance of surrounding material, the imaging sensor's 'well capacity', and the sensor's SNR. All these factors can significantly impact the image quality. An often overlooked factor is the exposure time (duration).

6.3.5 Exposure time

The 'exposure time', 'shutter rate' and 'shutter angle' are interchangeable terms in this context. The exposure time for mechanical shutters is set in terms of number of sector degrees that it is open. The exposure time for electronic sensors is either the reciprocal of the framing rate if no electronic shutter is used or the time that the electronically shuttered sensor is exposed (in microseconds). Shown below are the relationships for defining exposure time (*t*):

$$\text{Mechanical shutter} \quad t = \frac{RA}{360} \tag{6.3}$$

$$\text{No shutter} \quad t = \frac{1}{F} \tag{6.4}$$

$$\text{Electronic shutter} \quad t = t_e \tag{6.5}$$

where R is the rotation of the shutter (in revolutions per second), A is the shutter angle (in degrees), F is the framing rate (in fps) and t_e is the period of time for which the sensor is exposed.

The exposure time for an image determines how sharp, or blur-free an image is, regardless of the framing rate. The exposure time needed to avoid blur depends on the subject's velocity and direction, the amount of image magnification, the shutter speed or framing rate (whichever is faster) and the resolution of the imaging system.

A high velocity subject may be blurred in an image if the velocity is too high during the integration of light on the sensor. If a sharp edge of an object is imaged, and the object moves within one frame more than 2 pixels or a line pair, the object may be blurred. This is due to the fact that multiple pixels are imaging an averaged value of the edge. This creates a smear or blur, effect on the edge. To get good picture quality, the shutter rate should be 10 times that of the subject's velocity.

The image magnification can influence the relative velocity of the subject being recorded. The velocity of an object moving across a magnified field of view (FOV) increases linearly according to the magnification level. Instinctively, if an object is viewed from far away, the relative velocity in the FOV is less than that viewed close to the object.

Motion analysers use electronic or mechanical shutters that operate to give exposures as fast as 10 μs, which is fast enough to provide blur-free images of many high speed events. The shutter controls the amount of light that reaches the sensor by the cyclic rate of the shutter and the time for which the shutter is open. The cycle time is set by the framing rate. The shutter then determines the exposure time. If no shutter capabilities exist for the imaging sensor, then the framing rate will determine the effective exposure time. Therefore, for a high velocity object, higher framing rates are required. The shutter is synchronized to the sensor timing. Multiple cameras can be synchronized together if their shutters can be controlled in unison. Table 6.7 lists typical subjects the velocities of which have been averaged and converted to frame rates and exposures.

A proper shutter speed may be calculated as shown in Figure 6.5. If the object's velocity, the field of view, the imaging sensor's dimensions and pixel count are known, the shutter speed required to produce a sharp image can be calculated. The relative velocity (V_r) at the sensor can be calculated by reducing the subject's velocity by the optical reduction at the sensor. The pixel size must be calculated by dividing the sensor size in the dimension of interest (*x* or *y*). Knowing that a relative velocity at the sensor plane that is less than 2 pixels or a line pair will produce a good image, the pixel size is multiplied by 2. Therefore, the shutter speed is calculated by dividing (2 × pixel size) by the relative velocity (V_r). The reciprocal yields the minimum shutter speed, or, in the case of an imaging system without a shutter, it is the minimum framing rate for sharp images.

Table 6.7 Typical framing rates and exposure times for a range of applications for high speed video

Subject	Minimum framing rate (fps)	Minimum exposure (μs)
Money sorting machine (single bill time)	500	100
Flame pattern test (fuel combustion)	3000	20
Wire bonding (one cycle)	1000	50
Surface mount (one placement cycle, no pickup)	1000	100
Food-crackers on process line (three samples)	250	1000
Potato chips being bagged (one cycle)	250	1000
Tyre testing, front and rear over glass plate	500	100
Hot glue applied to film box flap	500	500
Blood stream (one cell motion across screen)	1000	20
High voltage circuit breaker (one cycle)	1000	1000
Label pickup (one label)	250	1000
Golf ball impact and flight (club)	1000	20
Composite material fracture	1000	100
Car crash test (impact)	1000	100
Airbag inflation	3000	70

$$\text{Exposure (shutter rate)} \leq \frac{2 \times \text{Pixel size}}{V_r} \quad (6.6)$$

where

$$V_r = \text{Sensor dimension} \times \left(\frac{\text{Field of view}}{\text{Object's velocity}}\right) \quad (6.7)$$

and

$$\text{Pixel size} = \frac{\text{Pixel dimension}}{\text{Toxal pixels}} \quad (6.8)$$

Note that the pixel dimension should correspond to the dimension used for the total pixel count.

Consider an example of this calculation. A subject is moving at 15.65 m s⁻¹ (35 mph or 616 inch s⁻¹). The camera is perpendicular to the object and looking at a view 3.048 m wide (10 feet or 120 inches wide). The camera's sensor is 12.7 mm (0.5 inch) wide and has a resolution of 200 pixels. The camera's view of 3.048 m (10 feet) is optically reduced onto the 12.7 mm (0.5 inch) sensor. This also optically reduces the velocity from 15.65 m s⁻¹ in the object space to 65.21 mm s⁻¹ (2.6 inch s⁻¹) at the sensor. The sensor resolution of 200 pixels per 12.7 mm (0.5 inch) means that each pixel is 63.5 μm (0.0025 inch) wide. As a rule of thumb, an acceptable amount of blur is less than two pixels, in this case 0.127 mm (0.005 inch). Therefore, the object will move the width of two pixels in 0.0019 s. The inverse of 0.0019 s is 520, and thus shutter time of 1/520 s or less will provide a sharp image of the object. This example is also shown in Figure 6.5.

The resolution of a motion analyser is generally expressed in terms of the number of pixels in the horizontal and vertical dimension. A *pixel* is defined as the smallest unit of a picture that can be individually addressed and read. At present, high speed camera resolutions range from 128 × 128 to 512 × 512 pixels. Future resolutions will go as high as 1024 × 1024 pixels. Generally, the limiting resolution of the imaging system is due to the imaging sensor.

A rule of thumb for capturing high speed events is that the smallest object or displacement to be detected by the camera should not be less than 2 pixels within the camera's horizontal field of view.

The sensor resolution may be expressed also in terms of line pairs per millimetre (lp mm⁻¹ or lpm). The meaning of line pairs per millimetre is an expression of how many transitions from black to white (lines) can be resolved in 1 mm. To calculate a sensor's theoretical limiting resolution in lines per millimetre, take the reciprocal of two times the pixel size. Thus, the limiting resolution of a sensor with a 16 μm pixel may be calculated, i.e.

$$\text{Theoretical limiting resolution} = \frac{1}{2 \times \text{Pixel size}} \times 1000$$

$$= \frac{1}{2 \times 16} \times 1000$$

$$= 31.25 \text{ lp mm}^{-1}$$

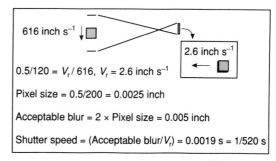

616 inch s⁻¹

2.6 inch s⁻¹

0.5/120 = V_r/ 616, V_r = 2.6 inch s⁻¹

Pixel size = 0.5/200 = 0.0025 inch

Acceptable blur = 2 × Pixel size = 0.005 inch

Shutter speed = (Acceptable blur/V_r) = 0.0019 s = 1/520 s

Figure 6.5 Calculating the correct shutter-speed or framing rate.

Typical sensor resolutions and bandwidths are given in Table 6.8.

6.3.6 Sensitivity

Most modern image sensors have a sensitivity that is equivalent to a film exposure index (EI) value of between 125 ISO and 480 ISO in colour and up to 3200 ISO in monochrome. The sensitivity is a very important factor for obtaining clear images. An inexperienced user may confuse motion blur with a poor depth of field. If the sensitivity of the camera is not high enough for imaging an object for a given scene, the lens aperture must be opened up. This reduces the depth of field so that the object remains in focus. As the object moves, it could take a path outside the area that is in focus. This would then give the appearance of an object with motion blur or, in reality, it is out of focus.

In practice, a single 600 W incandescent lamp placed 1.22 m (4 feet) from a typical subject provides sufficient illumination to make recordings at 1000 fps with an exposure of 1 ms at $f/4$. This level of performance is fine for many applications, although some demanding high speed events have characteristics where greater light sensitivity may be preferred.

6.3.7 Depth of field

Depth of field (DOF) is the range in which an object near or far would be in focus within a scene for a given lens and its settings. The DOF is the greatest when a lens is set to infinity. The smaller the f-number the smaller the DOF. If the object moves closer to the lens, the DOF also decreases. Lenses of different focal lengths will not have the same DOF for a given f-number.

The DOF considerations are similar to those used in normal photography. In photography, the DOF is directly proportional to the diameter of the circle of confusion (C), the f-number of the lens (N) and the square of the focused distance (u), and inversely proportional to the square of the focal length (f). This can be expressed as:

$$\text{DOF} = \frac{(2u^2\,NC)}{f^2} \tag{6.9}$$

The value of C is taken as being approximately equal to the width of a pixel in the sensor (Figure 6.6).

6.3.8 Image sensor dimensions

It is important to know the size of the image sensor within a camera. Some common sensors have diameters of approximately 12.7 mm (0.5 inch), 16.92 mm (0.66 inch) and 25.4 mm (1 inch). The 1-inch sensor has an effective width of 12.8 mm, while the 0.66–inch sensor has an effective width of 8.8 mm. A lens that works properly on a camera having a small sensor may not produce a large enough image to work correctly on a camera having a large sensor. This is due to distortion in the fringe (peripheral) areas of the lens. Knowing the width of a sensor prevents image blur because users can calculate parameters such as the required exposure time. The sensor's width also allows users to calculate the depth of field for a given aperture.

6.3.9 Recording modes

The motion analyser's various methods of recording are one of the most distinguishing features of high speed videography. It is also a feature that high speed film cameras cannot match. The motion analyser's greatest asset is its *continuous record mode* where the camera runs and runs, replacing its

Table 6.8 Typical sensor resolutions and bandwidths

Framing rate (fps)	Sensor size (pixels)	Rate (Mbit s⁻¹)	Resolution (pixels)	Framing rate (fps)	Sensor size (pixels)	Rate (Mbit s⁻¹)	Resolution (pixels)
200		13		200		26	
400		26		400		52	
500		33		500		66	
1000	256 × 256	66	65 536	1000	256 × 512	131	131 072
2000		131		2000		262	
3000		197		3000		393	
4500		295		4500		590	
200		52		200		210	
400		105		400		419	
500		131		500		524	
1000	512 × 512	262	262 144	1000	1024 × 1024	1049	1 048 576
2000		524		2000		2097	
3000		786		3000		3146	
4500		1180		4500		4719	

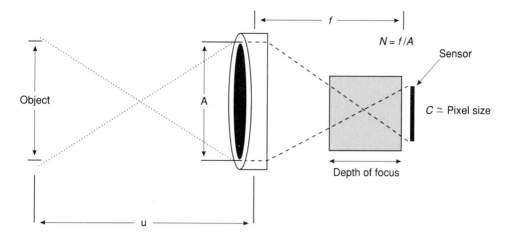

Figure 6.6 Optical factors determining depth of field.

oldest images with the newest until an event occurs and triggers the camera to stop. Further flexibility allows the operator to programme exactly how many images before and after the events are to be saved. For engineers and technicians trying to record unpredictable or intermittent events, the continuous record, trigger or *record on command* (ROC) modes are the only feasible options (Figure 6.7).

There are several other record modes that need to be discussed. One of the most powerful, but the least understood and hence least used, is the ROC mode. This mode is powerful because images may be selected according to a user supplied signal. An example of this is illustrated in Figure 6.8. The objective of this recording is to capture over 1000 images of a box lid being closed. There is an error in how the lid is closed, but it is intermittent and

difficult to trigger. By using a tachometer pulse from the shaft driving the closing mechanism, precise timing can be derived for indicating the exact position when the lid is being closed. This timing pulse is used to qualify the image to the motion analyser memory. If the pulse exists, images are written into the motion analyser's memory. In the absence of the pulse, no images are recorded. Therefore, only images of the lid in an exact position will be recorded until the motion analyser's memory is full. In addition, a range of motion may be recorded if the pulse is longer than a single frame period. In other words, if the motion analyser is operating at 1000 fps and the pulse into ROC is 5.5 ms long, then five images per pulse will be stored. The use of this recording technique is only limited by the user's imagination.

Another obscure recording technique for motion

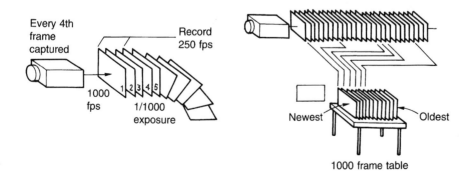

Figure 6.7 Continuous record and record on command (ROC) modes.

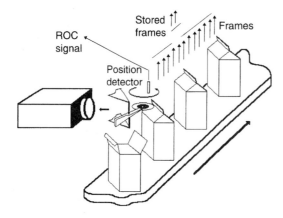

Figure 6.8 The imaging of the closing of a lid.

analyser's with DRAM memory is that of *slip sync*. This recording technique is used to operate the motion analyser at a frame rate that is defined by a user's signal. Again, the application in Figure 6.8 may be used to explain this operation. The principle of operation of slip sync is very similar to the use of a strobe when it is operating synchronously with an object that has a repetitive movement. Therefore, in this example, the user would input a frequency that was synchronized to the tachometer. As the frequency is varied, the images captured will be synchronized with the tachometer in a positive or negative direction. This allows any position of the lid movement to be observed and captured. Another example would be that of an accelerometer voltage that is fed to a voltage to frequency converter. As the acceleration changes, so does the frequency out of the converter. This frequency then drives the framing rate of the motion analyser. Why should this be of interest? A higher frame rate is needed to record objects that move faster than objects that move slower. Therefore, the rate of change is directly proportional to the rate of recording. Application examples include a crush test for materials using a strain gauge, a flame propagation study in a combustion engine using a pressure sensor, an automotive car crash using an accelerometer or an explosion that has a light sensor detecting the detonation. This mode of recording is unique with DRAM based motion analysers.

6.4 Colour considerations

6.4.1 Colour temperature

Understanding colour is difficult but necessary even for monochrome imaging. The colour of light is determined by its wavelength. The longer wave-

lengths are 'hotter' in colour (red). The shorter wavelengths are 'cooler' (blue).

Colour perception is a function of the human eye. The surface of an object either reflects or absorbs different light wavelengths. The light that the human eye perceives is unique in that it produces a physiological effect in the brain. What is red to one person may be perceived slightly differently by another person. Terms that further describe the colour of an object are *hue*, *saturation* and *brightness*. Hue is the 'base' (spectral) colour such as red, blue, violet, yellow and others. Saturation is the 'shading', which varies from the basic colour to that almost without colour tint. Brightness, also known as *luminance*, is the intensity of light associated with the colour. The subject of colour would take an entire book to explain fully. However, use of a colour chart can give the user some insight into the colour composition of a scene.

Colour temperature is a common way of describing a light source. Colour temperature originally derived its meaning from the heating of a theoretical black body to a temperature that caused the body to give off varying colours ranging from red hot to white hot. This term was developed by Lord Kelvin and his name was associated with the unit of measurement. Table 6.9 lists the kelvin (K) values for common light sources.

Table 6.9 Colour temperatures associated with common light sources

Source	Colour temperature (K)
Candle	2000
Sunlight, daybreak	≥ 2000
Tungsten	2900
Sunlight, noon	4400
Sunlight, afternoon	5400
HMI lamp	5800
Sunlight, evening	6500
Sunlight, cloudy	6800
Sunlight, cloudless	≥10 000

HMI, Hydragyrum (mercury), medium–arc iodide

6.4.2 Colour versus monochrome

Most of the early high speed film stocks were black and white. Once colour film became available, the use of black and white declined. The use of high speed colour film set the format standard that video has attempted to meet. Over the years, monochrome images only were all that could be recorded

on most motion analysers. Today's motion analysers can produce images that replace colour film for some high speed applications. Full 24-bit colour images are now possible from equipment such as the Kodak EktaPro motion analyser, model 1000HRC. To understand the strengths and weaknesses of both colour and monochrome in different high speed video applications, some background information must be discussed.

There are various methods of producing colour in high speed video. Figure 6.9 shows three of the most widely used techniques. The colour filter wheel is best used in still imaging where the subject does not move during the recording with the three colour filters. This technique is not suitable for high speed video due to the motion differences between each successive image. Using three imaging sensors with different colour filters and a beam splitter, true colour reproduction is possible. True colour means that the primary colours and all their saturations are possible. This technique is costly since all the electronics are tripled in order for three imaging sensors to be supported. The alignment of the three sensors must be very precise, otherwise colour misregistration will occur in the images. The last technique is a cost saving compromise. A colour filter array (CFA) provides a more cost effective means of producing colour (only one imaging device). Individual colour filters are deposited on the surface of each pixel. There can be some combination of red, blue and green or a complementary colour array. Each pixel is isolated to respond to a certain colour spectrum. Although the pixels are filtered, the raw data must be *interpolated* to provide the missing pixels in each colour plane.

Now that the main methods for producing colour have been discussed, it is possible to review the reasons for using colour and not monochrome. Generally, monochrome images have better image quality. Monochrome cameras are more sensitive due to the lack of colour filtering. The resolving capability is better than CFA imaging sensors. This is due to the fact that no interpolation is involved. The disadvantage of a monochrome image is the loss of colour difference information. A slight change in grey levels is harder to observe than a change in hue or saturation. Colour is valuable for determining different shades. It also produces a bridge from colour film to colour video.

6.5 Lenses and optics

The function of the lens in a motion analyser is to capture enough light to record the action, keep the action in focus and produce an image that is the proper size to resolve the action. A motion analyser is greatly affected by the lens settings. High framing rates require more light. If the lens can capture more light, the camera's framing rate can be increased until the level of illumination is insufficient to see the subject. If the lens can capture more light, the lens aperture can also be decreased. Decreasing the aperture increases the depth of field. These are but a few of the reasons why the choice of a lens for imaging at high framing rates is very important.

As a camera is pointed at a subject, light reflects from the subject and passes through the lens of the camera. The reflected rays of light are inverted as they pass through the lens (Figure 6.10). All lenses are classified by their *focal length*, usually measured in millimetres. The focal length of the lens indicates what size of image it will produce. As the lens focal length increases, the image size or sensor area occupied by the image of the subject also increases.

How a fixed focal length lens is categorized depends on the type of camera it is used with. The ratio of the focal length (f) of the lens to the diagonal measurement (k) of the camera's sensor may be used to determine whether a lens is classed as normal, wide or telephoto when used with a particular camera. As an example, the format (sensor) diagonal of a 35 mm camera film frame is approximately 43 mm, and a 50 mm lens is considered as having an approximately 1:1 ratio, i.e. a normal lens for a 35 mm camera. A normal lens offers the least distortion of viewing perspective.

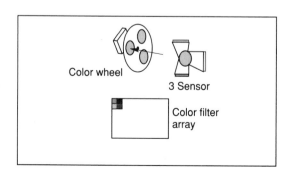

Figure 6.9 Methods for producing colour video.

Figure 6.10 The inversion of an image by a lens.

Wide angle lenses have relatively short focal lengths and good depth of field. This lens type produces an image with a wide field of view without moving the camera farther away. Telephoto lenses (long focus) have longer focal lengths than normal lenses. This type of lens is used to produce an image that fills the video monitor with a small detailed area in the scene or an image of a subject far away. Macro lenses can be used to magnify small fields of view. Some telephoto lenses have a macro capability. The macro lens offers the capability of extremely close focus and high magnification, so the image may even be seen larger than the actual subject. A zoom lens has a variable focal length. The variable focal length is convenient since the field of view can be increased or decreased and the subject's image size will change without moving the camera position. However, a zoom lens typically is not very fast, i.e. the *f*-number is larger. This makes focusing in dim light more difficult. Also, these lenses do not hold their sharpness and focus as the focal length is changed, so refocusing is required after each alteration.

A *close-up lens* enables near focusing of a subject and produces a large size image of the subject. A close-up lens attaches to the front of a normal, telephoto or zoom lens. Close-up dioptre attachments allow use of these lenses for closer than normal work, even closer than some macro lenses. Two close-up lenses can be stacked together to increase the number of dioptres used and subsequent magnification. The disadvantage of a close-up lens is that the depth of field is normally very small. Consequently, the range of motion in focus will be very limited. This can be compensated for by a smaller *f*-number and/or a longer exposure. Extension tubes can be used with either a macro or a close-up lens to increase the magnification even further. Some extension tubes have an additional negative lens inside to form a ×2 *extender* that doubles the focal length of a given lens. A disadvantage of extenders is the reduction of light. Therefore, longer exposures are required. A ×2 extender requires two additional *f*-numbers (+2 EV) of exposure to get the equivalent light to the sensor. Table 6.10 gives a summary of the various lenses that may be used in a motion analysis application.

6.6 Lighting

6.6.1 Fundamental lighting techniques

The proper lighting for an application can produce dynamic results even given poor light management. There are four fundamental directions for the lighting of high speed video subjects, i.e. front, side, fill and backlight. Placing a light behind or adjacent to a lens is the most common method of illuminating a subject. However, some fill lighting or side lighting may be needed to eliminate the shadows produced by the front lighting. It is advisable to have the light behind the lens in order to avoid specular reflections into the lens. Side lighting is the next most common lighting technique. As the name implies, the light is at an angle from the side. This can produce a very pleasing illumination. In fact, for low contrast subjects, a low incident lighting angle from the side can enhance detail. Fill lighting may be used to remove shadows or other dark areas. Fill lighting may also be used to lessen the flicker from lamps that have poor uniformity. Fill lighting is typically from the side or top of a scene. Backlighting may be used to illuminate a translucent subject from behind. It is not used very frequently in high speed video. However, certain applications such as microscopy, web analysis or flow visualization make use of backlighting. All these techniques are important for getting a high quality image.

6.6.2 Light source characteristics

There are a number of light sources available for high speed video. Some care must be taken in selecting lighting due to several factors related to the source. These include the type of light, the uniformity of the light source, the intensity of the light, the colour temperature, the amount of flicker, the size of the light, the beam focus properties and the handling requirements. All these factors are important to match the lighting to the application.

6.6.3 Estimate of lighting requirements

The estimation of the amount of light required for fast moving subjects is often a trial-and-error process. However, an estimate can be made by calculation before starting a trial-and-error type test. To estimate the illumination level (E) required for a subject, the following equations are used:

$$E = \frac{KN^2}{St} \tag{6.10}$$

where N is the *f*-number, S is the equivalent exposure index of the imager (in ISO), t is the shutter speed and K is a constant (25 for E measured in foot-candles, or 270 for lux).

$$\text{Total lumens required} = AE \tag{6.11}$$

where A is the subject area to be illuminated (in square metres).

$$\text{Number of lamps required} = \frac{AE}{B} \tag{6.12}$$

where B is the beam lumen output of a selected lamp.

The value of t is calculated depending on the type of shuttering, i.e. either:

Table 6.10 Lens types and their characteristics

Lens Type	Equivalent lens (²⁄₃ in sensor)	Characteristics	When to use
Normal	25 mm, f/0.95, 1 : 1	Minimum distortion	All applications
Wide angle	7.5–18 mm, 1 : 2	Short focal length, wide field of view	Wide field of view needed, limited distance from subject
Telephoto	≥50mm, 2 : 1	Long focal lengths, image fills screen, requires more light	Subject details important, safety concerns need more distance
Macro	90 mm, f/2.8, 1 : 1	Extremely close focus, high magnification, needs more light	Long telephoto application, close-up work, ×3 to ×4, plenty of light or small f-number
Zoom	28–90 mm, f/2.8	Single lens solution	All applications
Close-up	–	Attaches to lens, diopters stack	Close focusing, large image format
Extension tubes	40, 20, 10, 5 mm	Metal tube, no lens, increases focal length	Close-up/macro lens used, needs more magnification
Extender	×2 increase	Metal tube, lens increases focal length	Very small f-number, plenty of light available

$$t \text{ (no shutter)} = \frac{1}{F} \tag{6.13}$$

where F is the number of frames per second given by the imager, or:

$$t \text{ (mechanical shutter)} = \frac{W}{360F} \tag{6.14}$$

where F is the shutter opening in degrees, or:

$$t \text{ (electronic shutter)} = T \tag{6.15}$$

where T is the effective readout time of the sensor.

6.6.4 Types of lighting

Apart from direction, lighting can be identified by two other characteristics, namely the physical design of the luminaire and the method of producing the light. The physical characteristics include the optics, reflector, packaging and bulb design. The method of producing light includes tungsten, carbon arc, fluorescent and hydragyrum (mercury) medium–arc iodide (HMI) sources.

6.6.4.1 Tungsten lighting
Tungsten lighting is also known as 'incandescent' lighting and is very suitable for continuous lighting for video work. A tungsten studio lamp has a colour temperature of 3200 K. Tungsten halogen is an alternative type of tungsten lamp, but is a hotter source since the heat of the bulb operates the regenerative tungsten cycle. Tungsten lamps are reasonably efficient in their light output, but when used in combination with daylight, a blue colour conversion filter is required to bring the colour temperature to around 5600 K.

6.6.4.2 Stroboscopic lighting
Lighting that is pulsed has a stroboscopic effect and is used to get multiple exposures within a frame or to reduce the motion blur similar to the effect of a shutter. Such stroboscopic lighting is either pulsed illumination from a xenon lamp or a laser source. Examples of subjects that require a short duration strobe to prevent motion blur are listed in Table 6.11.

Table 6.11 Examples of subjects that require motion blur reduction with the aid of a stroboscopic flash

Subject	Strobe flash duration required (µs)
Dynamite cap	0.1
Bullet	1
Golf ball swing	10
Birds' wings	100

Most common strobes used for video work have a xenon source. Some difficulties encountered with xenon strobes are uneven uniformity of the illumination, the *afterglow* once a flash has been triggered and the amount of light produced for a given flash duration. The uniformity is greatly influenced by the bulb envelope design. If the bulb is constructed in a helix shape and the reflector is designed to focus the light, this will minimize the light variations and produce more uniform lighting. This lighting level variation is also known as *arc wander*.

The afterglow is a by-product of the bulb design. Certain gases have a longer or shorter afterglow. If

this is a concern, it is best to consult the recommendations from a manufacturer before selecting a lamp for strobe use.

The shorter the flash duration the less light that is produced. To produce more light requires very large power supplies. A typical flash duration of 10–30 μs is commonly used for high speed video work.

6.6.4.3 Carbon arcs

This type of lamp uses an arc formed between two carbon electrodes. The arc produces a gas which fuels a bright flame that burns from one electrode to the other. In time, this consumes the carbon. This type of lamp is not widely used in high speed video.

6.6.4.4 Gas discharge lamps

Fluorescent tubes are one example of a gas discharge lamp. At the end of each tube are electrodes. The tube is normally filled with argon and some mercury. As current is applied at the electrodes and the mercury is vaporized into the argon gas. The mercury vapour emits ultraviolet radiation, which then strikes the inside of the tube that is coated with a phosphor. The phosphor then transforms the ultraviolet to visible light. Most fluorescent lamps emit a dominant green hue, which is not very suitable as a colour balanced light source. In addition, the discharge produces a non-uniform light that is easily detected as a 50 or 60 cycle mains flicker when playing back images recorded using a high-speed motion analyser. To reduce this flicker effect, it is necessary to use dominant fill lighting or, even better, to turn off the fluorescent lights.

6.6.4.5 Arc discharge lamps

The HMI (mercury medium–arc iodide) source is the most common lamp in this class of lighting. As current is passed through the HMI electrodes, an arc is generated and the gas in the lamp is excited to a light emitting state. The spectrum of light emitted includes visible as well as ultraviolet. This light source typically has an ultraviolet filter to remove any harmful emissions. The HMI light source is suitably balanced for colour recording use. It generates an intense white light. If a switching ballast is used with the HMI source, uniform light output with very low flicker is produced. Other types of ballast are not as well regulated.

HMI lighting with switching regulated power supplies is used widely in the automotive industry. This light source is very well suited for high speed video. Given comparable size light sources, the HMI produces more light than most other lamps. However, the cost of a HMI source is greater than most other light sources. As the light output is adjusted, it also changes the colour temperature of the source. This can be an advantage for colour work. Undoubtedly, in the future HMI lamps will be increasingly used in video work.

6.6.4.6 Lasers

A laser is a device that amplifies electromagnetic waves by stimulated emission of radiation and can emit in the visible, ultraviolet and infrared regions. This process of emission occurs when atoms, ions or molecules absorb energy; they will then emit coherent light.

Copper vapour lasers are used in video applications. These lasers are pulsed and emit in the visible spectrum. The laser can be synchronized with a variety of imaging devices. High framing rates are achievable with these lasers. The study of internal combustion flame propagation makes particular use of such lasers, as does flow visualization.

The beam from these lasers is not only pulsed, but can also be continued for an extended period of time. If a cylindrical lens system is placed in front of the laser, it spreads the beam out into a sheet of light. This arrangement is very useful for flow studies.

The power output of lasers used in motion analysis varies from milliwatts to tens of watts. The pulse frequency can be as high as 200 kHz. These light sources are very specialized and expensive. They need careful consideration in matching them to the specific application.

6.7 Synchronization

Applications requiring multiple cameras often need the images to be correlated in time. This means that the cameras need to run in synchronization. Each image needs to be precisely exposed. This can be done by clocking the shutters in unison or operating the cameras at a common framing rate that is synchronized. With each camera in synchronization, the images can then be analysed using a common timebase. This process allows three-dimensional views to be obtained from actual images and helps produce computer models of the motion. This area of image study is very important in automotive crash safety, airborne ordnance certification and sports medicine studies. Figure 6.11 shows an example of synchronous timing.

6.8 Field of view

'Field of view' (FOV) is a term given to the subject area that is imaged through the lens. The actual FOV is determined by the lens focal length and the distance to the subject. If the distance to the subject remains constant, the lens focal length will then determine the FOV. Figure 6.12 indicates the FOV for several lenses of different focal length.

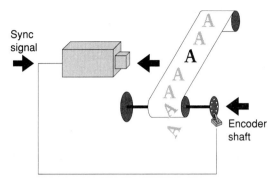

Figure 6.11 Synchronous recording timed from a shaft encoder.

6.9 Time stamping

Time stamping is the process of marking or encoding each video frame with a time. The time mode could be *real time*, *elapsed time*, *IRIG timing* or *user defined time*. Real time contains the date and time of day. Elapsed time is the commutative time starting at the beginning of recording and going to the end. It can be expressed as a negative number if the time corresponds to frames that are before the *trigger frame*. The trigger frame is defined as frame zero and corresponds to when the analyser begins counting time as positive integers. Typically, elapsed time

is expressed in hundreds of microseconds. IRIG timing is a government standard defined as a time code. This time code has different formats and resolutions depending on the class of IRIG: IRIG A has a resolution of 1 ms, IRIG B has a resolution of 100 μs and IRIG C has a resolution of 10 μs. The time code format combines the date and time of day down to the resolution of the standard. Applications needing multiple cameras that are separated require them to be synchronized to a common time standard. Typically, the master IRIG generator sends out a radiofrequency signal that is received by all the IRIG receivers. The IRIG receivers then re-synchronize to this broadcast signal. The IRIG system is widely used in military and range applications.

All these time formats are written either into the analogue video signal as an embedded time code, or are written into the file format for each image. Therefore, time stamping is the method of correlating the video images to time.

6.10 High speed video equipment for motion analysis

A variety of equipment is available from a number of manufacturers and it is useful to discuss briefly the salient features, properties and applications of a number of contemporary systems, produced in particular by the Motion Analysis Systems Division (MASD) of Kodak, NAC in Japan and ImageExpress.

Figure 6.12 The field of view for lenses of various focal lengths at a fixed distance from a subject.

Note that the term *imager* is used here as the analogue of a film camera. Data on contemporary equipment is given in Table 6.12.

6.10.1 Kodak EKTAPRO Hi-spec Motion Analyser

The Kodak EKTAPRO Hi-Spec Motion Analyser is a system designed to record high speed events and provide immediate, slow motion playback. With its rugged design and ability to capture up to 12 000 pfps, this imager is ideal for motion studies. At the heart of the system is a high speed digitizer and electronic DRAM memory module that can store up to 19 565 full frames of information. To make the imager even tougher, Kodak has ruggedized it to Mil-Standard 810 specifications for shock and vibration. The analyser is designed to be very compact and lightweight. As a result, it is very transportable and also easy to mount in space limited areas.

Upon receiving a signal from an external trigger, the analyser will continue recording until its memory is full. In this way, the analyser can capture both the pre-event and post-event frames of an uncontrolled occurrence. Dual image overlay is also possible using two of the imagers to record different views simultaneously. Once captured by the analyser, digital images may be downloaded to RS-170 (NTSC/PAL) or transferred through an optional GPIB interface.

6.10.2 Kodak EKTAPRO Motion Analyser (Model 1000HRC)

The Kodak EKTAPRO Motion Analyser, Model 1000HRC, is a state of the art, full colour (24 bit) digital motion analysis system that provides powerful data acquisition and communication capabilities. The HRC has a 512 × 384 pixel sensor with a sensitivity equivalent to either 480 ISO for a colour imager or 2100 ISO for a monochrome imager. Both types of imager have electronic shuttering that operates up to 50 μs. The imager also has *anti-blooming*, which reduces any scene 'washout' from bright light sources in the field of view.

With high resolution recording at rates up to 1000 ffps, plus comprehensive data, triggering, download and storage options and proprietary colour technology, the HRC system may be a complete solution for many motion studies.

External data, recorded at 10 samples per frame, is correlated with the visual images through the use of a Kodak EKTAPRO Multi-Channel Data Link accessory. Computer control and data communication are available through a wide variety of interface ports, such as RS-232, RS-422, GPIB and SCSI II. An optional internal removable optical disc drive is available for archiving digital image files. The HRC can also download to RS-170 (NTSC/PAL) or S-VHS formats to a digitally controlled professional (RS-232) VCR.

Flexible triggering modes allow efficient capture of either controlled or unpredictable events. The HRC processor can be triggered by virtually any kind of sensing device, including optical, acoustical, impact, acceleration, temperature and proximity sensors.

Memory options allow over 5 s of continuous recording time at full speed and resolution. In addition, the processor memory can be partitioned into subsections, allowing multiple recording sessions to reside in memory. An IRIG timing option allows IRIG data to be inserted into each data frame.

6.10.3 Kodak EKTAPRO HS Motion Analyser (Model 4540)

The Kodak EKTAPRO HS Motion Analyser, Model 4540, is an ultra-high speed video recording

Table 6.12 Summary of the properties of contemporary high speed video equipment

| Property | Motion analyser | | | | | | | | |
	EM 1012	HRC	HS4540	RO	Video QC	Memrecam	Ci Memrecam	CCSHSV 500	HSV 1000
Entry price ($)	50 000	130 000	130 000	55 000	15 000	117 000	53 000	71 000	83 000
Framing rate (full, split)	1000/12 000	1000	4500/40 500	1000/3000	240/600	500/2000	200/400	250/500	500/1000
Resolution	49 152	196 608	65 536	196 608	153 600	580 × 434	510 × 246	641 × 491	641 × 491
Sensitivity (ISO)	100	480/2100	1600	480/2100	1800	200	1600	80	80
Shutter speed	1/frame rate	50 μs	1/frame rate	50 μs	0.01 ms	0.01 ms	0.01 ms	0.01 ms	0.01 ms
Image format	NTSC, PAL, TIFF	NTSC, PAL, TIFF	NTSC, PAL, TIFF	NTSC, PAL, TIFF, BMP	NTSC, PAL	NTSC, PAL, TIFF	NTSC, PAL, TIFF	NTSC, PAL	NTSC, PAL
Image type	Mono	Colour/mono	Mono	Colour/mono	Mono	Colour	Colour	Colour	Colour
Frame size	256 × 192	512 × 384	256 × 256	512 × 384	640 × 240	–	510 × 244	410 × 340	410 × 340
Maximum recording time	19 s	5.4 s	3.3 s	8 s	6.4 s	3.1 s	80 s	40 min	14 min
System weight (lb)	43	54	56	13.2	–	11	11.4	107	118
Imager size (inch)	4 × 5 × 9	5.2 × 8 × 15.4	6.1 × 6.1 × 13.1	4 × 5 × 11	–	5.5 × 11.8 × 9.6	3 × 3 × 5	5.2 × 7 × 12.7	5.3 × 7.2 × 11.8

system with the ability to record up to 4500 ffps and up to 40 500 pfps for immediate playback. The 256 × 256 pixel sensor has a sensitivity equivalent to 3000 ISO. Up to 5120 full frame and 81 920 partial frame images may be stored in a digital memory. Multiple modes of recording are possible, including *record*, *continuous record* and *trigger recording*. Once captured by the analyser, the stored images can be downloaded to standard video tape or to a computer through the GPIB interface for future reference and analysis. This analyser is suited to capturing extremely rapid events such as airbag deployment, flow visualization and ballistics studies.

6.10.4 Kodak EKTAPRO RO Imager

The Kodak EKTAPRO RO Imager combines high speed and high resolution colour within a small, ruggedized package designed for use in severe environments. The sensor has 512 × 384 pixels and a sensitivity equivalent of 480 ISO for colour and 2100 ISO for monochrome. The electronic shutter operates up to 50 μs. Anti-blooming reduces any scene washout from bright lights.

The RO imager is designed to operate similarly to the film cameras currently being used in harsh environments. The compact, lightweight housing allows it to mount easily on a sled or crash test vehicle and other high *g* mechanisms. The camera is controlled through an RS-495 interface or a simple dedicated hardwired interface. Imagers can be networked together and programmed to trigger in unison or at specific intervals from a common bus. This means the cabling is simple. Prior to recording, the camera is in a low power mode. A signal is sent to ready the camera for recording. An additional signal from the user triggers the camera to begin recording that continues until the memory is full. Up to 500 images can be recorded in an internal DRAM memory. Up to 1000 full ffps can be recorded in applications such as automotive crash sleds, airborne ordnance testing and other harsh environments.

The images can be downloaded automatically to either a PCMCIA hard drive or a flash memory card. The card is removed from the camera and inserted into a desktop computer or image server for display and analysis. Designed as a stand-alone camera, an accompanying processor is not required, thus reducing the cost to about half that of a tethered system. The high resolution images are in a compact format and can be transformed into 24-bit colour TIFF images using a desktop computer.

6.10.5 Kodak EKTAPRO Motion Analyser (Model 1000HRC IS)

The Kodak EKTAPRO Motion Analyser, Model 1000HRC IS, provides a fast image conversion platform for the RO imager described above. IS stands for 'image server' and this has all the attributes of the HRC processor, except the capability to attach to an imager. It is used to play images from a *record only* (RO) or HRC imager. These images are read from either an external PCMCIA reader or an optional optical disc drive. The IS can read 500 frames and play full 24-bit colour images in 3 min. It is an economical means for image playback and analysis.

6.10.6 Kodak Video QC

The Kodak Video QC is a low cost, easy to use motion analyser designed for applications in production maintenance. QC stands for 'quick cam'. The small tethered monochrome imager has a sensor with 640 × 240 pixels and equivalent sensitivity of 1600 ISO. It can record 240 full frames and 600 partial frames and is ideal for applications where viewing images in slow motion helps to figure out what is wrong in a machine's operation. It is very simple to set up and is virtually self-contained.

6.10.7 Kodak EKTAPRO Intensified Imager (Model SI)

The Kodak EKTAPRO Intensified Imager is specifically designed to solve one of the biggest challenges encountered in high speed imaging, i.e. not enough light to image. The 3200 ISO sensitivity captures even dimly lit subjects at high framing rates, and the robust, high resolution tube technology gives long life and outstanding image quality. The complication and expense of special lighting set-ups is greatly reduced. The unit is intended for use with a Kodak EKTAPRO Hi-Spec Motion Analyser. Greater light gain also means larger *f*-numbers and, consequently, greater depth of field. This is particularly important in applications with subjects moving through multiple foreground–background image planes. The great depth of field and high framing rate combine to produce detailed images for easy and accurate motion analysis.

6.10.8 Kodak MEGAPLUS Camera (Model ES 1.0)

The Kodak MEGAPLUS Camera, Model ES 1.0, is a mega resolution CCD camera and, although not very fast compared to other high speed cameras, it has high resolution. The CCD interline transfer sensor has 1008 × 1018 pixels with a progressive scan readout system. An electronic shutter gives exposure times as short as 100 μs. A double exposure mode is also available, capturing two images separated by a user controlled delay ranging from 1 to 400 μs. The camera outputs 8 bit digital images

with 256 levels of grey and provides image detail to supplement lower resolution systems.

6.10.9 NAC HIGH SPEED VIDEO Motion Analyser (Model HSV-500)

The HSV-500 is an economical entry level motion analyser, providing colour images and long recording times, up to 43 min on a standard VHS or S-VHS cassette. The VHS cassettes also play on standard VCRs. Either 250 ffps or 500 pfps in colour can be recorded. A hand-held keypad controls all the functions and has a simple fingertip rotary control for changing playback speeds and direction. A scene number and time code are displayed on the monitor with images during record and playback. The imager has a variable mechanical shutter to help capture sharper images. Operation is switchable to monochrome operation for those times when a black and white image is preferred. The recorder and video monitor are mounted on an integral cart fitted with pneumatic tyres, providing a convenient way to move the unit. The HSV-500 system is well suited to studies of paper manufacturing machinery, military range activities and biomechanical work.

6.10.10 NAC HIGH SPEED VIDEO Motion Analyser (Model HSV-1000)

This system is an advanced high frame rate motion analyser providing colour images and long recording times up to 14 min on a standard VHS or S-VHS cassette. The VHS cassettes also play on standard VCRs. Either 500 ffps and 1000 pfps in colour are available. Other features are as for the HSV-500 model.

6.10.11 NAC Memrecam Motion Analyser (Model Ci)

This unit is a fully self-contained high speed, high resolution video camera with an internal digital memory. A single CCD sensor is used that has anti-blooming and resolution of 580 × 434 pixels. Recording is either at 500 ffps or 2000 pfps. The motion analyser operates from 28 V DC and the maximum full frame recording time is 3.1 s. The Memrecam Ci is a very portable and compact motion analyser.

The housing contains everything necessary for a user to programme the camera's non-volatile control memory and digitally record an event. The rear panel has a touch keypad built-in. Image playbacks in the Memrecam are in full colour. Digital images may also be downloaded to a data magazine (a SCSI II hard drive) for later readout. A multi-camera synchronization unit is available for multiple camera control and downloading to VHS or S-VHS tape.

The Memrecam Ci is ideal for debugging those production and research problems that are difficult to see and where a stand-alone camera is required.

6.10.12 NAC Memrecam Motion Analyser (Model CCS)

This unit was the first motion analyser with image compression technology, which is an advantage since it provides a much longer record time for DRAM storage. Images are compressed in real time before being written into memory. Since the image size is reduced, more images can be stored.

The sensor resolution is 510 × 246 pixels and the sensitivity is 2000 ISO. It can record 200 ffps and 400 pfps. The electronic shutter operates as fast as 100 μs. The unit is a tethered motion analyser and the imager is very small for getting into tight spots. The processor is also compact. It can record either up to 80 s with two additional memory boards and full image compression, or uncompressed for 4 s. Images can be downloaded in various ways and multi-camera operation is possible via a synchronization unit.

The Memrecam CCS is ideal for applications requiring recording times longer than most analysers with digital memory. Due to its high sensitivity, the CCS can make use of the electronic shutter to get good motion stopping power and depth of field. This analyser is advanced in its use of image compression.

6.10.13 ImageExpress Workstation (Model 100)

The ImageExpress is an easy to use turnkey motion analysis workstation. It automatically digitizes monochrome or colour images and provides the tools needed to analyse the motion depicted in the image sequence. Motion analysis features designed into the software allow automatic target tracking and calculate the data needed for motion studies.

The unit accepts live or pre-recorded video images at 30 fps and converts them to a TIFF file. If it has the optional interface for Kodak's motion analysers, it can read digital images directly from either a PCMCIA reader, GPIB interface or a removable optical disc drive. Easy to understand icons guide the user through an intuitive graphical interface with minimum training. During image review, the user has a second window for viewing detailed areas up to 32× zoomed.

Most objects can be tracked through obstructions and even through variable lighting conditions. Compensation for camera jitters is possible. Up to 50 objects in one image can be tracked. Points that are connected by line segments can be displayed as two-dimensional stick figures. Point kinematics data such as position, velocity or acceleration, are selec-

ted by the user for constant display. Graphs of the point data, line segments or areas may be obtained. The software is a Windows based program; it is intuitive to use and automatically tracks selected targets fast.

6.11 Setting up an application for motion analysis

The successful application of motion analysis depends on correctly setting up the subject or problem. Listed below is a short checklist to outline the application of motion analysis to any subject. The objective is to define the problem and clearly identify the subject under investigation.

6.11.1 Defining the problem

- Target the problem area as closely as possible and narrow the zone of sharp focus.
- Measure the size of the subject within the event area, its width, height and depth.
- Identify other physical characteristics, including:
 (a) how fast the subject may be travelling (which will indicate what framing rate is required),
 (b) the size of travel area (which will give the approximate field of view).

6.12.2 Can motion analysis help solve the problem?

- Does the subject or area of interest move so fast that it requires high speed video?
- Are instant replay and variable slow motion rates required?
- Is immediate access to analysis results required?
- Are data storage and retrieval required?
- Are sensors needed to trigger the activity for capture?

If the answers are 'Yes', then a motion analyser will help to solve the problem.

6.11.3 Defining measurable and observable parameters for analysis

- What type of information is needed to collect and analyse?
- Is there a specific area within the field of view that will give these data?
- Can the event be measured according to a scale?
- Can the reticle be used for scale measurements?
- What calculations will be required to convert the scaled measurements to data?
- What sensors should be used to trigger the event?
- Are there special circumstances for setting up a record or analysis of the data?

6.11.4 Identifying environmental constraints and equipment requirements

- What safety factors need to be considered?
- How far will the camera have to be from the subject?
- What is the light source?
- Is additional fill lighting required?
- Are there pre- and post-event activities that need to be captured?
- What equipment is required?

These questions and their answers should help to define how and what should be analysed. Doing this planning and analysis before setting the equipment up can save time and money. The results will be achieved with the satisfaction that it was well planned.

6.12 Analysing the data

After the subject has been captured, analysis may be required to obtain any useful information. Typically, analysis will proceed in the following manner:

1. Define the sequence to be analysed.
2. Define parameters for viewing/processing/displaying tags.
3. Define the data to be saved or exported.
4. Analyse the sequence – define the targets and their location on each image.
5. Save the data.
6. If desired, purge the intermediate analysis data.

The above series of steps is a general outline. However, many of the parameters set in step (2) can be reset or changed any time in the analysis.

The targets to be tracked are usually points, lines, or areas. However, there are some differences between points, lines and areas, and target points, target lines and target areas.

Target points are (initially) placed by the user, and target areas are (initially) defined interactively. Target lines are defined by their end-points, which *must* be either a target point or the centroid of a target area. Therefore, lines are tracked by virtue of the fact that their end-points are tracked; lines move when their end-points move. Lines are not defined outside the context of their end-points.

Typically, there are three modes of tracking the targets:

- *Manual*: define targets on the first image; when the next image is displayed, targets are initially placed in the same location. These can then be moved interactively.
- *Semi-automatic*: define targets on at least two images; when a new, unanalysed image is displayed, the initial location of the image is moved

using the velocity vector calculated using the two previously defined positions.

• *Automatic*: define targets on at least two images; when a new, unanalysed image is displayed, the initial location of the image is moved using an algorithm that distinguishes between the target and surrounding features. Typically, a threshold level within a region of interest is applied to recognize the target. This is a form of pattern recognition.

Before analysing the targets, the image planes may need calibrating. This is accomplished by noting some pre-measured object in various image planes within the field of view. This *calibration* must be done for each image plane to be analysed. Some analysers can use perspective once a starting and ending plane have been defined.

Next are the actual measurement and tracking of objects. First, determine the measurements to be collected. Select a measurement set to be applied to each image sequence. Acquire an image, select a region of interest and perform image enhancement processing if necessary. Identify features, extract measurements and export data. Automate the pro-

cesses with macros, where possible, to avoid operator fatigue. Figure 6.13 illustrates the features of a typical motion analysis workstation.

6.13 Beyond the year 2000

The next 10 years will usher in a new era of technology for motion analysers. These new technologies will enable motion analysers to be smaller in size, lighter in weight, higher in resolution, more sensitive to light and be able to record digital images for a longer time.

The size of motion analysers has reduced over the last 10 years. Systems that weighed 125 kg in 1980 are now replaced with a higher performance motion analyser that weighs 5 kg and is one-sixteenth in size. The recording technology used and the miniaturization of electronics have had a large influence.

Resolution is steadily increasing as the semiconductor industries venture into higher density integrated circuits. The pace of this advancement has been mirrored by DRAM production. DRAM memories are very similar in structure to an imaging

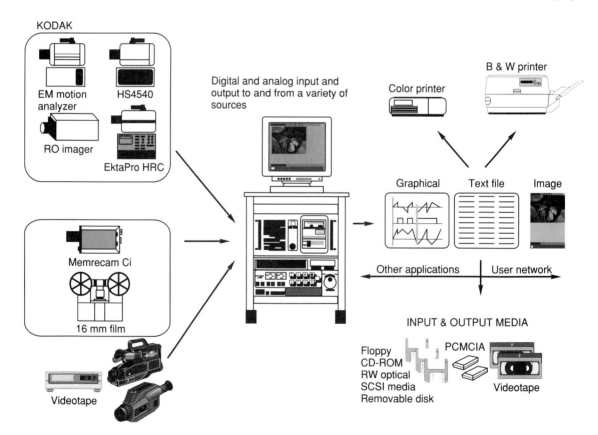

Figure 6.13 A typical motion analysis workstation showing the components of the system.

sensor. Today, DRAM units are approaching 64 Mbyte. In the next 10 years they will approach 1024 Mbyte densities. Within the next 5 years, imaging sensors should reach 1024 × 1024 × 1000 fps, or 1 Gpixel. Therefore, it is feasible that a 4- to 16-fold increase in resolution over today's standard of 512 × 384 pixels is achievable.

Most motion analysers at present use CCD technology for imaging. Their sensitivity has been increasing over the older NMOS sensor technology. During the 1980s, the sensitivity of motion analysers could be characterized as being under 200 ISO. Today, the same measure for sensitivity would be under 2000 ISO. Within 10 years, the sensitivity should double once more. The size of the *pixel well* will be larger and the *well depth* will be greater. However, although this is technologically possible, an economic factor in the size of the silicon wafer will bear on what actually is produced.

Today, motion analysers use DRAM based storage technology. In the past, longer record times were possible with magnetic storage technology. In the future, either higher density DRAM memories or real-time image compression will be used to extend the record time. However, if the sensor resolution remains the same, this could be a true prediction. If the resolution increases 4- to 16-fold, a new storage technology will be needed. It may necessitate going back to low cost, high capacity magnetic recording in the digital domain.

If the past is any indication of where our industry is heading, the technology will continue to advance; motion analysers will become simpler to operate and they will have higher performance. Advancement is possible due to the synergy with other key technologies. These include high definition digital television, computer peripherals, video-on-demand products and military imaging applications. All have contributed to the technology required for the next generation of motion analyser.

Acknowledgements

The assistance and collaboration of Peter Fuller in the preparation of this chapter is gratefully acknowledged.

7 Smear and streak photography

Hallock F. Swift

7.1 Introduction

Smear and streak photography are two classes of image recording technique essentially unique to the realm of high speed photography. Each can be used to produce images of fast moving objects according to principles that are strikingly different from those employed by conventional cameras. In addition, each of the techniques can be used to produce continuous plots of position versus time for individual motions within rapidly evolving events so that intricacies of critical phenomena controlling them that would otherwise pass unnoticed can be revealed. Generally, smear and streak photography prove useful for visualizing motions in only a single direction.

7.2 Smear photography

Smear photography is the simpler and more basic of the two techniques. A *smear camera* consists of an objective lens which images the scene under investigation onto a photographic film (or an equivalent electronic image sensing surface). Means are provided to move the image continually in a single direction over the photorecording surface during the exposure period. In the camera's simplest form, an objective lens focuses an image onto the gate mask of a camera while film is drawn continuously through the gate starting before the event begins and extending until after its completion. If motion within the image is restricted to being perpendicular to film motion, the resulting film record becomes a graphic plot of object position versus time, i.e. the camera produces a line image from a point image.

Consider, for example, using a smear camera to record output from an oscilloscope with a fast-quenching phosphor the sweep circuit of which has been disabled (Figure 7.1). Time-varying voltage applied to the oscilloscope input causes the beam to move in one direction in proportion to instantaneous voltage applied. If the image of this beam is recorded by a smear camera oriented so that film motion is accurately perpendicular to beam motion, the image of the beam produces a record that may be interpreted as a plot of input voltage versus time.

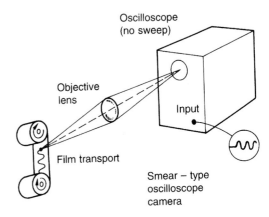

Figure 7.1 Smear camera set-up to produce an oscillogram. A high performance reel-to-reel smear camera can resolve somewhat better than 1% of full-scale voltage reading while resolving 250 ns temporally for periods of up to 1 s.

The *temporal resolution* (τ_r) is just the time required for a recorded image to move its own width in the direction of general image motion. The *recording time* (τ_{re}) is simply film length divided by film velocity. Thus

$$\tau_r = \frac{y_i}{U_f} \qquad (7.1)$$

and

$$\tau_{re} = \frac{L_f}{U_f} \qquad (7.2)$$

where y_i is either the image dimension in the direction of film travel or the film resolution limit (whichever is larger); U_f is the film velocity and L_f is the film length.

Consider a smear camera with a 122 m (400 feet) reel of 16 mm motion picture film that can be drawn through the camera at velocities up to 100 m s^{-1} (item 1 in Table 7.1). A quality optical system working with a well-focused oscilloscope can just resolve a beam spot image on the film of 25 μm diameter, which infers a temporal resolution of just under 250 ns. Such a camera can maintain its film velocity for

Table 7.1 Capabilities of available image transport technologies for smear and streak cameras

Technology	Image velocity	Temporal resolution	Minimum f-number	Spatial resolution (lp mm^{-1})	Maximum writing time (at top speed)	Notes on operational command structure
Reel-to-reel (16 mm film)	0.1 mm µs^{-1}	250 ns	‹1.0	800	1.0 s	Continuous
Film-in-a-box (35 mm film)	0.15 mm µs^{-1}	167 ns	‹1.0	1600	0.1 s	Commandable
Rotating drum (35 mm film)	0.3 mm µs^{-1}	66 ns	4.5	1600	4.2 ms	Commandable
Rotating mirror (35 mm film)	20 mm µs^{-1}	1.0 ns	›15	1200	100 µs	Continuous access
	20 mm µs^{-1}	1.0 ns	›15	1200	100 µs	Synchronous
Electronic swept image	300 m ns^{-1}	‹100 fs	‹1:0	650	200 ps	Commandable
Digital electronic	20 mm µs^{-1}	100 ns	‹1.0	‹100	500 µs	Commandable

periods exceeding 1 s. Since the excursion of the beam in its signal direction (perpendicular to film motion) may be read with total accuracy of better than 1% of maximum deflection, an oscilloscope/ smear camera combination becomes an analogue data recording instrument of formidable capability. (In digital recording parlance: 4.0 MHz sample rate by 7 binary bit voltage resolution by 4 million memory locations.)

Smear cameras may also be used to provide actual images of objects moving in straight lines in two separate but related ways. First, a steadily illuminated moving object imaged by the stationary camera objective lens upon the film gate impresses a clear and undistorted image on the film if image velocity is made identical to film velocity (i.e. speeds are identical, as are directions of motion). Thus, steady lighting may be used to produce clear photographs of rapidly moving objects without the benefit of conventional camera shutters. This situation is realized when the ratio of the film velocity (U_f) to the object velocity (U_o) is precisely equal to image magnification (m). Hence

$$U_f = mU_o \qquad (7.3)$$

In practice, this situation is very difficult to achieve because it requires precise *a priori* knowledge of object velocity. Even small deviations of film speed from image speed produce image blurring. An effective *index of motion blur* is ($\delta d_i/y_0$), where δd_i is the magnitude of image motion across the film while the object passes across the camera viewfield and y_0 is the image length measured in the direction of object motion. It may be evaluated from

$$\left(\frac{\delta d_i}{y_0}\right) = \left(\frac{\chi_{fov}}{x_0}\right)\left(\frac{\delta U}{U_0}\right) \qquad (7.4)$$

where χ_{fov} is the camera field of view in the direction of object motion, x_0 is the object dimension in the direction of its motion, and δU is the difference between object velocity and its expected value.

The situation may be eased significantly by illuminating the object with a pulsed light source, which reduces sharply the system exposure time. When a camera employing stationary film is used to photograph a moving object, exposure time limits to prevent unacceptable motion blurring ($\delta\tau_{sf}$) become extremely strict. These exposure time limits can be eased considerably when a smear camera is used for image recording because the velocity of image motion across the film (which must be frozen by exposure duration) is reduced in proportion to the accuracy with which object velocity can be estimated. Thus, a light source with an effective exposure time of 1 µs may do the job of a source with a duration of only 100 ns if the object velocity can be estimated to within ±10.0% and compensated for.

Cine sequences of a moving object may be taken on smear camera records by using trains of ultrashort duration light pulses such as those produced by various types of solid-state laser. In this case, the smear camera provides spatial separation between the successive images so that overlap is eliminated and a cine sequence of images is produced. The critical parameter for evaluating operation of such a cine camera is the ratio of exposure duration to interframe duration. A value of 0.01 infers that motion blurring of stationary objects under observation is 1% of the frame width (a marginal situation for optically pleasing results). Conversely, a ratio of 0.001 infers motion blurring of 0.1% of frame width, which produces acceptable results for all but the most critical photographic situations. Thus, laser pulses with durations of 10 ns provide only marginal motion blur suppression for smear cameras operating at framing rates near 10^6 pictures per second (pps), but provide excellent results for similar cameras operating at 10^5 pps.

7.3 Streak photography

Streak photography is a direct outgrowth of smear photography. In this case, a second optical element is added between the objective lens of a smear camera and the film gate. The objective lens images the camera viewfield upon a secondary plane within the camera where a slit is introduced that blocks light from the scene being viewed except that part which passes through a slit orientated perpendicular to the direction of image motion. A *relay lens* system within the camera then images the slit and the light passing through it onto the film plane. A wide variety of slit widths may be used with streak cameras, depending upon the application. The layout of the components of a streak camera where image motion is provided by a rotating mirror is shown in Figure 7.2.

7.3.1 Cross slit photography

For the first application of streak photography, consider the continuously illuminated single frame recorded with a smear camera. The smear camera system was considered ineffective in cases where object lighting is continuous because of the strict requirement that image velocity must be synchronized with camera film velocity accurately enough to prevent motion blurring during the entire time the object remains in the camera viewfield. As the viewfield of the camera in the direction of image motion is restricted by slit width in a streak camera, the *motion compensation* restriction is progressively relaxed, since each point on the image is exposed only during the time required for the camera film to pass the slit width. The situation is represented in Figure 7.3, where a silhouette image of a bullet in

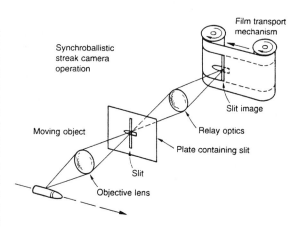

Figure 7.3 Basic arrangement for recording synchroballistic images. The viewfield of the streak camera is restricted by the slit so much that an image can be produced by steady illumination without recourse to a shutter.

flight is wiped onto a streak camera film. We have a situation equivalent to a smear camera being used to photograph an object illuminated by a pulsed light source (with the light source duration being the time required for the slit image to move its own width across the film plane). If the slit image width on the film plane is 0.5 mm and its velocity across the film plane is 5.0 km s^{-1} (5.0 mm μs^{-1}), the effective exposure time for the image is 100 ns. Let us suppose further that the image of an object travelling at 1 km s^{-1} is motion compensated within 10% so that the image moves across the film at only 100 m s^{-1}. The 100 ns exposure time will thus produce a motion blur of only 0.01 mm, which allows as clear

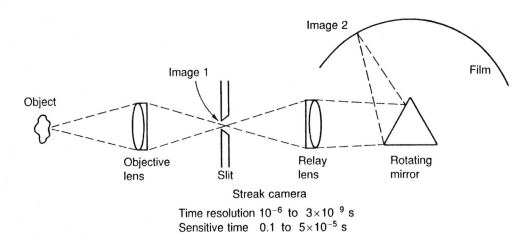

Figure 7.2 Schematic of a practical streak camera where the image of a slit is swept across a curved film gate by means of a rotating mirror.

rendition of the object as can be achieved with ordinary film.

Often, high speed camera systems do not receive sufficient illumination to expose photosensitive surfaces adequately. Maximizing the width of the slit in a streak camera maximizes the light flux available for film exposure by extending the time each point in the image plane receives light. Trade-offs are generally made between maximizing slit width to increase film exposure and minimizing slit width to reduce effective exposure time, thereby relaxing motion compensation requirements between image velocity and film velocity. Situations often occur where illumination is sufficient to allow streak cameras to operate at slit image widths equal to the resolution of the image recording media. (Slit width should never be reduced below the resolution limit of streak camera optics because light is wasted. In addition, diffraction effects, the extent of which are inversely proportional to slit width, may actually degrade temporal resolutions of camera systems using overly narrow slits.) Under resolution limit conditions, streak cameras always produce clear images of moving objects with no perceptible motion blur (as long as adequate illumination is available). The effective exposure time of a streak camera operating in this mode is, simply, the time required for the slit to move across the optical resolution length of the camera optics operating with the image sensing media. Figure 7.4 shows a striking example from a *synchroballistic camera* used to observe a gun-launched rocket in flight.

A second phenomenon develops that distorts images systematically if motion compensation between image velocity and slit sweep speed is lost to a significant degree. The magnification of an image in the direction of image motion along the film is the ratio of image velocity to object velocity. Magnification in the direction perpendicular to object velocity is the optical magnification of the

system (m). These two magnifications become equal and no distortion is produced when the camera system is compensated properly (i.e. when slit sweep velocity is equated to object velocity times camera magnification). Thus

$$\left(\frac{y_i}{\chi_i}\right) = \left(\frac{y_o}{\chi_o}\right)\left(\frac{U_i}{mU_o}\right) \tag{7.5}$$

where y_i is the height of the image (in the direction perpendicular to the object motion) and y_o is the length of the image (in the direction parallel to the object motion).

Images become *elongated* in the direction of image motion when slit velocity exceeds that required for proper compensation. Conversely, images become *foreshortened* in the direction of image motion when image velocity falls below that required for proper compensation. Fortunately, the extent of motion compensation loss can usually be established independently using Equation (7.5). This result can then be used to correct streak camera images for either elongation or foreshortening, either analytically or optically.

7.3.2 Parallel slit photography

An entirely different action occurs when a streak camera is orientated so that critical motions within the image of a dynamic event occur along the camera slit rather than across it (parallel slit streak photography). A situation develops that is analogous to a smear camera observing an oscilloscope. Objects whose images move along a slit are observed continuously as their positions versus time are recorded graphically. The slit width of the streak camera is almost always set equal to the camera's optical resolution limit during parallel slit photography. The continuous observation feature of parallel slit streak photography is especially advantageous when observing complex motions such as those which occur during the operation of dynamic mechanisms.

For example, consider a flat metal plate launched from the face of an explosive block toward a target plate mounted a few centimetres away (Figure 7.5). Upon detonation, the plate in contact with the explosive is launched violently in a direction perpendicular to its face (i.e. directly toward the target plate which it impacts). Upon impact, strong shock waves are produced in both plates; these propagate away from the impacted surface. Once the wave in the target plate crosses the plate thickness, it causes the rear surface to recoil at almost precisely twice the velocity at which the target plate material was accelerated by the impact-induced shock wave. This event may be diagnosed with a fast streak camera the slit of which is oriented perpendicular to images

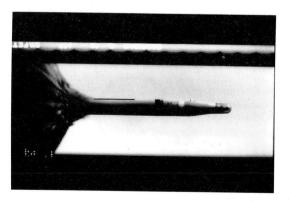

Figure 7.4 Synchroballistic photograph of a gun-launched rocket photographed in sunlight at the US Army Proving Ground at Yuma, Arizona.

Experiment

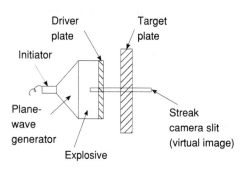

Streak record

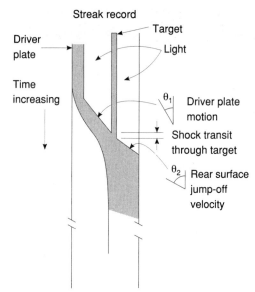

$$v_o = v_{fm} \text{ Tan } \theta$$
v_o = object velocity
v_f = slit image velocity
θ = streak angle
m = magnification

Figure 7.5 Streak camera record of an explosive/impact experiment where an explosive charge is used to launch a flat plate (projectile) into a flat target plate. Launched plate velocity, shock wave transit time in the target plate and target plate recoil velocity may all be determined from this image if the optical magnification of the camera optics and the image speed are known.

of the front and rear target faces (and also the face of the explosively launched plate). Figure 7.5 also shows a print of the resulting streak camera record. A rear illumination source was used to backlight the experiment as viewed by the streak camera. Action begins as the explosive charge launches the projectile plate to a fixed velocity (U_{pl}), which may be evaluated from the streak camera record and known characteristics of the optical system:

$$U_{pl} = \frac{U_i}{m \tan\theta} \tag{7.6}$$

where θ is the angle between the streak camera image and the camera slit.

Impact time is signified by closing of the gap between the launched plate image and that of the front target face. Little of interest occurs within the streak image during the time required for the impact-produced shock wave in the target plate to propagate between the front and rear faces. Shock wave arrival at the rear face of the target is signified by initial face movement, as observed in the streak record. The distance along the record between impact and initial motion of the rear surface may be used to infer shock transit time in the target plate from which shock velocity may be inferred. The time between events recorded by a streak camera (τ_t) may be evaluated from images using

$$\tau^t = \frac{\delta_i}{V_i} \tag{7.7}$$

where δ_i is the distance along the streak record between images of events and V_i is the slit image velocity across camera recording medium.

The recoil velocity of the rear surface of the target plate may be determined from its angle measurement with respect to the spatial axis of the record (direction parallel to the camera slit) and the same parameters used for determining explosively launched plate velocity by using Equation (7.6). The rear surface velocity of the target plate may then be equated to twice the shocked material velocity in the target (particle velocity behind the shock).

Another particularly interesting example of parallel slit motion analysis is shown in Figure 7.6, where parallel slit and cross slit streak photography are used simultaneously to observe a spherical projectile launched to hypervelocity along the axis of an evacuated ballistic range at the US Air Force Materials Laboratory. Backlighting was used to produce silhouette images of projectiles travelling along the range axis. Here, the streak camera was positioned so that the projectile image travelled along its slit. Care was taken to compensate image velocity as the product of projectile velocity times camera optical magnification in order to produce

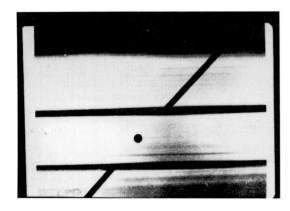

Figure 7.6 Streak camera record of a sphere travelling along the axis of an evacuated ballistic range. The streak camera is orientated so the projectile image moved along the slit to produce a plot of position versus time. A dove prism was used to rotate the central portion of the slit 90° so the projectile crossed it to produce an image of itself.

an accurately ballistic synchronized image. A small *dove prism* is used to rotate the image of the on-coming projectile through 90° so that the image crosses the camera slit, thereby producing a shadow-gram of the sphere in flight. Since velocity compensation was achieved almost perfectly and the sphere projectile was launched without distortion, the cross slit image is nearly a perfect circle. This camera record identifies the projectile, shows that it was launched intact, verifies that it is travelling alone and provides unambiguous data for evaluating flight velocity.

7.4 Camera designs and their capabilities

7.4.1 Resolution and timing

Streak and smear cameras have been designed using a range of mechanisms to transport images across photosensitive recording surfaces. The two key parameters for determining camera performance are total *optical resolution* in the spatial direction (usually expressed as a resolving power in line pairs per millimetre) and *temporal resolution*. The latter has a variety of definitions, the most common of which is the time required for an image to advance in the temporal direction the minimum resolution distance of the optical system and recording medium. A related parameter is the maximum *camera writing rate*, which is the velocity achieved by the slit image as it moves across the photosensitive surface. A variety of parameters important to streak camera optical sensitivity include the *f*-number of the optical train, slit widths used and sensitivity of the image recording medium. Total *camera writing time* is con-

trolled by writing speed and the length of image sensing material available in the direction of slit motion (writing time is occasionally normalized with respect to image resolution time, especially for cameras with notably short record lengths). Resolution of streak camera records in the direction perpendicular to slit image motion is controlled by slit image length and spatial resolution of the recording medium.

Finally, restrictions that the camera places upon experiment timing become important factors affecting experiment design. Various timing limit possibilities include:

- *Continuous operation*, where the camera is started well before the experiment begins and runs until well after the event of interest has been completed.
- *Continuous access operation*, where the camera repeats its sensing cycle without a 'blind' time gap between the end of one cycle and the start of the next. (In this case, illumination of the object under study must be initiated or a shutter must be opened just before event initiation and the event must be darkened or the camera 'blinded' immediately after the event to prevent writing over useful image space, termed *overwriting*.)
- *Commandable operation*, where the event must produce a signal to initiate camera operation as the event starts, so that the finite operating time for the camera can be synchronized to record the desired data, after which camera operation is locked off until it is re-armed for another operation.
- *Synchronous operation*, where the camera must produce an event-triggering signal as it becomes sensitive, so that the event may be recorded before the camera shuts down for an extended blind period prior to again becoming sensitive.

A listing of each category of smear/streak camera design is given in Table 7.1. Discussions of each type are detailed below.

7.4.2 Reel-to-reel cameras

Perhaps the slowest smear and streak film transport involves an objective lens which images an event upon a film gate through which motion picture film is moved continuously from one reel to another. This technology produces continuous camera operation. Maximum film velocity for such cameras is limited by the maximum force that can be applied to the film, the film length and the maximum rotational rates that the film reels can withstand. When high image velocities are specified, such cameras waste substantial amounts of film during prolonged acceleration to stabilized recording velocity. Relatively long film lengths (up to several hundred metres) lead to correspondingly long 'sensitivity' (recording) times, which can be quite useful for oscillography applications

and for observing those events whose initiation times cannot be controlled or foretold accurately.

7.4.3 Film-in-a-box cameras

A related camera technology for moving film continuously through camera gates, referred to as 'film-in-a-box', involves storing motion picture film strips up to tens of metres long by folding them loosely back and forth in a delivery canister. The film end is fed through a guide into the camera's film gate and then between a pair of rollers the separation of which is just greater than the film thickness. One of the rollers is free to turn but is initially stationary. The other is connected to a flywheel that is set spinning at high speed. The camera is triggered by moving the two rollers together with the film between them. Film acceleration is nearly instantaneous as it is drawn rapidly from the delivery box and deposited into a receiving box. Film speed can be made quite constant by using a flywheel with enough rotational energy to maintain almost all its rotational velocity during film motion or by using an electric motor to replace flywheel kinetic energy as fast as it is expended. Such cameras are commandable. They avoid using the film lengths needed for acceleration by reel-to-reel cameras, but generally they can only store shorter lengths of useful film for event recording than is available from reel-to-reel units.

7.4.4 Rotating drum cameras

Rotating drum cameras also eliminate film waste during camera start-up. They can provide higher film velocities than can be achieved by other moving film technologies. They employ rapidly rotating metal drums that contain internal tracks near their outer peripheries into which film strips are installed. A conventional smear or streak optical system is used with such cameras. An optical turning mirror must be inserted between the final lens and the film to turn the optical system's axis so that geometric limitations of mounting film within the rotating drum can be accommodated. A shutter in the optical system is closed between film installation and event start. During this time, the drum is accelerated relatively slowly to its operating speed, which may approach the *burst speed* (destructive velocity) of the drum–film combination. Film velocities exceeding 300 m s^{-1} have been reported for carefully designed rotating drum cameras. The shutter is opened just prior to the event and is closed within a single drum rotation period to protect the film strip from rewrite, thus requiring commandable or synchronous operation.

Generally, camera drums are made from hard aluminium. They expand sufficiently during rotation at near top speed to move the film out of the focal plane of the camera optics, causing defocus. For critical experiments, the operator must load the camera with expendable film, accelerate the drum to its preselected rotation rate, and undergo the excitement of focusing the camera optics with the drum moving. The drum is then stopped, the sacrificial film removed and the actual film installed before the drum is re-accelerated to the rotational speed where it was focused in preparation for the actual experiment.

Experience has shown that the optical quality of drum camera images can be degraded by air turbulence near the film plane when drums are operated at near maximum performance levels. The air turbulence also causes significant local heating which can damage recording film strips. For these reasons, very high speed drum cameras are either flushed with helium gas during operation or their drum cages are evacuated.

7.4.5 Rotating mirror cameras

Enormous increases in streak camera velocities become available when rotating mirror technology is employed to provide slit image transport (see Figure 7.2). Here, the film is mounted stationary in a track which forms a portion of a circle near the centre of which is mounted a small mirror spun by a high-performance gas turbine. Mirror rotation rates extend up to 25,000 rev s^{-1} (rps) equivalent to 1 500 000 rev min^{-1} (rpm). Light from the objective lens of a smear camera configuration or the relay lens of a streak camera configuration is directed onto the mirror face on its way to eventual focus at the film surface which is approximately locally planar. Motion of the rotating mirror sweeps the image along the film plane while maintaining camera system focus. The *writing rate* of such cameras (U_i) may be calculated using

$$U_i = 4\pi R_f \omega_t \tag{7.8}$$

where R_f is the radius of the film track and ω_t is the rotation rate of the camera mirror (in rps).

In principle, this writing rate may be increased indefinitely by enlarging the radius of the film track and using progressively longer focal length lenses in the optical train to produce the final slit image. Difficulties arise quite quickly, however, because the mirror in the rotating mirror streak camera is located far from a field stop position within the camera's optical train. Therefore, optical distortions in the region of the mirror degrade and widen the slit image on the film plane which, in turn, reduces the time resolution capabilities of the camera. Air turbulence near the rotating mirror can also degrade the quality of images projected onto the film plane. Typically, the mirrors of smear and streak cameras are shielded and are operated in either helium-flushed or evacuated environments. A more insidious image degradation problem involves mirror distortions caused by centrifugal forces produced by their high rotation rates. Mirror distortions produced by centrifugal forces can be minimized by tailoring mirror materials. Beryllium has been found

to be the best available material because of its advantageous ratio of rigidity to density. Mirrors made from beryllium can be used to develop streak camera configurations with resolution times down to 1 ns, which is generally regarded as a limit to rotating mirror camera technology. A related problem is the limited light gathering efficiency of high performance rotating mirror streak and smear cameras caused by geometric factors. The small sizes of the rotating mirrors together with the lengths of the arms between mirror and film combine to limit *f*-numbers of the optical trains to high values (typically above *f*/20). This factor curtails the light-gathering efficiency of rotating mirror cameras which, in turn, limits illumination strategies that can be used effectively.

Rotating mirror cameras are designed in two categories. One uses flat rotating mirrors to produce relatively inexpensive units with superior optical characteristics (due to the mirror surface being located near its axis of rotation). Such cameras must be operated synchronously with the event to be recorded since they remain 'blind' during most of the mirror rotation cycle. The second group uses multi-sided mirrors (three to nine) to achieve *continuous access* operation. Their designs are made critical by problems associated with the mirror surfaces being located some distance from their rotational axes and the need for multiple mirror faces to be transposable into the optical train of the camera without sensible effect.

7.5 Electronic camera technology

The fastest streak and smear cameras developed to date are swept electronic units. A photocathode mounted at the forward end of a large electron tube is used to produce electron analogues of rapidly changing optical images. The resulting electrons are accelerated to high velocity and are focused upon a large phosphor screen at the rear end of the tube. Here, a self-luminous streak or smear image is produced. The electron beam from the photocathode may be swept across the extended phosphor screen at extremely high velocities through use of rapidly changing electrostatic fields produced by varying voltages applied to plates mounted within the tube adjacent to the electron trajectories. Electronic streak cameras with temporal resolution times below 10^{-14} s (10 fs) have been reported. This electronic sweep feature together with the ability to turn photocathode output on and off as required make electronic streak cameras into commandable units.

In operation as a streak camera, an objective lens of any *f*-number desired may be used to image the event to be recorded upon the photocathode of the camera tube, which may in turn be masked with a narrow slit oriented perpendicular to the sweep motion. The image of the slit is swept over the rear phosphor screen to provide the camera output. The resulting illumination may be recorded by a conventional still camera. Higher optical efficiency is developed if the image is transferred through a coherent fibre optic plate to a photographic film pressed against the output end of the system. Alternatively, image light may be directed to a charge coupled device (CCD) array of an electronic camera for recording. Finally, image light may be routed through coherent fibre optics to an electronic *image intensifier* which increases image luminance by up to 100 000 times before the image is recorded either photographically or electronically. These features make electronic streak cameras extremely efficient light gathering instruments as well as very fast ones.

7.6 Digital streak cameras

The final image transport technology is the *digital electronic streak camera*. These instruments are relatively recent introductions and are currently in the early stages of development. Basically, the slit for the camera is made up of a row of photodetectors (or optical fibres which lead to photodetectors). Output from each photodetector is digitized and fed to a memory chain which is indexed so that detector output is stored as a function of time as the memory fills. The memory is frozen at the end of the event and output is then displayed as a sequence of parallel lines with obvious shifts in colour or luminance occurring to differentiate detector signal levels. In this way crude images of either self-luminous or dark objects crossing a backlit slit may be observed as the camera is operated. Contemporary cameras are limited to a spatial resolving power of $1.0\,\text{lp mm}^{-1}$ by using rows of detectors spaced 1.0 mm apart. Temporal resolutions of 100 ns have been achieved by using 10.0 MHz clock rates for the memory chains.

Considerable possibilities exist for extending the capabilities of digital streak cameras using available technology. Clock rates for data storage may be increased by factors of up to approximately 20 beyond current experience. Spatial resolution can, in principle, be extended indefinitely by using optical fibres of smaller diameter and adding more detector/memory units, but logistics problems become extreme if many more than 100 detectors are used. These values of temporal and spatial resolutions lag behind alternative technologies, but the fundamental digital nature of the process appears to ensure that very substantial performance increases must merely wait for applications being identified where digital camera technology provides clear and important advantages.

Acknowledgements

The photographs used at the end of this chapter are reproduced courtesy of the Defence Test and Evaluation Organization (DTEO), Pendine, and were supplied by Graham Haddleton.

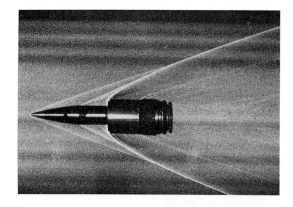

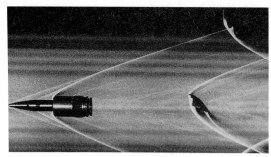

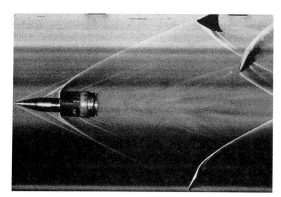

Smear photographs of a 30 mm armour piercing discarding sabot (APDS) round (velocity: 1200 m s^{-1}). This method also uses a modified schlieren technique for shock wave visualization.

Smear photography of submunition ejection, (velocity: Mach 2.5 (850 m s^{-1})).

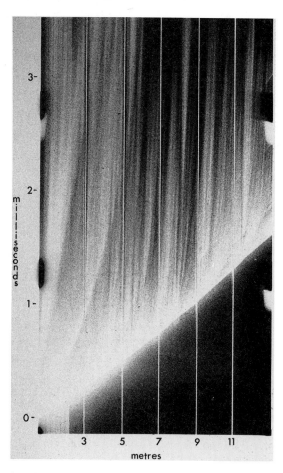

Streak photography of a shaped charge jet for velocity measurement. Velocity measured was in excess of 10 000 m s^{-1}.

Streak photography for the post-impact delay measurement of a shell impacting a multi-plate target.

8 Electro-optical camera systems

Joseph Honour

8.1 Introduction

Many of the constraints that restrict fast framing and streak recording when using high speed cameras are imposed by mechanical limitations of the film and the materials from which the cameras are constructed. Compounding these limitations are problems associated with overcoming inertia, friction and physical forces associated with the rapid acceleration necessary to generate high recording speeds (framing rates). The need to overcome the mechanical inertia results in delays which make synchronization to ultra-fast phenomena extremely difficult, and in many circumstances virtually impossible, particularly if the event is unpredictable.

The construction of mechanically driven cameras often dictates the optical paths which dramatically attenuate the image forming light before it reaches the recording media, usually photographic film, making them unsuitable for recording faint events. An important consideration in the design of these cameras is the containment of the high velocity components in the event of material failure; this invariably results in instruments which are both bulky and heavy, and which are often best suited for operation from a fixed position. However, equated to these limitations is the excellent image quality obtainable on both colour and black and white film 'stock', i.e. sensitized materials.

Various alternative systems have been developed in which the moving parts in cameras have been replaced by non-mechanical components. Initially these cameras used the birefringent properties of liquids and crystals which overcame some of the problems associated with obtaining short exposure times, e.g. the Kerr cell. However, these materials have restrictions as light transmitters or light valves. As vacuum tube technology improved and dedicated electro-optical devices become more effective, the benefits offered by cameras incorporating these principles were readily realized. The type of tube used in *image converter cameras* is an extension of the 'generation one' type (G I) image intensifier offering an appreciable photonic gain and facilitating the use of large aperture lenses.

During the period after World War II a significant breakthrough was achieved in the development of the caesium antimonide ($CsSb_3$) or S11 type photocathode. This improved photocathode offered considerable gain and, when used with the concurrent advances in phosphor technology, resulted in greatly improved image tubes. In the UK, emphasis centred on *proximity focused* devices, whereas in the USA and Germany *electrostatic focused* tubes were developed.

At about the same time, in the early 1950s, attempts were made to pulse image tubes, thus using them as high speed shutters. Exposures of the order of 10^{-6} and 10^{-7} s were possible, with efficiencies considerably higher than offered by the Kerr cell device.

As nuclear research became more sophisticated the need for higher framing rates became more crucial, and so during the 1950s new ideas were developed and incorporated into the manufacture of electronic cameras. In 1955 an image tube was manufactured by the Radio Corporation of America (RCA) in the USA and incorporated into a camera manufactured by TRW in which the only moving component was a beam of photoelectrons. The foundation of the image converter camera was established, the camera being so named because photons were converted to electrons and back to photons. Although photoelectrons have mass it is infinitesimal compared to that of moving components in mechanical cameras. A group of Russians proposed ideas which allowed *shuttering* of the electron beam, thereby making it possible to record sequences of images at high framing rates.

The image converter camera concept, like many of its mechanical counterparts, was a compromise between the ideal and what was achievable. However, these shortcomings were accepted and for the past four decades this camera type has been the workhorse for many projects involving high speed imaging, particularly where synchronization between camera and event has necessitated microsecond accuracy. Such cameras offer ease of synchronization, high sensitivity to low light phenomena, portability and, more recently, when used with charge coupled device (CCD) technology, the rapid assessment of recorded data. Table 8.1 lists some of the features and properties of various types of ultra-fast camera systems.

Table 8.1 A comparison of some of the features of different types of ultra-fast camera

Feature	Camera type						
	Hamamatsu C4187	*HPL Imacon 792*	*HPL Imacon 468*	*Ultranac*	*Cordin Model 170*	*Typical rotating mirror*	*Thomson TSN 506*
Mode of operation	Framing and streak	Framing and streak manual	Framing at moment Computer control	Framing at moment Computer control	Framing and streak manual	Framing/ streak framing or streak	Framing
Mainframe	C4187	Shutter tube	Gated MCP and CCD	Shutter tube	Shutter tube	Rotating mirror, turbine driven	TSN 5061
Cathode type and size (mm)	S20 15×25	S20UV 8×9 15×9 (LC)	S25 18 (diameter)	S25	S20 and S20UV, S1	n/a	S20
Spectral response (nm)	200–850	180–850	385–900	400–700	UV–visible– NIR	Visible	550 (max.)
System gain	MCP › 1000	50	0–7000	5	10	n/a	Variable
Output phosphor	P20	P20	P20	P11 or P20	P11 or P20	n/a	P20
Spatial resolution (lp mm^{-1})	13	8–32	22	15	10	35	12
Framing rate (pps)	10^2–3×10^6	10^4–5×10^7	10^8 (max.)	5×10^3 to 2×10^7	4×10^7 (max.)	5×10^4 to 2.5×10^7	4×10^7
Frame interval	300 ns to 10 ms variable	100 μs to 20 ns fixed	10 ns to 10 ms variable	40 ns to 40 μs variable	50 ns to 2 ms variable	1:1	400 ns to 100 μs
Exposure time	50 ns to 1 ms	20% of interframe	10 ns to 1 ms	10 ns to 100 μs	5 ns to 10 μs	50 ns	25 ns to 5 μs
Number of frames and size, H × W (mm)	1: 20×20 2: 20×10 4: 10×10 8: 7×10	8: 6×18 16: 8×18 4: 30×18 (LC)	64 (max.)	8: 16×15 12: 14×16 18: 14×10 24: 14×7	3: 17×25 5: 11×25	12 – 26 typical 25.4×19	1: 25 (diam.) 3: 16×18 6: 8×12
Minimum exposure time	25 ns	Fixed to framing rate	10 ns	10 ns	5 ns	500 ns	25 ns
Streak unit	Yes	Plug-in control	No	PC control	Plug-in control	Turbine control	Yes
Streak speed	50 – 1250 ps mm^{-1}	1 ns to 100 μs mm^{-1}	n/a	1 ns to 10 μs mm^{-1}	0.4 ns to 200 μs mm^{-1}	Possible	n/a
Minimum time resolution	10 ps	200 ps	n/a	200 ps	100 ps	3 ns	n/a
Spatial resolution (streak) (lp mm^{-1})	7.6	12	n/a	Not specified	8	50 typical	Not specified
Delay to writing (ns)	500	Half interframe time	10	20	50	Not quoted	20
Recording media	Polaroid film	Film/digital	Digital	Film/digital	Polaroid film	Film	Film

8.2 Image tubes

The principle of the image converter camera centres around vacuum tube technology, which is a discipline not normally associated with photographic recording. In its simplest form, an evacuated envelope has a transparent *photocathode* deposited on the *input window* and a *phosphor screen* at the *output window*. Photoelectrons emitted from the photocathode when irradiated by light are accelerated to the phosphor screen by applying a high voltage between the cathode and screen, where the image projected onto the cathode is then visually replicated. This form of image tube produces a single image and exposure is implemented by electronic pulsing to switch on the tube. Submicrosecond exposures are normally achievable. However, to secure subnanosecond domains it is required that the tube becomes part of a co-axial line which is connected to a *pulse generator*.

Electronic cameras capable of producing multiframe sequences use image tubes with complex internal electrode assemblies that enable the beam to be moved progressively over the phosphor screen to create a series of discrete images. For many years image tubes were constructed from glass, but more recently the trend has been towards tubes that are manufactured from ceramics and a range of nickel alloys. This combination offers better dimensional accuracy.

The optical input and output windows are accurately parallel and made from a variety of different optical materials which have differing spectral transmission characteristics (Figure 8.1). This can be used to advantage where specific wavelengths or wavelength bands are to be recorded. To maximize the performance of image tubes used in high speed cameras, both the photocathodes and phosphor screens are selected for particular applications.

The types of tube described, which are used in commercially available cameras, rely on electrostatic focusing to generate the image on the phosphor screen. Earlier image tubes used magnetic focusing which produced better image quality but required large power supplies to generate the magnetic field produced by the solenoid type focusing coils.

To operate satisfactorily, the electrostatically focused *crossover tube* requires between 15 and 20 kV at a modest current of, typically, a few microamps. This power requirement can be satisfied by *voltage multipliers* which can be accommodated in housings the size of matchboxes.

8.3 Photocathodes

Photocathodes of transparent semiconductor materials are used for a number of applications, either directly or indirectly. In some instances the photoelectron output is *avalanche amplified* to produce an electronic signal. These devices are known as *photomultipliers* and can be employed to initiate recording of faint phenomena using electronic cameras. Photocathodes, as used in image forming tubes, utilize different principles in that an optical image focused onto the cathode causes ejection of electrons in proportion to the incident radiation. These electrons are then accelerated to and electrostatically focused on the phosphor screen which is held positive with respect to the cathode, thus reproducing an intensified photon image of the original scene. Intensification results from the additional energy imparted to the photoelectrons by the high voltage applied between the cathode and phosphor screen. When electrons impact the phosphor screen, light is emitted as they decay to lower energy bands.

Photocathode spectral sensitivity varies depending on the chemical composition of the layer, which

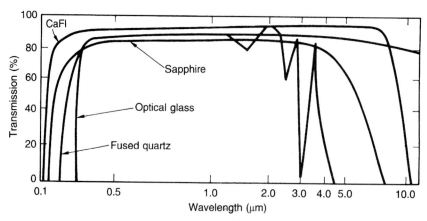

Figure 8.1 Spectral transmission characteristics of various optical materials.

is derived from reactive alkaline metals such as caesium (Cs), potassium (K), sodium (Na) and antimony (Sb). These materials are extremely volatile at 200–300°C, which is the temperature range in which photocathodes are processed. Accurate control of chemical composition is required to ensure maximum selected spectral sensitivity. A variety of typical spectral sensitivity curves is shown in Figure 8.2, with conventional identification codes such as S1 and S20.

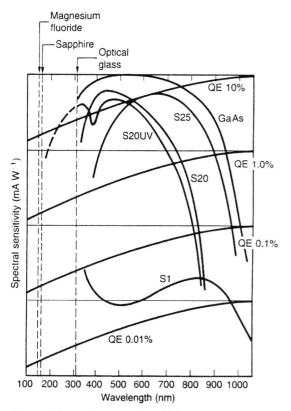

Figure 8.2 Typical spectral sensitivity curves for photocathodes. The dotted vertical lines indicate the limit of transmission of short wavelength radiation by various window materials. QE, Quantum efficiency.

Exposure to atmospheric pressure immediately destroys the photocathode as a result of rapid oxidation. The response to visible light is measured by illuminating the cathode with light from a standardized source calibrated at 2856 K. Quantum efficiency (QE), often quoted in photocathode specifications, is a measure of the conversion of photons to electrons and gives a definitive indication of the sensitivity at specific wavelengths.

Photoelectrons emitted from the cathode by the incident radiation are accelerated to the phosphor screen where a visual image is reconstructed. Image converter tubes can be used to change wavelengths, as ultraviolet and infrared radiation incident on the cathode can generate on the phosphor screen a visual image of phenomena which are normally invisible to the eye, assuming a cathode with the appropriate spectral sensitivity is used.

8.4 Phosphor screens

A phosphor screen is selected so that its inherent spectral output matches the spectral sensitivity of the recording medium (Figure 8.3). The output from a P11 type phosphor closely matches the peak

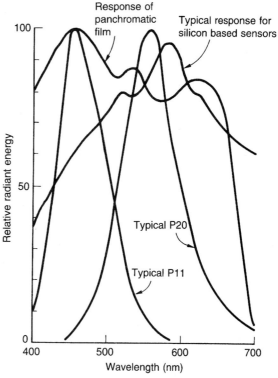

Figure 8.3 Spectral energy distribution characteristics of P11 and P20 type phosphors and the response of silicon based sensors.

sensitivity of panchromatic film, whereas the P20 type is more compatible with the response of silicon based CCD detectors. Effective recording sensitivity can be forfeited by a mismatch of tube components to the recording medium, be it either film or solid state sensors.

An extremely thin aluminium layer covers the phosphor to prevent light generated at the phosphor screen reaching the photocathode and causing secondary emission. In some tubes the conducting aluminium layer can be the anode, as phosphors are not electrically conducting.

8.5 The Imacon camera series

A tube design concept pioneered at the UK Atomic Weapons Establishment and later commercialized by John Hadland (Photographic Instrumentation) resulted in a versatile camera system (Imacon) for recording ultra-fast phenomena (Figure 8.4). The first Imacon camera was designed around a triode type image tube manufactured by Associated Electrical Industries (AEI) and in standard configuration offered framing rates up to 50 million pictures per second (pps). A derivative of this tube design was used in the later Imacon 675 design which is capable of framing rates of 600×10^6 pps and is still the fastest commercially available ultra-high speed framing camera being manufactured.

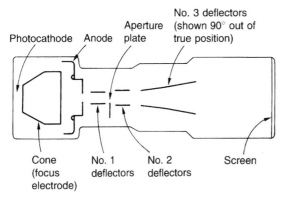

Figure 8.4 Construction and components of an Imacon 790 series camera tube.

The image tube as used in the Imacon 790 camera has a semi-transparent photocathode deposited on the ultraviolet transmitting sapphire input window and a phosphor coated screen on a fibre optic output. A series of deflection electrodes can shutter the electron beam to produce a sequence of discrete images on the phosphor screen.

Conventional optics focus an image on the photocathode which generates a beam of electrons in proportion to the incident radiation when a 17 kV potential is applied between the cathode and anode. When the electron beam is stationary a single focused image is displayed on the middle of the phosphor screen allowing composition of the subject and focusing. To record a sequence of images from a dynamic event a sine wave deflection voltage is applied to the shutter deflector plates which are situated in the drift section of the tube. When awaiting the trigger signal, which initiates the framing sequence, the electron beam is biased (deflected) onto the *aperture plate* to prevent premature exposure of the film.

When the electron beam is deflected over the slit in the aperture plate by the electrostatic influence of the high voltage sine wave an image is projected to and focused on the phosphor screen each time the beam passes over the aperture. To compensate for the rapid oscillatory movement of the electron beam a second pair of electrodes is positioned behind the aperture plate to which is applied a sine wave of the same magnitude and frequency to that of the shuttering potential but at 170° out of phase (Figure 8.5).

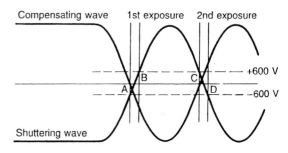

Figure 8.5 Shuttering waveform used for Imacon 790 series cameras.

After each pair of images has been recorded, a *step function* is applied to the shift plates which electrostatically deflect the electron beam laterally across the phosphor screen. The purpose of this *staircase function* is to prevent the *overwriting* of images recorded earlier in the sequence. The framing speeds are controlled by plug-in modules, which house tuned oscillators and can be changed in a few seconds. Two images are generated for each cycle of the sine wave; therefore, the framing rate is twice the frequency of the oscillation.

An alternative streak recording mode can be achieved by using plug-in modules that generate symmetrically balanced push–pull ramp voltages which are applied only to the shift plates on the image tube. This deflects the electron beam linearly across the phosphor screen, producing an intensity–time record. The sine wave operation, although extremely reliable, does not permit the flexibility offered by other methods of shuttering.

8.6 Recording methods

The visual image generated on the phosphor screen may be recorded directly on 3000 ISO Polaroid film which is held in intimate contact with the fibre optic output window. This recording medium produces a hard copy of the result in less than 30 s and analysis of the results allow immediate changes to be made to experimental procedures. Resolution of the Polaroid film is approximately 22 lp mm^{-1}, which is adequate under ideal recording conditions to accommodate the dynamic resolution of the camera.

Images displaying better dynamic range can be obtained using normal negative film materials but these require processing which extends the time elapsed before inspecting the recorded image. A further consideration is that the processing chemicals are now regarded as being dangerous and a potential health hazard. Results recorded on negative film can, however, be used for subsequent enlargement and publication purposes.

More recently a *digital readout* system has been developed for use with the Imacon 790 type camera (Figure 8.6) that has found wide acceptance as a means of recording dynamic sequences which can be critically interrogated using a personal computer

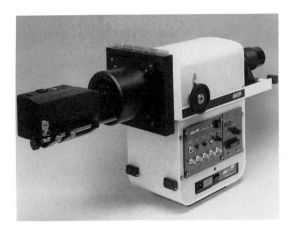

Figure 8.6 An Imacon 792 camera fitted with a digital readout system.

and dedicated software. The recorded image can be displayed on a high resolution video monitor within 0.5 s of the event being recorded and later can be transferred to the computer's hard disc for permanent storage. After the image sequence has been stored on the hard disc, rapid retrieval can be undertaken to allow further critical evaluation and measurement to be made without recourse to more time consuming analytical procedures, yet retaining overall flexibility to select results for the printed page. Hard copy prints can be available within 0.5 min, and these may supplement the engineer's notes, which can be particularly helpful for discussions away from the experimental facility.

The Imacon 790 series technology was first developed in the 1950s and in recent years electronic components have been dramatically improved, thereby opening up opportunities for circuit designers to incorporate new concepts in electronic cameras. Alec Huston put forward ideas which not only extended operational parameters such as variable interframe and exposure periods in electronic framing cameras, but also made it possible to use

much lower shuttering voltages. He advocated *control grids* in close proximity to the photocathode which would allow the electron beam to be more readily shuttered to enable variable interframe and exposure periods to meet changing experimental requirements.

This concept has been expanded upon in the Ultranac camera (manufactured by Imco) (Figures 8.7 and 8.8); however, some performance has been

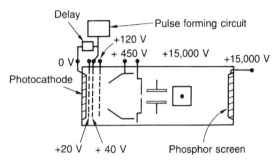

Figure 8.7 Construction and components of an Ultranac camera image tube. (Courtesy of Imco.)

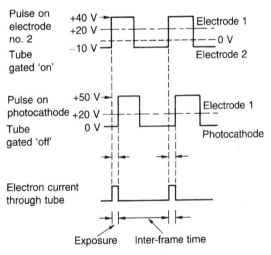

Figure 8.8 Shuttering waveforms used for Ultranac cameras. (Courtesy of Imco.)

compromised by the need to incorporate three control grids. The overall operational concept offered a marked improvement on previous cameras which have exposure times fixed to framing rates. The image tube incorporates current technological trends and is constructed from ceramic and stainless steel with fibre optic input and output windows.

Photocathodes are processed outside the tube and transferred to the image tube using vacuum transfer

techniques. The transfer process is particularly critical to avoid introducing secondary emission resulting from cathode materials deposited on the grids. The Ultranac camera incorporates solid state circuitry that permits programmable framing operations using a personal computer and dedicated software (Garfield and Riches, 1989).

Image sequences can be recorded using either Polaroid film packs or conventional negative film materials. Contact between film and output window is improved by an integral vacuum system. An optional digital recording system can be optically coupled to the camera output which both extends data collection and provides detailed analysis of the recorded image sequence. The framing formats offer between 8 and 24 images, depending on recording requirements. However, as with all single tube framing cameras, an increase in the number of frames per sequence results in a decrease in image format size. The camera also outputs programmable signals to trigger electronic flash lighting and/or to synchronize to other data collecting instrumentation.

8.7 The X-Chron 540 camera

This particular electronic camera (Figure 8.9) was developed to record X-ray and visible–ultraviolet emissions from fusion research (Hadland *et al.*, 1984). The camera has been designed around an image tube based on Photochron II geometry, which facilitates picosecond (ps) recording. The construction differs from that of more conventional image converter cameras because the image tube is continuously evacuated using a $50\,l\,s^{-1}$ turbomolecular vacuum pump which forms an integral part of the camera. A new approach was used in the design and manufacture of the image tube. Ceramic and stainless steel were used for two reasons: first, the dimensional accuracy required to ensure that the comprehensive specification could be achieved; and, secondly, to make the tube demountable to allow changes to be made to the electron optical configuration. The latter factor also allows the replacement of the cathode and extraction of the grid in the event of either sustaining damage during usage. The phosphor screen section of the tube can be replaced by either phosphors of different spectral output or solid state sensors.

A novel feature of the camera is a *manipulator* which allows inspection of the photocathode and grid for damage without the need to vent the camera to atmospheric pressure. The manipulator arm, to which the photocathode is attached, can be operated by an external control which is indexed to aid positional accuracy. If either the cathode or extraction grid have been damaged they can be changed in less than 5 min after the tube has been vented to

Figure 8.9 The Hadland X-Chron 540 camera.

atmospheric pressure. A needle valve is incorporated into the vacuum line to allow dry nitrogen to be used when venting the system. This dramatically reduces the time taken to pump down the system because water vapour, a serious contaminant to vacuum devices, is absent. For many applications the camera is bolted directly to the experimental chamber, and to avoid having to raise the camera to atmospheric pressure, an electropneumatic gate valve is used to isolate the camera from the chamber. The photocathode can be positioned to within a few micrometres by locating it on *register pins* secured to the interface between the manipulator and the camera tube.

The direction of incident radiation is tilted by 3° with respect to the electron optical axis of the image tube. This is to prevent direct X-ray excitation of the phosphor screen, which could mask the image produced by the photoelectron beam.

A number of different types of photocathode are available for use with the camera. For setting up and alignment, a resolution chart of photoetched gold on a Spectrasil substrate is used in conjunction with an ultraviolet source. This allows the electrostatic focusing to be accurately adjusted to optimize camera performance. Dynamic calibration of both the resolution and linearity of the streak ramps can be established using a high voltage electrical discharge.

To record emissions from dynamic phenomena, photocathodes are manufactured using a 30 nm thick gold layer which has been evaporated onto a 50 nm thick parylene substrate. Free formed caesium iodide can also be used for emissions up to 25 keV, but this type of cathode is more vulnerable to physical damage. Cathodes used in the X-Chron 540 are considerably longer than those available in other electronic cameras for X-ray recording and have an effective length of 20 mm. The delicate photocathode is formed on a metal support which can be attached to the manipulator arm for active use.

8.8 Streak recording

Although the X-Chron 540 camera was designed for both framing and streak operation, to date all the users have satisfied their recording demands with the streak facility which is derived from the proven Imacon 500.

A wide range of *writing speeds* can be provided, ranging from 20 ps mm^{-1} to 5 ns mm^{-1}, using modular drive units. Variants of other Imacon 500 drive circuits are available including *synchroscan* operation in the range 65–250 MHz. Trigger signal jitter is normally ±20 ps and delay to the start of writing is 8 ns at maximum writing speed.

For recordings which require subnanosecond temporal resolution a 40/40 proximity focused microchannel plate (MCP) intensifier is required, which is supported by circuitry incorporated in the camera.

The streak image produced on the 50 mm diameter phosphor screen is recorded directly onto 3000 ISO Polaroid film placed in intimate contact with the fibre optic output window. For a more critical assessment of the recorded image, a camera such as the Hadland Photonics 2D PC can be used (Bowley, 1987). This incorporates an intensified CCD sensor with 576 × 385 pixel resolution which is electronically cooled to −30°C to improve the signal to noise ratio and allow the image to be digitized to a full 16 bits. Both the hardware and software are well proven and have been used on the Imacon 500 for a number of years. This type of digital system has extended the scope of streak cameras by allowing the integrity of the image to be examined and quantitative data to be confirmed. A full range of dedicated analysis software functions complement the hardware package.

8.9 Cine X-ray systems

The dynamic processes of many fast phenomena are obscured by secondary by-products of the event. As a result the possible investigation will be unsatisfactory using conventional photographic techniques. To record such events *cine X-ray systems* have been used with considerable success to penetrate the smoke, plasma and dust, which would otherwise totally obscure detailed recording of the process. By combining different types of X-ray source with electronic X-ray intensifiers and image converter cameras, it has been possible to record sequentially events with velocities up to 8 km s^{-1}. A typical system is the Hadland Imacon type 792LC image converter camera with large cathode. For events that require more modest exposures to arrest image movement X-ray sources may be used which can be pulsed for 2 or 3 ms duration.

This type of system then relies on the exposure time of the camera to be sufficiently short to capture the event without image blur. However, for phenomena with velocities of 8 km s^{-1} very much shorter exposure times are required. As the framing rate of an Imacon 792LC camera is directly linked to exposure time a different approach was necessary to record the mechanical processes under investigation. Flash X-ray sources offer very short duration pulses, typically 20 ns, but the physical size of the flash tube head makes it unsuitable for sequential recording from a common viewpoint, thereby making quantitative results difficult to interpret.

The Hadland Imax system (Figure 8.10) was developed to offer sequential radiographic recording from a common viewpoint which then makes detailed analysis less complicated. This system consists of a multi-anode flash X-ray source and an X-ray intensifier to convert the X-ray shadowgraph to a visible image which can then be recorded by the final component, a high speed image converter camera (Honour, 1992). Previously, limitations experienced with this type of system were overcome as the direct result of using a phosphor with submicrosecond decay characteristics on the output window of the X-ray intensifier. The longer decay characteristics of phosphors normally used in the intensifier stage resulted in image degradation caused by *image retention*. If the phosphor decay time is longer than the recording interframe time, the image retention causes confused detail and poor contrast. The longer the duration of the recording time, the greater is the loss of image quality. Incorporating a submicrosecond decay phosphor allows satisfactory framing rates up to 10^6 pps. However, to record an ultra-fast event using a single X-ray pulse of 20 ns duration, the phenomenon described above again becomes the limiting factor.

Flash X-ray sources used with intensifier screens

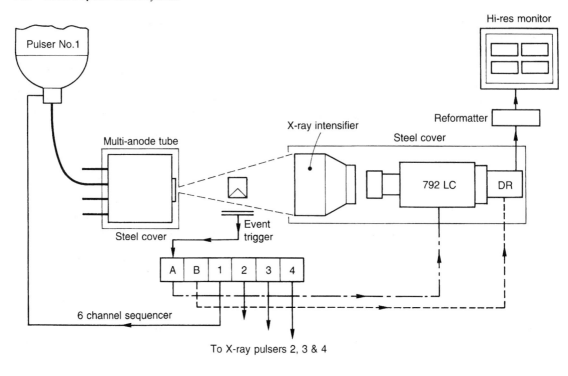

Figure 8.10 Schematic drawing of the Imax flash X-ray system.

and photographic film produce excellent results, with exposure times in the nanosecond region. Sequential radiographs of very fast events are possible, but the physical size of the X-ray source dictates that subsequent images are recorded from widely differing viewpoints, making meaningful analysis more difficult.

Using a multi-anode flash X-ray source in place of individual heads offers cine radiographic recording from virtually a common viewpoint. When synchronized to the exposure period of an Imacon 792LC camera, these individual sources offer temporal resolution of 20 ns, irrespective of framing rate.

A *delay generator* can be used to synchronize the 20 ns duration flash X-ray pulse to the framing sequence of an Imacon large cathode image converter camera. Changing from one framing rate to another requires the triggering of the X-ray sources to coincide with the exposure period of the camera. This necessitates the accurate synchronization of the X-ray pulses to the fully exposed period of the individual frames (Figure 8.11).

Because at slower framing rates the exposure time of an Imacon 792LC camera is directly linked to framing rate, the exposure period is longer and shorter at higher framing rates. Consequently, the *sequencer* is necessary to synchronize the X-ray pulses to the camera.

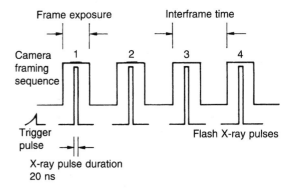

Figure 8.11 Exposure and synchronization characteristics of the Imax flash X-ray system. Interframe and frame exposure times vary with framing rate.

8.10 Ultra-fast electronic streak cameras

An ultra-fast type electronic camera has been designed for streak recording of phenomena with time scales in the picosecond and subpicosecond domains. Experimental procedures that would be studied using this type of camera are invariably confined to laboratories that concentrate on laser related investigations. As laser pulses have become

shorter, the greater have become the expectations and requirements of the recording instrumentation by the scientist.

More detailed images in terms of qualitative and quantitative records have now pushed the development of streak type image converter cameras almost to the limits of what is physically possible. A temporal resolution of 250 femtoseconds (fs) is now a reality, during which time light travels only a few tens of micrometres.

In many instances the sensitivity of the camera is inadequate to record the emission from the laser induced phenomena being investigated at time scales which permit detailed examination. The need for additional intensification of the image for recording has resulted in highly sensitive solid state imaging systems which combine high gain MCP intensifier systems that are fibre optically coupled to silicon based sensor arrays. The whole image acquisition package requires a *controller* which exceeds normal manual capabilities and incorporates a sophisticated management system based around microprocessor technology.

Image tubes used in ultra-fast streak cameras have to meet rigid constraints imposed by the temporal domains of the events under investigation. A number of different modular drive circuit configurations plug into the basic camera mainframe to extend the flexibility of operation. These modules include one for *single shot operation*, where one exposure has to provide enough photoelectrons to produce a recordable image. Similarly, *synchroscan operation* is used to record a repetitive event of low intensity and relies on a very high frequency power oscillator to scan the electron beam across the phosphor, building up an image with time. For the latter type of operational mode to produce satisfactory results, the repetitive path of the electron beam must accurately *overwrite* across the same part of the phosphor screen. The trigger used to drive the oscillator is derived from the experiment itself and can operate at frequencies between 70 and 500 MHz. Alternatively, *retrace blanking* can be used in a similar manner to synchroscan. However, for this function to be beneficial, the return sweep of the electron beam must be biased off the phosphor screen. The trigger to synchronize the oscillator to the event is again derived from the experiment, operating between 70 and 500 MHz. The precise control operations required for both synchroscan and retrace blanking necessitate a high degree of sweep linearity, which imposes rigid constraints on both tube and circuit design.

The spectral response of the photocathodes used in streak tubes is particularly important as many of the events under investigation have emission in the near infrared. Recent improvements in the S1 type photocathode has extended sensitivity to 1.6 μm. The input optics have to be carefully matched to the spectral response of the image tube and depend on the application.

8.11 High gain image intensifiers

For many low luminosity events it is necessary to increase the intensity of the image forming light reaching the sensitive material to a level which will then produce a recordable image at framing rates that allow an adequate sequence of images for analysis. Often an image converter camera which has an inherent optical gain of some 50 times requires additional sensitivity to produce an adequately exposed image. Film cameras, which are many times less sensitive than their electronic counterparts, require even greater intensification to compensate for the light losses resulting from complex optical systems.

To record faint events which have spectral emissions outside the range of the camera it is also necessary to increase, and sometimes convert, the incident radiation to produce visible images. Intensifiers have been used at the output stage of image converter cameras, but often with accompanying design trade-offs that restrict image size, reduce the image sequence to fewer frames and introduce distortion.

Hitherto it has not been possible to use intensifiers in front of high speed cameras because the output phosphor has long delay characteristics, causing *image stacking*, which in turn reduces contrast and resolution. Image degradation results from the early images that are part of a rapidly changing event being retained on the phosphor screen, resulting in poor resolution and low contrast of later frames.

Fast decay type phosphors have been developed which exhibit extremely short retention characteristics, and these are now available for image intensifier screens, allowing the device to be used in front of cameras. The design of the Hadland Cinemax camera incorporating high gain image intensifiers has been described by Honour and Hadland (1987). Typically, decay times for some of these phosphors is 300 ns, to 10% of maximum brightness (Figure 8.12), which allows recording at framing rates up to 10^6 pps using image converter cameras.

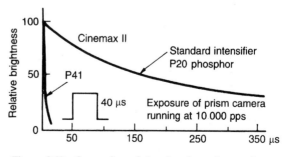

Figure 8.12 Comparison of phosphor decay times and camera exposure.

Other constraints imposed by the fundamental nature of image intensifiers require that adequate protection circuitry is incorporated to prevent damaging the tube. To achieve a worthwhile brightness gain a number of individual intensifier tubes are optically coupled together by fibre optic plates to produce a module which has a typical photon gain of 2.5×10^5 for white light. However, this is later reduced when optically coupled to the camera. The careful selection of photocathodes, phosphor screens and the transmission of the input windows has resulted in an image intensifier with ultraviolet sensitivity to 180 nm making it ideal for recording of hydroxyl (OH^-) radical emissions characteristic of 'lean burn' combustion in automobile engines.

The operational functions of the Cinemax II camera and the overload protection afforded to the intensifier module are controlled by a dedicated microprocessor (Honour, 1993). Tactile controls and visual indicators allow a definitive recording performance necessary to meet the requirements of the most stringent engine research programme.

As an indication of performance, when used in conjunction with image converter cameras it has been possible to record at 10^6 pps using the light of a single candle.

8.12 Single frame electronic cameras

Many different types of *single frame electronic cameras* have been developed, encapsulating a wide spectrum of technical ideas. For many applications a single short exposure image can detail fast phenomena within that time domain. However, to investigate complete mechanical processes a sequence of discrete images is necessary to record those rapid changes. If consideration is given to the operation of single shot devices, it becomes apparent that for some dynamic processes adequate data can be obtained using this type of camera. A camera produced by Proxitronic incorporates a high resolution proximity focused intensifier that is fibre optically coupled to a CCD sensor and operates at a framing rate directly linked to mains frequency. This type of camera records at 50 fields per second which are interlaced to produce 25 images (frames) per second. However, it is possible to control the effective exposure time by gating the intensifier synchronously with the frame rate. Frame exposures down to 1 μs are possible and this value is orders of magnitude shorter than the normal 20 ms integration period (exposure) for this type of camera. This camera can be operated in a number of different modes and the standard recorded image sequence of 25 fps can be stored on S-VHS tape. Single images can be held in a solid state frame store device.

The ease with which the camera can be synchronized to the event allows comprehensive time sampling of repetitive events. However, to detail the complete dynamic process of an event requires a sequence of images, therefore, a *multi-framing camera* is essential.

A camera giving a single high resolution digital image can provide adequate data from an event, a notable example being the Hadland Photonics SVR camera (Figure 8.13) which has, on many artillery proof ranges, replaced mechanical streak cameras (Bowley, 1988; Speyer, 1990). The quality of images available from this camera is comparable to that from some film cameras, but with the added advantage that the result can be displayed within 0.5 s. Furthermore, because the image is stored digitally, it can be subsequently critically interrogated using a personal computer (PC) and dedicated software, thereby allowing changes to test procedures to be made with minimum of disruption to the overall programme.

Figure 8.13 The Hadland Photonics SVR camera.

Unlike many of the single shot electronic cameras, the SVR has been designed and packaged for a specific application. Consideration has, therefore, been given to the requirements of high speed image acquisition in hostile environments and the construction incorporates features not found on other single frame cameras.

The CCD sensor used in the SVR camera has 1134×468 pixels and generates an image with over half a million information points. To allow different types of intensifier to be incorporated, high aperture optical coupling is used between the intensifier and sensor stages. The image is downloaded via a RS 232

link to a dedicated framestore, which is normally situated away from the immediate test area. Local controls on the camera allow focusing and image composition on the camera's integral monitor and for tests to establish correct exposure for recording the dynamic event. Once the camera's position has been confirmed it can be remotely controlled by the PC secured in a protective bunker. A single flash is normally adequate to illuminate the projectile; however, multiple flash heads can be synchronized to provide lighting for special effects when the camera is rapidly re-triggered. To record the projectile at different trajectory positions, multiple camera heads can be multiplexed to operate from the control computer. Exposures of 1 μs are possible in appropriate daylight conditions, without additional lighting. A colour version of this SVR camera adds an additional dimension to an already high resolution image. The single optical axis is divided into the necessary three image-forming paths by means of beam splitting optics. Narrow bandpass complementary filters are interposed in the image forming light paths between the beam splitter and CCD sensors. Software recombines the three separate images to display a colour image with high resolution on the display monitor which can, for example, highlight areas of temperature variations. The colour SVR can also be used to record a sequence of three discrete black and white images. Comprehensive analysis software can be implemented to determine accurately measurements of distance, velocity, angles and area, within a few minutes of the images being recorded.

8.13 CCD technology for high speed cameras

The standard recording parameters of CCD based cameras are limited by the long integration period and the time required to transfer the image from the sensor. This means that effective exposure times are too long for ultra-fast image acquisition and also that the transfer process limits the number of frames that can be recorded in a given time scale. To overcome this problem it has been possible to combine CCD and proximity focused image intensifier technologies with considerable success. This particular type of intensifier, which offers image quality of high resolution and exhibits virtually zero distortion, can be fibre optically coupled to the CCD for use as a high speed shutter.

Two types of proximity focused intensifier are in general use: *generation one* (G I) and *generation two* (G II) (Figure 8.14). A third generation device (G III) is available, but its use for normal high speed photographic applications is restricted by cost.

The generation one proximity focused device uses a simple construction with input and output fibre optic windows on which are deposited a photocathode and phosphor screen, respectively. By applying a short high voltage pulse across the tube it can be made to behave as a *fast shutter*. The high energy photoelectrons traverse the small space between cathode and screen to produce a focused visible image on the phosphor. The photon image is relayed to the CCD sensor via a fibre optic coupler. Typical spatial resolving power for this type of intensifier is 40–45 lp mm^{-1} and the device has a gain of approximately 50 times for white light.

The construction of generation two tubes incorporates a MCP electron multiplier. This type of tube has two distinct advantages. First, it can exhibit high luminous gain, which can be readily controlled. Secondly, the tube can be 'gated' on and off by a much smaller voltage excursion, which in turn allows shorter exposure times.

Both of the systems described above are *single channel devices* where the recorded electronic image is held in a *frame grabber* and then transferred to a random access memory (RAM). The overall image quality of the recording system is dependent on the

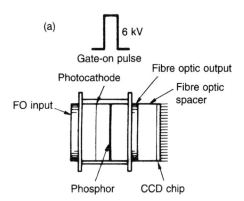
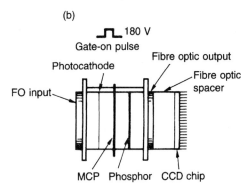

Figure 8.14 Proximity focused image intensifiers optically coupled to a CCD array via a fibre optic plate: (a) Generation I type; (b) Generation II type.

image tube, the number of pixels on the CCD and the level of digitization. For a recording system operating at room temperature (i.e. with no assisted cooling), a dynamic range of 256 grey levels (8 bit) is normal. To improve this performance any further requires a forced cooling system for the array, which increases both size and cost.

For some applications, a single high resolution image can provide relevant data from an event. However, where high speed processes have to be recorded in their entirety, to permit a fuller understanding of the mechanisms of that event, it is necessary to record a dynamic sequence of the phenomena under investigation. Sequential framing records have been produced by using a number of such single shot cameras mounted side by side. However, the geometric displacements of the individual optical axes introduce perspective anomalies during analysis of the recorded data, because each image has been recorded from a slightly different viewpoint. Hadland Photonics have resolved this problem by designing an optical beam splitter which allows up to eight framing and streak images to be recorded through a single optical input, marketed as the Imacon 468 camera (Honour, 1994) (Figures 8.15 and 8.16).

Normally, beam splitters impose restrictions that outweigh any advantages offered by this concept. This particular design, however, allows the iris diaphragm or aperture stop (which is managed by the in-camera microprocessor) to control both light transmission and depth of field using proprietary lenses. Engineered to the beam splitter housing are individual interfaces which allow multiples of the MCP single channel cameras to be used.

The miniaturization of electronic components has enabled the associated electronic circuits to be positioned to maximize recording parameters derived

Figure 8.16 The Hadland Photonics Imacon 468 camera.

from a 100 MHz quartz controlled clock, thus ensuring a high degree of temporal accuracy. Variable exposure, interframe times and gain for each individual channel are computer programmable. A fibre optic communications link facilitates high speed data transfer between the camera and the computer and eliminates signal degradation and interference. Image quality surpasses anything currently available from other electronic framing cameras and gives in excess of 221 000 information points per image. Geometric distortion is virtually eliminated and intensity variation is less than 5% across the image format. Simultaneous framing and streak recording of the event under investigation are possible, and are managed by a single PC, making this camera

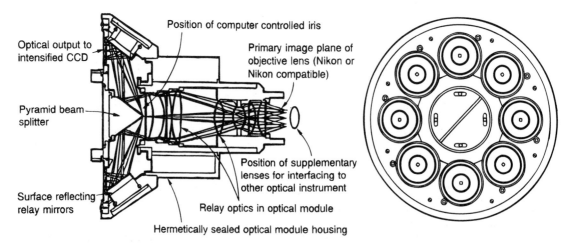

Figure 8.15 Schematic diagram of the optical module of the Imacon 468 camera.

possibly the most versatile design that current technology can provide.

8.14 Camera control

The increasing use of a PC to initiate and control experimental procedures has resulted in research becoming more reliable, because variables introduced by human performance have largely been eliminated. Moreover, the operational sequence can be coded and stored for rapid access to allow direct comparisons to be made. Although computer control has been extended to mechanical cameras, the inherent problems associated with overcoming inertia and friction still remain, limiting the advantages offered by this concept. However, the electronic camera can be accurately controlled using a PC, thereby extending its versatility.

Electronic cameras have been dependent on limited manual control; however, this has been restricted to basic functions such as the opening of capping shutters, placing film in contact with the image tube output window and focusing the camera lens. It is now possible to operate an electronic camera without direct manual input. Once the camera has been positioned relative to the event, all controls can be carried out remotely, sometimes at distances of 2–3 km.

It is possible to focus the camera lens, set the iris diaphragm to control depth of field and establish correct exposure level, all remotely from a PC, using either a fibre optic ground link or transmission by modem. Exposure levels can be readily adjusted and test images displayed in millisecond time scales, accommodating changing environmental lighting conditions, although with the high framing rates and very short exposure times involved, natural lighting has little influence on overall exposure.

The current trends in image converter camera control require that the operator sets up operational parameters by moving a cursor on the computer monitor screen or by using the keyboard and alphanumerics. Whichever option is used the result is accurate and reproducible recording sequences, allowing experimental data to be defined more readily.

Control software is invariably written by computer programmers who are conversant with the acquisition of high speed images. A sound understanding of the recording processes involved is particularly relevant to optimize software functions to acquisition requirements.

The use of CCD sensors, which are silicon based imaging devices, in place of photographic film, produces images which do not compare to film in terms of resolution and absolute image quality. The surface of the silicon device has been photomechanically etched to generate exceedingly small photo-sensor elements (pixels) which typically measure approximately 20×20 μm. Compared to the silver halide crystals in a fine grain emulsion these pixels are quite large. Moreover, they are not randomly dispersed. Consequently, an image produced by a CCD sensor will not be as detailed as that resulting from a fine grain photographic film. However, as technology improves this difference will become less obvious.

The convenience of having an image sequence displayed within a few hundred milliseconds of it being recorded represents a useful saving of time. Of equal importance is the fact that the image recorded by the CCD array can be digitized for computer evaluation. This permits critical interrogation using a PC and also allows an image to be modified and enhanced, so that recorded data can be selected and image definition improved.

Direct measurements can be made within seconds of the image sequence being recorded, allowing modification to experimental techniques. Images can be conveniently stored on small but easily accessible electronic retrieval systems and, importantly, because images are in digital form, a copy of a copy can be made without loss of image quality. Data from image sequences can be transmitted around the world by modems, connected to international telephone links, which considerably reduces the time taken by more conventional methods of image communication.

A wide range of video printers are available which produce excellent hard copy prints and transparencies for conference presentation.

The limitations of short recording times, a restricted number of images and reduced picture quality, are more than outweighed by the convenience and quantitative analysis that can be obtained using electronic imaging systems.

8.15 Lighting for electro-optical cameras

High speed image acquisition using ultra-fast cameras normally requires significant levels of subject illumination to produce correctly exposed image sequences. The complex optical path common in mechanical cameras necessitates that the illuminating source has to be particularly bright to overcome light losses encountered in the camera system. For example, to record at 10 000 pps with a rotating prism camera requires several kilowatts of continuous lighting, which invariably produces more heat than light.

From the usual equation for photographic exposure (H)

$$H = Et \tag{8.1}$$

where E is image illumination and t is exposure duration, it can be established that as time is

reduced illumination must be increased to maintain the correct exposure level. It then becomes apparent that, when recording at very high framing rates, illumination becomes a serious consideration. For example, to produce the necessary level of illumination for high speed recording may require a number of light sources, and if space around the event is limited, the logistics become increasingly difficult.

The light gain offered by an electro-optical camera combined with the use of large aperture lenses dramatically reduces the levels of subject illumination required. To use continuous lighting with an image converter camera has distinct disadvantages because excessive levels of illumination incident on the photocathode can have a detrimental effect and in some instances cause irreparable damage to the image tube. To reduce the possibility of damage to the photocathode, electronic flash units are used which produce adequate illumination that can be programmed to the recording duration. These electronic light sources have fast rise times and offer the additional advantage that they are virtually instantaneous and can readily be synchronized to both the event and the camera to ensure uniform illumination at the time of recording. The time window for recording fast phenomena is comparatively short; for example, an event such as a 0.303 calibre bullet travelling at 800 m s^{-1} penetrating a metal target requires a recording time of 100–150 μs. It is therefore necessary to concentrate the light output into this timescale.

To detect the start of the event a sensor is required which will generate a trigger pulse to initiate the electronic flashes and the camera recording sequence (Figure 8.17). There are a number of recognized methods of deriving appropriate trigger pulses that produce excellent image sequences from image converter cameras. To obtain a correctly exposed recording sequence, it becomes apparent that critical synchronization is an important requirement. It is therefore essential that event parameters are established before attempting to record the process under investigation.

It is fundamental that the trigger signal that initiates the recording sequence is derived early enough to enable the formative stages of the event to be recorded. This is particularly important when the event is not self-illuminating, and allowance must be made for an electronic flash to reach maximum output. Modern electronic circuits respond to input pulses within nanosecond time scales but a delay of a few tens of nanoseconds can cause the loss of information from the initial stages of an event. Often it is the early stages which provide the most interesting data.

For ultra-fast phenomena the synchronization of the experiment to the camera becomes a critical issue, particularly if the event is not self-illuminating. The rise time of an electronic flash unit is 40–50 μs to half peak; therefore, if a projectile is travelling at 2000 m s^{-1} (that is 2 mm μs^{-1}) the trigger detector has to be positioned at least 125 mm from the target to allow the lighting to reach maximum output. An *acoustic detector* would be used for this event, as this type of detector responds to the supersonic shock wave created by the projectile. Any projectile with a velocity greater than 340 m s^{-1} at sea level will create a shock wave.

If the detector is positioned at too great a distance from the target, then variations of velocity in flight

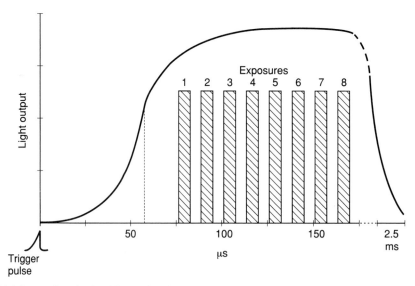

Figure 8.17 Lighting synchronization. The synchronization of electronic flashlight output with the framing sequence of an electro-optical camera using a trigger pulse.

can result in poorly synchronized images. Other fast phenomena such as high voltage discharges can be used to induce voltages in small coils of wire wrapped around the conductor to provide a simple yet reliable means of triggering the electronic camera. Some events have to be triggered from the camera to ensure recording of the total process. Under these circumstances, the electronic circuit transition time has to be taken into account so that recording is coincident with the start of the event.

References

Bowley, D. J. (1987) Two-dimensional analysis systems linked to streak and framing cameras. *Proc. SPIE* **832**, 210–215

Bowley, D. J. (1988) A new single shot high resolution video image capture system for ballistics photography. *Proc. SPIE* **981**, 331–334

Garfield, B. R. C. and Riches, M. J. (1969) A new programmable image converter framing camera. *Proc. SPIE* **115**, 457

Hadland, R., Bowley, D. and Honour, J. (1984) X-Chron 540 – a new picosecond X-ray streak camera. *Proc. SPIE* **491**, 1080–1094

Honour, J. (1992) Multi anode line flash X-ray system. *Proc. SPIE* **1801**, 643–648

Honour, J. (1993) Cinemax II. A UV sensitive image intensifier for combustion research. *J. Photogr. Sci.* **41**, 180–182

Honour, J. (1994) A new high speed electronic multi framing camera. *Proc. SPIE* **2513**, 28–34

Honour, J. and Hadland, R. (1987) Cinemax intensifier for high speed cameras. *Proc. SPIE* **832**, 361–364

Huston, A. E. (1983) Two grid gating. *UK Patent GB 2109659*

Speyer, B. (1990) High speed still video photography for ballistic range applications. *Proc. SPIE* **1358**, 1216–1221

9 Pulsed lasers in high speed imaging

Keith Errey

9.1 Introduction

Although a relatively recent development, lasers have been used almost since their invention as photographic light sources. The first laser was reported in 1960 (Maiman, 1960) and by 1964 (Leith and Upatnieks, 1964) the remarkable properties of laser light were used to record three-dimensional photographic images or holograms. Today, lasers are used in a wide range of applications in high speed imaging to produce results which are considerably superior to, or impossible to achieve with, conventional light sources. One of the most interesting aspects of the increasing use of lasers as high speed light sources is that they open the door to new analytical processes based upon high speed photographic techniques where the aim is to obtain a two-dimensional data set which may or may not maintain the 'pictorial' content of the image. A good example of this is *particle image velocimetry* (PIV) which is one of a growing number of quantitative techniques which are essentially 'photographic' in nature, but do not provide information in the form of 'pictures'.

Why use lasers? The aim of this chapter is to answer this question by providing information on the operation and design of the various laser systems most commonly encountered in high speed imaging applications. Since lasers are fundamentally different from non-laser light sources, a reasonable understanding of the basics of lasers and how these are manifested in actual devices will prove a worthwhile addition to the knowledge base of the high speed photographer and will enable him or her to critically read manufacturers' data sheets, more readily comprehend new work published in the scientific literature and apply the benefits of laser illumination efficiently and safely.

9.2 What is a laser?

The acronym *laser* for 'light amplification by stimulated emission of radiation' is now well known. The acronym provides some clues as to the characteristics of laser emission which set it apart from light generated by conventional sources such as incandescent lamps, gas discharge tubes and bulbs, and spark sources.

In 1905, Einstein proposed that a photon encountering an energized or excited atom or molecule could induce (or *stimulate*) the atom or molecule to emit another identical photon. Such an event can only take place if the excited species is in a favourable energy state and the radiative transition to a lower energy state (i.e. the emission of the stimulated photon) is allowed by the rules of quantum mechanics. For laser action to take place there must be a greater number of species in an appropriate higher energy state than in the correlated lower energy state. This essentially unstable condition is known as *population inversion* and must be established by an external energy source. Clearly, in a medium with an inverted population containing a large number of excited atoms or molecules, stimulated emission is exponential and rapid *amplification* occurs. However, in reality, most laser devices are in fact oscillators, that is amplifiers in which some of the output is returned to the input in the correct phase. This view of the laser as a tuned oscillator incorporating some amount of feedback is beneficial in understanding the operation of laser devices and has been used extensively in the literature (e.g. Yariv, 1976).

The process of stimulated emission by which one photon can generate a very large number of identical photons leads to the characteristic properties of laser light, since in this case 'identical' means being of exactly the same wavelength (or frequency), the same phase and the same polarization. Thus the light output from a laser tends to be monochromatic (of narrow bandwidth), coherent (in phase) and of high flux density (radiant power which is able to be delivered in the narrow bandwidth beam). All of these laser properties have been exploited for high speed imaging and other photographic applications.

It is instructive to consider stimulated emission compared to *spontaneous emission*, which is the process by which light arises in conventional light sources. In spontaneous emission, an energy source excites atoms or molecules which then lose energy by radiative (photon emitting) action in an essentially random process. Figure 9.1 illustrates the difference between spontaneous and stimulated emission.

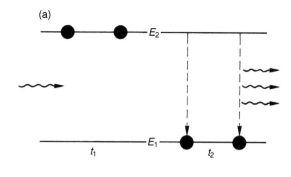

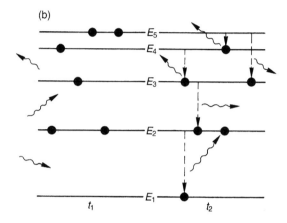

Figure 9.1 Stimulated and spontaneous emission. (a) Stimulated emission. A single photon gives rise to many identical photons. Energy state $E_2 > E_1$. A larger number of atoms or molecules are in energy state E_2. This population inversion allows laser amplification to take place. Time $t_2 > t_1$. (b) Spontaneous emission. Random photons from random events. No population inversion. Photons may possess any direction, phase or frequency as determined by the energy structure of the excited atoms or molecules.

Actually, many laser devices produce multi-wavelength (or multi-colour) outputs. However, in these cases the output is in the form of one or more laser emission lines the bandwidths of which are very narrow, generally much less than 1 nm.

Coherence is a property which sometimes causes confusion. A useful analogy which is often invoked is that of a troop of soldiers marching toward a bridge. It is well known that the order to break step is given to prevent undue forces on the bridge resulting from all left (or all right) feet hitting the road at the same time. If the soldiers were to proceed over the bridge, all marching in time (that is, in phase) without breaking step, the situation is analogous to a coherent beam. Crossing the bridge, out of step in random phase, resembles an incoherent light source such as conventional lighting or strobe sources.

Coherence may be measured across the beam

(*spatial coherence*) or along the beam (*temporal coherence*). It is related to other laser parameters such as laser *line bandwidth* and *beam divergence*, which refers to the amount by which a laser beam diverges from an ideal parallel beam (see Section 9.6 for further discussion on divergence). The *coherence length* differs from one laser type to another and in many high power lasers it is very short, typically a few centimetres or less. The coherence of a laser beam is the cause of the familiar *speckle pattern* often encountered when using laser illumination (see Section 9.6).

9.3 General laser components and types of laser

In general, a laser requires three elements or constituent systems to operate:

- A laser medium in which the stimulated emission takes place.
- An energy source to provide the energy to the laser medium. (In laser parlance the process of supplying energy to the laser medium is referred to as 'pumping'.)
- A laser cavity (or resonator) to provide feedback and/or the required beam characteristics. In its simplest form a laser cavity consists of two mirrors, one of which is partially coated to allow some of the light out of the cavity as laser output emission. The ratio of reflectance to transmittance of the output mirror is determined by the amount of gain in the laser medium and, consequently, the amount of feedback required.

Solids, liquids and gases are all used as laser media. In each category a range of different media is employed and energy sources and resonators are designed to be most efficient for each medium. Some basic understanding of the physics and engineering of the most commonly used lasers will enable informed choices to be made in the selection of the most appropriate laser for a particular high speed illumination requirement.

9.3.1 Solid state lasers

The first laser utilized a solid medium, namely, a ruby crystal (Maiman, 1960). Today all devices using solid laser media are generally referred to as 'solid state' lasers and in terms of the number of units are by far the most widely used. The main reason for this is that the ubiquitous low output *laser diodes* used in compact disc (CD) players and printers fall into this category. Solid state laser media may be optically pumped with photons from an external source or by electrons from a current

passing through the medium. An example of the former is the *ruby laser* in which a flash tube provides broad band, incoherent light which is absorbed and then re-emitted at a well defined wavelength by the ruby crystal. An example of the latter is the semiconductor diode laser in which stimulated emission occurs in the vicinity of the p-n junction.

9.3.1.1 Nd.YAG lasers

Although the ruby laser was the first to be employed as a very high brightness, short duration light source for photographic and holographic illumination, the solid state laser which is now the most commonly used in high speed imaging, particularly for PIV and other quantitative high speed visualization

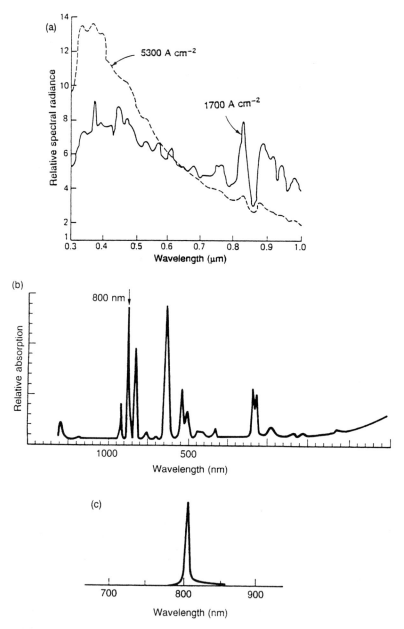

Figure 9.2 Spectral properties. (a) Xenon lamp emission spectrum. High current output from the lamp for optical pumping of Nd.YAG laser. Note the broad band black body background radiation. (From Koechner, 1992.) (b) Nd^{3+} Absorption. Note the strong absorption around 800 nm. (c) 805 nm laser diode output.

techniques, is the Nd.YAG laser. In this system trivalent neodymium ions (Nd^{3+}) are present as impurities in yttrium aluminium garnet and laser action occurs in the Nd^{3+} ions at 1.064 μm.

Nd.YAG lasers may be optically pumped by flash-lamps in a manner similar to the ruby laser or by semiconductor diode lasers. This latter technique is currently the subject of intense investigation and development since laser diode pumping offers a number of significant advantages over lamp pumping. Figure 9.2(a) shows the emission spectrum from a xenon lamp (most commonly used for high power pulse applications). Figure 9.2(b) shows the absorption spectrum of Nd^{3+}. Figure 9.2(c) shows the output emission from a laser diode which has been manufactured precisely to match the absorption peak at 805 nm.

From this it is clear that much of the radiant energy produced by the lamp is not used to excite the Nd^{3+} ions and some proportion is absorbed by the host YAG crystal, causing unwanted heating. The flash-tube itself also produces large amounts of heat which must be removed by often complex cooling arrangements. Conversely, the output of the laser diode is all absorbed, and because the diode produces only narrow bandwidth output without broad spectrum, black body heating, overall efficiencies are high. In addition, more thermally stable operation is possible and more compact and rugged systems may be realized. The disadvantages of laser diode pump sources are that they are expensive and still limited in the absolute amount of power they can deliver. Regardless of the pump source, Nd.YAG systems include the basic elements shown in Figure 9.3, with the resonator mirrors mounted externally to the laser crystal. Such an arrangement allows a number of additional components to be placed within the laser cavity (see Section 9.4.3).

The fundamental output of the Nd.YAG laser is 1.06 μm which is in the infrared. In order to use the Nd.YAG laser with common film or charge coupled device (CCD) cameras, a technique known as *second harmonic generation* (SHG) or '*frequency doubling*' is used to produce laser output at half the wavelength, namely, 532 nm. Frequency doubling exploits the very high power densities which may be obtained from a laser to produce a non-linear response in a crystal of suitable material (see e.g. Koechner (1992).

9.3.1.2 *Semiconductor diode lasers*

Semiconductor laser diodes are now finding applications in their own right as high speed imaging illuminators. Although laser diodes are available with a large range of output wavelengths, those of most interest for high speed imaging applications are around 800 nm, which is in the near infrared spectral region. The reasons for this may come as somewhat of a surprise to those who are used to regarding photography, particularly at high speeds and short exposures, as the domain of visible light illumination systems, and is related to the increasing use of CCD cameras. Figure 9.4 shows the spectral response of a standard silicon based CCD sensor. An illuminator with a wavelength of around 800 nm corresponds to the peak of the response curve and is therefore a good spectral match for a CCD camera.

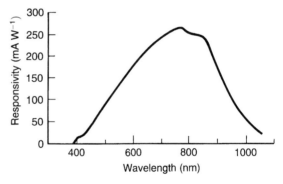

Figure 9.4 CCD spectral response. (Courtesy of EEV Ltd.)

Advances in laser diode development have produced readily available products with continuous output powers of 10 W or more. In pulse mode operation laser diodes can provide 100 W or more. Even at these power levels, diode lasers are very small since the laser resonator may be fabricated as an integral part of the device itself. Figure 9.5 shows a high power pulsed diode laser illuminator.

9.3.2 Gas lasers

Gas lasers are probably the most familiar class of laser at the present time. The helium neon (HeNe)

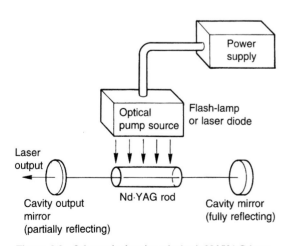

Figure 9.3 Schematic drawing of a basic Nd.YAG laser.

Figure 9.5 A 100 W high power laser diode system. The small size of the laser diode allows a complete system including laser and optical components for light sheet delivery to be integrated into the small black enclosure in the foreground. (Oxford Lasers Ltd.)

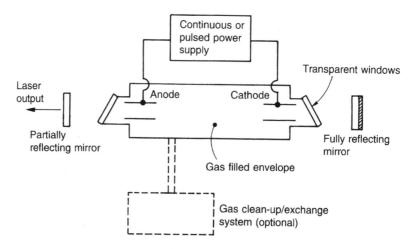

Figure 9.6 General features of a gas laser.

red (628 nm) laser is well known and employed in a large number of applications, but due to its low power is of little interest in this discussion. The two laser types which are most widely used for high speed illumination are both gas lasers, namely the *copper vapour laser* and the *argon ion laser*. Likewise, *excimer lasers*, which produce high energy ultraviolet output, have also been used for some specialized applications, particularly for visualizing processes by laser induced fluorescence (LIF).

Copper vapour, argon ion and excimer lasers are pumped by electrical discharges and, although the discharge parameters and circuit requirements are different in each case, these systems share the common feature of a gas contained within a volume which is directly excited by electrons from a discharge current. The gas envelope usually contains windows which allow the laser light to pass through. The laser resonator mirrors are then mounted outside the gas envelope. Figure 9.6 shows the general features of a gas laser.

9.3.2.1 Copper vapour lasers

Copper vapour lasers are inherently pulsed devices which produce short, high repetition rate pulses of laser emission at two visible wavelengths, namely 511 and 578 nm. The energy of each pulse is in the range of a few millijoules and the pulse length is around 30 ns (10^{-9} s). Taken together this means that the power in each pulse is of the order of 100 kW. Copper lasers are very efficient sources of visible laser output, being able to convert around 1% of the electrical input power into laser output power.

Pump power for the copper vapour laser is provided by a very fast, high voltage discharge circuit, and in lasers employed in high speed imaging applications the main switching element is generally a hydrogen thyratron. For other applications such as laser machining or laser isotope separation, solid state switches (e.g. thyristors) may be used in conjunction with magnetic components to increase the current rise time and voltage to that necessary for laser operation. However, the flexibility in repetition rate desirable for high speed imaging illuminators is best achieved by thyratron switched circuits.

The operation of the copper vapour laser is simple in concept. A high temperature ceramic tube contains copper heated by the electrical discharge to around 1400°C at which temperature the partial pressure of metal vapour is sufficient for the laser mechanisms to operate in the free copper atoms. The discharge tube is contained within a gas envelope containing neon at low pressure and is insulated to control heat loss. In practical systems, waste heat is removed by air or water cooling. All copper vapour lasers need a period of 'warm up' before laser output can commence. Typically this

period is around 45 to 60 min. Figure 9.7 shows schematically the construction of a copper vapour laser.

Apart from the copper vapour laser in which the metal in its elemental form is vaporized at high temperatures a number of other lasers utilizing the copper laser transitions have been devised and occasionally employed in high speed imaging applications, particularly in Eastern European countries. Typically such systems use a molecular species such as copper bromide to provide the copper atoms by

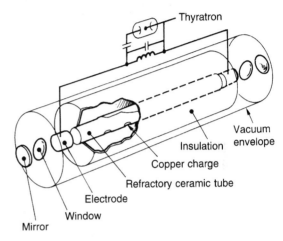

Figure 9.7 Schematic drawing of the arrangement of a copper vapour laser. (Oxford Lasers Ltd.)

dissociation of the molecule. This has some advantages since the dissociation occurs at a significantly lower temperature than that required in the elemental copper vapour laser. Lower temperature operation reduces some of the stringent high temperature engineering demands encountered in the design of elemental copper vapour laser systems. However, copper halide systems do not easily provide the same repetition rate flexibility, although in some cases very high repetition rate operation (greater than 50 kHz) is possible.

9.3.2.2 Argon ion lasers

Argon ion lasers are extremely versatile and widely used instruments, not only as high speed illuminators, but also in many areas of scientific research and development, industry and entertainment. The principal output wavelengths of the argon ion laser are the familiar blue-green lines at 488 and 514 nm. In addition to these lines there are many transitions in the range 275–477 nm. In practical devices only some of these may be selected to appear in the laser output. The electrical power to laser output conversion efficiency of argon ion systems is very low, being in the range 0.1–0.01%

according to the design and construction of the particular device.

Argon ion lasers have a very close relative in the *krypton ion laser*, which also produces a large number of discrete output wavelengths, in particular a relatively strong red line at 647 nm. Lasers containing a mixture of argon and krypton are available from several manufacturers. These mixed gas lasers produce *quasi-white light* outputs and have found a place in printing and entertainment (light shows, etc.). The relatively low output from these mixed gas lasers preclude their use as high speed light sources, despite their superficial attractiveness for full colour illumination.

The vast majority of argon ion lasers, and certainly all those in common use, are continuous output laser systems. Such lasers are commonly referred to as *CW* or *continuous wave* devices. Pump power is supplied by a high current power supply which provides a DC discharge through argon gas at very low pressure. The construction of the laser tube is somewhat complicated due to the need to stabilize the discharge, maintain a very high current density and remove the large amount of power which is not converted into laser emission and appears in the form of heat. Figure 9.8 shows the construction of a typical modern high power argon ion laser.

9.3.2.3 Excimer lasers

Excimer lasers are high pressure gas lasers which produce laser output from the dissociation of a rare gas halide molecule such as xenon chloride (XeCl) or ´krypton (KrF) fluoride. The main feature of excimer lasers is very short duration, high energy pulses in the ultraviolet. Typical wavelengths are 308 and 248 nm for XeCl and KrF systems, respectively. Pulse energies are 100–500 mJ with durations of around 10–50 ns. Peak powers are typically tens of megawatts.

Excimer lasers are of interest in high speed imaging applications for visualizing flow patterns in two phase (gas and liquid) flows by laser induced fluorescence techniques, particularly in combustion studies. In such work an ultraviolet sensitive image intensifier is usually specified. Excimer lasers are also used as pump sources for dye lasers (see below).

9.3.3 Liquid lasers

Organic dye lasers are by far the most common lasers that use a liquid as the laser medium. As shown above and in Table 9.1, the common high power lasers provide laser output at well defined, discrete laser wavelengths. However, for a number of applications, the ability to 'tune' a laser continuously over some range of wavelengths is necessary. Dye lasers offer tunable outputs by means of a solution containing organic dye molecules. The dye

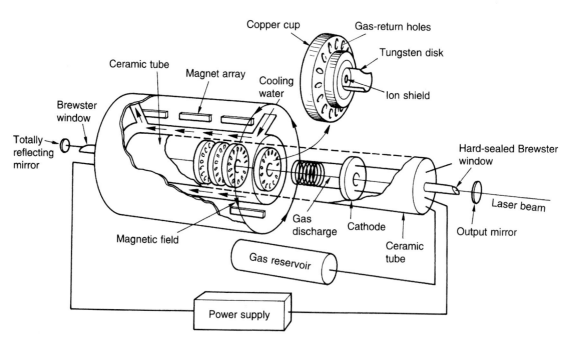

Figure 9.8 Schematic drawing of the construction of a modern high power argon ion laser. (From Davis, C. C. (1996) *Lasers and Electro-Optics, Fundamentals and Engineering.* Cambridge University Press, Cambridge.)

Table 9.1 Properties of lasers commonly used for high speed illumination

| | *Laser type* | | | |
Property	Copper vapour	Nd.Yag	Argon ion	Excimer
Wavelengths	511 nm (green); 578 nm (yellow)	1060 nm (IR); frequency doubled to 532 nm (green)	488 nm (blue-green); 514 nm (green); many others of lower intensity in the range 275–477 nm	193 nm deep UV (ArF); 248 nm UV (KrF); 308 nm UV (XeCI)
Average output power (W) (typical values for high speed imaging work)	10–35	1–5	1–20	20–40
Pulse technique	Inherent in laser medium	Q-switching in laser cavity	Shutter or optical switch external to laser cavity	Inherent in laser medium
Peak pulse power (typical values)	50–100 kW	10–200 MW (low pulse repetition devices) Around 100 kW (High pulse repetition devices)	1–20 W	10–200 MW
Pulse length (ns)	20–30	10–20	Selected by shuttering system	10–50
Pulse energy (mJ)	1–8	1 (high PR devices) to 500 (low PR devices)	Depends on pulse length (e.g. around 0.5 μJ at 30 ns, around 1 mJ at 90 μs)	100–500
Applications, notes/comments	Fast flows, combustion, sprays, ballistics, very high speed machinery. Excellent all-purpose illumination source for high framing rate cameras; good for analytic techniques such as time-resolved PIV	Large area flow fields, very dense sprays, combustion. Widely used for PIV techniques. High energy pulses but most available systems have low pulse repetition rate	Widely available in many laboratories redeployed from LDA/LDV systems. Very low peak powers and low pulse energies when pulses are very short. Good for slow flow PIV analysis	High energy UV output ideal for LIF imaging especially in gas flow fields. Requires toxic and expensive gases. Set-up and running costs are high. Cameras usually require image intensifiers

IR, infrared; LDA, laser Doppler anemometry; LDV, laser Doppler velocimetry; LIF, laser induced fluorescence; PIV, particle image velocimetry; UV, ultraviolet.

absorbs light over some range of wavelengths and fluoresces over another range. Provided the wavelength shift between the absorption and fluorescence bands is large enough the dye acts as an efficient wavelength converter. A laser cavity is placed around the dye and is designed so that only a very narrow band of wavelengths may be selected and amplified, thus giving a system which can be tuned over wavelengths within the fluorescence band. A range of laser dyes is available to cover the spectrum from the near ultraviolet to the near infrared.

Dye lasers must be optically pumped. Flash-lamp pumped dye lasers exist but, more commonly, dye lasers are pumped by other lasers. Copper vapour, argon ion, excimer and frequency doubled Nd.YAG lasers are all used for this purpose. It is important to note that in a dye laser, the dye output is always at a longer wavelength (or lower frequency) than the pump input.

Dye lasers have a relatively limited use in high speed imaging. They have been used to produce maps of combustion species in automotive and other engines by laser induced fluorescence by tuning the output of the dye laser to excite only one particular species such as OH or a particular NO_x compound (McMillin *et al.*, 1990). In another interesting application, a dye laser pumped by a copper vapour laser has been used for high speed cinematic holography (Lauterborn *et al.*, 1993). In this example the dye laser was essentially used as a coherence converter, since the coherence of the copper laser was considered to be too short for recording the holographic images.

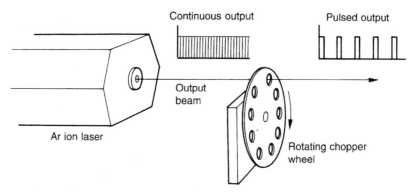

Figure 9.9 Pulsed output from an argon ion laser using a chopper wheel. Note that in this method of pulsing the laser does not increase the amount of power in each pulse. Electro-optic and acousto-optic shutters are also used.

9.4 Pulsed lasers

9.4.1 Inherently pulsed lasers

In the above sections we have encountered the copper vapour laser and the excimer laser. Both these lasers are *inherently pulsed* and, although the laser mechanism in each case is entirely different, each produces laser output in the form of pulses in the range 10–50 ns. Thus, for these lasers, no additional components or design work are necessary to produce the short pulses necessary for high speed illumination.

9.4.2 Pulsed output from argon ion lasers

Although pulsed output from argon ion lasers has been obtained using a pulsed electrical discharge circuit, commercially available argon ion lasers are all CW devices. In order to be effective as short duration light sources, some method of temporally chopping the output must be employed. The simplest device to achieve this is a mechanical chopper wheel (Figure 9.9), which is essentially a spinning disc with holes or slots. Whilst this is an effective and low cost approach, it is not clear that using the laser in this mode offers significant advantages over a lamp which may be chopped in the same way. Also, synchronization to external trigger signals is very difficult and the inertia of the spinning disc does not allow fast changes in the pulse length and repetition frequency.

A more sophisticated approach is to use an electro-optic or acousto-optic device to modulate the output. In an *electro-optic modulator* such as a *Pockels cell*, an applied electric field alters the optical properties (actually the birefringence) of a crystal in such a way that the polarization state of an incoming beam can be changed, typically being rotated through 90°. The crystal is placed between two crossed polarizers and an incoming polarized

beam will be able to pass through the cell only if subject to a change of rotation when the electric field is switched on. The typical transmission efficiency of a Pockels cell shutter is around 90%. A Pockels cell shutter is shown in Figure 9.10.

In an *acousto-optic modulator*, a transducer is attached to an optically transparent material with suitable acousto-optic properties. The transducer is driven at high frequency (about 40 MHz) and an acoustic wave is transmitted through the material, setting up a diffraction grating. Providing that the

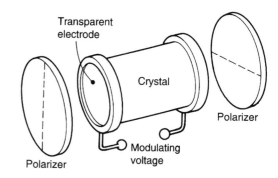

Figure 9.10 Pockels cell electro-optic switch. Pockels cells are used as fast shutters to provide pulsed output from argon ion lasers or as *Q*-switches in Nd.YAG lasers.

material parameters and acoustic wave frequency have been optimally selected for the wavelength of the incoming light, the beam is deflected by *Bragg scattering* when the transducer is on. When the transducer is off the light passes through the material without deflection. Figure 9.11 illustrates how this is used as an optical shutter or switch.

Both electro-optic and acousto-optic devices

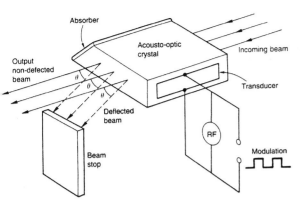

Figure 9.11 Acousto-optic switch. Acousto-optic devices may be used to provide pulsed output from CW lasers or to rapidly change the direction of the beam. They are also used as *Q*-switches in Nd.YAG lasers.

can operate as very fast shutters and are able to 'open' and 'close' in time scales of a few nanoseconds with effective pulse repetition rates of more than a megahertz. Commercial devices are widely available, and since most of these can be driven from standard pulse generators at TTL levels, system synchronization and operation are straightforward.

Because the argon ion laser is a CW device, in practice it is often used without any chopping or shuttering of the output. The short duration exposure times are obtained using a fast shuttered camera, in which case the laser is used in a manner similar to a lamp but with the additional laser properties that allow simple fibre delivery and the production of thin light sheets (see Section 9.6 below).

9.4.3 Pulsed output from Nd.YAG lasers – Q-switching

Nd.YAG lasers may be continuously (CW) or pulse pumped. In the case of pulse pumping, most high

energy Nd.YAG lasers are pumped with pulse durations in the range 0.2–20 ms. Even allowing for careful circuit design it is difficult to obtain pulses shorter than about 10 μs from the standard xenon flash tubes which are used for this purpose. If it were not possible to significantly shorten the pulse length of the laser output below the value of about 10 μs available from the xenon lamp, there would be little reason to use the laser as a fast illuminator and strobe source. An elegant technique known as *Q-switching* is used to achieve very short pulses (10–20 ns) from a Nd.YAG laser with high energies (typically 50–500 mJ).

Q-switching refers to altering the *quality factor* (*Q*) of the laser cavity. In a manner analogous to a tuned electrical oscillator circuit, *Q* is defined as the ratio of the energy stored in the cavity to the energy loss per cycle. Thus, the higher the *Q* factor, the lower the losses. *Q*-switching allows energy to be stored in the laser cavity and then released in the form of short, high peak power pulses. We should note that, in this case, the laser pulses are generated within the laser cavity.

The simplest method of *Q*-switching uses a rotating disc with a hole (Figure 9.12). As the disc spins there is only one position in each revolution in which the laser light is able to be reflected from the mirror and fed back into the cavity. The light which is fed back is able to bring about an enormous and rapid burst of amplified stimulated emission, which emerges from the laser as a short, high power pulse. *Q*-switching may be used with CW or pulsed pumping. In either case it is necessary to synchronize the rotating disc with the pump source so that there is an optimum amount of energy stored in the Nd.YAG crystal when the hole passes in front of the mirror. Although the rotating disc is simple to understand, all modern Nd.YAG lasers use either electro-optic or acousto-optic devices (see Section 9.4.2) as *Q*-switches. Figure 9.13 shows the arrangement of a typical Nd.YAG laser employing an intracavity Pockels cell *Q*-switch and an external frequency doubler to produce pulsed visible laser output.

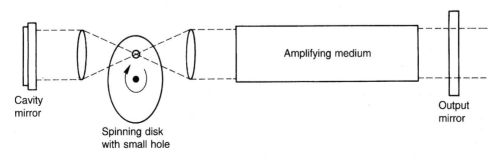

Figure 9.12 Rotating disc *Q*-switch.

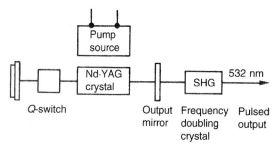

Figure 9.13 Schematic drawing of a Nd.YAG laser, showing the Q-switch and the frequency doubling crystal. This simplified representation does not show the often complex cooling system required for high power operation. SHG, Second harmonic generation.

9.5 Quasi-pulsed CW systems compared to inherently pulsed systems: argon ion laser versus copper vapour laser

It is possible to compare a 10 W argon ion laser with a 10 W copper vapour laser. Both of these laser systems provide intense output powers at around 500 nm and, as such, are used as general purpose illuminators for a range of photographic applications, including high speed work.

For the case of the inherently pulsed copper vapour laser the 10 W output power is the average output and is in the form of a train of short duration, high peak power pulses. A typical value for the pulse repetition frequency is 10 kHz and, as noted in Section 9.3.2, the pulse length is around 30 ns. The energy in each pulse is obtained from the relationship

$$\text{Power (watts)} = \frac{\text{Energy (joules)}}{t \text{ (seconds)}} \qquad (9.1)$$

and noting that

$$\text{Pulse repetition frequency (kHz)} = \frac{1}{\text{Period (seconds)}} \qquad (9.2)$$

hence

$$\text{Power} = \text{Pulse energy} \times \text{Pulse repetition frequency}$$

thus

$$\begin{aligned} \text{Pulse energy} &= \frac{\text{Power}}{\text{Pulse repetition frequency}} \qquad (9.3)\\ &= \frac{10}{10 \times 10^3}\\ &= 10^{-3} \text{ J}\\ &= 1 \text{ mJ} \end{aligned}$$

From Equation (9.3), using Equation (9.1), and noting that $t = 30 \times 10^{-9}$ s, the power of each pulse can be calculated to be 33 kW. (This assumes that each pulse is rectangular, which is not exactly the case but for this illustration is a reasonable approximation.) In summary, this shows that the copper vapour laser provides 10 000 pulses every second (10 000 Hz) and the power of each pulse is 33 kW. It is useful to note that the mechanism which provides the pulsed output in the copper vapour laser is in the laser medium itself.

Now consider the comparable situation for the argon laser, that is 10 kHz pulses with a pulse width of 30 ns. In Section 9.4.2 it was shown that 'pulsed output' from an argon ion laser was obtained by chopping or shuttering the beam. In this case the pulse mechanism lies entirely outside the laser system, which delivers a continuous 10 W beam. Using a Pockels cell or acousto-optic modulator it is relatively straightforward to obtain pulses at 10 kHz with a 30 ns pulse duration. However, since the laser provides a continuous 10 W, no matter how short the pulse duration is, each pulse will only deliver 10 W. In comparison to the copper vapour laser this is at least 3000 times less power in each pulse. Figure 9.14 shows this clearly.

An alternative way of looking at this is to consider the pulse energy, rather than the peak power. From the foregoing discussion it can be seen that the copper vapour laser has a pulse energy of 1 mJ. Using Equation (9.1) we can see that the energy in each argon laser pulse is $10 \times 30 \times 10^{-9} = 0.3$ µJ, which again is 3000 times less than that from the copper laser. In order for the argon laser to be useful and provide sufficient light for high speed photographic applications the pulse length needs to be longer than the 30 ns duration of the copper laser. In this case blurring criteria must be considered. In order for the argon laser to deliver the same energy per pulse as the copper laser, the pulse duration must be $30 \times 3000 = 90$ µs, which is very long for a pulsed strobe light source.

It is useful to recall that the pulsed output from a copper vapour laser is an inherent property of the laser and arises within the laser medium itself. For argon ion lasers, pulsed output is achieved by switching or shuttering the output, a process which, whilst retaining great flexibility in terms of pulse repetition rate and pulse duration, results in significantly reduced output power.

9.6 Why use lasers?

Now return to the original question: 'Why use lasers at all when a large number of conventional light sources have been developed and used as high speed illumination sources?'. The foregoing discussion has given an overview of the laser devices currently used

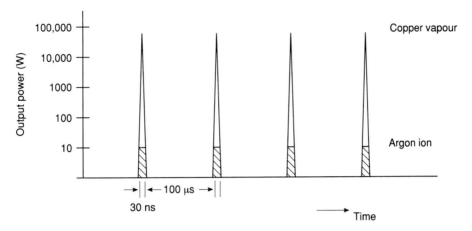

Figure 9.14 Comparison of the outputs of a copper vapour laser output and a pulsed argon ion laser. Note that the vertical axis is a log scale; the horizontal axis is not to scale.

in high speed imaging applications, and with this information the advantages (and occasional disadvantages) of lasers can now be better understood. The greatest difference between conventional light sources and laser sources is that, although conventional sources may be constructed to operate effectively with one or other of the key requirements listed in the following sections, only laser sources are able to achieve all of them simultaneously.

9.6.1 Very short pulse durations and high pulse powers

Conventional strobe or flash sources cannot achieve very short time duration and high pulse energy light output simultaneously. Even a specialized system such as the Strobokin unit using a quenched arc is only able to operate with pulse durations down to about 1 μs. Shorter duration spark sources are available, e.g. the Palflash unit, with a pulse duration of around 200 ns, but the light output is somewhat limited. Some very small flash units are available based on short duration sparks in air which provide pulse durations of less than 100 ns, but the output intensity is so low that, except for tiny subjects (a few square millimetres or less), such devices are not useful.

On the other hand a laser source is able to provide very short duration pulses (down to 10 ns) and very high peak powers in each pulse, particularly in the case of the copper laser or the Q-switched Nd.YAG laser. In these systems it is useful to recall that the energy in each pulse is contained within one or two narrow bandwidths rather than being distributed across an extended spectrum from the near infrared to the near ultraviolet as is the case for many conventional sources.

9.6.2 Low divergence output (high beam quality)

'Divergence' refers to the amount by which a light ray angles away from an ideal bundle of parallel rays, or the amount by which a nominally parallel beam or bundle of rays expands over some given length of travel. Divergence can be considered as a property of the photons in the beam and arises in the generation of the photons. In a laser where the photons arise through stimulated emission it is clear that the laser output beam will tend to be of low divergence. Although many conventional sources approximate point sources, a close analysis shows that the arc or discharge is actually distributed over a relatively large area and, unlike stimulated emission, the light output, which arises from spontaneous emission, has no inherent directionality (see Section 9.2). Various reflector and lens configurations have been devised to collimate the light output in order to increase the power density over the area of interest, but none of these comes close to matching the laser as a low divergence light source.

Divergence is important since it is the low divergence of the laser which allows the laser to be focused into small diameter spots for efficient transmission down optical fibres and for the production of thin light sheets. Whilst a number of xenon strobe systems now use *light pipes* (often liquid filled with diameters of around 5 mm) to deliver light to the point of interest, these light pipes are limited to very short lengths (typically 200–500 mm) and relatively low coupling and transmission efficiencies. Laser light, on the other hand, can be focused into optical fibres with diameters less than 1 mm, with coupling and transmission efficiencies of 70% or more and lengths of up to tens of metres. Thus laser illumination offers the possibility of decoupling the light

source and the subject, a considerable advantage when illumination in difficult, restricted or hazardous areas is required.

The low divergence of the laser also makes it possible to tightly focus its output in one dimension in order to produce a *light sheet* with sufficient intensity for analytic imaging techniques which rely on scattering, diffraction or fluorescence from particles or droplets in a gas and/or liquid flow field. Without laser illumination, these techniques are not practicable over any area large enough to be of interest.

A final point on divergence which is worth noting. Since the divergence of a beam is in some sense inherent, there is no way that the familiar tools of geometrical optics (lenses, mirrors, prisms, etc.) can reduce this divergence. Although it is a common procedure to 'reduce the divergence' by expanding the beam, this really does not help much if the requirement is for a tight focal point. Essentially there is a quantity which is invariant for a light beam propagating through an optical system and that is the *Diameter × Divergence product*. For low divergence beams which can be focused to small points or can be used to form thin light sheets, it is necessary to generate low divergence output from the source, and this is where lasers have an undisputed advantage over conventional light sources. Laser manufacturers generally give figures for beam diameter and divergence, usually in milliradians (mR), in published data or specification sheets. The divergence of the laser output beam must be taken into account when designing beam delivery and other optical systems involving lasers.

9.6.3 High pulse repetition frequency

Although a number of flash and spark sources are able to provide illumination at multi-kilohertz pulse repetition rates, the time for which the illumination sequence can be sustained is usually very short, of the order of a few milliseconds. On the other hand, lasers, particularly the copper vapour laser and the frequency doubled Nd.YAG laser, are able to operate at multi-kilohertz pulse rates for as long as required. In addition, high repetition rate conventional sources are often notoriously difficult to synchronize to the event under study as well as to the camera. Synchronization of the laser source is generally simple.

9.6.4 Advantages of laser sources

The overall advantage to be gained by using a laser source is that the points covered in Sections 9.6.1–9.6.3 can be achieved simultaneously, and it is this concurrence which makes the laser a unique and desirable tool for most high speed imaging applications.

9.6.5 Disadvantages of laser sources

Laser sources are by far the most versatile and useful high speed illumination devices at the present time. Yet, despite this, lasers are not a universal replacement for conventional sources in all applications. Lasers, as we have seen, are able to provide extremely bright and very short pulses of light, but the absolute quantity of light can often be limited so that photographing a large object may be difficult. In cases such as this where very large areas require large amounts of light, a large conventional strobe is likely to produce a better result.

Secondly, lasers generally cannot provide white light illumination and those lasers which can produce white light (from several discrete laser lines) are low power CW devices and not very useful. A high power, pulsed white light laser could be manufactured but the cost would rule it out for fast illumination work. White light is best provided by conventional strobes or very bright continuous arc lighting, in which case some kind of shuttered camera is required.

A third difficulty which sometimes arises is that the *coherence* of the laser produces a speckle pattern, especially if the beam is projected onto a screen for backlighting. Speckle makes an extremely poor background and can often lead to misleading results if included in the image. Fortunately, the coherence of the copper vapour laser and the Nd.YAG laser is relatively low and several methods to overcome the effects of speckle have been devised. The simplest and easiest method uses an optical fibre to deliver the light. Transmission along the fibre tends to reduce the coherence by a process known as *mode scrambling* (or, often, simply *scrambling*). Bending the fibre several times through a series of curves just outside the minimum bending radius further enhances scrambling and usually can remove virtually all the coherence in the laser output from the fibre. Speckle is not a problem when illuminating from the side, as is the case with sheet lighting.

9.7 Applications of lasers

The applications of lasers as high speed photographic illumination sources are very wide and for a comprehensive treatment a whole volume would be required. Lasers have been used for most high speed imaging applications, and generally, apart from the limitations discussed above, are preferred as illumination devices over earlier high speed flash or strobe systems, for reasons of ease of use, smaller size and superior performance.

A small selection of laser applications are shown in the figures at the end of this chapter.

9.8 Safety

Safety is an important consideration when lasers are used for illumination. In general, all the lasers used for high speed photographic and imaging applications are *class 4* lasers. Essentially this means that at all times the laser output beam must be considered hazardous and all relevant safety precautions should be taken. Large institutes and companies often have their own safety rules for the use of laser equipment; however, where this is not the case, a small volume published by the Laser Institute of America, is recommended (Smith, 1993), which provides a useful and readily comprehensible guide.

The safety of laser devices is covered by two principal standards, one for Europe and one for the USA:

- BS EN 60825: 1992 *Radiation safety of laser products, equipment classification, requirements and user's guide* (British Standards Institution, Milton Keynes).
- 21 CFR Parts 1000 and 1040 *Laser Products; Amendments to Performance Standard; Final Rule.* (Federal Register Part III, Department of Health and Human Services, Food and Drug Administration).

Both these publications contain a useful amount of background information pertaining not only to the manufacturing requirements for laser equipment, but also to their safe use. However, where lasers are used for illumination purposes, it is necessary to recognize that not all safety recommendations can be followed to the letter. A good example of this is that all beam paths should be enclosed. But this is often very difficult in practice when it is necessary to illuminate a subject, and the whole idea of the set-up is to capture some of the scattered or reflected laser light with the camera. In such cases, a good understanding of the operation and safe use of the laser is essential, as is the use of personal protective equipment (usually laser safety spectacles) by those working in the vicinity of the laser.

Used with safety, skill and imagination, lasers are superb tools for high speed qualitative and quantitative visualization and imaging.

References

Koechner, W. (1992) *Solid-State Laser Engineering.* Springer Series in Optical Sciences. Springer-Verlag, Berlin

Lauterborn, W., Judt, A. and Schmitz, E. (1993) High-speed off-axis holographic cinematography with a copper-vapor-pumped dye laser. *Optics Lett.* **18**, no. 1

Leith, E. N. and Upatnieks, J. (1964) Wavefront reconstruction with diffused illumination and three dimensional objects. *J. Opt. Soc. Am.* **54**, 1295

Maiman, T. H. (1960) Stimulated optical radiation in ruby masers. *Nature* **187**, 493

McMillin, B. K., Lee, M. P., Paul, P. H. and Hanson, R. K. (1990) Planar laser induced fluorescence imaging of shock-induced ignition. In *Proceedings of the Twenty-Third Symposium (International) on Combustion*; pp. 1909–1914. The Combustion Institute

Smith, J. F. (ed.) (1993) *Laser Safety Guide.* Laser Institute of America, 5151 Monroe Street, Toledo, OH 43623, USA

Yariv, A. (1976) *Introduction to Optical Electronics.* Holt, Rinehart and Winston, New York

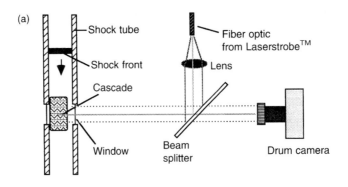

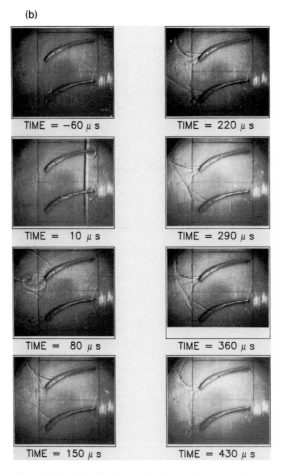

Figure 9.15 Visualization of shock waves in aeroengine vanes. (a) Experimental
set-up. On-axis illumination with a retro-reflective screen provides maximum
resolution of shock waves. (b) Copper vapour laser illumination. Filmed on
35 mm FP4 film in a rotating drum camera in streak mode at 12 000 pps. (Photo-
graphs courtesy of R. Parker and J. Brownall of Rolls-Royce plc.)

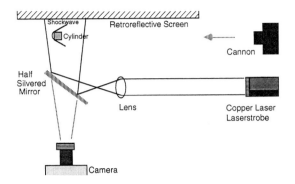

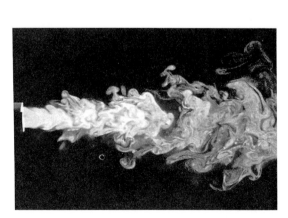

Figure 9.16 Photographic record of a high speed object. (a) Experimental set-up. On-axis illumination with a retro-reflective screen provides maximum resolution of shock waves. (b) Copper vapour laser illumination. Filmed on 16 mm Ektachrome VNF in a Hadland High Speed Camera with half height head giving 20 000 pps. The object velocity is up to 1500 m s^{-1}. (Cine film courtesy of AWE Foulness, UK.)

Figure 9.17 Medical nebulizer. Illumination by Nd.YAG laser with 15 ns pulse length. Sheet lighting used and a single exposure on 35 mm film. (Photo courtesy of A. Shand, AEA Technology plc.)

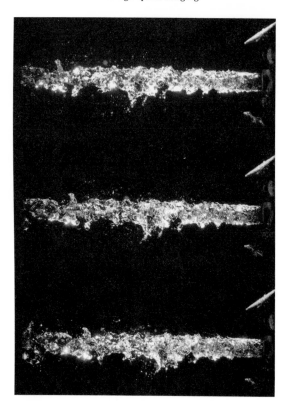

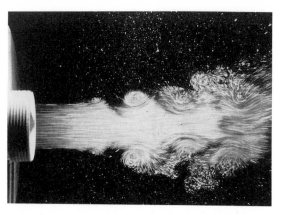

Figure 9.19 Water flow visualization. Copper vapour laser sheet illumination. Single frame 35 mm film camera used. In this image the laser is pulsed 10 times to reveal the overall flow structure. In practice, two or three pulses are used for PIV analysis of areas of greatest interest. Fluorescent seeding particles are used to provide effective discrimination against background scatter from bubbles and spurious particles in the water. (Photo courtesy of J. Katz, John Hopkins University, USA.)

Figure 9.18 High velocity co-axial spray (rocket fuel injector). Copper vapour laser sheet illumination. Sequence of three frames from a strip of 80 filmed using Kodak T-Max 400 film in a rotating drum camera in streak mode at 20 000 pps. The sheet lighting used allows investigation of the thick core near the nozzle. The spray velocity is 22 m s^{-1} and the air velocity is 155 m s^{-1}. (Photos courtesy of D. Krülle, DLR, Germany.)

10 Rotating mirror and drum cameras

Vance Parker and Christine Roberts

10.1 Introduction

Rotating mirror framing cameras and framing drum cameras both work using the Miller principle, named after David Miller who was searching for a tool to study detonation in aircraft engines in the late 1930s. They subsequently served as valuable tools in the Manhattan project of the 1940s. Both Berlyn Brixner and Willard Buck, working at Los Alamos, were instrumental in developing rotating mirror cameras and rotating mirror technology. Such cameras now serve as research tools for a wide variety of projects such as hypervelocity impact studies in support of the space programme, improving mining explosives, dynamic stress analysis and various military applications.

Rotating mirror streak cameras and drum streak cameras have been around much longer than rotating mirror framing cameras, and have been used by scientists since the early 20th century.

Although the cameras record at extremely high framing rates, they only use a short length of film. The film can be processed in a 35 or 70 mm film tank. There is no need to process 120 m (400 feet) of film to see 3 m (10 feet) of data.

10.2 Camera types
10.2.1 Rotating mirror cameras

Rotating mirror cameras fall into basically two major categories: *framing cameras* and *streak cameras*. Both of these subdivide into *continuous access* and *synchronous access* cameras (Figure 10.1). The distinctive feature of rotating mirror cameras is that the film is stationary and the picture is moved along the film. This eliminates the problem of moving film at extremely high velocities and allows framing cameras to be used at up to 25×10^6

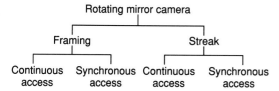

Rotating mirror camera

Framing

Streak

Continuous access

Synchronous access

Continuous access

Synchronous access

Figure 10.1 Categories of rotating mirror cameras.

pps and the streak cameras to be used up to 30 mm μs^{-1}. It is all done with mirrors!

Continuous access cameras are ready to write at all times. As the rotating mirror turns, it is capable of recording data at any angle of the mirror if light is available. They are useful in recording events that cannot be timed precisely, such as terminal ballistics and dynamic stress analysis. Synchronous access cameras must trigger the event to be recorded, since they record for approximately 20% of a revolution of the rotating mirror and are blind for 80% of a revolution. Both types will *re-write* (double expose) when the next facet on the rotating mirror comes up, unless the light source is quenched or the optical path closed using a *blast shutter* or other fast shuttering system for self-luminous events.

10.2.2 Drum cameras

Drum cameras also fall into the two basic groups of framing and streak types. By their nature, all drum cameras are continuous access. The film is transported in a rotating drum. They can write until the full length of film is recorded and will re-write if the shutter is not closed or the light source quenched. One advantage of the drum camera is the fact that a standard mechanical shutter can be used to prevent re-write.

10.3 Rotating mirror cameras
10.3.1 High speed rotating mirrors

The heart of the rotating mirror camera is the high speed rotating mirror. This is turbine driven using either compressed air or helium. Early mirrors were made of polished tool steel with silver sleeve bearings. To suppress resonance, the bearings were suspended in an O-ring. As demands for higher speeds increased, it was found that the oil system must be pressurized to provide adequate lubrication.

The mirrors are run at speeds very near the *burst speed* due to centrifugal forces. In streak cameras, this resulted in the face of the mirror taking on a cylindrical shape and thereby shifting the focal plane. Some of the early streak cameras had various cylindrical correctors that were used at specific turbine speeds to correct this problem. Shaft resonance has always been a problem when trying to run large mirrors at high speeds. The use of beryllium as a

mirror material has almost eliminated both of these problems. Beryllium is about one-fifth the weight of steel and 30% stiffer.

Modern rotating mirrors are usually made of beryllium and run on ball bearings, a great improvement from the cumbersome oil systems of early cameras. Maximum rotational speeds of the rotating mirrors are in a range from 1000 rps for a 100×125 mm mirror face to 10 000 rps for a 24×30 mm mirror face, and finally to 20 000 rps for a 12×25 mm mirror face.

10.3.2 The Miller principle

In the rotating mirror camera, an image is formed by a camera objective or relay lens system on or near the face of the rotating mirror. As the mirror rotates, the light beam is swept across an arc of relay lenses that sequentially relay the image at the face of the mirror to the static film which is held in an arc shaped track. If the image is formed at the proper position near the surface of the rotating mirror, the image will be very nearly stationary when recorded in each frame of the camera. This property is known as the Miller principle, named after David Miller, the discoverer.

The first image is formed by an objective lens (Figure 10.2). This image is relayed to the face of the rotating mirror by the relay lens. The entrance stop shapes the optical beam and is, in turn, imaged onto the relay lens bank by the combination of the relay lens and the field lens, which is located near the rotating mirror. The entrance stop is sized so that its image is the same shape and size as the framing lenses in the *lens bank*. As the mirror rotates, the image of the entrance stop is swept across the relay lenses sequentially, and a frame is recorded on the film track as each framing lens is illuminated.

An extension of the Miller principle is used in framing drum cameras. If the image is formed a short distance behind the mirror face, the image moves during exposure. If it is formed ahead of the mirror, it moves in the opposite direction during exposure. Willard Buck, the inventor of the framing drum camera, exploited this fact. In a drum camera, the film is carried by a rotating drum which drives a multi-faceted rotating mirror. If the image is formed at the proper distance from the rotating mirror, the speed of the image can be made to match the speed of the film in the drum and a high quality image can be recorded. Since the film is moving, only one lens system is required to record a large number of frames. Each facet on the rotating mirror records a frame as it sweeps the light beam across the framing lens. A typical optical configuration for a drum camera is shown in Figure 10.3.

The primary difference between the configuration of a drum camera and a framing camera is that there is generally no field lens near the rotating mirror and the camera uses a multi-faceted rotating mirror. In this example, there are only two relay lenses: one above the incoming optical axis and one below. As the mirror turns, a frame is exposed when the image of the entrance stop is swept across the lower lens, and a second frame is exposed when the image of the stop is scanned across the upper lens. The speed of the rotating mirror is set such that as the previously exposed frame moves out of the exposure path, the next mirror facet records the next frame. This could be done with a single final relay lens, but the writing rate can be doubled by using a lens both above and below the optical axis. The paths to the film are offset, and so two rows of 16 mm width pictures can be recorded on a strip of 35 mm film. If two relay lenses

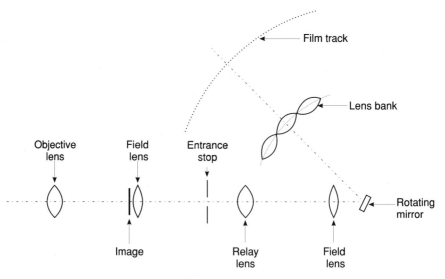

Figure 10.2 Optical configuration of a rotating mirror camera using the Miller principle.

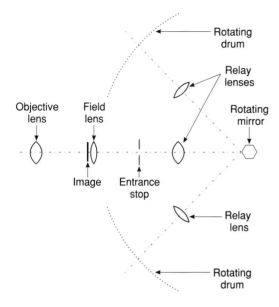

Figure 10.3 Optical configuration of a rotating drum camera.

are used above and below the optical axis, four rows of 16 mm width pictures can be recorded on 70 mm film, or on two strips of 35 mm film. Drum cameras presently have maximum recording rates of 35 000–200 000 pps. They normally record 200–500 16-mm gauge frames on a 1 m length of film.

10.3.3 The lens bank of the framing camera

In order to maximize the number of frames in a framing camera, the lenses in the lens bank are 'sliced', using only the central portion. After slicing, they look more like rectangles than the circular shape associated with lenses. The angle between frames can be anything, but, over the years, two angles have evolved. For many synchronous framing cameras, the rotating mirror turns 1.44° between frames. In this case, a rotational speed of 2000 rev s^{-1} corresponds to a framing rate of 500 000 pps, and 4000 rev s^{-1} corresponds to 1 000 000 pps. For continuous access cameras, an angle of 1.5° is common. In a continuous access camera, the angle between frames must divide evenly into 360°. Since the reflected beam from a rotating mirror rotates twice as fast as the rotating mirror, these two mirror angles result in lens bank spacings of 2.88° and 3.0°, respectively.

In a continuous access camera, the number of degrees that the film track must cover is given by

$$A_t = \frac{720}{N} \qquad (10.1)$$

where A_t is the angle covered by the film track and

N is the number of faces on the rotating mirror. As an example, in a camera with three faces on the rotating mirror, there must be 240° of film track and framing lenses or the camera will not be continuous access. This is frequently done with two 120° tracks.

10.3.4 Image drag

If it were possible to construct a rotating mirror with the mirrored surface on the axis of rotation, this topic would not be included, since the Miller principle would define the solution. For real cameras, the mirror must have a finite thickness. For mirrors with a finite thickness two things happen. First, there is only one frame in each quadrant of the camera that will be stationary during exposure. All other frames have a finite radial motion. Two track drum cameras use the stationary frame in each quadrant. Second, the image is 'pumped' during exposure. By this it is meant that the image moves axially along the optical axis of each of the relay systems during exposure.

Although both of these motions are relatively small, they both degrade the image slightly. These motions are referred to as *residual image drag* and are directly related to the distance from the centre of rotation of the mirror to the face of the mirror. Since continuous access cameras inherently have greater centre line to face distances, they generally also exhibit a greater resolution loss due to image drag.

10.3.5 Framing camera exposure and interframe time

The *interframe time* is defined as the time interval between frames. The *exposure time* appears on the surface to be equally easy to define, but that is not the case. Due to the unusual exposure profile, it is defined by the capability of the camera to stop image motion rather than the time for which light is on any given frame.

The exposure profile for a rotating mirror framing camera looks like an isosceles triangle. The base of the triangle represents time and the altitude of the triangle represents the light intensity. In a camera with rectangular stops, the total exposure time is twice the interframe time. Early in the development of rotating mirror cameras, it was argued that the effective exposure time was half the total exposure time, since 75% of the light energy was transferred to the film during the central half of the exposure time. This results in the exposure time being approximately equal to the interframe time. In the 1960s, it was argued that the complexities of the exposure and image pumping resulted in an actual effective exposure time of 35% of the total exposure time. Since there is also dead space between the lenses, it works out that 35% of the exposure time is about 50% of the interframe time. Since the late 1960s, the effective exposure time has been defined as 25% of

the total exposure time, or half the interframe time. By this, it can be seen that exposure time is a definition for a very complex function since the image comes to best focus at the same time that the image intensity is maximum. The current definition does give an accurate basis for calculating the motion stopping capability of the camera.

Figure 10.4 illustrates exposure in a rotating mirror camera and shows how the image of the *entrance stop* is scanned across the rectangular framing lenses. The bottom graph shows the light intensity at the film versus time as the stop is scanned across each of the lenses. As the image of the entrance stop reaches the edge of the framing lens, the amount of light passing through the framing lens increases linearly until the image of the stop coincides with the centre of the framing lens. At that point, the illumination for that frame begins to decrease. Soon after reaching the peak of illumination of one frame, it begins to expose the next frame.

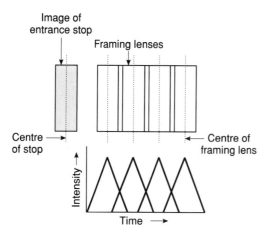

Figure 10.4 Image illumination and exposure in a rotating mirror camera.

The shuttering in drum cameras is exactly the same, except that in such cameras the lenses are not packed as they are in the standard framing camera. The exposure time in drum cameras is generally designed to be about 1–1.5 µs at the maximum framing rate. This provides excellent motion stopping capability. Both rotating mirror and drum framing cameras have additional half and quarter stops (slits) to reduce the exposure time to one-half and one-quarter the exposure time with a full stop, as illustrated above.

10.3.6 Framing camera resolution

Rotating mirror cameras are specified with two resolution figures. One is for resolution along the film and the other for resolution across the film. These are frequently referred to as *temporal resolution* and *spatial resolution*, respectively. Two things contribute to a reduction in temporal resolution: diffraction, since this is the narrow axis of the sliced relay lens; and image drag.

In synchronous cameras, resolutions of 60×40 lp mm^{-1} or better are common. For continuous access cameras, resolution ranges from 56×40 to 30×20 lp mm^{-1} depending on the design of the camera. Half and quarter stops reduce the effect of image drag but increase the effects of diffraction, so reducing the temporal resolution.

10.3.7 Some general parameters of framing cameras

The parameters may be listed briefly:

- If a continuous access camera is chosen over a synchronous access camera, half the light and half the resolution are lost.
- Synchronous access cameras as a rule have an effective aperture given as an *f*-number of *f*/16. Continuous access cameras are one to two stops worse.
- The effective exposure time for framing cameras is given by half the interframe time for full stops, one-fourth the interframe time for half stops, and one-eighth the interframe time for quarter stops.
- The effective aperture as an *f*-number increases numerically by one stop equivalent (1 EV) each time the camera goes to a lower category of entrance stop.
- Diffraction reduces resolution at lower categories of stops.
- Since changing to a lower category of stops changes both the *f*-number and the exposure time, a change of one such entrance stop results in a two stop (2 EV) change in exposure.

10.4 Rotating mirror streak cameras

In contrast to a framing camera which records a two-dimensional picture, a streak camera records one dimension versus time. A framing camera samples time, a streak camera records continuously. The forte of a streak camera is its ability to resolve time very accurately. The maximum time resolution of a streak camera will be a few nanoseconds. The maximum writing rate for rotating mirror streak cameras is about 30 mm µs^{-1}.

A rotating mirror streak camera consists basically of an objective lens, a slit, a relay lens, a rotating mirror and a film track (Figure 10.5). An image is formed on the slit by the objective lens. The portion

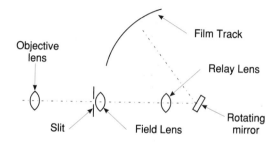

Figure 10.5 Optical configuration of a rotating mirror streak camera.

of the image passing through the slit is relayed to the film track by the relay lens after reflecting from the rotating mirror. The image in this case is a line, the height of which is set by the slit opening. As the mirror rotates, the image of the slit is swept along the film track. Due to the mirror thickness, the curve of constant focus that makes up the film track is not circular. The film track is cut to the curve of constant focus.

10.4.1 Writing rate non-linearity

In a rotating mirror streak camera, the writing rate would be uniform at all positions on the film track if the mirror centre line to face distance were zero. The effect of a rotating mirror with a finite thickness is that the writing rate is slightly different at each position on the film track. For synchronous access streak cameras, the non-linearity is ±0.25–0.50%. For continuous access cameras, where the centre line to face distances are greater, the non-linearity can increase from 2% to 5%. The writing rate of

streak cameras is generally defined at centre track. The shape of a typical writing rate graph is shown in Figure 10.6; the curve shown is typical for a continuous access streak camera.

10.4.2 Streak drum cameras

Streak drum cameras have a very simple optical configuration (Figure 10.7). The objective lens forms an image on the slit. The relay lens relays the image of the slit to the drum using a turning mirror.

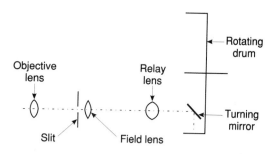

Figure 10.7 Optical configuration of a streak drum camera.

The slit must be vertical so that the slit lays across the film. The writing rate of a drum streak camera is set by the speed of the rotating drum and exhibits a uniform writing rate. Drum cameras have writing rates of up to about 0.30 mm μs^{-1}.

10.4.3 Streak camera exposure time and time resolution

The exposure time of a streak camera is not 'locked' to the rotational rate of the rotating mirror in the

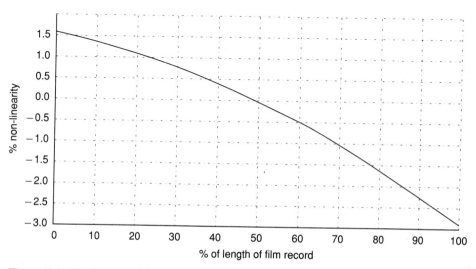

Figure 10.6 Non-linearity of the writing rate of a rotating mirror streak camera.

same way it is in framing cameras. The exposure time of a streak camera is a function of the slit width and the writing rate of the camera. The exposure time of a streak camera can be varied at the same streak writing rate by varying the slit width. This will change the time resolution (defined below) of the streak camera. The exposure time is the time for which the film is illuminated. This is the time that the camera takes to write the width of the slit as projected onto the film. If the camera has a unit (1 : 1) internal magnification, then the slit width image on film equals the slit width. Otherwise, the slit width must be multiplied by the internal magnification of the camera:

$$T = \frac{W}{R} \qquad (10.2)$$

where T is the exposure time (in nanoseconds), W is the slit width at the film plane (in micrometres), and R is the writing rate (in millimetres per microsecond). As a general rule, the slit width should be selected so that the image of the subject doesn't move more than 0.05 mm on the film during the effective exposure time. This is dependent on the speed of the event and the objective lens focal length.

The *time resolution* of a streak camera is the minimum time the camera can resolve. This is generally a few nanoseconds for most rotating mirror streak cameras. The time resolution is a function of the writing speed, the slit width and the resolution of the camera and the film. The time resolution of the camera can be expressed as

$$T_r = \frac{(8.3 + W)}{R} \qquad (10.3)$$

where T_r is the time resolution (in nanoseconds), with W and R defined as above.

Equation (10.3) assumes a camera/film combination capable of a limiting resolution of 60 lp mm^{-1}. At narrow slit widths, the effects of system resolution are significant. At larger slit widths, these effects become increasingly insignificant.

10.4.4 Selecting the streak writing rate

To minimize data reduction errors, a streak image would ideally travel at 45° across the film. This infers that the image velocity on film should equal the writing rate of the camera. In reality, a writing rate between half the velocity of the image on film and twice the velocity of the image on film produces acceptable results. The ideal writing rate can be calculated as

$$R = Vm \qquad (10.4)$$

where R is the writing rate (in millimetres per microsecond), V is the subject velocity (in kilometres per second) and m is the magnification.

10.5 Camera operation

10.5.1 Operating rotating mirror and drum cameras

By their nature, rotating mirror cameras and drum cameras are brought to full operating speed before they are ready to be used. This can take a few seconds for a rotating mirror camera or several minutes for a drum camera. A rotating mirror camera can only be held at full speed for 1 min while waiting for an event. The ball-bearings run dry if they are run too long at high speeds. They are designed for very high speed on an intermittent basis and normally require 10 min of cooling time between runs so that the porous bearing retainers can re-lubricate the balls. A drum camera can run for several minutes without any damage. Because of these time limitations, careful preparations must be made before starting the sequence. The control systems used makes everything automatic once the sequence is put into action.

10.5.2 Operating synchronous rotating mirror cameras

When operating systems that are capable of recording submicrosecond events, fairly sophisticated equipment is required. Timing is everything. It is important to know exactly the speed of the camera and the angle of the mirror. Early cameras used a small generator mounted on the shaft of the rotating mirror. This worked, but the phase shift at various speeds required an elaborate calibration. Newer systems use an optical pickup. An infrared beam is directed at the rotating mirror and detected by a photodiode. This provides one pulse each time a mirror face comes around. For single faced mirrors, the mirror period can be measured directly. For a multi-faced mirror, a 'divide by n' circuit is required to read the speed of the mirror. The optical pickup can be used for timing the camera, but it must be known when the pulse comes relative to when the camera begins to write either a streak record or the first frame of a framing camera. For simplicity of timing calculations, the optical pickup is placed 36° before starting to record on the film track. This is 10% of the *period* of the mirror.

Timing the event consists of triggering a *time delay generator* with the mirror pulse once the camera is at operational speed. The event is triggered with a delay of 10% of a period minus the inherent delay of the event. Another channel of the time delay generator is generally used to trigger a light source. This channel of the time delay

generator is set to 10% of the period minus the inherent delay in the light source. The light source is set to turn off before the camera re-writes. If the event is self-luminous, it is frequently necessary to prevent re-write by using a blast shutter or explosively shattering a mirror in the optical path. All these items must also be timed to the event. Over the years, there have been many interesting designs of fast closing shutters. In most cases, it is possible to control re-write by controlling the light source duration.

10.5.3 Control parameters

The parameters that are of interest in setting up the camera are those that affect the timing in any way. A partial list is given below. Not all the factors listed are applicable in every shot, and others not listed may be important in some applications.

- Time from the mirror pulse to when the camera starts to write.
- Period of the rotating mirror.
- The inherent delay of the event being triggered and photographed.
- The inherent delay of the light source.
- The time duration of interest in the event to be photographed.
- The inherent delay of the light source.
- How the duration of the light source is controlled.
- For self-luminous events, the duration of the event and the duration of the afterglow.
- The inherent delay and closing time of the blast shutter, where one is necessary.
- The inherent delay and duration of fiducial markers, where necessary.
- The velocity at which the items of interest will be moving.
- The magnification of the event provided by the objective lens.
- The framing rate necessary to prevent motion blur during exposure.
- The writing rate needed for the streak record.
- The slit width needed to provide proper exposure or time resolution, depending on which is dominant.

It would be unusual to know all the parameters of interest before commencement, but with a versatile tool such as an ultra-high speed camera, it is usually possible to take a few test shots and determine any timing unknowns.

The camera control for this type of camera will allow acceleration of the turbine to the proper speed. The camera control will open the mechanical shutter at half speed, and trigger the event when the camera reaches the predetermined speed. If the delays are set correctly, a picture is obtained. In addition to triggering the event at the proper speed,

the camera control records the actual speed of the rotating mirror when the event was triggered.

10.5.4 Operating a continuous access camera

Operating a continuous access camera is easier in some respects than a synchronous access camera, and the range of events that can be photographed is expanded. Since the camera has no 'dead time', the camera doesn't have to trigger the event at a particular angle of the rotating mirror. In the case of a self-luminous explosive which has a short afterglow, all that is necessary is to point the camera at the event, bring it to speed and trigger.

In most cases, it is still necessary to know exactly when to photograph the event. In events such as a hypervelocity impact, it is necessary to detect when the projectile has passed a certain point. This trigger can then be used to time the light sources and, when necessary, trigger a blast shutter. It is not possible to photograph this type of event using a synchronous access camera.

Since continuous access cameras frequently have to wait for an event, and since camera speed is always important, it is common to use a servo system to control the speed of the camera. New systems can control speed to a fraction of a per cent and then give a readout of the exact rotating mirror rate when the event was photographed.

10.5.5 Exposure requirements

When rotating mirror cameras are used, there is always concern about the amount of light available. Rotating mirror and drum cameras have exposure times measured in microseconds or submicroseconds. The effective *f*-number is relatively large. This combination calls for a lot of light. The following exposure calculation can be used to determine light requirements:

$$S = \frac{K N^2 (m + 1)^2}{tER_r} \qquad (10.5)$$

where S is the film speed required (ISO), t is the exposure time (in seconds, not microseconds), N is the effective *f*-number of the camera, m is the linear magnification, E is the illuminance (in lux) and R_r is the fractional reflectivity of the scene (18% reflectivity would be expressed as 0.18). The value of the constant K depends on the units used, and is typically 2.66 for E measured in foot-candles and 28.62 for E measured in lux. Then, if the light source is rated in its luminance value

$$B = R_r E \qquad (10.6)$$

where B is the luminance (in candles per square metre) and R_r and E are as defined above.

10.5.6 Light sources

To supply the large amount of light required, two types of light source are commonly used: high power strobes and argon candles. Large strobe units providing 100 million lux or more are used routinely for photographing non-explosive events. Fibre optic light guides used in conjunction with the strobe units have been used to illuminate small subjects. When photographing explosive devices, it is more common to use an *argon candle*, sometimes referred to as an *argon bomb*. The argon candle is basically a cardboard tube with a sheet of explosives across one end and a thin clear plastic window on the other end. The tube is filled with argon gas. When the explosive is detonated, the shock wave glows brightly as it travels through the argon. When the shock wave reaches the plastic window, the light goes out. The duration of the light source is set by the length of the tube. Argon candles can produce many tens of millions of lux of illumination, depending on the design.

A number of special photographic situations can be identified and described.

10.6 Synchroballistic recording

Synchroballistic recording is the process of recording a single high quality frame of a moving subject using a streak camera. It is used in ballistic studies and frequently requires a continuous access camera. It is usual to be able to make a 70×150 mm negative of high quality using this technique. The theory is fairly simple, the objective lens images the subject onto the slit. As the subject travels past the camera location, the image of the subject moves across the slit. The speed of the camera (rotating mirror) is set so that the image is moving at the same velocity as the image of the slit is moving across the film. If they are moving in opposite directions, the image lays down on the film and appears to the film to be stationary. Any errors in the speed of the camera versus the speed of the subject will result in a lengthened or shortened image, but does not degrade the image much.

When calculating the proper streak velocity required, it is important to remember that the velocity of interest is the velocity of the subject at the film track. This means that the velocity of the subject must be corrected for the demagnification effect of the objective lens. For example, if the subject is travelling at 2000 m s^{-1} and there is a magnification of 0.10 through the objective lens, the image of the subject will be moving at 200 m s^{-1} at the slit plane. If the camera has an internal magnification of unity (1 : 1), the streak velocity of the camera should be 200 m s^{-1} or 0.2 mm µs^{-1}.

If the slit is swept up the film track, the motion of the image should be down the film track. If the camera cannot be rotated or placed in a position where this would be possible, an *image rotator* such as a *Pechan prism* can be used. Note that if the direction of travel of the image is reversed, a picture is still obtained but the quality may be poor, depending on the slit width. If the velocity of the image is exactly equal and opposite the slit velocity, any slit width could be used without degrading the quality of the picture. The slit width can therefore be used to control the exposure time. To determine the system magnification accurately, it is common practice to place a graduated ruler where the projectile is expected and record a static image. This can be measured to determine the proper writing rate. The same procedure is used with both rotating mirror and drum cameras.

10.7 Multi-camera coincidence using synchronous cameras

10.7.1 Multi-camera coincidence

Multi-camera coincidence is the process of timing an event so that multiple synchronous cameras running at various predetermined speeds can record the same event. This does not restrict each camera to recording the whole event, but can be used to have a second or more cameras sequentially record when one comes to the end of its recording capacity.

Accurate coincidence operation requires a piece

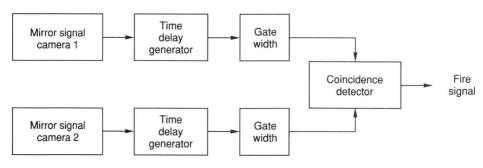

Figure 10.8 Schematic diagram of two camera synchronous operation using a coincidence unit.

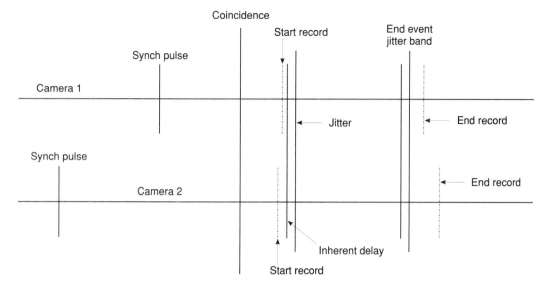

Figure 10.9 Layout of a timing graph for multi-camera coincidence operation.

of equipment called a *coincidence unit* consisting of a multi-channel unit that can be programmed to extend the mirror synchronization pulses from the cameras by some amount. It then determines when all of these signals are high and issues a fire pulse. If the synchronization pulses are delayed properly, multiple cameras can record the same event. The block diagram in Figure 10.8 shows the steps in the process.

The concept of a coincidence unit is relatively easy to understand. If many cameras are running and looking at the same subject then, at random intervals, they will all be ready to start writing near the beginning of each of their respective film tracks. These times are called *coincidence*. The *gate width* determines how near to the beginning of each film track each camera is required to be when the event is started. A wide gate width allows the cameras to start writing later in the film track. The right gate width is determined by the length of the event and the writing time of the respective camera. If it was possible to start the event and have the light sources up and running at this point in time, then it would be possible to record the event with all of the cameras.

10.7.2 Information necessary to set up a multi-camera coincidence

- The recording time of each camera at the speed selected for it.
- The inherent delay of the event to be photographed.
- The duration of the event to be photographed.
- The jitter of the event to be photographed. This includes the *jitter*, inclusive of all components in

the system. In timing systems, jitter is only positive; there is rarely a negative jitter.
- The delay of each camera from synchronization pulse to the start of recording.
- The gate width settings for each camera.

10.7.3 The layout of a timing graph

A *timing graph* is used to determine when everything must occur. In order better to understand the process, a sample problem is useful for demonstration. In this problem, a simple two camera set-up is defined. The speed of each of the cameras has been predetermined, and parameters are:

- The writing time of camera 1 is 26 µs.
- The writing time of camera 2 is 32 µs.
- The inherent delay of the event is 7 µs.
- The event duration of interest is 20 µs.
- System jitter is 2 µs.
- For camera 1, running at 5000 rps, the time from the mirror signal (synchronization pulse) to the start of recording is 20 µs.
- For camera 2, running at 2500 rps, the time from the mirror signal (synchronization pulse) to the start of recording is 40 µs.
- The gate widths will be determined from the timing graph.
- Assume both camera rotors are controlled to ±2% of the desired speed.
- The time delay setting for both cameras will be determined from the timing graph.

Refer to the timing graph in Figure 10.9 for the following operations.

1. First go to the middle of a piece of graph paper and draw a vertical line. Call this line *coincidence*. Everything will be scaled from this line, with increasing time to the right. Determine a suitable scale, possibly 1 μs per two mm.
2. Now draw two horizontal lines across the full width of the paper and label one of them *camera 1* and the other *camera 2*.
3. Since the inherent delay of the event is 7 μs, measure 7 μs to the right of the coincidence line and draw a vertical line and label it *inherent delay*.
4. Since the system jitter is 2 μs, measure 2 μs to the right of the inherent delay line and place a line. Label this line *jitter*. The event will be triggered somewhere between the two lines. This is the jitter band.
5. Next, add the event duration to the graph by measuring 20 μs from both the inherent delay line and from the jitter line. The spacing between these lines indicates the *jitter band* at the end of the event.
6. The location of the *recording window* of each of the cameras is next added. Before that can be done, the uncertainty caused by the control tolerances on the rotating mirrors must be determined and added. The time from the mirror signal to the start of recording for camera 1 is 20 μs with a ±2% tolerance. Therefore, the uncertainty from the mirror pulse to the start of writing is plus or minus 0.4 μs. A total band of almost 1 μs. The uncertainty for camera 2 is ±0.8 μs. A total band of 1.6 μs, rounded to 2 μs. Place a dashed vertical line 1 μs before the inherent delay line of camera 1, and a dashed vertical line 2 μs before the inherent delay line of camera 2. Label both these lines *start record*.
7. The recording time of camera 1 is 26 μs ±2% for the control tolerance. With the tolerance, the recording time will be between 25.5 and 26.5 μs. The shortest time is the one to use. Measure 25.5 μs to the right of the *start record* line and draw another vertical line and label it *end record*. Repeat the process for camera 2, but since it has a recording time of 32 μs plus or minus the control tolerance of 0.6 μs. Measure 31 μs to the right of the *start record* line and insert the *end record* line.
8. The final piece of information to add to the graph is the timing of the synch pulse for each camera. For camera 1, measure 20 μs to the left of the *start record* line and draw a vertical line and label it *synch pulse*; do the same for camera 2, but in this case, measure 40 μs to the left of the *start record* line.
9. Measure the time from the *synch pulse* line to the *coincidence* line of each camera. The times for this example are 14 μs for camera 1 and 34 μs for camera 2. These are the times for which each

of the mirror synch pulses must be delayed before sending them to the coincidence unit.
10. The final piece of information to be taken from the timing graph is the gate width. For camera 1, the end of its recording time and the end of the event are separated by only 2 μs. In this case, assign a gate width of 2 μs. For camera 2, there are 6 μs from the end of the event to the end of the record. Assign a gate width of 6 μs to camera 2. This provides adequate information to set up the the cameras and the coincidence unit.

Note: The gate width allows a tolerance regarding how far back on the film record it is possible to allow the event to be recorded. It does not present the danger of the event occurring before the start of track.

When setting up the experiment in this example, run the synchronization pulses from camera 1 through a time delay generator set to delay the pulses by 14 μs. The synch pulses from camera 2 are delayed by 35 μs. These outputs are fed to the coincidence unit with the gate width for camera 1 set at 2 μs and the gate width for camera 2 set at 6 μs. When the coincidence unit sees both gates open at the same time, the sequence will be initiated.

Where light sources need initiation, they and their delays must be added to the graph and the initiation time set to the component with the largest inherent delay. Other time delay units may be required to initiate sequential parts of the experiment. If the longest inherent delay is longer than the time from the synchronization pulse to the start of recording of one of the cameras, the timing for that camera must come from the previous mirror synchronization pulse. (One 'flip' of the mirror.)

10.7.4 Estimating time to coincidence

Since rotating mirror cameras can only be run for about 60 s at maximum speed, it is desirable to attain coincidence in less time than this if possible. Otherwise many runs may be necessary to achieve coincidence. The average time to coincidence can be estimated from the equation

$$C_m = \frac{1}{1\,000\,000\,P_r} \qquad (10.7)$$

where C_m is the mean time to coincidence (in seconds) and P_r is the individual camera recording probability. Also,

$$P_r = P_r(1)\,P_r(2)\,P_r(3)\ldots P_r(i) \qquad (10.8)$$

and

$$P_r(i) = \frac{G(i)\,S(i)\,N(i)}{1\,000\,000} \qquad (10.9)$$

where $G(i)$ is the the gate width of camera i (in microseconds), $S(i)$ is the rotating mirror speed of camera i (in revolutions per second) and $N(i)$ is the number of polished faces on the rotating mirror of camera i. For a two camera system with single faced mirrors and gate widths of 2 and 6 µs, respectively, and turbine speeds of 5000 and 2500 rps, then $P_r(1)$ = 0.01; $P_r(2)$ = 0.015, so P_r = 0.00015, and hence C_m = 0.0067 s or 6.7 ms. When there are four or five cameras involved, gate widths must increase substantially to get something that will occur in a reasonable amount of time. If four cameras are used, two with each of the previous recording probabilities, then C_m increases to 44 s.

These calculations assume random probabilities, but some impossible situations may be visualized, such as one camera running at exactly twice the speed of the other. If speed regulation is good, coincidence would never occur. It is bad practice to set up an experiment this way.

10.8 Using coherent lighting with rotating mirror cameras

10.8.1 Front lighting

When using a pulsed laser to illuminate a scene with short pulses, a streak camera is the easiest camera to use, since the laser pulse serves as the shutter for the camera. With current technology, the use of a laser for frontal illumination is limited to less than 50 000 pps. Lasers with enough power for front lighting are not currently capable of running faster. If a framing camera is used, a *synchronizer* must be installed in the camera to trigger the laser when the camera is ready to take each picture. This works equally well with drum cameras and rotating mirror cameras.

10.8.2 Backlighting

When using a laser for backlighting, the recording speed can be increased to several hundred thousand frames for streak cameras and to several million pictures per second using framing cameras. Special preparation must be taken when backlighting both streak and framing cameras with coherent lighting. The laser beam must be 'shaped' as it goes through the camera, so there is no vignetting at all. If any part of the beam is vignetted, that portion of the picture will be missing.

Drum streak cameras have one advantage over most continuous access rotating mirror cameras, because most continuous access rotating mirror streak cameras use *aperture splitting* to attain continuous access. Aperture splitting works as an image splitter and not a beam splitter with coherent lighting (does not apply to front lighting). Therefore, a continuous access camera must be used in synchronous mode, using only the first half of the track. In spite of the obvious simplicity in using streak cameras with lasers rather than framing cameras, with current laser technology, streak cameras cannot be used as framing cameras much beyond 500 000 pps. This is dependent on the length of the laser pulse and the height of the frame. Frames 25 mm high are limited to about 200 000 pps and 10 mm high frames are limited to about 500 000 pps with a 10 ns laser pulse.

10.8.3 Guidelines for using a pulsed laser to record framing pictures using a streak camera

Framing pictures can be recorded using a streak camera if a very short laser pulse is used for illumination. Naturally, the slit must be replaced by a framing mask.

As a rule, the motion of the frame during exposure (laser pulse duration) should be limited to between 0.05 and 0.1 mm depending on the quality of the image being recorded. When using a streak camera, the primary motion is generated by the sweeping of the streak camera. The image motion during exposure can be calculated as

$$M_e = \frac{R L_p}{1000} \qquad (10.10)$$

where M_e is the motion during exposure (in millimetres), R is the camera writing rate (in millimetres per microsecond), and L_p is the laser pulse duration (in nanoseconds). Using this equation, 5 mm µs^{-1} is as fast as the camera can write with a 10 ns laser pulse and a limit of 0.05 mm motion during exposure.

10.8.4 Setting the laser pulse frequency

When setting the frequency (or framing rate) of the laser pulses, time must be allowed for the camera to move one full frame between pulses. If the internal magnification of the camera is unity (1 : 1), the height of the framing mask determines the framing rate as given by

$$F_r = \frac{1\,000\,000\,R}{M_h} \qquad (10.11)$$

where F_r is the laser pulse rate or framing rate (in pictures per second), R is the camera writing rate (in millimetres per microsecond), and M_h is the mask height (in millimetres).

Current laser technology limits exposure times to several nanoseconds. It is generally not possible to use a streak camera much above 500 000 pps for a 10 mm high image.

10.8.5 Guidelines for using a pulsed laser with a rotating mirror framing camera

There is more complexity in using a framing camera with a pulsed laser because a synchronizer must be installed in the camera to generate a synchronization pulse at the centre of the exposure window for the camera. If the timing is incorrect by much, part of the frame will be recorded by one lens and part by the next lens (the framing camera form of image splitting). If the timing is right, both rotating mirror cameras and drum cameras respond well to laser illumination and can generally be used to their maximum framing rate. Continuous access capability is not sacrificed when using framing cameras, unless the camera uses aperture splitting rather than a beam splitter internally. The majority use beam splitters.

10.8.6 Exposure and laser power calculations

To determine the feasibility of a system, It is necessary to determine the power requirements to expose photographic film. If the spectral frequency of the light coming from the laser or laser diode is within the spectral sensitivity range of the film, then the data in Table 10.1 will provide a reasonably accurate solution to the question 'How much light energy must be delivered to the film'?

Table 10.1 Laser power and photographic exposure requirements

Film speed rating (ISO)	Energy required to expose the film (erg cm^{-2})
100	0.6
200	0.3
400	0.15
800	0.075
1600	0.038
3200	0.019
6400	0.009

The next natural question is: 'How much laser power is needed'? Equations (10.12) and (10.13) give a preliminary answer to the question.

$$P_a = \frac{100EA}{TT_e} \tag{10.12}$$

where P_a is the average power during the exposure time, EA is the energy requirement (in ergs per square centimetre), T is the exposure time (in nanoseconds), and T_e is the optical system transmission fraction. The value of T_e may be calculated using

$$T_e = Z^V Y^U D_f X 0.45^Q \tag{10.13}$$

where V is the number of lenses in the system, U is the number of mirrors in the system, Q is the number of beam splitters in the system, D_f is the fraction of light collected from the laser or laser diode, X is the ratio of frame area to laser beam area, Z is the fractional transmission of the lenses in the system (typically 0.9 to a first approximation) and Y is the fractional reflectivity of the mirrors (with 0.85 as a first approximation). Transmission fraction values from 0.02 to 0.2 can be expected, depending on the complexity of the optical system. This can result in a requirement of hundreds of watts of peak power. It may be necessary to purchase optics with a special coating to improve the system transmission.

10.9 Shadowgraph objective system design

10.9.1 Design for a framing camera

Rotating mirror cameras impose unique limitations on the objective system design. Figure 10.10 shows a typical shadowgraph optical system. The magnification of the image is the ratio of the image height at the entrance of the camera to the field height in the shadowgraph field. Figure 10.11 shows the shadowgraph system mated to a rotating mirror framing camera. The focal length of the objective lens needed may be calculated using the following equation and the notation given in Figures 10.10 and 10.11:

$$F_o = \frac{m [S_h F_h - d (S_h - F_h)]}{F_h - M (S_h - F_h)} \tag{10.14}$$

where m is the desired magnification, F_h is the focal length of the schlieren head, F_o is the focal length of the objective lens, S_h is the distance from the schlieren head to the subject and d is the distance between the schlieren head and the objective lens. The units used are not important, only that all units are the same. There will be some trial-and-error work to be done. The objective lens must not vignette any of the edge rays. The diameter (D) of the beam at the objective lens can be calculated using the following equations, where H is the diameter of the schlieren field:

$$D = \frac{KH}{F_h} \tag{10.15}$$

$$K = \frac{F_h D}{H} \tag{10.16}$$

$$d = K + F_h \tag{10.17}$$

Because there are more variables than equations,

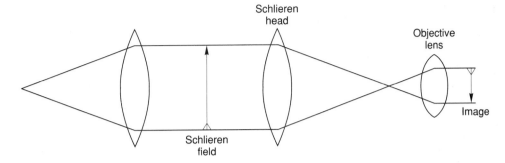

Figure 10.10 Optical system for shadowgraph operation.

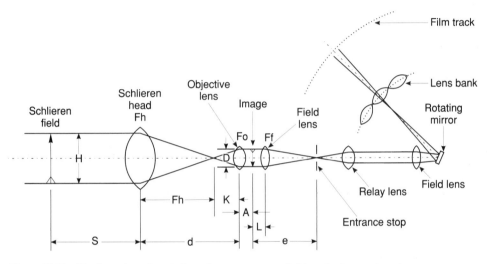

Figure 10.11 Configuration of a rotating mirror camera coupled to a shadowgraph system.

Equation (10.16) is used to determine K after assigning a value to D. A reasonable starting place is to assign D a value based on the format of the image, using $D = 8$ mm for 16 mm format, $D = 16$ mm for 35 mm format and $D = 32$ mm for 70 mm format. The design can then be refined after initial values are established. After calculating the desired focal length, if commercially available lenses are used, the focal length of the commercial lens nearest to that calculated can be selected. The actual magnification (m) can be calculated using the focal length of the lens selected in

$$m = \frac{(F_o F_h)}{S_h (F_o + F_h) + d (F_h - S_h) - (F_o F_h)} \quad (10.18)$$

The image location as distance A from the objective lens can be calculated using

$$A = \frac{F_o [d (S_h - F_h) - S_h F_h]}{(d - F_o) (S_h - F_h) - S_h F_h} \quad (10.19)$$

The final step in the design is to select a field lens

that will image the waist of the beam near enough to the entrance stop so that the entire beam will pass through the entrance stop. Some care must be exercised in verifying the design. The waist of the beam must not be imaged exactly at the entrance stop. If it is, the laser will be focused on the front of the framing relay lenses and will probably damage them.

Referring to Figure 10.11, the focal length (F_f) of the field lens needed can be determined using

$$F_f = \frac{(e - L) [(K - F_o) (A + L) - K F_o]}{(K - F_o) (e + A) - K F_o} \quad (10.20)$$

Select the nearest available lens, or have a custom field lens made after evaluating the design with a ray trace.

10.9.2 Design for a streak camera

The design of the objective lens for a streak camera follows exactly the same procedure as for a framing camera. Equation (10.14) is used to calculate an

objective lens focal length. The nearest available lens is then selected and the magnification checked using Equation (10.18).

Figure 10.12 shows the optical configuration for a streak camera coupled to a shadowgraph system. Because there is no entrance stop in a streak camera, the field lens performs a different function. In a streak camera, the field lens is used to overcollimate slightly the beam so that the beam is contracting as it travels from the image plane toward the relay lenses. For the majority of streak cameras, this will allow the extreme rays to pass through the shutter and relay lenses.

Using the notation given in Figure 10.12, a reasonable value for the focal length (F_f) of the field lens needed is given by

$$F_f = \frac{F_h(A - L + K) - K(A - L)}{1.1(F_o - K)} \qquad (10.21)$$

The beam will have a waist somewhere near the rotating mirror; this guarantees that no vignetting occurs at the mirror. To prevent damage to the rotating mirror, the waist should not be imaged on the mirror face. The design found using this procedure should be usable, but is probably only an excellent starting point for refinement. The design may be verified by making a paraxial ray trace of the extreme rays of the system to check that none are vignetted, and that the images are formed where it is believed they should. From this point, the design can be fine tuned.

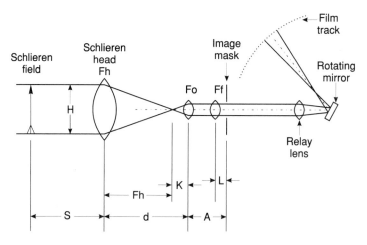

Figure 10.12 Configuration of a streak camera coupled to a shadowgraph system.

11 Data extraction and film analysis

Christopher Edwards

11.1 Introduction

High speed photography allows the capture and analysis of events which would otherwise remain hidden to the casual observer. To obtain the maximum benefit, some method of replaying the images at a slower rate is required so that the sequence can be analysed in greater detail. The use of a high speed camera to obtain a sequence of images results in large quantities of visual data being generated. In some cases the amount of data captured is so great that it can be a problem to analyse. Simply looking though a 1 s section of film taken at 3000 frames a second (fps), typical of a car crash test, would take approximately 1 h at a viewing rate of 1 fps. In addition, much of the image data obtained may be of limited use in the analysis of the subject under investigation.

For example, in the case of the car crash test mentioned above, the information required may be how far the front of the car deforms relative to the passenger cell under impact from a head-on collision. In this case the relevant measure is how far a point on the bumper moves with respect to the passenger cell. Once the position of these points has been measured for each frame, then the data from the photographic image have been reduced from a full pictorial representation to a series of co-ordinate points plotted against time. From this can be derived the secondary data types (velocity, acceleration, etc.) and the results presented as tabulated data or in graphical form. This is the science of *data reduction*; i.e. to simplify and reduce the amount of data to that which is of interest to the user undertaking the investigation.

11.2 Sources of data and equipment

High speed images may be in the form of a film, video or a computer file of digital images. Each of these different formats will require a different approach to the analysis from the point of view of the analysis equipment involved. The simplest way to perform analysis on a high speed image sequence is to replay the images at a slower rate than recorded, and simply view the image by eye in order to get a qualitative impression of what the image sequence reveals. With video and electronic imaging cameras it is possible to use the same equipment to view the images as was used to acquire them. However, with high speed films it is necessary to employ specialized film readers in order to play back and view the images.

If qualitative analysis is all that is required, then special film projectors with the ability to replay the film at any speed, in both forward and reverse directions, is all that is required. The images are projected onto a screen and viewed in the same way as any other film. However, if a more detailed quantitative analysis is required then the film reader must have the means by which the co-ordinates of the points of interest can be identified and measured for each frame of interest in the sequence.

11.3 Source materials

Whilst data analysis and reduction techniques can be applied to any film or video tape, the task can be made easier if certain actions are taken at the image acquisition stage. With video or electronic imaging systems the frame rate is set by the camera or system operator, with due regard to the limitations of the system, and the speed is accurately controlled by the system *time base*. However, with film systems, not only does the camera require time to run up to its operating speed, but also the final run speed may not be as exactly as programmed due to tolerances in the camera transport and control system. In order to provide accurate timing data, a *timing mark* must be inserted on the edge of the film at the time of exposure. Typically this will consist of a light emitting diode fed from a crystal controlled time base at 100 or 1000 Hz depending on the camera speed setting, i.e. framing rate. Upon analysing the film, this provides an accurate reference, and can be used to calculate the exact framing rate at the time of exposure. In addition, some cameras will also allow an *event marker* to be inserted on the other edge of the film to allow synchronization of the captured sequence of images with the event and other data recording equipment.

If accurate quantitative measurements are to be made from the film, the *registration* of the camera must be accurate, i.e. each consecutive frame must exactly overlay the previous one, otherwise errors will occur when entering the co-ordinates of the points of interest with the *film analyser*. Small errors which would go unnoticed under normal viewing conditions will be very noticeable when trying to make accurate measurements from consecutive still frames from a sequence.

In order to obtain accurate results from the analysis, the camera system will need to be calibrated. This can be as simple as knowing the distance between two points on the object being photographed. However, a calibrated scale in the field of view of the camera and located at the same distance from the camera as the measurement plane of interest will make the calibration of the film analyser easier and more accurate. It is important to realize that the film analyser will only measure accurately in two dimensions, although setting up and calibrating the system for different object planes at various distances from the camera can give some useful three-dimensional data.

In many cases the camera will be in a fixed position relative to the subject being recorded. Under these circumstances the errors in measurement caused by assuming a fixed plane of measurement are limited. Often the data analysis software will be able to compensate for the increasing distance from the camera position as the subject moves further off the camera axis, this is termed *depth correction*. Some applications of high speed photography do require that the camera is mounted on a pan and/or tilt head or running on a track parallel to the event. Under these circumstances the positional data of the camera mount will need to be recorded and used in conjunction with the film data if a record of the true position of the subject is required.

11.4 Data extraction

A *film analysis system* consists of several components, including a *projection head* to transport the film, a *screen* onto which to project the image, a *cursor* for entering the data points, and a *computer* and *software* for storing and manipulating the data.

The function of the projection head is to transport the film so that the various frames may be viewed either as a sequence or one frame at a time. There are a number of differences between a projection head for high speed analysis and that of an ordinary film projector. The film transport mechanism must be sufficiently robust to withstand repeated stopping and starting, but at the same time be constructed to high tolerances in order to minimize the risk of film breakage under these conditions. The transport mechanism should be capable of running in a con-

tinuous mode, in both the forward and reverse directions, from full analyser speed (i.e. normal projection rate) down to a frame by frame (step by step) advance mode. The option of a mode of automatic frame advance by a pre-set number of frames to skip intermediate frames allows some data reduction at the data input stage and is useful for when there is insufficient movement of the point of interest on a frame by frame basis. In all cases the projection head should provide flicker-free operation at all speeds in order to minimize visual fatigue in the operator. Care must be taken with the design of the light source and illumination optics in order to minimize the amount of heat generated and directed onto the film frame in the projector gate. Long periods of projection of a single frame could distort or even burn the film.

As with the camera, the registration of the analyser must be accurate, as any positional errors here will affect the overall accuracy of the analysis. Typically, for 16 mm film the frame should be positioned to within ± 0.03 mm in order to achieve less than 1 mm of positional error on the screen at a projection magnification of 25–35 typical of film analysers. The complete projection head assembly should be capable of being rotated relative to the screen in order to position the horizon or any other chosen datum line horizontally on the screen.

The viewing screen should be of an adequate size to ensure the easy identification of the points of interest. For 16 mm film this will require a magnification of the order of 30 times the film negative size. Too large a magnification and the analyser would require a more powerful light source to achieve an adequate screen illumination. Even with this modest magnification it is often necessary to operate film analysers in subdued lighting conditions.

The co-ordinate data for a chosen image point can be obtained by electromagnetic sensing, for example in the NAC model 160F analyser, where the screen has a built-in electronic grid. When the cursor is placed over the point on the screen, the corresponding x and y co-ordinates are displayed, indicating the position of the cursor on the screen relative to the lower left corner, which is taken as the origin of these Cartesian co-ordinates. Pressing a button on the cursor then transfers the data in digital form to a computer. Multiple points can be entered for each frame, although, in order for the computer to keep accurate track of them, the chosen points must be entered for subsequent frames in the same order as for the first frame.

A *trace* or *draw* facility allows the continuous input of data whenever the cursor button is depressed at a sampling rate which may be pre-set by the user. This permits the drawing of outlines around an object in each frame and, in conjunction with appropriate software, allows the calculation

and display of the rates of change of the selected areas or zones.

In operation, the user loads the film reel and selects the section of the film to be analysed. After each point of interest in the first frame in the sequence has been identified and the data entered, the analyser either advances to the next frame or advances by a specified number of frames pre-set by the operator; the process is repeated for the remaining frames in the sequence. The ability to advance the film automatically by a pre-set number of frames allows a reduction in the amount of data input and hence an increase in the speed of data processing for subsequent software calculations. This is useful to minimize the amount of data entry when there is little movement of the points of interest between consecutive frames.

With video systems, the playback equipment for analysis is usually the same as that used for the recording, and the entering of data points follows the same basic procedure. An *electronic cursor* is overlaid onto the video image and controlled by using either a stylus and tablet or a computer mouse. Calibration is carried out in the same way as for a film system, although the determination of the exact framing rate is unnecessary, as it is more tightly controlled and accurate with video systems.

11.5 Software

Data analysis software is the means by which the raw co-ordinate data from the film or video analyser is processed into usable data. The analyser output consists of a set of uncalibrated x and y positional co-ordinates for every point of interest in the frame, and repeated for the total number of frames being analysed. There is usually no restriction to the number of datapoints output by the analyser or the total number of frames, although the software may put a restriction on the number of data sets it can handle. For example, the combination of a NAC 160F film analyser and associated MOVIAS motion analysis software caters for up to 256 measuring points per frame for a maximum of 999 frames, subject to an overall maximum of 10 000 measuring points for each analysis session.

The data from the analyser are stored as a complete file ready for use by the analysis software. The data must be calibrated by reference to two fixed points on the screen a known distance apart. Once the positions of the two points on this datum line have been entered, together with their known distance apart, the software can calculate the correct *scaling factor* to apply to further measurements. Then, after specifying an origin or reference point from which all points are measured, the software enables positional data to be read out directly in metres or feet rather than as arbitrary co-ordinate

values. The reference point (origin) need not be fixed in reference to the frame; it may be allocated to a moving point in order to give relative movements.

Two points to note are that: first, the calibration for scaling factor may need to be done for both the x and the y directions, depending on the type of analyser; and, secondly, the calibration will only be valid at a fixed object plane distance from the camera. If measurements at other object distances are required then another reference dimension must be obtained at this distance and the calibration repeated.

In a similar way, the calibration of the camera framing rate can be carried out with reference to the timing marks recorded on the film at the time of exposure. Once this has been completed the derived subject parameters of velocity, displacement, acceleration etc., can be calculated and the results displayed in the most appropriate units of measurement. Other processing facilities offered by some motion analysis packages include those of *data averaging* or *smoothing*, which can be used to lessen the effects of vibration from the camera, and lens correction data to reduce the effects of curvilinear distortion due to the lens.

The results from the analysis can be displayed on the screen in forms such as tabulated data, graphs of trajectories, outline drawings and stick diagrams. The results from a number of sequential frames can be overlaid on each other in order to give a clearer display of relative movement. The tabulated data can be exported in spreadsheet form and combined with other data, e.g. data from camera movement sensors, for a more detailed analysis if required. Note that the resultant displays do not contain the original image as there is usually no facility for storing the full image in the computer. The original image must continue to be viewed on the film analyser.

11.6 Conclusions

The analysis of high speed film recordings is an important part of the overall technology of high speed photography. The need for quantitative rather than qualitative analysis has led to the development of specific designs of film readers and associated software packages that are designed to reduce the time taken to obtain results. Although under threat from the newer technologies of video and digital electronic imaging applied to high speed recording, the resolution and framing rate of film camera systems still make them an attractive proposition in some investigations. The increasing processing power of computers has led to the evolution of *hybrid* systems whereby a film camera is used to capture the images but the resultant film is then

digitized and the digital image data stored and analysed directly on a computer.

Thus the framing rate and the resolution of the film system can be maintained, but with the added advantages of increased facilities for image processing and the availability of the visible image as part of the displayed data.

It should be noted that in order to maintain the resolution of the original film record, the digitizing system must have sufficient pixel density to maintain or exceed the original film line pairs per millimetre equivalent. Otherwise resolution will be lost in the transformation process. This is not always consid-ered and if it is not observed, users can be assuming resolution quality which is not there.

A significant amount of analysis time can be saved by employing *autotracking algorithms* instead of manual input of data points. The general availability of computers and the interchangeability of computer files now make this an attractive option. However, the inconvenience of having to wait for the laboratory processing of the exposed film, and the rapidly increasing performance of digital systems, will inevitably lead to a further reduction in the use of film camera systems for all but the most specialist applications.

12 High speed photography of insects in free flight

John Brackenbury

12.1 Introduction

It is virtually impossible to obtain a well-focused image of an insect in free-flight conditions relying exclusively on the human eye and a hand-held camera. This results from the unpredictable nature of the flight path and from the inherent slowness of the human optomotor response. A third factor is the relatively large delay involved in activating a conventional manual shutter. To take a best-case scenario: an obliging insect flies straight towards the lens of the hand-held camera at a conveniently slow speed of 10 km h^{-1} (2.78 m s^{-1}). The photographer has less than 10 ms to react as the insect snaps briefly into focus but, compared with this, the human eye-to-hand response time alone is approximately 250 ms. Add to this a delay of a further 250 ms in the camera shutter mechanism and the insect would have flown to a point almost 1.5 m behind the focused object plane (referred to here and later for convenience as the 'focal plane' of the lens) before the shutter had opened.

A system needs to be designed that allows the insect to trigger its own photography, with minimum possible delay, as it traverses a pre-focused plane in space (Figure 12.1). A standard 35 mm camera is mounted with the optical axis of the lens (in the experimental set-up described, a Nikon Micro-Nikkor 105 mm f/2.8 lens is used) intersecting a helium–neon (HeNe) laser beam. The point of intersection coincides with the focused point of the lens (focal point in the object plane). The beam is detected by a photocell which triggers an iris diaphragm shutter (available from Ealing Electro-Optics, Watford, UK) attached to the front of the lens, as the beam is broken by the flying insect. The camera focal plane shutter is redundant and should be set in the fully open position (the B or T setting on the shutter speed selection control). The opening time of the iris diaphragm shutter is approximately 8 ms and the fully open blades momentarily complete a circuit with a series of flash-guns suitably positioned

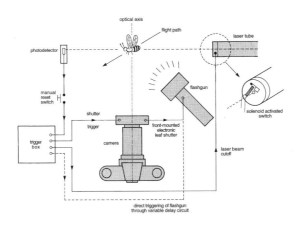

Figure 12.1 Layout of components for the photographic recording of insects in free flight.

to provide the necessary illumination. Naturally, only those subjects that break the beam exactly at the focal point are likely to produce a successful image, although a triggering system based on two intersecting laser beams, both of which must be activated simultaneously to trigger the shutter, could be designed in order to reduce film wastage.

To prevent multiple activation of the shutter–flash assembly as a result of different parts of the insect's body breaking the beam in rapid succession, the first signal from the photocell instantly triggers a relay which is then reset manually before the next exposure can be made. An addition to the basic design consists of a solenoid-operated switch mounted on the side of the exit port of the laser tube. This is activated by the photocell and cuts off the beam before the shutter opens (laser cut-off response time ‹2 ms), preventing the beam from registering as a red streak on the film.

12.2 Technical considerations

12.2.1 Exposure response time

The time delay (t) between the moment that the laser beam breaks and the moment the flash discharges must be short enough to ensure that the insect has not travelled more than a few millimetres beyond the focused plane of the lens before the exposure is made. The unpredictability on the flight path means that it is not generally practicable to compensate for the delay by stationing the camera at a pre-selected spot downstream of the laser beam (insects are not bullets with wings!). If v is the mean flight velocity of the insect and d is the depth of field of the lens, then an in-focus image should be obtained provided that

$$t \leq \frac{d}{2v} \tag{12.1}$$

This assumes that d is equally divided in front of and behind the focused plane, and that the insect hits the beam exactly at the focused point. In the worst case, the insect will be travelling directly towards or away from the lens, within the focused plane: in this case the insect will remain within focus but may well have passed beyond the edge of the frame by the time the exposure is made. In practice, the above equation can only provide a crude guide to the delay time as only a rough estimate can be assigned to v. The value of d can be calculated knowing the image reproduction ratio (magnification) and the f-number of the lens diaphragm, or it can be read off depth-of-field tables supplied by lens manufacturers. In practice, it is easier to gauge d directly by pre-viewing through the camera lens in the stopped down position.

The foregoing arguments can be illustrated by an example: an insect, say a butterfly, with a maximum body dimension (wing span) of 50 mm and a velocity of 2 m s^{-1}. Assume that the insect is flying along the optical axis. For photographic purposes, the dimensions of the subject would be suitably framed by setting an image magnification of 0.25: the image

frame in this case would measure some 140 × 92 mm (based on a usable format of 35 × 23 mm). For maximum depth of field an f-number of $f/22$ is selected. In these circumstances $d \approx 29$ mm and $t = 7.3$ ms. This is only slightly faster than the electromechanical delay of the iris diaphragm shutter (8 ms), and so the majority of the flight paths chosen by this particular insect could be dealt with. Within the same 8 ms, if the insect had been travelling at right angles to the optical axis, it would have moved 29 mm closer to the edge of the frame when the exposure was made, possibly clipping some 5 mm of the body or wingtip. Clearly, the cited butterfly represents a borderline case and it might be wiser to reset the lens at a lower magnification, say 0.15, giving a smaller image, but one that is likely to be both fully focused and fully in frame.

Adjustments of the above nature can be made according to the particular size and speed of the insects involved, once the electromechanical shutter delay is known, but there are many cases involving either very small or very fast flying species where an exposure time of 8 ms will be limiting. In these cases the shutter delay can be obviated by triggering the flash gun directly from the photocell. The author's system incorporates a variable delay circuit allowing the guns to be triggered 0–10 ms after the beam has been broken, but tests must be carried out to ensure that the shutter blades have opened enough to avoid vignetting. Also, because the shutter will not be fully open when the guns discharge, the effective illumination of the subject will be reduced.

The luminous flux versus time diagram of a magnetic shutter indicates that there is a finite delay between the arrival of the opening pulse from the power supply and the initiation of blade movement. This 'opening delay' is the time required to energize the electromagnetic coil and take up the slack in the mechanical linkages, and may amount to 5 ms. The 'opening time' of the blades is, in the system described, a further 3 ms. It is only in this latter phase that any advantage can be gained by direct triggering of the flash-guns from the photocell, and at most this will amount to only 1 or 2 ms.

Alternative methods can be adopted to minimize t. First, the delay can be virtually eliminated by operating with a fully opened shutter in darkroom conditions, and triggering directly from the photocell. But this presents operational difficulties, not least of which is the unwillingness of most insects to fly in the dark or in the presence of safety lighting. A second, more practical option is to use a liquid crystal shutter (supplied by Ealing Electro-Optics, Watford, UK) with a delay time of as little as 10 μs. A liquid crystal shutter consists of a transparent plate coated with a ferroelectric liquid crystal which acts as a voltage switchable, half-wave plate. The main drawback of this option, apart from cost, is that the shutter continues to transmit approximately 0.5% of the incident light in the closed state. This may sound low, but it would soon lead to fogging of the exposed film

when the camera focal plane shutter was opened in preparation for a 'run'. The third option comes ready-made in certain medium format cameras, notably those from Rollei, which are equipped with a leaf shutter driven by a linear induction motor. The shutter delay is said to be a fast 3 ms but, on the debit side, the lenses form an integral part of a very expensive camera system that could not be easily adapted to a cheaper and more practical 35 mm format.

12.2.2 Exposure duration

While the exposure delay limits the maximum flight speed of insects that can be photographed without blur, the minimum exposure duration is governed by the *rotational velocity* of the wings (Wing span × Wing beat frequency). Usually the speed of the wings will be much greater than the translational speed of the body, and hence they will be more prone to motion blur. In practice, it is unlikely that an exposure of more than 1/4000 s (0.25 ms) will freeze the motion of the wings even in relatively slow beaters. It should be pointed out that even though some modern 35 mm cameras boast a top shutter speed of 1/8000 s (0.125 ms); this is unlikely to benefit the insect flight photographer because the mechanical delay in the shutter mechanism is still far too long. Moreover, focal plane shutter cameras can only synchronize with flash at shutter speeds of up to 1/250 s (4 ms), rendering the very fast shutter speed redundant unless an attempt is made to use ambient lighting rather than flash. It can easily be shown that, in order to preserve the same photographic parameters as those considered optimal in this laboratory situation (i.e. magnifications of 0.15–0.5, f-number setting of f/22, film speed rating of 50–64 ISO), the ambient light levels would need to be 100–150 times those encountered in full sunshine. Adequate exposure could only be obtained by employing intense artificial lighting or by using film with an ISO rating of 1600–3200, which would reduce image resolution below acceptable levels.

Flash is by far the most practical method of achieving the extremely high light intensities that are needed during very brief exposures. Flash durations of 1/10 000 s (0.1 ms) or even 1/20 000 (0.05 ms) are available on large commercial 'hammer-head' units and these cover most applications. However, rapid discharge can only be achieved at the expense of power output: for example, to secure the 1/10 000 s regularly employed in the author's own studies, the flash units need to be operated at 1/32 the nominal power rating. As a result, to guarantee adequate exposure on slow film, the unit or units must be positioned within 200 mm of the subject. Moreover, the inverse square law dictates that even quadrupling the number of units only permits a doubling of the subject to source distance. One solution is to opt for a much more powerful custom-built flash-gun. Such units generate flash durations of 1/20 000 or even 1/ 40 000 s (25 µs) and, although extremely costly, are the ideal light source. Another possibility is to use backlighting, with the light source imaged onto the camera lens by a large diameter condenser lens. This technique produces a silhouette image, which is acceptable if the wings are transparent, but is of less use in the case of moths and butterflies.

12.2.3 Performance evaluation

As in any photographic system, performance must ultimately be evaluated in terms of image quality. When the photography also serves a scientific purpose, the information content of the image will be judged directly by the level of detail resolved within the most rapidly moving element, in this case the wings. In general, large insects with relatively slow wing beats (<100 Hz) are adequately served by exposure durations of 1/10 000 s (0.1 ms). High wing beat frequencies (say, >150 Hz) immediately pose a problem, with wing blurring at 1/ 10 000 s exposures. The smaller the insect, the more pressing the problem, since higher magnifications increase the effective speed of the image (i.e. the moving wing) across the film. Most true flies (Diptera), bees and wasps (Hymenoptera), beetles (Coleoptera) and plant bugs (Hemiptera) have wing beat frequencies exceeding 150 Hz and require exposures of 1/20 000 s (50 µs). On the other hand, the relatively sedate wing movements of butterflies and moths (Lepidoptera), dragonflies and damselflies (Odonata), and large grasshoppers and bush-crickets (Orthoptera) are faithfully rendered by an exposure of 1/10 000 s (0.1 ms). However, an additional complication may well arise in these cases because the linear body velocities achieved by some grasshoppers and plant bugs such as frog-hoppers and leaf-hoppers are greater than the wingtip velocities. These not only require the very fastest flash exposures (1/20 000 to 1/40 000 s, (50–25 µs)), but also evade capture by electromagnetic leaf shutters: they are simply too fast to be caught within the standard 8 ms response time. In these specialized cases, an extremely fast shutter with a response time of approximately 3 ms is required. This can be achieved, without sacrificing the electromagnetic leaf-shutter principle, by reducing the number and size, and hence the mechanical impedance, of the moving parts (Brackenbury, 1995).

Examples of insects successfully captured in flight by high speed photography are shown in the colour plates section of this book.

References

Brackenbury, J. H. (1995) *Insects in Flight*. Blandford, London

Bibliography

Dalton, S. (1975) *Borne on the Wind*. Chatto & Windus, London

13 Project design and planning

Peter W. W. Fuller

13.1 Introduction

High speed photography is normally used for events which occur over short time scales, where the subjects under investigation move at high speed and fast framing rates and short duration exposures are required to achieve clear, blur-free images. In some instances high framing rates may be employed to enable events to be shown in slow motion, by replaying the record at a slower rate than that used for recording. Sometimes this slow motion technique is used in an artistic way and can often produce striking images from the natural world. It is also used extensively for advertising purposes. However, in these cases the main purpose is not to gain precise data but rather to entertain and inform.

Apart from this area the bulk of high speed photographic work is carried out to obtain data, make measurements and observe some form of scientific experiment. All measurement is a compromise between the ideal achievement of results and practical expediency. As a measurement tool, photography has the advantage of being non-intrusive and, in general, exerts no modifying effect on the process under observation.

As with all scientific projects, good planning is vital for success. Decisions must be made as to what quality or characteristics are required of the event under observation. A decision must be made as to whether it will be qualitative or quantitative and, if quantitative, what order of resolution and accuracy of measurement are we striving to achieve.

Following these decisions a measuring method and procedure must be selected. If no established technique exists a new technique may need to be developed. Following the selection of method, other relevant items must be identified and a plan evolved for the way in which the experiment will be carried out.

Finally, when all these areas have been covered the experiments will be made, the records obtained and the analysis of results carried out. The process is one of constant interaction and reassessment between all parts of the activity, the final required result being the first consideration in the planning process.

One may ask, why should we go to so much trouble to obtain accurate measurements? Lord Kelvin stated the case very convincingly:

> When you can measure what you are speaking about, and express it in numbers, you know something about it; but when you cannot measure it, when you cannot express it in numbers, your knowledge is of a meagre and unsatisfactory kind; it may be the beginning of knowledge but you have scarcely in your thoughts advanced to the stage of science, whatever the matter may be.

In this chapter, although emphasis will be placed on the scientific and quantitative approach to high speed photography, many of the points raised will be common to both quantitative and qualitative planning.

In order to produce a satisfactory final result, photographers must possess not only a detailed knowledge of all aspects of their craft, but also a working knowledge and understanding of the subject and its expected behaviour.

13.2 Guidelines for project planning

13.2.1 Guidelines

Some of the more important points which may influence and guide the planning process are listed below.

- *Simplicity*: the methods and equipment used should be as simple as possible, the degree of complexity only being sufficient to achieve the desired results. The more simple the arrangements, the easier they will be to operate. In general, costs will be lower and the chance of making expensive errors in operation will be reduced.
- *Minimum transformations*: the ideal situation is to be able to analyse the data directly from the primary recording medium. Transformations involving reprocessing, magnification, conversion from film to digitized image, etc., should be kept to a minimum as each change introduces another possible source of errors.

- *Maximize observations*: many of the processes under observation will be of short duration, so the number of frames or images should be maximized to gain as much information as possible in the time available.
- *Research and discussion*: maximum use should be made of previous written records of work similar to the current experiments. All knowledge that can be gathered of previous efforts in the field is valuable, even if they were not successful. A few hours of reading may save weeks of unfruitful practical experiment. It may also provide an alternative approach not previously encountered. Perhaps most important of all, previous work may give valuable clues as to the resolution and accuracy required in the final record to give good results. In addition to reading, it is worth seeking advice from fellow workers in the appropriate field. Make use of local colleagues and names of other contacts which may have been obtained from the reading survey.
- *Expediency*: during the planning stages, the time, money and equipment available will play a large part in determining the final way in which the experiment is conducted. As in many other areas of endeavour, the ideal approach may not be feasible because of restrictions of time or equipment availability. It may be necessary to choose a less favoured approach and try to compromise on results. Often inventiveness and ingenuity can make up for shortcomings in equipment. If the time scale is very important, a revision of plans may be necessary if initial experiments are unsuccessful. Thus, where possible, some time and resources should be kept in reserve. They may represent the difference between success and failure.
- *Reliability and reproducibility*: the chosen methods should be reliable and reproducible. This is particularly important if many similar experiments are to be made. Evidence of reliability can be inferred from previous experiments or from external sources. Reproducibility is vital in order to sustain a required level of results.
- *Records*: complete and careful records should be kept of experimental work done. This should include descriptions and details of the apparatus used and the settings of controls. In addition, plans of the placement of equipment and event should be made, together with important measurements of distances, angles, etc. Often a pictorial photograph of the set-up can be very valuable at a later date for reference, particularly if an experiment is repeated. Failures or unsuccessful methods with reasons for failure should also be recorded for future reference. These notes will not only be of use in one's own future work, but will also be valuable to others engaged in similar experiments. If the failure has been due to inadequate technology, future technology advances may make the method a success.

Finally, all photographic records, on whatever medium, must be very carefully listed and identified with the experiment name, date, calibration details and relevant notes. If possible, some identifying label should be placed directly onto the medium as well as on boxes or reels, in case they are subsequently confused. The importance of good records cannot be emphasized too highly. Lost or unidentified data make for wastage and inefficiency and can be disastrous if the event under observation is unrepeatable.

13.2.2 Safety

Whilst photography may not normally be considered a hazardous proceeding, the events to be photographed, their location or the associated equipment involved may introduce serious hazards. Safety considerations should thus be an important aspect in design and planning. Photographic studies of events such as explosions or ballistic applications pose obvious dangers, but many industrial processes may also involve dangerous sitings for equipment and personnel. Flying particles, gases, sparks or splashes from corrosive liquids can also produce problems which must be foreseen and protected against. Moving machinery or vehicles may pose hazards to camera set-ups if the equipment is not placed well away from used paths. In open locations, ground bases which are rock hard in dry conditions may become bogs after a heavy rainfall, leading to overturned tripods and damaged equipment.

It cannot be too strongly emphasized that in all photographic experimental work we are often dealing with events and processes which are in a state of early development and which are not completely understood. It is thus very important that the photographer does not undertake such work unless guided by an expert in the particular subject matter involved. That expert or knowledgeable guide should be present throughout the period of work to instruct and educate the photographer in the possible hazards involved and allow him or her to become sufficiently acquainted with the process to be able to make the correct photographic decisions required. In turn, the photographer may well be able to suggest methods of approach or procedure, backed by his or her photographic knowledge, which may enhance the observations made.

Photographers must also be aware of hazards associated with their own equipment. When loading or unloading film cameras they must be in complete control of the power supply to the camera. This is particularly important in planning work where it is necessary to operate cameras or lights remotely so that the control point may be visually hidden and

out of earshot. Provision should be made to allow direct communication between camera position and control point so that no testing is carried out without the knowledge of all concerned. Similarly, where lighting is remotely triggered the same precautions should be applied. It is no joke when a large number of laboriously replaced flash bulbs are all fired wastefully by an uncoordinated test check. Great care must also be taken when planning events which are initiated by camera control and in the initial design phase there should be safety break-circuit plugs incorporated into the circuitry involved to prevent accidents.

Light sources may also pose hazards from burns or electric shock, and the use of sources such as lasers and high voltage electric sparks represent formidable dangers. Particular care must be taken when setting up experiments using lasers, intense point light sources or ultraviolet sources. If the subject is illuminated by laser light, for example, caution must be taken when alignment and focusing of cameras is being carried out. The increased light gathering properties of large objective lenses and the focusing of the light into eyepieces may raise the hazard level above that permissible when observed directly with the naked eye. This may move a laser in an otherwise eye-safe class up into a higher danger class if its light is viewed through an eyepiece. Thus all work involving lasers and intense sources should be approached with caution backed by expert knowledge of the hazards involved. Where possible, focusing and alignment should be conducted by imaging onto screens rather than by looking directly into eyepieces. In some situations laser safety goggles may be needed. In this case the goggles will be chosen to filter out the laser light wavelength and the beam may no longer be visible through the goggles. Care must be taken not to move inadvertently into the beam path and extreme care exercised if goggles are removed to check the beam position on the subject. The best compromise is to use goggles of a density which cuts the laser light to a safe level whilst allowing sufficient response for setting up.

Finally, if the photographer is attempting to employ photographic techniques previously unused, or only known from a theoretical viewpoint, the presence of an already knowledgeable practitioner for the first few runs may not only save costly mistakes but also save the novice from injury.

It cannot be too highly emphasized, that in all the situations in which potential hazards exist, some of

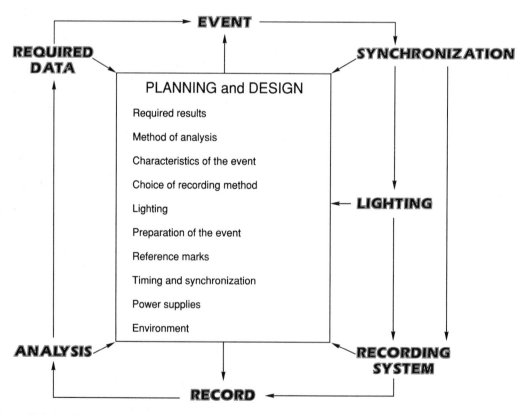

Figure 13.1 The interactions between planning, design and experiment.

which have been outlined above, expert advice must be sought. This is particularly true in situations where there is a potential for damage to the sight or in the case of electrical hazards where the dangers may not be so obvious.

13.3 The cycle of planning philosophy

Figure 13.1 shows diagrammatically the complex interactions of both planning background philosophy and practical elements in the design of photographic projects and experiments. The process is a cyclic progression with constant interaction between the major elements and the various requirements listed in planning and design. These requirements can be explored in more detail using the following list:

- What is the nature of the event to be studied?
- What is the desired information or measurement required from the study?
- When can the events take place, when are the results required, and what funding and personnel or equipment are available?
- What is the state of current knowledge? Have previous similar experiments been done? Is it possible either to make some preliminary observations, or apply 'quick look' measures to increase planning knowledge, using methods such as unaided or stroboscopic visual observations, or some tentative still or cine pictures for repetitive or cyclic events?

The event should be analysed using theoretical predictions for its range of change, the extent and speed of movement and its overall duration.

- Obtain a firm idea of the form the final record will assume, using established criteria.
 (a) What parameters are to be measured?
 (b) What image format is needed?
 (c) How will timing marks or fiduciary marks be inserted?
 (d) What are the necessary spatial and temporal resolutions?
 (e) How will the subsequent analysis be carried out? The usual choices include:
 (i) visual observation of projected film,
 (ii) machine assisted measurement of film frames,
 (iii) machine assisted analysis of multiple still exposures on a single frame.
 (iv) multiple sequential still exposures,
 (v) projection of electronic camera records on a video screen coupled with cursor or computer analysis,
 (vi) analysis of print-out of electronic camera pictures,
 (vii) measuring-microscope analysis of negatives.
- Consideration of choice of equipment to produce the above requirements, including the lighting needed. Equipment is chosen on the basis of:
 (a) still or cine recording camera required,
 (b) mechanical or electronic type,
 (c) framing rate and exposure time needed,
 (d) focal length of camera objective,
 (e) depth of field needed,
 (f) the required intensity of light from the subject and the source luminance needed to provide this,
 (g) whether or not lighting is to be strobed with the camera,
 (h) the way in which the image capture will be synchronized with the event,
 (i) whether or not extra lighting (intermittent or continuous sources chosen from alternatives such as flash bulbs, arc lamps, electronic flash, tungsten filament, argon bomb, sunlight, high voltage spark, continuous laser, flash X-ray, and laser flash) will be required,
 (j) what type, speed and gauge of film is needed,
 (k) what type, size and length of tape is required,
 (l) whether or not the equipment required is available in-house? If not, can it be hired or borrowed and, if so, where from?
 (m) logistics of loan procedures (How much will it cost? Can we operate it or will an operator also be needed?).
- Preparation of an event for optimum observation:
 (a) consideration of environment and location,
 (b) consideration of needs for and availability of power supplies,
 (c) supplies of film stock, tape and computer discs,
 (d) auxiliary equipment required,
 (e) transport of all equipment to site,
 (f) number and type of personnel required,
 (g) how will the recorded material be processed or prepared to a state ready for analysis? Who will do this task?
- In what form will the final data be presented to the sponsor? Will it be purely visual, purely data, or a mixture of visual examples and data? Will the sponsor carry out the analysis or must data production be included in the workload?
- What are the contingency plans to allow for setbacks in any or all of previous stages? Try to reserve some funds and time if possible.

13.4 Factors directly affected by required results

The required results from the images obtained during the project may vary widely from a high

quality pictorial record of an event to highly resolved data of subject velocity, spatial position with time, dimensional change or other dynamic characteristics. The images may include the subject interaction with other objects or its effect on the surroundings, e.g. shock waves in the atmosphere surrounding a supersonic projectile.

A decision must be made as to whether a single image will be adequate, or if a series of single images will be sufficient. Likewise, it must be decided whether it will be required to see the event as a complete sequence viewable by projection. If the final record requires detailed analysis, other considerations must also be addressed.

13.4.1 Method of analysis

If it is required to view the event as a smooth sequence then recording will require the use of a cine film camera or a video system providing at least 30–100 sequential frames, depending on event duration and chosen framing rate. If data on movement direction and velocity only are needed, then perhaps only 5–10 carefully timed single frames may be enough. In some instances, several images exposed on a single frame may be adequate for velocity determination.

If it is desired to project the series of frames as an enlarged image onto a screen, a cine film camera using film stock for which projectors are available will be needed. Alternatively, if video tape recordings are employed they can be played back on a visual display unit. A similar argument applies if analysis is to be carried out on an analysing cine projector or console measuring device. For single images or short lengths of cine film, analysis may be made by viewing on a projection analyser or by use of a travelling microscope.

Whatever method is used, the recording medium must be compatible with the measuring system. These points must be considered and clarified before equipment choices are made. If the requirements dictate that a particular recording system must be used which is not compatible with in-house analysing facilities, then provision must be made to obtain or hire suitable equipment well ahead of production of the first records.

13.4.2 Framing rate and exposure time

The analysis process will be intimately concerned with the available resolution of the record. This in turn will be governed by the recording system characteristics, the recording medium, and factors such as framing rate and exposure time.

In order to make the initial choice of framing rate it is necessary to have some idea of subject velocity and acceleration. If these are not known from previous knowledge or from other measuring methods it may be necessary to make one or two tentative records at fairly widely separated framing rates to obtain a working guide.

Choice of framing rate can be considered from two points of view. Firstly, if the requirements are to analyse visually an event by slow motion projection, the framing rate will be the most important consideration. Depending upon the rate of movement of the subject it may be found that too high a reduction in movement rate may make it difficult for the eye to appreciate changes. Thus very high framing rates may not be advantageous during the filming process and more modest rates should be selected. If it is considered that a certain length of viewing time in projection will be required, the actual shooting duration needed can be calculated from the ratio of shooting and projection rates. As film projection rates are normally 16–24 frames per second (fps) (typical video may be 30 frames per second) the ratio of recording to projection rate can easily be calculated.

Secondly, if it is necessary to analyse the film frame by frame, then *image blur* becomes the important factor and exposure times must be short enough to achieve the required spatial resolution. As framing rate and shutter opening time are mostly interdependent on ordinary cine cameras, short exposures will normally mean high framing rates.

In a typical high speed cine camera, shutter speed is related to framing rate in the following way:

$$d = \frac{p}{F} \tag{13.1}$$

where d is the duration of exposure (in seconds), F is the number of frames per second, and p is a constant, the *shutter duration period ratio*. In this case, the *period* is the time interval between frames or the reciprocal of framing rate. A typical value of p for a 16 mm cine camera might be 0.5.

13.4.3 Spatial and temporal resolution

The avoidance of blur is concerned with exposure time and spatial resolution. The time t which an object takes to move through its own length is the critical factor. In considering the image quality required, the critical factors include exposure time, recording medium response and resolution, event and recording layout and geometry, object size and speed. If effective exposure per picture is less than $0.001\,t$, then the image resolution will be equal to acceptable results using a 35 mm camera with stationary objects. If exposure extends to $0.002\,t$, resolution is about equal to good quality broadcast television pictures. For exposures of $0.2\,t$, only gross differences in object shape will be distinguished. Obviously, very small, fast objects are the most difficult to capture at high resolution.

By comparison, a temporal resolution of one to three orders of magnitude less than event duration is desirable. For example, an event lasting 1 ms may be recorded using framing rates between 1000 and 1 million pps. The actual number of exposures will be a function of the available framing rate and recording length of medium used.

A particular problem occurs with the filming of fast periodic motion such as a vibrating reed; here the situation is somewhat analogous to *aliasing* in the recording of periodic sinusoidal waveforms. If the framing rate is such that the exposure always occurs at the same instant during one cycle, the subject may appear to be stationary. One might then argue that if the framing rate is known accurately the reed vibration rate can be deduced. However, the reed could also be vibrating at integral multiples of that framing rate. This can be avoided by changing the framing rate to be out of synchronization, and perhaps increasing it to give several images per cycle.

Blurring of the image must not exceed the diameter of the *circle of confusion* (*C*). This diameter relates to the size of the disc which when viewed by the normal eye under ordinary conditions, appears as a point. A typical diameter of 0.05 mm (0.002 inch) is considered adequate for the analysis of cine records. Thus, for each exposure the image of the fastest component of the subject should not move more than 0.05 mm in the image plane of the camera. Allowance must, of course, be made for lens magnification.

Blurring will be worst when the subject is moving at right angles to the camera axis, and for most exposure calculation purposes this velocity will be appropriate. If the subject is not moving at right angles to the camera axis the component of velocity at right angles can be calculated by multiplying the true velocity of the subject by the cosine of the angle between the focal plane of the camera and the subject's path (Figure 13.2). The degree of blurring can be expressed as:

$$b = dmV\cos\theta \tag{13.2}$$

where *b* is blur (in millimetres), *d* is exposure duration (in seconds), *m* is the ratio of image size to object size or magnification, *V* is the subject velocity (in millimetres per second), and *θ* is the angle between the direction of motion and the film plane.

At the other extreme, if the subject is moving *along* the camera axis, then longer blur-free exposures will be possible, but the depth of field must be adequate to cover the distance moved by the subject during the filming duration.

Spatial resolution is defined in two ways. The first is the number of pairs of equal black and white lines just resolvable per millimetre on the film (line-pairs mm^{-1}, or lpm, or lp mm^{-1}). The second defines the number of line-pairs per frame. For planning

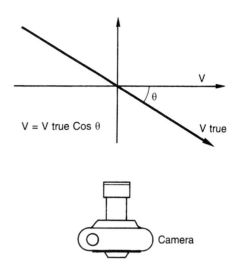

Figure 13.2 The component of velocity at right angles to the camera axis.

purposes line-pairs per frame is more useful, as normally the view is arranged to use the maximum subject to frame proportion. Quoted *frame resolution* thus makes it easier to refer resolution in the record back to the known size of the subject.

For stationary subjects, resolution is dependent upon the light available from the subject, the emulsion used, the image contrast, the resolution of the lens system involved, the size of frame and the developing technique used. In photography of stationary subjects maximum information will be obtained by using the highest resolution obtainable.

However, in high speed photography we are normally concerned with moving subjects or subjects that are changing rapidly in appearance. In this case the resolution criteria may change. To obtain the best spatial resolution, use is made of slow speed, fine grain film, large frame size, low contrast development and large numerical aperture lenses. For the best temporal resolution, the light level is often under the optimum value to satisfy the demands of short exposures and high framing rates, so fast coarse grained materials, forced development, small frame size (to assist image transport) and small numerical aperture lenses are needed. The requirements for good spatial and good temporal resolution are thus at odds with each other.

For moving subjects, more than one spatial dimension and time may be interconnected, depending upon the orientation of their path relative to the film plane of the camera. Both spatial and temporal resolution must be good. Spatial resolution may be smeared by image movement during a long exposure, or temporal resolution may be marred by poor spatial resolution due to inadequate light reaching the recording medium. Thus the best

method may be to attempt a compromise and obtain the optimum result by making the blur due to spatial and temporal resolution of a similar amount.

13.4.4 Classes of recording

Photographic recordings belong to one of three major classes, depending on whether a *single picture* or a *series of pictures* or a *continuous record* is taken. The image is a two-dimensional record so the three classes will represent, a two-dimensional record either at a single instant, or a series of different instants or a one-dimensional record with the other dimension representing time.

The single picture only offers information at one instant in the event history. Multiple pictures sample the event history at known intervals but give no information on what is happening in the unrecorded time. Thus event development rate and framing rate must be matched carefully. If the event is of very short duration it may occur within the *interframe time* of the camera. It has been known for events to apparently disappear due to this phenomenon! If events are of such short duration, framing rates must be substantially increased to ensure that the event is captured. If available equipment is already being used at its peak framing rate it may be necessary to either find alternative equipment or consider the use of continuous *streak photography* so that the shutter is open all the time. In the third class where one dimension is given over to time, a continuous time record is possible, but only one-dimensional information on subject movement is available. This last method must obviously be chosen with care and is only applicable to certain events where the one-dimensional characteristic can give meaningful results, as the image ceases to be a normal pictorial representation of the subject.

In the first and second classes of method a third dimension of information in a direction parallel to the line of sight can be obtained by the use of mirrors to provide a simultaneous *orthogonal view*. Alternatively, cameras with synchronized shutter exposures can be placed to view the event orthogonally. This extra dimension is obtained at the expense of more complex analysis requirements. When using this method it is also vital that some correlating factor is introduced into the scene so that all views have at least one common reference line or object, otherwise it will be very difficult to relate position and dimensions in the analysis stage.

In the case of *multiple images* recorded on a single frame there may be problems of adequate contrast if too many images are recorded on the same area of film. Usually beyond five or six images the picture quality will begin to degrade excessively due to cumulative overexposure. A second problem may arise if exposure interval and rate of movement of the subject are not well adjusted. If several successive images are partially superimposed, it may become very difficult to analyse the picture due to problems in differentiating between outlines. However, the method may have advantages in some applications. Having all images in view simultaneously may give a more clear visual impression of changes in movement rate with time. In some instances, having all images on one frame may allow a more accurate analysis than having to measure multiple frames separated along the film length.

13.4.5 What will be recorded?

A very important point in the planning to fulfil the recording requirements is concerned with the basic recording process and the characteristics of the event or subject. The final record presented for analysis will be a *non-linear recording* within a limited spectrum of emission wavelengths coming from the subject. If the subject is solid and well lit, its external dimensions and features appearing on the record will probably represent their true extent. However, if the subject is self-luminous or ephemeral the recording medium sensitivity to intensity and wavelength will become very important. Great care must be taken to ensure that the recording accurately defines the limits of the subject and that the characteristics and thresholds of the image forming system are truly equivalent to the characteristics of other systems which may be used to observe and assess the event.

If some parts of the subject are emitting at too low a level or emitting radiation outside the recording range of the camera system they may not appear on the record. *Thus an important point to remember is that the image obtained may not truly represent all aspects of the event and, if it does not, we should be aware of the location and extent of the shortcomings.*

A typical example may occur in *X-ray flash photography*. For a typical event, what is actually recorded as an image will be a function of the characteristics of the recording medium, the subject absorptions and relative 'hardness' of the X-rays used. Due to particular combinations of subject density and the penetrating ability of the X-rays in use, some parts or subjects may be invisible on the record but are nevertheless still there and taking part in the event. A good example of this effect is shown in Figure 13.3, where both pictures are made by X-rays but show different aspects of the event. The pictures show an aluminium bar being penetrated by a bullet. Small glass beads are spread on top of the bar. In Figure 13.3(a), 'soft' X-rays have been used and the emitted debris and the disturbance of the glass beads due to the shock passing through the block can be clearly seen. However, the X-rays are not hard enough to penetrate the bar. In Figure 13.3(b), 'hard' X-rays have

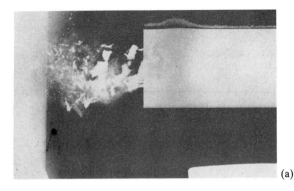 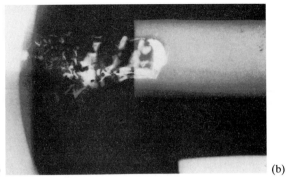

(a) (b)

Figure 13.3 A comparison of (a) soft and (b) hard X-ray pictures of the same event.

been used and the penetration of the projectile into the bar can be seen. In this case, the X-rays are attenuated so little by some of the debris and the glass beads, that these objects have apparently disappeared.

13.4.6 Camera record calibration

If analysis will require the determination of subject velocity by reference to the extent of the movement between frames, the interframe interval must be known to high accuracy. If film recording is used a *time base* will be required, recorded onto the film edge. Thus a camera will need to be selected that has an integral time base. If an electronic recording system is chosen, interframe timing will usually be internally selected to high accuracy in the setting of the framing rate, and separate calibration will not be needed. In some slower processes it may be possible to include an analogue or digital clock in the field of view. The time resolution of such a device will need to be compatible with the duration and rate of change of the subject under observation. Similarly, if the subject is rotating, an indication of angular position in each frame can be useful during the analysis phase, e.g. observation of internal flow in an internal combustion engine.

If cine film is used and good accuracy is required, it will be worth choosing a time base that denotes multiples of the *timing marks* (e.g. every 5, 10 and 100) by different markers. This is a great help in timing analysis. Also, to gain an accurate idea of timing intervals, several sections of film should be analysed and an average taken to allow for distortion of the film in a lengthwise direction.

For situations using single or multiple short duration light pulses, the sources will usually be triggered at specific intervals set by the operator. However, it may be worth providing an independent record of time intervals between exposures by the use of a light detector connected to a recording oscilloscope or a digital event recorder.

13.5 Planning the project

13.5.1 Characteristics and preparation of the event or subject

The characteristics of the event will obviously control the decisions as to what data need to be recorded or what it is feasible to record. In some instances it may be possible to prepare the event or subject in such a way as to enhance recording possibilities and to assist in achieving the desired results.

The frontal lighting required for high speed work tends to minimize contrast in subjects and this can be greatly enhanced by painting important elements in the scene to make them stand out.

Moving surfaces can be painted white or can have a fine strip of retroreflective tape glued on to counteract the effects of uncontrolled shadows, distorted rendering of shape or form, or low illumination within recessed areas. Sometimes several different coloured paints may be useful in distinguishing parts that are superimposed or whose outlines may become confused when using a single colour. In this case, of course, colour photography will need to be employed.

Similarly, areas or subjects that are naturally bright, but which have no value in the recording, can be toned down by a matte spray to reduce their distracting effects.

By artificially enhancing important elements analysis will be much more simple and accuracy will be improved. When viewing the scene under the high light levels usually required for high speed photography it is often useful to have a *neutral density viewing filter* available with an optical density of around 1. Without such a filter, the eye will find it difficult to distinguish where highlights and shadows occur and in judging whether a balanced subject illumination has been achieved.

If some parts of the subject, which are not vital to or involved in the observed process, conceal or disrupt the view of a vital element, they should be

removed. Similarly, other distracting surrounding objects not involved with the event should be removed, particularly if they are behind the subject. If feasible it is very helpful to insert a plain matte background behind the event to clarify a silhouette and produce a scene with the minimum amount of distracting clutter. Care should also be taken to remove objects or surfaces that may reflect back event lighting into the camera, particularly if the lighting is not continuous (i.e. flash or spark). In this case the problem will not be immediately obvious during setting up with continuous lighting.

In preparing a subject for high speed photography it must be realized that in scientific applications the main objective is to obtain data and make measurements and the pictorial considerations of images for entertainment or the study of nature do not apply. In extreme cases, only a few of the vital moving elements may be enhanced to remain clearly visible and the pictorial nature of the subject will disappear.

13.5.2 Event or subject location

High speed photography presents enough difficulties without adding others, so if the event or subject to be observed can safely take place within a studio location and can be moved, it should be relocated. If essentially an outdoor event, attempts should be made to see whether the event, and certainly the camera, can be under cover and protected from the elements by a temporary or semi-permanent housing. The performance of both camera and operator will be greatly enhanced if they are warm and dry.

13.5.3 Reference marks and scales

When studying the motion of solid objects (e.g. the functioning of industrial machinery) it may not always be necessary to include the whole subject in the field of view. A well defined reference edge or a series of marks on a portion of the subject may be all that is required.

However, another clearly defined mark or marks on a stationary object in the field and in the same focal plane must be included as a reference, preferably with an accurately calibrated scale. This will allow measurements taken on the film to be accurately expressed as absolute unit equivalents. For close-up work it may be possible to incorporate a *vernier scale* with one scale on the moving and one on the stationary part.

For larger scale work it is often very useful to place *grid lines* on a screen behind the subject or event. Black on white or white on black is to be preferred. If this system is used it must be remembered that the measurement grid may not be in

exactly the same plane as the event under observation and due allowance for scaling must be made in the analysis stage. If the depth of field used is not large enough to allow both subject and grid to be in focus, auxiliary optical assistance can be used. In this case, the setting up process for the experiment may be more complex but may well be justified by the results obtained.

Two methods are available. In the first, a board upon which an accurate grid pattern (e.g white on black) has been drawn is placed to one side of the camera. A semi-transparent mirror or *beam splitter* is placed in front of the camera lens at 45° to reflect the grid image into the lens (Figure 13.4).

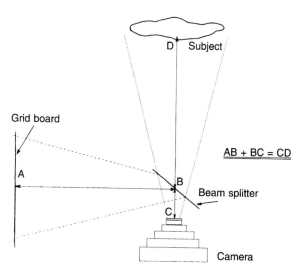

Figure 13.4 The method of superimposing picture grid lines using a grid board image.

Grid position is adjusted so that the optical paths of the subject to lens and grid to lens distances are the same. Great care must be taken to see that *grid board* and subject movement plane are carefully set up in the vertical direction and at a true 90° in the horizontal direction. The beam splitter must also be truly aligned at 45° to both planes and held rigidly with respect to the camera. This arrangement requires a great deal of room to set up and takes time to align.

The alternative is to use a high quality grid transparency with backlighting and an intermediate lens to allow focusing onto the image plane (Figure 13.5). Similar care must be taken with angles and alignment, but the reference system can be of relatively small dimensions. Some care will be needed to ensure that grid lines in the camera are accurately scaled to give a true equivalent to real lines in the subject plane. While the grid will provide a reference, it is worthwhile to include an accurately scaled

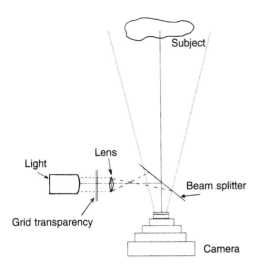

Light

Lens

Grid transparency

Subject

Beam splitter

Camera

Figure 13.5 The method of superimposing picture grid lines using a grid transparency.

fiduciary mark in the event plane to facilitate absolute scaling.

Another useful reference can be provided by small *fibre optic light guides*. These can be used as very bright point light sources and can be placed at carefully defined points in the primary plane used for focus on the subject. Both fibre optic light guides and suitable high intensity lamp sources are readily available commercially. They can be used as scaling markers on the subject and/or to provide static reference points against which subject movement taking place in the field of view can be assessed. As they are self-luminous and very intense they do not require illumination by the main subject lighting source and may still be visible if smoke or steam should partly obscure the field of view during an event.

If flash X-ray pictures are to be taken, it is again vital to include *fiduciary wires* in the field of view. These may include plumb wires to give a true vertical reference and taut wires between supports adjusted to give a true horizontal reference. If dimensional measurements are required, accurately machined references must be placed as near as possible to the plane of subject motion. If the X-ray photographs will be analysed with reference to variations in image density, *calibrated step wedges* must be included in the field of view and the exposing beam, and as near as possible to the main plane in which the event is occurring.

13.5.4 Power supplies

A most important aspect of planning for a photographic experiment is to ensure that there are ade-

quate *power supplies* at the site. For studio or indoor laboratory locations a variety of supplies will probably be readily available. However, for outdoor or remote locations, provision of a suitable power supply may become a major problem.

Power supplies will be needed to run cameras, lighting and auxiliary equipment at the location. It will be necessary to check that either alternating current (AC), or direct current (DC) voltages are available within the range of correct values for the equipment, that the current capacity of the source is adequate, and that, for special auxiliary equipment such as computers, the supply is adequately filtered and protected from *voltage spikes*. If mains supplies are not available at the site, then portable generators or battery supplies must be procured.

If power sockets are available, the form of socket and pin layout should be checked to ensure that the equipment leads have compatible plugs. If equipment produced in another country is used, the voltage required may be different from the site supply. In this case step-down or step-up transformers of adequate capacity will need to be included in the kit.

Some cameras using continuous film motion can draw large currents during the initial acceleration phase, and if long supply cables are used voltage drop in the cables may become important.

Where possible, supplies for cameras and large lighting arrays, should be drawn from separate outlets or generators. If other instrumentation equipment is connected to the same supply, the sudden drop in voltage when cameras or lights are switched on may *pre-trigger* equipment or even cause it to shut down. In a complex experiment, interference from camera supplies could cause problems by premature triggering of the event.

Voltage drop in a cable run can be calculated using the simple formula

$$V_D = C_L r I \qquad (13.3)$$

where V_D is the voltage drop (in volts), C_L is the cable length (in metres), r is the cable resistance (in ohms per metre of cable), and I is the required current (in amperes). This simple formula will be adequate for equipment using DC and, within reasonable limits, for AC. To ensure that all will be well the voltage drop over the required cable run can be calculated and checked against the permitted percentage voltage drop allowed for safe equipment operation.

The resistance values in ohms for cable lengths can be obtained from electricians' tables. Note that, if figures for the resistance per metre values of *single* wires are found from tables, care should be taken to double the total run length to obtain the resistance for a simple two wire circuit. This will give the total

outward–return drop value. Voltage drop for a given current will be lower for a smaller cable resistance. Resistance falls as the cable conductor cross-section becomes larger. It is thus good practice to use the heaviest cables practicable in the circumstances.

If there is an appreciable drop in voltage over the cable run, it will be necessary to check that lighting levels will still be adequate for the experimental requirements. For example, in the case of gas-filled tungsten lamps, the light output will vary with voltage drop as

$$\frac{\text{Actual lumens}}{\text{Rated lumens}} = \frac{\text{Actual volts}}{\text{Rated volts}} \qquad (13.4)$$

In practice, it is probably best to take light level readings under the experimental conditions and make adjustments, rather than relying on theoretical calculations. For some older types of film camera, the operating speed will depend upon supply voltage. Data curves for this are usually supplied by the manufacturers. Modern versions have running speed well controlled, once set framing rates have been reached. If a specific framing rate is important, and it usually is, then in circumstances where any doubts as to power supply integrity exist, it is safest to run a test under experiment conditions and check that framing rates are correct. This is not an extravagance, as probably other aspects of the experiment including triggering can be checked at the same time. It is better to seek out faults and correct them at this point, rather than to waste a valuable event or subject unnecessarily.

13.5.5 Environmental considerations

Cameras are precision instruments, whether mechanical or electronic, and while they are well constructed and enclosed in adequate housings they must be treated with care and respect. If designed to operate reliably at normal ambient temperatures, their operating characteristics may change considerably if they are used outside their rated temperature range or are subjected to sudden large changes in temperature. If cine film cameras are to be used extensively in very low ambient temperatures they can be cleaned and relubricated with low temperature lubricants and reset for critical tolerances to suit the new conditions. Once 'winterized' such cameras should not be used in warm conditions until after 'de-winterization'. Very cold conditions will also affect film and may change effective film speed and colour balance, as well as dimensional and mechanical properties. Where possible, cameras should be housed in protective covers or within covered surroundings. Similar problems with film

characteristics and camera lubrication, will be encountered in very high temperatures, and again the best solution is to try to keep the camera in a protected environment. In wet conditions or where there is a high level of humidity there is a high risk of *fungal growth*, particularly on film. All equipment should be kept dry and cleaned regularly. Film should be kept in sealed containers with dessicant, before and after use, exposure to the atmosphere being kept to a minimum.

13.5.6 Camera positioning and set-up

Many considerations will come into play when selecting location, viewpoint, protection and environment during the setting up of the recording system. The following are some of the most important.

Find a position which gives maximum practicable image magnification, considering available lenses, and camera to subject distance, in order to have an image of a suitable size for analysis. Do not include more than absolutely necessary in the field of view. Remember that, apart from its special abilities to record high speed events, the camera can only record what is in its field of view as observed by the eye. If the eye cannot see a clear *field of view*, then neither will the camera. When it is only possible to set up using slow movement of the subject, check to see that at high speeds (when the motion may follow a different path) the subject still remains in the field of view.

Try to position the camera so that its focal plane is parallel to the plane of the principal subject motion to minimize errors caused by optical distortion. In some cases this may not be practicable because of site geometry and obstructions. Sometimes an oblique view may give better visualization of relative motion between parts.

When using rotating prism cameras, long focal length lenses give better image resolution for a given image magnification. Thus relatively long camera to subject distances will be advantageous.

The camera should be shielded from spray, flying particles, sparks, blast or any external effects which may cause damage or vibration. The lens area is particularly vulnerable and it may be necessary to film through a protective window or to use a disposable filter. Generally, if damage is likely the camera should be enclosed in a protective cover. When explosive events are being recorded, the camera may need to be placed behind a substantial blast shield or wall with a viewing port or set to view the event via a mirror. Environments containing spray, mist or steam can sometimes give misting on the lens. Lens condensation can often be eliminated by directing a jet of dry nitrogen gas from a cylinder onto the area. The best siting for the nozzle, flow rate and angle can be established by experiment. In very misty or dusty environments the whole camera

can be enclosed in a plastic bag with provision for access to lens and controls.

Normally, camera orientation will be set to show the image the right way up when projected. However, if the motion is principally in the vertical direction the frame format may be more efficiently used by turning the camera on its side.

For film cameras it is advantageous to place them so that the side of the loading door is clear of obstruction. This not only makes loading and unloading easier, but facilitates cleaning and removal of film chips from the prism and film transport.

If mirrors are used to provide a view of subject to the camera, they should be kept clean and fixed rigidly in place to minimize vibration. The strength and steadiness of the camera stand or tripod is very important to prevent problems during analysis. Stands should be adjustable to give a rock-steady stance on uneven terrain and allow good movement in terms of height, pan and tilt for the camera. Once set, all moving parts should be lockable in place to prevent slippage. As a general rule, the heaviest and most robust support practicable in the circumstances should always be the choice. In some instances sandbags or other heavy objects may be used to anchor the stand and help prevent vibration or alteration of position. For extreme conditions of vibration the camera can be firmly mounted onto a base which is itself standing in a deep *sand tray* or connected to a *ground isolated mount*. If the camera must be operator supported for tracking purposes, then there are several counterbalanced rigs available to assist smooth vibration-free panning.

13.6 General camera considerations

13.6.1 Camera features

Cameras and lighting will usually need to be considered as a complementary pair. Some of the camera setting requirements are given below:

- *Magnification:* the magnification required, i.e. the ratio of image size to subject size, will be decided by the resolution required in the subsequent analysis of the image. This, in turn, will be a function of blur from a moving subject and the inherent resolution obtainable from the camera/recording medium.
- *Exposure duration:* the exposure duration will be chosen to keep the blur caused by subject motion to acceptable limits for the resulting image.
- *Framing rate:* the framing rate will be chosen to provide an acceptable number of exposures during the event observation period. It will also be a function of the distance moved by the subject during the interframe period and the movement

allowable between frames from the requirements of analysis.
- *Focal length:* the focal length of the objective lens will be chosen with reference to the restraints of camera to subject distance and the magnification needed.
- *Depth of field:* the depth of field is the range of subject distances that result in an acceptable circle of confusion on the recording medium. It is a function of lens focal length, *f*-number, subject distance and necessary circle of confusion.

13.6.2 Factors affecting camera choice

Choice of recording method will depend on a variety of considerations, the primary ones being the characteristics of the event under study and the form of the final record which is required.

13.6.2.1 Event characteristics

The event is characterized by its duration, extent of movement and planes of movement, together with the subject velocity and acceleration. The type of subject motion may be linear, rotational, curvilinear, transient, steady state or periodic. There may also be special cases such as an exploding subject, where motion will be three-dimensional and may combine several basic forms of motion.

13.6.2.2 Final record

The form of final record required includes discrete samples over a period (e.g. spark photographs), continuous discrete samplings over a period (e.g. cine recordings), continuous recordings (e.g. streak records), as multiple discrete images on a single frame and as multiple superimposed images on a single frame. The recording material may be either film or video tape, but there will be restrictions as to the material and camera used in terms of light sensitivity, framing rate required, exposure time, total recording time needed and final method of analysis.

13.6.2.3 Camera characteristics

In planning experiments, the general form of recording instrument appropriate to the event should be sought. Each recording system will have inherent characteristics which will also affect choice. The *sensitivity* is the smallest change in value of a measured parameter to which the camera can respond in terms of detectable change on the recording medium. The *reproducibility* is the degree of closeness in the repeated measurement of a given quantity. This will be very important if a series of similar events are to be observed. The *accuracy* is expressed as the difference between the actual value and the recorded value. This may be quite difficult to define unless some additional reference scale can be obtained, e.g. comparison of the camera

measurement of a movement which is of known length, the extent of which has been measured by some other independent means. The *speed of response* will be the rate at which the camera responds to an external signal. Whilst film or charge coupled device (CCD) detectors may have very fast response once the light image falls upon them, there may be delays in shutter opening or presentation of the recording material to the incoming image. The *dynamic error* is the difference between the actual value of a changing quantity and its measured value, when static error is neglected. One source of dynamic error will be image blur caused by subject motion.

13.6.2.4 Final choice

Having established the system characteristics necessary to fulfil event and analysis requirements, a final choice can be made from the huge variety of equipment currently available. Whilst, at the time of writing, *film cameras* still provide the best resolution related to short exposures and fast framing rates, video recording must be considered very seriously as a constantly improving contender. The benefits of *video recording* include instant replay, on-screen analysis, long recording times, ease of setting up in terms of previewing scene coverage and adequacy of lighting, re-use of recording medium, direct computer interfacing and very wide response to light level. For many requirements their complementary use for setting up purposes and preparation for the use of film is unsurpassed. For events of relatively low movement rates or for analysis of machinery motion and diagnosis of mechanical faults they are more versatile and efficient than film cameras. In the area of still video, very short exposures are now possible, coupled with very high repetition rates. Drawbacks are the limited number of exposures and, sometimes, rather confusing multiple images on a single screen. However, for some applications, such as ballistic work, they are likely to supersede film cameras in many applications.

Another system of relatively recent development, which is old in basic concept but which has made a quantum leap in capability, is the use of a combination of cine camera and *stroboscopic laser* light sources. Previously used as a combination of stroboscopic flash tubes and cine cameras, the emergence of *metal vapour lasers* now permits synchronized exposure times down to tens of nanoseconds at framing rates governed by the camera.

Whilst it may be easy to decide which type of camera system will best suit the requirements, practical considerations in terms of available equipment, finance or time, may mean that a less than optimum approach will need to be adopted. This will probably result in less accurate data or a less complete coverage of all aspects of the event. This choice should involve early discussions with the sponsor to decide the best compromise solution. In some cases where specific equipment is not available in-house, it may be possible to hire on a temporary basis. However, some care should be taken when *hiring* to ensure that operators who are completely familiar with the equipment are also available, either in-house or also hired. Otherwise, a large portion of the hire period could be spent becoming expert in the equipment, to the detriment of progress on the work in hand.

13.7 Lighting

During the planning and design stage, the means of lighting will be chosen to complement the camera and event. In circumstances where the lighting system also becomes the means of shuttering the system, e.g. spark or flash photography, it may assume equal importance to the camera.

13.7.1 Intensity

Several major points must be considered when planning the lighting set-up, including the intensity of the image and of light both from and on the subject.

Image intensity (illuminance) is the intensity needed adequately to expose the recording medium during the chosen exposure time to give an acceptable image. It will be a function of the recording medium characteristics and the exposure time required to prevent blur.

In order to give an adequate image intensity the light coming from the subject surface must be of suitably high level. It will be a function of the subject brightness, the relative transmission of the camera lens and the lens aperture for a lens focused at infinity. For subjects at a relatively close distance the lens magnification factor will also be involved.

To allow adequate light intensity to come from the subject it must be illuminated, unless sufficiently self-luminous, by external means. The external light level must be enough to allow for losses due to the absorption characteristics of the subject surface and the angle of incidence between the illuminating source and the camera lens.

In high speed photography the predominant feature is always the problem of obtaining enough light. Spark and flash photography usually require no extra light source as they combine both a means of setting light level and exposure duration. Conversely, high speed cine film cameras will require continuous lighting or synchronized high intensity intermittent lighting. In some cases, bright sunlight may be adequate or the subject may be self-luminous. The gradual introduction of electronic and video cameras has reduced the essential required

light levels considerably, but extra lighting is still necessary in most cases.

13.7.2 Basic lighting principles

The general principles of lighting for scientific high speed photography follow those for other forms of photography, except that the amount required is usually several orders of magnitude higher. This high intensity requirement may result in rather flat lighting and deep shadows. The requirement of maximum information content in the record may be better achieved by going some way towards more aesthetic techniques by using some spot sources for modelling and general illumination to help illuminate the shadowed areas. However, the complex lighting set-ups used in still or low speed cine photography are often not feasible in high speed applications and a compromise must be found. The basic methods of lighting arrangements for high speed photography are shown in Figure 13.6, which covers most possibilities.

When planning the general lighting set-up it will also be necessary to make provision for screens for background use. These will be either in simple plain surface form to give a clear silhouette type picture or more specialized screens such as those covered by *retroreflective material*, which may be needed where shadowgraph techniques are employed. These screens will give a vastly enhanced return to light falling on the screen in a near-normal direction.

13.7.3 Types of light source

The light sources used will be either *continuous* or *intermittent*, depending upon the application.

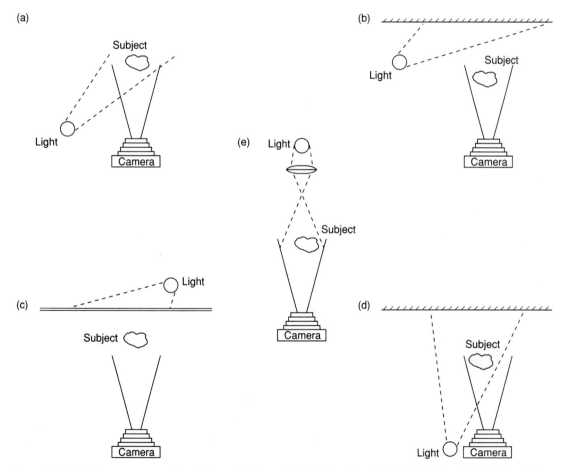

Figure 13.6 Lighting arrangements for high speed photography. (a) Normal front lighting. (b) The subject is silhouetted against a front-lit screen. This could be a plain or retroreflective screen. (c) The subject is silhouetted against a transluscent screen lit from behind. (d) The subject is lit directly from the front and also in shadowgraph mode against a retroreflective screen. Note that in this case, in order to obtain maximum benefit from the retroreflective properties of the screen, the light source is placed as near as possible to the camera viewing axis. (e) The subject is lit directly from behind.

13.7.3.1 Intermittent sources

Intermittent sources include the following:

- *Expendable flash bulbs* are very popular in high speed photography where medium short duration, high intensity lighting is required, coupled with compactness and low cost. Accurate timing of the flash to the event and camera is vital to allow for burn-up time. They are used extensively in outdoor work for cine filming on ballistic ranges. The introduction of multi-bulb control systems allows single programmed flashes, multi-bulb flashes and sequenced flashes, where, if sufficient bulbs are available, a continuous light output lasting up to several seconds is feasible.
- *Electronic flash* can provide short duration outputs down to microseconds for open shutter still and stroboscopic still and cine applications. They are compact and portable, but are not generally suitable for shadowgraph or schlieren type set-ups due to their large source area.
- *Argon bomb flashlights* are used for the study of explosions and are highly specialized. A small charge of explosive is used to excite by shock a gas such as argon which produces a very intense short duration light output. The necessity to employ explosives restricts their use to government and military establishments.
- *High voltage spark sources* are used a great deal in work on shadowgraph and schlieren systems as they combine microsecond or submicrosecond duration with high intensity and small source dimensions. They are also used in multi-spark set-ups for short interval multi-exposure systems.
- *Flash X-rays* are used for special applications where it is necessary to record in areas of high ambient light, general obscuration by smoke or particles, or where it is required to observe the internal processes of an event normally hidden from conventional photography. Some special systems can capture enough images in quick succession to give flash X-ray cinematography.
- *Laser flash sources* are used where very intense, short duration sources are required. Durations down to nanoseconds are common. They are used in conjunction with cine cameras in a synchronized mode to obtain highly specialized cine records of such things as the combustion processes inside internal combustion engines.

13.7.3.2 Continuous sources

Continuous sources include the following:

- *Bright sunlight* is adequate for some cine filming situations if fast film and forced development is used. Framing rates up to about 20 000 fps are possible. Unfortunately, bright sunlight cannot always be relied upon to be present at the correct time and it is best to plan to have an alternative source available.
- *Arc lamps* can be used for continuous lighting, but in the past have not been very suitable for high speed photography due to flicker. More recent hydragyrum (mercury) medium–arc iodide (HMI) types are smoother and offer high luminous efficiency.
- *Tungsten filament lamps* are used extensively in high speed photography. Photoflood types are overrun to give high output but at the expense of reduced life. Tungsten–halogen lamps can replace photoflood lamps and have a much longer working life with nearly constant colour temperature.
- *Continuous laser sources* are relatively expensive but have the advantage of very high intensity and a monochromatic characteristic which makes them very suitable for the lighting of subjects which are self-luminous. In this case a very *narrow band filter* can be used to allow only the laser illumination to be recorded, extraneous light being cut off from the camera.

13.8 Film processing

13.8.1 General points

If a project is studio or laboratory based it is likely that film processing and viewing equipment will be either available on site or readily accessible. However, if the work is being carried out on an outdoor location or industrial site, processing facilities may not be available and the planning phase must include suitable provision to allow for these shortcomings. If the work will be carried out using video recording the processing aspect will, of course, be avoided and replay facilities will usually be included in the equipment features, thus avoiding problems.

If experimental work is being done it will be necessary to check progress by developing and viewing each experimental film in order to see what is being recorded and whether alterations need to be made to the recording process or the event set-up. It is always better to have film processed in a professional processing laboratory to get the best results, but if the photographer is adequately skilled and equipment is readily available, processing can be carried out on site. In some instances it may be possible to use a *mobile laboratory van* which can be parked conveniently near the work site. If mains water is available it will avoid the need to carry supplies on board. If the van is well equipped, processing will not be a great deal more difficult than when using permanent facilities and high quality work should be possible.

However, if no van is available life becomes much harder for the photographic team. On-site processing, particularly if carried out with makeshift equipment, will generally be of lower standard than

processing carried out in a specialized laboratory. However, in deciding where processing will be done several factors will come into consideration:

- *Time*: in an on-going experiment results will need to be monitored constantly and it will not usually be expedient to wait while film is taken away and returned before progress can be assessed.
- *Security*: in some work the results may be of a confidential nature. In this case processing must either be done by the photographer or by a specially approved laboratory.
- *Price*: processing laboratories are normally not keen to receive short lengths of film, coming at irregular intervals and requiring a fast turnaround time. If they undertake such work, prices will probably include an added premium.
- *Quality*: in the initial stages of a project, lower film quality may be acceptable as long as a good idea of the event history is being obtained. Once the event and recording processes have been brought to a satisfactory standard it will then be necessary to consider a change to the best quality processing available to produce the best results from analysis.
- *Processing*: if proper processing facilities are not available, a light-tight enclosure can be contrived somehow. Makeshift arrangements may range from processing in buckets to the use of portable film processing devices. Bucket processing is a last resort, but may save the day in extreme situations. There are numerous types of manually operated processor available. When planning, some thought must be given to how the appropriate processing solutions will be provided, carried and stored. If some estimate of the number of processing operations is known, provision can be made for adequate backup supplies for replenishing. If reversal film is not used, negative film will often be adequate for qualitative judgments, but a positive print will usually be necessary for projection. Printing is best carried out by a specialized department, either in-house or commercially.

13.8.2 The later phases

In the later phases of the project, lighting, exposure, framing rate, synchronization, triggering and event reproducibility may have reached a point where checks between experiments are not so vital. A series of sequences may be taken, without waiting for development between tests, and a batch of films can be collected and sent off for more leisurely processing by a professional laboratory in the expectation that results will be as required and there is no risk of wasted experiments.

13.9 General aspects of good practice

An attempt has been made to give some guidance on the processes involved in designing and planning a high speed photographic project. Whilst detailed plans are feasible when adequate notice of such work is given, often little or no notice is received and actual filming is required almost immediately. In these cases the photographer will need to rely on previous experience in order to keep to deadlines and attempts must be made to plan as the work proceeds. For such short notice projects, much valuable time can be saved by following good house-keeping rules applicable to any similar form of work.

- *Stocks*: where possible, keep up good stocks of frequently required consumables such as film, tape, flash bulbs, batteries, processing chemicals and printing paper.
- *Maintenance*: keep all equipment in a well maintained state and ready for use, with recharged batteries, where these are used.
- *Stores*: store everything in well ventilated conditions with a dry atmosphere and at a sensible temperature. Keep all stores easily accessible and well labelled in assigned places, to which they are returned immediately after use. Keep equipment normally used as a group together.
- *Cases*: have good quality transport cases for all valuable and delicate equipment.
- *Handbooks*: have vital handbooks or instruction material either stored safely with the equipment to which it refers or in a well organized library for such material.
- *Laboratory vans*: if your equipment includes laboratory vans, make sure that they and their prime movers, if needed, are kept in good condition and in a state of constant readiness.
- *Darkroom*: ensure that darkroom facilities are kept clean, well stocked and in a constant state of readiness.
- *Analysis*: if analysis equipment is available in-house make sure that it is in good working order and any consumable supplies for it are kept replenished.
- *Checklists*: make checklists of equipment and auxiliary materials required for particular assignments and keep them available and up to date as new projects are undertaken and new experience is gained on what is needed.
- *Standard forms*: a standard form for the provision of photographic services should be produced and a copy used whenever a task is undertaken. It should be given to the sponsor when the task is first requested and should be completed and received by the photographer before work commences. After some consideration the photographer can

then discuss the task and its requirements with the sponsor before the form of the request is finalized. At this stage the photographer will have the opportunity to point out any changes which may improve the final result and also give the sponsor a realistic appraisal of what can be achieved with the equipment available and within the time scale requested. A document of this kind is essential to make sure that the sponsor's ideas of what he actually requires are clarified, and the photographer has a clear basis upon which to plan and work. At the end of the project a reappraisal of the results can be made against the original requirement to see whether all objectives have been met and shortcomings, if any, can be assigned appropriately. If requirements are revised during the course of theproject an addition can be made to the original request to keep it up to date. This aspect is particularly important if the payment for the task will be affected.

- *Attitude*: above all, a positive attitude should be adopted to short notice assignments and they should be looked on as a challenge and a chance to learn. On the other hand, one must be realistic in terms of what is possible under the given circumstances. Nobody wins if an unrealistic acceptance of a task ends in disaster.

14 High speed photography in ballistics

Peter W. W. Fuller

14.1 General introduction

Webster's Dictionary defines ballistics as: 'The scientific study of projectiles, their launch, flight and impact'. Consciously or unconsciously, mankind has studied ballistics since he first learned to throw stones. Over the centuries, as projectiles have become more complex and their methods of launch more varied, many of the foremost scientific brains have been engaged in the search for explanations of ballistic processes, the production of theories and the experimental verification of those theories in continuing attempts to understand the science fully. During that long period, as scientific methods and new means of measurement have been devised they have immediately been applied to ballistics studies. In fact, many new measurement methods have emerged in the first instance from attempts to measure specific ballistic phenomena.

As with many other branches of science, the invention of photography offered a new and powerful means of observation and measurement. It had particular advantages for ballistics, bearing in mind that, by their very nature, guns and projectiles are not easy or particularly safe to measure and observe. With photography, measurements could be made at some distance from the danger zone, observations could be made on otherwise inaccessible projectiles in flight and, perhaps most valuable of all, unlike most transducers, a photograph could give information on more than one parameter at a time.

It is in the nature of ballistics that phenomena are often of short duration, processes proceed at high rates and objects tend to travel very fast. It is natural therefore that high speed photography should be used a great deal in all areas of ballistic studies. Whilst a large range of high speed photographic systems are now available to the ballistic experimenter, this was not always the case. Ballisticians of the middle and late 19th century were very fortunate that a high speed photographic method in the form of the electric spark was available to them very soon after the emergence of photography as a scientific tool. Spark photography was to remain their only real means of high speed photography until the 1890s. This good fortune was recognized by many scientists and much use was made of *spark photography*, allowing ballistics to be in the forefront in scientific exploitation of the new technology.

14.1.1 Historical development

The use of photography in ballistics work extends over a period of more than 140 years, it being recorded that a cannon ball was photographed in flight at Plumstead Marshes, near Woolwich Arsenal in London, by T. Skaife in 1853 (Skaife, 1853). This picture is shown in Figure 14.1. At that time photography was still in its infancy and somewhat of a mystery to the average person. It is thus not surprising to read that Mr Skaife was asked in all seriousness 'How did you manage to stop the cannon ball in mid-flight in order to take its picture?'. Skaife took the picture using a camera of his own invention. This had a shutter consisting of two small flaps like miniature barn doors, which were driven by elastic strings running round small bobbins on the flap hinges. When triggered, the doors opened for about 0.02 s. This camera, shown in Figure 14.2, can still be seen in the Science Museum in London.

By 1883, Mallard and Le Chatelier had made streak records of flames from explosions. Le

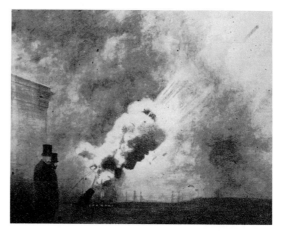

Figure 14.1 Cannon ball captured in flight (Skaife, 1853).

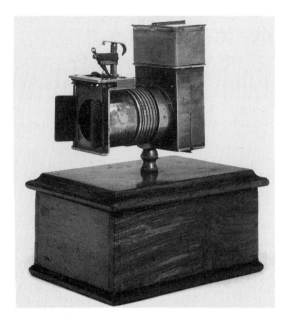

Figure 14.2 Camera made by T. Skaife, *ca.* 1853 (Pistol-graph).

Chatelier used a photographic plate dropping under gravity upon which the flame image was projected. This could be considered as an early form of *streak photography*.

In 1884, Ernst Mach in Prague was making use of spark photography to record bullets in flight, which he continued to do for many years. Mach employed a simple schlieren apparatus, recording quite small images, and triggered the optical spark by firing the bullet through a series gap in the circuit which fed the main light producing gap.

Mach had been led into ballistics studies following his attendance at a lecture on ballistics by the Belgian expert Meisen. Meisen had proposed that part of the effect of bullet impact was due to a parcel of highly compressed air which the bullet carried ahead of its nose. To explore this theory Mach attempted to make photographs of bullets in flight.

In his initial attempts he produced no sign of flow in front of the bullets but showed shock waves proceeding from the spark itself. He concluded that the bullets were travelling below the speed of sound and that shock waves would only become visible when they exceeded this velocity. Following help from the Naval Academy at Fiume he was able to fire bullets at supersonic velocities and obtain pictures of their associated shock waves. By firing bullets through plates he was able to show that Meisen's theory was incorrect and that the compressive effect ahead of the nose was a continu-

ous process due to motion, the shock waves reforming again following their passage through the plate.

By 1892, Sir Charles Boys in England was continuing the spark photography begun by Ernst Mach (Boys, 1893). Boys realized that it was not necessary to use schlieren methods to visualize flow, and used simple *shadowgraph* techniques to obtain high quality photographs of shock waves and disturbances around projectiles.

Boys also added to the experimental knowledge by measuring the duration of the spark. The flash from the spark was reflected from a mirror revolving at some 1000 rps (60 000 rpm) and recorded on film. This was an early use of the high speed *rotating mirror camera* principle (Boys, 1893). The length of the recorded trace was used to determine the flash duration using the known revolution rate and the geometry of the set-up. Boys also attempted to determine *spin rates* by drilling holes in the projectile at right angles to its axis and taking two consecutive spark photographs at different points along the trajectory. Lights were set up along the trajectory to backlight the holes. By observing the changed positions of the holes at the two photographic stations and knowing the distance between the stations he could calculate the spin rate. It was not a very efficient method, but it is interesting as being one of the earliest attempts to measure spin of projectiles in flight.

Also in 1892, the Prussian Armaments Testing Commission developed a multi-camera system with a revolving disc shutter capable of a framing rate of 1000 pps and exposure times of 100 μs. This had been strongly influenced by the work of Muybridge in California in the 1870s. However, whereas Muybridge had used a line of cameras each of which was triggered separately, these later experiments used 12 cameras arranged in a vertical circle and shuttered by a revolving disc with radial slits. By the late 1890s, Cranz and Koch began taking spark photographs to study rifle barrel vibrations. Exposures were made at increasing delay times after firing to build up a picture of the whole vibration cycle (Cranz and Koch, 1899).

From the 1900s onwards there were steady improvements and innovations. The principles of rotating mirror, disc and drum cameras became well established, and framing rates increased.

By 1905, Kranzfelder and Schwinning had succeeded in discharging 10 capacitors through a single spark gap in rapid succession to give a series of light pulses. The sequential discharges were achieved by using a rotating switch. This was followed in 1909 by Cranz building a multi-spark camera capable of 5000 pps. This used an oscillator feeding a pulse network to discharge a spark gap. With this apparatus he was able to take multiple pictures of projectiles of a wide variety of calibres.

In 1913, Major Franz Duda of Vienna took a series of photographs of projectiles in flight using a camera having a cylindrical slit shutter. Sequential photographs were recorded on a single plate which was moved by clockwork between exposures. Timing marks were introduced by a tuning fork moving another separate shutter. In 1916 in Germany, Ernemann built a cine camera using a rotating polygonal mirror for optical compensation with a speed of 500 pictures per second (pps). This camera was used successfully for ballistic studies during World War I.

Rumpff proposed to increase the effective framing rate by using three such cameras connected in parallel with an appropriate shift in the relative exposure times. Such a system was built but, as Schardin has pointed out, the picture quality of a multi-camera system of this kind is inferior to that of a single camera operating at a correspondingly higher framing rate. If the exposure time of one frame is greater than the reciprocal of frame frequency, the blur caused by object motion is magnified. In practice, three cameras in parallel connection have a time resolution only one-third higher than one of them operating alone.

In the early 1920s, Dr G. Bull used a drum camera with a synchronized magneto driven spark to take multiple pictures of bullets in flight. By 1925, Karolus had succeeded in using the principle of electro-optic polarization of liquids, discovered by Kerr, in a practical camera shutter. These shutters, known as *Kerr cells*, were used for photographing atomic bomb explosions soon after World War II and are still used today in ultra-fast cameras.

Also in 1925, P. P. Quayle tried to resolve the controversy as to whether projectiles continued to accelerate after leaving the muzzle of a gun. At the US Bureau of Standards he used improved spark gaps and a shock operated diaphragm trigger switch to take a series of photographs of bullets leaving a rifle barrel. These showed clearly that the bullet continued to accelerate up to 150–200 mm (6–8 inch) after exit. He also produced much interesting new information about the gas flow in the *intermediate* ballistics area, i.e. the period just after shot exit from the muzzle.

In 1926, Jenkins produced a camera with a ring of rotating lenses capable of 3200 pps using 35 mm film which later led to cameras such as the Vinten HS3000 in 1939. In 1938, Western Electric Corporation in the USA introduced the Fastax camera, which is still in use in many ballistic research establishments. This camera used the rotating prism system for optical movement compensation (Taylor, 1937). Also in 1938, H. E. Edgerton perfected his high speed gas discharge lamps, which could be used as an alternative to spark light sources (Edgerton, 1949).

By the 1940s most of the current techniques of ballistic photography, including image converter tubes for electronic cine and streak cameras, had been established or were being developed.

World War II provided a boost to ballistic and general high speed photography development, particularly in high speed streak and framing cameras for the study of explosives and high speed cine of projectiles and rockets in flight. In the latter part of the War, the C4 rotating mirror camera capable of 200 000 pps was developed at Aldermaston for the study of explosive reactions. Just after the War, rotating mirror cameras capable of over 1 million pps were developed for the study of atomic bomb explosions.

Since the War, probably the main advances in the application of high speed photography in the ballistics area have been in high speed laser photography, image converter cameras, image intensifiers, the development of cine radiography, improvements in intensifying screens, the use of high speed video techniques and improved light sources. Photographic methods have needed to advance to keep pace with advances in ballistics. During the 1960s and early 1970s, light *gas guns* developed very quickly and it became necessary to be able to study projectiles travelling at hypervelocities, i.e. Mach 5 and higher, and to visualize impact processes at similar velocities. Since then, the renewed interest in electromagnetic guns, liquid propellant guns, shaped charges, higher velocity long rod projectiles and explosively formed projectiles, together with continuous research into new types of propellants, has produced new problems for the ballistics photographer. The constant leap-frog progress of new weapons and counterdefences has ensured that there are always more problems to which high speed photography can be applied. Today ballistics research investigators have a formidable range of techniques to call upon wherever a photographic record is required and there are few areas of ballistics to which photography cannot make a very valuable contribution.

14.2 Application areas

14.2.1 Introduction

The use of high speed photography in the ballistics field is probably one of the most interesting and challenging areas for the photographer. The variety of applications is such that, apart from a few special areas where routine repetitive methods are employed, each project represents a new problem and, possibly, the development of a new technique. In addition, the exacting requirements are such that a huge range of cameras, lighting and backup equipment are likely to be employed, including the latest state of the art developments. Add to this the

difficulties of often having to operate literally 'out in the field', in possibly far from ideal weather conditions and away from the benefits and convenience of the studio, and it can be seen that this area of photography is both rewarding and demanding.

In order to achieve blur-free photographs of the very fast movements encountered in ballistics much use is made of short exposure shutters or short duration light sources. One way of looking at the problems of blur for a variety of sizes of subject, is to consider the time it takes for the subject to move through its own length. If this time is t, then exposures of the order of $0.001\,t$ will give quality equal to good 35 mm photography of stationary objects. If exposure time rises to $0.002\,t$, then quality falls to the standard of good quality television pictures. Consider, for example, a project to record a good quality picture of a 7.62 mm bullet moving at right angles to the camera axis. Consider the worst case where the image is required to nearly fill the frame area. If its velocity is about 853 m s^{-1} (2800 feet s^{-1}), it will cover its own length in about 30 µs. Thus for a good quality picture an exposure in the order of 0.03 µs is needed. This is readily obtainable with modern equipment, but serves to illustrate the demands of a typical ballistic photography problem.

High speed photography is employed directly in all branches of ballistics, including *internal*, *intermediate*, *external* and *terminal* ballistics. It is also applied to the study of explosives, hypervelocity ballistics, rockets, flow visualization in wind tunnels and ranges and in every sphere of research and development which has applications to ballistics. Whilst the term 'ballistics' conjures up thoughts of guns and projectiles, many of the projects may involve studies of combustion, the observation of processes, mechanisms or machinery and in the research area, subjects which at first glance have little obvious involvement with ballistics at all. Photography is also used extensively in an indirect way as a recording device for information from transducers of various kinds via oscilloscope traces or other means of visualizing waveforms.

14.2.2 Two forms of basic studies

Studies in the main areas of interest are split into two kinds: basic research and development, or routine and field testing. Whilst basic photographic techniques will be common to both areas, the general approach and requirements for method and apparatus will be different (Table 14.1). Thus, while a particular research problem may be solved using a new or adapted old technique, the transformation of that technique into one which can be used routinely in the field may take some time and considerable effort.

14.2.3 Five main areas of interest

In the following paragraphs a selection of five main regions of interest are defined together with the kind of measurement required in each region, so that it can be seen in what way and where photographic methods may be applied.

14.2.3.1 Internal ballistics
This region is concerned with the gun and projectile during the period between charge ignition and shot exit. This involves the pressures and temperatures in the chamber, the axial and yawing motions of the projectile in the bore, the motion of the gun barrel and carriage and the general interactions between the gun and projectile, including the flow of propellant gas. Internal ballistics presents obvious problems of access for photography; however, the projectile can be observed directly down the bore or through the barrel with X-rays. In some experiments, windows or fibre optic paths in the barrel wall have provided alternative means of access. The external behaviour of the gun can be followed more easily, and direct photography of gun movement and barrel vibration occurring during the in-bore motion of the shot can be carried out with less restrictions. Observations of barrel temperature changes can also be made using thermal imaging. Internal ballistics is also a major area where photography is used as an indirect recording means for information from transducers of many kinds.

14.2.3.2 Intermediate ballistics
This region is concerned with the period during which the projectile has just escaped from the physical restraints of the barrel but is still within the influence of the escaping propellant gases. Access for observations is easier but is complicated by the presence of the hot self-luminous propellant gas full of particles and the blast waves which accompany it. However, these problems can be overcome in some measure by the use of special techniques. In this region it is required to study projectile velocity, physical condition, orientation, spin rate, sabot separation processes, the temperature composition and flow patterns of the propellant gas and flow patterns about the projectile itself. X-ray shadowgraphs are particularly useful in this region, together with special selective optical techniques using differential focusing or laser light. Many of the techniques employed in flow visualization can be used here (see Chapter 17).

14.2.3.3 External ballistics
This region is concerned with the projectile during the time in which it escapes from the influence of the propellant gas to its arrival at the target. In the case of full range firings in the open, the trajectory of the projectile may well be such as to prevent direct

Table 14.1 Comparison of two basic kinds of ballistic study

Research high speed photography	*Routine testing high speed photography*
Initially short term	Long term
Can be complex	Preferably simple
Can require careful handling	Preferably rugged
May demand new techniques	Preferably well proven techniques
May need long setting up period	Preferably short set-up
Initially may need a favourable environment	Operates in a hostile environment
Possibly unreliable	Preferably reliable
Specific application	General application
Can perform at most favourable time	Should perform on demand
Opportunity for many attempts	Every attempt should count
May be in development	Fully developed
Processing and data extraction may be long and complex	Processing and data extraction should be simple and quick

observation. However, in closed range firings or in high velocity flat trajectory firings on open ranges the projectile will be accessible for the majority of its flight path. Here we are concerned with the orientation of the projectile (yaw), spin rate, its condition, velocity, deceleration (drag) and surrounding flow field. If it is possible to set up sufficient photographic stations as in an aeroballistic range, the trajectory can be reconstructed. Data can be produced for many of the observations mentioned, together with the yaw cycle times. In this case spark photography provides a convenient means of illumination and shuttering for shadowgraphs. In addition, *ballistic-synchro cameras* or *flight follower systems* can be used for front-lit photography on the open range together with single or multiple shot cameras. Flash bulbs, flash tubes, sparks or laser light are used for illumination. As well as looking at projectiles fired from a variety of launchers, studies may also be made of various 'stores' carried on rocket propelled sledges. In this case high speed cine may be used as well as the methods mentioned above.

14.2.3.4 Terminal ballistics

This region concerns the moment when the projectile strikes the target and the processes which follow. In this case observations are complicated by the possible presence of self-luminosity from the impact and the production of flying fragments. It is required to observe the way in which the projectile penetrates the target, the condition of the projectile and target with time, the production of debris and the formation of shock waves. X-ray processes again play a particularly important role in this area, although ordinary photographic methods can also be used, usually with long focal length lenses to allow the cameras to be placed at a safe distance away.

14.2.3.5 Dynamic processes

A further region which does not fit conveniently into any of the others is a very important one which we can call *dynamic processes*. These processes, whilst highly dynamic, do not involve movement over long distances that requires the camera to be tracked to keep the subject in view. In this region we can include the study of explosions, the burning of propellants, the action of primers and ignition devices, the action of mechanisms, rocket motors, studies of models in wind tunnels and shock tubes, shaped charge and explosively formed projectile processes and a large number of other ballistic related phenomena which do not fit into the four primary regions. Nearly all types of photography will find application in this region, but because of the nature of the phenomena exposures will usually have to be extremely short.

14.3 Equipment for ballistics photography

14.3.1 Lighting requirements

Lighting requirements are usually demanding due to the short exposure times needed in ballistic events and the photographer invariably wishes more light were available. Both continuous and short duration lighting is used as appropriate, including strobe lighting synchronized with cine cameras and short duration flash to provide short exposure times for still or multiple-still photography.

14.3.2 Light sources

The types of light source used are summarized in Table 14.2.

Table 14.2 Light sources used in ballistics photography

Source	Typical duration (s)
Sunlight/daylight	Continuous
Tungsten filament lamps (various types)	Continuous
Arc sources	Continuous
Flash bulbs	0.5×10^{-3} to 5×10^{-3}
Electronic flash	$10^{-3} - 10^{-6}$
Argon bomb	$10^{-6} - 10^{-7}$
Electric spark	$10^{-6} - 10^{-9}$
X-ray flash	$10^{-7} - 10^{-9}$
Pulsed laser	$10^{-6} - 10^{-12}$
Super radiant light sources	10^{-9}

14.3.2.1 Sunlight/daylight

This is used as much as possible, but of course has the disadvantage of not being fully under the control of the photographer. In bright sunlight using wide aperture rotating prism cameras, framing rates up to 10 000–20 000 pps are possible using fast film. Forced processing may also be needed to achieve satisfactory image density.

14.3.2.2 Tungsten filament lamps

These have a low efficiency and low colour temperature and are not very appropriate for ballistic subjects. Tungsten–halogen lamps are used for general lighting purposes, including studio type photography of static or slow moving subjects. Projector type lamps which incorporate a reflector are often used where general lighting is required. Low voltage types such as those which operate on 6 or 12 V are particularly useful in external trials where it may be difficult to have mains AC supplies available. In general, mains operated continuous lighting lamps of the filament or discharge type should be used with caution as the light often fluctuates at 50 or 100 Hz. Whilst appearing continuous to the naked eye, the fluctuations may cause problems when short duration exposures are used such as are common in ballistics.

14.3.2.3 Gas discharge lamps

Xenon gas discharge lamps are suitable for many applications and the short arc high intensity point source types are very useful where intense collimated beams are required, for example in illuminating down gun barrels or other long narrow apertures. Metal halide discharge lamps have a high efficiency, but also have a particularly high fluctuation level when used on AC mains.

14.3.2.4 Expendable flash bulbs

These occupy an intermediate position in that their useful light emitting duration (operating time) of some tens of milliseconds makes them suitable for both cine and single flash photography. For ballistic applications the exposure time is rather long for any but the slowest moving events, but separate shuttering can always be used if necessary. Their light output is roughly equivalent to a 1000 J electronic flash tube and this factor combined with their small size, weight, portability and simple power requirements make them very efficient light sources. In addition, their relative cheapness and expendability make them ideal for photographic situations where the light source may be damaged or destroyed. As a consequence they are extremely valuable as photographic light sources for ballistic purposes.

By simultaneous firing of large numbers of bulbs, large areas can be lit to a level equivalent to many kilowatts of light output from other sources. Using modern control devices, bulbs can be fired singly or in groups, or *ripple fired* to give almost steady light output over 0.5 s or longer. Because of their long burn-up time, appropriate delays must be allowed in synchronization circuits. A major drawback is the need to replace all bulbs after each firing. Flash bulbs are used extensively for cine applications such as synchroballistic studies.

14.3.2.5 Flash tubes

Electronic flash tubes are used extensively in ballistics photography for many applications. The flash duration may range from 1–2 ms down to 1 µs or less, output levels decreasing as duration decreases. The flash tube is convenient as it will operate in a single or repetitive mode and can be synchronized with a cine camera if required to flash during the period in which the shutter is open. Synchronization is relatively simple as triggering delays are very short, a useful attribute for ballistic subjects. Several sources can be fired simultaneously from a common trigger or can be fired from built-in triggers which detect the light from another flash unit. Flash tubes are often used in *range photography* where a short section of the range is enclosed in a temporary light-proof tunnel; the projectile passes through the tunnel piercing thin covers at each end of the section. The flash tubes are triggered during the passage through the centre of the tunnel and good front-lit pictures can be obtained, the lighting being controlled by the placing of the flash tubes.

14.3.2.6 Argon bombs

Argon bombs are a light source reserved nearly exclusively for ballistics photography. They are intended primarily to allow the photography of highly self-luminous events such as explosions or shaped charges, and produce sufficient light output to allow any self-luminosity effectively to be ignored. The light is produced by detonation of a small explosive

charge which sends a shock wave through a container of argon gas. The shock wave ionizes the gas, which produces an intense light flash. The intensity is governed by the strength of the shock and the length of its path through the gas. The high intensity of the argon light allows the camera lens to be stopped down to a point where the light from the explosion under study can be ignored.

Typical duration times for these sources are of the order of 50 µs or less and they are suitable for use with high speed rotating mirror cameras which provide the necessary short duration shuttering required. Because of the use of explosives in its construction and its primary application areas, this device is usually only found in government or approved research establishments. It was shown by Winning and Edgerton that the flash duration is equal to about 2 µs for each 10 mm of the argon path. Many types of argon explosion driven source have been made (Michel-Levy and Muraour, 1937; Sewell *et al.*, 1957; Bagley, 1959).

14.3.2.7 Spark sources

As mentioned earlier, *spark light sources* have an important place in the history of ballistics photography. For many years the spark source was the only available method for effective freezing of ballistic subject motion and much very important work was carried out using it. Shadowgraph photography is an important method in the study of projectile aerodynamics, and spark sources are ideal for this application as they can have short durations and can be constructed relatively easily as point sources. Durations are normally 1 µs or less and sparks can be fired singly, repetitively or in groups from multiple positions. A very important application is in *aeroballistic ranges* where multiple orthogonal spark pictures are taken and analysed to reconstruct projectile trajectories. A particular feature of point source sparks is that they can be employed to obtain high quality shadowgraph photographs using only the spark source and a sheet of film.

14.3.2.8 X-rays

X-rays are used in many areas of ballistics due to their unique ability to penetrate normally opaque objects. Being particularly applicable in the internal and terminal regions, both flash and cine X-rays are widely used. This area of ballistics photography is covered in some detail in Chapter 15 and so will not be covered here.

14.3.2.9 Lasers

Lasers have made a very significant contribution to methods of ballistics photography. Usable either in continuous mode or as a single or multiple pulsed source, the laser has made possible many new techniques. Its inherent characteristics of monochromatic output, intense light levels, low disper-

sion and extremely short pulse duration have brought many benefits to the ballistics photographer. Lasers are used in synchronized mode with cine cameras for short duration exposure cine photography, in conjunction with narrow band filters to observe highly self-luminous subjects, to freeze the motion of extremely fast small objects and to allow still and cine holography of ballistic events. Another very useful attribute is the ease with which the output can be coupled into a fibre optic and conveyed into areas otherwise inaccessible to an illuminating beam. Another benefit is the wide range of wavelengths available including infrared, which can be used in some areas where visible light may be absorbed or highly attenuated. Pulse duration can be down to a few nanoseconds (Dugger and Hendrix, 1975).

14.3.2.10 Super radiant light sources

Super radiant light (SRL) sources represent an alternative to argon bombs or lasers as intense short duration light sources. They are obtained by applying a short intense burst of electrons to certain special crystals. A typical source might be a plate of cadmium sulphide (CdS), backed by a thin aluminium grounding foil. The crystal plate is stimulated much in the same way as a crystal laser, the individual crystals lase to produce an intense light output during the duration of the electron burst. These SRL sources are not widely known or used as they require an electron beam tube for operation and dedicated tubes are not possessed by many laboratories. However, many flash X-ray systems can be used in a dual role as electron beam sources and can be modified for SRL work. Exposure durations down to a few nanoseconds ensure that very fast moving objects can be imaged without blur. For specific applications on self-luminous events or where very fast objects must be frozen in motion SRLs are very appropriate.

14.3.3 Photographic recording devices

14.3.3.1 Camera requirements

Camera requirements range over an extremely wide sweep of capability and complexity and a choice is made bearing in mind the subject's characteristics. Some of the techniques and equipment in current use are described in the following sections. As ballistics photography is such a wide ranging subject it is only proposed to cover techniques that are reasonably well established and have been shown to be suitable for use 'in the field'. To give coherence to a variety of camera descriptions, the cameras are ranked roughly in order of increasing framing speed and decreasing exposure times.

Generally, in ballistics work events take place quickly and objects move at high speeds. In order to freeze motion and give clear pictures the exposures

are usually short. As object movement becomes faster, exposure times must decrease and illumination must increase, or the image brightness must be enhanced electronically.

Subjects may range from a guided missile launch where framing rates of 400 pps may be adequate, to the detonation of explosives where a framing rate of 10^6 pps or above may be required. Exposure times may range from 0.001 s to tens of nanoseconds or less. In each case the method and apparatus are selected according to the subject characteristics, available light, synchronization, event duration, location, etc. Particularly important will be the form in which the record is required and the purpose of the record, i.e. pictorial or data retrieval.

14.3.3.2 Slow speed cine

In the slow speed cine camera the shutter is mechanical and the film motion is intermittent. The film remains stationary in a gate during the exposure time and is advanced to the next frame while the shutter is closed. There are various methods of achieving this motion, but all are limited to an intermittent film speed of about 5 m s^{-1} to avoid overstressing the film. This results in framing rates limited to about 300–400 pps for 35 mm gauge film. Exposures are usually of the order of 0.001 s. This type of camera is particularly useful for high quality pictorial work where the subject movement is not too fast. Typical applications might be the initial stages of rocket launch, studies of gun recoil motion and other subjects which have a characteristic time span of seconds rather than milliseconds. Video cameras are finding ever increasing usage in the range of application of slow speed cine.

14.3.3.3 Medium speed cine

This type of camera gives cine sequences up to about 10 000 full height pps and up to 40 000 pps with *quarter height* frames using 16 mm gauge film. It is extremely versatile and probably the most widely used in ballistics work. Beyond 300–400 pps the cine film must be moved continuously past the lens and image motion compensation must be provided to prevent a blurred image. Most commonly used cameras use a rotating glass block or prism geared to the film drive sprockets to provide movement compensation.

The picture image is arranged to sweep in the same direction as the film motion in order to provide compensation and, although compensation is not perfect at the frame edges, definition is adequate for all but the most demanding requirements. Exposure duration will be about 1/3 to 1/8 of the frame repetition rate. Framing rate is controlled by the motors driving the sprocketed drive wheel and take-up spool, which in turn are controlled by applied voltage. In some cameras, frame exposure duration will be variable by the use of different sector shutter discs. Useful recording time is governed by the time used in accelerating the camera film to operating speed. Use of electronic control systems in current cameras such as the Fastax 11, Hadland Hyspeed or similar types ensure fast acceleration and a long controlled operating speed utilizing 70–80% of footage for useful recording. It is common practice to record a *time base* on the film edge to allow accurate film speed determination during analysis. Formerly achieved by small spark gap light sources or pulsed neon lamps, this function is now performed by pulsed light emitting diodes (LEDs). In some systems, coded pulses can print either information on each frame of elapsed time from event start or the frame number from a given reference.

Synchronization with the event is usually achieved by triggering the camera from an external detector and then allowing the built-in control system to take over. In earlier cameras a separate system was used, one well known example being the 'Goose' control unit used on Fastax cameras. Most recent camera designs have the control and timer units built into the camera itself, making for a compact and portable system. Alternatively, the camera may be allowed to control the event, sending out a triggering pulse when it has reached operating speed and is ready to record.

Special cameras such as the Lexander type, which use controlled pinch rollers to carry a short loop of film through the camera at high speed, overcome some of the drawbacks of the normal designs. They are very economical on film, have formats up to 70 mm and only need a few milliseconds from trigger instant to full speed recording. The main disadvantage is that the top framing rate is limited to 1000 pps.

Subject illumination is not usually adequate from natural sources and artificial lighting must be used. This will be from continuous high intensity lamps or shutter synchronized strobe using flash lamps or lasers. In many ballistic applications banks of simultaneous or sequentially fired flash bulbs will be used. Continuous high intensity lighting uses a great deal of power. In the field, flash bulbs giving a light duration of 50–500 ms can be used to advantage, although synchronization must allow for burn-up time for the lamps to reach full brilliance. Over the last few years, more and more applications are being found in ballistics work for combinations of metal vapour laser and medium speed cine cameras, where the laser pulses are synchronized with camera shutter opening. This allows much shorter exposure times than the camera alone is capable of, but retains the advantages of a cine record.

14.3.3.4 High speed cine

Beyond a certain acceleration rate and velocity, the movement and handling of unsupported film becomes impracticable as the film fails mechanically

and higher framing rates must be achieved by alternative means. There is a large variety of high speed film cameras, with rotating drum, rotating prism and rotating mirror types being currently the most widely used. In the rotating drum camera, the film is supported by being fixed outside or inside the periphery of a rotating drum. Thus, although the film may be moving at an extremely high speed, it is not subjected to destructive forces. These cameras will give framing rates into the hundreds of thousands of pictures per second.

Alternatively, rotating prism and rotating mirror cameras allow the film to remain completely stationary and sweep the image across it. They are constructed in two forms, as streak or framing cameras and, according to their construction, will be synchronous or continuous access types. They are capable of writing rates of several tens of millimetres per microsecond or several million pictures per second. These cameras are used very often for the study of explosive events or hypervelocity impact processes as, despite their extremely high framing rate capability, they produce excellent quality pictures.

Drawbacks for range use are the large amount of light required to illuminate the subject, i.e. they have high *f*-numbers, plus problems of event and mirror position synchronization, a limited number of frames per film length and general bulk and power requirements. They therefore tend to be set up in test facilities where they can be left in place for a long time and where the work is brought to them rather than the other way round. Backup lighting will often be supplied by the use of argon bombs. Because of their high framing rates and limited film capacity, at top speed they are only applicable to very short duration events of the order of 0.5 ms or less.

14.3.3.5 Image converter cameras
If still higher framing rates are required than are readily available with high speed film cameras, then the experimenter must turn to electronic recording techniques. Image converter cameras, coupled in some cases with image intensifiers, have two main advantages, they can electronically enhance the brightness of an observed event and, through this property, can give very short exposure pictures which can be transferred to ordinary film, i.e. they have relatively low effective *f*-numbers. They can also have extremely high framing rates for cine sequences, although the number of frames is limited. For example, the framing rates of the Hadland Imacon type 468 camera can range from 100 to 10^8 pps, with exposure times down to 10 ns. The cameras can also be used in streak mode. With the advent of multiple tube cameras of this type it is now feasible to manipulate framing rate, framing intervals and exposure durations all in the same recording sequence, which then offers imaging possibilities not available in other types of camera. Images stored on charge coupled device (CCD) arrays can be output directly

to frame grabbers and thence to computers for subsequent analysis. For the ballistic experimenter the immediate availability of the image, as with video cameras, offers great advantages of time and money. Decisions on whether to proceed with a firing series can be made very quickly and vital measurements can be available very soon after an event.

It can be argued that resolution and quality may still lag behind film possibilities but for many requirements this is not a major problem. Also, some of the advantages of electronic cameras are unique to the type. As with all photographic work, equipment is chosen to give the best usage and results for a given project. These cameras are extremely versatile and are used for a large number of purposes such as impact, explosion and initiator research, and in fact for any extremely fast events where the very high framing rates are invaluable. Synchronization requirements for these cameras are relatively modest as the response times are almost instantaneous. Due to their low light level capabilities their lighting needs are less onerous than those of film cameras under equivalent lighting conditions. Cameras such as the Hadland Imacon 468 and Imco Ultranac types can be set up remotely and controlled by computer.

14.3.3.6 Video systems
Over the last decade video cameras have been increasingly used in ballistics work. As in other high speed photographic work, video cameras are already playing an important role. Whilst still not suitable for cine applications at the high speed end of the scale, variations on the basic systems are becoming extremely powerful tools for ballistic work.

The immediate playback, on-screen analysis, re-usability of tape and comparatively low complexity of operation are extremely valuable in ballistics testing. The arrival of solid state video storage has also added new features in terms of variable framing rates, absence of moving parts and programmed recording, so that no memory is wasted during a sequence. Test facilities such as ranges are extremely costly to hire and the long wait for results by conventional film processing has always been a problem. Using video, subsequent analysis work, the immediate production of results and the enhanced possibilities for automation are very attractive.

For areas where short exposures and fast framing rates are essential, developments such as the *still video camera* (SVC) have made an enormous difference. In general, the inability to produce fast video framing rates is due to the problem of clearing the CCD array in a very short time ready to receive a new image. The CCD response itself is very fast and the SVC system takes advantage of this by recording multiple images on the array which can then be downloaded at a relatively low rate. Images may be superimposed or placed on different sections of the pixel area. Whilst the number of images is limited,

the quality and definition is good and, in many instances, no other photographic system is required.

Where the higher framing rates and resolution of film cameras are considered really essential, video cameras are often used to provide enough information to enable film cameras to be set up and optimized relatively quickly. As time passes, video capabilities steadily improve and much research is going on to devise video camera replacements for aeroballistic range cameras. In this area analysis time for film is extremely long and labour intensive and video coverage could allow extensive automation of these processes.

14.3.4 High speed still photography

An alternative method of obtaining short duration exposures is to allow the light source duration to become the means of 'shuttering' the film whilst using an open shutter on the camera. Convenient sources for

this are flash tubes, sparks, argon bombs, flash X-rays and lasers. Any good quality camera is suitable for this kind of photography, but advantages such as interchangeable lenses, interchangeable film backs and variable camera geometry are very worthwhile.

Multiple spark photographs can be made using repetitive triggering of a single gap or multiple gaps. By controlling the spark interval, valuable time related information can be obtained. A typical example is the Cranz–Schardin system where multiple independent source cameras are arranged in a block, all using a common large lens and recording onto a common film (Figure 14.3). In a case where a subject is self-luminous, e.g. gas at a gun muzzle or a rocket jet, a spark can be used with special optical arrangements to enhance the spark source light whilst cutting out most of the extraneous light (Figure 14.4).

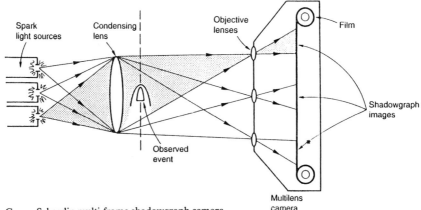

Figure 14.3 Cranz–Schardin multi-frame shadowgraph camera.

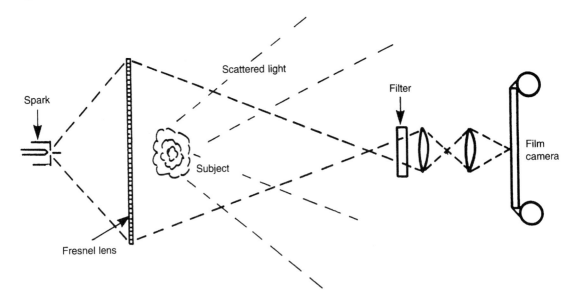

Figure 14.4 Optical system using a Fresnel lens for spark photography of self-luminous events.

14.3.5 Special techniques

14.3.5.1 Streak photography

When the camera is used without image motion compensation, the procedure is called *streak photography*. Streak cameras usually employ a slit, which is placed perpendicular to the direction of film motion. The incoming image is relayed to the film by the slit. Two different types of record can be produced. In the first, the camera is oriented so that film motion is perpendicular to the subject motion. In the second it is oriented such that film motion is parallel to subject motion. (For the perpendicular case see Section 14.3.5.3.) In the parallel case, it is particularly applicable to explosives studies and the record is taken in a continuous exposure as the film passes the lens. It records boundary and particle motions and intensity changes from the subject image which fall within an area defined by a slit in front of the lens parallel to the direction of subject motion. The film motion is used directly to show movement with high time resolution without the interframe gaps that would normally be present. As only a narrow strip of the subject is seen it ceases to be recognizable as a discrete object. The record for a solid subject will appear as a diagonal shadow on the film, its angle being dependent on subject velocity and film velocity (Figure 14.5). With a knowledge of film velocity and the geometry of the photographic set-up, the subject velocity can be calculated. If V_p and V_f are the velocities of projectile and film, respectively, m is the optical magnification of the system and θ is the angle between the streak image and a stationary image of the slit, then

$$V_p = \frac{V_f}{m \tan\theta} \tag{14.1}$$

This method is often used to record the outputs from a series of fibre optics placed to observe the arrival time of flame fronts arising from burning processes. In this case the sources of light are not moving so they form parallel records along the film. Alternatively, fibre optics embedded in an object and illuminated from an external source can show the passage of a shock wave through the subject as their light is sequentially cut off. The streak method is applicable to most cine cameras and these may include medium speed rotating prism, high speed rotating mirror or prism cameras, drum cameras and image converter cameras in which the image motion compensation is temporarily removed. Streak photography is very valuable in the ballistics field due to the very high time resolutions obtainable. Writing rates of several tens of millimetres per microsecond are common with time resolution of 2–3 ns.

An ingenious method of combining streak and synchroballistic photography has been used at Wright Patterson Airforce Base in the USA (Swift, 1967). It has already been mentioned that the essential difference between the two systems is the orientation of the camera relative to subject travel direction. When using a streak system to obtain projectile velocity, a small Dove prism, which turns incoming light beams through 90°, was inserted into the middle of the field of view which covered the path of the projectile. The placement was so arranged that as the projectile passed the field of view of the prism

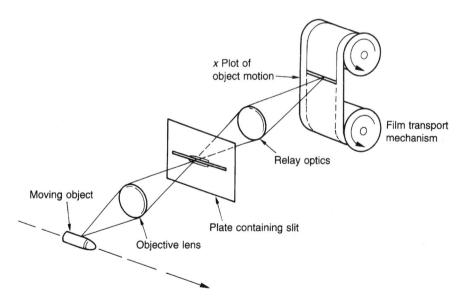

Figure 14.5 Streak camera concept operating in 'parallel slit' mode.

the slit orientation was effectively turned through 90°. The resulting picture showed the normal diagonal line with a break in the centre in which there was a synchroballistic image of the projectile. This effect would not necessarily be possible in all such set-ups, as the optical system, and actual projectile size need to be compatible in scale. Also, projectile trajectory must be predictable to close limits.

14.3.5.2 Projectiles in flight

When there is a requirement to photograph projectiles in flight, several possible methods are available. The usual requirement is to make the view normal to the trajectory so that the projectile is seen from the side. Unfortunately this represents the hardest problem from the point of view of obtaining a blur-free picture and also filling the picture frame with the object. The reasons for this are two-fold; first, movement normal to the camera plane requires very short exposures to ensure a blur-free image; and, secondly, precise synchronization is needed to ensure that when the exposure is made the subject is within the camera field of view.

One way round the problem would be to stand back from the trajectory and take a wide angle view. This will give a chance of registering the projectile at some point in the field of view, even if synchronization is not too well resolved. Also, as the crossing rate is lowered, the exposure time will not need to be so short.

Unfortunately, using this approach, the subject image will be so small that usually it will not be of much practical use. Also the picture will not be very well exposed. Another approach would be to somehow follow the projectile with the camera in order to reduce dramatically the *crossing rate*, or to arrange that the projectile image is synchronized with film movement. If this is possible it would then be feasible once more to reduce greatly the image size/frame size ratio. Fortunately, some special methods have been devised to overcome these problems.

14.3.5.3 Synchroballistic system

Synchroballistic photography is a powerful technique mostly using a medium speed cine camera in a streak mode with its compensating prism replaced by a slit perpendicular to the film motion. This technique produces high quality front-lit photographs of objects such as projectiles or missiles passing in front of the camera. This method is more commonly known in the world of sport where it is used to give a photographic record of competitors as they pass the finishing post. Due to loose correlation of film velocity and image velocity the pictures may be quite noticeably distorted in the horizontal dimension. Nevertheless, they indicate quite clearly the order of arrival of competitors. This system is used to decide the winner and has led to closely contested results of many kinds being described as *photo-finishes*.

In ballistic applications, the choice of an appropriate name for the method has been the subject of debate for many years and it is variously known as *ballistic-synchro*, *synchroballistic*, *smear*, *ballistic streak* or *image motion compensation* photography. More recently, the term *image-sync photography* has been suggested. As the method involves the attempted synchronization of image and film velocities and as in this chapter it is being applied to the study of ballistic subjects, the term *synchroballistic photography* has been chosen. The first ballistic application was by Paul in 1924 when he used a two slit system to measure projectile velocity.

The basic layout of the system is shown in Figure 14.6. The requirement is to project the image of the subject onto the moving film so that the velocity of image movement and film surface movement are as near the same as possible. This can be achieved by

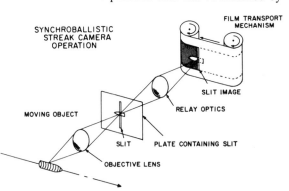

Figure 14.6 Streak camera concept operating in the 'perpendicular slit' mode as a synchroballistic system.

arranging a $1:1$ ratio by a suitable choice of lens, film velocity, the subject to lens/slit distance (or *stand off distance*) (L_o) and the lens/slit to recording medium distance (L_i). For reasonable success, it must be possible to estimate the velocity of the projectile to quite close limits. In Figure 14.6, V_p is the projectile velocity and V_f is the film velocity.

To produce a completely blur-free picture the film and image velocities need to be identical. In practice, the subject velocity is seldom predictable to a sufficiently accurate degree to achieve this requirement. It is thus arranged that the moving image is focused on a narrow slit perpendicular to the film movement. The slit may be placed very close to the film plane or the slit image may be refocused on the film or recording surface at some distance away. The image is relayed to the recording surface as a continuous series of narrow strips. The strips form a complete image of the projectile along the direction of motion of the film. By considering Figure 14.6, it is possible to formulate some of the relationships

$$\frac{1}{f} = \frac{1}{L_o} + \frac{1}{L_i} = \frac{(L_o + L_i)}{L_o L_i} \tag{14.5}$$

This is an exact solution for shorter stand-off distances. For long stand-off distances it can be seen that f will be approximately equal to L_i.

Scan rate will be limited by the camera characteristics, i.e. if the film can only be moved through the camera at velocity V_f then f and L_o must be arranged such that image scan rate is less than or equal to V_f. For example, if the maximum film speed is 60 m s^{-1} and the projectile velocity is 600 m s^{-1}, the stand-off distance/lens focal length ratio would need to be approximately 10 : 1. Thus a 250 mm lens would be used at a distance of 2.5 m from the trajectory. If the projectile was 40 mm in diameter and 200 mm long, the image would be 4 mm wide across the film width and 20 mm long. Its total scan time would be 0.2/600 or 1/3000 s. For a slit 1 mm wide the effective exposure time is reduced to $(1/3000) \times (1/20)$ or $1/60\,000$ s (16.7 μs).

With a fixed upper limit to camera film velocity, it will be seen that in order to achieve a reasonable image/frame size ratio some problems will arise as the projectile size is reduced and the projectile velocity rises. Cameras of the normal rotating prism type have a relatively low top film speed of about 60 m s^{-1}. In cameras specially built for synchroballistic work, speeds of up to about 85 m s^{-1} are possible. For a reasonable picture, such cameras will only be suitable for projectiles of, say, 30 mm diameter travelling at less than about 600 m s^{-1}. If it is required to photograph projectiles which are smaller and faster, the reduction ratio required will reduce the image size to the point where little useful information will be obtained. As projectile size increases, the ability adequately to capture higher velocity subjects will of course also increase. Other types of film camera do have higher possible film velocities. However, they also have relatively short film lengths and thus will need very highly resolved and accurate synchronization, particularly in the case where projectile velocity is not accurately predictable. Because of such problems, the only other type of camera which is practicable for regular use with smaller and faster projectiles is an electronic image converter type, which has a very high range of sweep speeds. The sweep speeds available allow low reduction ratios to be used and, as sweep speeds can be finely controlled, it is easier to match the sweep speed to the projectile velocity (Hadland and Hadland, 1970).

A slight mismatch in relative velocities of film and subject image only causes the recorded image to be slightly longer or shorter than its true proportions, the length mismatch being proportional to the velocity mismatch. The vertical size will remain constant for a velocity mismatch as it is independent of velocity. A typical result is shown in Figure 14.7.

Figure 14.7 Synchroballistic photograph showing 105 mm sabot separation FSAPDS (projectile velocity 5000 ft s^{-1}) taken using a Hytax 2 camera at ft s^{-1}. Lighting using the Visual Instrumentation continuous xenon high intensity photographic illuminator (HIPI).

involving the various parameters. The ratios of the distances L_o and L_i must be arranged such that,

$$\frac{V_p}{V_f} = \frac{L_o}{L_i} = \frac{P_d}{I_d} \tag{14.2}$$

Where P_d and I_d are the projectile length and image length, respectively. Also, the time t taken for the projectile to travel its own length (P_d) is given by

$$t = \frac{P_d}{V_p} \tag{14.3}$$

The time taken is also t for the image of the projectile to traverse the edge of the slit. If the slit width is W then the exposure time for one slit width of the image (t_i) is

$$t = \frac{W}{I_d} \tag{14.4}$$

This value of t will also be the *effective exposure time* of the whole image as it is composed of multiple slit widths. Image exposure time is thus a function of slit width. If the slit image width could be reduced to be equal to the film resolution there would be no blur at all. However, in practical terms this is not feasible and the slit width is normally reduced to a point where blur satisfies the criteria of the experiment. Reduction beyond a certain point is not practicable as the narrow slit will cause diffraction problems. We can also note that exposure time is effectively reduced without the usual penalty of having to increase the lighting level. When L_o and L_i have been determined the actual focal length f of the lens required can be calculated from the lens conjugate equation:

A valuable attribute of the system is that it records all objects passing the camera during the recording period and relates them in time and sequence. This attribute is particularly useful when a multi-part projectile and sabot is being studied, when a projectile breaks up, or when unknown objects fly before or behind the main projectile. When using normal detectors for velocity measurement, incorrect velocities will be measured if objects other than the projectile trigger the detectors. If false readings are suspected, the use of the single or dual synchroballistic system will enable such objects to be seen and identified. Other projectile characteristics such as velocity, angular attitude and spin rate can be obtained from single synchroballistic records, but are not often calculated as other independent methods are available that are generally more easy to analyse (McDowell *et al.*, 1990).

14.3.5.4 Dual synchroballistic system

The synchroballistic method can also be used as a velocity measuring system using two or more camera stations (viewpoints) arranged to record their images on a common film. The earliest record of a similar system is from Paul in 1924. His system used only one incoming image but had two fine slits about 300 mm apart. The ratio of projectile to film velocities was deliberately made unequal so that two separate images were formed on the film. Knowing the film velocity and using the system geometry, the projectile velocity could be deduced. A system

recording multiple separate views from two and four stations on the same film was produced at Fort Halstead, England, in the 1960s. In this case the station images were all combined into one imaging lens and slit by the use of mirrors and beam splitters. In the USA, the arrangement is sometimes known as the *Hall system* (Hall and Atkins, 1960). This system was slightly different because, instead of using a slit placed in front of the film, the effect of the slit is reproduced by the use of fine-line light sources placed on the further side of the trajectory or by viewing the backlit image via a slit before it passes onto the objective lens. All these systems give shadowgraph images at the film plane. Layout geometry will need to take into account the fact that all the images will need to lie within the confines of the film width (Figure 14.8).

The dual synchroballistic system has two major attributes: it allows the measurement of object velocity to high accuracy; and, in common with the single system, it records all objects which pass the camera during the exposure period and relates them sequentially and in time scale with one another.

In some instances the views can be arranged to give orthogonal images, if required. Analysis is usually done by reading the film using a travelling microscope. The distance between viewing positions along the trajectory is accurately known and the time of separation of the images can be deduced from a knowledge of the film velocity. Usually, the images will be contained within a short length of film

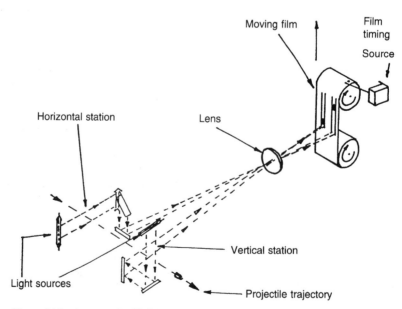

Figure 14.8 A two station Hall Velocity Measurement system. One station provides a view of the passing projectile from a horizontal viewpoint, and the other provides a view from a vertical viewpoint. Note the displacement of the images on the film.

and so film speed variations can be ignored. If projectile velocity is V_p, the film velocity is V_f, and X_t and X_f are the distances between the axes of the viewing stations along the trajectory and the distance between the shadowgraph images on the film in the direction of travel, respectively, then

$$V_p = \frac{X_t V_f}{X_f} \tag{14.6}$$

As the system is primarily intended to measure projectile velocity and not produce high quality pictures, the film and image velocities do not need to be so closely matched. Elongation or shortening of the projectile images will be the same for the several images and will not affect the measuring accuracy. Disadvantages are the delay during film processing and another delay in making the readings using a travelling microscope. Obviously it is essential to have very good time calibration on the film.

14.3.5.5 Flight follower systems

For a single object the synchroballistic method will give a single high quality picture at one point along the trajectory of the object. It will, of course, record a series of single pictures of any objects which pass the camera during the recording period. If, however, a close-up cine record is required of the projectile during a reasonably long section of its trajectory, then the synchroballistic method is not suitable and an alternative must be found. In subjects such as motor racing it is feasible for the cars to be photographed for quite long distances by the camera operator panning the camera to keep the cars in view as they pass. However, the translational rate of projectiles is so fast that moving the camera in this way to keep the subject in view is not feasible. An alternative and feasible approach is taken in the flight follower system, where the camera is kept stationary and the image of the moving subject is relayed into the camera objective via a fast panning mirror (Figure 14.9(a)).

The basic principle is simple, but practical implementation is relatively difficult. The first successful system using the swinging mirror principle was produced at RARDE UK (Damant and Knowles, 1962). In order to follow the trajectory and direct the image into the camera, the mirror must be swung at a varying rate. Initially it must be accelerated to a peak rate when the projectile is normal to the viewing axis, and then decelerated to follow a parabolic curve as shown in Figure 14.9(b). For a projectile velocity of V_p, the correct angular displacement θ of the line of sight to give perfect tracking will be when

$$\tan\theta = \frac{V_p t}{D} \tag{14.7}$$

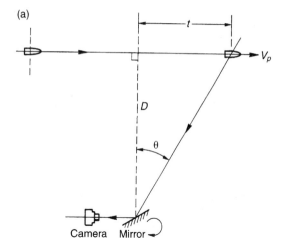

(a)

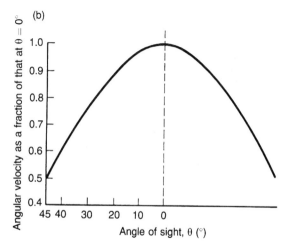

(b)

Figure 14.9 Flight follower system: (a) optical arrangement in basic layout; (b) angular velocity for correct tracking.

where t is the time taken by the projectile to cover the distance from a point where the line of sight is normal to the trajectory to the point under observation, and D is the stand-off distance of the camera, normal to the trajectory. The angular rate of rotation of the line of sight is then given by

$$\frac{d\theta}{dt} = \frac{V_p \cos^2\theta}{D} \tag{14.8}$$

where $d\theta/dt$ is the change of θ with respect to time (t). The mirror angular speed is half this rate.

In the RARDE system, mirror movement was achieved by mounting a mirror on a large galvanometer coil and driving the coil with a series of increasing pulses from storage capacitors. At the point of highest swing rate the pulses were reversed

in polarity and gradually reduced to slow the swing rate again. The pulses were fed in via a wiper arm connected to the coil which swung across a series of contacts. The total swing angle was about 90°. To accommodate various projectile velocities the pulse size could be graduated to vary the swing rate up to a maximum of 40 rad s^{-1}. By using various stand-off distances and varying the focal length of the camera lens a variety of lengths of trajectory and image to frame size ratios is obtained. The system could be operated from rechargeable lead–acid batteries so that it was independent of mains supplies.

Because of the inherent inertia in the mirror mechanism the mirror swing (panning) must be started before the projectile comes into view such that the panning rate has reached synchronous speed by the time the subject first appears in the mirror view as it exits the muzzle. This was achieved by triggering the mirror swing from the gun firing with an appropriate delay or monitoring the projectile movement within the bore. Obviously, a close estimate of predicted subject velocity was required in order to set the apparatus. If a series of experiments were scheduled of approximately the same projectile velocity, the system values could be quickly adjusted to keep the projectile in the middle of the field of view. For bench calibration purposes several systems are used. In one system, a line of small diodes was set up and pulsed sequentially at varying rates to represent the positions of a passing projectile. This data could be recorded on the film during a bench test and the panning accuracy determined. The possible distance of trajectory over which the projectile can be observed will be a function of mirror panning angle and stand-off from the trajectory. Panning angle is limited by the angle subtended from the extremes of trajectory span such that the mirror will be able to reflect the projectile into the camera.

Consider the setting up calculation for a perfect situation where V_p is 1500 m s^{-1} and the required trajectory observation length (L) is 100 m. The projectile is 1 m long and a field of view of 2×1.3 m is needed, i.e. approximately proportional to the 16 mm film frame format. If the full 90° swing is used, $\theta = \pi/4$. Then

$$\tan\theta = \frac{(L/2)}{D} \tag{14.9}$$

where D is the camera stand-off. Then, $D = (L/2)/\tan\theta$. Substituting, $D = 50(\tan\pi/4) = 50$ m, let the angular rotation rate of the line of sight be U. Then

$$U = \frac{V_p}{2D}\cos^2\theta \tag{14.10}$$

The maximum value of U is when $\theta = 0$, i.e. $U = V/2D$. The maximum value of U is then $1500/50 \times 2 = 15$ rad s^{-1}.

The lens is required to give a field of view of 2×1.3 m at 50 m. Considering the horizontal field, the magnification (m) will be

$$m = \frac{\text{Field width on film}}{\text{Field width at projectile}} \tag{14.11}$$

Using 16 mm film the frame size is 10.4×7.4 mm then, $m = 0.0104/2 = 0.0052$. Using the conjugate relation $(1/m) + 1 = u/f$, where u is the distance of the object and f is focal length, then for the horizontal field $f = u/[(1/m) + 1] = 50/193.3 = 258$ mm. The lens required will have a focal length of 258 mm.

To allow for errors in tracking and settings, the actual lens chosen will be of shorter focal length than the ideal to give a slightly wider field of view. In practice, image/frame size ratios are often more like 1 : 3 or greater, although with a series of firings at very close velocities the lower ratios are possible.

Whilst the original system worked adequately it did have some areas where it could be improved. As a consequence, alternatives to, or developments of, the original system have been made or proposed. In the mid-1980s a system was developed for Aberdeen Proving Ground in the USA. A 300 \times 500 mm nickel plated beryllium mirror backed by a honeycomb structure was panned using a servo-motor. Mirror acceleration profiles for some 20 velocity variations were stored in a computer and selected according to the particular gun and propellant charge in use. Closed loop control allowed peak accelerations of 10^5 degree s^{-2}, with mirror position feedback coming from a laser rotary encoder. Sensors on the gun tracked the projectile motion in the bore and started the mirror panning motion at the appropriate time to allow for a 3 ms start-up delay that would have the mirror pointing at the muzzle at projectile exit time and allow the projectile velocity to be calculated. With this information the computer switched in the appropriate acceleration program for the mirror. Typical mirror swing rates reached 600 degree s^{-1} and driving currents for the servo motor were 200 A at 165 V DC. The system has worked effectively taking pictures typically at 1 m intervals along the trajectory (Yeaple, 1988).

The latest UK design includes a servo-galvanometer carrying the mirror which is driven by a current supply controlled by a microprocessor. Initially, the mirror and camera are carefully aligned with the gun and the expected trajectory to ensure that the projectile will remain in view over the required distance. After experimental details have been fed into a computer, the processor selects a tangent acceleration curve appropriate to the expected projectile velocity. The mirror is positioned automatically to allow for a few milliseconds delay in reaching programmed swing rate such that its

line of sight will coincide with the muzzle as the projectile exits. For even more precise tracking or where the projectile velocity cannot be closely predicted, a velocity detector system can be placed close to the muzzle. The velocity is determined in real time and the mirror is instantly adjusted in sight angle to the correct position relative to the projectile velocity. Simultaneously, the corrected new tangent velocity curve is applied to the control of the mirror swing rate. Extra features include the ability to operate on either side of the trajectory, as the mirror operation can be bi-directional, and the possibility of sequential operation of several units each programmed with corrected information and triggered to take up the record as the previous unit reaches the end of its sweep coverage. This would allow a long sweep of trajectory to be covered. The units will be compact and man portable, and capable of operation from mains or battery supplies.

14.4 Flow visualization

Flow visualization is used extensively in research ballistics to assist in the design of projectiles, missiles and various stores. Flow visualization enables the shock waves and flow around bodies passing through liquids and gases to be determined. This enables the designer to see where external shapes can be modified to cut drag and generally increase aerodynamic effectiveness.

In recent years flow visualization has become very important in the study of interactions between bodies flying in close proximity to one another. Typical examples include multiple long rod or segmented long rod projectiles, and the launch of tandem small arms bullets and the interaction between missiles or shells and their submunitions during the release phase. In intermediate ballistics the way in which sabot segments separate from the main projectile also comes under detailed study.

Initial studies are made in wind, shock or water tunnels and then proceed to model or full scale studies in free flight conditions. Shadowgraph, schlieren and, to a lesser degree, interferometry and holography techniques are all used to build up the information required. The various techniques used are discussed in some detail in Chapter 17. An excellent example of flow visualization around a projectile using differential interferometry is shown in Figure 14.10.

14.5 Synchronization and triggering

Synchronization and triggering are extremely important in ballistics photography due to the gen-

Figure 14.10 Differential interferometry in YAG laser polarized light: projectile calibre 20 mm; velocity 500 m s^{-1}; Mach number 1.46; Reynolds number 2.7×10^6; exposure time 15 ns.

erally fast movement encountered and fine resolution required for effective triggering of exposures. Triggering techniques are much the same as for general high speed photography in the sense that similar physical parameters will be used. However, in the ballistics area there is a need to make all equipment in extra robust form to withstand the rigours of blast, overpressure, heat, shock and vibration. In many cases it may also be necessary to make devices which will not survive more than one experiment, so considerable ingenuity may be required to produce reliable and cheap equipment. The various types of triggering and synchronization methods are discussed in some detail in Chapter 3. Most types are applicable to ballistics use.

14.6 Specific applications

In the following sections more specific details are given of some of the types of problems and high speed photographic solutions that may be encountered in the main areas of ballistics photography. It must be emphasized that they represent only a very small sample of the huge range of ballistic work which is done with the help of high speed photography. Unfortunately, much of the most interesting work is not made public for security reasons; however, many reports are published and for further details the reader is referred to the proceedings and meetings listed in the References and Bibliography at the end of this chapter.

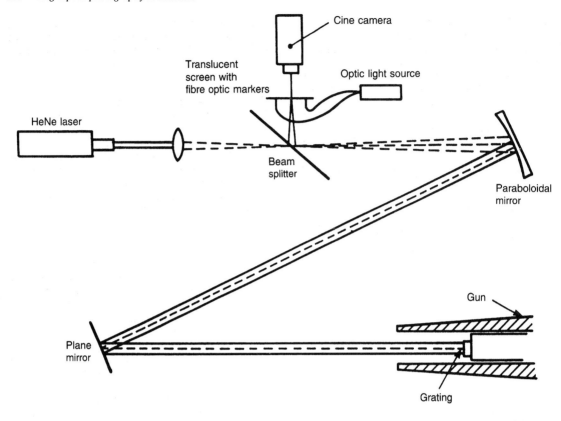

Figure 14.11 Fuller system for measurement of in-bore yaw.

14.6.1 Interior ballistics

14.6.1.1 Shot movement from rest

The measurement of shot acceleration and velocity within the gun barrel from rest to shot exit is currently carried out using microwaves or laser beams using a Doppler system (Fuller and O'Conner, 1981). Before the development of these methods, various other electronic instrumentation methods had been employed. In some early experiments in this area, a photographic method was used. Observation of the initial movement of the shot was made possible by cutting the gun barrel down until it was only a few feet long. A long rod connected to the projectile nose and moving within a centralized guide at the end of the barrel was photographed from the side by a cine camera. The motion of the rod tip could be seen against a reference background and hence the shot movement could be monitored with time as it accelerated from rest.

14.6.1.2 Gas blow-by

As mentioned earlier, direct observation of the projectile in an unmodified gun can only be carried out by observing down the barrel. This can be difficult if propellant gas escapes past the projectile and gets in front of it, hence obscuring the observation path. This gas blow-by is also of interest to the gun and ammunition designers, as any blow-by shows a loss of propellant gas which should be assisting the projectile from the gun and thus represents a waste of energy. A method of observing this phenomenon has been devised in which a powerful collimated beam of light is directed down the bore via a sacrificial mirror. The source can be a high intensity xenon beam or a laser beam. The light is reflected from a pattern of retroreflecting tape fixed onto the face of the projectile. The tape reflects the light beam back along the barrel where it is then redirected into a cine camera and recorded. The gas blow-by can be clearly observed as the reflections are cut off and gas leaks in front of the moving shot. Reference to the synchronized and calibrated film record gives a timed history of the process. The system has an added bonus as spin rate can also be measured from the record (Fuller, 1979).

14.6.1.3 In-bore yaw

The yaw of the projectile as it moves up the gun barrel is of great interest to gun and ammunition designers as it has an effect on wear and accuracy. Several methods have been devised to measure the angular yaw. Again access is via the muzzle with a powerful collimated beam of light being shone down the barrel onto the front of the projectile. Mirrors are attached to the projectile nose so that the movements of the reflected beam can be recorded by a cine camera. Whilst successful to a degree, these methods suffered from complex calibration requirements (Uffelmann, 1963; Kirkendall, 1970; Haug, 1976). A different approach used a special diffraction grating on the projectile nose (Figure 14.11) (Fuller, 1980, 1982). This grating has two halves inclined at 90° and reflects a double line of three dots which are at right angles and superimposed to give a square of light spots with another spot in the centre. The spot pattern is reflected back and recorded on a cine camera (Figure 14.12).

Figure 14.12 Measurement of projectile in-bore yaw. An orthogonal grating is positioned on the nose of the shot. A collimated beam enters the barrel and the zero- and first-order line diffraction patterns exit. The pattern rotates and moves with the projectile. The spot pattern displacement is unique to the grating design angle in that $\sin\theta = n\lambda/(a + b)$, where λ is wavelength, n is an integer, a is the linewidth, b is the space width of the grating and θ is the angle of diffraction.

As the projectile spins and yaws while it progresses up the barrel, the spot pattern also turns and moves across the film frame. The spot separation distance is a function of the diffraction grating design and thus each film frame carries its own calibration, allowing the yaw angle for each frame and the spin rate to be measured. Static fibre optics are rear illuminated and placed to also appear in each frame and provide an absolute measuring reference. The calibration markings on the film provide a time scale against which the motion can be plotted.

14.6.1.4 In-bore movement

There is interest in the way the projectile moves within the bore and also in the way that propellant burns and moves within the gun chamber and bore. Flash X-rays have been used to observe both phenomena. Radiographs of internal functions in guns require high energies in order to achieve penetration. Sometimes a temporary barrel may be made of a material such as fibre glass and resin which is less opaque to X-rays. Often the metal gun barrel will be machined to give a thinner section at the area through which the X-rays will need to pass. In the study of charge movement and burning, lead salts are often mixed with the propellant as propellant has a low absorption of X-rays and is difficult to picture. Lead salts have a higher absorption of X-rays and thus show propellant movement much more clearly.

Alternatively, the barrel may be made of transparent material or have windows fitted along its length. High intensity lighting and ordinary film cameras can then be used to show the internal events (Fuller, 1984). As transparent materials such as plastics will not have the same tensile strengths as steel, the constructions will sometimes fail under the pressures involved, but by then the desired observations will have been made.

14.6.2 Intermediate ballistics

The region just beyond the muzzle where the projectile is moving through the expanding propellant gas is a particularly difficult region for photographic observations due to the large amount of flash emanating from the burning gases and their high particle density. Radiographs can be used to study the mechanisms of sabot detachment and the integrity of the projectile itself (Bracher and Huston, 1976). Using X-ray photography against a background of pre-set datum wires the projectile yaw can also be seen. For smaller calibres the smoke and flash problem is not so great and the normal methods of flow visualization can be used (Fuller 1977, 1979).

To combat the problem of high flash levels, a special optical arrangement has been employed (Schmidt and Shear, 1975). A Fresnel lens is used to focus the light from a point source spark into the camera (see Figure 14.4). The event takes place between the lens and the camera and diffusion takes place of any non-focused flash from the gun. The camera lens can be stopped down to receive the focused light. Sometimes a narrow band filter is also

used to remove even more of the unwanted illumination.

To study the growth of expanding shocks from the propellant cloud, multiple spark pictures can be used (Schmidt and Shear, 1975). Knowing the intervals between the sparks the shock velocity can be found in two dimensions.

The incandescent muzzle gas cloud is used successfully as a light source to take cine photography of the exit of projectiles into the intermediate region. The camera is placed down range and focused on the muzzle area. The expanding gas cloud provides a luminous background against which the projectile is clearly seen. The illumination lasts sufficiently long for the discard process of sabotted projectiles to be observed.

Holography has also been applied in the muzzle flowfield (Bettinger, 1964). A Q-switched laser with a pulse length of 20 ns was used in a double pulse mode to make holograms of the flow from the muzzle of a 20 mm cannon. One exposure was made without the disturbance and the other during the firing. The beam was initially split into two parts, one passing straight to the photographic plate and the other passing through the disturbance. Three-dimensional shock formation about the projectile was clearly evident in the reconstituted holograms.

14.6.3 External ballistics

In the case of full range firings the projectile trajectory will usually be so high that normal detailed photographic studies will not be possible. However, photography is still used to provide a record using *trackers* which follow the trajectory of projectiles and missiles. Once confined to film cameras this region of interest now uses video systems as well. As in other applications the ability to apply digital processing directly to the image carries with it many advantages. In the case of firings in enclosed ranges or for flat high velocity trajectories on open ranges, the projectile will be photographically accessible over much of its flight path. Several of the methods used in this area are discussed in detail in Section 14.3.5.

Considerable use is made of mirrors placed to give views of several dimensions of the projectile on a single frame. Temporary enclosures also offer the ability to control the lighting type and level over a short part of the trajectory. Thin walls at each end allow unimpeded passage of the projectile whilst keeping light out.

Flash X-rays are not used so much in external ballistics as conventional photography is usually more effective in this area. However, X-rays can be usefully employed for observations near the gun muzzle to study the condition and operation of internal mechanisms such as fuses after the launch process.

14.6.3.1 Rocket sledge experiments

As an alternative to free flight observations many projectiles and missiles are tested on *rocket sledges* which are confined to move on rail tracks. The use of rockets enables very high velocities to be obtained. Such tests have many advantages where the free flight aerodynamic characteristics of the object are not the paramount study. The specific constraints of movement allow instrumentation to be set up with the certainty that the subject will pass in a certain direction or distance from a measuring device. Thus cameras and lights can be set near to the rails to give close-up detail of events. Together with complex instrumentation and recording devices, they can also be placed on the sledge to move with the subject. This of course is a huge advantage compared with free flight conditions where on-board instrumentation is very limited.

In some instances, synchroballistic pictures may be taken or flight follower techniques may be appropriate if a record covering a long distance of travel is needed. Subjects other than projectiles or missiles will also be studied. These will include investigations into the operation of aircraft canopy release and the launch of aircraft ejection seats and parachutes at realistic velocities.

14.6.3.2 Aeroballistic ranges

A special test facility for external ballistics is the aeroballistic range. In both the pre- and post-design stages of projectile development as much information as possible is required of the aerodynamic behaviour of the device in actual flight. In the early stages this may be gained by firing scale models, but it will eventually have to extend to full scale experiments. The desired measurements can be gained by firing the device in a controlled and instrumented facility called an 'aeroballistic range'. Such ranges may be completely enclosed or have only part of the trajectory enclosed. In both cases the main observations will be recorded photographically. The experiments are normally carried out in darkness and shadowgraph pictures are recorded on multiple cameras arranged in orthogonal pairs at carefully measured positions along the trajectory. Spark sources are employed to provide lighting and to control exposure time. At each station pairs of retroreflective screens provide a background against which the projectile is imaged (Figure 14.13). Suspended catenary wires along the full length of the range carry small markers at carefully measured intervals. These wires appear in all the photographs with at least one wire appearing in both photographs of an orthogonal pair (Figure 14.14). They provide a means of relating the photo-pairs to each other and

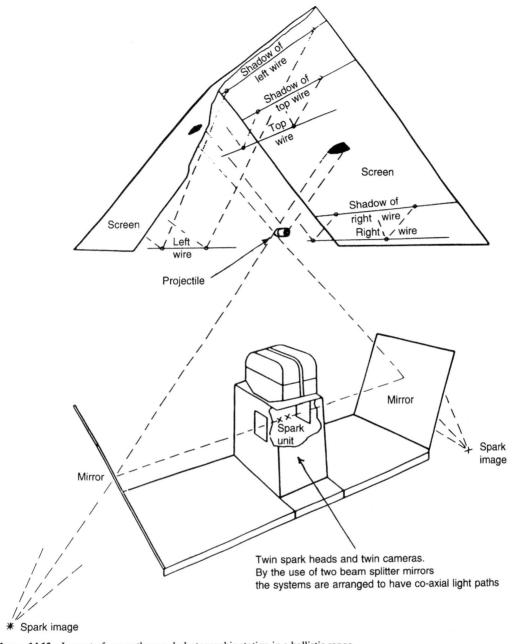

Figure 14.13 Layout of one orthogonal photographic station in a ballistic range.

to the successive photo-pairs along the length of the range. The cameras are focused on the shadowgraph picture on the retroreflective screen. The front-lit image of the projectile is thus out of focus. If both camera and light source axes can be arranged to be coincident, the out of focus image will appear within the confines of the shadowgraph image. This makes for a less cluttered picture and assists analysis. The pairs of photographs thus obtained can provide information on yaw, pitch, precession, nutation and projectile status. From this the full projectile trajectories and three-dimensional orientations can be reconstructed.

The analysis of the photographs and the reconstruction of the trajectories used to be a long and tedious manual process which, with cuts in man-

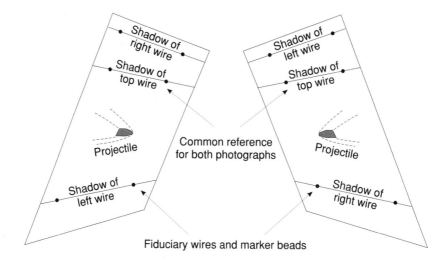

Figure 14.14 Pair of complementary photographs from one orthogonal range station.

power and funding, led to the closing of several such test facilities. However, much of the work has been automated and complex computer programs now calculate the results in a much shorter time. To enable the process to be automated further, much effort is being expended on replacing the film cameras with very high resolution CCD cameras (Snyder and Kosel, 1990). If this can be done, the electronic images will be fed directly into computers, scanned and analysed in a relatively short time. As well as basic design studies, the aeroballistic range is used to study other phenomena, such as the interactions between multiple simultaneously launched projectiles and the launch process of submunitions. The enclosed, permanent and controlled nature of the aeroballistic range allows the use of complex photographic methods such as schlieren, shadowgraph and interferometer systems to be set up on a long term basis.

14.6.4 Terminal ballistics

Terminal ballistics is an area where high speed photography can be widely applied. Many target materials of great interest are metal or other materials which are opaque to normal photographic methods. Flash radiography thus offers a unique method of observing the interactive process between projectile and target during penetration. Another advantage of radiography is the ability to photograph through the smoke and luminosity often associated with impact. By 1938, Steenbeck was already demonstrating the usefulness of radiography in records of bullets penetrating wood targets.

In order to adequately observe this kind of phenomenom multiple exposures are desirable.

Multiple exposures enable the speed of growth of craters and the rate of material flow to be observed. Much use is made of cine X-rays to allow a *time history* of the process to be produced. The penetration of projectiles through plates and the production of ejecta and projectile break-up can be seen as a continuing process. Flash X-rays are also valuable in the study of explosive processes where the insensitivity to the self-luminosity of the phenomena is a valuable asset. Although explosives are fairly transparent to X-rays the progress of detonation waves can be followed due to the local increase in absorption in the temporarily compressed material as the wavefront passes. If a calibrated wedge is also simultaneously photographed, calculations of the detonation wave density can be made.

Other methods including still video, high speed rotating mirror cameras and multiple pulsed lasers are all used successfully for external impact observations. Some very interesting results have been obtained of the growth of the jet from a shaped charge, using short duration pulses from ruby lasers as the illuminating source. Usually with shaped charge studies the accent is on the performance aspects when the jet strikes the target, and the actual processes in the formation of the jet have not been given so much prominence. Previously, the jet has been observed from the side with X-rays, giving a two-dimensional picture. The changing shape of a copper cone as it turns inside out and forms into a thin metallic jet had been previously modelled on computers but had not been observed experimentally by normal photography (Shaw *et al.*, 1992) (Figure 14.15). *Q*-switched ruby lasers were used in conjunction with special image converter cameras using exposure durations of 20 ns to give front-lit

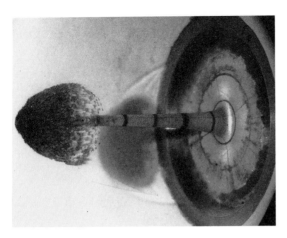

Figure 14.15 Ruby laser photograph of a shaped charge jet, taken with an image converter camera at 50×10^6 pps.

views of the jet growth process. By arranging the view to be at a small angle to the emerging jet it was possible to view up into the inside of the cone. Similar pictures were also made using argon bomb illumination and high speed rotating mirror cameras. Work has also been done using a ruby laser stroboscope to study impact phenomena. The ruby stroboscope offers recording duration (1 ms) at frequencies up to 500 kHz with exposure times down to 20 ns (Kleinschnitger *et al.*, 1992).

14.6.4.1 Holography
Holography has also been used in the impact region to study debris clouds, explosively formed projectiles and their effects. The three-dimensional

view possibilities offered by holography are very valuable in the impact study area as most techniques only give two-dimensional information and much information is lost due to foreground objects obscuring objects in the middle and far fields. After the holograms are taken they can be analysed with a variety of visualization techniques to obtain the required information. Researchers have applied holography to ballistics over several decades (Heflinger, 1966; Redman, 1971; Smigielski *et al.*, 1971; Belozerov, 1976; Mishin, 1985; Royer, 1985).

More recently, a *Q*-switched ruby laser with a duration of 30 ns has been used with a special camera unit to observe explosively formed projectiles (Cullis, 1990). The laser was placed in a separate location while the object and reference beams were contained within beam pipes to carry them to the camera.

Other experiments have been made to observe debris clouds from projectile impact. In this case a new departure was the use of curved film topography to enhance the holographic coverage (Hough and Gustaffson, 1990; Hough *et al.*, 1991). Again, a pulsed ruby laser has been used of about 10 ns duration. Particles down to 100 μm have been resolved. The system layout is shown in Figure 14.16.

14.6.4.2 Wound ballistics
During the development of small arms rounds, there is great interest in what happens when the bullets penetrate human tissues. The penetration is often associated with the production of temporary cavities that produce extreme trauma. In order to study such phenomena, specially prepared translucent gelatin blocks that have similar properties to human tissue

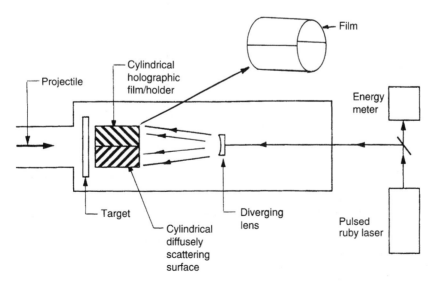

Figure 14.16 Schematic of the shadowgraphic hologram.

are employed as target material. High speed cine cameras are used in conjunction with strong back-lighting to observe the growth history of the cavities produced. The records can later be analysed to make time history plots of the shape and size of the cavities. Similar studies are made in the development of bullet-proof vest designs. Although the bullets do not penetrate the vest, there is distension of the area immediately behind the impact region which can be relayed to the wearer via the protective layers and can cause blunt trauma and bruising. In this case the studies may be made from the side using cine X-rays or by high speed film or electronic cameras looking at a sectioned sample. An image converter camera has been used in conjunction with flash-lamps to observe such phenomena (van Brie and van Riet, 1990).

14.6.4.3 Bird strikes

In the civilian area much work is done to study the effects of bird strikes on aircraft cockpit covers and their effects on turbine blades if ingested into jet engines. Here the strike velocities are rather lower and extensive use is made of medium speed cine and video cameras. The target subjects are real full scale objects and, in the case of engine tests, individual fan blades may be impacted in the laboratory to see the detailed effects of strikes at different points on the blade. Tests on full size engines running at flying speed revolution rates are also made in open air facilities. The birds are sometimes dummy objects made from materials with similar properties to real birds. However, it has been found difficult to simulate accurately real bird consistency. Most realistic tests are made with dead chickens or other suitably sized birds which are enclosed in sabots and fired from compressed air or propellant guns into the inlets of the engines under test.

In the study of cockpit covers the birds are fired in a similar fashion at the front panels. Various materials and shapes can be tested to see how the impact is resisted. Even if the cockpit is not penetrated, there are possible dangers from articles that are attached to the cover and which may fly off and strike the pilot. Several cameras may be employed to view from a variety of angles. Lighting can be difficult due to the number of reflecting surfaces involved. Sometimes a camera may be placed inside the cockpit to avoid the reflection problems.

14.6.4.4 Bullet-proof vests

Other types of test might be made on bullet-proof vests or helmets and the fibres used in their construction. Here high speed rotating mirror cameras or image converter types will be used to obtain the necessary framing rates that are needed. Multiple single plate studies have also been made using high repetition rate spark sources such as the Strobokin system. Having all the images on one frame can be very convenient, particularly in the study of the behaviour of single fibre breakage (van Brie and van Riet, 1990; Field and Sun, 1990).

Similar tests are made to observe the mode of break up of the ceramic tiles often used as facings for vests. Here there is interest in the rate at which the penetration takes place, the rate of crack propagation in the ceramic and the break up or distortion of the projectile itself. These processes will occur in a very short time scale, so very high speed film cameras will be required or image converter cameras may be used together with high intensity lighting.

14.6.5 Dynamic processes

This area will include those processes which are dynamic but remain in the camera's field of view for the total event time, e.g. an explosion. Much work is done to observe the blast waves coming from large scale explosions using flow visualization techniques (Kinsey *et al.*, 1990; Dewey and McMillin, 1990). Typical of processes in this area are the study of small full scale samples or models of projectiles and missiles in wind tunnels, water or shock tunnels. Here the device is suspended on a sting in the tunnel and air or water flows around it to simulate flight conditions. Schlieren and/or shadowgraph pictures are taken to study the flow patterns, and for some subjects, which may have an oscillatory flight, medium speed cine sequences will be used to record the motions (see also Chapter 17).

14.6.5.1 Gun recoil and barrel vibration

The motion of the total gun or particular parts of the moving mechanisms such as the recoil system or loading system are slow enough to be recorded by medium speed cine or video cameras. Sometimes a particular element of the subject may be painted with a bright colour or have a piece of retroreflective material fixed to it in order to increase its visibility in the pictures. As the subject is basically static, lighting is relatively easy and some time can be spent in placing sources to the best advantage.

The study of barrel vibration is often required when analysing new designs or when attempts are being made to optimize gun performance and accuracy. In large guns vibration before shot exit, although significant ballistically, is very small in actual amount and must usually be measured using very sensitive electronic or electro-optical devices. However, after shot exit the movement can be of quite a large extent and can be studied using high speed film cameras or high speed video. The view will normally be from the side, sometimes in orthogonal arrangements and normally incorporating a scaled grid background to assist analysis. In some experiments a line of bright reflectors has been placed centrally

along the length of the barrel and illuminated with a high power strobe source. Observations have been made with high speed cine cameras, far enough away to include the complete barrel in the field of view. Firing at night to reduce background interference has resulted in the film showing a line of bright dots undulating with time and analysis has given a motion versus time history. Fixed point sources were incorporated for reference purposes.

14.6.5.2 Combustion

A large part of the work in this area is concerned with combustion in all forms. The action of firing devices such as squibs, detonators, caps and primers takes place in very short time scales, ranging from microseconds to milliseconds. High speed rotating drum, rotating mirror or electronic cameras are used to record their action in framing or streak mode. Lighting is supplied by flash bulbs, flash tubes or high intensity continuous sources (Chaudhri, 1992).

For explosions, similar types of camera will be required but, as there is a large amount of self-luminosity, lighting can be by argon bomb or high power laser pulse. Filters are also used to cut out selectively the light from the combustion process. However, in some cases it is required to study the progress of flame fronts and in this case colour photography will be employed to assist the definition of various areas. In some instances fibre optics can be placed to transmit the arrival time of the flame front from various positions on the explosive charge. These times are recorded by streak cameras. For these experiments cameras have to be well protected from blast effects and may either view the scene through thick windows in a safe enclosure or be behind blast walls and set to view the event via relay mirrors.

Flash X-rays are also used to study explosive processes, and in this case the problems of self-luminosity do not apply as the X-ray cassettes can be completely enclosed to visible light. X-rays are particularly useful when the motion of metallic parts of an exploding device are needed. In this case cine X-rays or multiple sequentially fired X-ray units surrounding the area will be used. When X-rays are used the film and intensifying screens will usually have to be placed quite close to the explosion site. Over a long period of experimentation, many-ingenious systems have evolved to allow the film to be recovered intact. Film cassettes include internal foam padding and are sheathed externally in plywood covers. They are also often not rigidly fixed in place but are allowed to be blown away by the blast to be recovered after the event. This resilient placement avoids much of the direct shock damage that would be experienced by a rigid attachment.

14.6.5.3 Arena firings

Sometimes the primary objective is to find out the general action of an exploding store and its fragmentation performance. It is then set up in a temporary enclosure often known as an *arena*. The store is placed in the centre and around one half of a surrounding enclosure sheets of straw board are placed which are used to trap fragments. Around the other half are placed light support sheets faced on the inside with thin metallic foil. Under the semi-circular foil wall mirrors are placed to show the wall surface to a series of cine cameras arranged in protective enclosures around the outside of the wall. Bright continuous lighting or synchronized flash bulbs are arranged to illuminate the outer surface of the wall. When the store is fired, fragments from one half of the device are trapped in the strawboard wall and are later recovered, their location, weight and shape being recorded. When the flying fragments from the other half reach the foil screen wall they pass through and their passage is marked by the appearance of a star-like spot on the camera record due to the external light sources now becoming visible through the hole. Their time of appearance can be deduced from the cine timing record. This will also provide data on the velocity of the fragments as their flight path distance will be known. From this information a comprehensive analysis of fragment size, velocity and direction can be obtained. The temporary arena structure will usually be wrecked but not before the data have been recorded (Figure 14.17).

14.6.5.4 Gun temperatures

The temperature history of gun barrels during firing is of great interest as it is closely linked with wear rate. Measurements are often made with thermocouples or other devices placed on the gun structure. A method has been developed (Fuller, 1989) in which the output from a thermal imaging device is recorded to give a time history of temperature change over a section of the barrel. Thermal imagers have a relatively long response time if a recognizable image is required. This is due to the scanning action used which gradually builds up the image from a series of horizontal scans which are rastered down the viewing screen. However, the time of one scan can be quite short (some 5 ms), and if the picture is limited to a narrow strip equal to one scan width it becomes possible to produce a time history of temperature change over the area under observation. The scanner produces a false colour picture in which colour represents a temperature band. In the experiments these pictures were recorded on film and also plotted on a colour printer from a digital store. Changes in the rate of rise of barrel temperature could be observed when heat transfer reducing additives were incorporated into the cartridge systems.

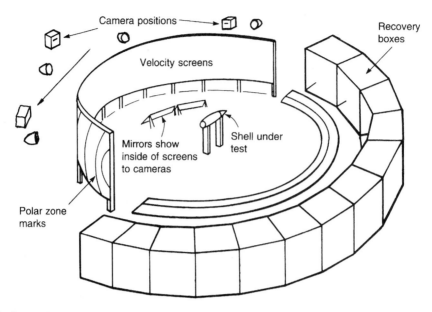

Figure 14.17 Layout for arena firing.

14.7 Summary

High speed photography has been a valuable tool in ballistics research for well over 100 years. The applications and usage are constantly expanding. New methods of applying established techniques are regularly discovered and there is a steady growth of new methods particularly in the electronics/photonics area. Video capabilities pose a constantly increasing challenge to film systems. However, long established film methods such as medium and high speed cine, and flash and spark photography continue to form a large part of general day to day usage, particularly for work requiring the highest resolution. Means of data recording of waveforms using electronic methods continue to grow in number and complexity and in most areas have taken over from conventional photography of oscilloscope displays. It is certain that in the future ballistic work will make increasing use of video and other types of electronic recording. Whatever the methods used the ballistics experimenter is likely to affirm in the future, as in the past, 'that a good image is worth a thousand words' or, more likely, 'several megabytes', of explanation.

Acknowledgement

The help of J. Bowman in checking this chapter is gratefully acknowledged.

References

Bagley, C. H. (1959) *Rev.Sci. Instrum.* **30,** no. 2, 103–104

Belozerov, A. (1976) Use of holographic interferometry in ballistic experiments. *Sov. Phys. Tech. Phys.* **46**, no. 9, 1987–1989

Bettinger, R. (1964) *Application of Holographic Interferometry to the External Flowfield in the Muzzle Environment of a 20 mm Cannon.* Report No. AD-A013–465, Case Institute of Technology, USA

Boys, C. V. (1893) Photography of flying bullets. *Nature* **47**, 415–421, 440–446

Bracher, R. J. and Huston, A. E. (1976) High speed radiography of projectiles. *Proc. 12th Int. Congress on High Speed Photography*, Society of Photo-Optical Instrumentation Engineers, Bellingham, NY

Chaudhri, M. M. (1992) The working of a small arms cartridge. *Proc. SPIE* **1801**, 108–114

Cranz, C. and Koch, K. (1899–1901) Investigations on the vibration of rifle barrels. *K. gl. Bayerische Academie der Wissenschaften Munich Abhandlungen* 19–21

Cullis, I. *et al.* (1990) Holographic visualization of hypervelocity events. *Proc. SPIE* **1358**, 52–64

Damant, E. and Knowles, F. (1962) The flight follower – a device for the cinematography of objects in rapid translational motion. *Proc. 6th Int. Congress on High Speed Photography*. Society of Motion Picture and Television Engineers, Bellingham, NY

Dewey, J. M. and McMillin, D. J. (1990) Analysis of results from high speed photogrammetry of flow tracers in blast waves. *Proc. SPIE* **1358**, 246

Dugger, P. H. and Hendrix, R. E. (1975) Laser photo-

graphy at AEDC. *Optical Spectra* **9**, May

Edgerton, H. E. (1949) Electronic flash photography. *J. Soc. Motion Picture Engrs* **53**.

Field, J. E. and Sun, Q. (1990) High speed photographic study of impact on fibres and woven fabrics. *Proc. SPIE* **1358**, 703

Fuller, P. W. W. (1977) Instrumentation for the determination of the shot exit time in guns. *7th Int. Congress on Instrumentation in Aerospace Simulation Facilities,* pp. 182–194. Institute of Electrical and Electronic Engineers

Fuller, P. W. W. (1979) High speed photography in ballistics. *8th Int. Congress on Instrumentation in Aerospace Simulation Facilities,* pp. 112–123. Institute of Electrical and Electronic Engineers

Fuller, P. W. W. (1980) Measurement of yaw in bore. *Proc. 5th Int. Symp. on Ballistics,* Toulouse. American Defense Preparedness Association, USA

Fuller, P. W. W. (1982) Aspects of yaw in bore measurement. *Proc. 3rd US Army Symp. on Gun Dynamics.* USA

Fuller, P. W. W. (1984) Instrumented investigation of the internal ballistics of a low velocity launcher. *Proc. 8th Int. Symp. on Ballistics,* pp. 1B5–1B1. American Defense Preparedness Association, USA

Fuller, P. W. W. (1989) *Gun Barrel Temperature Studies using Short Time Scan Thermal Imaging.* ICIASF Record 89CH2762-3, pp. 159–167. Institute of Electrical and Electronic Engineers

Fuller, P. W. W. and O'Conner, J. (1981) A Michelson interferometer for high resolution of shot start movement using a CO_2 laser. *9th Int. Congress on Instrumentation in Aerospace Simulation Facilities,* pp. 169–178. Institute of Electrical and Electronic Engineers

Hadland, J. and Hadland, R. (1970) The design and application of a ballistic-synchro system using the Imacon image converter camera. *Proc. 9th Int. Congress on High Speed Photography.* Society of Photo-Optical Instrumentation Engineers, Bellingham, NY

Hall, D. A. and Atkins, W. W. (1960) New technique for the measurement of the velocity of high speed objects. *Proc. 5th Int. Congress on High Speed Photography.* Society of Motion Picture and Television Engineers, Bellingham, NY

Haug, B. (1976) *Optical Device for Determining Small Angular Motions.* Ballistic Research Laboratory, Aberdeen Proving Ground, USA

Heflinger, L. U. (1966) Holographic interferometry. *J. Appl. Phys.* **37**, no. 2, 642–649

Hough, G. R. and Gustaffson, D. M. (1990) Ballistics applications of lasers. *Proc. SPIE* **1155**, 181–188.

Hough, G. R. *et al.* (1991). Enhanced holographic recording capability for dynamic applications. *Proc. SPIE* **1346**, 194–199

Kinsey, T. J. *et al.* (1990) Hycam camera study of the features of a deflagrating munition. *Proc. SPIE* **1358**, 914

Kirkendall, R. (1970) *The Yawing Motion of Projectiles in the Bore.* BRL Technical Note 1739. Ballistic Research Laboratory, Aberdeen Proving Ground, USA

Kleinschnitger, K., Hohler, V. and Stilp, A. J. (1992) The EMI ruby stroboscope and its application in terminal ballistics. *Proc. SPIE* **1801**, 278–287

McDowell, M., Klee, H. and Griffith, D. (1990) A new approach to synchro-ballistic photography. *Proc. SPIE* **1358**, 227–236

Michel-Levy, A. and Muraour, H. (1937) Photographs of phenomena accompanying explosions of brissant explosives. *Comp. Rend.* **204**, 576–579

Mishin, G. (1985) Optical methods of ballistic research. *Proc. SPIE* **491**, 426–432

Redman, J. (1971) Holography of hypervelocity projectiles with front-surface resolution. *Appl. Opt.* **10**, no. 10, 2362–2363

Royer, H. (1985) Holography of very far objects. *Proc. SPIE* **600**, 127–130

Schmidt, E. and Shear, D. (1975) Optical measurements of muzzle blast. *AIAA J.* **13**, 1086–1091

Sewell, J. *et al.* (1957) High-speed explosive argon flash photography system. *J. SMPTE* **66**

Shaw, L. L. *et al.* (1992) Electro-optic frame photography with pulsed ruby illumination. *Proc. SPIE* **1801**, 92–105

Skaife, T. (1853) *The Times,* 29 May, 14 July, 5 August 1858; *Liverpool Manchester Photogr. J.* Oct.–Nov. 1858

Smigielski, P. *et al.* (1971) Holographie ultra-rapide. *Nouv. Rev. Opt. Appl.* **2**, no. 4, 205–207

Snyder, D. R. and Kosel, F. M. (1990) Application of high resolution still video cameras to ballistic imaging, ultra high and high speed photography, videography, photonics and velocimetry. *Proc. SPIE* **1346**, 216–225

Swift, H. F. (1967) *The Airforce Materials Laboratory Hypervelocity Ballistic Range.* AFML Technical Report AMFL-TR-67-2. Wright Patterson Air Force Base, Dayton, OH, USA

Taylor, H. D. (1937) On the use of rotating parallel plate glass blocks for cinematography, *Proc. Phys. Soc.* **49**, 663–670

Uffelmann, F. L. (1963) The initial disturbance affecting the direction of trajectory of a shot fired from a high velocity gun. *Proc. R. Soc., London* **272**, 331–362

van Brie, J. L. and van Riet, E. J. (1990) Use of an image converter camera for the analysis of ballistic resistance of lightweight armour materials. *Proc. SPIE* **1358**, 692

Yeaple, F. (1988) High speed mirror tracks projectile. *Design News,* 5 Sep., 122–123

Bibliography

Edgerton, H. E. (1949) Electronic flash photography. *J. Soc. Motion Picture Engrs* **53**

Fuller, P. W. W. (1994) Aspects of high speed photo-

graphy *J. Photogr. Sci.* **42**, 42–43, 66–71, 100–105, 133–135, 169–177, 210–217

Jamet, F. and Thomer, G. (1976) *Flash Radiography.* Elsevier, London

Jones, G. A. (1952) *High Speed Photography.* Chapman & Hall, London

Saxe, R. F. (1966) *High Speed Photography.* Focal Press, London

Proceedings

The International Congress on Instrumentation in Aerospace Simulation Facilities. Published by the IEEE Aerospace and Electronic Systems, Society, USA (meetings every 2 years)

The International Congress on High Speed Photography and Photonics. Published by SPIE, USA (meetings every 2 years)

The International Symposium on Ballistics. Sponsored by the ADPA, USA (meetings every year)

15 High speed photography in detonics and ballistics

Manfred Held

15.1 Introduction

High speed photography plays an important role in research and development in the field of high explosives. Very many of the applications focus on the detonation behaviour of the explosives. The insight into the process of detonation and, in particular, into the initiation of conventional high explosives and phenomena which today are summarized by the term *detonics* (Johannson and Persson, 1970), is certainly closely related to the development of diagnostic techniques and especially to that of high speed photography. The reaction and detonation velocities found in the field of detonics are of the order of several 1000 m s^{-1}, involving pressures of many gigapascal (GPa). Related phenomena occur at speeds of over 10 000 m s^{-1} and may involve shock pressures of more than 100 GPa.

To obtain pictures of the detonating events with little motion blur and high time resolution, exposure times of less than 10 ns and framing rates higher than 10^6 pictures per second (pps) are desirable. A few decades ago, new discoveries and improved knowledge in the field of detonics were heavily dependent upon developments in high speed photography. At the present time, however, special cameras are available for diagnosing detonation phenomena, and their commercial development has produced reliable and easy to use instruments.

Thus, the scientist working on detonic problems can now concentrate on developing measuring techniques instead of developing measuring instrumentation, and the research engineer can now concentrate on the essential problems such as the development of measuring methods, because there is no longer any need to undertake the design and manufacture of the necessary instruments. This chapter gives a short overview of the optical instrumentation most used in the field of warhead and detonation diagnostics, as summarized in Figure 15.1 (Held, 1993b).

15.2 Radiation sources

Light sources used for recording rapid ballistic events and detonative phenomena are applied in two ways. The short exposures from high speed shutters and/or the high framing rates of high speed cameras require extremely bright illumination in order to obtain satisfactory exposures from phenomena that have little or no luminosity of their own. Up to now, the so-called *argon bombs* have been used. These produce enough light to permit direct light recordings with framing rates of 10^6 pps. Argon gas is extremely luminous when it is exposed to a detonative shock wave. For an observation time of 100 µs, a tube made of cardboard is filled with argon gas of technical grade. A strong shock wave is fed into the argon atmosphere by detonating a small high explosive charge such as a few hundred grams of Composition B. A translucent white balloon filled with argon with a 100 g high explosive charge behind it is sufficient to supply background lighting for shadowgraph records using Kerr cell or image converter shutters, which have an open or exposure time of 5 ns.

Argon bombs can also be used as flash sources. This means that the light source duration is so short that fast events can be recorded on a stationary film frame with the camera shutter in the open position. There are several arrangements and applications for this purpose, while a special arrangement can create a bright light output of only 0.5–2 µs duration (Held, 1968).

The *laser* certainly provides a new type of light source. However, because of its high cost and relatively intricate measurement arrangements, it is at present only used in special cases.

Without doubt, *flash X-ray radiography* (Held, 1985) has acquired a particular significance in the whole field of detonation physics and warhead design and testing. The fast discharge of several hundreds or thousands of volts is achieved by means of a Marx pulse generator. The flash X-ray technique also permits observations to be made of detonation waves inside a high explosive charge itself (Dafelmair *et al.*, 1983).

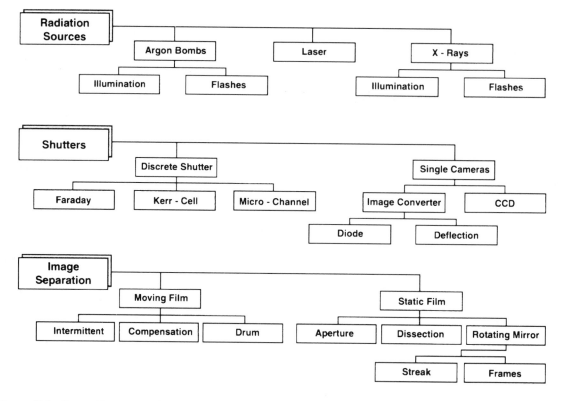

Figure 15.1 Types of instrumentation used in detonics and ballistics.

15.3 High speed shutters

The Faraday shutter providing exposures up to 1 μs and the Kerr cell shutter providing exposures up to 5 ns are not so frequently used nowadays. Image converter and recent charge coupled device (CCD) cameras have replaced them, as the latter have much better shut-off factors and possibilities of high light amplification.

Apart from short shutter times, the image converter camera also allows high framing rates to be obtained by means of adequate deflection systems in the special image converter tube. In this way, the breakthrough of a detonation front at the end face of a high explosive charge can be obtained as a self-luminous event, with high resolution at a rate of 5×10^6 pps and the corresponding exposure times of 40 ns. By magnification of the detonating surface the change in the undulating front of the detonation wave can be recorded with 20×10^6 frames per second (fps) and is visible from the cessation of the gap luminosity (Held, 1993b).

Often now the microchannel plate is also used as a powerful light amplifier together with its high speed shutter function. Using this combination, cameras have been designed for the daylight photography of bullets or explosively formed projectiles.

More CCD cameras are now available for high speed photography in detonics. Cameras for simple projectile photography with 756 × 480 pixel resolution and 1 μs exposure time are relatively inexpensive. When equipped with a multi-channel plate their light sensitivity is higher by a factor of 1000 and a 5 ns exposure time is possible. Ballistic range cameras with 1134 × 486 pixel arrays, a minimum exposure time of 0.2 μs and multi-exposure capability give not only excellent dynamic projectile pictures but also are well suited for the study of detonation events and phenomena (Held, 1994). Newer developments include the possibility of getting four to eight frames of 576 × 385 pixels in colour, as for example given by the Hadland Imacon 468 camera.

15.4 Framing cameras

In normal cinematography, the separate frames are given by a moving film that is intermittently stopped for exposure. In such intermittent film transport

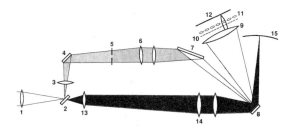

Figure 15.2 Optical paths in a rotating mirror camera (Cordin model 200) for the streak record (lower path) and for framed image (upper path). 1, Camera objective; 2, slit and mirror; 3, field lens; 4, mirror; 5, first aperture; 6, framing lens; 7, mirror; 8, rotating mirror; 9, projection lens; 10, second aperture; 11, framing lenses; 12, film plane for frames; 13, field lens; 14, streak lens; 15, film plane for streaks.

cameras for 16 mm film, a framing rate of 500 pps up to a maximum of 600 pps can be achieved. Such rates are by no means sufficient to resolve detonic events.

In a so-called *compensation camera*, a rotating prism allows a sequence of pictures to be recorded onto the continuously moving film. This film moves with a constant velocity of up to 80 m s^{-1}. This camera type is often called a *rotating prism camera*. A typical example being the Hycam, which, with an eight-sided compensation prism can give 10 000 full-format frames per second or 40 000 quarter-format frames per second. However, even this is not sufficient to record detonation phenomena, except when observing explosively formed projectiles with a velocity of about 2.5 km s^{-1}, or the jet particles of shaped charges at 8 km s^{-1} more or less in the direction of their trajectory, i.e. with little transverse velocity, as is done by the method known as the *objective technique* (Held and Nikowitsch, 1974). This technique is mentioned here because it is a typical example of how simple equipment such as a relatively inexpensive compensation camera can be used to obtain significant information on detonation

and warhead phenomena, such as the rate of rotation of rod fragments, the formation and stability of explosively formed projectiles, or the dispersion and erosion of fast shaped charge jet particles.

Rotating mirror cameras can expose millions of frames per second. A typical example of this type of camera is the Cordin Model 200 which, apart from streak recording, permits framing records with up to 2 × 10^6 fps (Figure 15.2). The particular advantage of this feature is that, apart from the streak record, which is continuous in time, there is also a spatial picture of the same event in the framing record. The latter also shows whether the desired event has been recorded on the streak record (Sultanoff, 1962). With the Cordin model 200 camera, the event to be recorded must be controlled by the camera with an accuracy of microseconds in order that the relatively small recording 'window' can be hit. Events that are less specific in time can be recorded using an alternative camera such as the Cordin Model 330 which has continuous writing for simultaneous streak and framing records. Pictures taken with a rotating mirror camera are of such high quality that the formation of natural or of controlled fragments produced by the detonation of a high explosive charge inside a cylinder can be traced and observed.

As stated previously, single frames and streak records can be obtained with certain types of image converter cameras by means of a suitable deflection system. This is not to suggest that the image converter camera and the rotating mirror camera are competing instruments in the diagnostics of detonation phenomena; an analysis of the advantages and disadvantages of these cameras will show that the instruments complement rather than compete with each other (Table 15.1) (Held, 1979). The specific advantages of rotating mirror cameras are the number of frames, recording time and, in particular, the resolution and the possibility of simultaneously taking streak and framing records. The image converter camera, on the other hand, has a higher framing and recording rate and, in particular, a greater effective aperture. It is easier to operate and

Table 15.1 Comparison of the characteristics of rotating mirror and image converter cameras

	Rotating mirror	Image converter
Number of frames	+	−
Framing rate	−	+
Recording (writing) time	+	−
Writing velocity	−	+
Aperture	−	++
Resolution	+	−
Colour	+	−
Triggerable	−	+
Handling	−	+
Simultaneity of streak and frames	+	−

(a)

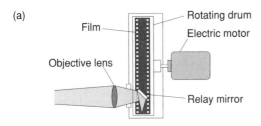

(b)

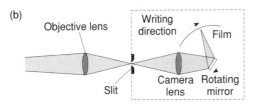

(c)

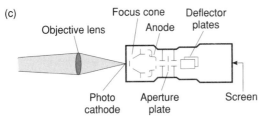

Figure 15.3 Configurations of typical streak cameras. (a) Rotating drum type up to 0.3 mm μs^{-1}. (b) Rotating mirror type up to 200 mm μs^{-1}. (c) Image converter type with image deflection tube providing up to 1000 mm μs^{-1} writing velocities.

can be triggered by the event itself. The two types of camera complement one another for problems in the diagnostics of ballistic detonics.

15.5 Streak cameras

The original type of camera used for streak recording was certainly the drum camera. In its simplest design, the film is attached to the outside of the drum, which allows for film velocities up to 0.1 mm

μs^{-1} (this limit being set by the ultimate strength of the film base and the centrifugal force applied). Higher velocities can be achieved when the film is placed inside a high strength drum, but this requires that the event be imaged, via a mirror arrangement, to the film inside (Figure 15.3). At 0.2 mm μs^{-1}, friction and eddies of air heat the outer casing and, in particular, the film to such an extent as to establish another practical limit. With the interior of the camera evacuated it is possible to drive the speed up to the ultimate strength of the drum material. High grade materials can endure high peripheral velocities, and hence film velocities of 0.3 mm μs^{-1} are possible. However, this is the limit for drum cameras.

Streak velocities of 10 mm μs^{-1} and more can be achieved with rotating mirror cameras, where the light from the entrance slit is imaged to the film plane via a rotating mirror (Figure 15.3(b)). Rotating mirror streak cameras can achieve streak velocities of 20 mm μs^{-1}, which means an increase by a factor of 100 over drum camera types. With this, a time resolution of 3 ns and a recording time of 15 μs are possible.

The writing speed can be increased considerably by using an electronic image converter camera. With this type of camera it is possible to attain ranges of recording speeds that are no longer of interest to detonics, because the recording times involved are too short. For example, the Hadland Imacon 790 image converter camera has a recording time of 0.075 μs and a time resolution of 0.15 ns at a recording velocity of 1000 mm μs^{-1}. This is by no means an upper limit for this type of electronic camera. However, such values are rarely needed in warhead or detonation diagnostics.

Table 15.2 lists the maximum streak velocities (v_s), the recording times (t_s), the time resolutions t_R at maximum streak velocities, and the *quality ratio* (Q) of the three types of streak camera described above. The ratio Q, which is the ratio t_s/t_R, is one measure of the *quality* of the particular type of camera. It should be noted, however, that the time resolution cannot exceed the limit inherent in the particular type of camera. Of course, each camera type can also be operated at a slower recording rate and hence with a longer recording time. However,

Table 15.2 Characteristics of different types of streak camera

	Camera type		
	Drum	*Rotating mirror*	*Image converter*
Maximum streak velocity, v_s (mm μs^{-1})	0.3	20	1000
Streak time, t_s (μs)	2900	15	0.075
Time resolution (t_R) at maximum streak rate (ns)	200	3	0.15
$Q = (t_s/t_R) \times 10^3$	14.5	5	0.5

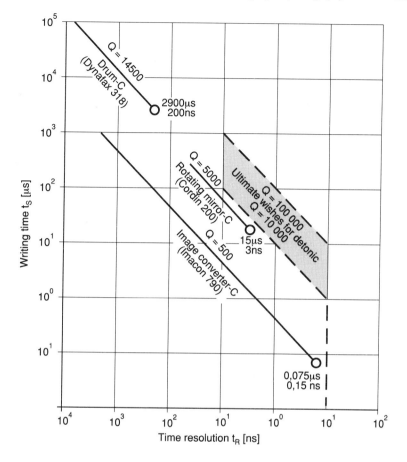

Figure 15.4 The quality index (Q) for the different types of streak camera. $Q = t_s/t_R$, where t_s is the writing (recording) time and t_R is the time resolution.

the time resolution will then be lower, if the quality ratio of that particular camera remains constant.

This is shown graphically in Figure 15.4. The typical writing time (t_s) of the three fundamental types of streak camera are shown as a function of the associated resolution (t_R). It can be seen that the Imacon electronic image converter camera has the highest resolution of 0.15 ns, but then only with a recording time of 0.075 μs. However, this camera can also record very slowly, up to several hundred microseconds.

The Cordin Model 132, which is a typical rotating mirror camera, has a maximum resolution of only 3 ns, but with a writing time of 15 μs. The image converter, on the other hand, has a recording time of only about 1 μs at the same resolution. Rotating mirror cameras are usually not very effective at low mirror rotational speeds. Their writing velocity spans only one order of magnitude, so their maximum writing time is around 150 μs. Apart from very

special cases, this recording time is sufficient for detonation events.

The drum camera has a maximum time resolution of only 200 ns, but the recording time available at this speed is as long as 2900 μs. Also, the drum camera can be operated slower over two orders of magnitude, but then, of course, the resolution will be poorer.

The resolution required in shock wave and detonation physics is in the range 10–1 ns at recording times of 10–100 μs, yielding Q ratios of 10^4–10^5. The image converter camera meets the requirements with respect to resolution, but not with respect to the recording time. The best compromise is reached with the rotating mirror camera. The drum camera does not have the time resolution needed in shock and detonation physics, and therefore the long recording time cannot be utilized.

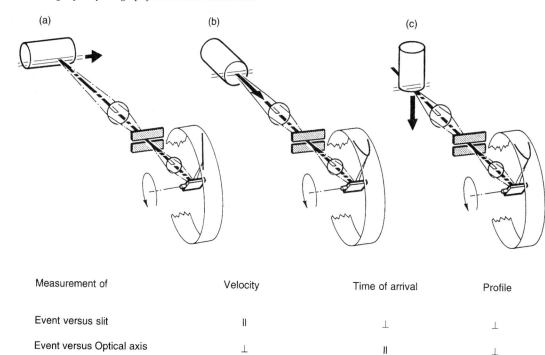

Measurement of	Velocity	Time of arrival	Profile
Event versus slit	‖	⊥	⊥
Event versus Optical axis	⊥	‖	⊥

Figure 15.5 Comparison of three streak techniques for the measurement of (a) velocity, (b) arrival time and (c) profile.

15.6 Streak techniques

Three different methods based on streak recording (Held, 1974) can be defined as a function of the direction of the velocity vector of the event under observation versus the streak slit position and the optical axis of the camera (Figure 15.5). The three methods are:

- Velocity measurement (velocity vector of the event parallel to the streak slit and perpendicular to the optical axis of the camera).
- Arrival time measurement (velocity vector perpendicular to the streak slit, but now anti-parallel to the optical axis).
- Profile measurement (velocity vector perpendicular to the streak slit as well as to the optical axis).

Each of these methods exhibits its own advantages and possibilities for application in detonics and ballistics. Combinations of two methods are also often used. The different methods developed and the techniques used are described in detail in the available literature; a summary is given by Held (1974, 1993).

15.7 Simultaneous streak and framing records

A streak record is continuous in time and with an extremely short time of exposure, thus entailing very little motion blur. Hence, time resolution is very good for each individual camera system. Also the spatial resolution is very good along the plane or planes of observation. Frames, on the other hand, picture the process in space. This is useful for observing the process outside the streak plane and, in particular, for an understanding of the event or process (Figure 15.6).

The streak and framing mode recording, simultaneous and by the same camera, e.g. the Cordin Model 200 or Model 330, unites the advantages of the two methods and at the same time also indicates whether the streak record had actually been taken in the expected or predetermined planes of observation. In this manner, faulty analysis and wrong interpretation, which were frequent problems in the early days of streak recording, can be eliminated completely (Held, 1990).

One example which can be given is in the testing of the initiation of acceptor charges by means of shaped charge jets with different velocities and the determination of the associated delay times and build-up distances (Figure 15.7). The streak records

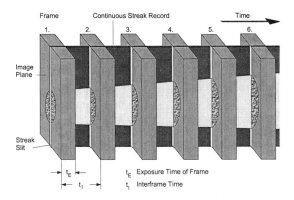

Figure 15.6 Comparison of a continuous streak record with very high temporal and spatial resolution in the observation direction with a series of frame images with two-dimensional pictures of the event.

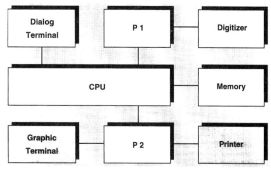

Figure 15.8 Computer system for the interpretation of information from streak camera records.

can also only be understood and analysed with the help of the framing pictures of these events (Held, 1989).

15.8 Computer analysis of streak records

Streak techniques are not commonly used and are generally not easy to understand. Every time, the user has to acquire the 'feel' for these distance versus time recordings anew. Moreover, analysing the numerous data contained in one streak record requires some effort, at least when this is done manually. Computer analysis techniques are a considerable help in this, especially when serial measurements, frequently recurring recordings, and more complex recordings are to be analysed.

The streak records are first digitized by means of a scanner and a given program (P1), which through a dialogue terminal interfaces with the central processing unit (CPU), and the data are stored in a memory (Figure 15.8). These data are, in general, only the information on the space and time coordinates. Another program (P2) is then used to convert the data to the desired quantities at the proper scale and writing speed, and either to print

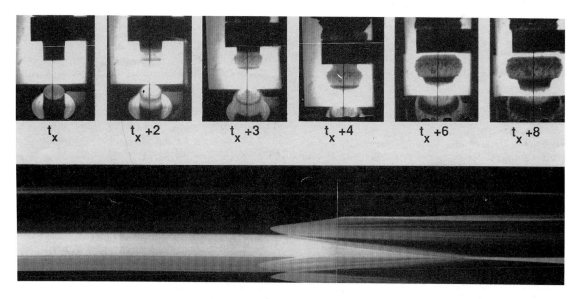

Figure 15.7 Successive frames and corresponding streak record of the jet initiation of a 40 mm long acceptor charge. The analysis of the streak record (bottom) shows the axial breakthrough of the detonation front, build-up distance in the radial breakthrough of the detonation wave, and axial expansion velocity. The record can be interpreted only with the framing pictures (Held, 1989).

them at the line printer or to present them at a graphic terminal and to make a hard copy, or to draw them as curves on a plotter. The rather voluminous amount of data from a streak picture can in this way be stored conveniently and quickly, and the desired quantities can readily be obtained in the form of diagrams. Thus, computers and their peripherals can very much facilitate the analysis and understanding of streak records.

15.9 Recommendations

In this overview it is possible to highlight only the essential instrumentations in the field of high speed photography for detonics. It is not possible to include the historical developments, which would lead to a better understanding of what has been achieved to date, or to give a detailed account of all possibilities with regard to measurement equipment, and the numerous varieties of different diagnostic techniques. Certainly the Proceedings of all the Congresses on High Speed Photography and Photonics and of the Symposia (International) on Detonation are the main sources for a literature search.

In summary, refined and new insights into warhead and detonic phenomena are very often correlated with advances in diagnostic techniques in the field of high speed photography. However, such progress is achieved, for the most part, not through new measurement equipment but rather by unique test arrangements that utilize the existing equipment to the fullest. This insight and advice is addressed especially to those who cannot afford the optimal equipment for every problem, but who must for many years meet a great number of different requirements with only one or two high speed photographic instruments.

15.10　Flash radiography in ballistics

15.10.1　Introduction

The first quantitative measurements of particles moving at high speeds were made by Carl Cranz by means of electric sparks in air. The electric spark was bright and short enough to produce shadowgraphs of the motion of projectiles and fragments. Even today, the spark approach is the basis of many short-exposure photographic techniques, but with significant improvements in brightness and shortened exposures.

A special type of spark is the vacuum spark, i.e. a discharge in a vacuum in which the electrons are set free by field emission from sharp edges or needles. A strong electric field accelerates the electrons from the cathode towards the anode where they impact at a high velocity. X-rays are emitted when these electrons are slowed down in the anode. Owing to the short duration of vacuum breakdown, the duration of X-ray emission is also very short. In this sense it is possible to speak of a *flash X-ray* (FXR).

Flash radiography is an important technique in all fields of ballistic experimentation, with the main emphasis undoubtedly on terminal ballistics. The following discussion does not deal with the fundamentals of flash radiography; for such details the reader is referred to Jamet and Thomer (1976) and Charbonnier (1983), both of which contain extensive lists of references. Further layout practice for test set-ups and examples in the field of ballistics with one or more FXR units are given by Held (1993a). The Proceedings of Flash Radiography Symposia are also a source of detailed examples of FXR technologies (Webster and Kennedy, 1984, 1986, 1989).

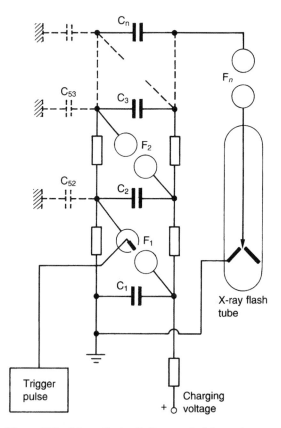

Figure 15.9　Schematic circuit diagram of a Marx pulse generator, in which the capacitors (C_1–C_n) are charged in parallel and are then discharged in series across the X-ray flash tube, via the spark gaps (F_1–F_n).

Table 15.3 Characteristics of flash X-ray systems (data from Physics International)

Nominal peak voltage (kV)	150	300	450	1000	2300
Nominal pulse duration (ns)	70	30	25	25	40
Dose per pulse at 1 m (mR)	1.6	8	20	55	40
Penetration in steel at 2m (cm)	n/a	1	2.3	5	8
Remote tube-head	Yes	Yes	Yes	Yes	n/a
Dual tube-head	n/a	Yes	Yes	Yes	n/a
Soft X-rays available	Yes	Yes	Yes	n/a	n/a
Electron beam	n/a	Yes	Yes	Yes	Yes

Table 15.4 Characteristics of flash X-ray systems (data from Scandiflash)

	System model					
	150	*300*	*450*	*450S*	*600*	*1200*
Output voltage (kV)	75–150	100–300	150–450	160–480	250–600	500–1200
Output peak current (kA)	2	10	10	10	10	10
Pulse width (ns)	35	20	20	25	20	20
Dose per pulse at 1 m (mR)	1.6	9	20	24	30	65
Penetration of steel at 2.5 m[a] (mm)	3	18	30	34	37	60
Source size[b] (mm)	1	1	1	2.5	2.5	2.5
Dual tube option	No	Yes	Yes	Yes	Yes[c]	No

[a] Using Du Pont NDT 9 intensifying screen and Kodak XAR 5 film. Film gross density 0.7. Systems 150, 300, 450 and 450S with 5 m pulser to tube co-axial cable; systems 600 and 1200 with tube in pulser.

[b] The source size can be varied by using different anodes. The values given are typical.

[c] Dual tubes can be used up to 450 kV.

15.10.2 Flash X-ray equipment

Events in ballistics are, in general, of short duration. Projectiles have velocities ranging from several hundreds of metres per second for bullets from pistols or rifles, up to 10 km s^{-1} for detonations or shaped charge jets. To minimize motion blur, a very short duration FXR has to be used. The generally used technique, to get very high, but short voltages, is a discharge of capacitors in a Marx pulse generator (Figure 15.9). This produces an extremely short high-current discharge with a duration of 20 ns and output voltages from a few hundred kilovolts up to several megavolts, with charging voltages in the range of only 30 kV. Today, such FXR units consist of modular components that are usually encapsulated in plastic so they are much more compact and space saving. The spark gaps are pressurized and enclosed.

Remote tube-heads, connected to the pulser by high voltage co-axial cables, are particularly useful in ballistic or explosive studies where the event is very violent; use of a remote tube-head makes it easier to protect the high voltage pulser from damage. It is also possible, with appropriate higher impedance tubes, to divide the output of the pulser into two remote tubes, allowing synchronized or orthogonal views for three-dimensional reconstruction of an event.

Commercial FXR systems are available over a range of voltages (from approximately 100 to 2000 kV). The two primary companies manufacturing such systems are Physic International in the USA and Scanditronix in Sweden. The published characteristics of systems from these companies are summarized in Tables 15.3 and 15.4.

Like the spark method used in early ballistic studies, the FXR method produces a shadowgraph of a ballistic event. The event is located between the FXR tube and the film plane and uses the radiation of the X-ray spectrum rather than the visible spectrum. Despite the use of intensifying screens and sensitive film materials, high radiation intensities are needed, owing to the short exposure times and the long distance between the X-ray tube and the film that is necessary for warhead testing. For medical applications, very sharp pictures are usually required, for example, in order to be able to recognize bone fractures. In ballistic work, such sharp pictures are not usually needed. For this reason, intensifying screens made either of calcium tungstate or, more recently, fluorescent materials using rare earth components, which are more efficient but give less resolution can be used. The film is placed between two of these intensifying screens. Specific cassettes have been developed that contain intensifier foils and ensure that the film surfaces are in close contact with the screens.

The film cassette is, in turn, put into a protective cassette to shield it from the blast wave of the exploding charge or from the fragments or other debris from detonating warheads. The protective cassette is, in general, very robust so it can withstand even the detonation of a high explosive charge weighing several kilograms at a distance of as little as 0.3–0.5 m. In general, the cover plate is a 10–20 mm thick aluminium alloy plate. Some space is left free between this cover plate and the film cassette, and is lined with plastic foam so that under the blast pressure loading the cover plate can bulge without damaging the film cassette (Held, 1993).

15.11 Applications in ballistics

Flash radiography has been adopted in the entire field of ballistics. By means of refined experimental techniques in *interior ballistics*, even an observation of the burning and of propellant charges in the barrel of a weapon is possible (Hornemann, 1978). The position of a tubular propellant charge in a booster motor was also recorded by flash X-radiography shortly before cut-off (Held, 1993a). The separation of a triple projectile, still inside the rifle barrel, can be observed only by means of FXR recording.

As a supplement to other measurement techniques, extremely soft X-rays have been used to image the gas flow in the field of *intermediate* or *muzzle ballistics*. The processes occurring at the muzzle of the weapon during the separation and discard of the sabot from the core in subcalibre munitions cannot be observed by optical means. The escaping propellant gases, which in part react with the oxygen of the air, are not optically transparent. These processes in the immediate vicinity of the muzzle can be recorded only by means of flash radiography (Schmidt, 1978)

Flash X-radiography is sometimes also quite important in special cases in the field of *exterior ballistics*. Projectile velocities, fragment velocities, questions of stability and ablation problems can be treated in most cases just as well by means of other recording techniques, even though flash X-radiography has the advantage that a dark firing location is not needed because the film is always packed in a light-proof cassette. From an experimental point of view, FXR units have certain advantages in this respect, but usually they are not frequently used because of the large quantities of film materials needed and the associated processing costs.

Safety and arming functions of flying projectiles are also sometimes observed by means of flash X-radiography because the arming process on firing can be observed unambiguously only by radiation through the fuze casing. The response sensitivity and delay times of impact fuses can also be very well measured (Held, 1984).

The principal domain of FXR radiography is undoubtedly in the field of *terminal ballistics*. It is suitable for penetrating through a high explosive charge as well as through the reaction products of detonation of a high explosive, enabling all processes occurring inside to be observed, such as detonation waves, shock waves, compressions, material velocity, fragmentation, fragment acceleration, shaped charge jetting, or projectile formation of explosively formed projectile (EFP) charges. These processes are hardly accessible by any other measurement technique.

The compression of materials by shock waves, known as *Hugoniot data*, can be measured quantitatively. Apart from measuring the shock or detonation fronts, the flow of the reaction products can be determined by embedding contrast foils (Held, 1993a).

Particularly convenient is the measurement of the acceleration and velocity of fragments projected by a detonating high explosive charge; here it can immediately be determined from flash X-radiographs the fragmentation, fragment velocities, angles of fragment projection, fragment rotation and, to some extent, the shape and mass of fragments (Held, 1988).

Flash radiography is essential in developing the range of shaped charges, such as hollow charges, flat cone charges, and EFP charges. The motion of the liner during the early stages can be very satisfactorily imaged using the FXR technique (Figure 15.10). A particular application of flash radiography is the observation of penetration and perforation phenomena of pro-

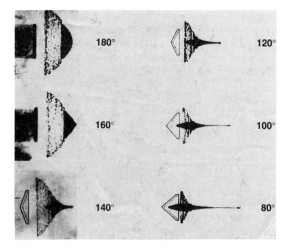

Figure 15.10 Acceleration and deformation of metal can be recorded particularly well by means of X-ray flash radiography. This picture shows the formation of the jet and slug of copper liners at angles ranging from 180° to 80°.

jectiles, fragments and the jets from shaped charges. Target deformation during penetration and cratering can also be determined using FXR techniques.

Once an FXR unit has been installed it can be used for many purposes and problems far beyond that for which it was originally intended. A large number of further applications in ballistic and other fields can be found in the referenced literature.

References

Charbonnier, F. (1983) Flash radiography. In *The Nondestructive Testing Handbook on Radiography and Radiation Testing*, Section 11. American Society for Nonstructive Testing, Columbus, OH

Dafelmair, X., Klee, C., Nowicki, G. *et al.* (1983) Investigation of detonation wave perturbations and their influence on shaped charge performance. In *Proc. 7th Int. Symposium on Ballistics*, pp. 535–540. American Defense Preparedness Association, Washington, DC

Held, M. (1968) Selectives, Stroboskop. In *Proc. 8th Int. Congress on High Speed Photography*, pp. 232–236. Almquvist and Wiksell, Stockholm

Held, M. (1974) Streak technique as a diagnosis method in detonics. In *Proc. 1st Int. Symposium on Ballistics*, pp. 177–210. American Defense Preparedness Association, Washington, DC

Held, M. (1979) Techniques in detonation diagnostics. In *Proc. 2nd Int. AVL Symposium*, pp. 1–14, AVL

Held, M. (1984) Procedure for measuring the response time of mechanical impact fuzes for projectiles. *Propellants, Explosives, Pyrotechnics* **9**, 139–146

Held, M. (1985) X-ray flash radiography in ballistics. *Mater. Evaluation* **43**, 1104–1110, 1123

Held. M. (1986) Streak techniques in detonics. In *Proc. 17th Int. Congress on High Speed Photography and Photonics*, pp. 421–443. Society of Photo-Optical Instrumentation Engineers, Bellingham, NY

Held, M. (1988) Fragment generator. *Propellants, Explosives, Pyrotechnics* **13**, 135–143

Held, M. (1989) Analysis of shaped charge jet induced reaction of high explosives. *Propellants, Explosives, Pyrotechnics* **14**, 245–249

Held, M. (1990) The advantage of simultaneous streak and framing records in the field of detonics. In *Proc. 19th Int. Congress on High Speed Photography and Photonics*, pp. 904–913. Society of Photo-Optical Instrumentation Engineers, Bellingham, NY

Held, M. (1993a) Flash radiography. In *Tactical Missile Warheads* (J. Carleone, ed.), vol. 155, pp. 555–608. American Institute of Aeronautics and Astronautics, Washington, DC

Held, M. (1993b) High speed photography. In *Tactical Missile Warheads* (J. Carleone, ed.), vol. 155. American Institute of Aeronautics and Astronautics, Washington, DC

Held, M. (1994) Detonation phenomena observed with a CCD camera. In *Proc. 21st Int. Congress on High Speed Photography and Photonics*, pp. 1028–1039. Society of Photo-Optical Instrumentation Engineers, Bellingham, NY

Held, M. and Nikowitsch, P. (1974) Objectivtechnik. In *Proc. 11th Int. Congress on High Speed Photography*, pp. 65–71. Chapman & Hall, London

Hornemann, U. (1978) Investigation of propellant combustion in X-ray transparent gun tubes. In *Proc. 4th Int. Symposium on Ballistics*. American Defense Preparedness Association, Monterey, CA

Jamet, F. and Thomer, G. (1976) *Flash Radiography*. Elsevier, New York

Johannson, C. H. and Persson, P. A. (1970) *Detonics of High Explosives*. Academic Publishing, London

Schmidt, E. M. (1978) *AIAA J. Spacecraft Rockets* **3**, 162–167

Sultannoff, M. (1962) Some philosophical aspects of high speed photographic instrumentation. In *Proc. 5th Int. Congress on High Speed Photography*, pp. 411–416. Society of Motion Picture and Television Engineers, New York

Webster, E. A. and Kennedy, A. M. (eds) (1984) *Proc. 1984 Flash Radiography Symposium*. American Society of Nondestructive Testing, Columbus, OH

Webster, E. A. and Kennedy, A. M. (eds) (1986) *Proc. 1984 Flash Radiography Topical*. American Society of Nondestructive Testing, Columbus, OH

Webster, E. A. and Kennedy, A. M. (eds) (1989) *Proc. 1989 Flash Radiography Topical*. American Defense Preparedness Association, Arlington, VA

Bibliography

Proceedings of International Congresses on High Speed Photography and Photonics

1. Washington, USA, 1952: SMPTE, New York (1954)
2. Paris, France, 1954: Dunod, Paris (1956)
3. London, England, 1956: Butterworth, London (1957)
4. Köln, Germany, 1958: Verlag Helwich, Darmstadt (1960)
5. Washington, DC, USA, 1960: SMPTE, New York (1962)
6. The Hague, Netherlands, 1962: Tjeenk Willink & Zoon, Haarlem (1963)
7. Zurich, Switzerland, 1964: Verlag Helwich, Darmstadt (1967)
8. Stockholm, Sweden, 1966: Almquvist & Wiksell, Stockholm (1968)
9. Denver, CO, USA, 1970: SMPTE, New York (1971)
10. Nice, France, 1972: ANRT, Paris (1973)
11. London, England, 1974: Chapman & Hall, London (1975)
12. Toronto, Canada, 1976: SPIE, Washington (1977)
13. Tokyo, Japan, 1978: JSPE, Tokyo (1979)
14. Moscow, USSR, 1980

15. San Diego, USA, 1982: SPIE (vol. 348), Bellingham (1983)

16. Strasburg, France, 1984: SPIE (vol. 491), Bellingham (1984)

17. Pretoria, South Africa, 1986: SPIE (vol. 674), Bellingham (1986)

18. Xiang, China, 1988: SPIE (vol. 1032), Bellingham (1988)

19. Cambridge, England, 1990: SPIE (vol. 1358), Bellingham (1990)

20. Victoria, Canada, 1992: SPIE (vol. 1801), Bellingham (1992)

21. Taejon, Korea, 1994: SPIE (vol. 2513), Bellingham (1994)

Proceedings of International Symposia on Detonation (Nos 1–10), Available from Naval Surface Warfare Center, White Oak, Silver Springs, MA, USA

Technical literature

Cordin Corporation, 2230 South 3270 West, Salt Lake City, UT 84119, USA

Hadland Photonics Limited, Newhouse Laboratories, Newhouse Road, Bovingdon, Hertfordshire HP3 0EL, UK

Physics International Company, Olin Corporation Aerospace Division, 2700 Merced Street, P.O. Box 5010, San Leandro, CA 94577–0599, USA

Scandiflash AB, Box 706, Seminaregatin 33F, S-75 130 Uppsala, Sweden

16 Shock waves from explosions

John M. Dewey

16.1 Introduction

16.1.1 Explosions

An explosion is caused by the sudden release of energy from a source such as a spark, the rupture of a pressurized vessel, or a chemical or nuclear detonation. The rapid expansion of the exploding materials produces a *blast wave*, which has a supersonic *shock front* at its leading edge. As the shock front expands through the ambient atmosphere it causes a virtually instantaneous change of all the physical properties of the air through which it is passing. The increases in pressure, density and particle velocity are the features of blast waves that cause injury and structural damage. The increase in density also causes an increase in the refractive index of the air, and this in turn allows the shock front to be visualized and recorded photographically.

High speed photographic techniques are invaluable tools for the study of blast waves from explosive sources ranging in size from the microscale, such as a spark, a laser discharge or the detonation of a sub-gram chemical charge, to those at very large scale such as a nuclear explosion, which may have an energy release equivalent to millions of tonnes of trinitrotoluene (TNT). Small scale explosions can be created in a laboratory, where visualization methods such as shadowgraph, schlieren and interferometry (see Chapter 17) can be used to record the position of shock fronts and other strong gradients in the air density. However, blast waves from free field explosions are three-dimensional, and this complicates the interpretation of photographic measurements, even if spherical symmetry could be assumed.

16.1.2 Refractive image methods

Refractive-image photography of a spherical blast wave is based on the same principle as shadow photography in the laboratory, i.e. light from the background behind the explosion is refracted by the large density gradient at the shock front, and distorts the image of the background. This image can then be used to determine accurately the position of the shock front. If a series of such photographs is obtained, then the velocity of the front can be calculated. Refractive-image photography therefore requires a suitable background against which an explosion can be photographed.

16.2 Small scale explosions

16.2.1 Laboratory methods

Explosions of small charges, up to a few grams, can be studied in the laboratory using shadowgraph and schlieren techniques. A suitable facility for recording such events which has been used at the Ernst-Mach-Institut in Freiburg, Germany (Reichenbach and Kuhl, 1989), is shown in Figure 16.1. It consists essentially of a strong metal box with high quality windows mounted in opposite walls. Figure 16.2 shows a schematic diagram of the schlieren system used in conjunction with this facility. The point source was a spark generated in a small circular aperture. The output from a pulsed Q-switched ruby laser could also be used for this purpose, with the beam passing through a diverging lens to form a virtual point source at its principal focus. The point source is placed at the principal focus of a parabolic mirror to produce a beam of parallel light covering

Figure 16.1 Schematic drawing of an explosion chamber with schlieren windows, used to study blast waves from 0.5 g nitropenta charges. The dimensions are in millimetres. (Courtesy Ernst-Mach-Institut, Freiburg/Br., Germany.)

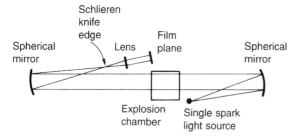

Figure 16.2 Diagram of the schlieren system used to study blast waves produced in the explosion chamber at the Ernst-Mach-Institut, Freiburg/Br., Germany.

the field of view defined by the windows of the explosion chamber. After passing through the windows the light is refocused by a second mirror and then imaged onto film. Images produced by this system are shown in Figure 16.3.

16.2.2 Camera systems

A Cranz–Schardin camera can be used to record a time-resolved sequence of shadow or schlieren photographs such as those shown in Figure 16.3 (North, 1960; deLeeuw *et al.*, 1962; Conway, 1972). This technique uses an array of up to 24 parallel optical systems, each with its own light source, with all the images being recorded on the same sheet of 18 × 24 cm film. With modern electronics a sequence of spark sources can be triggered at very

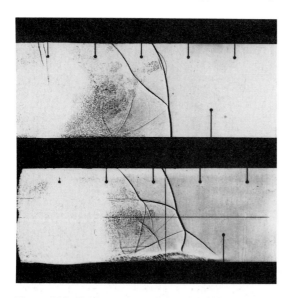

Figure 16.3 Schlieren photographs of the Mach reflections produced by a 0.5 g nitropenta charge detonated above a Makrolon ceramic surface. The fiducial markers at the top of the pictures are 10 mm apart. The upper photograph illustrates the blast wave in a uniform atmosphere.

high frequencies to give a correspondingly high framing rate. Alternatively, a pulsed laser can be used as the light source with a typical pulse frequency of 50–100 kHz and a pulse width of 10–50 ns. In this case a single optical system is used, and a streak or rotating prism camera is required to separate the images. A diagram of such a camera is shown in Figure 16.4. In order to determine the velocity of a shock front, three or four images can be superimposed on a single piece of film.

16.2.3 Photographic materials

The film used for the photograph in Figure 16.3 was Ilford ORTHO, developed for 10 min in a 1 in 25 solution of Agfa Rodinal at 20°C. Kodak Plus X Pan film with D19 developer can be used to record single shadow and schlieren photographs, and SO-173 holographic film has been satisfactory for recording images produced with a laser source. Polaroid Positive/Negative 665 black and white film is also useful when taking a single picture because of the ability to view the results immediately. This is particularly useful when making adjustments to the optical system.

16.3 Large scale explosions

16.3.1 Visualization

High speed photography of the refractive image of the shock front has been used extensively as a blast wave diagnostic tool for the study of large scale explosions, including the nuclear tests carried out by the USA and the UK. A suitable background against which the image of the shock front could be visualized was made by using an array of smoke trails formed by rockets fired a few seconds before the detonation of the nuclear device. Because of the intensity of light produced by a nuclear explosion, the exposure characteristics of the cameras were such that the natural sky background was not photographed, but the smoke trails were illuminated by the light from the fireball to form a background against which the refractive image of the shock front could be visualized. The very large scale of such events made it possible to use a relatively slow framing rate of about 200 pps to record the motion of the shock front accurately.

Since the implementation of the nuclear test ban, large scale chemical explosions of TNT and ammonium nitrate fuel oil (ANFO) have been used to simulate the characteristics of a nuclear explosion, producing a blast wave without the associated thermal and radiation effects. For the photography of blast waves from explosions of chemical charges weighing up to several hundreds of tonnes, the array of smoke trails used on nuclear tests has been

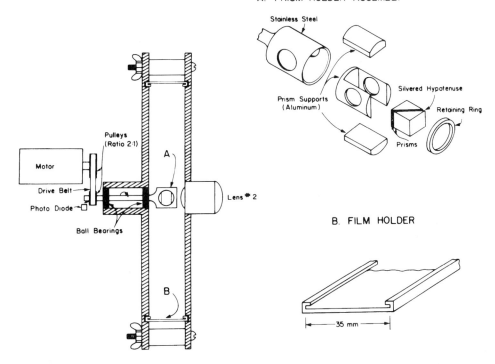

Figure 16.4 Diagram of a rotating prism camera which can be used with 35 mm film to record either streak images or, with a pulsed laser source, individual frames at frequencies up to 50 kHz.

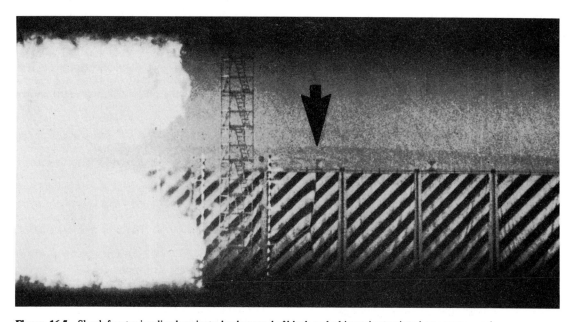

Figure 16.5 Shock fronts visualized against a background of black and white stripes painted on canvas panels approximately 15 m in height. This photograph shows the simultaneous detonation of two identical 500 kg charges, one at a height of 8 m and the other at a height of 24 m. The purpose of this experiment was to study the ideal reflection produced by the interaction of the blast waves from the two charges.

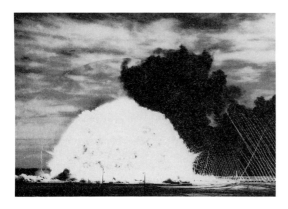

Figure 16.6 450 tonne TNT explosion. The refractive image of the hemispherical shock can be seen against the cloudy sky background. A series of white smoke trails, which acted as flow tracers in the blast wave, are visualized against a black smoke background produced by burning crude oil in a shallow trench. (Courtesy of the Defence Research Establishment, Suffield, Canada.)

replaced by panels of black and white stripes painted on large canvas screens that can be hoisted to heights of about 15 m (Figure 16.5). To best visualize the shock front, the stripes should be at an angle of about 45° to the direction of the front. For charges larger than about 500 tonne the refractive image of the shock front can normally be seen against the natural sky background, particularly if there are some scattered clouds or the outline of hills, and no specially prepared background is required (Figure 16.6).

For visualizing complex shock structures, such as those that occur when an intense blast wave from an air-burst explosion is reflected from the ground, Wisotski (1979) successfully used a background of Scotchlite screens illuminated by a pulsed ruby

laser. The sequence of shadow images was photographed with a high-speed framing camera. The pulses from the laser were of such short duration and high frequency that no special synchronization between the laser and the camera was necessary. One of the frames recorded using this technique is shown in Figure 16.7, and illustrates double Mach reflection produced by an air burst explosion.

16.3.2 Cameras and timing

To record the shock fronts from charges ranging from 500 kg to 4 ktonne, framing rates from 3000 to 300 pps, respectively, have been used. For these framing rates, and with film speeds of up to 1000 ISO, sunlight provides sufficient illumination of the background. Cameras and films similar to those for shock front photography can also be used to photograph the fireball produced by a nuclear or chemical explosion, the outer boundary of the detonation products or the fragments from a ruptured pressure vessel. However, the initial movement of these features may be extremely fast so that higher framing rates will be required. The initial flash from a nuclear explosion, and even from a chemical explosion, is extremely bright, and very short exposures are required in order to resolve such features. The initial shock front formed by such explosions may be of such high temperature that it will be self-luminous, and opaque to the products of the charge itself.

If measurements are to be made from the film of an explosion it is necessary to know the time of exposure of each frame relative to the initiation of the charge. Most high speed cameras have a mechanism for placing *timing marks* on the edges of the film, outside the field of view. In this way a 'zero' timing mark can be placed on one edge of the film at the time of detonation, and timing marks at a known frequency on the other edge. The light sources for

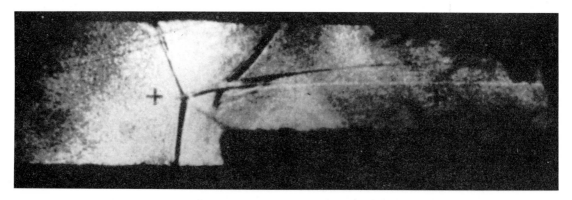

Figure 16.7 Pulsed laser shadowgraph of the complex Mach reflection produced above the ground by the blast wave from a 450 kg Pentolite charge. The shocks are visualized against a Scotchlite background and recorded at a framing rate of approximately 30 kHz. The fiducial marks on the background are about 0.6 m above the ground. (Courtesy J. Wisotsky, Denver Research Institute, Denver, CO, USA.)

these timing marks will not be at the film gate, and for each camera it is necessary to measure the distance along the film from the timing light to the film gate so that the exact time for each frame can be calculated. It should not be assumed that a high speed camera will run at a constant framing rate and it will be necessary to plot a timing calibration curve of frame number versus time. An alternative to the above system is to use the timing light in the camera to place a binary coded series of marks along the edge of the film, related to a universal timing signal. This permits the time of each frame to be related to other events, the times of which are related to the same universal signal. Because the timing marks are usually placed along the edges of the films, outside the field of view, care must be taken to ensure that the timing marks are also copied when the film is duplicated.

16.4 Small scale underwater blasts

Schlieren photography has been used to study small scale underwater blasts (Glass and Heuckroth, 1963). In this work underwater explosions were produced by bursting 50 mm diameter glass spheres containing air at a pressure of 3.654×10^6 Pa (530 psi). The progress of the resulting shock waves was visualized using a schlieren system and a high speed multi-source camera (deLeeuw *et al.*, 1962), similar in principle to the Cranz–Schardin camera described above. The oscillations of the gas bubble were visualized using the same equipment. A similar technique can be used to record the underwater explosion of small chemical charges.

16.5 Interpretation of refractive images

Care must be taken with the interpretation of refractive images of spherical blast waves, which are optical effects rather than opaque objects, because there is no fixed plane of measurement parallel to the film plane. Figure 16.8 shows a plan view of the spherical shock front of a blast wave. The line of sight from the camera is tangential to the spherical surface so that the point being visualized traces a circular path, in the horizontal plane, the diametric end points of which are the charge centre and the camera. Therefore the radius of the shock is not linearly related to the apparent radius measured in the film plane. The required geometrical corrections are more complex in the case of single or double air burst explosions such as those discussed by Dewey (1964), and Dewey *et al.* (1977). Details of the geometrical transformations, and methods of analysis which have been applied to refractive image data are presented in Section 16.7.

The thickness of a shock front is 10–20 mean-free-path lengths of the air molecules, which corresponds

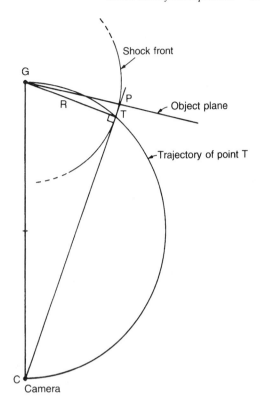

Figure 16.8 Plan view of a spherical shock front centred at G. The object plane through G is parallel to the film plane of the camera, and the refractive image of the shock will appear to be at point P in the object plane. The line of sight from the camera to P is tangential to the shock at T, which is also the intersection of CP and the circle with CG as diameter. GT is the actual radius of the shock.

to a distance of about 1 μm, i.e. only a few light wavelengths. It is therefore not possible to image the shock front accurately without considering diffraction and other wave effects. A Mach 2 shock in air is travelling at about 0.7 mm μs^{-1}, so that if the pulse length of the light source is of the order of one 1 μs, which is probably the case for a spark source, the movement of the shock during that time will determine the thickness of the shadowgraph image of the shock. If a pulsed laser is used with a pulse length of 10 ns, the shock will only move about 0.07 mm in that time. In this case the image of the shock will be a diffraction pattern, and the apparent thickness of the image will be that of the central fringe of the pattern. Analysis of this diffraction pattern can be used to determine accurately the position of the shock (Julian, 1970).

The shadowgraph and schlieren techniques described above permit accurate measurements of the positions of shock fronts, and of the shock velocity when a timed sequence of images is recorded. The

way in which the shock velocity may be used to determine the physical properties of the gas immediately behind the shock is discussed later. However, in the case of blast waves from centred explosions, the physical properties vary rapidly with distance behind the shock, but the density gradients in these regions are not large enough for shadow or schlieren photography to give useful information about the flow field. In the laboratory, interferometry may be used to map the density field, but such a technique is not possible for large scale blast waves. In this case the flow field can be mapped by using *particle tracer photography*.

16.6 Particle tracer methods

Particle tracer photogrammetry is a powerful method for determining the physical properties of blast waves. The decaying shock front at the leading edge of a blast wave leaves the air in a state of radially decreasing entropy. As a result there is no single valued functional relationship between the physical properties of a blast wave measured at a fixed point. For this reason, in order to describe all the properties of a blast wave it is necessary to measure independently at least three of the thermodynamic parameters. Alternatively, it has been shown (Dewey, 1964, 1971) that a knowledge of the time-resolved particle trajectories in a blast wave is sufficient information to provide all the physical properties without reference to other measurements. For this reason, *particle tracer photogrammetry* has been used extensively as a diagnostic tool on large scale high explosive tests carried out since the 1960s in the USA, Canada and Sweden.

Particle tracer photogrammetry of blast waves requires a mechanism for creating smoke trails or puffs immediately ahead of the incident shock in a plane containing the charge centre and approximately parallel to the film plane of the camera. If spherical symmetry about the charge centre can be assumed, smoke trails released from projectiles fired from mortars may be used (Dewey, 1964). For flows which are two-dimensional in the object plane of the camera, such as those which result from the ground reflection of the blast wave from an air burst explosion, a grid of smoke puffs is required (Dewey and McMillin, 1981). In order for the smoke tracers to be photographed there must be a suitable contrast between the smoke and the background. This may be achieved by using smoke of appropriate colour, e.g. red or black against the sky and white against dark hills. Alternatively, an artificial background of black smoke can be created by burning oil against which white smoke is well contrasted (see Figure 16.6). The current practice is to use alternating black and white trails so that some will always be visible against most backgrounds.

In order for the particle tracers to follow the rapidly accelerated flow in a shock wave they must be formed of submicrometre particles, which when released are suspended by Brownian motion. This criterion is met by an 8 : 1 mixture by volume of fumed silica and titanium dioxide for white smoke, and artist grade carbon black for black smoke. Trails of smoke formed with these materials can be made to reach a height of about 15 m by placing the powder in a plastic pipe, about 50 mm in diameter and 1000 mm long, with the lower end loosely sealed. The pipe can be projected from a launcher made from a slightly larger pipe closed at the lower end with a cast iron plumbing cap containing 3 cm^3 of gunpowder ignited by an electric squib. The launcher should be fired about 0.5 s before the arrival of the blast wave. Smaller versions of this type of smoke launcher have been used to form narrow trails to a height of about 5 m when studying small scale explosions and boundary layer effects. Laminar jets of smoke as narrow as a few millimetres and 300 mm long can be formed inside an explosion chamber for the study of very small explosions.

When used with large scale explosions the smoke trails are photographed with sunlight illumination and camera framing rates similar to or slightly less than those used to record the refractive image of the shock front. For the study of laboratory scale explosions front or back lighting can be used in order to obtain the correct exposure at the high framing rates which are required. The particle tracer trajectories and the refractive image of the shock front can usually be recorded simultaneously with the same camera system.

16.7 Analysis of photogrammetric results

High speed photography of shock and blast waves is often used qualitatively in order to understand the phenomenology of an explosive event. In addition, a large amount of quantitative information is available from an accurately timed photographic sequence. Most other blast wave measurement techniques are able to record only a single physical property, such as hydrostatic pressure, dynamic pressure or density, at a single position. The gauge itself may also be intrusive, affecting the flow that is being measured. Photogrammetry, on the other hand, is almost entirely non-intrusive, even when flow tracers are used, and measurements can be made throughout a large volume of the flow, rather than at a single point. It is shown below that simple measurements from a film of the positions of the shock front and smoke trails may be used to determine all the physical properties of most blast wave flows.

In order to make accurate measurements of the positions of shocks, density discontinuities and flow tracers, it is necessary to correct for optical distor-

tion throughout the field of view. Such corrections are particularly important with schlieren photographs, which are usually made using an off-axis system. The easiest way to make these corrections is to place an accurate grid of fiducial markers in the object plane (Dewey and McMillin, 1985). This grid may be photographed simultaneously with the flow field or immediately before or after the experiment, and before any optical components have been moved. The subsequent calibration must include the playback optics, such as the projector of a digitizer or an enlarger, because the lenses of these components may be the largest source of distortion. If the measurements are made from photographic prints, distortions may result due to the non-uniform drying of the print paper. High quality photogrammetry paper should be used to reduce this error.

Fiducial markers need not be placed precisely in the object plane as long as their positions are accurately surveyed relative to the camera. Experience has shown that, when photographing large scale explosions, it is best to have arrays of fiducial markers in three planes: one close to the object plane; one about midway between the object plane and the camera, and the third close to the camera. Due to surveying errors, it is not always possible to achieve a perfect match between the observed and predicted positions of the fiducial markers. In such a situation it may be necessary to reject some markers, or correct the surveyed position of the camera if that seems to be at fault. These corrections are discussed by Dewey *et al.* (1977). Fiducial markers that are incorporated within the camera itself have been found to be unreliable for making accurate measurements in the object plane. Even with sprocket cameras there is some wandering of the image relative to the film gate of the camera, and a very small movement in the image plane introduces a large measurement error in the object plane.

The position of a shock front measured from a sequence of shadow or schlieren photographs permits the shock velocity to be calculated. This is a useful measurement, in that a knowledge of the shock front Mach number may be used in the Rankine–Hugoniot relationships (Wright, 1961; Bradley, 1962; Gaydon and Hurle, 1963) to give an accurate measure of all the physical properties of the gas immediately behind the shock. The relevant relationships are given later in this section. The reliability of the shock velocity method is such that it is often used to calibrate other measurement devices such as pressure transducers. The method is most useful for shocks with Mach numbers in the range from about Mach 1.05 to Mach 3. For shocks stronger than Mach 3 real gas effects become important and must be taken into consideration when using the Rankine–Hugoniot relationships. In the case of very weak shocks the dependency of the physical properties behind the shock on the Mach

number is small so that the shock velocity must be known with great accuracy in order to obtain accurate values.

The Mach number of the shock can then be calculated in terms of the speed of sound in the ambient gas ahead of the shock, which requires an accurate measure of the temperature of that gas. The appropriate relationships are as follows:

$$M_s = \frac{V_s}{a_0} \tag{16.1}$$

where M_s is the shock Mach number, V_s is the normal component of the shock velocity and a_0 is the speed of sound in the gas ahead of the shock, and

$$a_0 = a_n \left(\frac{T_0}{T_n}\right) \tag{16.2}$$

where a_n is the known speed of sound in the gas at absolute temperature T_n, and T_0 is the absolute temperature of the ambient gas ahead of the shock. In air, for example, it is convenient to let a_n equal 340.29205 m s^{-1} and T_n equal 288.15 K, the values at normal temperature and pressure (NTP). The local speed of sound (a) is also influenced by the relative humidity in accordance with the relationship

$$a = \frac{a_0}{\sqrt{1 - (Q/P_0)0.32}} \tag{16.3}$$

where $Q = 1.33 \times 10^{-3} P_v$ RH, where P_v is the vapour pressure (in torr) for the specific ambient temperature T_0, obtained from the *CRC Handbook of Chemistry and Physics*, and RH is the percentage relative humidity. The relative humidity correction is small and can usually be neglected unless great accuracy is required.

The ratios of the physical properties of the gas immediately behind the shock to the corresponding property in the ambient gas, in terms of the shock Mach number, are:

$$\frac{P}{P_0} = \frac{2\gamma M_s^2 - \gamma + 1}{(\gamma + 1)} = 7M_s^2 - \frac{1}{6} \tag{16.4}$$

if $\gamma = 1.4$;

$$\frac{\rho}{\rho_0} = \frac{(\gamma + 1)M_s^2}{(\gamma - 1)M_s^2 + 2} = \frac{6M_s^2}{M_s^2 + 5} \tag{16.5}$$

if $\gamma = 1.4$;

$$\frac{T}{T_0} = \frac{(2\gamma M_s^2 - \gamma + 1)(\gamma - 1)(M_s^2 + 2)}{(\gamma + 1)^2 M_s^2}$$

$$= \frac{4(7M_s^2 - 1)(M_s^2 + 5)}{36M_s^2} \tag{16.6}$$

if $\gamma = 1.4$; and,

$$\frac{u}{a_0} = \frac{2(M_s^2 - 1)}{(\gamma + 1)M_s} = \frac{5(M_s^2 - 1)}{6M_s} \qquad (16.7)$$

if $\gamma = 1.4$, where P is the hydrostatic pressure, ρ is the density, T is the absolute temperature, u is the particle velocity, γ is the ratio of specific heats, and the subscript zero refers to the state of the ambient gas.

Dynamic pressure (P_d) can be calculated from

$$P_d = \frac{\rho u^2}{2} \qquad (16.8)$$

where ρ and u are the density and particle velocity, defined by equations (16.5) and (16.7), respectively.

The total or stagnation pressure (P_t) can be calculated in terms of the dynamic pressure (P_d) and static pressure (P), but depends on whether the particle velocity is locally subsonic or supersonic. The local Mach number of the particle flow (M_u) for air with a ratio of specific heats $\gamma = 1.4$, is given by

$$M_u^2 = \frac{1.43 P}{P_d} \qquad (16.9)$$

If $M_u^2 \lesssim 1$, the total pressure is given by

$$P_t = P(0.2 M_u^2 + 1)^{3.5} \qquad (16.10)$$

If $M_u^2 > 1$,

$$P_t = \frac{P M_u^2 (3.58 \times 10^{-3})}{[1.167 - (0.167/M_u^2)]^{2.5}} \qquad (16.11)$$

In the case of a spherical blast wave the shock speed decays as the shock front expands. From a sequence of photographs of such an expanding shock, the radius (R) of the shock can be calculated using the geometry illustrated in Figure 16.8. The time (t) of each photograph relative to the initiation of the explosion is known from timing marks on the film. The shock speed can be determined from these values of R and t by making a least-squares fit to an appropriate function. Dewey (1971) suggests a function of the form

$$R = A + Ba_0 t + C \ln(1 + a_0 t) + D\sqrt{[\ln(1 + a_0 t)]} \qquad (16.12)$$

where A, B, C and D are the fitted coefficients, and the other symbols are as defined above. This function works well for data covering a large range of R, from close to the explosive source out to distances at which the shock speed has fallen to Mach 1.1 or lower. For shorter ranges of data close to the charge

$$R = A + Ba_0 t + C \ln(1 + a_0 t) \qquad (16.13)$$

is recommended, and for weaker shocks Sadek and Gottlieb (1983) recommend

$$R = A + a_0 t + B \ln(1 + a_0 t) \qquad (16.14)$$

The derivatives of these functions give the shock velocity, (V), in terms of R and t and this can be

used in equations presented above to give the peak values of the physical properties of the blast waves immediately behind the shock.

As a blast wave expands and decreases in strength it leaves the air in a state of radially decreasing entropy. As a result there is no single valued functional relationship between the physical properties of the flow behind the shock front. This means, for example, that a measurement of pressure does not permit a determination of the gas density. It has been shown however, (Dewey, 1964, 1971), that a knowledge of the time resolved particle trajectories in the blast wave is sufficient to determine all the physical properties. The particle trajectories can be obtained by high speed photography of smoke tracers established just before the arrival of the shock front. An analytical method to do this is given by Dewey (1971), in which a three-dimensional surface is described by a set of orthogonal polynomials fitted to the observed particle trajectories. The disadvantage of this technique is that the order of the polynomials used is arbitrary, and the solution may not lead to the correct thermodynamic relationship between the calculated physical properties.

An improved technique is described by Lau and Gottlieb (1984) who used numerical modelling in conjunction with photogrammetric observations. In a further development of this method, a particle trajectory close to an explosive charge, obtained by

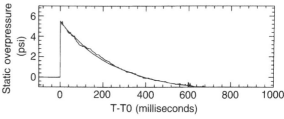

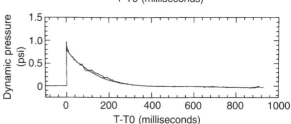

Figure 16.9 Time histories of hydrostatic and dynamic overpressure at a distance of 715 m from surface burst explosion of 2.65 ktonne of ANFO. The smooth curves were obtained from an analysis of the trajectories of smoke trails recorded using high speed photography at a framing rate of approximately 300 pps. The 'noisier' signals were recorded by electronic gauges. The excellent agreement between the results from the two measurement techniques illustrates the ability of high speed photography to provide quantitative results with an accuracy equal to or better than that of other methods.

photography of a flow tracer, is used to define a piston path in a numerical model. A piston following this trajectory generates a blast wave and the model is used to calculate the trajectories of a series of massless particles with initial positions corresponding to those of the observed flow tracers. The calculated and the observed particle trajectories are compared, and the piston path is iteratively adjusted until an optimal match of the calculated and observed trajectories is obtained. This technique, using only the data obtained from the high speed photography of the flow tracers, gives an excellent measure of all the physical properties in the blast wave, and even permits reasonable extrapolation beyond the range of the observed flow tracers. An example of the results that can be obtained with this method is illustrated in Figure 16.9.

References

Bradley, J. N. (1962) *Shock Waves in Chemistry and Physics*. Methuen, London

Conway, J. C. (1972) An improved Cranz–Schardin high-speed camera for two-dimensional photomechanics. *Rev. Sci. Instrum.* **43**, no. 8, 1172–1174

deLeeuw, J. H., Glass, I. I. and Heuckroth, L. E. (1962) *A High-Speed Multi-Source Spark Camera*. UTIAS Technical Note No. 26. University of Toronto Institute for Aerospace Studies

Dewey, J. M. (1964) The air velocity in blast waves from TNT explosions. *Proc. R. Soc., London Ser. A,* **279**, 366–385

Dewey, J. M. (1971) The properties of a blast wave obtained from an analysis of the particle trajectories. *Proc. R. Soc., London, Ser. A,* **324**, 275–299

Dewey, J. M. and McMillin, D. J. (1981) An analysis of the particle trajectories in spherical blast waves reflected from real and ideal surfaces. *Can. J. Phys.* **59**, no.10, 1380–1390

Dewey, J. M. and McMillin, D. J. (1985) Observation and analysis of the Mach reflection of weak uniform plane shock waves. Part 1. Observations, *J. Fluid Mech.* **152**, 46–66

Dewey, J. M., McMillin, D. J. and Classen, D. F. (1977) Photogrammetry of spherical shocks reflected from real and ideal surfaces. *J. Fluid Mech.* **81**, no. 4, 701–717

Gaydon, A. G. and Hurle, I. R. (1963) *The Shock Tube in High-Temperature Chemical Physics*. Chapman & Hall, London

Glass, I. I. and Heuckroth, L. E. (1963) Hydrodynamic shock-tube. *Phys. Fluids* **6**, no. 4, 543–547

Julian, R. J. (1970) *On Fringes Observed when Making Shadowgraphs of Shocks using Monochromatic Light from a Ruby Laser*. University Microfilms, Ann Arbor, MI

Lau, S. C. and Gottlieb, J. J. (1984) *Numerical Reconstruction of Part of an Actual Blast-Wave Flow Field to Agree with Available Experimental Data*. UTIAS Technical Note No. 251. University of Toronto Institute for Aerospace Studies

North, R. J. (1960) *A Cranz–Schardin High-Speed Camera for use with a Hypersonic Shock Tube*. NPL Aero Report No. 399. British National Physics Laboratory

Reichenbach, H. and Kuhl, A. (1989) HOB experiments with 0.5 g charges. *Proc. 11th Int. Symp. Military Applications of Blast Simulation*, pp. 597–611

Sadek, H. S. and Gottlieb, J. J. (1983) *Initial Decay of Flow Properties of Planar, Cylindrical and Spherical Blast Waves*. UTIAS Technical Note No. 244. University of Toronto Institute for Aerospace Studies

Wisotski, J. (1979) Ultra high-speed ruby laser photographic light system. *6th Symp. Int. Appl. Militair. Simul. Souffle*, Cahors, France, pp. 1.13–1.25

Wright, J. K. (1961) *Shock Tube*. Methuen, London.

17 Flow visualization

Peter W. W. Fuller

17.1 Introduction

In scientific research and engineering the requirements to study the dynamic behaviour of fluids range over a very wide area. Some problems involve the study of substances which are colourless, transparent and non-luminous, making observation by eye or photographic methods difficult. Requirements may range from measuring the formation of shock waves and flow lines about a model aircraft in a wind tunnel, or the behaviour of cavitation bubbles around a spinning ship propeller, to the flow of liquid metals in casting or in an electric arc.

In addition to photographic observation, measurement data are often gained by the use of appropriate *transducers*. For example, these may be employed to measure pressure, temperature, forces or other phenomena. However, the most widely used method is by visual observation or by photographic or video recording. Whilst some of the processes are reasonably slow in their rate of change, most will be fast changing and highly transitory. In order to form adequate records the framing rates and exposures required will bring them into the field of high speed photography.

In scientific research, photographic records of phenomena are particularly useful. Unlike most transducers which can only measure one type of parameter, the pictorial record can often offer several measurements simultaneously and consequently provides an economical means of gathering data. In *flow visualization*, a valuable bonus is the ability to replay and watch flow processes at much slower than real time rates. This can offer a much greater understanding of how the process actually occurs and can be repeated as often as required. As with all photographic data gathering, the method of observation and recording will be chosen to suit the subject characteristics.

17.2 Methods of flow visualization

There are three principal methods of flow visualization:

- Observing changes in refractive index.

- Adding particles or tracing elements to the flow.
- Introducing energy into the flow.

17.2.1 Density changes

Often the phenomena of interest involve changes in the refractive index of the flowing or disturbed media. These can then be visualized or photographed by using special optical methods which can detect changes in the mode of light transmission due to refractive index variations.

17.2.2 Flow tracers or particles

Flow details and patterns can also be made visible by *seeding* or adding particles to the flow. These may take the form of smoke, vapours or dyes or other larger solid particles. Other mechanical methods can include *tufts* or *streamers* placed on or about the surface under observation. Alternatively, *boundary layer flow* may be detected by the use of oil films or chemical layers on the body surface which change shape or colour as the flow develops. These methods can all use photographic recording for later study. These first two methods can be thought to coincide roughly, but not exclusively, with compressible and incompressible flows.

17.2.3 Added energy

A third method involves the introduction of extra energy into the flow in the form of local heating or by electrical discharge. In these cases the introduced energy converts selected portions of the flow into luminous or visible areas which can then be photographed. These methods are applicable to low density gas flows. They have the disadvantage that the addition of extra energy may affect the flow characteristics.

17.3 Early flow studies

Flow fields and fluid dynamics have always been an area of great interest in scientific research. The processes involved are extremely complex and pose a difficult challenge for mathematical analysis. Many assumptions and approximations have to be made

and results are difficult to verify except by experimental observations. In more recent years the growth of computer usage has enabled the handling of the complex formulae and equations to become both easier and quicker. Earlier workers lacking the benefits of modern computational methods relied heavily on experimental research. The emergence of photography in the mid-19th century provided a valuable new method of observation and recording.

When considering flow visualization research, the names of Prandtl and Reynolds figure prominently. Both contributed a great deal to the pioneering study of fluid mechanics and both are remembered by having terms in fluid mechanics named after them in the form of *Prandtl number* and *Reynolds number*. However, another pioneer, Ernst Mach, probably merits even more consideration. His fundamental beliefs considered that visual sensations, which could be shared and analysed by many observers, were the basis upon which science and scientific facts could be established and advanced. Flow visualization was a specifically representative instance of these beliefs, and consequently figured largely in his scientific investigations throughout his career. In the late 1800s a great deal of pioneer work was being carried out on *ballistics* and one of the prime areas of interest was information on the disturbance and flow of air about fast moving bodies. Spark sources were found to be very effective for making *shadowgraph* pictures of flow fields about projectiles. Once the principle had been proven, many scientists were quick to use the system for their own particular interests.

In the late 1880s, Ernst Mach and Joseph Cranz in Germany used sparks to make shadowgraph pictures of bullets in flight. These were complemented later by spark schlieren pictures which showed even more detail of flow and turbulence. In order to synchronize and operate the spark circuits, they developed many ingenious switches and triggers, operated by the projectiles in flight. For the first time they were able to make visible the variations in flow patterns around bodies of various shapes. Differences in turbulence behind sharp and blunt projectiles could be qualitatively observed and reasons found for the drag reduction which resulted with the use of streamlined shapes.

In the 1890s, Professor Boys in England also used *spark shadowgraphs* for bullet aerodynamics research using sparks with a duration of 1 μs. In order to carry out the experiments, he set up a firing range on tables placed in a passageway at the Royal College of Science in London. It is difficult to imagine that this would be allowed under modern safety rules and regulations. He was able to make many pioneering observations on the nature of reflected shock waves and the vibrations induced in impacted objects.

By the early 1900s, Marey, Wood, Kranzfelder and many others had moved to *multiple spark photography* using sequential discharge of capacitances or fast interrupters and coils – the sparks were produced in a similar manner as in magneto-ignition systems for cars. By 1912, Cranz was using a large capacitance feeding a free running smaller capacitance and spark gap to produce a sequence of sparks. In 1920, Dr G. Bull used an improved but similar system in conjunction with a *drum camera*. The resulting pictures of a bullet and its surrounding shock waves are reminiscent of similar pictures which might be taken with a quarter-frame rotating prism camera in more recent times. Some of these early equipments and pictures made with them can be seen in the photographic section in the Science Museum in London.

Also in the early 1900s, Professor Worthington made a detailed study of splashes whilst working at the Royal Naval Engineering College at Devonport. He used electric sparks in conjunction with a special timing device so that exposures could be delayed to show various stages in the splash cycle (Worthington and Cole, 1897; Worthington, 1908).

Meanwhile in France, E. J. Marey had built a primitive wind tunnel into which he introduced streamers of smoke from burning tinder. With this apparatus he was able to study the flow of air around objects of various shapes. Pictures of the flow patterns were taken using magnesium flash. This use of smoke streamers is still employed in modern wind tunnel research, and this appears to be one of the earliest records of use of such a tracing method (see Section 17.12.1) (Marey, 1901).

In the early 1920s Harold Edgerton developed gas filled flash tubes and a new short duration source was introduced to challenge the spark supremacy. Edgerton followed Worthington's work on splashes to produce his well known pictures of milk drops. He went on to develop *multi-flash tubes* and was able to introduce quasi-cine observations into his studies using what he called a *strobe flash*. The emphasis on spark and electrical flash light sources in early fluid dynamic studies has continued to the present time. It is supplemented now by laser light sources and cine techniques using very short duration exposures which were not available to the early experimenters.

World War II produced a leap forward in the technology of high speed photography. Improvements and new techniques which were developed under the driving necessities of war have carried on into the present time. In particular, a great deal of work was required in wind tunnel research for new aeroplanes and rockets. Studies of the flow around ships and submarine hulls were used to assist the design of faster and more efficient craft. Research was also needed into methods of reducing cavitation damage to propellers. This work, aided by advances in light sources and cameras, led to many develop-

ments and refinements of flow visualization techniques. Currently, in ballistic, aerodynamic, hydraulic and metallurgical research, high speed photographic methods are deemed vital tools for any fluid flow observations. This usage is likely to continue for a long time to come with the growing use of video and opto-electronic techniques.

17.4 Techniques and methods

Because it is often difficult to observe or photograph fluid flow phenomena without using special optical techniques or by modifying the appearance of the flow in some way, it is necessary to describe and explain the various methods used. The fluids involved are normally clear enough to allow optical observations. In general, when observing fluid flow the experimenter is dealing with gases or liquids in their normal state, but the fluid may sometimes be in the form of a molten solid or a vapour where the fluid is not in its natural state at normal temperature and pressure (NTP). In some instances we may be interested in the movement and behaviour of liquids in the form of droplets. However, the majority of observations are made in gases, notably air, for aerodynamic data purposes. In particular, much work is carried out in *wind tunnels* and *shock tunnels* in various flow regimes or in *water tunnels* to observe cavitation or other fluid phenomena. In these cases the flow will be contained within closed channels and will be moving about stationary models or test objects. Due to the enclosure the photographic studies will normally be made through transparent windows. Alternatively, in other areas such as ballistics research, the objects will be moving through static fluids and the experiments will often take place in the open air.

17.4.1 Effects involved with changes in density

The most direct way of observing fluid flow in gases is to observe the changes in refractive index which occur with changes of density. This may be because a mixture of substances of different density are present or because a single substance has undergone density variations due to temperature or pressure changes. Generally, for a gas the density and refractive index can be related approximately as

$$n - 1 \approx k\rho \qquad (17.1)$$

where ρ is density, n is the refractive index and k is a constant for a particular gas and a particular wavelength of light. This is often known as the Gladstone–Dale constant. For example, at 0°C and 101.325 kN m^{-2} (760 mmHg) pressure using light with a wavelength of 589.3 nm (sodium D line), the

refractive index of air is 1.000292, argon is 1.000284 and hydrogen is 1.000138.

For more convenient use the equation can be rewritten as

$$n - 1 \approx (n_1 - 1) \; \frac{\rho}{\rho_1} \qquad (17.2)$$

where n_1 is the refractive index and ρ_1 is the density, at a reference temperature and pressure and using a specific wavelength of light.

Alternatively, this can be expressed as

$$n - 1 \approx K \left(\frac{\rho}{\rho_1} \right) \qquad (17.3)$$

For air and visible light, the value of K is between 2.9 and 2.98 × 10^{-4}. Such information for a range of gases and conditions can be found in reference tables of physical and chemical constants (e.g. Kaye and Lab, 1986).

17.4.2 Velocity of light and refractive index

The velocity of light (c) is related to the refractive index (n) by the relationship $c = (1/n)c_0$, where c_0 is the velocity of light in vacuum. Changes of refractive index at a given region will thus change the velocity of light passing through that region. This effect manifests itself in various ways according to the optical system used.

17.4.3 Three main methods of visualization

The optical refraction effects brought about by local density changes can be made visible for photographic purposes by three principal methods:

- Shadowgraph techniques.
- Schlieren systems.
- Interferometry.

These all depend for operation on their ability to detect various types of density variation as follows:

- A shadowgraph system responds to a rate of change of density gradient along a distance x, i.e. $d^2\rho/dx^2$.
- A schlieren system responds to the density gradient, i.e. $d\rho/dx$.
- Interferometry responds to a uniform change in density (ρ).

The mathematical derivation is complex, but a simple analogy is a light beam passing through glass. The single uniform change in density is similar to a light beam passing through a plane glass parallel sided block and is detected by interferometry only.

A simple change in the density gradient can be compared to a beam passing through a triangular prism and is detected by both interferometery and schlieren systems. A variable rate of change of density gradient can be compared to a beam passing through a lens and will be detected by all three systems (Hilton, 1951). Note that for this analogy to hold, the field must be entirely covered by the plate, prism or lens.

Alternatively, consider a small beam of light passing through a medium in which there are density variations. When emerging from the far side of the disturbance the beam will be altered as follows:

- It will be *displaced* from its original position, this will be observed on the shadowgraph due to the rate of change of density gradient normal to the beam.
- It will be *deflected* through an angle from its original direction, this will be sensed by the schlieren system due to a change in density gradient normal to the beam.
- The time of arrival of the beam on the far side will change with changes in the density of the medium, i.e. its *velocity* will change. This will be sensed by the interferometer by a comparison of the time of arrival of the undisturbed beam and disturbed beam, i.e. the production of interference fringes.

17.5 The shadowgraph

Shadowgraphs are the least demanding in terms of apparatus of all the flow detecting systems. Shadowgraphs can be taken using only a short duration point light source and a sheet of film or equivalent (Figure 17.1) and can give excellent results. To follow this method the event must take place in darkness, but this is often not a problem. Shadowgraphs are used a great deal in the study of flow about projectiles (Mikhalev and Warken, 1995).

17.5.1 Simple shadowgraph

If the density gradient normal to the light beam is non-uniform, the rays will be deviated by different amounts and will tend to diverge or converge after passing through the medium. This will produce a *shadow image* on a screen or directly on to film. Shadowgraphs are not very sensitive to low energy disturbances. For sharp images the light source should be small. A basic system is shown in Figure 17.2(a). It will be noted that as the beam is diverging the shadow thrown onto the film or screen will be enlarged relative to the actual size of the subject. For a given source to subject distance, the magnification will increase as the subject to screen distance is increased. Thus this method should not be used for objects which are of significant width in the beam direction since the image of parts of the object may fall on the screen with different degrees of magnification.

17.5.2 Principle of operation

In a region where the density gradient is constant, all light rays passing through the field will be deflected by the same amount. In regions where the density gradient is changing the deflection of the rays will not be constant and this will produce a variation in light intensity on the screen or film plane. If the density gradient is increasing (i.e. $d^2\rho/dx^2$ is positive), the light rays will diverge and the image illumination on the screen will decrease. Where the density gradient is decreasing, the rays passing through will converge and the light intensity on the screen will be increased. The definition of the subject shadow can be affected by diffraction at the subject. Consider Figure 17.2(b) showing the simple diverging shadowgraph layout and the way in which the light from the source is affected in its passage through a *shock wave*. In this case, a shock wave in air. A shock wave occurs when a moving pressure wave exceeds the local speed of sound. This causes an abrupt change in pressure, density and particle velocity. The light from the point source throws a shadow of the body and shock waves onto a screen or film. Undisturbed air away from the wave will give a uniform density on the screen. A limiting ray OB will be tangential to the shock wave and all rays below this will pass through the shock and be deviated towards the oncoming shock. Thus OB will fall at C leaving a dark area between B and C. Other rays will be more sharply deviated and these will form a focus near C so that shock waves will appear as a dark line on the screen with a line of increased

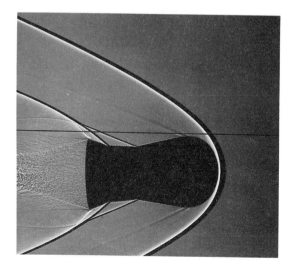

Figure 17.1 Shadowgraph of a projectile. A model of an explosively formed 30 mm projectile. Velocity 1400 m s^{-1}; spark flash duration 200 ns.

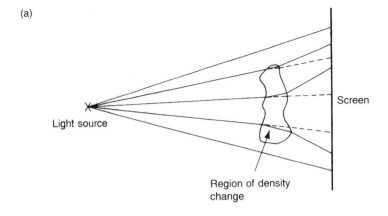

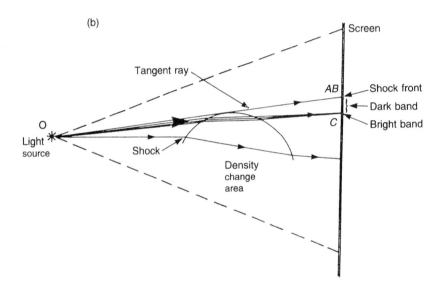

Figure 17.2 The shadowgraph. (a) Principle of shadowgraphs. (b) Shadowgraph of a shock wave.

brightness just behind. Similarly, where the density gradient is decreasing, rays will be bent in the other direction away from the region of decreased density. The shadowgraph is superior to other techniques where sharp indications of flow discontinuities are required.

The best results from direct divergent shadowgraph will only be available when the subject can be photographed without any intervening glass window. Any intervening glass will reduce the quality of detail obtainable from the open system and also decrease the amount of light reaching the subject, screen or film due to reflection.

In the most simple direct divergent system all that is required is a short duration point light source and a sheet of film. Pictures exposed in this way have no aberrations from optical apparatus and are immune

to vibration effects, provided that the exposure time is short. This is a very effective technique and will produce excellent detail of strong disturbances. Another major advantage is that no expensive optical apparatus is needed. The size of the image is governed by the size of the film format available. X-ray film is often used and the individual envelopes in which the film sheets are packed provide convenient light-tight carrying cases.

17.5.3 Disadvantages of the direct shadowgraph

The direct divergent shadowgraph has two principal disadvantages, particularly for use in large scale experiments:

- It requires the experiment to be conducted in complete darkness.
- It requires an area of film larger than the area to be studied according to the distance between the subject and the film.

17.5.4 Collimated beam shadowgraph

The direct shadowgraph uses diverging light, but it is possible to collimate the light from the point source so that the subject of interest lies within a parallel beam. This eliminates the unwelcome problem of the diverging beam which gives variable degrees of magnification when viewing a wide subject. The beam can be collimated by the use of a large diameter lens (Figure 17.3(a)). The disadvantage here is that the subject under observation must be smaller than the size of the beam and thus smaller than the diameter of the lens. However, the collimating of the beam does make more efficient use of the available light.

17.5.5 Focused collimated beam

In some situations, e.g. observing across a wind tunnel working section, it may not be easy to place the film plane near to the working section window. In this situation a variation on the collimated direct shadow system can be used. A second lens or concave mirror can be used to bring the collimated beam back to a focus for recording (Figure 17.3(b)). Because of the finite depth of focus the image is not exactly as would be produced on the original screen or film plane, but is an integration of all the parallel planes spread along the collimated beam.

It has been found that the direct shadow method can show whether flow in a surface boundary layer is laminar or turbulent and also indicate the position along the surface at which a change from laminar to turbulent flow occurs (Pearcey, 1950). These effects are indicated by the presence of a white line in different positions near to the surface, standing off and parallel to the surface in laminar flow and close to the surface in turbulent flow. These effects are caused by different rates of change in the density gradient in the two cases.

17.5.6 Camera recorded shadowgraph

When using the direct shadowgraph, the requirement that the event should take place in the dark can be most inconvenient and sometimes dangerous under particular circumstances. If the photographer needs to move about in the dark to place and recover the film, there may be danger from high voltage apparatus, unseen obstacles or moving objects.

An alternative method is to use the camera recorded shadowgraph. Two alternative methods are shown in Figures 17.3(c) and 17.3(d). In the first, the camera views the subject against the illuminating source. The light from the source is thrown onto a translucent diffusing screen. The use of this method has the disadvantage that the scattered illumination may reduce fine detail. Alternatively, the light can be gathered by a condensing lens and focused onto the camera. This uses the light more efficiently but needs more careful alignment. These systems do not give as effective results as the direct shadowgraph. This is due to the introduction of lens or mirror aberrations and the failure of the optics always to trap all the scattered light due to their limited areas. The advantages are that experiments can take place in the light and the camera can be operated remotely if required.

17.5.7 Retroreflective screen shadowgraph

A final variation which is widely used is shown in Figure 17.3(e). This system uses the diverging illumination of the direct system and a camera which is placed close to the light source. A *retroreflective screen* is placed behind the subject and the shadowgraph image is formed on this screen. The camera is focused on the screen image. The retroreflective screen is composed of a flat screen onto which a carpet of tiny glass spheres is fixed. Due to internal reflections in the spheres, light falling onto the screen is reflected back along its incident path. For rays reflected close to the incident beam direction an extremely high reflectance can be obtained. The intensity falls off very sharply as the angle of view moves away from the line of the incident beam. As the reflection from the screen is so dependent upon the incident angle, any deviations in the light passing around the subject which cause the rays to strike the screen away from the normal drastically reduces the intensity of their return and they are recorded by the camera as darkened areas. Thus a camera placed with its optical axis close to the axis of the illuminating beam will view a bright image from the screen, including the flow perturbations.

Sometimes a beamsplitter is placed at 45° to the camera axis to allow the light beam and camera axis to be coincident, the light coming in from the side. In this case the front-lit image of the object is contained within the screen shadow. If light and camera axes are not coincident, an out of focus, front-lit and a focused shadowgraph image will be obtained. This is not a serious problem, but in some instances can reduce the clarity of the final image if part of the screen shadowgraph image is obscured. Also, if the location of the subject in space is being measured by taking simultaneous orthogonal images, the analysis becomes more difficult if the images are not coincident.

Using the shadowgraph system the image on the

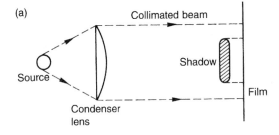

(a)

Collimated beam

Source

Condenser
lens

Shadow

Film

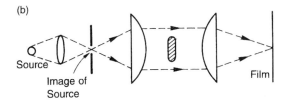

(b)

Source

Image of
Source

Film

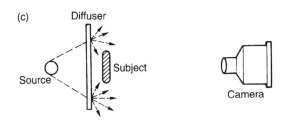

(c) Diffuser

Source

Subject

Camera

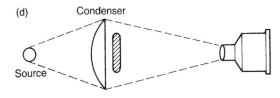

(d) Condenser

Source

Camera

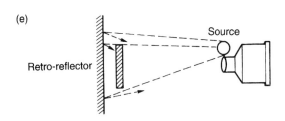

(e)

Retro-reflector

Source

Figure 17.3 Types of shadowgraph. (a) Collimated direct shadowgraph. (b) Focused collimated direct shadowgraph. (c) Camera recorded shadowgraph using a translucent screen. (d) Shadowgraph using a condenser lens. (e) Shadowgraph using a retroreflective screen.

screen is always the same distance from the camera and thus remains in focus. This is important, for example, in ballistic firings where the actual path of the shot may vary across the width of the range.

The use of retroreflective material and a camera

allows large events to be photographed as the screens can be made to cover the necessary area required. It also enables the event to be photographed in subdued daylight as the image returned from the screen is much brighter than the interference from the general illumination. A polarizing filter can also be used on the camera to cut down stray light. This is a very effective system, but as with other camera shadowgraph systems the images are not as good as with the direct system. If the natural light is extremely bright, a covered tunnel of dark cloth or cardboard can be erected temporarily to lower the ambient light levels.

17.5.8 Multiple-exposure shadowgraph

The image contrast available using the retroreflective screen is high enough to allow several successive superimposed images to be recorded on the same film frame. This is impressive, as multiple-image shadowgraph photography, in common with other multiple-image photography, has the problem that successive exposures on the same film, reduce the contrast between the silhouetted image and its background. It has been shown by Barkofsky (1952) that, if the optical density of the exposed image is D, then

$$D = \gamma \left(\log NH - \log i \right) \qquad (17.4)$$

where γ is negative gamma, N is the number of exposures, H is the exposure of the photographic film per flash (in lux-seconds), and i is the inertia point on the characteristic (H and D) curve (in lux-seconds). Then

$$\Delta D = \frac{\gamma \log N}{N - 1} \qquad (17.5)$$

where ΔD is the density difference between the multiple-image silhouette and its background. Up to eight accurately measurable superimposed images have been obtained in experimental work (North, 1970).

17.5.9 Shadowgraph source size

Normally the shadowgraph source will be made close to a point source, either by virtue of its basic design, or a large irregular source will be focused down onto an iris which then acts as the effective light source. The source will normally be made with as small dimensions as possible in order to keep the image sharpness at its maximum. The lack of image sharpness (resolution) relative to source size is given by

$$s \approx \frac{xd}{f} \qquad (17.6)$$

where s is the resolution, d is the source diameter, f is the focal length of the lens or mirror used, and x is

the distance between the disturbance and the viewing screen. For uncollimated sources the resolution is inversely proportional to the diameter of the source and directly related to the ratio of the distance between the source and the viewing screen and the distance between the disturbance and the viewing screen. As the source size is reduced a limit

is reached where the resolution depends upon diffraction and is of the order of $\sqrt{(2/\lambda)}$, where λ is the wavelength of the light used. In practice, the latter factor does not often need to be considered. The *detection sensitivity* of the shadowgraph is directly related to the rate of change of the density gradient in the medium and the distance between the disturb-

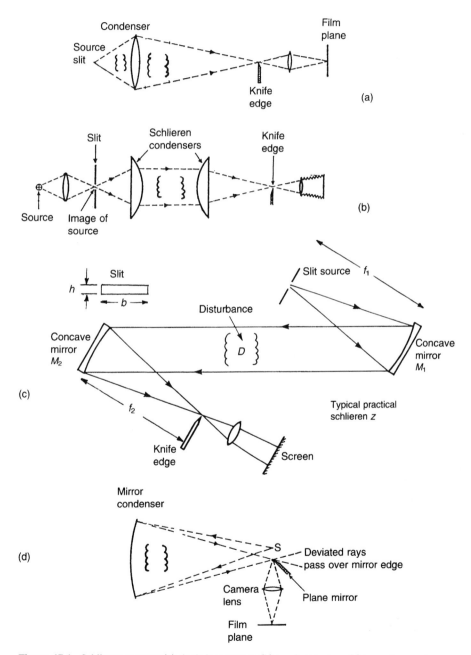

Figure 17.4 Schlieren systems: (a) single lens system; (b) two lens system; (c) two mirror system; (d) double pass system.

ance and the photographic film. Sensitivity and optical resolution are thus in opposition for a disturbance of a given intensity and a compromise becomes necessary in deciding upon the distance between the disturbance and viewing screen.

17.6 Schlieren systems

Schlieren systems are used in the study of high speed fluid flows in wind tunnels and shock tunnels, and to observe mixing and free and forced convection in and around heated bodies. The schlieren effect was first discovered by Foucault in 1859 and was initially used to show up defects in glass components such as lenses, mirrors and observation windows. Later, Toepler (1866) pointed out that it could also show up inhomogeneities in air. The name stems from the German word for 'streak' or 'striation' (*schliere*). It was soon realized that the method could be a powerful tool for observing variations in flow density and, because of its reliance on dρ/dx, it was more sensitive in low pressure conditions where density changes were more subtle. The general principle of a typical system is shown in Figure 17.4(a), although this is only one of several possible layouts. Either large diameter lenses or mirrors can be used to produce the collimated beam in which the event takes place. Mirrors are preferably used, as high quality mirrors are cheaper than the same size diameter lenses and the set-up occupies less space. High quality is essential as, due to the mode of operation, any small defects are shown up with high clarity.

17.6.1 Basic principles

A basic system is shown in Figure 17.4(a). Light from the slit is focused onto a plane by the lens. A knife edge is placed in the plane and positioned to cut off a portion of the slit image. A screen or camera is placed to receive the plane image. If a medium of constant refractive index is placed between the lens and the knife edge the camera film will be evenly illuminated. If a refractive index change occurs at D, say, a light ray previously cut off by the knife edge may be deflected enough to now reach the camera and produce a light image. If the refractive index change was in the opposite sense then other rays which originally passed through may now be blocked by the knife edge to give a dark image. Thus a disturbance at D will produce a picture of the refractive index gradients or medium density changes which occur (Figure 17.5). Note the complementary light and dark effect, above and below, due to the use of a horizontal knife edge.

If the knife edge is adjusted to just cut off the whole slit image, then the camera image will be dark in the absence of disturbances. A refractive index gradient in the right sense will now produce a

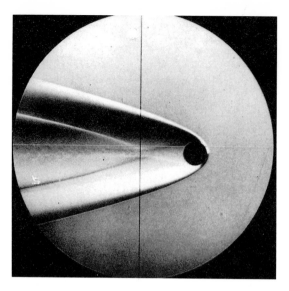

Figure 17.5 A schlieren image. Note the complementary light and dark shock (top and bottom, respectively) from the use of a horizontal knife edge.

picture, whilst a gradient in the opposite sense will not. For a given gradient a more narrow slit will give a larger contrast since the deflection at the knife edge is a larger percentage of the slit width. Thus the *system sensitivity* will be inversely proportional to slit width. However, reduction of slit width beyond a certain point is not practicable, as diffraction effects begin to degrade the image.

17.6.2 The double lens system

The beam displacement at the knife edge will be proportional to the distance between the disturbance area and the knife edge so an increase in lens focal length will also increase system sensitivity. Lens diameter and focal length will limit the size and location of the disturbance due to the limits of the focusing cone involved. To have a maximum parallel working volume of lens diameter, the lens must be replaced by two similar lenses so that the working volume occurs between them. This is the arrangement found in the typical schlieren set-up (Figure 17.4(b)). If the disturbance causes an angular deflection θ, the image at the knife edge will move approximately $f_2\theta$, where f_2 is the focal length of the second lens.

It should be noted that, because light from all points in the disturbed area is brought to a final focused image on the screen or camera film plane, it is not displaced by the deflection of the rays produced by the refractive index gradients in the disturbance. However, these deflections will bring about changes in the tones which make up the image.

Although there are several methods available for

detecting the displacement of the light source image, the knife edge method due to Toepler is used extensively. Whilst deflections of the source image towards or away from the knife edge will cause changes in the screen image, deflections parallel to the knife edge will have no effect. Thus the edge must be orientated to be at right angles to the direction in which the density gradients of interest will occur. For example, for the most sensitive observation of boundary-layer effects the edge will be arranged parallel to the body surface, and for shock waves it will be set parallel to the main shock front.

17.6.3 Sensitivity and working range

Holder and North (1963) made an exhaustive study and analysis of practical schlieren usage. For anyone setting out to make schlieren pictures this work is an invaluable guide. This section follows their explanation of *sensitivity* and *working range*.

If, initially, the knife edge is left out of the system shown in Figure 17.4(b), the screen will be uniformly illuminated and the illumination (I_0) can be expressed as

$$I_0 = \frac{Bbh}{m^2 f_1^2} \tag{17.7}$$

where B is the luminance, b is the breadth, h is the height of the illuminated slit source, m is the magnification of its image on the screen and f_1 is the focal length of the first mirror or lens. The dimensions of the source image at the knife edge plane are $(f_2/f_1)h$ and $(f_2/f_1)b$. If all but a height (a) of the image is cut off by placing a knife edge parallel to the breadth (b) of the source, the screen illumination falls to a new level (I) given by

$$I = \frac{Bba}{m^2 f_1 f_2} \tag{17.8}$$

where f_2 is the focal length of the second mirror. When an optical disturbance produces an angular deflection ($\delta\theta$) of the light rays, the image of the source is displaced at the knife edge by an amount $f_2\,\delta\theta$, so the change in illumination for that part of the image is given by

$$\delta I = \frac{Bb\,\delta\theta}{m^2 f_1} \tag{17.9}$$

The *contrast* (C) with the original background is given by

$$C = \frac{\delta I}{I} = \frac{f_2\,\delta\theta}{a} \tag{17.10}$$

and the *contrast sensitivity* (S) is given by

$$S = \frac{dC}{d\theta} = \frac{f_2}{a} \tag{17.11}$$

If the image of the source is displaced completely off or onto the knife edge, the illumination will be I_0 or zero. Thus the maximum *range of displacement* possible will be equal to the height of the slit image at the knife edge and this is $(f_2/f_1)h$. The maximum *angular deflection range* will be $\delta\theta_{max} = (h/f_1)$.

Usually the system will be set up so that the range is equal for deflection to and from the knife edge. Then the set-up value (a) is given by

$$a = \frac{f_2\,\delta\theta_{max}}{2} \tag{17.12}$$

and the corresponding illumination of the screen by

$$I = \frac{I_0}{2} \tag{17.13}$$

In this case,

$$S = \frac{2}{\delta\theta_{max}} \tag{17.14}$$

Thus, in general, the maximum sensitivity for a given range is inversely proportional to the range and is independent of the properties of the optical system or light source. The range of the system can be increased by making f_1 of shorter focal length or by increasing the height of the slit source.

For very low density flows the schlieren sensitivity may become so low that resort must be made to an alternative system. In experimental tests, Holder and North (1963) found that observations can be made with schlieren systems down to the point where the density of the free-stream flow is equal or greater than about 0.01 of air density. It should be noted that, in the study of flow in plasmas, the refractivity is enhanced by the presence of ionized gas. This permits the use of conventional systems at densities which would normally be impractically low.

17.6.4 Alternatives to the Toepler knife edge

In transonic and subsonic wind tunnels it is often necessary to use a schlieren system with a large range, and it may be difficult to provide a large enough uniform source to allow for this need. If the range is adjusted by altering the source dimensions the knife edge position may need to be changed in off-axis systems (Figure 17.4(c)) due to astigmatism.

Alternatives to the knife edge may be used, including:

- A graded filter.
- A circular cut-off.
- Colour schlieren.

17.6.4.1 Graded filter

An alternative method is to replace the knife edge in the focal plane of the second mirror by a filter with neutral density graded in one dimension. As the source image is displaced across the graded direction, varying proportions of the light are transmitted. As the filter can be made to any reasonable size a wide range can be obtained. In this arrangement a point source can be used, allowing both schlieren or shadowgraph pictures to be taken.

In some instances the use of a graded filter can improve the sharpness of the schlieren image. When using a knife edge, diffracted light from fine detail of the flow is cut off by varying amounts across the source image, whereas using a shallow graded filter the diffracted light is hardly affected across the image width as it is nowhere completely cut off. As required sensitivity increases the advantages of graded filters decrease, and for very sensitive systems no worthwhile advantage is obtained.

17.6.4.2 Circular cut-off

The normal Toepler knife edge is sensitive to deflections perpendicular to the knife edge. This allows the approximate directions of the density gradients to be determined by rotating the knife edge in the vertical plane and also allows the edge to be set to show selected features of the flow to be observed with high sensitivity. If gradients in all directions are of interest, at least two consecutive photographs must be taken with the knife edge in perpendicular positions. An alternative is to use a circular light source and a circular aperture and show gradients in all directions. The regions of density gradient all appear darker than the background, as displacement only results in decreasing illumination. The results are ambiguous in the sense of angular orientation as there is now no reference direction of the knife edge. An alternative arrangement can use an opaque circular stop which cuts off the circular source image. Any displacements will then give an increased illumination at the viewing screen.

17.6.4.3 Colour schlieren

Schlieren photographs in colour can be obtained using one of several methods to give a multi-coloured image in which the various hues correspond to particular density gradients. One method is a variation on the graded filter replacement for the Toepler knife edge and uses a point source and banded colour filter in the focal plane of the second mirror. The filters may be constructed of bands of coloured gelatin film or strips of glass fixed edge to edge on a transparent backing plate. The central colour strip is made approximately equal to the width of the normal slit image. According to the extent of the deviation of the different parts of the image they will pass through different parts of the filter to give multi-coloured images. A three-colour combination of red, yellow and blue is often used to provide good contrast between adjacent stripes (Holder and North, 1954).

In another method, a prism is placed in front of a source of white light located at the focus of the first mirror in Figure 17.4(c). This gives a spectrum at the focal plane of the second mirror. The colour of the screen image can be changed by moving a slit placed at the usual position of the knife edge, parallel to the bands of the spectrum. When a density gradient occurs the original colour is displaced and an adjacent spectral colour passes through the slit to show the density gradient region against a background of the original colour. The colour sequence is fixed by the natural spectrum so it is not so easy to place highly contrasting colours next to each other as in the banded colour filter (Holder and North, 1952). A similar system described by Maddox and Binder (1971) uses a diffraction grating instead of a prism.

A further system provides colour modification to the schlieren system that uses the circular cut-off detector. It also indicates the direction of the deflection angle in the x–y plane. A white light source is focused on a source filter which consists of four different coloured slit filters arranged in a square (Settles, 1970). The source filter is placed at the focus of the first mirror and the colours merge to illuminate the subject area. A squared slit aperture, a little smaller than the size of the source filter and aligned in the same orientation, is placed at the knife edge position. The direction of the density gradient changes decides which colour combination passes through the slits to form the image.

An electronic colour schlieren system has been devised in which the image is recorded by a television camera. The camera output is monitored by signal level detectors which switch in pre-selected colour inputs to give a coloured output relevant to the grey level of the original black and white image (McDowell and Miller, 1976).

Colour schlieren offers several advantages:

- The eye can differentiate changes in hue better than shades of monochrome light.
- The flow field can be more easily differentiated from the subject boundaries which remain black.
- The pictures are generally more aesthetically pleasing, and can be made to produce very striking images (see book-cover).

There is a penalty in more complex film processing requirements, but the use is often justified for pictures taken for showing to non-specialized audiences, particularly in the case of demonstration cine films. It must be remembered that the colours

are *false colours* and bear no intrinsic relationship to the flow under observation, colours associated with a particular density change being dependent only on the make up of the colour filter system in use at the time.

17.6.5 Practical considerations of schlieren

17.6.5.1 System arrangements
In systems in which the event takes place within a parallel beam arrangement, either mirrors or lenses can be used. For lens systems the source, lenses, knife edge and screen can all be on a single optical axis. However, when mirrors are used it is necessary to place the source and knife edge to one side so that they do not interfere with the working volume. Ideally, *off-axis parabolic mirrors* designed to have their foci to lie to one side of the parallel beam should be used, but these are extremely expensive. In normal practice ordinary mirrors are used and, while some aberrations such as coma and astigmatism occur, their effects can be alleviated by careful adjustment. Coma problems are greatly reduced if source and knife edge are arranged to be on opposite sides of the main beam, and astigmatism can be reduced by adjustment of source and knife edge positions. Generally the problems are not serious if the mirror focal length to diameter ratios (*focal ratio* or *f-number*) are reasonably large, i.e. large *f*-numbers, and the angular off-sets are less than about 10°.

17.6.5.2 Mirrors, lenses and windows
For schlieren work, optical components need to be of high quality, since the nature of the schlieren effect tends to show up small aberrations in components. In general, the working volume of the system is required to be as large as possible and as this is dictated by lens or mirror diameter; mirrors are often used as, for a given diameter, they are usually cheaper than an equivalent lens of the necessary quality. Mirrors will have front surface reflection coatings and the surface will often be protected by a special abrasion resistant film. The reflecting surface must be treated with great care and cleaning is best avoided by keeping the mirrors covered except during periods of use. Cleaning, if necessary, is a process best left to someone experienced in the art, as the surface can be swiftly ruined by incorrect cleaning. Lenses must be of very high quality and free of scratches, bubbles, inclusions or regions with different refractive index.

If the subject is photographed through glass windows, e.g. in a wind tunnel working section, the glass must be of high quality and free of blemishes, as with lenses. Surfaces need not be parallel, but must be flat to within one wavelength per 25 mm (1 inch) and have a high surface polish. Windows are often selected for schlieren use by testing in another schlieren system.

17.6.5.3 Mountings
Mountings for all components need to be rigid, vibration free and robust. It may often be convenient to mount components on sections of optical bench. Items that from time to time need positional adjustment should have multi-axis fine screw controls built in, which should be lockable once adjustments have been made. Once apparatus has been set up it is an advantage to keep covers and dust sheets over all components when not in use. For long term set-ups it may be advantageous to build semi-permanent housings around them with access doors for adjusting components where necessary.

17.6.6 Variations on schlieren layouts

17.6.6.1 Non-parallel systems
The basic parallel light system is as shown in Figure 17.4(b, c). If non-parallel light is used the systems will be set up as shown in Figure 17.4(a), when only a single lens is used. The subject perturbation may come between the source and the lens or the lens and the knife edge. Whilst only one lens is required it may be necessary to have a larger outer diameter than if parallel light were used in order to cover the perturbed area.

17.6.6.2 Double pass systems
Some systems can be employed in a double pass mode (Figure 17.4(d)). Here the source is placed at the centre of curvature of the main mirror and part of the reflected image is further reflected from a sharp edged plane mirror onto the screen or camera. In this case the mirror edge acts in a similar way to the normal knife edge in the Toepler system. A disadvantage is that the incident and reflected rays follow slightly different paths and two slightly offset images are produced. An alternative arrangement uses a graded filter at 45° to the axis at the mirror centre of curvature. The source is placed to one side and a lens focuses the source onto the filter and part of the light is reflected to the main mirror. The reflected image passes back to focus at the source image on the filter and then passes onto the screen. In this way incident and reflected beams can be made to coincide. Once a perturbation occurs, however, some loss of image sharpness may result.

In the double pass system, as the incident and reflective images are not in focus simultaneously, the reflected beam image is usually used, as further refraction occurs in the second passage through the perturbation. Advantages are that the double passage produces increased sensitivity, aided by the fact that the source is imaged at the main mirror centre of curvature instead of its focus. Uses are for situations of very low density flow.

There are many other schlieren system variations, which can be found in Holder and North (1963) or other specialist texts.

17.6.7 Schlieren photography

Schlieren photography produces relatively low contrast images compared to ordinary pictorial photography, and exposure times are also relatively very short. For best printed results, experiment suggests that the negative contrast (γ) should be about 0.5. From Equations (17.7) and (17.13), the exposure (H) is approximately given by

$$H \approx \frac{Bbht}{2m^2 f_1^2} \qquad (17.15)$$

where t is exposure time. This can act as a guide if the speed rating of the emulsion proposed for use is known.

For very short exposure times the *reciprocity law* will often not apply, but for schlieren work this is not significant if suitable emulsions and development are used (Jones, 1952; Castle and Webb, 1953; Holder and North, 1956).

If schlieren pictures are taken using colour film, the film will normally present true colour rendition with either tungsten or daylight illumination. Thus the use of spark or flash tube photography may require corrective filters. However, for most qualitative work, true colour rendering will be of relatively low importance, the use of colour normally being looked upon as an aid to defining various regions of flow using colour filters rather than for artistic effects. If transient light sources are used, it is often arranged that a steady point light source can be arranged to come from the same point as the transient source, allowing adjustment of focus and knife edge cut-off to be set. The amount of cut-off is usually set by trial and error; oversensitivity is counter productive to good pictures. Cine schlieren can be very informative, particularly in wind tunnel flows where the formation of shocks or their movement along a model can be studied in detail with a slow-motion replay. If the pressure of the observed flow becomes too low, normal schlieren pictures may fall off in quality and sometimes a double pass system is used to enhance the results. Alternatively, the schlieren system may be enclosed completely in the low density area so that all the beam paths are in the same pressure region.

17.7 The interferometer system

The first simple *interferometer* was designed by Jamin in 1856 and consisted of two parallel glass plates inclined at an angle to an illuminating beam (Figure 17.6(a)). The working area was limited and the *Mach–Zehnder interferometer* (MZI) was developed around 1891 to overcome this drawback. Interferometry can produce excellent pictures of shock and flow formation. Interferometry also makes it possible to deduce flow density over relatively large areas compared with schlieren by calibration and count of the fringe shift. However, the method is not easy to employ accurately, and in practice is challenged by other measuring methods which are easier to use. A special ability of the MZI is that the location of the fringe measuring pattern can be adjusted at will.

17.7.1 The Mach–Zehnder interferometer

The most common interferometer for the photographic observation of flow fields in wind tunnels is the Mach–Zehnder type (Figure 17.6(b)). This is only one of many possible types of interferometer and layouts of components. As with all types of interferometry, one undisturbed part of an original monochromatic beam is mixed with the disturbed part to form *interference fringes*. The primary beam is split into two parts and directed around two opposite sides of a rectangular frame and recombined at the camera screen. The interferometer structure is extremely strong and stiff. Initially the two beam paths are set to be as near as possible the same length. If this can be done the beams form an *infinite fringe* formation and a plain field will appear on the screen. Small changes in the mirror angles will give changes in the path lengths. Various fringe widths, numbers and orientations can be produced by careful manipulation of the mirrors (Zehnder, 1891; Mach, 1892).

17.7.2 Working principle of the MZI

The MZI is a complicated instrument with a complex working principle and many subtleties in its settings. Thus only a simplified description of its working principles is given here. More complete dicussions can be found in textbooks devoted to the interferometer, of which there are many. Further details of the photographic usage of interferometers can be found in, for example, Kinder (1946), E. Winkler (1947, 1950), J. Winkler (1948) and Hauf and Grigull (1970). The operation of the instrument can be understood by assuming a wave theory of light. If we consider Figure 17.6(c), it can be seen that if the two beam wavefronts are in constructive interference (i.e. exactly in phase when the difference between the wavefronts is an even number of half-wavelengths), they will reinforce each other to produce a maximum field brightness. If they are out of phase in destructive interference (i.e. the difference between the wavefronts is an odd number of half-wavelengths), they will give a minimum field brightness. The intensity will then

Figure 17.6 The interferometer. (a) An early simple type due to Jamin. (b) Schematic diagram of a Mach–Zehnder interferometer. (c) Beams that are in and out of phase. (d) The interferometer field – interference between slightly inclined plane waves producing fringes.

change from bright to dark as the wavefront phase is shifted from 0 to $\lambda/2$, where λ is the wavelength of the light used.

Consider Figure 17.6(b), the original monochromatic beam is split into two beams of approximately equal intensity. After passing round the two sides of the system the two beams are recombined into one and focused onto a viewing screen or camera plate. If the system is so arranged that the path lengths are identical and the density (and thus the wavelength of

the light) of the gas in both path lengths is homogeneous and identical, then the recombined beam will be the same as before it was divided. The intensity of the light on the screen will be uniform and slightly less bright than when it set out due to transmission losses. If any part of the system becomes imperfectly aligned, or the density/wavelength in one path is changed, then the phase of one path will be shifted with respect to the other and interference will occur. At the recombining stage the wavelengths of both waves are the same; however, the wave in which the density change occurred is shifted in phase because its total optical path length has been changed due to the wavelength change whilst passing through the disturbance area. If the density change is uniform in a plane normal to the beam, the entire field will be brightened or darkened according to the amount of phase shift produced. Similarly, if the density varies in a plane normal to the beam the waves will be shifted in phase by a corresponding amount at each point. Each ray shifted by an even number of half-wavelengths will produce a brighter spot on the screen, and all rays shifted by an odd number of wavelengths will give a darker spot on the screen. If the density increases at a constant rate across the beam the phase shift will be by alternately even and odd numbers of wavelengths and a series of uniformly spaced fringes will appear on the screen. Similarly, as the overall density gradient increases the number of phase shifts in a given distance will increase and the fringes will become closer together. Thus sensitivity will be a function of fringe separation.

If initially all elements are perfectly aligned, a plain or 'infinite fringe width' state will exist at the screen. In order to make use of the system to show the patterns of density variations and to provide a calibration, an artificial equivalent of a density gradient can be introduced into the system by slightly tilting one of the mirrors. If we suppose that the mirror is tilted sufficiently to change the path length in that arm by, say, 10 wavelengths, then compared with the undisturbed path, the phase will be shifted by one wavelength for each tenth of the distance, and one light and one dark band or fringe will be produced. Thus a total of 10 fringes will be created on the screen. The distance between fringes will be a function of mirror tilt angle and the wavelength of the light in use. The more closely parallel the two wavefronts are, the greater the spacing between adjacent interference fringes; conversely, the greater the angle between the wavefronts, the closer the fringes will be to one another.

If for a given system the density change per phase shift is known then the fringes will represent a density gradient of known magnitude. Thus, fringe shifts caused by unknown path density changes can be compared with the known variations and trans-

lated into density changes. Whilst this appears to be a straightforward means by which interferometric photographs can yield flow density information, the practical situation requires several less obvious relationships to be outlined. It has already been shown (Equation (17.2)) that

$$\frac{(n-1)}{\rho} = K = \frac{(n_1 - 1)}{\rho_1} \qquad (17.16)$$

this can be written as,

$$\frac{\rho_1}{\rho} = \frac{n_1 - 1}{n - 1} \qquad (17.17)$$

Taking 1 from each side,

$$\left(\frac{\rho_1}{\rho}\right) - 1 = \left(\frac{n_1 - 1}{n - 1}\right) - 1 \qquad (17.18)$$

then

$$\frac{\rho_1 - \rho}{\rho} = \frac{n_1 - 1}{n - 1} - \frac{n - 1}{n - 1} = \frac{n_1 - n}{n - 1} \qquad (17.19)$$

and

$$n_1 - n = \left(\frac{\rho_1 - \rho}{\rho}\right)(n - 1) \qquad (17.20)$$

Now, by definition (see Section 17.4.2), the velocity of light in air (c) is related to the refractive index (n) by

$$c = \left(\frac{1}{n}\right)c_0,$$

where c_0 is the velocity of light in a vacuum. Then

$$\frac{1}{n} = \frac{c}{c_0} ; n = \frac{c_0}{c} \qquad (17.21)$$

The velocity of light (c) equals the wavelength (λ), multiplied by the frequency (f). Then,

$$c = \lambda f \qquad (17.22)$$

and,

$$c_0 = \lambda_0 f \qquad (17.23)$$

Then,

$$\frac{c_0}{c} = \frac{\lambda_0 f}{\lambda f} = n \qquad (17.24)$$

Let the length of the area where a density change has taken place be L, in line with the light beam. For the area of normal density (ρ), the light wavelength is λ. For the disturbed area the density will be ρ_1 and the light wavelength λ_1.

In a length L in the undisturbed area there will be L/λ wavelengths or fringes, and in the disturbed area there will be L/λ_1 wavelengths or fringes. If the number

of phase shifts (i.e. the difference in the number of fringes) is d, then,

$$d = \frac{L}{\lambda_1} - \frac{L}{\lambda} = L\left(\frac{1}{\lambda_1} - \frac{1}{\lambda}\right) \tag{17.25}$$

then,

$$\frac{d}{L} = \frac{1}{\lambda_1} - \frac{1}{\lambda} \tag{17.26}$$

Multiplying through by λ_0 the wavelength of light in a vacuum,

$$\frac{\lambda_0 d}{L} = \frac{\lambda_0}{\lambda_1} - \frac{\lambda_0}{\lambda} \tag{17.27}$$

From Equation (17.24)

$$n = \frac{c_0}{c} = \frac{\lambda_0}{\lambda} \tag{17.28}$$

and

$$n_1 = \frac{\lambda_0}{\lambda_1} \tag{17.29}$$

Then, substituting in Equation (17.27),

$$\frac{\lambda_0 d}{L} = n_1 - n \tag{17.30}$$

From Equation (17.20),

$$\frac{\lambda_0 d}{L} = \frac{(\rho_1 - \rho)(n - 1)}{\rho} \tag{17.31}$$

or

$$\frac{\lambda_0 d}{L(n-1)} = \frac{\rho_1 - \rho}{\rho} = \frac{\Delta\rho}{\rho} \tag{17.32}$$

where $\Delta\rho$ is the relative change in density of the disturbed length L. Thus λ_0 is known, n is known or can be measured and d can be counted; so L and ρ must be determined by independent measurement, e.g. for L by knowing the width of the flow field (e.g. in a wind tunnel the distance between the inside surface of opposite windows) and for ρ by separate density measurements in the undisturbed flow.

Sometimes it can be difficult to count the number of fringe shifts, for example across a shock wave. Gronig (1967) has suggested a solution, in which a small slit of the field of view is illuminated with a white light source which assists in tracing the movement of a certain fringe.

Note that the simple explanation above is for a one-dimensional flow situation (e.g. a wind tunnel) and not for axisymmetric flow fields. The interferometer basically measures *optical path differences* (OPDs) and, as such, has to be very well made and must not be subject to physical distortion or vibra-

tion. If the MZI is used across a wind tunnel working section, *compensating plates* must be introduced into the undisturbed leg to balance the presence of the tunnel windows. Monochromatic light is essential for interferometers. The colour of light varies with wavelength. White light, being a mixture of colours, will have many wavelengths involved in the interferometric process, thus making it difficult to obtain regular fringes. Monochromatic light, however has only one wavelength and thus gives sharp fringes. A typical interferometer picture is shown in Figure 17.7. Note the original setting of fringes in the region undisturbed by the flow.

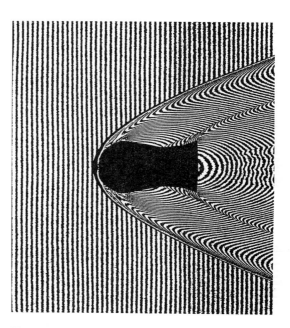

Figure 17.7 An interferometer image. A model of a 30 mm explosively formed projectile (velocity 1400 m s^{-1}). Note the undisturbed fringes.

Before the laser allowed easy production of monochromatic light an alternative method had to be employed. An often used method, still applicable where lasers are not used, is to employ an intense mercury vapour source and pass its output through a very narrow band filter to limit the output to close to monochromatic light. A typical filter might be in the green band. The availability of the laser as a highly monochromatic light source with very good coherence, has allowed the use of a small cross-section reference beam to give savings in component cost (Grigull and Rottenkolber, 1967). There are many variations on the basic interferometer system, including the use of *diffraction gratings* and *Wollaston prisms* which produce a combined schlieren system –interferometer.

17.8 Light sources for schlieren, shadowgraph and MZI

Selection of a light source for schlieren or direct shadowgraph photography needs consideration of luminance, dimensions, duration and possibly its spectral properties. For schlieren sources the dimensions required for slit sources have already been discussed (see Section 17.6.1). Similarly, it has been noted that sources for direct shadow methods must be small to produce sharp images. As emulsion sensitivity depends on the wavelength of the incident light, the source properties will be important. For spark sources, emission of the longer wavelengths is much lower than for tungsten filament sources. The spectral distribution of spark and flash tube sources varies with time and is rich in the ultraviolet and blue in the early stages of discharge at peak current. With time, the light output intensity falls and becomes more red. The blue portion of the output is of relatively short duration, but the total output time is stretched by the *tailing off* of the red portion. It is often suggested that the effective duration can be reduced by using a blue sensitive emulsion. Exposure duration will depend upon the subject and the particular observations being made. Flow that is fundamentally steady may have small variations with time, which will produce blurred images unless exposures are short. Similarly, areas that are unsteady will be undergoing rapid changes and flash sources should have a duration of 1 μs or less. Alternatively, if the flow oscillates between limits, a longer exposure may give a better idea of the true boundaries over a period of time. If an unsteady flow needs to be studied a series of images obtained with short exposure and high framing rate may be of value. In this case a high speed cine camera with continuous lighting or pulsed synchronous flash may be used. These points are discussed fully by Werle (1984), where results of long and short durations are compared.

17.8.1 Continuous light sources

Before photographs are taken it may be required to study visually the flow patterns on a screen. Tungsten filament projector lamps will be adequate for this purpose and can be obtained in a variety of powers and filament sizes. For cine photography and a brighter visual image, compact source discharge lamps are used extensively. High pressure mercury vapour lamps are very appropriate. The small source size and high luminance are suitable for schlieren photography. These lamps require special starting equipment and ballast resistors, and if used for cine photography should, where possible, be run from a direct current (DC) supply to avoid intensity modulation.

An alternative is the xenon gas discharge lamp, again available in various sizes. Gas discharge lamps run extremely hot and the source is very intense, so there are safety hazards from burns. Direct viewing of the source should be avoided in order to prevent eye irritation and damage.

The above sources are suitable for both visual observation and photography if the required exposure time can be achieved by the use of mechanical shutters. They can also be used for setting up purposes if flash or spark photography is subsequently to be used. In this case the optical system will be arranged so that the continuous and spark or flash sources have the same dimensions and emanate from the same point on the optical axis. This can be achieved by mirrors and lenses or by direct substitution methods. The steady source can then be used to align and focus the image ready for the use of the flash or spark source.

17.8.2 Short duration light sources

If the exposure times available with mechanical shutters are not short enough, use can be made of *flash tubes* or *spark gaps*. A flash tube is basically a spark gap sealed into a glass tube with gas under pressure. The light output is produced by applying a very high voltage (usually thousands of volts) across the tube or spark gap. In the case of flash tubes the voltage may vary from a few hundreds of volts to thousands of volts. The voltage is built up across a capacitor connected in parallel with the gap. When the gap breaks down, the gas between the electrodes becomes ionized and an arc discharge begins. The path across the gap has a low resistance, and a large oscillatory current flows through the gap, discharging the capacitor. As the stored energy is drained away the oscillatory current rapidly decreases in amplitude. The gas in the gap heated to a high temperature produces a bright flash of light.

If we assume that the arc resistance is very low, the peak current amplitude (I_p) will be given by

$$I_p = \frac{V_0 \sqrt{C}}{L} \tag{17.33}$$

where V_o is the applied voltage, C is the capacitance and L is the total circuit inductance. For a design in which the capacitor is critically damped,

$$I_p = \frac{V_0}{e} \sqrt{\frac{C}{L}} \tag{17.34}$$

where e is the Napierian constant.

For a given gap the light emitted increases with peak current and the rate of current rise. Current rise time is inversely proportional to the oscillation period. The light duration decreases as the oscillation period proceeds. Thus, for a given system, the desirable properties of high intensity and short duration are achieved by using a high voltage, a

large value of C/L and a small LC. When C is increased to give more light output, the oscillation period and associated inductance also increases. Thus the best compromise is to make the capacitance small and the total inductance of the system (including leads) as small as possible. For short duration sources the light output is usually in the region of 0.1–1.0 μs duration, although spark sources are commercially available with durations down to tens of nanoseconds (10^{-9} s). The light output lags behind the current peak, and even after the current ceases the ionized gas has a short *afterglow* dependent upon the gas and nature of the gap construction. The shortest afterglow occurs with air. The afterglow is a disadvantage when a short intense light pulse is required and can lead to a rapidly fading blurring of the trailing edge of the images of fast moving subjects. The light intensity from a given gap can be increased by the use of gases such as xenon, argon or mercury vapour to act as the current conductor. Unfortunately, the use of these rare gases increases the afterglow time.

For situations requiring very high light outputs the peak light output and duration increases and the afterglow using rare gases becomes relatively less important. For a given current the light output is increased by increasing gap length or the surrounding gas pressure. Increased gap length will require an increased driving voltage, but increased gas pressure will allow a shorter gap length for a given applied voltage.

For practical purposes, flash tubes and spark gaps are more complex than the simple circuit described above. To enable the instant of light emission to be controlled, an additional trigger system will be used. For spark gaps this may be in the form of a series gap or by an extra electrode on the main gap. Flash tubes may have similar electrodes or a wire on the outside of the tube to which a high voltage is pulsed. Gaps will be constructed so as to produce the desired shape of the light source according to the particular purpose for which it is required. Alternatively, auxiliary lenses and slits can be used to adjust the size and shape of the source.

Once the system has been set up it is vital that the light source position does not move. Open spark gaps may produce a certain amount of variation in the position of the arc path from shot to shot. Where necessary, the spark path can be constrained to a well defined path by the use of a fine jet of argon between the electrodes. The jet forms a preferred path for the ionization process and ensures that the arc remains consistent.

Direct shadowgraph systems usually use small circular light sources, whilst schlieren systems use elongated slit sources that are arranged to coincide with the knife edge orientation. Note that whilst, in many cases, schlieren systems use slit sources, in systems where the knife edge may be frequently reorientated, a point source is used to avoid having to realign both the knife edge and the slit each time.

Another important short duration light source is the *laser*. Lasers have many advantages over conventional sources, among which are monochromaticity, very short duration pulses, very high light outputs and a very narrow spectrum of emission. In recent years lasers have tended to be used more and more where these special advantages can be exploited. One area of usage is in the production of shadowgraphs of self-luminous subjects. In this case the camera can be masked by a narrow band interference filter tuned to the laser wavelength, so that only the laser light will be allowed through to the camera.

17.9 Cameras

The normal range of cameras can be used for flow visualization photography as for other high speed photographic purposes. These can range from still cameras used with open shutters for flash and spark photography, or in some circumstances no camera at all, to pin registered, rotating prism, drum, rotating mirror, image converter and video cameras. The appropriate camera type is chosen to suit the particular conditions and requirements.

For still photography, it is an advantage to use a large format camera with a bellows and adjustable back, often called a *technical camera*. It is convenient to have a large format for focusing and observing the image before taking the photograph. These cameras may be mounted on an optical bench and have provision to change the film back, shutter and lens to suit the job in hand.

For cine cameras, the availability of certain features much improve their ease of use for flow studies, these include:

- A reflex viewfinder with a magnified image.
- Direct viewing of the image on the film in the gate to check composition and focus.
- Electrical operation.
- The ability to reload the camera without disturbing alignment.
- The provision of in-camera timing marks.
- As large a film format as feasible for the situation.

Drum cameras and high speed cine and image converters can also be used in the *streak mode*. A continuous source is provided and the typical schlieren set up shown in Figure 17.4(b) or 17.4(c) can be provided with a slit parallel to the direction of motion of the flow or shock fronts and perpendicular to film movement. Over the limited view provided by the slit, a continuous record of flow motion can be recorded on the camera. Knowing system geometry and film speed, a well resolved knowledge

of flow velocity can be obtained from the angle of the recorded streak.

For the highest framing rates, multiple still photographs using multiple sparks, laser flashes or image converter cameras can be used, either to give multiple exposures on a single frame or as stroboscopically synchronized exposures with moving film cameras. Still video cameras can also be used very effectively, although, as with all multiple single frame systems, the number of images is limited before the superimposition of images limits the readable information.

17.9.1 Synchronization

In flow field photography the requirements for synchronization of subject and the instant of image capture will range over a very wide time span. For general pictorial photography in long term steady flow conditions, the photographer may observe the subject status visually and then manually trigger the photograph(s) at a selected time. In this case the synchronization requirements of the subject state and position with exposure instant will be low resolution and manually operated. At the other extreme, photography of a high velocity projectile and its associated flow field will require suitably placed detectors, delay systems and fast response shuttering. To capture the subject while it is in the camera field of view will require high time resolution synchronization and will, of necessity, be automatically operated.

If many sequential short exposure pictures are required, the spark or flash tube can be triggered repetitively and either multiple images produced on a single frame, or a drum camera or synchronized framing camera can be used. Synchronization is required to initiate the sequence. A single spark or flash tube will be limited in its repetition rate due to a finite time being required for the gap to de-ionize ready for the next flash. If a higher repetition rate is required then a *multiple spark camera* of the Cranz–Schardin type can be used for shadowgraphs. Alternatively, a series of sparks can be fired consecutively using a variety of alternative arrangements, and these would be suitable for schlieren or shadowgraph purposes, as detailed by North (1958, 1960) and Fuller and Wlatnig (1974).

17.9.2 General notes

Photographs obtained with all three flow visualization systems described above will normally be made with short duration exposures. Spark and schlieren systems are used extensively in wind tunnels and shock tunnels. Interferometry is not so widely used due to the cost and complexity involved. The applications of the three systems can be summarized as follows:

- Divergent direct shadowgraph – open air applications, very good detail of small turbulence and mild shock waves.
- Focused or parallel light shadowgraph – large amplitude shocks in confined regions (e.g. wind tunnels).
- Schlieren – good for faint shocks and gradual density changes.
- Interferometry – gives a density survey of the whole field, but has limited applications due to cost and complexity.

17.10 Striped backgrounds

A simple system which does not come under the direct heading of schlieren, shadowgraph or interferometry is the use of *striped backgrounds*. To visualize strong shock waves and turbulence good results can be obtained by photographing the model against a striped background. In this case the camera will be focused on the model and a front-lit image will be produced. However, the out of focus background stripes show up shock wave positions very clearly. Whilst not having the sensitivity of shadowgraph or schlieren this is an inexpensive and simple technique. Pulsed laser light provides a suitable source as an alternative to spark or flash sources.

17.11 High speed holography

Holographic images are produced by recording phase comparisons between light from a reference beam and light from the same source which has been scattered from the object under observation. In 1949, Gabor, a pioneer in holography, used a filtered mercury lamp with a fine slit. Light sources with high temporal and spatial coherence are needed to make good holographic images and these properties were not readily available until the advent of the laser. For a full hologram the exposure time must be short enough to restrict object movement relative to the film to less than a quarter-wavelength of the recording illumination. As most flow visualization subjects often involve fairly fast motion, this was a limiting factor in the use of holography until the arrival of very short laser pulses (10^{-10} to 10^{-11} s).

Holography has some major advantages for flow visualization:

- The images are three-dimensional and may be inspected over a wide range of angle of view of the subject.
- The depth of field is mainly determined by the coherence lengths of the taking and viewing radiation, which can now be up to several metres in length.

• The images are almost perfect replicas of the subject and are thus able to provide very accurate information on its properties.

• Once an image has been recorded it can be viewed and analysed using a variety of techniques to extract information.

The taking of single and multiple high speed holograms of surface movement, flow and shock wave studies has been developing over many years. Over the last few years it has been extended to impact shocks and debris scatter using curved film sheets. Taking rates up to tens of millions of pictures per second have already been achieved. High speed holography requires complex set-ups and needs considerable skill for successful execution. However, the amount of information which can be extracted from the images is very impressive and the technique can be expected to assume an increasing role in flow studies in the future. Representative techniques are discussed by Lowe (1970); Raterink and Lamberts (1970), Ehrlich *et al.* (1992), Culler *et al.* (1990), Hough and Gustaffson (1990), and Hough *et al.* (1991).

In some holographic systems it may be necessary to produce two coherent beams from one original simple wavefront, and where diffuse illumination of an object is required it is advantageous to use a controlled partial diffuser or *scatter plate* as a beam splitter. Scatter plate holography has been used to observe the changes in refractive index that occur in the gas in a light bulb as it is warmed by an electric current passing through the filament (Stevens, 1976). The process is not normally visible to the naked eye and the poor optical quality of the bulb envelope prevents the use of conventional interferometry. The photographs in Figure 17.8 show reconstructions of three-dimensional images from a time sequence of holographic recordings formed on one photographic plate. Each hologram is a double exposure recording with 20 ms between exposures. The holograms are overlapped such that each

Figure 17.8 Scatter plate holograms of refractive index changes in a light bulb as it warms up.

exposure acts as the first exposure for one hologram and the second exposure for the previous hologram. The light source used was a 1 ms pulsed ruby laser.

17.12 Other visualization methods

Gaseous or liquid flows can also be made visible by using other methods. This can be done by introducing a *tracing medium* which will be carried by the flow without affecting its motion. This implies small lightweight particles or some method by which small elements of the flow or the complete flow become visible to observation. Tracers will show the presence of eddying, stream separation, laminar and turbulent flow.

The foreign material added to the flow must be composed of particles which can be assumed to move with the flow in terms of the magnitude of velocity and direction. Thus the experimenter attempts to use particles having similar densities to the flowing substance. The method is really an indirect observation in that it is the material introduced that is observed rather than the flow itself. The method is excellent for smooth flow fields but is degraded in unsteady flow where the finite size of the material gives false results, or where the thermodynamic state of the flow varies, as in compressible flow. Here, although the densities are similar, the thermodynamic properties of the material may well be different and give rise to differences in mechanical response.

When tracer materials are added to the flow the interpretation of the records relies on some definitions of the material movements:

• *Streamlines* are curves tangential to the instantaneous direction of the flow velocity in all parts of the field. For example, if small particles in the flow are photographed with a known exposure duration, the result will be a series of streaks. Streamlines will be the curves tangential to these streaks.

• *Filament lines* are the instantaneous loci of all particles that have passed through a fixed point in the field. For example, they can be observed by injecting dye into the flow from a selected position.

• A *particle path* is the path traced by a specific particle in the flow field over a period of time.

The type of line will depend upon the point at which the particles are introduced, their rate of release and the length of the recording exposure. The interpretation of data will also depend on whether the camera or observer is stationary or moving relative to the flow. The interpretation of data from tracer photographs should thus be made with caution until all relevant facts are known.

17.12.1 Smoke tracers

For gaseous subsonic or supersonic flow, smoke can be introduced into the flow field either as discrete fine streamers or as an overall cloud. Smoke particles are extremely light and fine and will respond to rapid fluctuations in the flow. White smoke is usually preferred and set against a black background. Smoke can be produced by using heated oil vapour or smouldering straw or cigars soaked with light oil. At high flow velocities smoke streamers tend to break up and lose their continuity over a relatively short distance. For observing flows in a large volume where a general coverage of smoke or vapour is required, dry ice (solid carbon dioxide) has been used successfully. In the past, ammonium chloride and titanium tetrachloride have also been used.

Fine vapour can also be used, but at low pressures the vapour may evaporate rather quickly. The contaminant is usually introduced through a rake of nozzles upstream of the working area. The nozzles form individual filaments that distort as they come under the influence of the flow to move around or through the object under study. Illumination can be by short duration or continuous light sources, but care should be taken to ensure even illumination.

17.12.2 Particle tracers

For flow with high turbulence rather larger particles are preferred. Small particles of balsa wood, small paper chips and chalk dust are typically used. Particles are used with due consideration of the flow velocity to ensure that they are of a suitable size to be carried without affecting the flow. In general, light coloured particles are preferred against a dark background. Special particles which fluoresce under light of a specific wavelength are also used. They appear as bright light points following the flow contours.

In liquids, air bubbles, immiscible liquid globules, small plastic chips, powdered cork and aluminium powder are suitable tracers for various applications. In the past, carbon tetrachloride has been mixed with benzene to give immiscible globules of a specific gravity nearly the same as water. The globules are visible due to the fact that their refractive index is different from that of the surrounding water.

17.12.3 Liquid flows and cavitation

For laminar liquid flow, ink or dye *streamers* are used in a similar way to smoke in gaseous flows. For the study of surface flow or the shape of liquid surfaces *lycopodium powder* is used sprinkled on the surface. Some additives for liquid flows can produce a double refracting or birefringent effect. The effect is related to the rate of shearing strain in the liquid.

If polarized light is used for the photographic study of liquids containing such additives, isochromatic patterns similar to those seen in solid photoelastic test specimens are observed. A common double refracting material for liquids is *bentonite clay* dispersed colloidally in water. Particles become aligned with the flow lines to produce the changes in the polarized light used for illumination. In cavitation studies, the bubbles produced by the cavitation flow are often adequate tracers without the addition of extra contaminants. They will usually persist long enough downstream to act as flow tracers (see Section 17.14).

17.12.4 Tracer problems

In the use of tracer materials, as with all measurement systems, there is always the danger that the measurement method may affect the values of the parameters being measured. Care has to be taken to see that:

- The tracer material density is as near as possible to the density of the fluid under investigation.
- Inherent properties (e.g. buoyancy), do not tend to make the tracer move in a direction other than the flow direction.
- If it will later be discarded into dumps or drains or the atmosphere, the tracer does not have toxic or other environmentally damaging properties.
- If it is used in facilities such as wind, water or shock tunnels, the tracer will not damage the test structure, pumps, etc.

Note that, under current health and safety regulations, substances such as benzene and carbon tetrachloride would be classified as hazardous substances. Many of the substances mentioned in this chapter as having been used for flow tracing, including liquids, smoke and particles of many types and sizes, may now be restricted by law as to their use. As a general rule, any substance considered for use as a tracing material should be carefully checked for safety hazards and the advice of a professional safety advisor should be sought before its use.

17.13 Illumination and recording in tracer systems

The choice of system will be partly governed by flow velocities and particle size. There are two main recording methods. The first involves a controlled exposure of the complete field in which the movement of multiple particles can be observed. This method is best for long term flow patterns. The second involves measurement of the velocities of particles in a selected controlled volume of the flow

as a function of time. This is more suitable for turbulent flows. In the first method, if an overall illumination is used with a known exposure time, the recorded particle streaks can be used to give velocities at those points. Errors can occur from unwanted scattered light and the selection of particles that are moving in a direction normal to the viewing plane.

17.13.1 Light sheets

These problems can be overcome by using a very thin *light sheet* which reduces the scattered light so that only particles within the beam are registered by the camera. The camera axis is aligned parallel to the direction of maximum light scatter, which is perpendicular to the illuminating plane. Background noise can be reduced if the tracing material can be confined mostly to the illuminated area. Light can be supplied by conventional sources or from laser beams. Light flash duration can be controlled more precisely than the shutter opening time of mechanical shutters and this will be the preferred approach. Even then some sources may have an afterglow, so maximum accuracy can be obtained by the use of a sequence of two or more very short pulses.

The light sheet method has been used successfully in both gaseous and liquid flows. The point source can be a white light or laser source and its light is expanded by a lens system to the width required and then formed into a collimated beam. This beam is passed through a cylindrical lens telescope to form a very thin collimated light sheet which is projected across the area of interest. The surrounding area is kept dark and the camera is placed to view at various angles normal to the beam plane. The flow perturbations will become visible as they pass through the beam plane and can be photographed continuously or intermittently. Some assistance by one of the commonly used fluorescent flow tracers mentioned above is often required to show up the flow variations. The illumination used can be continuous or can be intermittent and synchronized with the shuttering of the imaging system.

This is a powerful technique, as it allows specific areas of flow to be highlighted whilst ignoring other areas not in the light plane. The light plane can be manoeuvred to any convenient orientation and can be placed to show flow through a plane perpendicular to a surface or placed parallel to a surface cross-section (e.g. a wing profile). If required, the light plane can also be traversed slowly to explore long duration flow fields about a static model in a tunnel facility. In this case it will be assumed that the flow patterns do not change significantly during the traversing sequence.

Ingenious use has been made of light sheet techniques to show flow direction and velocity (Busignani *et al.*, 1993). Three light sheets formed by three different coloured lasers are aligned across the flow in the same plane. They are pulsed in a sequential pattern with the first having a short pulse, the second a rather longer pulse and the third again a short pulse. During the pulse sequence the particles in the flow are photographed using colour film with an exposure sufficiently long to encompass the pulse sequence. The particles then appear as short lines in one colour with a dot of different colour at the ends of the lines. The line length can be interpreted in terms of velocity and the coloured dots indicate the direction of flow.

17.13.2 Exposure duration

For smoke or particle flow visualization either short or long exposures can be used depending upon flow velocity and the observation requirement. For instantaneous pictures of flow formation and patterns at particular instants using particles, short exposures will be preferable to reduce blur. However, to show flow direction and velocity, longer exposures can be used. These will show the particles as extended lines rather than point sources and much information can be gained about the overall flow patterns. The angle of the smeared lines will show the direction and direction changes. To measure velocities, the length of a trace over a known exposure time can be measured or the distance moved by the same point on the trace (e.g. the start) can be measured from frame to frame.

17.13.3 Tracing blast waves

Smoke trails are often used to trace the shock wave growth from large explosions. Just before the event black smoke is generated to form a dark background. At an appropriate time smoke rockets or smoke mortar shells are fired into the surrounding area to give a parallel array of fine vertical smoke trails. The expanding blast waves distort the smoke trails, which are photographed by high speed cameras. In a similar way, the passage of blast waves across a surface can be shown by emitting a large number of smoke puffs from a pattern of holes in the surface just before arrival of the wave. The resulting films can later be analysed to show the blast wave progress by observing the movement and distortion of the smoke puffs (Dewey and McMillin, 1990) (see Chapter 16).

17.14 Fluid flow

Fluid flow is studied in the design of ships propellers, underwater equipment and models of shorelines, rivers and estuaries. There is also much interest in the behaviour of bodies that fall or are projected into liquids, both during the entry phase

and the subsequent immersed motion. Entrained air will often accompany the body for some distance after entry. Fluids may also sometimes be used instead of air to study flow about models of aircraft, vehicles or buildings. Liquids are more versatile than gases in terms of their range of tracing effects. Also, under the correct scalar conditions, using appropriate Reynolds and Mach numbers, the higher densities of the fluids allow equivalent flow measurements to be made using lower flow velocities. This is an obvious advantage in terms of photographic exposure times.

Perturbations will be shown in a similar way to gases. Coloured dyes, fluorescent solutions, powders and particles can all be used. In some situations streams of bubbles can be generated to be carried by the flow. The bubbles may be introduced via a rake of nozzles or sometimes by the use of fine wires which are heated to give disassociation of the liquid into local bubble sources. However, these must be used with caution as they will naturally tend to flow in a vertical direction due to buoyancy effects unless kept to very small dimensions consistent with flow velocity and density. A fine example of streamline flow visualization around a model car body can be seen in Figure 17.12.

Some of the most important work is done in the study of turbulence and cavitation, particularly for propeller design. When bodies move through liquids, local lowering of the pressure occurs which can lead to the formation of vapour bubbles, called *cavitation*. This is an inherently unstable phenomenon and the bubbles collapse on reaching an area of higher pressure again. Collapse of the bubbles produces high impact pressures which can have serious effects on turbine and propeller blades. Dark field or side lighting tends to show up bubbles and entrained air to advantage. Varying exposure times will again be used depending on the effect required. For subtle changes, shadowgraph, schlieren and interferometry can all be used, particularly to show small density gradients due to temperature changes or the mixing of fluids with different densities.

17.14.1 Droplets and sprays

Droplets and spray studies are important in the study of engine fuel distribution, agricultural and domestic sprays, fire fighting apparatus and the composition of droplet clouds of all kinds. Tracers are not needed for droplets because they act as their own tracing medium. The droplets can be observed using a condenser optical system or a dark field illumination. Front or side lighting gives specular highlights in each droplet but will not necessarily show their full size. It is sometimes possible to incorporate a scale object in the spray, keeping the depth of field very small so that only droplets in a

small band will appear sharp in the same plane as the scale. Considerable work has been done on droplet visualization using sparks, multi-sparks and, more recently, the metal vapour laser/cine camera technique (Figure 17.9) has been used successfully. When photographing through thick spray clouds, it can be difficult to obtain clear pictures of small selected areas due to out of focus droplets outside the area of interest. This has been overcome by using long extension tubes on the illuminating source and recording objective so that only a small volume of the spray actually appears in the field of view (Stubley, 1995).

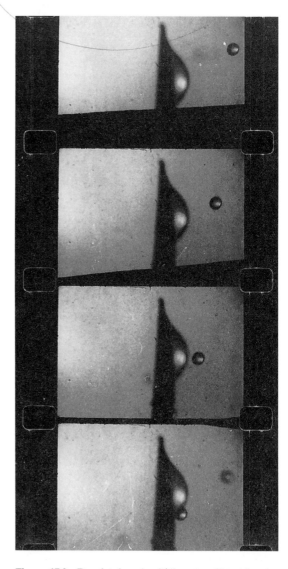

Figure 17.9 Droplets in a cloud (diameter of hypodermic needle 500 μm). Taken with a metal vapour laser from Oxford Lasers and a Hadland Hyspeed 16 mm camera.

17.15 Surface flow structure in gases

It is often required to study the behaviour of gaseous flow over surfaces in the boundary layer region where the gas flow is being affected by the presence of the surface. These effects are of particular interest for aircraft and missile studies in the various regions of subsonic, trans-sonic, supersonic and hypersonic flight.

17.15.1 Tufts

Surface flow over bodies involving turbulence or flow separation can be visualized very simply at lower flow velocities by using mechanical indicators. These can take the form of short threads (*tufts*) fixed in a pattern on the surface under study. These will align themselves with vortices and the flow direction and can be photographed using transient or continuous methods with long or short duration exposures. Exposures may need to be chosen with care to give a true indication of tuft alignment angle, particularly if the tufts are fluttering at a fixed rate.

17.15.2 Surface coatings

An alternative method is to use various surface coatings that are worn away or distorted by the flow to bring out direction and flow patterns. Usually the coatings can be made to obscure a bright underlayer which is steadily made more visible as the coating is removed from the surface. Heat transfer to the surface can also be shown by temperature sensitive coatings which change colour according to flow conditions. These will be photographed repeatedly over a period of time in order to introduce a time scale. These methods often require precise timing in observation as the effects produced are often transitory and may cease to appear at all after a short time. All these methods will be recorded by means of either cine or still photographs. The use of removable surface coatings can also be applied to liquid flows. Liquid flows (e.g. water tunnels) can often be used to test objects which would normally move through gases (e.g. scale models of aircraft) (Figure 17.10). Suitable conversion of results must of course be made to allow for the different medium involved (Decker *et al.*, 1993).

17.16 X-ray applications

In some fluid flow studies, particularly those of liquid metals, the photographer is hampered either by the presence of an opaque container or by bright self-illumination, which will defeat ordinary photographic systems. Both problems can be overcome by

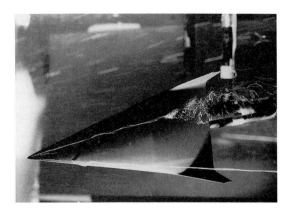

Figure 17.10 Model of hypersonic research vehicle ELAC 1 in a water tunnel. Taken using a xenon flash-lamp with 1200 ns duration.

the use of X-ray methods. X-ray photographs can be taken as single or multiple exposures with short exposure times. They can thus be used to study the flow of liquid metal during a casting process or can be used to show droplet transfer in arcs or electric welding operations.

The X-ray voltage and penetrating ability will be chosen according to the application and materials involved. For a casting process, the mould must be penetrated but the cast metal should show up clearly. High speed cine X-ray systems are particularly useful for metal flow studies as they introduce the time history element into the observation. They will consist of an X-ray source of either long duration or gated type, an X-ray to visible light converter in the form of a scintillator screen, or an X-ray image intensifier and a high speed rotating prism camera or image converter camera. As the film materials can be shielded from visible light, X-rays are used in studying self-luminous events such as arc welding. Again, short duration exposure cine systems are preferred. According to the system chosen, framing rates between a few thousand and a million pictures per second can be attained.

X-rays have also been used to study the formation of spray jets by incorporating metallic salts into the liquids. This enables the jets to be shown more clearly by the X-rays by increasing the normal absorption level. If flash X-rays are used very small particles can be frozen in flight due to the very short duration of exposure (Krehl and Warken, 1990).

17.17 Energy addition systems
17.17.1 Spark tracing

Spark tracing is a specialized method of showing gaseous flows. It has the benefit of showing a three-dimensional view of the flow. It can be applied to

flows of tens of metres per second up to high Mach numbers, and from a few torr (133.22 N m⁻²) up to tens of atmospheres pressure. In *spark tracing*, a luminous ionized plasma channel is produced by a spark discharge across a pair of electrodes placed at a suitable point in the flow. Because the luminous ions of the discharge come from the flowing medium the indicator has nearly the same mass as the medium and thus moves in unison with it.

The primary pulse forms a discharge between two wires or points so that its path is across the direction of the flow. High voltage pulses are then fed at rapid repetition rates to the same electrodes to ensure that before the ionized plasma channel becomes de-ionized it retraces the path of the primary spark. However, in this interval the de-ionizing plasma path has been moved by the flow and a series of luminous lines move with flow velocity, and at the same time adopt the pattern of the flow. The spark discharges are of short duration and can be up to 100 000 Hz (pulses per second), the *repetition frequency* being chosen according to flow velocity. Photographs are taken on a single frame using a large format camera with open shutter. If three-dimensional information is required, two cameras can be set up to view the scene from two directions. Some idea of flow velocity can be obtained by noting the distance moved by the spark trace in the spark interval (Figure 17.11) (Frungel, 1976).

17.17.2 Laser induced bubbles

Cavitation bubbles in liquids have been studied in detail by using very high speed still video techniques to photograph single bubbles produced by a high intensity pulse from a Nd.YAG laser (Ward and Emmony, 1990). Changes in the bubbles and surrounding liquid were visualized using interferometric techniques.

17.17.3 Laser induced plasmas

High intensity laser light can also be employed to produce self-luminous plasma bubbles in gaseous

flows (Klingenberg and Schroder, 1976). The luminosity of the bubbles falls off fairly rapidly but their tracks can be recorded using high speed photography. Short duration laser light sheets have also been used to study flames. The flames are illuminated by a scanned pulse from a flash-lamp pumped dye laser source and during the pulse several frames are recorded using an image converter and charge coupled device (CCD) camera. Fibre optics are used to provide small light spot registration marks in each frame. The system provides three-dimensional information of the flame during a very short time duration of a few microseconds.

Laser induced *plasma spots* have also been used to trace muzzle flow fields in guns (Miller, 1967). In this case the bright plasma spots are imaged to pass across a photodetector with a grid across its face. The sequence of light pulses is recorded to give the flow velocity at the plasma formation point. Other pictures are also taken to give an overall view of position and flow direction. By moving the point at which the plasma spots are produced, a picture of the whole flow field can be built up by a series of similar firings.

17.17.4 Spark induced bubbles

An alternative method for wind tunnel flows is to fire a spark discharge across a small gap placed in the flow. A spherical *blast bubble* is formed which expands and also travels with the flow. These bubbles have a rather longer life time than plasma spots and can thus be used in higher pressure and lower velocity flows (Miller, 1967).

17.17.5 Photochromatic indicators

Another liquid tracer technique uses *photochromatic indicators* injected into the liquid which become fluorescent when irradiated by a pulse of focused ultraviolet radiation. A development of this method uses a high pulse energy nitrogen laser to produce high resolution grid patterns in the flow. The grids are in the form of two intersecting sets of parallel lines. The grids move with the flow and become distorted and decay very rapidly. A strobe

Figure 17.11 Flow visualization using multiple spark tracing.

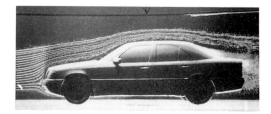

Figure 17.12

light and 35 mm still camera are used to record the grid deformations. Measurements of velocity, shear rate, circulation and vorticity can be obtained (Hummel, 1976).

References

Anderson, R. *et al.* (1990) Conversion of schlieren systems to high speed interferometers. In *Proc. 19th Int. Congress on High Speed Photography and Photonics*, Vol. 2. (Garfield, B. and Rendell, J., eds), pp. 992–1002. Society of Photo-Optical Instrumentation Engineers, Bellingham, NY

Barkofsky, E. (1952) Multiple image silhouette photography for the NOTS aeroballistic laboratory. *J. SMPTE* **61**

Busignani, S. *et al.* (1993) Combined streak spot imaging analysis method using multicolour light sources. *Fluid Eng. Div. ASME* **172**

Castle, J. and Webb, J. (1953) Results of very short duration exposure for several fast photographic emulsions. *Phot. Eng.* **4**, 51

Cullis, I., Parker, R. and Sewell, D. (1990) Holographic visualization of hypervelocity explosive events. In *Proc. 19th Int. Congress on High Speed Photography and Photonics, Cambridge, England*, Vol. 2 (Garfield, B. and Rendell, J., eds), pp. 52–64. Society of Photo-Optical Instrumentation Engineers, Bellingham, NY

Decker, F. *et al.* (1993) Low-speed aerodynamics of the hypersonic research configuration ELAC 1. *J. Flight Sci. Space Res.* **17**, no. 2, 99–107

Dewey, J. and McMillin, D. (1990) The analysis of results from high speed photogrammetry of flow tracers in blast waves. In *Proc. 19th Int. Congress on High Speed Photography and Photonics, Cambridge, England*, Vol. 2 (Garfield, B. and Rendell, J., eds), pp. 246–253. Society of Photo-Optical Instrumentation Engineers, Bellingham, NY

Ehrlich, J. *et al.* (1992) A new system for high speed time-resolved holography of transient events. In *Proc. 20th Int. Congress on High Speed Photography and Photonics, Victoria, Canada* (Dewey, J. and Racca, R. eds), pp. 372–375. Society of Photo-Optical Instrumentation Engineers, Bellingham, NY

Frungel, F. (1976) High frequency spark tracing and application in engineering and aerodynamics. In *Proc. 12th Int. Congress on High Speed Photography and Photonics*. Society of Photo-Optical Instrumentation Engineers, Bellingham, NY

Fuller, P. and Wlatnig, E. (1974) A multiple spark system incorporating fibre optics and an electronic timer for projectile photography. In *Proc. 11th Int. Congress on High Speed Photography and Photonics*. Society of Photo-Optical Instrumentation Engineers, Bellingham, NY

Grigull, U. and Rottenkolber, H. (1967) Two beam interferometer using a laser. *J. Opt. Soc. Am.* **57**, 149–155

Gronig, H. (1967) New MZI technique for shock tube measurements. *J. Am. Inst. Aeronautics Astronautics* **5**, 1046–1047

Hauf, W. and Grigull, U. (1970) Optical methods in heat transfer. *Adv. Heat Transfer* **6**, 131–366

Hilton, W. F. (1951) *High Speed Aerodynamics*. Longmans, Green and Co., London

Holder, D. and North, R. (1952) A schlieren apparatus giving an image in colour. *Nature* **169**, 466

Holder, D. and North, R. (1954) *Colour Schlieren System Using Multicolour Filters of Simple Construction*. National Physical Laboratory/Aer/266. HMSO, London

Holder, D. and North, R. (1963) *Schlieren Methods*. Notes on Applied Science No. 31, National Physical Laboratory. HMSO, London

Hough, G. and Gustaffson, D. (1990) Ballistics applications of lasers. *Proc. SPIE* **1155**, 181–188

Hough, G. *et al.* (1991) Enhanced holographic recording capability for dynamics applications. *Proc. SPIE* **1346**, 194–199

Hummel, R. (1976) Non-disturbing flow measurement using the photochromic tracer technique. In *Proc. 12th Int. Congress on High Speed Photography and Photonics*. Society of Photo-Optical Instrumentation Engineers, Bellingham, NY

Jones, G. (1952) *High Speed Photography*. Chapman & Hall, London

Kaye, G. and Laby, T. (1986) *Tables of Physical and Chemical Constants*. Longman, London

Kinder, W. (1946) Theorie des mach-Zehnder interferometer und beschriebung eines gerates mit einspiegelein stellung. *Optik* **1**, 413–448

Kleine, H. (1995) Shock wave diffraction – new aspects of an old problem. In *Shock Waves at Marseilles*, Vol. 4, pp. 117–122. Springer-Verlag, Vienna

Kleine, H. and Gronig, H. (1990) Colour schlieren methods in shock wave research. In *Shock Waves*, pp. 51–63. Springer-Verlag, Vienna

Kleine, H. and Gronig, H. (1991) Colour schlieren experiments in shock tube and tunnel flow. In *International Workshop on Strong Shock Waves*, pp. 41–48. Chiba, Japan

Klingenberg, G. and Schroder, G. (1976) Gas velocity measurements by laser-induced gas breakdown. *Combustion and Flame* **27**, 177–187

Krehl, P. and Warken, D. (1990) Flash soft X-radiography, its adaptation to the study of breakup mechanisms of liquid jets into a high density gas. In *Proc. 19th Int. Congress on High Speed Photography and Photonics, Cambridge, England*, Vol. 2, (Garfield, B. and Rendell, J., eds), pp. 162–173. Society of Photo-Optical Instrumentation Engineers, Bellingham, NY

Lowe, M. (1970) A rotating mirror hologram camera. In *Proc. 9th Int. Congress on High Speed Photography and Photonics*. Society of Photo-Optical Instrumentation Engineers, Bellingham, NY

Mach, L. (1892) Uber einen Interfernez refraktor. *Z. Instrum.* **12**, 89–93

Maddox, A. and Binder, R. (1971) A new dimension in the schlieren technique, flow field analysis using colour. *Appl. Opt.* **10**, 474–481

Marey, E. (1901) Les mouvements de l'air étudies par la chronophotographie. *La Nature* **29**, 232–234

McDowell, R. and Miller, C. (1976) Colourisation of schlieren images. In *Proc. 12th Int. Congress on High Speed Photography and Photonics, Toronto, Canada.* Society of Photo-Optical Instrumentation Engineers, Bellingham, NY

Miller, H. (1967) Shock on shock simulation and hyper-velocity flow measurements with spark discharge blast waves. *J. Am. Inst. Aeronautics Astronautics* **5**, 1675–1677

Mikhalev, A. and Warken, D. (1995) Experimental investigation of aerodynamics and flow patterns of typical explosively formed projectiles. In *Proc. 15th Int. Symposium on Ballistics, Jerusalem, Israel* (Mayseless, M. and Bodner, S. eds), pp. 419–426. Society of Photo-Optical Instrumentation Engineers, Bellingham, NY

Miyashiro Seiji (1992) Short duration spark source for colour schlieren methods. *Proc. Society of Photo-Optical Instrumentation Engineers* **1801**, 248–257

North, R. (1958) A Cranz–Schardin high speed camera for use with a a hypersonic shock tube. NPL/Aero/399. In *Proc. 4th Int. Congress on High Speed Photography.* Society of Photo-Optical Instrumentation Engineers, Bellingham, NY

North, R. (1960) *High Speed Photography Applied to High-speed Aerodynamics at NPL.* NPL/Aero/406. HMSO, London

North, R. (1970) Spark photography of models in free flight in a hypersonic shock tunnel. In *Proc. 9th Int. Congress on High Speed Photography.* Society of Photo-Optical Instrumentation Engineers, Bellingham, NY

North, R. and North, N. (1956) Tests to determine the suitability of various commercially available emulsions for photography of high speed airflow with short duration spark light sources. In *Proc. 3rd Int. Congress on High Speed Photography.* Society of Photo-Optical Instrumentation Engineers, Bellingham, NY

Pearcey, H. (1950) *The Indication of Boundary Layer Transition on Aerofoils in the NPL 20 × 8 in. High-speed Tunnel.* A.R.C. C.P.10. National Physical Laboratory. HMSO, London

Raterink, H. and Lamberts, C. (1970) Holographic interferometry applied to high-speed flame research. In *Proc. 9th Int. Congress on High Speed Photography.* Society of Photo-Optical Instrumentation Engineers, Bellingham, NY

Settles, G. (1970) A direction indicating colour schlieren system. *J. Am. Inst. Aeronautics Astronautics* **8**, 2282–2284

Stevens, R. (1976) Three-dimensional time resolved measurements from holographic records. *Optics Laser Technol.* **8**, no. 4, 167–173

Stubley, P. (1995) Sprinkler spray interaction with fire gases: further development of a quasi field model. Ph.D. thesis, CERC South Bank University, London

Toepler, A. (1866) Beobachtungen nach einer neuer optischen methode. *Poggendorf. Ann. Phys. Chem.* **127**, 556

Towers, C. *et al.* (1990) A laser light sheet investigation into transonic external aerodynamics. In *Proc. 19th Int. Congress on High Speed Photography and Photonics,* Vol. 2 (Garfield, B. and Rendell, J. eds), pp. 952–965. Society of Photo-Optical Instrumentation Engineers, Bellingham, NY

Ward, B. and Emmony, D. (1990) Interaction of laser-induced cavitation bubbles with a rigid boundary. In *Proc. 19th Int. Congress on High Speed Photography and Photonics,* Vol. 1358 (Garfield, B. and Rendell, J. eds), pp. 1035–1045. Society of Photo-Optical Instrumentation Engineers, Bellingham, NY

Werle, H. (1984) Etude des courants fluides a l'aide de photographie et cinematographie rapides. In *Proc. 16th Int. Congress on High Speed Photography and Photonics, Strasbourg, France* (Andrée, M. and Hugenschmidt, M., eds), pp. 801–808. Society of Photo-Optical Instrumentation Engineers, Bellingham, NY

Winkler, E. (1947) *Analytical Studies of the Mach–Zehnder Interferometer. Part 1.* Naval Ordinance Laboratory Report 1077. Naval Ordinance Laboratory, USA

Winkler, E. (1950) *Analytical Studies of the Mach–Zehnder Interferometer. Part 2.* Naval Ordinance Laboratory Report 1099. Naval Ordinance Laboratory, USA

Winkler, J. (1948) The Mach interferometer applied to studying an axially symmetric supersonic air jet. *Rev. Sci. Instrum.* **19**, 307–322

Worthington, A. (1908) *A Study of Splashes.* Longmans, Green & Co., London

Worthington, A. and Cole, R. (1897) Impact with a liquid surface studied with the aid of instantaneous photography. *Phil. Trans. R. Soc., London, Ser. A* **189**, 137–148; **194A**, 175–200

Zehnder, L. (1891) Ein neuer Interferenz refraktor. *Z. Instrum.* **11**, 275–285

Bibliography

Arnold, C., Rolls, P. and Stewart, J. (1971) *Applied Photography.* Focal Press, London

Fuller, P. (1994) Aspects of high speed photography: Part 4 – Study of fluid flow. *J. Photogr. Sci.* **42**, no. 4, 133–139

Hyzer, W. (1962) *Engineering and Scientific High-Speed Photography.* Macmillan, New York

Merzkirch, W. (1974, 1992) *Flow Visualisation.* Academic Press, London

Saxe, R. (1966) *High-Speed Photography.* Focal Press, London

18 Industrial applications of high speed photography

John T. Rendell

18.1 Introduction

18.1.1 Early applications

Twenty years elapsed from the taking of the first spark photograph to stop motion by Fox Talbot in 1851, before short duration photography came into general use for studying the behaviour of moving objects. In Chapter 1 it was noted that many attempts were made to record military projectiles in flight from about 1885 to the early 1900s. As photographic emulsions improved, so attempts were made to record these by using sparks for lighting and, remarkably, also by using daylight. By 1900, excellent still photographs were being recorded by Professor Boys and others. Even the surrounding airflow and shock waves of projectiles could be studied in shadowgraph pictures. These methods were continued well into the 20th century and particularly during World War I (1914–1918). However, a single photograph limited the detailed study of motion to one point in time, although some attempts were made to overcome this with multi-spark lighting on a single photograph, which was a half-way step to true analysis of motion.

By 1877, Professor Muybridge had developed a successful mechanical camera shutter giving an exposure of 1/1000 s, as a result of being requested to settle an argument as to whether the four hooves of a trotting horse left the ground together. His now famous arrangement of a row of 12 cameras that were successively triggered by the horse, overcame the problems of a still photograph and allowed study of the animal's movement.

Marey developed a 'gun camera' using a circular plate onto which he could record a series of pictures of a bird in flight, and by 1889 this camera could record 100 pictures per second (pps).

18.1.2 The 1930s

Following the development of the cine (movie) film, this technology was mainly used for entertainment purposes. Techniques of *time lapse* and *slow motion filming* were limited to special effects in these early silent feature films, and produced by under- or over-'cranking' the hand turned cameras. It was not until the early 1930s that Eastman Kodak introduced a so-called 16 mm 'substandard' gauge cine film that was originally intended for the growing amateur movie film market. At about the same time, F. J. Tuttle designed the rotating prism high speed camera. Almost immediately after this, the Eastman High Speed camera was marketed. Using the new 16 mm film stock, these cameras could run initially at 2000 pps and soon afterwards at 3000 pps. Within 2 years the Wollensak Fastax camera, which could reach 4000 pps, was launched.

Probably for the first time in its history, high speed photography was used for an industrial application at the Bell Telephone laboratories in the USA. Electrical relay switches, as then used in telephones, were suffering from premature failure. By studying the behaviour of the electrical contacts, engineers discovered considerable 'bouncing', which resulted in excessive electrical arcing and caused erosion and failure. These studies resulted in a full scale research and development programme to modify and improve switch design so as to reduce the bouncing each time the contacts were open or closed.

Throughout the USA, industrial engineers increasingly used high speed photography to solve problems associated with complex fast moving mechanisms. By studying the action in slow motion playback, or by frame by frame analysis, it was possible to solve problems in fields from automobile research to zip fastener manufacturing. The effects of increasing the speed of machinery could be studied and, in many cases, speeds successfully increased without malfunction. This helped manufacturers to reduce failures, to improve their output and, ultimately, to lower costs.

18.1.3 World War II (1939–1945)

World War II (1939–1945) placed greater demands on the capabilities of high speed cameras to help boost war time production and especially the testing of munitions. By this time the ubiquitous Eastman and Fastax cameras shouldered much of this burden.

Fastax cameras in particular now had improved driving motors and control systems, and by 1939 were able to operate at 8000 pps (full frame) and 16 000 pps (half-height frame). Both makes of camera were used extensively in the testing of military weapons.

Many alternative forms of new cameras were designed in both Europe and the USA to observe ultra-high speed phenomena. Cameras running up to several million pictures per second were developed by atomic weapons research laboratories in the USA and the UK, to observe the early stages of detonation in both conventional and newly developed nuclear warheads.

18.1.4 The post-War years (1945–1965)

After the War the interest in high speed photography for industrial purposes in the UK was probably generated by Kodak Limited at Harrow. As well as producing a high speed camera, Kodak Limited operated a high speed photographic service to industry. Former Royal Air Force photographer John Hadland joined the two man team at Harrow, to manage this operator service to industry, equipped with an Eastman III High Speed camera outfit. This unit was disbanded after a short period, but the equipment was then bought by John Hadland to commence a service from his Chipperfield home in 1957. This service was available throughout the UK, operating on a daily consultancy basis in order to generate interest in the technique. By 1958, this business had grown to a point where many clients wished to have their own cameras and John Hadland then became UK distributor for Wollensak Fastax cameras. The high speed photography service to industry has continued ever since, although the company has now moved entirely into ultra-high speed electronic imaging systems.

Traditionally, film cameras have been extensively used for troubleshooting as well as for basic research and development work in industry. Their ability to pin point production machinery problems as well as assisting in the design of basic machines was legendary. No other instrument was able to record fast moving machinery and reduce the action to a comfortable slow motion level, or to permit frame by frame viewing to take measurements. The only real problem with the use of film was waiting for the result. This could take at least 2 days, but usually up to a week, before the processed results could be analysed. By this time, the fault could change, or even disappear for a time and reappear when the cameras had been removed. Processing a 30 m (100 foot) roll of cine film was not easy. It required at least a darkroom, a sink with running water and space in which to dry the film. To overcome this, Hadland developed a simple table-top film processing machine in 1960. This could be run without running water, or a darkroom. It only needed a domestic electrical supply. Consequently, it could often be seen sitting alongside the production machines on the factory floor. A roll of film could be processed in 30–45 min 'dry-to-dry' and be viewed on a simple analyser in under an hour. Changes could then be made as necessary to the machine under surveillance and further exposed film recorded and analysed. The high speed film camera/processor/analyser combination became an almost essential system in the industrial set up. A 'table top' film processor is shown in Figure 18.1.

Figure 18.1 A black and white cine film processor as represented by the Bray 16/35 Table Top Model 'Mini B'. (Picture courtesy of Bray Imaging Technologies Ltd.)

18.2 The introduction of video technology

From the mid-1960s, attempts were made to overcome the obvious disadvantages of film. Video technology was the obvious alternative with the benefits of

- Instant replay of records.
- Simple operation compared with film systems.
- Twin camera viewing for either two angled viewing or for stereo comparator analysis.
- Extremely low running costs.
- Long play capability to record elusive events.

First attempts using video analysis were made with modifications to existing cameras. Initially, video was used to spot check industrial production line processes, but the slow framing rates then available severely restricted their use for true slow motion. Even by the end of the 1970s video systems had only reached 120 frames per second (fps).

For a while in the early 1980s, Mekel Engineering in the USA launched their unique instant film system using Polaroid Super 8 film cassettes. This could run at 300 pps and for a short period. It was the fastest motion analysis system which could run at this rate in colour or black and white and be able to produce a finished result for analysis in under 2 min. It was particularly popular for industrial purposes where the recording rates were sufficiently high for production line processes. Its popularity was short lived due to the demise of the special Polaroid cine film required and the contemporary advances being made in video technology. Nevertheless, film supplies continued for at least 10 years.

In 1981, NAC of Japan released their new high speed video motion analysis system, the Model HSV 200. It could record at 200 fps and replay in slow and stop motion, both forwards and in reverse. In a single stroke, the new system almost doubled the framing rate of its nearest video rival. By 1981, Kodak had launched their Model SP 2000 system (Figure 18.2) and with it the potential of rivalling film camera rates at 2000 full fps, or 12 000 split fps. High speed video technology continued to improve over the next 15 years, during which time colour recordings could be made at 1000 fps and the Kodak 4540 motion analysis system could reach 4500 full fps to 40 500 split fps.

High speed video has one overwhelming feature, i.e. the ability to replay recordings immediately, considered essential with many industrial events. As well as the traditional research and development and troubleshooting roles, video systems can be used to 'tune' a machine. After overhaul periods, a production machine needs careful 'retuning' to run efficiently. Normally this is a laborious manual process. However, using a high speed video system, early recordings clearly show any timing discrepancies in the dynamic mode, which could in turn lead to unreliable running, poor output, or both. Making timing changes whilst the machine is running and checking the result with the high speed video system helps the operator to pinpoint and eliminate the problem. As a result, machine tuning and 'down times' are reduced to a minimum. Often, high speed video systems never leave the shopfloor, to enable them to be called upon at any time.

Despite their differences, both film and video technologies continue to co-exist in industry. With its data gathering potential still well ahead of electronic imaging, film is now used where it is most needed; in particular, where ultimate image resolution and high framing rates are needed.

Where is high speed photography being used today? Few industries exist that have not been able to use this technology to study and improve fast moving machinery. A selection of examples are considered in detail below.

18.3 Cigarette manufacturing and packaging industry

This was probably one of the first industries to need high speed analysis as a troubleshooting tool, since cigarette making uses extremely fast machinery, often needing camera rates of up to 10 000 pps. Initially, Eastman Kodak and Fastax rotating prism cameras were used as early as the late 1950s. Nowadays the industry has, with few exceptions, converted to high speed video analysis, in particular since 1985 the Kodak SP 2000 and Ektapro camera systems (Figure 18.3). The cameras are invariably used in *split frame mode* to obtain maximum framing rates. Coincidentally, the cylindrical shape of a cigarette suited the split frame format and only needed careful camera alignment! The recording of packaging came well within the video full-height format framing rates. The main application is machine tuning using the method already described and, again, high speed video equipment rarely leaves the shopfloor.

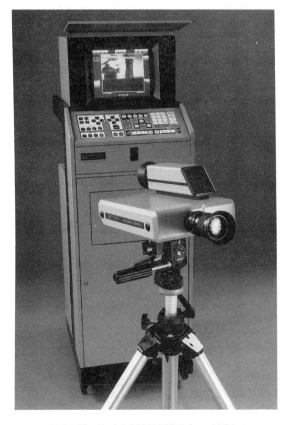

Figure 18.2 The Kodak SP2000 High Speed Video Motion Analysis System of 1983. (Picture courtesy of Kodak Ltd.)

Figure 18.3 A Kodak SP2000 Motion Analysis System in use with Molins cigarette machinery, Sanderton in 1985. (Picture courtesy of Molins Ltd.)

18.4 Manufacture of electrical and electronic components

First applied at the Bell Telephone company in the 1930s, high speed photography has been used worldwide ever since. Most relays and switches have at some time been recorded using a high speed camera and this has aided their subsequent design and manufacture.

Similar problems of 'arcing' affect even the largest switching mechanisms. In the 1960s, National Grid switching operations were greatly assisted by use of the high speed camera. While running at 8000 pps, cameras recorded on colour film the arcing of a switch, or a circuit breaker running at full load. Special 'arc chutes' were designed to disperse the high current, high voltage arcing as quickly as possible before serious damage occurred. Observing the arcing assisted in the design of a chute.

Ultra-high speed photography requiring the use of rotating mirror cameras recorded the behaviour of various devices built to safely disperse any lightning strikes to National Grid power lines during thunderstorms.

High speed video systems have been mainly used in printed circuit board assembly to observe in close-up the automatic positioning of electronic components onto the board at high speed. Faulty positioning can be detected and rectified so that machines can be made to run at their maximum possible speeds for long periods without breakdown.

18.5 Film making and advertising industries

In many aspects of movie film and television production, the high speed film camera predominates because of its ability to:

- Provide high resolution colour or monochrome master films.
- Run at higher framing rates than any video system up to 10 000 pps (16 mm) and 3000 pps (35 mm).
- Provide a master film for the cinema or television to any of the world's appropriate standards.

About one in four broadcast television commercials use high speed photography in some form (Figure 18.4), at speeds of 100–10 000 pps. Film and television probably use more film material than any other industry, because high speed photography plays such an important role in this field.

18.6 Food and drink industries

Since the early post-War years, probably at least half of the industrial high speed photography carried out has been with food production machinery, mainly being used for trouble shooting purposes. From the late 1950s to early 1980s, film cameras of the Fastax or Hitachi types were used. Framing rate requirements were not high and the immediate playback provided by the competitive video systems

Figure 18.4 The making of a TV commercial for Lenor, showing the product being dropped onto clothing. (Picture courtesy of David Bowley, Hadland Photonics Ltd.)

introduced in 1980, ideally suited the application. Their framing rates (100–2000 fps) could cope with the diverse applications found in this industry. Multi-coloured goods and packaging ideally suited the new high speed colour video systems, such as those from NAC, Japan. Colour images helped to identify the product being recorded and assisted analysis. Machine tuning soon became the main application for these systems.

The food and drink industry can roughly be divided into four sections: confectionery; bakery; vegetable and fruit preparation and canning; and the bottling and canning of drinks.

18.6.1 Confectionery

The packaging of sweets and chocolate bars tends to monopolize the usage of high speed video cameras. Fast moving complex machinery requires continuous monitoring in order to avoid product jamming and machine down-times. The high speed video camera can usefully help to maintain production. However, some unusual manufacturing processes demand inspection. In particular, the moulding of chocolate bars, or making a chocolate egg with vibrating chocolate sheets can be studied in detail.

18.6.2 Bakery

Biscuit packaging has been studied since the earliest days of high speed recording. Plain brittle biscuits are particularly vulnerable to damage, making the product unacceptable to customers. Much work has been carried out since the 1960s to solve the breakage problem, using transparent materials to observe the biscuits at various points throughout the machine.

18.6.3 Vegetable preparation and canning

Also during the 1960s, new automated machines were being developed to remove flawed vegetable particles in machines used for cutting and dicing. For example, Brussels sprouts were carefully stripped from the stalk and peas were individually pricked to avoid bursting when cooked. All these processes were carried out at production machine rates, and high speed film cameras assisted in the progressive development of these machines. Later, high speed video systems were introduced and these are often used both for research and development and the tuning of canning and packaging machines.

18.6.4 Bottling and canning of drinks

The bottling and canning of aerated soft drinks and beer is done at extremely high speeds. The filling of quarter or half litre bottles, or of cans of gaseous mineral waters or beer without spillage, plus cap-

ping, date stamping and crating, requires the ultimate in precision engineering. High speed video motion analysis systems have assisted in the development and the subsequent day to day maintenance of such packaging machines. As an example, the behaviour of an aerosol spray emerging from a can is shown in Figure 18.5.

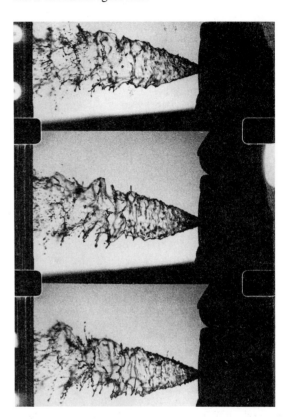

Figure 18.5 A cine sequence taken at 5000 pps showing a domestic aerosol spray emerging from a nozzle. A Hadland Hyspeed 16 mm camera was used with a synchronized copper vapour laser 'Laserstrobe'. (Picture courtesy of Oxford Lasers Ltd; photographer John Rendell.)

18.7 Glass making industries

High speed cameras have been used by the glass making industry since the 1950s. Originally, a number of problems with 'gob' cutting machinery for bottle making purposes was affecting output, so film cameras recorded the action of the knives as the section or gob of glass was cut from the molten glass stream before being blown into bottle shapes.

Considerable research and development has been carried out to study crack propagation in windscreen glass destined for vehicles and aircraft. In aircraft, the effect of rain droplets on the windscreen of low flying high speed aircraft has been researched in

detail. In both cases, ultra-high speed photography has been necessary, using rotating mirror and image convertor cameras capable of operating at rates of several million pictures per second.

18.8 Power industries

18.8.1 Coal

High speed cameras of moderate framing rates have observed the behaviour of drive chains on conveyor belts used in transporting coal from the working face to the pit head, operating in extremely harsh conditions. Higher speed recordings are needed to study the characteristics of atomized coal burners. Figure 18.6 shows investigations into the behaviour of a dust extractor.

18.8.2 Gas

During the transition from town (coal) gas to North Sea gas in the 1960s, a number of tests were carried out on the underground gas mains which now cover the UK. It was essential to establish if these very high pressure pipes could be safely ruptured when buried. Field tests were made with long sections above the ground and filmed using a row of several high speed film cameras to study the rupturing of pipes in order to comply with strict safety standards. This was the only way in which to obtain detailed information of the behaviour of these pipes in field tests.

Using schlieren illumination, concerns such as the cause of noisy gas jets, the transfer of heat and the study of shock fronts in a gas explosion can be

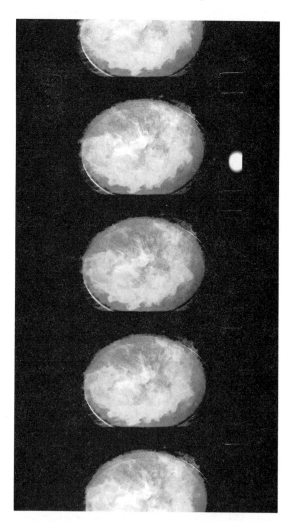

Figure 18.6 Frame enlargements of two sequences from a high speed cine recording of the operation of an industrial dust extractor taken using a Photec camera at 5000 pps and a synchronized pulsed copper vapour laser (Oxford Lasers 'Laser-strobe') providing a light sheet. (Pictures courtesy of the Department of Mechanical Engineering, University of Wales.)

analysed in great detail. Figure 18.7 shows the results obtainable from a shock tube.

18.8.3 Oil

Atomized fuel oils and spirits require similar recording techniques to those used in gas and coal tests. In particular, the behaviour of heavy oil burners as used in electrical power generators has been studied. For maximum detail in the oil spray, high resolution still photographs have been recorded using spark or electronic flash sources with a still

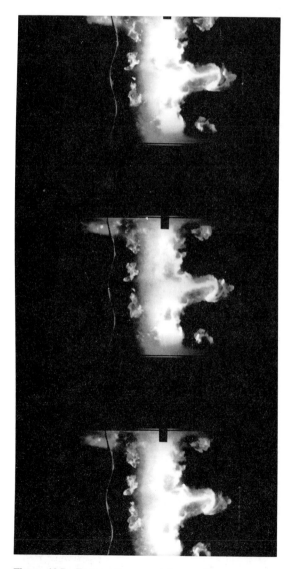

Figure 18.7 Frame enlargements from a cine sequence of an event in a shock tube, recorded with a Photec camera at 7000 pps and an Oxford Lasers 'Laserstrobe'. (Picture courtesy of AWE, Foulness.)

camera. However, to complete the study, high speed cine filming at rates up to 10 000 pps was essential.

Much research work has been carried out with oil based fuels in petrol and diesel engines. Such work on diesel engines is described in detail in Chapter 26.

18.9 The steel industry

Practically every process in the steel industry has used high speed photography, from the smelting and tapping of molten steel to wire extrusion, bar and sheet steel rolling, and to the final coiling or cutting of the finished product. From early Bessemer type converters to the most modern stainless steel arc processes, recordings have been made with rotating prism film cameras at 500–5000 pps since such cameras were first used on a simple 'flying shear' application in 1960. On this occasion, an acute synchronization problem was solved by a single recording. Considerable savings resulted from these troubleshooting runs and cameras were then used for research and development into the various steel processes, particularly smelting, to improve quality. It is remarkable that, despite its considerable size and bulk, steel production machinery transports wire, bar or sheet sections with great speed and precision.

18.10 The transport industry

18.10.1 Aircraft

During World War II, military aircraft were the first to benefit from the use of high speed photography. Originating from the first Gun Sight Aiming Point cameras, which accompanied each fighter aircraft to record target strikes, other cameras were fitted to the wings or in the bomb bay to study bomb and store releases. At only 64 pps framing rates could hardly be considered as high speed, but small shutter angles of 20° or less could provide exposure times of less than 1 ms and so the records could just qualify as high speed photography. Ground based 35 mm cameras such as the Vinten HS 300 recorded parachuted stores, torpedoes and bombs to observe events such as aircraft clearance, parachute deployment and bomb trajectories. Most famous of these trials were those for the Barnes Wallis 'bouncing bomb', most of the recordings of which can be seen to this day. Framing rates for these trials were usually 100–275 pps.

By the mid-1950s, in the UK and the USA new intermittent action cameras were developed that were able to reach 500 pps and were ideally suited for observation purposes when mounted on aircraft.

Since the early 1960s, rotating prism cameras have met the higher framing rate demands of the faster

events encountered in high speed wind tunnel tests with aerofoil and fuselage sections, as well as metal fatigue studies and rain erosion testing. These are described in detail in Chapter 22.

Since 1958, aeroengine manufacturers worldwide have been responsible for a major usage of high speed photography. All types of aeroengines are subjected to intense bird, ice and blade-off tests before the engine is ever flown. Some 10–20 cameras are used on each trial to study the behaviour of a gas turbine aeroengine running at full power when it is subjected to the ingestion of a flock of birds. Such tests ensure that a damaged engine will contain the resultant damage, which will not then affect the rest of the aircraft structure.

18.10.2 Motor vehicles

The development of the motor car and commercial vehicles over the last 40 years has been considerably aided by recordings obtained with high speed cameras.

At the manufacturing stage, practically every component has at some time been tested with the aid of a camera, particularly with regard to the engine. Engine research projects are often made through university mechanical engineering groups (Chapter 26). For example, detailed studies have been made of carburettors, fuel injectors, the two stroke and four stroke cycles, respectively, of diesel and petrol engines, including those within the combustion chamber, valve operation and lubrication. Figures 18.8 and 18.9 show examples of fuel injection studies, and Figure 18.10 shows an arrangement for recording car tyre behaviour at speed.

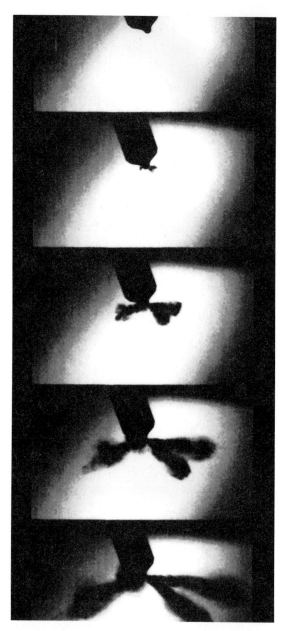

Figure 18.9 Frame enlargements from a cine film sequence showing diesel fuel injection. The camera used was a Hadland Hyspeed 16 mm type at 17 000 pps with a 25 ns exposure per picture from an Oxford Lasers 'Laserstrobe' in diffused backlit mode. (Picture courtesy of John Rendell and Brian Walder of Oxford Lasers.)

Figure 18.8 Petrol injection droplets shown in a single exposure taken at 0.5 μs using an argon spark source ('Palflash', Pulse Photonics Ltd). The approximate field of view is some 10 mm and shows petrol droplets between the injector and combustion chamber. (Picture courtesy of the Department of Mechanical Engineering, University College, London.)

The same intensive studies have been made of the remainder of the vehicle, including wheel behaviour and brake operation, door locking mechanisms, windscreen crack propagation tests, windscreen wiper washers and judder, and safety harnesses.

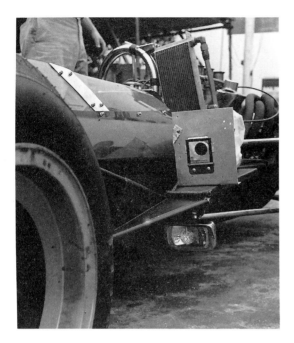

Figure 18.10 A Milliken 16 mm intermittent action, pin register high speed camera capable of 25–400 pps mounted on a McClaren racing car to observe the behaviour of Goodyear tyres during cornering at speed. (Picture courtesy of Hadlands Photonics; Photographer David Bowley.)

Once built, each new model of car or lorry, complete with dummy driver and passengers is subjected to crash tests against solid objects and other vehicles at various impact angles. Throughout these tests, several high speed cameras running at 1000 pps observe the impact and the effect on the passengers (dummies) from all angles, and from the bottom of the vehicle. On-board ruggedized cameras can closely observe special items of interest, if required.

18.10.3 Railways

Since the 1960s many railway subjects have been studied. High speed cameras were first used to inspect the behaviour of new de-icing fluid equipment for electric conductor rails and simultaneously to record conductor shoe 'bounce', where the rail transferred from the left to the right of the track.

Soon after high speed electric trains entered service on the North West main line in the UK, pantograph power collectors were observed by high speed photography to ensure constant contact was being made with the high voltage overhead line.

Railway tracks require constant monitoring for wear. At one time this involved an experienced person walking along the track to observe and report any wear, particularly at points and crossings. Then film cameras providing short exposure times were used to photograph the track from the train. Nowadays, video cameras with short duration synchronized electronic flash observe long sections of track from a moving train. Normal speed video cameras are used at 25 fps, but flash durations of 10–20 µs provide blur-free pictures for frame by frame analysis to check the state of the track.

Probably one of the most spectacular rail events involving high speed photography was carried out in 1984, when a nuclear container ('flask') containing spent nuclear fuel was struck deliberately by a train at high speed. The train was completely wrecked on impact, but the nuclear container remained intact without leakage. Up to 32 instrumentation cameras sited by the Central Electricity Generating Board, plus 17 cameras for other interested organizations, including several high speed cameras, successfully recorded this single incident from every conceivable angle for subsequent analysis.

18.10.4 Ships

Although not often considered a high speed subject, ship launching occasionally requires a slow motion study at 100 pps, to observe the sudden lowering of the stern as it enters the water.

Most high speed photography of boats or ships is made with scaled down model ships in large water tanks. To simulate the behaviour of a vessel at sea in a storm or in fair-weather conditions, a reduced scale model is subjected to the effect of waves at a proportionally scaled up rate. Running the high speed camera at the same scaled up rate of, say, five-fold or 125 pps, it will only be necessary to replay the film (or video) at 25 pps to produce a ship and wave motion, which appears normal. It is not possible to simulate true sea conditions, due to the lack of foam; even the addition of detergent to the water still looks slightly unreal. The use of a wide angle lens and a camera viewpoint close to the subject heightens the effect of realism. Despite some slight drawbacks, it does provide advance information as to how a ship would behave in unusual sea conditions.

Cavitation around ships' propellers causing wear and erosion at the tips is probably the greatest cause of wear. This effect eventually leads to a lowering of efficiency and propeller failure. Studying cavitation needs high framing rates even in general views. Framing rates up to 10 000 pps are usually adequate, but detailed studies of individual cavitation bubbles require short duration xenon flash or laser strobe sources. Once again, water tanks permit high speed studies under controlled conditions.

18.11 Conclusions

After more than 60 years, high speed photography systems continue to provide a unique instrumentation service to industry. It is possible to observe events too fast for the human eye to follow, record these for subsequent viewing or analysis, and provide essential data that could lead to the rectification of faults, or supply vital data to improve new products.

19 High speed cinematography in advertising

John Hadfield and Conrad Kiel

19.1 Choice of camera

Two basic types of film camera are used for this kind of work: *pin-registered* cameras and *rotary prism* cameras. The former are preferred, given their rock-steady registration and superior image quality. However, the limiting factor of pin-registered cameras is their comparatively low framing rate. For example, 16 mm cameras such as the Photo-Sonics Actionmaster 500, designs 1PL and 1VN (Figure 19.1), are limited to a maximum framing rate of 500 pps. Because of its larger format, a 35 mm camera such as the Photo-Sonics 4ER (Figure 19.2) is further limited to a maximum framing rate of 360 pps, while the Photo-Sonics 4ML version (Figure 19.3) gives only 200 pps.

If the subject requires a higher framing rate, then a rotating prism type camera has to be used. For example, a 16 mm camera such as the NAC E10/EE rotary prism camera (Figure 19.4) has a framing rate in the range 300–10 000 pps, while in the 35 mm format the Photo-Sonics 35 mm 4C or 4B type rotary prism camera will only give up to 2500 pps. A list of camera features is given in Table 19.1.

Typical applications of pin-registered high speed cameras are to produce slow-motion sequences involving the pouring of liquids or cereals, the splashing of liquids, large explosion effects, car

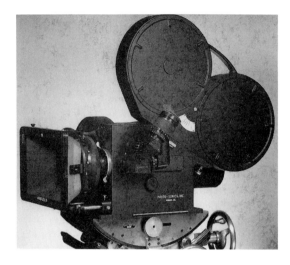

Figure 19.2 The Photo-Sonics 35 mm 4ER camera.

stunts, missile firings and sports action. Likewise, they are used for any type of *special effect* that may require additional or later optical or matte work.

The faster rotary prism cameras are used to depict in slow-motion scenes such as the deployment of vehicle airbags (where 2000–5000 pps is necessary), cereal falling through the 'frame' (field of view), small scale explosion effects, impact studies on structures and, perhaps, even a bullet exiting from a gun barrel.

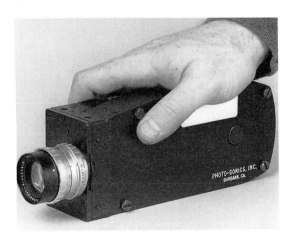

Figure 19.1 The Photo-Sonics 16 mm 1VN camera.

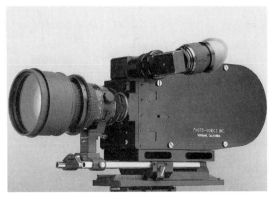

Figure 19.3 The Photo-Sonics 35 mm 4ML camera.

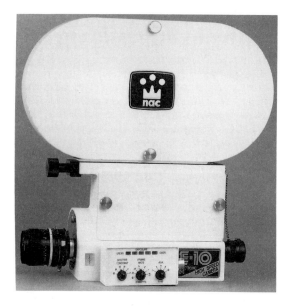

Figure 19.4 The NAC E-10/EE camera.

The primary disadvantage of a rotary prism camera is that small amounts of image bounce and/ or weave are produced. In order to minimize such *bounce and weave*, the design of one camera, the NAC E10/EE, includes two sprocket wheels which

work to good effect to remove weave, but cannot completely eliminate bounce. These bounce and weave effects usually go unnoticed to all but the trained eye, and are almost undetectable if the scene has no obvious registration points. For example, if the subject is a water droplet hitting the surface of water, there is no direct reference in the frame to reveal the image bounce. The scene begins showing a surface of water with no hard edges or lines. When the droplet enters the frame it is in motion, then when it hits the surface of the water, the water is set in motion. Therefore, there is nothing in the scene that needs to be rock steady.

19.2 Shutter speed and exposure time

The majority of 35 mm pin-registered high speed cameras use a reduced shutter angle (θ) because of the need for a longer ratio of film transport time to effective exposure duration. In the case of the Photo-Sonics 4ER camera mentioned above, the shutter angle is 120°. However, in 16 mm pin-registered cameras, the shutter angle starts at 160°.

The simplest way to calculate the exposure time (t) in fractions of a second for a given framing rate (R) in pictures per second (pps), is by using the formula:

Table 19.1 Properties of high speed cameras

Photo-Sonics 16 mm 1VN	**Photo-Sonics 35 mm 4ML**
24–200 pps	100–200 pps
Quick change magazines	Quick change 60 m (200 foot) or 120 m (400 foot)
Extremely small, compact and versatile	magazines
28 V DC operation	Compact and rugged design for high *g* use
C type lens mount	High speed, intermittent, dual pin registered
High speed, intermittent, pin registered	Continuous reflex viewing
30 m (100 foot) daylight load magazine	28 V DC operation
30 m (100 foot) and 60 m (200 foot) darkload	Arri wide angle eyepiece
magazines	Arri base available
	Reflexed Nikon lens mount
	Shuttered video tap available
Photo-Sonics 35 mm 4ER	**NAC E-10/EE**
6–360 pps	300–10 000 pps
Jurgens/Arriflex orientable viewfinder	Electronic exposure guide (EE)
Compatability with Arriflex matte box and	Nikon or C type lens mount
accessories	Reflex viewing 'through the lens'
Operational in any position	Regulated speed control
200 W internal heater	Timing and event synchronization
Mid-shutter pulse for strobe synchronization	
12 pull-down arms	
4 register pins	
Vacuum-assisted gate	
300 m (1000 foot) capacity magazines	
24 pps slate switch override	

$$t = \frac{1}{R\,(360/\theta)} \qquad (19.1)$$

For example, when R is 500 pps with a 120° shutter angle, $t = 1/500(360/120) = 1/(500 \times 3) = 1/1500$ s. This equation can be used with most motion picture cameras, including rotating prism types. If the camera employs a beam splitter in a reflex viewfinder, the associated light loss must also be compensated for. In most cases, this amounts to an additional half a stop increase (+0.5 EV), as beam splitters with a 50:50 ratio of reflection to transmission are commonly used.

19.3 Reciprocity law failure

Most contemporary film materials ('stock') do not require compensation for reciprocity law failure effects unless the exposure time is less than 0.001 s. However, because many directors of photography prefer a camera negative image that has been slightly overexposed (colloquially referred to as a 'thick negative'), especially for the purposes of transferring to video tape, it is common practice to overexpose colour negative material anyway. It is not uncommon to overexpose by a half to two-thirds of a stop (+0.5 to +0.66 EV) when using high speed cameras. A rotary prism camera operating in the range 2000–10 000 pps may cause some reciprocity law failure. The usual operational remedy is to open the lens aperture by one to two 'stops' (+1 to +2 EV).

19.4 Subject velocity

The velocity of the subject (V_s) as it actually enters the film frame is of considerable importance, especially when filming objects in extreme close-up, such as falling coins or cereal flakes, since the effective velocity of the image (V_i) across the film surface is the product of true (subject) velocity and the magnification (m):

$$V_i = mV_s \qquad (19.2)$$

Similarly, the effect of the framing rate of the camera should not be reduced by an unnecessary increase in the velocity of the subject. For example, if raisins are being filmed falling through the field of view, they should not be dropped from a height of 450 mm (18 inch) before entering the scene. The law of gravity applies and accelerates the raisins to an increased velocity. Instead, the raisins should be dropped from 50 mm (2 inch) above the field of view before, so having a lower velocity and giving more usable footage and frames for projection. The law of gravity is often overlooked or its effects underestimated on a film set for commercials or feature films.

19.5 Strobe lights

Synchronized strobe lights, such as those of the Unilux type (Figure 19.5), are often used with 16 and 35 mm pin-registered cameras. A stroboscopic source has some advantages over a continuous light source. The greatest advantage is the short effective exposure duration of 10 µs (1/100 000 s) provided by the flash discharge. This brief exposure duration gives added sharpness that is almost impossible to obtain by simply reducing the shutter angle in the camera to reduce effective exposure duration. With a strobe unit, the camera shutter itself is in effect not used other than as a 'capping shutter'. Where a camera is fitted with a variable shutter, it must be set to the widest opening. Normally, when using constant light, image sharpness can be increased by reducing the shutter open angle in order to reduce effective exposure duration so as to help freeze action. But to obtain a short exposure time of 1/100 000 s, it would be necessary to work in light levels that would most likely melt the product and/or the set!

Another advantage of a strobe source is that its

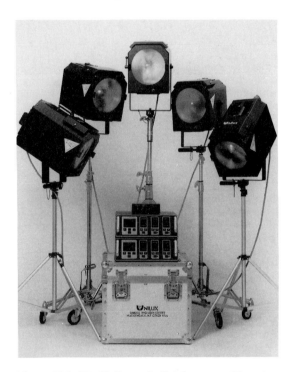

Figure 19.5 The Unilux strobe lighting system. The unit consists of a control console, a combined power supply and a light head with 10 m of connecting cable. Up to three light heads can be controlled by the console, and flashing rates, shutter speed ranges and other information are displayed on a digital panel. Synchronization up to 500 pps is possible with a minimum flash duration of 10 µs.

selected intensity remains constant. The strobe is a short duration, pulsed light that is triggered at the midpoint of opening of the shutter. Consequently, the exposure level remains the same, regardless of the framing rate in use. It is vital to synchronize accurately the strobe source to the camera shutter operation. The synchronization routines for the Actionmaster AM500 1PL or 4ER cameras are fairly simple:

- For the AM500 or 1PL cameras, a pickup device is connected to the camera motor shaft.
- The sync cord supplied with the strobe is connected.
- The camera is set to the framing rate that will be used.
- The strobe is pointed into the lens port or at the movement drive coupling.
- The time delay on the strobe system is adjusted to fire not only when the shutter is open but also when the register pins have reached their apex and are beginning to retract. (The reason for this is that the film has been registered to the gate and is now in a 'relaxed' state. This also gives the vacuum assisted gate (in the case of the 4ER camera) enough time to suck the film frame against the pressure plate.)

Because the 4ER camera also uses a beam splitter in the reflex viewfinder of the camera, only one strobe firing per frame is required. If a camera is in use that employs a spinning mirror for reflex viewing, then two flashes must be given: one for the eye and then one for the film frame. Viewing through the lens port during the synchronization process should show a double image. One image will be the camera aperture, with the leading and trailing edge of the shutter equally spaced above and below the aperture. The other image will be the ground glass.

Strobes of the Unilux type are capable of flashing up to 600 times per second, which is ideal for both 16 and 35 mm pin-registered cameras. Unilux strobes produce very little heat and may be used in a 'mixed lighting' situation with direct current (DC) lighting or flicker-free hydragyrum (mercury) medium–arc iodide (HMI) sources.

These strobe sources may be metered in a relatively simple fashion to provide exposure information with the aid of a light meter, as follows:

- The exposure meter is set to read with a 'gate' duration of 1/60 s, in its strobe (electronic flash) mode.
- The strobe system is set to its metering mode, which gives 60 flashes per second at normal working intensity.
- A meter reading is taken by pushbutton operation.

Because the meter is sampling over 1/60 s, the intensity of only one flash needs to be read, as this is what each frame will be exposed to, when properly synchronized to the camera shutter. It is common practice and sensible to sample the light several times to ensure that the meter received a full flash. The only compensation needed between the meter indication of the *f*-number required and the *f*-number set would be to open up half a 'stop' (+0.5 EV) for the presence of a beam splitter, if applicable.

Although the strobe system seems to become brighter as the camera runs up to the required framing rate, each flash is of the same intensity. It just appears brighter to the eye, because the number of strobe firings per second increases and these integrate due to visual perception.

Note that it is advisable to mix in some tungsten lighting (3200 K) when filming moving solid objects such as cereals, small sweets, coins or coffee beans. This is because the strobe has an effective exposure time of 1/100 000 s, making the image in each frame extremely sharp. The objects are in motion but have no associated blur, which can result in a 'pixilated' or 'chattering' visual effect. This effect becomes more pronounced as the velocity of the object increases, since the faster it moves, the further it has travelled between successive exposures (frames). Slower camera framing rates accentuate the problem for the same reason. The addition of some tungsten light at an appropriate level to illuminate the subject further will add a 'tail' or blur to the image of the object, and this superimposed secondary image helps blend one frame to the next. This combination of a sharp and a blurred image also helps with the necessary persistence of vision effect, which is the ability of the eye to retain a previous image. In many cases, this appears as a double image when projected. But when analysed frame by frame, the subject normally appears as a single sharp image.

19.6 The use of rigs

When high speed cinematography is used for advertising commercials, extreme close-ups are very often used. So this situation invariably results in the situation of the camera, a dolly with geared head, lights, rigs, flags, stands and at least eight people ending up cramped in and around a set the size of a telephone box and with an illumination level of anywhere between 500 and 2000 lux (some 5000 and 20 000 foot-candles) provided by the lighting. Then comes the moment to ask someone (usually the props person) to reach in and drop the subject, such as sweets, to be dead centre in a field of view some 75 mm (3 inch) across, while being restricted to a depth of field of about 18 mm (0.75 inch). The casual cautionary comment to this unfortunate

person of 'and by the way, it's about 200° in there, so don't burn yourself . . .' does not guarantee a successful result or avoid injury. For this reason it is sensible, whenever possible, to use tried and tested rigs to automate the process of introducing the subject into the field of view. Devices such as miniature conveyor belts are extremely useful when shooting cereals, sweets or other small objects that are to fall through the framed scene. If the shot requires someone's hand to be in frame, it is also good practice to set up some fixture to help the person maintain repeatability. Remember, the situation is one of a lot of heat, a small field of view and a very shallow depth of field while expensive film is passing through the camera at a velocity of between 1.5–45 m s^{-1} (5–150 foot s^{-1}).

20 High speed filming of natural history

Jonathan Watts

20.1 Introduction

The filming of plants and animals differs from all other uses of high speed recording. The involvement of life forms implies both legal and ethical arguments which must be taken into consideration before any attempt at filming can take place.

All those who wish to indulge in this activity are referred to the Wildlife and Countryside Act 1981, which can be found in local libraries. This text details species of plants and animals which are protected in some way. Species included are either under threat or are of great economic importance.

The degree of protection will vary from species to species and may depend on the time of year to account for breeding seasons. Bats, for instance, may not be disturbed, and currently a fine of up to £2000 may be imposed per bat upon those who would ignore the law. It is possible, given good reason, to obtain an appropriate licence to photograph bats or to handle them.

Each country will have its own laws that determine which species are protected and to what extent. Needless to say, one must be aware of the law and act accordingly.

20.2 Environmental factors

Stress kills. Heat, light, noise and humidity are all factors which can kill. All of these can be introduced or modified in the normal course of filming. The presence of a camera alone let alone the presence of an operator, can produce reactions varying from panic to curiosity.

Heat, as a product of extra lighting, is a critical factor. Not only should ambient temperature be monitored but, more importantly, direct infrared emissions from light sources should be filtered out. This is important with *poikilothermic* or so-called 'cold-blooded' animals, particularly if they are of low mass since they have no physiological mechanisms for regulating body temperature and will heat up rapidly and die.

The photographer should beware of water droplets on the surface of plants and animals. These act as lenses, thereby concentrating any heat and light onto the epidermis causing 'pin-prick' burns. Should there be any doubt about the effects of heat and light in any given circumstances, the practice of testing it on oneself is advocated. By placing one's head into the situation in which is proposed to film the subject, and gradually bringing the lights up. Do not expose an animal to conditions that would not be tolerated by the photographer unless the animal is specially adapted to cope with it. Hopefully, common sense will prevail. Evidently, life forms which exist only in cold habitats will be less tolerant of heat than most, and vice versa. Rapid changes in temperature hardly ever occur in nature and it must be borne in mind that physiological mechanisms take time to work. The reaction to rapidly changing environmental factors is invariably behavioural. Heating effects should be kept to an absolute minimum and any behavioural changes noted accordingly.

It is easily forgotten that the spectrum of light extends in both directions beyond the limits of human vision. Many plants and animals are sensitive to parts of the spectrum to which humans are blind. For example, pit vipers have special organs for detecting body heat which helps them detect their prey. Insects, on the other hand, have vision which extends well into the ultraviolet range. This is used extensively for navigation, especially on cloudy days, and exposes many things such as nectar guides on flower petals which are not visible to humans. Ultraviolet radiation is frequently emitted in quite high intensities by gas-discharge lamps, which, depending upon the circumstances, can be of use or a danger to all concerned. The spectrum of gas-discharge lamps should be checked. There is often information enclosed with the lamp. If necessary, the manufacturer must be consulted and safety instructions followed.

Noise from cameras often poses a problem, although the author has never found any adverse reaction from any of the invertebrates, despite the fact that the majority have excellent hearing. The problem becomes more apparent with the more highly evolved vertebrates. Reptiles tend not to find camera sounds stressful, although they may orientate themselves to investigate the source.

Birds are both sensitive to and highly stressed by

any loud and unfamiliar noises. The camera will need to be blimped in such cases unless it is used at some distance from the subject.

A technique which has often been employed by wildlife cameramen in order to overcome this problem and to get very close shots of birds in flight is the rather amoral practice of *imprinting*. The cameraperson ensures that he or she is the first thing that the chick sees when it hatches. The result is that the chick thereafter thinks that the cameraperson is its mother. This is reinforced by hand-rearing. The bird will then automatically follow 'mummy' everywhere. The cameraperson then hops into the back of a truck and is driven away. The bird follows by flying alongside the vehicle, providing the cameraperson with the shot required.

Mammals and marsupials vary in their response to noise, depending upon their previous experience. A tame or domesticated animal will show little fear. Some people have even been reported to vacuum their pets to remove loose hair and discovered that their victims clearly enjoy the experience, despite the noise. Wild subjects will simply disappear unless other familiar sounds blot out the sound of the camera. One sound that it is hard to escape from is that of the internal combustion engine. This is something which will be familiar to almost all animals and may be introduced at times to disguise less familiar sounds. A small generator thumping away in the background, even if it is only used to recharge camera batteries, can break the silence and allow a camera to run unnoticed.

20.3 Ethics

The ethics of setting up circumstances to be filmed are the domain of the individual. There have been long and heated debates about feeding live mice to an owl in order to obtain footage of the kill. One might suppose this to be unacceptable until the zookeeper puts the bird back in its cage and feeds it the mouse anyway. The keeper will undoubtedly kill the mouse less efficiently, before handing it over, than would the owl, as if feeding the owl a dead mouse is in some way better.

The personal feelings of the author are to not become involved in filming any predator/prey sequences that are not set up involving a vertebrate victim. Anyone involved in natural history filming is open to the criticism of public opinion, which is more often the product of sentiment than reason. It is quite likely that someone who would regard the practice of tethering and releasing insects for filming purposes unethical will the next moment unthinkingly swat a fly with a rolled-up newspaper.

There is a large grey area here and each person must make his or her own decisions on the ethics involved. The moral high ground is advocated, and

insistence that, whatever the decision, it is the result of careful consideration.

20.4 Lighting

Footage which is shot for film or television use must be lit using key lights in order to meet acceptable standards. Key lighting is usually twice as intense as the fill lighting, and yet it is the fill light which determines the exposure. Key lighting only serves to increase the potential problems of heat and light. One solution is, of course, to use a fast film stock, but this may clash with the rest of the sequence if that has been shot on a fine grain stock.

In recent years improvements in film stocks have provided fine grain and good colour saturation, permitting the increased use of fast films for natural history filming, especially if the film is overexposed by half a stop (+0.5 EV). This practice helps to retain the contrast and colour saturation levels and makes differences less noticeable when scenes are intercut with those taken using slower materials.

The techniques that are employed for the removal of heat from light sources fall neatly into two categories: removal of heat by absorption and removal of heat by reflection.

The removal of heat by *absorption* depends on the presence of the sulphate ion (SO_4^{2-}) either in a glass matrix or in aqueous solution. Heat filter glass is expensive, but easy to use. It may be placed between the lamps and the subject and allowed to perform its function. If it is placed close to or over a lamp it must be fan cooled since not only will it heat up rapidly but it also heats up unevenly, creating internal stresses in the glass. The result is dangerous and inevitably the glass will shatter sending off shards of extremely hot glass. However, used with due care, this kind of filter works well and has much to recommend it. It must be allowed to cool for 10 min or so after use before dismantling, since not only will it be hot but also it may break due to residual internal stresses in the glass.

Sulphate ions in aqueous solution absorb infrared effectively and form a cheap means of heat reduction. Potassium sulphate forms a colourless solution and, if mixed with a little copper sulphate which is blue, may even be used to correct tungsten sources approximately to daylight.

The concentrated solution is placed preferably in an open Pyrex (heat resistant) or borosilicate glass flask or tank and used between the lamp and the subject. The vessel must not be closed because when sufficient heat has been absorbed the solution will start to boil. Left unobserved, a closed vessel could explode. There is nothing inherently wrong with allowing the solution to boil gently in its flask as long as it is not too vigorous. However, it is recommended that, as a precaution, when the flasks reach

boiling point filming is stopped to allow the flasks to cool down.

The use of round flasks for containing the sulphate solution has other advantages. If supported in front of a lamp such as a Red Head type they may be used to focus the light down onto a small area, providing very intense and cool illumination suitable for filming. This technique, although more cumbersome to set up, can solve almost all the problems in any situation if applied intelligently and used for limited durations.

The removal of heat by reflection or by 'hot' and 'cold' mirrors is a newer technique which has become available as the technology for coating thin multi-layer dielectric films has improved.

Heat reflecting mirrors (*hot mirrors*) reflect rather than absorb heat as infrared radiation, so that if angled at 45° to the light source the heat can be diverted towards the ceiling or a location where dissipation is more convenient. Care must be taken to ensure that the reflected heat is dissipated in a known and safe way. These mirrors should not be used normal (at 90°) to the incident light, since the radiation will be reflected back into the lamp and overheat the system, and blow the bulb.

Heat transmitting mirrors (*cold mirrors*) transmit infrared and reflect visible light in 0° and 45° versions in polished Pyrex. They may be used to reflect cold light from the lamps onto the subject, while allowing the heat to pass straight through the filter. As with hot mirrors, care must be taken to ensure that the heat dissipation is dealt with sensibly and safely. Concave and convex versions of both types of mirror are available. However, these mirrors may need to be made to order and are not cheap.

Gas-discharge strobe lamps may be used as an alternative to tungsten lamps since they tend to have low infrared emissions. However, they must be of the 'flicker-free' or square wave ballast type. Lamps of the hydragyrum (mercury) medium–arc iodide (HMI) type can work quite well, but not all versions sold are truly 'flicker-free' so it is necessary to try them before purchase.

At this point it is desirable to clear up a point of confusion over flicker and tungsten lighting. From time to time, people have experienced flicker from tungsten lighting whilst using a mains-driven camera and assumed that because of the thermal capacity of a tungsten filament it is impossible for the light source to be the problem. Convinced that the problem must lie with the camera, hours are wasted stripping it down or having it serviced only to find that the problem is not resolved. If the speed of the camera is affected by a pulse width control servo it will switch the motor on and off for varying periods of time, drawing not inconsiderable current from the mains, often at about 10 Hz. If the mains supply is only just adequate to handle both the camera and the lights, the voltage on the mains ring will fluctu-

ate at this sort of frequency. This fluctuation will then affect the lights and make them flicker because, despite the thermal capacity of the filament, the frequency is low enough to allow the light level to fluctuate.

The policy of running mains powered cameras on a different phase from the lights solves this problem and helps to reduce the stresses applied to the electrical supply in a building. If access to an oscilloscope is available, it is interesting to monitor the mains whilst running such a camera on a poor supply (the oscilloscope should preferably be powered by another source).

20.5 Backgrounds and movement

Unless filming takes place in the wild or a well constructed set the background can cause a problem since it will need to match or be a credible substitute when edited in with the previous shot in a sequence. There are several approaches to this. The easiest is for the operator to use an *ultimat* background. This consists of a plain background of a specific colour (usually blue) which is used for 'matting' techniques on video. The ultimat background may then be exchanged for another previously shot image.

In order to do this successfully the background must be evenly illuminated and the exposure set from the background. The subject is then introduced to the foreground and matched in exposure, with care being taken not to generate new shadows on the background. The same focal length lens as was used for filming the background should be used for filming the subject in order to maintain continuity of perspective. The same film stock should be used so that there is no difference in grain size. Also, the focus of the background should be arranged so that it is less sharp than the most distal part of the foreground. There is nothing worse than a picture in which the foreground is sharp and then softens through focus matted onto a crystal sharp background. As long as these rules are observed and the subject's action is designed to match the background movement the rest can be left to whoever is in charge of post-production.

Backgrounds can also be projected either as an *aerial image* through a condenser lens or *front projected* onto a beaded screen using film in a projector synchronized to the camera. These techniques require a considerable amount of work to synchronize the two, and should not be attempted by the faint-hearted; the physical and optical arrangements are standard and not relevant to this text. Rear-screen projection is not capable of producing adequate exposure levels for filming at much over 100 pps and has seldom been used for this purpose. The use of large colour transparencies backed by

diffusing material to avoid hot spots and illuminated from behind by an adequate cold light source is a very successful method which, in essence, is not dissimilar from rear-screen projection but is capable of providing sufficient image luminance for most exposure purposes. However, linear movement may be imported to the transparency, giving the impression that the camera is being panned during the shot. A linear bearing from a filing cabinet has been successfully used for this purpose. The background is mounted on the bearing, with an elastic band arranged in such a way that it will impart the movement required. The movement is released by a solenoid triggered either by hand or by the camera's event circuit.

The foreground consists of a sheet of glass upon which a small perspex tube has been glued in order to accept a piece of fine wire upon which an insect is mounted. Careful arrangement of the camera angle ensures that the mount and wire are obscured by the insect. Black material draped over the camera prevents reflections in the glass caused by any light spillage. As an extension of this the glass and insect may be moved using the same system, giving the impression that the insect is progressing upwards and through frame. This is usually preferable in filmic terms since it not only gives a less contrived feel to the image, but it also provides cutting points for the editor.

It is interesting to note that, despite all these techniques being reinvented by the film industry every 5 years amid a blaze of self-satisfaction, they have their origins in entomological experiments dating well back into the last century. Mounting insects in gymbals and wire structures providing several axes of movement was not an uncommon practice in an attempt to understand the rudimentary mechanisms of flight. A search for original records of such set-ups would undoubtedly provide the cameraperson with a host of well developed tools with which the feel of the final image may be improved.

A technique which must have a more modern origin is the use of a single strand of dental floss for tethering an insect. The diameter of such a synthetic monofilament is often in the order of a few micrometres and will usually fail to register on film, although if it should find itself exactly in the focused plane and just happen to catch the light then it may become apparent. A strand of such floss can be used on such things as butterflies and used much like a dog leash. A little practice will allow a camera assistant to gently guide the path of the insect so that it alights on the intended flower. This is used not only for high speed recording but also for normal running speeds. It is so effective that the 20th century butterflies as seen in television commercials could be thought to have a strange affinity for bottles of fabric softener!

There is no information about anyone having successfully obtained footage of insects in flight in a wind tunnel unless they were tethered, although the possibilities must exist. The use of vertical wind tunnels for flying winged seeds and the like is commonplace, easy to effect, repeatable and can produce spectacular results. The use of an ultimat or black background provides the opportunity to matt the image onto an appropriate background so that it cuts with the rest of the sequence filmed in the field.

The alternative to such techniques is, of course, to use a hand-held camera with a wide-angle lens to give the best possible depth of field and film 'from the hip'. On the face of it there would seem to be little chance of success. Surprisingly, the results of this activity are often quite successful and it can be recommended to anyone who has become impervious to the degree of embarrassment that it may cause.

The camera lens is prefocused at a distance of some 100–150 mm and a ruler or stick is taped to the bottom of the camera body to indicate the location of the focused plane, but not intruding into the bottom of the frame area. The insect is then stalked and filmed flying just above the tip of the ruler. A short sequence of even a couple of seconds at 500 pps will provide an adequate length of shot. Under reasonable circumstances and with a little previous practice (with an empty camera) most people should find this achievable.

Shorter shots flying through and away from frame can be obtained by using a Perspex tube of about 75 mm diameter with two saw cuts placed in either end. The saw cuts accept pieces of card which act as doors at either end of the tube containing the insect. The whole thing is mounted on a stand and orientated so that the exit is towards the light.

The presence of daylight in a Perspex tube will encourage the insect to fly and allows the cameraman to judge the activity inside. The camera is prefocused on the area around the tube exit, run up to speed and the insect released. With luck, some high speed footage of untethered flight is obtained. In the event that the insect fails to take its cue and stays in the tube, the distal end of the tube may be darkened with black cloth or paint.

A similar technique which involves ejecting insects from a tube by forced air has produced interesting footage, but for obvious reasons is not one that the author has practised or would recommend.

20.6 Other useful hints and techniques

Although each animal will present a different set of problems, the key to success is an understanding of the animal's behaviour. The cost of film makes it

imperative that the animal performs on cue, so behavioural observation must be regarded as the groundwork and filming as the final stage.

There are a few generalities that can be made about certain animals that may help. Gulls and terns will regularly hover behind fishing boats while they are thought to be a likely source of food, so providing an excellent opportunity to obtain footage from close quarters. Similarly, most of the Coleoptera or beetles will climb up a stem to the top before orientating themselves and then taking off. This helps both with focusing and with filming, since the act of orientating gives a warning of impending flight.

Birds taking off give less warning and can be hard to time. One solution is to use a *collapsing perch* using a solenoid as a release. Observation of an individual bird will identify a favourite perch which may then be modified to include a hinge and a release mechanism that can be operated from some distance away. Although this trick is not in particularly good taste it is reliable, does no harm and, as long as the perch is out of frame, produces excellent results. The bird cannot be expected to fall for the same trick too often. Used only once a day there may be several chances, but if used too often the perch will be abandoned.

A list of wing beat frequencies for a range of insects is given in Table 20.1, which may be helpful in working out the appropriate camera framing rate for filming certain insects.

Table 20.1 Flight information for a range of insects

Insect	Wing beat frequency	Forward speed	
	(Hz)	m s^{-1}	mph
Hawk moths	30–80	8.5–14.7	20–30
Large dragonfly	25–80	6.3–12.6	15–30
Deer bot fly	150–180	9.24–11.76	22–28
Horseflies	140–170	5.88–10.5	14–25
Common wasp	105	4.2–6.3	10–15
Medium butterflies	6–12	3.78–5.04	9–12
Honeybees	230–250	2.31–5.88	5.5–14
Desert locust	n/a	3.36–5.04	8–12
Hoverflies	130–200	2.52–3.57	6–8.5
Blowflies	160–250	2.52–3.36	6–8
Cockchafer	50–65	2.52–2.94	6–7
Bumblebees	140–160	1.68–2.94	4–7
Houseflies	200	1.68–2.1	4–5
Damselflies	15	1.68	4
Mosquitoes	600	0.63–1.05	1.5–2.5
Midges	1000	0.21–0.42	0.5–1.0

21 High speed photography at the Cavendish Laboratory, Cambridge

John E. Field

21.1 Introduction

The Physics and Chemistry of Solids Group of the Cavendish Laboratory, Cambridge, has a long tradition in high-speed photographic research. In the early days of the laboratory, there was a significant amount of camera development by Courtney-Pratt (e.g. Courtney-Pratt and Thackeray, 1957). However, in recent years commercial cameras have been used to concentrate on developing techniques for acquiring data from a diverse range of events and for combining high spatial resolution techniques (e.g. speckle and moiré) with the high-time resolution offered by the cameras. Some of this research is discussed in Section 21.2.

Table 21.1 details the various camera systems, both framing and streak, available at the Cavendish. These have been applied to such research areas as fracture, ballistic impact, shock physics, erosion processes (rain, steam turbine, solid particle, cavitation), explosive initiation and propagation, acoustic wave interaction with cavities, laser damage and a variety of fluid mechanics problems. Examples are given in this chapter, emphasizing the value of high-speed photography.

21.2 Optical techniques for dynamic stress analysis

Many optical techniques have been developed for the measurement of displacement, strain and stress. Conventional strain gauges can provide measurements at a single point, and combine a high degree of accuracy (a few microstrain) with good time resolution (potentially of the order of nanoseconds, given a suitable amplifier). However, strain gauges have two significant disadvantages: (a) they give information at only one point in the field of view; and (b) bonding the gauge to the specimen may provide local reinforcement, which perturbs the stress field. Optical techniques, on the other hand, generally provide whole field information and many are also non-contacting.

Many of the optical techniques currently used for

Table 21.1 High-speed cameras in use at the Cavendish Laboratory

Type	Make	Maximum framing rate (pps)
Fast video	Kodak Ektapro-100	2×10^3
16 mm film	Hadland Hyspeed	10^4
Strobe light source + drum	Frungel Strobokin + Strobodrum	5×10^4
Rotating mirror cameras	AWRE C4 (two) Beckman & Whitley 189 Beckman & Whitley 201	2×10^5 (140 frames) 4×10^6 (25 frames) 2×10^6 (12 frames)
Image converter	Beckman & Whitley 201	Two exposures, down to 5 ns
Image converter	Hadland Imacon (two)	10^7 (~12 frames)
Image converter	Hadland Imacon	Streak
Image converter	Imco Ultranac FS 501	2×10^7 and streak. Choice of interframe and exposure times for individual frames (up to 24)

studying dynamic events were originally developed for quasi-state applications. The *Handbook on Experimental Mechanics* (Kobayashi, 1987) provides an excellent background to the use of optical methods in experimental mechanics. In this section we outline the most frequently used techniques, typical applications and some promising new methods. Table 21.2 provides a concise summary.

21.2.1 Photoelasticity

This is one of the oldest and most widely used photomechanical methods, and relies on the fact that transparent materials become birefringent under an applied load. The birefringence is made visible by placing the sample between circular polarizers. A so-called 'isochromatic' fringe pattern is formed, which in two dimensions represents contours of $\sigma_1-\sigma_2$, where σ_1 and σ_2 are the principal in-plane stresses. The fringe sensitivity varies by several orders of magnitude between materials (e.g. approximately 400 kN m^{-1} fringe^{-1} for glass to 0.2 kN m^{-1} fringe^{-1} for polyurethane rubber). Due to their good spatial resolution, Cranz–Schardin cameras are often used to record the fringe patterns.

Photoelasticity is an appropriate technique for studying the response of model structures, but is less useful for investigating the mechanical properties of opaque materials. It has been used extensively in dynamic fracture studies (Wells and Post, 1958) where the dynamic stress intensity factor (K_{Id}) can be estimated by least-squares fitting a series expansion of the theoretical stress field to the measured fringe pattern. Another example is visualization of stress wave propagation through model granular material (Shukla *et al.*, 1990). Many other applications are reported in the literature.

21.2.2 The method of caustics

This approach was proposed by Manogg (1964) and was used extensively by, amongst others, Theocaris and Gdoutos (1972), Kalthoff (1987) and Zehnder and Rosakis (1990), mainly for studies of dynamic fracture. A collimated beam of light illuminates the specimen surface and the reflected or transmitted beam is recorded by a camera focused on a plane separated from the specimen surface by a small distance. The intensity distribution depends on the surface slope distribution (and hence on the in-plane stresses), but the analysis of general stress fields is difficult. In the presence of a crack, however, the surface displacement of the specimen is inversely proportional to the square root of distance from the crack tip, and the caustic pattern forms a characteristic, approximately circular, dark region centred on the crack tip. The diameter of this 'shadow spot' can be related directly to K_{Id}. One of the main advantages of the technique is its experimental simplicity. If the crack is moving, it is even possible to multiply expose a single picture using a strobed light source, thereby avoiding the need for a high speed camera.

21.2.3 Moiré techniques

A family of moiré techniques can be used to measure in-plane and out-of-plane displacement fields. For in-plane displacements, a grating is attached to the specimen surface. The grating can be recorded directly onto film, but the usual approach when the strains are low is to form moiré fringes by superimposing a second reference grating of almost the same spatial frequency. The camera need then only resolve the fringe pattern and not the grating lines. The pattern represents a contour map of the in-plane displacement component perpendicular to the grating lines, with a contour interval or 'sensitivity' equal to the pitch (p) of the specimen grating. Specimen grating frequencies of up to about 40 lines mm^{-1} (sensitivity 25 μm) can be used with white light illumination, but the sensitivity is dramatically improved (to submicrometre values) by the use of coherent light. The technique is then known as *moiré interferometry*. Applications include visualization of stress waves in graphite epoxy composites (Deason *et al.*, 1990) and dynamic fracture studies (Arakawa *et al.*, 1991). Intermediate sensitivities (5–10 μm) can be achieved by *high-resolution moiré photography* (Whitworth and Huntley, 1994), first proposed by Burch and Forno (1982), in which the specimen grating is imaged onto the reference grating with a masked camera lens. Figure 21.1 shows a high speed sequence of moiré fringe patterns produced in a polymethylmethacrylate (PMMA) plate following impact by a steel ball. The combination of an accuracy of approximately 1 μm together with microsecond time resolution make this method attractive for the dynamic stress analysis of many polymers and composites. This sequence was taken using a Hadland Imacon 792 (Huntley and Field, 1989).

21.2.4 Laser speckle

A range of techniques is based on the phenomenon of laser speckle, which is the granular pattern produced when a rough surface is illuminated by coherent light. The simplest method (*laser speckle photography*) involves recording double-exposure photographs of the object. The speckle pattern moves as though it were physically present on the specimen surface, so the displacement field occurring between the two exposures can be mapped by measuring the speckle displacement point by point from the developed photograph. This is normally done by probing the photograph with a narrow laser beam and measuring the spacing and angle of the

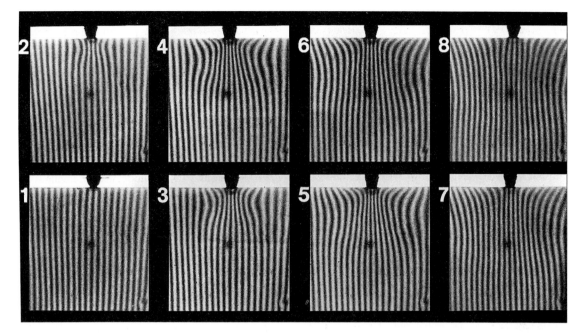

Figure 21.1 High-resolution moiré fringe patterns showing the displacement field produced by a steel ball impacting on PMMA. Horizontal grating; pitch 6.7 μm; interframe time 0.95 μs; field of view 16 × 16 mm (Huntley and Field, 1989).

Young's fringes in the diffraction halo. Figure 21.2 shows a double-exposure photograph of a fast crack in PMMA recorded by a double-pulsed ruby laser with an open-shutter camera. The Young's fringes produced by probing the photograph at several points are also shown. Figure 21.3 is the displacement field deduced by measuring 256 such fringe patterns.

The random error in the measured displacement component scales as the square of the diameter σ of the smallest speckle that can be resolved by the imaging system (Huntley, 1989). High-speed cameras with good spatial resolution are therefore necessary when recording sequences of speckle photographs. Cranz–Schardin cameras are unsuitable because light is scattered into all the lenses on each light pulse. Rotating mirror cameras with pulsed ruby laser light sources can, however, measure displacement fields to submicrometre accuracy with fields of view of several tens of millimetres and a time resolution of the order of 1 μs (Huntley and Field, 1994). The advantage of speckle photography over other techniques is that it is literally non-contacting and can be used on specimens with rough surfaces with little or no surface preparation required.

21.2.5 Speckle interferometry

This technique relies on the interference between two speckle patterns or a speckle pattern and a smooth reference wave. Depending on the optical configurations, it can be used to measure in-plane or out-of-plane displacement fields. Double-exposure photographs are recorded, and changes in speckle correlation due to the object displacement are made visible by spatial filtering. Figure 21.4 shows a sequence of fringe patterns from an in-plane speckle interferometer used to measure the transient displacement field round a stationary crack in an aluminium plate. The crack was loaded with a compressive stress pulse, and the exposures were recorded with a single pulse ruby laser (Huntley and Benckert, 1993). The sequence was built up by repeating the experiment several times with different time delays between the impact and laser pulse, but could have been recorded as one sequence using the camera/laser system described in Huntley and Field (1994). The fringe pattern represents the same quantity (horizontal displacement component) with the same sensitivity (0.4 μm) as would be obtained with moiré interferometry, but no grating was required on the specimen surface.

21.2.6 Holographic interferometry

This is a related technique in which a double-exposure hologram is recorded of the object before and after deformation, using a double-pulsed ruby laser for example. When the hologram is reconstructed, a fringe pattern is observed which can be related to the displacement component along the

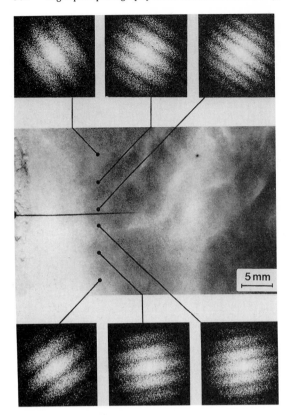

Figure 21.2 Double-exposure speckle photograph of fast crack in PMMA. Time between exposures 15 µs; crack velocity ≈ 300 m s⁻¹. (Huntley and Field, 1989.)

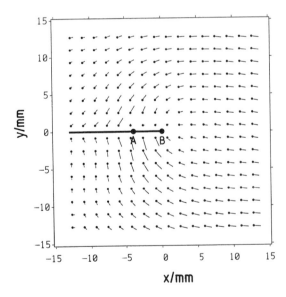

Figure 21.3 Displacement field measured from Young's fringe patterns, produced by pointwise filtering the photograph shown in Figure 21.2. (Huntley and Field, 1989.)

bisector of the illumination and viewing directions. The technique produces very high-quality fringe patterns, requires no specimen preparation, and can be used whenever a 'snapshot' of the displacement field is required. Fällström *et al.* (1989) describe one example of its application to the visualization of waves in isotropic and anisotropic plates. It is difficult, however, to record sequences of holograms with a high speed camera.

21.2.7 Shearing interferometry

This technique has recently been applied to dynamic fracture experiments under the name 'coherent gradient sensor' (Tippur *et al.*, 1991). An interference pattern is formed between two copies of the image, one of which has been laterally shifted or 'sheared' relative to the other. The fringes represent contours of constant surface gradient. The surface must have a mirror finish, but this has the advantage that the technique is much more efficient in its use of the available light than speckle or holographic methods, so that much lower power lasers (e.g. cavity-dumped argon ion lasers rather than *Q*-switched ruby lasers) can be used.

21.3 Applications

21.3.1 Granular flow

Video techniques are attractive if the events being recorded require relatively modest framing rates. With a Kodak Ektapro-100 video camera (see Table 21.1), it is possible to record at framing rates up to 1000 pps for a full image size and up to 12 000 pps with reduced image size. An interesting recent application in the laboratory (Warr *et al.*, 1994) has been the recording of the dynamics of a two-dimensional model granular system consisting of steel or PMMA disks under vibration between glass walls.

21.3.2 Fracture

The first extensive application of high speed photography to the study of fracture propagation in glasses was made by Schardin and co-workers. In 1937, Schardin and Struth, using a Cranz–Schardin camera, made the important observation that crack growth in soda lime glasses had a limiting velocity of about 1500 m s⁻¹. It is now known that cracks in brittle materials can be propagated stably at low velocities, depending on the applied stress and the environment, but when the stress intensity at the crack tip exceeds a critical value, they grow unstably, accelerating to a maximum velocity. If attempts are made to force a single crack past this maximum velocity, crack branching (bifurcation)

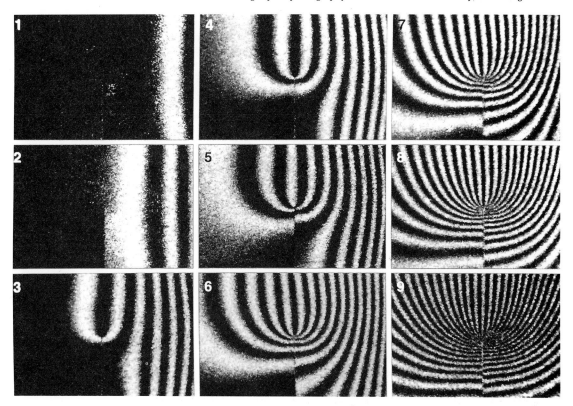

Figure 21.4 Speckle interferometry fringe patterns showing the interaction of a stress wave with a vertical crack. (Huntley and Benckert, 1993.)

Table 21.2 Summary of optical techniques for dynamic stress analysis

Method	Measurand	Sensitivity	Accuracy	Light source
Photoelasticity	$\sigma_1 - \sigma_2$	Variable	Variable	Incoherent
Caustics	$\dfrac{\partial u_z}{\partial x}$, $\dfrac{\partial u_z}{\partial y}$	Variable	Variable	Incoherent
Moiré interferometry	u_x or u_y	Grating pitch $p = \lambda$	$\sim p/10$	Coherent
Moiré photography	u_x or u_y	Grating pitch $p \approx 5$ to 1000 μm	$\sim p/10$	Incoherent
Speckle photography	u_x and u_y	Speckle diameter $\sigma = 5$ to 50 μm	$\sim 0.2\sigma^2/$(Spatial resolution)	Coherent
Speckle interferometry	u_x, u_y or u_z	$\sim \lambda$	$\sim \lambda/10$	Coherent
Holographic interferometry	u_x, u_y and u_z	$\lambda/2$	$\sim \lambda/50$	Coherent
Shearing interferometry	$\dfrac{\partial u_z}{\partial x}$ or $\dfrac{\partial u_z}{\partial y}$	$\sim \lambda/$(Shear distance)	$\sim 0.1\lambda/$(Shear distance)	Coherent

results. Figure 21.5 shows crack growth in a toughened glass specimen (Field, 1970). Toughened glass is glass which has been thermally toughened to produce a compressive outer layer, and so is stronger than annealed glass. However, if a defect extends through the outer layer it reaches material under tensile stress and crack growth proceeds catastrophically throughout the sample. Since the crack is maintained near its maximum velocity, there is repeated crack branching. The greater the thermal toughening, the smaller the crack length between branches and the smaller the particles which remain. The fractures shown in Figure 21.5 were initiated by the impact of a lead slug. The fracture front formed

by the tips of the cracks is part of a circle showing that all the cracks are propagating at the same velocity. Between the eighth and ninth frames a marked change in crack pattern occurs as the dilatational stress wave, set up by the impact, returns to meet the fractures after reflection at the lower and side surfaces of the specimen. This stress wave is travelling at about three times the velocity of the cracks and so meets them when they are about halfway down the specimen. This sequence was taken using a Beckman and Whitley Model 189 rotating mirror camera. Since this camera has film over only a 60° arc and it was only possible to synchronize the light source with the event, several experiments had

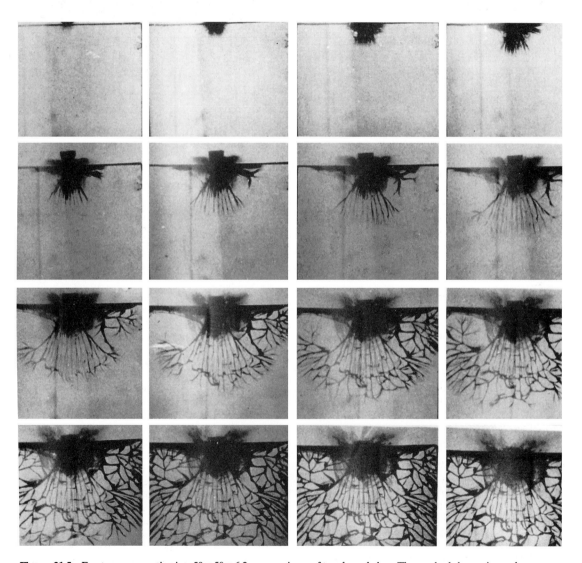

Figure 21.5 Fracture propagation in a 50 × 50 × 6.2 mm specimen of toughened glass. The marked change in crack pattern after the eighth frame (at the end of the second row) is caused by interaction with the reflected dilatational wave. Frame interval 2 µs. (Field, 1970.)

to be made before a successful sequence was obtained.

Recently an Ultranac FS 501 programmable image converter camera has been used to follow events which occur in glasses when they are subjected to intense (several gigapascals) one-dimensional shocks following plate impact. The records show that the shocks are followed by 'failure' waves. The interest is that these 'failure' waves take place under compression and shear stresses and before tension release waves arrive. For examples of the photographic records and a full discussion, see Bourne *et al.* (1995).

21.3.3 Liquid impact

It is well known that the impact of a liquid and a solid has important consequences in the rain erosion of aircraft, the erosion of steam turbines and in cavitation phenomena. Recently, high-velocity water jets have been suggested as a possible new method for rock-breaking and mining applications. Two methods have been used at Cambridge for simulating the impact of large water drops: the first involves projecting a jet of liquid at a stationary target, and the second uses a gas gun for firing 25.4 mm diameter specimens at stationary drops. The first method has the advantage of ease of operation, low construction cost and the velocity range which can be covered (up to several thousand metres per second). The second is nearer the practical rain erosion situation, since a spherical drop has struck; but has disadvantages with regard to the size of specimen which can be projected and the deceleration, without further damage, of the specimen after impact.

It is now possible to produce coherent jets with a smooth, slightly curved, front profile which produce damage closely similar to that produced by drop impact. The jets are formed by firing a projectile, or driving a piston, into a chamber and extruding liquid through an orifice. The detailed studies needed to optimize and characterize the jets were possible only by using an image-converter camera which gave the necessary ease of synchronization. High speed photography has also been used extensively in work to study the impact process and the development of damage in the target.

Figure 21.6 shows a high speed sequence taken with an Imco Ultranac FS 501 camera of a liquid jet impacting a PMMA target at 590 m s⁻¹. Such an impact causes an annular ring of damage (D_m) made up of many short circumferential cracks. The impact shock (S) is clearly visible from frame 1 onwards. A release wave (R) is generated at the contact periphery of the jet, and when this reinforces on the central axis it forms the subsurface damage (D_c). Note that this damage develops over several frames and then temporarily closes as waves pass over it.

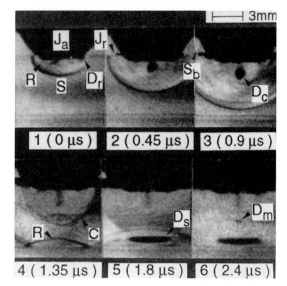

Figure 21.6 Ultranac camera sequence of a 590 m s⁻¹ impact by a liquid jet (J_a) on a PMMA target. S, Primary shock; D_r, ring damage; D_c, central damage; D_s, spall damage; D_m, middle damage; J_r, radially jetting liquid; S_b, an associated bow shock in the air. Frame interval 0.15 μs; exposure times 20 ns.

When the shock (S) reflects at the rear surface it becomes a tensile wave, and when the resultant tensile stress exceeds the failure strength the spall damage (D_s) develops. Finally, when this wave is reinforced by a wave associated with the closure of the damage site (D_c), a further crack (D_m) develops.

The streak record shown in Figure 21.7 for a similar impact shows these wave interactions more clearly. The streak axis was positioned along the axis of the liquid jet. Three fiducial marks were scribed on the far side of the block. The way in which these deflect allows the nature of the shock (compressive or tensile) to be identified, since they affect the density of the material differently. The shock wave (S) generated by the impact is clearly visible, and the line shift of the fiducial marks is large. The line parallel to this is the release, and shortly after this passes the central damage (D_c) forms; this then temporarily closes from the rear. The shock (S) reflects from the lower surface, and a little way into the material the spall damage (D_s) initiates. This persists as a strong horizontal line for the remainder of the record. Finally, when the reflected shock is reinforced by a wave (T) associated with the closure of D_c, a further crack (D_m) forms. D_s and D_m appear as horizontal lines in the streak record.

Only a brief description has been given, but clearly the combination of framing and streak photography is invaluable in understanding the complex events involved during the impacts. The reason why high-velocity liquid impact can cause

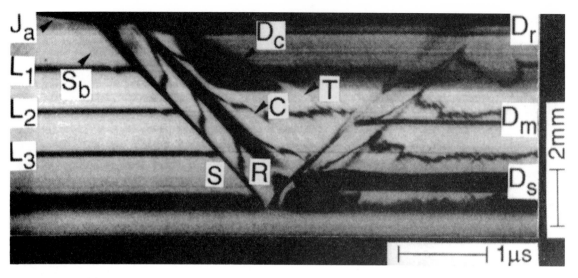

Figure 21.7 Ultranac camera streak record of a similar impact to that shown in Figure 21.6. Streak rate 200 ns mm^{-1}; time window 14 μs.

significant damage and erosion is that compressive behaviour, giving 'water hammer' pressures, can occur in the initial stages of impact. Fast lateral flow of liquid and intense stress waves also contribute to the damage.

It is difficult to see inside a raindrop while it is being impacted, since it is small and the shape refracts the light. These problems have been overcome by using two-dimensional drops cut from a gelatin layer which are then placed between glass blocks and impacted. Figure 21.8 gives an example of a 10 mm diameter drop impacted at 100 m s^{-1} by a metal slide. It is an Imacon camera sequence and schlieren photography was used to visualize the stress waves. The two-dimensional gelatin technique has been used to study a wide range of liquid impact and cavity collapse problems (Field *et al.*, 1985, 1989; Dear and Field, 1988; Bourne and Field, 1992).

Compressible behaviour occurs when a liquid drop impacts a target since the contact periphery initially expands supersonically (i.e. faster than the waves in the liquid or the solid). This allows a shock envelope to develop, initially attached to the contact periphery. However, when the contact periphery velocity falls below the shock velocity in the liquid, this shock advances up the free surface of the drop, release waves develop and rapid side jetting results. This takes place in frame Figure 21.8(e). It marks the end of the high pressure, compressible phase. The extent of the compressible stage depends on the radius of curvature of the drop and the impact velocity.

If a wedge of liquid is impacted, whether the contact moves supersonically or not depends on the angle between the liquid and the solid. Figure 21.9 shows a PMMA target impacting a gelatin wedge at approximately 100 m s^{-1}, with supersonic contact resulting. Note the way the shock envelope is attached to the contact point and the absence of jetting in the air wedge. A jet (J) forms only when the shock interacts with the right-hand boundary (frame (7)). If the air wedge angle had been larger the contact point would have moved more slowly, and below a critical angle waves would have advanced ahead of the contact point giving jetting. This kind of geometry is important in a range of impact situations and also in explosive welding (Field *et al.*, 1985).

A photographic study, using an Imacon camera, of the mechanics of high-speed liquid jets, in the range up to approximately 4 km s^{-1}, is described in Field and Lesser (1977).

21.3.4 Cavity collapse

The gel technique can also be used to study cavity collapse. Studies of this type are important in a range of problems, including cavitation damage and explosive initiation. An advantage of the gel method is that chosen arrays of cavities can be studied simply by punching out holes in a gelatin layer (Dear and Field, 1988; Bourne and Field, 1992). Schlieren photography is again used to visualize the shocks.

When a shock passes over a cavity the surface of the cavity involutes and produces a jet which passes across the cavity. The impact of this jet with the far side of the cavity or with an adjacent solid surface can give rise to high pressures. The impact of the jet can be an important factor in cavitation damage.

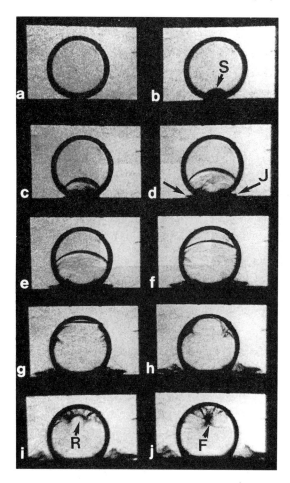

Figure 21.8 Imacon camera sequence showing the impact of a 10 mm diameter drop by a metal slider at a velocity of 100 m s^{-1}. Jetting is just visible in frame (c) and is labelled J in frame (d). The reflected wave, labelled R in frame (i), comes to a focus at F in frame (j) to produce a cavitation darkened region. Jet velocity 1170 ± 50 m s^{-1}. Frame interval 1 μs. (Field *et al.* 1989.)

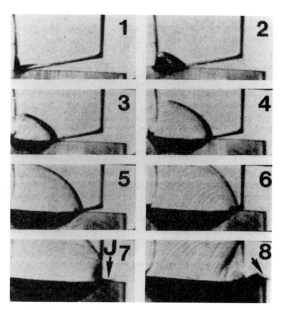

Figure 21.9 Impact between a PMMA target and a gelatine wedge; shocks in both the liquid and the solid can be seen. The air wedge angle is below the critical angle. The critical angle for a particular velocity is greater the more compliant the target. Interframe time 0.96 μs. (Field *et al.*, 1985.)

In Figure 21.10, three cavities have been formed in a horizontal column with the shock wave, labelled S in frame (1), travelling from left to right. The first cavity is collapsed by the shock wave and a jet can clearly be seen in frame (2). By frame (3), the cavity is totally collapsed and a rebound shock wave (S′) is formed. During this time of collapse (approximately 10 μs), the second cavity has been shielded from the initial shock wave and has experienced only a slight lateral compression (frame (3)); but when the rebound shock wave from the first cavity reaches its lower surface, it too starts to collapse to produce a jet. The third cavity in the line is collapsed in a similar way by the collapse and rebound of the second cavity. A chain reaction along a line of cavities is thus feasible, given the right conditions of shock strength, cavity diameter and spacing.

The above suggests that a rectangular array of cavities with each row directly behind the next row would allow little of the main wavefront to pass the first row. Hence the collapse of the second row of cavities should be due mostly to shock waves radiating from the collapse of the first row. This possibility has been examined with an array of 3 × 3 cavities (Dear and Field, 1988). The research has implications for the collapse of cavity clusters which can produce high pressures by concentrated collapse during cavitation and the production of 'hot spots' when explosives are shocked (Bourne and Field, 1991; Field, 1992).

21.3.5 Solid particle impact

Erosion by solid particle impact is an important wear process. In practice, a stream of irregularly shaped particles impinges at an angle against the solid surface. In work carried out, macroscopic solid particles of centimetre size have been used to simulate the impact and study the material removal processes. With metals, it can be shown that the damage scales with particle size and that the material removal processes are the same provided the particle size is a few times greater than the grain

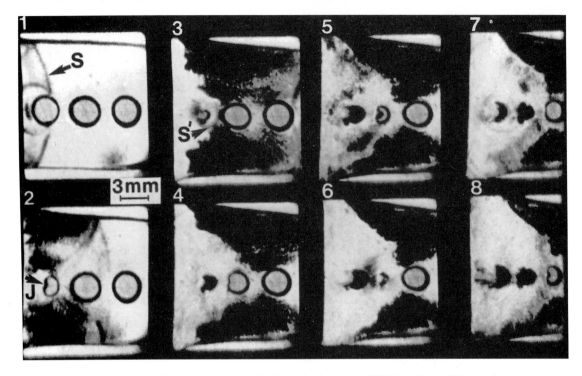

Figure 21.10 Three cavities, diameter 3 mm, perpendicular to the shock wave (S). J is the jet and S is the rebound shock wave from the first cavity. Note the step-by-step collapse. Interframe time 4.25 μs. (Dear and Field, 1988.)

size of the metal. The impact of blunt particles can readily be simulated using spherical projectiles, and that of angled particles by projecting plate-like particles at the specimen (Hutchings, 1977). Figure 21.11 shows an Imacon camera sequence of a 9.5 mm diameter spherical particle impacting a steel surface. The impact produces a crater by a ploughing action and a lip forms at the end of the crater. The lip in this sequence detaches in frame (3). A smaller marker tag has been attached to the sphere. From such sequences it is possible to measure the incident and rebound kinetic energies, the rotational energy and the coefficient of friction in the contact area.

Figure 21.12 shows the impact of an 8 mm square plate. The plate was projected from a gas gun with a rectangular (16 × 1.5 mm) cross-section. The plate was held in a light plastic sabot during acceleration. In the example shown, the plate rotates backwards after first contact and machines a chip from the target. In cases where the angle between the target surface and the impacting plate is greater, the particle impacts and rotates forward, leaving a deeper crater.

The mechanisms identified by this type of photographic work with macroparticles have proved invaluable in understanding material removal during erosion. (Field and Hutchings, 1987).

21.3.6 Drop-weight impact

The drop-weight impact test involves dropping a heavy weight onto a thin layer of material on an

Figure 21.11 Imacon camera sequence showing a 9.5 mm diameter steel ball striking a mild steel target at 210 m s⁻¹. The impact produces a crater by a ploughing action and a lip forms at the exit end of the crater. The lip detaches in frame three. The sphere has a small marker tag attached so that the rotational energy can be measured. Frame interval 19 μs. (Hutchings, 1977.)

Figure 21.12 Imacon camera sequence showing an 8 mm square plate impacting a mild steel target. The impact angle, rake angle (the angle between the vertical to the specimen surface and the front of the plate) and impact velocity are 30°, 15° and 187 m s⁻¹, respectively. Frame interval 19 μs. (Hutchings, 1977.)

anvil. It is used for testing materials at intermediate strain rates of approximately 10^2–10^3 s⁻¹, for studying the high-pressure behaviour of a layer of lubricant and for assessing the impact sensitiveness of explosives layers. Figure 21.13 shows schematically

Figure 21.13 Experimental arrangement at the instant of impact: W, drop weight; G, glass blocks; M, mirror; S, sample. The upper glass block is attached to the weight. (Heavens and Field, 1973.)

how it is possible to photograph the layer during the impact loading (Heavens and Field, 1973). The falling weight has a toughened glass anvil recessed into it. The layer to be studied is placed on a second transparent anvil. During impact there is a continuous light path from the flashlight source through the anvils and specimen by way of a mirror into the camera. The camera used in these experiments is an Atomic Weapons Research Establishment (AWRE), Aldermaston, designed model C4 continuous access rotating mirror camera capable of framing intervals down to 5 μs. One example from this work is given in Figure 21.14, which shows selected frames from a sequence in which 25 mg of a powder layer of the secondary explosive PETN (pentaerythritol tetranitrate) is being impacted. The frames before frame (1) simply show the layer expanding slowly at a few metres per second as it is compressed and compacted. Since the illumination is by transmitted light, the opaque powder layer appears black at this stage. However, in frame (2) the layer has clearly started to flow plastically since its rate of radial expansion increases rapidly to ›100 m s⁻¹. Once plastic deformation occurs, a sizeable fraction of the impact energy goes into the sample. In the case of PETN, this is sufficient to

Figure 21.14 Impact of a layer of granular PETN viewed in transmitted light. The sample flows plastically, melts and ignites at a number of sites. The thickness of the layer at the time of ignition is 50 μm. In frames (8) and (9), D is a flaw on the glass surface and I is an ignition site. Mass of sample 25 mg; frame interval 5.5 μs. (Heavens and Field, 1973.)

melt the layer. From frame (7) onwards, the whole layer is molten (and transparent) and its radial flow velocity is now approximately 300 m s^{-1}. It is at this stage that ignition occurs at three local sites. Not all explosives reach the molten stage when impacted but, in the case of pure samples, ignition invariably occurs after the layer fails plastically and begins to deform rapidly.

Other sequences obtained with the transparent anvil system are given in Field *et al.* (1982, 1992). The direct visual information which high speed photography provides is proving invaluable in understanding the complex, often surprising, behaviour when thin layers are impacted. We have applied high speed photography extensively to studies of explosive initiation and propagation (Chaudhri and Field, 1977).

21.3.7 Laser damage studies

The interaction of a laser pulse with a solid may last only a short time, but considerable damage can result with a variety of phenomena involved. High speed photography is clearly a valuable experimental approach for providing information on the processes taking place.

Figure 21.15 shows selected frames from a Beckman and Whitley 189 rotating mirror camera sequence, obtained by focusing with a lens of 40 mm focal length, a 10 J non-*Q*-switched ruby laser pulse into a PMMA block. In frame (1) three small cracks

have formed near the focus of the beam (arrows); by frame (4), other sites can be identified. The subsequent frames show the growth of the cracks and the initiation of new sites. Most of the cracks have their centres on the beam axis, although they have a variety of orientations. Crack A in frame (20) is angled so that the disk face is turned towards the camera; the others are seen edge on. Microscopic examination shows that there is a molten region at the centre of each disk; this is where strong absorption took place. This heated region would create spherically symmetric tensile stresses in the surrounding material. A crack is thought to form at a defect and then grow round, forming the disc. The disc then expands outwards. The main disc face is typical of brittle failure. It usually exhibits circular ripple marks which can be associated with the spiky nature of the non-*Q*-switched ruby laser pulse. Similar disc-type cracks form in other brittle materials. The laser is perhaps unique in being able to introduce penny-shaped cracks.

Figure 21.16 shows the result of focusing a 20 mW *Q*-switched ruby pulse into PMMA. The pictures are single-shot image converter images and so are of separate events. In Figure A the pulse is passing through the material and more than 50 individual microplasmas can be resolved. The resultant damage for this shot is illustrated in B. Finally, in C a delay of approximately 0.5 µs was introduced between the laser entering the specimen and the picture being taken. The plasmas have stopped

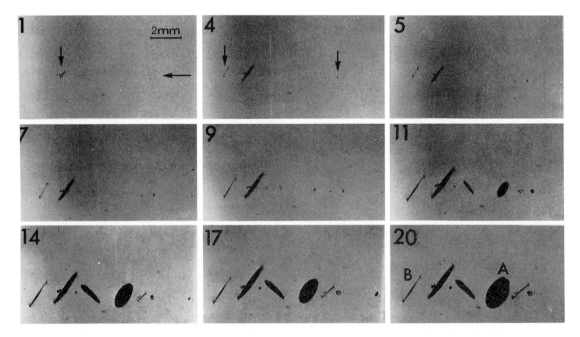

Figure 21.15 Some frames from a sequence showing laser damage in PMMA from a non-*Q*-switched ruby pulse. The horizontal arrow in frame (1) shows the beam direction travelling from the right. Frame interval 5 µs. (Field *et al.*, 1972.)

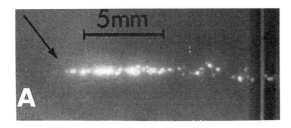

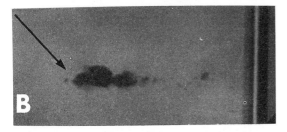

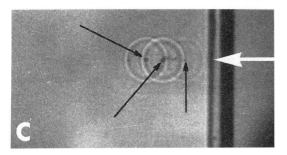

Figure 21.16 Single shot image converter pictures of *Q*-switched laser damage in PMMA. (A) Microplasmas (arrows) excited while the beam passes. (B) The damage resulting from shot A. (C) There was a delay of about 0.5 μs between the entry of the beam and the recording of the picture. The arrows mark the damage sites from which the stress waves developed. Exposure time 50 ns. (Field *et al.*, 1972.)

glowing, fractures have formed, and stress waves, centred on the damage sites, are spreading outwards (Field *et al.*, 1972).

21.4 Conclusions

The range of cameras available at the Cavendish Laboratory is such that we can record most high speed phenomena. The rotating mirror cameras give us the best resolution (approximately 25 lp mm^{-1}) and have been used successfully with laser speckle, speckle interferometry and moiré techniques, thus combining micrometre spatial resolution with microsecond time resolution. The image converter cameras, with their somewhat lower resolution (5–10 lp mm^{-1}), have been used successfully with moiré techniques where the moiré pattern, and not

the much finer moiré grating, is recorded. The mobility of image converter cameras (the AWRE C4 camera, see Table 21.1, weighs 2 tonne and is rarely moved), combined with their much greater ease of synchronization, has made them invaluable for impact studies. They were of particular value when it was required to optimize the liquid jets and establish a correlation between the jet and the drop impact. Without such cameras it is doubtful if the Laboratory could have built up a range of techniques for laboratory studies of rain, sand and ice (hail) impact.

The Ultranac camera is a programmable image converter camera with control of individual exposure and interframe times. There has been space to include only two examples in this chapter (see Figures 21.6 and 21.7), but the camera has already opened up exciting possibilities for impact research.

High speed photography is an important technique since it provides direct visual information of events taking place on a greatly enlarged time scale. As emphasized in the text, the results are always informative, occasionally surprising, and frequently aesthetically pleasing. A great many research groups already make extensive use of high speed photography; but undoubtedly research organizations and industry could make many further applications of these exciting techniques. If this chapter helps to stimulate increased interest in high speed photography, it will have achieved its main objective.

Acknowledgements

I thank my colleagues and former students Drs N. K. Bourne, J. P. Dear, S. N. Heavens, J. M. Huntley, I. M. Hutchings and T. Obara for providing pictures. Particular thanks to Dr Huntley for his development of high-resolution optical techniques and help with Section 21.2. Thanks to Catherine Byfield for typing the manuscript so effectively while I was on study leave at EPF Lausanne and communicating by fax. Finally, our EPSRC and MOD sponsors are gratefully acknowledged.

References

Arakawa, K., Drinnon, R. H., Kosai, M. and Kobayashi, A. S. (1991) Dynamic fracture analysis by moiré interferometry. *Exp. Mech.* **31**, 306–309

Bourne, N. K. and Field, J. E. (1991) Bubble collapse and initiation of explosion. *Proc. R. Soc., London, Ser. A* **A435**, 423–435

Bourne, N. K. and Field, J. E. (1992) Shock-induced collapse of single cavities in liquids. *J. Fluid Mech.* **244**, 225–240

Bourne, N. K., Rosenberg, Z. and Field, J. E. (1995)

High-speed photography of compressive failure waves in glasses. *J. Appl. Phys.* **78**, 3736–3739

Burch, J. M. and Forno, C. (1982) High resolution moiré photography. *Opt. Eng.* **21**, 602–614

Chaudhri, M. M. and Field, J. E. (1977) Fast decomposition in the inorganic azides. In *Energetic Materials,* vol. 1 (Fair, H. D. and Walker, R. F., eds), Chap. 8, p. 383. Plenum Press, New York

Courtney-Pratt, J. S. and Thackeray, D. P. C (1957) High speed photography. *J. Photogr. Sci.* **5**, 32–42

Dear, J. P. and Field, J. E. (1988) A study of a collapse of arrays of cavities. *J. Fluid Mech.* **190**, 409–425

Deason, V. A., Epstein, J. S. and Abdallah, M. (1990) Dynamic diffraction moiré – theory and applications. *Optics Lasers Eng.* **12**, 173–187

Fällström, K.-E., Gustavsson, H., Molin, N.-E. and Wåhlin, A. (1989) Transient bending waves in plates studied by hologram interferometry. *Exp. Mech.* **29**, 378–387

Field, J. E. (1970) Brittle fracture: its study and application. *Contemp. Phys.* **12**, 1–31

Field, J. E. (1992) Hot-spot ignition mechanisms for explosives. *Am. Chem. Soc.* **25**, 489–496

Field, J. E. and Hutchings, I. M. (1987) Surface response to impact. In *Materials at High Strain Rates* (Blazynski, T.-Z., ed), Chap. 7, pp. 243–293. Elsevier, Amsterdam.

Field, J. E. and Lesser, M. B. (1977) On the mechanics of high-speed liquid jets. *Proc. R. Soc. London, Ser. A* **357**, 143–162

Field, J. E., Hagan, J. T. and Zafar, M. A. (1972) High-speed photography of laser damage in solids. In *Proc. 10th Int. Conference on High-speed Photography, Nice* (Naslin, P. and Vivie, J., eds), p. 432. Association National de la Recherche Technique.

Field, J. E., Swallowe, G. M. and Heavens, S. N. (1982) Ignition mechanisms of explosives during mechanical deformation. *Proc. R. Soc., London, Ser. A* **382**, 231

Field, J. E., Lesser, M. B. and Dear, J. P. (1985) Studies of two-dimensional liquid-wedge impact and their relevance to liquid-drop impact problems. *Proc. R. Soc., London, Ser. A* **401**, 225–249

Field, J. E., Dear, J. P. and Ögren, J. E. (1989) The effects of target compliance on liquid drop impact. *J. Appl. Phys.* **65**, no. 2, 533–540.

Field, J. E., Bourne, N. K., Palmer, S. J. and Walley, S. M. (1992) Hot-spot ignition mechanisms for explosives and propellants. *Phil. Trans. R. Soc., London, Ser. A* **339**, 269–283

Heavens, S. N. and Field, J. E. (1973) The ignition of a thin layer of explosive by impact. *Proc. R. Soc. London, Ser. A* **338**, 77

Huntley, J. M. (1989) Speckle photography fringe analysis: assessment of current algorithms. *Appl. Opt.* **28**, 4316–4322

Huntley, J. M. and Benckert, L. R. (1993) Measurement of dynamic crack tip displacement field by speckle photography and interferometry. *Optics Lasers Engng* **19**, 299–312

Huntley, J. M. and Field, J. E. (1989) High resolution moiré photography: application to dynamic stress and analysis. *Opt. Engng* **28**, 926–933

Huntley, J. M. and Field, J. E. (1994) High-speed laser speckle photography. Part 1: Repetitively Q-switched ruby laser light source. *Opt. Engng* **33**, 1700–1707

Hutchings, I. M. (1977) Deformation of metal surface by the oblique impact of square plates. *Int. J. Mech. Sci.* **19**, 45–52

Kalthoff, J. F. (1987) Shadow optical method of caustics. In *Handbook on Experimental Mechanics* (A. S. Kobayashi, ed.). Prentice-Hall, Englewood Cliffs, NJ

Kobayashi, A. S. (ed.) (1987) *Handbook on Experimental Mechanics.* Prentice-Hall, Englewood Cliffs, NJ

Manogg, P. (1964) Anwendungen der Schattenoptik zur Untersuchung des Zerreissvorgags von Platten. Ph.D. thesis, University of Freiburg, Germany

Shukla, A., Sadd, M. H. and Mei, H. (1990) Experimental and computational modelling of wave propagation in granular materials. *Exp. Mech.* **30**, 377–381

Theocaris, P. S. and Gdoutos, E. (1972) An optical method for determining opening-mode and sliding-mode stress-intensity factors. *Trans. ASME: J. Appl. Mech.* **39**, 91–97

Tippur, H. V., Krishnaswamy, S. and Rosakis, A. J. (1991) A coherent gradient sensor for crack tip deformation measurements: analysis and experimental results. *Fracture* **48**, 193–204

Warr, S., Jacques, G. T. and Huntley, J. M. (1994) Tracking the translational and rotational motion of granular particles: use of high-speed photography and image processing. *Powder Technol.* **81**, 41–56

Wells, A. A. and Post, D. (1958) The dynamic stress distribution surrounding a running crack. *Proc. Soc. Exptl Stress Analysis* **16**, no. 1, 69–96

Whitworth, M. B. and Huntley, J. M. (1994) Dynamic stress analysis by high-resolution reflection moiré photography. *Opt. Engng* **33**, 924–931

Zehnder, A. T. and Rosakis, A. J. (1990) Dynamic fracture initiation and propagation in 4340 steel under impact loading. *Int. J. Fract.* **43**, 271–285

22 Applications of high speed photography and video in aircraft and armament engineering

George Randall

22.1 Introduction

Visual recording of events in aircraft and armament engineering is still the most satisfactory method of data acquisition. Instrumentation recording systems using transducers and other sensing devices can cover many recording tasks, but it is often required to see the event and other influences around the subject which cannot be satisfactorily recorded by other means. Pure instrumentation systems complement film and video systems, they do not replace them.

The experiences of the writer date back to the early 1950s, before video recording was available as an engineering tool, and he has seen the evolution of the much more sophisticated film and video cameras of today. This chapter is based on those experiences and is a somewhat parochial view of the subject.

22.2 Cameras

The film cameras used in the 1950s were of the well established 16, 35 and 70 mm types and formats. While film gauges have not changed over the years, camera designs have, as has the film stock available. Most previous work was on monochrome film and the small amount of colour film used was Kodachrome, while today both film and video recording is almost 100% in colour, with the availability of in-house film processing.

The *air cameras* available for aircraft use in the 1950s were mainly gun sight aiming cameras (Figure 22.1) left over from the war years, including the Bell and Howell GSAP and the Williamson G45. Later came the Vinten G90 and Telford Dekko cameras which used 16 mm magazine loading. Camera reliability was variable. Of this limited range, the highest framing rate was given by the Dekko fitted with a high speed motor providing 150 pictures per second (pps). The GSAP and Dekko types, although designed for fixed view photography, were fitted with pistol grips for hand-held use. The alternative 35 mm A4 Bell and Howell Eyemo camera (Figure 22.2) was also used hand-held for air to air photo-

graphy and was later locally modified for remote pulsed single frame operation, while a further modification included removal of the drive spring and the fitting of an electric motor for instrument recording in single shot mode. The GSAP and Dekko cameras were also used mounted on parachutists' helmets and powered from body belt battery packs to record air to air parachute openings.

One interesting and unique configuration of the Telford Dekko camera as used for parachute trials is worth discussing. The camera and magazine section was separated from the motor and gearbox, and the two parts were mounted for balance on each side of a helmet and connected by a flexible cable drive through a metal tube formed over the top of the helmet. A body belt battery pack was used for a power supply. This system was used a few times, but found to be heavy and unreliable.

Representative *ground cameras* using 35 mm film included: the Newman Sinclair (Figure 22.3), both the standard version with spring motor drive and framing speeds up to 48 pps and the high speed version up to 120 pps (Figure 22.4); the Eclair GV 35 giving up to 150 pps; and the Vinten HS 300 with 300 pps. These were all intermittent movement cameras, but 16 mm Eastman and Fastax cameras with rotating prisms were also available. Another frequently used camera was the 70 mm Vinten F47, which could not be classed as a high speed camera but is mentioned because of its regular use on airfields for recording the take-offs and landings of aircraft at 2 pps. This gives some idea of the speed of the aircraft it was used to record, most definitely not suitable for today's fast aircraft! There were many other cameras in use, but those mentioned above were the particular workhorses of the day. For comparison, a modern 16 mm high speed camera for ground use is shown in Figure 22.5.

High speed cameras currently used for airborne photography are built to a very high specification for aircraft use. They can operate in severe environments, at high g rates, and extremes of temperature. They have higher framing rates and are more compact and lighter. All have electronic speed controls and most are magazine loaded with various film length capacities.

a

b

c

d

Figure 22.1 Gun sight aiming cameras. (a) Bell and Howell GSAP type 16 mm gun sight aiming camera. Features include magazine loading, choice of 16, 24, 32 and 64 pps framing speeds and a changeable fixed sector shutter. A 90° shutter fitted as indicated. (*circa* 1940–1960s; refurbished versions of this camera can still be purchased and magazines of film can be obtained to special minimum orders.) (b) Williamson G45 gun sight aiming camera, 16 mm, 50 foot film magazine loading (*circa* 1930s–1950). (c) Vinten G90 type. Designed as a gun sight aiming camera, extensively used as a fixed view recording camera on aircraft and inside bomb bays to record the behaviour of bombs during carriage, release and clearance from the aircraft. Used 16 mm film magazine loading with 100 and 200 foot magazines (*circa* 1960s–1980s). (d) Telford Dekko camera with 16 mm magazine loading. Both 100 and 200 foot magazines were available; a few 400 foot magazines were made to special order. The lens plate had a standard C mount lens thread, so a good range of lenses was available. A top-hat shaped shield was usually fitted and wire locked as part of the lens assembly for safety. Two versions were available: normal and high speed up to 160 pps by changing the drive motor and gears. (*circa* 1960s–1980s. Many were purchased and a few are still in use for fixed view aircraft installations.)

The intermittent movement cameras have pin registration and even contemporary rotary prism cameras produce very stable pictures under the most arduous conditions of high *g* and vibration.

22.3 Aircraft trials

The recording of aircraft trials use cameras in three basic operational modes.

22.3.1 Fixed viewpoint cameras

Fixed viewpoint cameras (Figures 22.6–22.8), are used to record events within the aircraft, or to record items such as parachutes, stores, flares and weapons being dropped, released, jettisoned or fired (Figures 22.9–22.11). A remotely operated camera can be mounted either on the gun mounting or bomb rack of the aircraft or in a pod on the wing or fuselage. It may be possible to use the armament

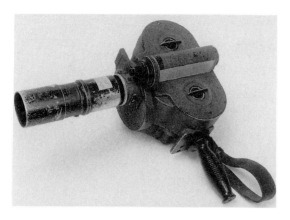

Figure 22.2 The Bell and Howell A4 Eyemo camera. Used 35 mm film 100 foot spool loading, up to 64 pps. Used for hand-held air to air photography. (*circa.* 1940–1960s.)

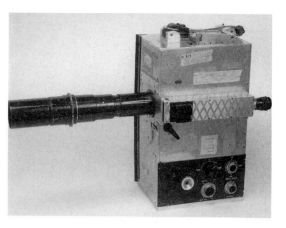

Figure 22.4 The Newman Sinclair High Speed 35 mm camera. With 200 foot magazine film loading, 12 V battery motor drive. The time base fitted into film gate was a spark gap which was driven by 100 Hz tuning fork, a car type ignition coil and a car battery. (*circa* 1930s–1960s.)

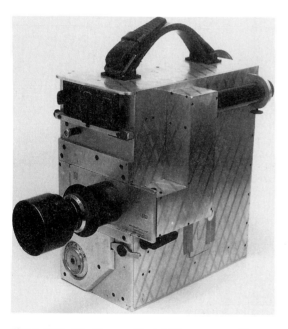

Figure 22.3 The Newman Sinclair 35 mm camera. Up to 48 pps with 200 foot magazine loading and spring motor drive. (*circa* 1920s–1950s.)

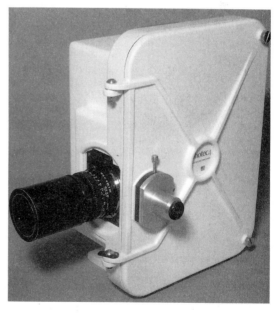

Figure 22.5 Photec 16 mm high speed camera. Continuous film movement image compensating prism type camera providing up to 20 000 pps. 400 foot spool film loading. Mains or battery powered versions available. A current camera model.

electrical wiring circuit to power and operate the camera. Jumper leads with compatible plugs and sockets can be made up to adapt the existing wiring so as that there is no need to change the standard plugs and wiring circuits of the aircraft.

Aircraft trials may not always be done in flight; in fact most aircraft, and functions such as ejection seats (Figure 22.12) bomb release, gun and rocket firings are first tested on the ground using test rigs, in hot and cold environment hangars (Figure 22.13)

and in blower tunnels. In these cases, the cameras are mounted on tripods at safe distances from the event, and are often remotely controlled. In cold environments it may be necessary to put a heater muff around the camera, although some cameras have a built-in heater.

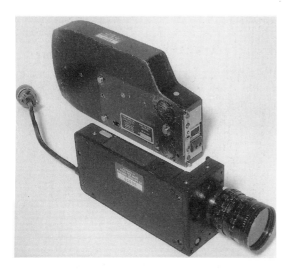

Figure 22.6 Photosonics 1VN camera. A 16 mm high speed camera with 200 foot film magazine and up to 200 pps. Time base and event markers in the film gate are fitted as standard. Data film gates with IRIG now available for this camera. A current camera model.

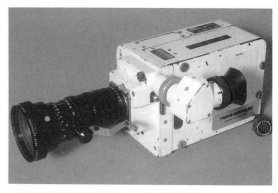

Figure 22.8 Photosonics 1P camera. A 16 mm high speed camera with 200 foot film magazine, fitted with Arriflex lens mount and reflex viewfinder for ground use. Can be fitted with a C mount lens plate, which would be more appropriate for fixed use. Camera has intermittent movement, a framing rate up to 500 pps and a variable sector shutter. A current camera model.

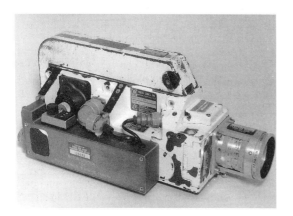

Figure 22.7 Photosonics 1B camera. A 16 mm high speed camera fitted with 200 foot film magazine and using an image movement compensating prism. Framing rate continuously variable to 1000 pps. A current camera model.

Figure 22.9 Photographer reloading an aircraft wing pod mounted Photosonics 1P camera for flight.

22.3.2 Hand-held cameras

It is not always practical or cost effective to install cameras in or on an aircraft; on such occasions hand-held cameras may be used, with the operator either in the trials aircraft or in an accompanying 'chase plane'. The pictures obtained can be used to assess the safe clearance and necessary behaviour of external stores both during and after release from the aircraft (Figure 22.14), or during gun firing to show the safe clearance distances for cartridge cases and ammunition clips from the aircraft engine air

intakes and control surfaces, and the rotors of helicopters.

The choice of camera depends on the framing rate required and the room available in the aircraft. In a high performance military aircraft fitted with ejector seats the choice is limited due to the consideration of safety to the operator, other crew members and the aircraft. For example, when hand holding a camera in flight, it is essential to be able to dispose of the camera quickly and safely in the event of an aircraft emergency. The first consideration is that the camera has to be compact (it has to be stowed somewhere safely and quickly in the event of an emergency), and, as it is electrically powered, the lead needs to be unplugged quickly or it could tangle

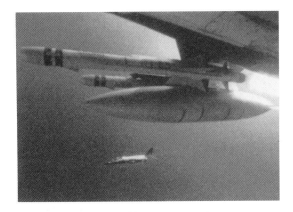

Figure 22.10 Still frame from a pod mounted camera of weapon launch. The chase aircraft can be seen in the background with the photographer on board filming release of the same store to show its behaviour and safe clearance from aircraft influence.

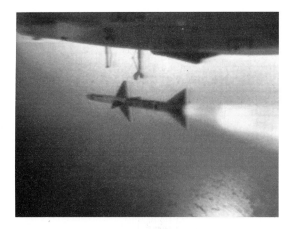

Figure 22.11 Still frame of a Skyflash missile release from a wing-mounted fixed view camera.

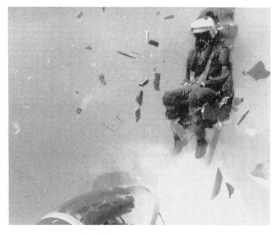

Figure 22.12 Still frame from a 35 mm high speed cine record of ejection seat trials. The Perspex canopy is painted with slow drying paint to show any Perspex collision marks on the dummy person. This is the rear seat of a double seat ejection test, the front seat is about to eject.

around the operator and impede an escape. One solution to such problems is to adapt an *instrumentation camera*, such as the Photosonics model 16–1VN which is the smallest high speed camera available. A hand-held version of this camera with a built-in battery pack is the Actionmaster 200, but it is not possible to use this in certain aircraft, as there is not enough head room in the aircraft canopy when looking out to the right, as the camera is not symmetrical.

Consequently, a custom designed hand-held camera configuration was built around the Photosonics 1VN (Figure 22.15). A pistol grip was specially designed and made with a trigger operated microswitch. A short power lead about 1 m in length

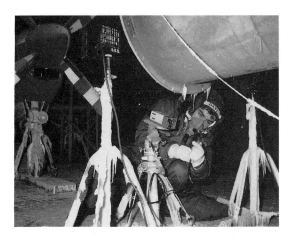

Figure 22.13 Setting up a film and video camera recording system in a cold environment hangar at −40°C.

Figure 22.14 Bomb release. A still frame from an air to air hand-held camera of release of a laser guided bomb from a Jaguar aircraft. The black and white squares on the bomb will indicate store behaviour, i.e. the rate of rotation.

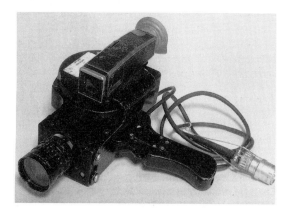

Figure 22.15 A Photosonics 1VN instrumentation camera adapted for hand-held aircraft use. It is fitted with 50 mm Nikkor cine lens, a 200 foot co-axial film magazine, a locally made pistol grip and a Bolex camera sight. A quick release snatch plug is fitted to the power line. Another 1VN camera has been fitted to a parachutist's helmet for airborne use, to record parachute opening sequence and rigging line behaviour.

The power supply panel is fitted with two circuit breakers, one for the time base supply the other for the camera power supply. The latter is a high sensitivity type which breaks the power in the event of a camera jam. This system enables the photographer to recover from a film jam situation fairly quickly, by a quick change of magazine and resetting the circuit breaker. If fuses are used it is difficult to replace them speedily with the ever-present risk of dropping fuses in the aircraft, when they become a potential loose object hazard.

A separate viewfinder was fitted to the top of the modified camera, such as the Octameter type from a Bolex cine camera, which usefully was adjustable for lenses of different focal lengths. The latest version of the Photosonics 1VN camera has an enlarged film gate to accommodate a data imprinting facility which can, with the appropriate add-on instrumentation, receive and print data and time on the edge of the frame. In addition, by using the Inter-Range Instrumentation Group (IRIG) international time base, additional cameras can be phase locked or time linked together in the air or on the ground for accurate reference between cameras. The IRIG formulated a time code transmission system for use on military ranges. It is necessary to transmit and record time in order to correlate several camera and instrument recording locations which may often be some distance apart. The serial

was wired from the pistol grip and terminated with a quick release plug, while the power supply socket was fitted to a panel in a conveniently accessible place in the cockpit of the aircraft. This socket was wired to the aircraft power supply. Also wired behind the aircraft panel was a small solid state 100 Hz time base unit. Two small light emitting diodes (LEDs) are fitted as standard in the film gate of this camera, which, when pulsed, enable a small mark to be recorded on the edge of the film. One LED is wired as an *event marker*, the other is pulsed by the time base unit to confirm the camera framing rate.

Figure 22.16 An air to air photographer suitably dressed and with 1VN camera, preparing for a photographic chase sortie in a Hawk aircraft.

pulsed time code is transmitted by land line or telemetry link. There are six code formats (A–G). The IRIG A and IRIG B are the most common code formats and have become industry standards, being used in many fields of industry and science. Some manufacturers of high speed cameras can provide these with IRIG time coding which is recorded beside the frame in an enlarged film gate. The coding can be in digital or binary format.

There is an acquired technique for successful hand-held camera operation in air to air photography. It requires a fair degree of skill and the photographer and pilot must work as a team to hold a camera steady and follow a moving target from a moving platform when in a dive or perhaps a 3g turn, or even in a negative g situation (Figure 22.16). On another day, the photographer may be sitting on the sill of the door of a helicopter at an altitude of several hundred metres, so a good head for heights is necessary (Figure 22.17). When a camera is being hand-held it is important not to rest either elbows or arms on any part of the airframe as vibration of the aircraft can be transmitted to the camera, which will cause the pictures to have the appearance of being out of focus.

The next operational consideration must be a suitable framing rate to obtain the information required. In airborne applications this often has to be a compromise between camera film capacity and event duration, with a mind on the object of the exercise, i.e. not to miss any of the information due to a too low framing rate.

With fixed viewpoint camera installations it may not be possible to change the film magazine during the flight. If more than one event is to be recorded during the sortie, great attention is required to switching off the cameras so as to conserve film. This may not be too much of a problem in recording the

dropping of stores or bombs as the cameras can be triggered electronically by the event itself, or the event can be triggered by the camera control system.

In air to air photography from a chase aircraft the camera is usually hand-held and manually operated. A reliable countdown procedure is required in order to synchronize the aircraft drop or release with the camera operator. This routine is usually done over the radio, by the trials range controller on the ground, or the pilot of the trials aircraft. A little more operational flexibility is also available here, as the photographer is able to change film magazines between recording runs. In estimating film consumption against the total number of events to be filmed, both sufficient film supply and time have to be allocated to allow the camera to run up to correct framing speed, and these in turn will depend on the camera type and the framing rate setting.

In a fixed viewpoint camera installation with the camera attached to a bomb rack or gun mounting, a small video camera can also be mounted on and harmonized with the film camera or used with a reflex device so that both cameras see the same view. An observer in the chase aircraft can then direct the trials aircraft into position by viewing with a remote video viewfinder linked to the video camera. This viewfinder image could also be transmitted to a ground station.

22.3.3 Ground based cameras

Ground based cameras are used to record events from the moment of release of the store to touchdown. This recording could show, for example, proper and safe store release, store trajectory and behaviour, ground impact, and also enable the time from release to impact to be calculated. Other applications regularly used are parachute opening sequence analysis and rates of descent.

A ground based camera and tracking system has been developed at DTEO, Boscombe Down. It is referred to locally as a Mobile Kine Theodolite, but is much more than this. The basic unit is a tripod mounted azimuth and elevation tracking and measuring system (Figure 22.18) which outputs and encodes this angular information into the video signal of a video camera mounted on the tracking head. A *time code* is also added to the encoded signal, which is then recorded on a video recorder. A high speed film camera can also be mounted on the tracking head and harmonized with the video camera (Figure 22.19).

The film camera normally has a lens of long focal length fitted in order to record a close-up view of the event for later frame by frame analysis. The video camera record is used to measure the accuracy of the manual tracking by the operator, the trajectory of the object and associated timing. This evaluation is done on playback using a linked computer fitted

Figure 22.17 Photographer filming parachutists from the sill of a Hercules aircraft.

Figure 22.18 Mobile Kine Theodolite system. The tracking head is able to have two cameras mounted, one each side of the centre column, usually a film camera and a video camera. Here it is in use for parachute tracking with just a video camera.

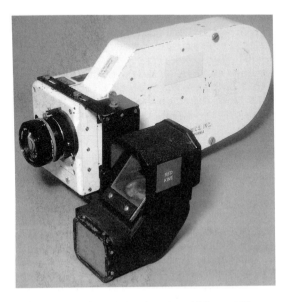

Figure 22.19 Photosonics 4ML 35 mm high speed film camera. Fitted with a 400 foot magazine and giving up to 200 pps. A tracking viewfinder is fitted with a locally made bracket. It can be used in this configuration with the Mobile Kine Theodolite.

with a frame grab video board. The picture area is calibrated and measurements made using a suitable CAD program. Corrections can be input to the calibrations to allow for inaccuracies of the manual tracking. Three of these tracking units can be synchronized and used for triangulation purposes using photogrammetric procedures. They are used principally for ejection seat trials, and the dropping of parachutes and stores from aircraft. With this equipment an instrumented range can be set up at any convenient location. Other essential instruments required for setting up would be a compass and some means of measuring the distances of baselines between theodolite units, a laser range finder is ideal.

22.4 Case histories

To illustrate some solutions to typical problems that have arisen recently, accounts are given of four selected case histories, in the hope that they may give an insight into problem solving in aircraft engineering.

22.4.1 Monitoring of a mass balance weight

The problem encountered was that during the programme of test flying of a particular aircraft, test pilots experienced vibrations and instability in the rudder control system when making certain aircraft manoeuvres. Physical damage also appeared on the skin of the tail fin, in the form of local bumps, leading to splits. Housed inside the tail of the aircraft is a balance weight, which is linked into the elevator control lines, and is designed to counterbalance the aerodynamic pressure on the elevator control surface during high performance manoeuvres.

It was suspected that this *mass balance weight* was vibrating laterally, to a degree that it was hitting the inside surfaces of the tail and splitting the skin. This fault had only shown up in the advanced flying test programme. The aircraft was about to go into service so an urgent diagnosis and solution was needed.

To investigate this problem, it was decided to install a camera actually inside the tail structure to record and monitor the behaviour of the mass balance weight during flight. The choice of equipment was limited by various considerations. There was very little space available in the tail, so a small camera and lens was the first requirement. Once the camera was installed there would be no access either to change film or make adjustments. The only access into the tail fin was by removal of the tailplane, which took 2 days and would keep the aircraft on the ground. Long sampling (recording) periods were

required, of the order of minutes rather than seconds, and many sample periods were required, during an hour long sortie. So the choice of camera type had to be video because there would be no access to change film magazine and the necessary recording duration would be longer than the capacity of a film magazine.

The engineer requiring the data already knew the frequency of the vibrations but now required information about their amplitude and the behaviour of the aircraft, both when the vibrations started and when the vibrations were at their most violent. A camera with a short relative exposure time would be necessary to produce sharp images of the balance weight for accuracy of measurement. Only 25 pps was possible, this being the limitation of the standard video system. Most current small video cameras now use charge coupled device (CCD) sensor arrays which permit electronic shuttering, with a choice of effective exposure durations. High speed video cameras and systems were available but they were much too bulky for this installation.

The camera finally chosen was a JVC Model TK900E type that operated from a 12 V DC supply and gave composite video output. An electronic shutter provided exposures of 0.001s. The lens mount was the standard cine C mount type, giving a wide choice of available lenses. A wide angle lens was required to provide a view of the balance weight and the inside skin of the aircraft tail fin. Choice of lens was again a compromise between the physical size of the lens and the field angle of view given. Ideally, a field of view (FOV) of about 90° was required, but many of the wide angle cine camera lenses available had front lens elements that were rather large and protruding, so would take up a lot of space, and most of the others were retrofocus types which are also quite long in their physical size. A compromise choice was a 16 mm cine camera lens, a Bolex Switar 10 mm. This was satisfactory for physical size and gave an angle of view of some 60°, which was just about adequate.

The size of the balance weight was approximately 125 × 75 × 75 mm. Black reference lines 5 mm wide were painted vertically down the weight, one down the centre and one down one side about 15 mm from the edge, plus an additional line drawn horizontally across the top and facing side (Figure 22.20). These lines were used later for calibration of the video screen and measurement at the analysis stage. The distance from each side of the weight to the skin of the aircraft was approximately 50 mm and the distance available from the subject to the bulkhead for the camera and lens installation was about 400 mm. The physical size of camera and lens took up a lot of this space.

There was no available light inside the aircraft tail fin, so a lighting unit had to be designed. This again had to be maintenance free, as access was not

Figure 22.20 Aircraft mass balance weight, removed for datum line marking.

possible after installation. A lot of thought and searching was done to find a suitable light source (Figure 22.21). It was finally decided to use aircraft specification tungsten lamps as used for anti-collision lights in aeroplanes. These lights were known to be reliable and could withstand vibration. If several lamps were used, there would be sufficient exposure latitude to tolerate failure of one lamp without the need for replacement. It was anticipated that the automatic exposure level control in the camera control electronics would take care of minor light level changes if one or even two lamps failed.

An enclosure was designed with a toughened glass front to contain the occurrence of any broken or damaged lamps. This enclosure was a rectangular box made of aluminium, size 150 × 75 × 60 mm, with three lamps rated at 26 W and 28 V DC, of the aircraft anti-collision type fitted with reflectors. The lamps became rather hot after just a short running time, so many small ventilation holes were needed in the top and bottom of the unit. Tests were made on the unit to check on its operating temperature during continuous running. It was run for double the

Figure 22.21 Camera and lighting unit installed in aircraft tail fin.

anticipated maximum flight duration to produce the maximum temperature condition. Temperature tests were carried out at ambient temperature. After 5 min running time the box top surface temperature was 55°C with a gradual increase to 115°C after 22 min, but there was no further increase for the remainder of the 120 min maximum running time of the test. These temperatures were recorded and reference made to the aircraft engineer to certify that they were not a hazard to the aircraft.

A video recorder had to be installed and consideration had to be given to access for tape changing before and after flight. The aircraft luggage bay was found to be the most convenient location. Consideration was also given to g forces on the tape mechanism during aerobatic manoeuvres and these also had to be considered in the design and mounting of the bracket for the recorder. A suitable switched power supply was also needed for the camera and video recorder.

The video recorder finally chosen was a standard VHS model which could be powered from an external 12 V DC supply. It was judged that a standard portable video recorder would be suitable and most cost effective after minor modifications. This choice involved checking all internal electrical connections and sealing all case screws to prevent them working loose during flight. The recorder was tested for reliability under manoeuvring stresses up to 4.5 g using a centrifuge and placing the recorder in five positional configurations, i.e. on each side and flat on its back. Failure occurred only in one position at over 3 g, when the recorder was on its top edge. These results influenced the design of the mounting for the recorder and its direction of travel in the aircraft. An aluminium enclosure was manufactured with a flap type access to the tape aperture. The enclosure was fitted with brackets and anti-vibration mountings to suit existing attachment points on the floor of the luggage bay.

It was also decided to incorporate a *time code generator*, a small unit which simply connected into the video line and would prove useful during the analysis of the results. It provided a time reference and a unique marker for every frame. A 250 mm 12 V video monitor was installed in the rear cockpit for in-flight viewing by an observer. It was necessary to run all the equipment from the aircraft power supply of 28 V DC. The equipment chosen all ran on 12 V so a solid state 28 to 12 V DC converter was necessary, also of aircraft specification.

For safety reasons, before bracket manufacture or installation could proceed, drawings had to be produced detailing all the items and their positions in the aircraft. The brackets had to be designed by a stress engineer and items for installation in the tail section had to be referred back to the design authority for the aircraft as it was required to fit brackets to the structure of the tail sections.

The planned flight test programme consisted of some 20 sorties at various aircraft speeds and manoeuvres. During the first flight, interference was experienced with the on-board navigation systems, causing the avionics compass system to give false readings. The video equipment was immediately suspected by the air crew and ground technicians. Previous electromagnetic compatability (EMC) tests had shown that the video equipment was not emitting electrical or magnetic interference. The only item that had not been tested for electrical emissions was the lighting unit, considered at the time to be an innocuous piece of equipment. The main concern at the time was its operating temperature, which proved after testing to be acceptable. The video installation was fully tested again, and found to be free of blame, so attention was then turned to the lighting unit. This was found to be emitting a significant magnetic field and the unit was about 450 mm away from an electronic compass unit and so proved to be the cause of the problem.

(Note that a modern aircraft is crammed full of navigation avionics and electronic equipment. This is particularly so in a military aircraft, which also has

explosive devices in the aircrew escape system, i.e. ejector seat and canopy jettison, plus the addition of the weapons system to fill its particular military role. All these systems and equipment are capable of producing their own magnetic or electrical radiation so there has to be assurance that there is no interaction or interference between or across these systems. Extensive tests are carried out to check the compatability of these systems and to ensure that one will not affect another.)

Initially the light unit was condemned and was to be removed from the aircraft, but because of the amount of work involved an alternative safe operating procedure was negotiated. A separate lighting switch was installed in the rear cockpit to be selected as each test was started. The compass was not required during the tests so this was acceptable, and there was an additional stand-by compass outside the influence of the lighting unit and not dependent on the electronic sensing unit.

The video recorder was switched on and the time code generator was zeroed and started just after engine start, so all the recording system was running during the whole of the flight, except for the lights which were only switched on during each flight test condition, producing a blank period between tests. This arrangement actually worked out very well as it aided the identification and separation of the recordings made. Audio recordings were also made and involved connecting the aircraft intercom system to the audio input of the video recorder. At the start of each test the flight observer voice recorded the flight and test conditions on the audio track, and additional comments were recorded by the pilot and observer during the flight tests.

When this system was requested and installed it was only required for image recording to confirm the suspicions of mass balance weight behaviour, but inevitably more information was required as each flight progressed. For example, it became necessary to measure the movement of the weight during different flight conditions.

Image measurements were made using a computer operated x–y plotter combined with the video picture. Only the side to side movement of the balance weight in the x (horizontal) plane was of concern, so it was a matter of calibrating this movement against the known size of the weight in the image (Figure 22.22). Twenty sorties, each of about 1 h duration, were flown using this equipment, with 100% successful recordings. One of the lamps in the lighting unit failed at some time during these sorties, but it was only just noticeable on the video recordings and there was no significant loss in picture quality.

It is worth noting that there are video camera systems available which can record at the equivalent of 50 pps. A normal video *frame* consists of two interlaced *fields*, each made up of 312.5 lines and

Figure 22.22 Print from a combined video frame of mass balance weight and computer x–y plotter, as used for analysis of side to side movement.

scanning a complete screen area in 20 ms. Alternate fields are displaced by half a line and scan between the lines of the previous scan. The two interlaced scans record a complete frame in 40 ms to give 625 lines in the PAL system. In a specially modified system these two interlaced scans can be separated into two separate fields consisting of 312.5 lines, giving 50 pps, but each obviously has only half the vertical resolution of a full video frame of 625 lines. With cameras using CCD sensors which have no scanning as such, and using electronic switching, short exposure times per picture can be obtained. This feature is limited by the sensitivity of the CCD sensor and the available light. Conventional scanning is used in the viewing and analysing system, and computerized plotting can be part of the package but adds to the cost.

Video systems were available with higher framing rates, such as the NAC 200 and 400 types, latterly the NAC 500 and 2000 types, as well as the Ektapro 1000 and 2000 systems, but none of these were suitable for this project due to their size and weight.

Since this trial was done much smaller video cameras have become available. Technology is moving so quickly that it is impossible to specify any particular item of equipment, as there will always be something better to do the job tomorrow. The cheapest and most efficient way is sought in the first instance to utilize and improvise equipment that may already be on the shelf.

Specially designed video cameras and recorders for use in aircraft are available. They are built to military aircraft specification, with internal connections and components specially selected to withstand the vibrations encountered in aircraft use. Electrical insulation is also a consideration in their design, due to insulation breakdown at high altitudes. The external case is also ruggedized. For these reasons they

cost about 15 times the price of a standard portable VHS recorder; even so, serious thought should be given to these machines if prolonged use or high altitude flying is anticipated. For the application described a standard portable VHS recorder was used as all flights were low level (less than 3000 m) and the installation was only for a limited period.

A Genlock system enables a computer with a CAD program and a video player with video frame grab to be synchronized together on a video monitor for analysis and measurement of the video recordings, and could be a cheaper and more flexible alternative to a commercial *xy* plotter.

22.4.2 Monitoring of oil flow

The problem as described was that of a suspected delay in oil supply to the main rotor gearbox on initial engine start-up in a particular helicopter, especially at low temperatures. The investigating engineer was not satisfied with suggestions of placing supplementary pressure gauges or switches in the oil system, but required visual evidence of the oil reaching the gearbox. This required a camera to record the flow of oil at a point where it entered the gearbox. This recording had to be linked in time to the moment the engine start button was pressed with a reference to engine revolutions in revolutions per minute (rpm).

There was very little space available in the aircraft engine bay, so a small camera was essential, which could have been either a film or video type. A video camera was chosen because the engine rpm was required to be recorded at the same time to establish the engine speed when full oil flow was achieved, so a second camera was mounted on the engine instrument panel, and a video mixer used to superimpose an image of the rpm instrument over the picture of the oil flow. An audio tone generator was connected to the audio input of the recorder and was switched in parallel with the engine start button, so producing a tone at the moment that the button was pushed. A video time code generator was also incorporated into the video line to count the time from engine start to full oil flow.

The oil flow camera installation consisted of a block of Perspex approximately 60 × 60 × 50 mm in size. A screw lens mount was fitted to the centre of the 60 mm Perspex face and a 9 mm hole drilled vertically through the centre top to bottom with oil unions screwed to each end of the hole to form an oil way for installation in the oil circuit as close to the gearbox as possible (Figure 22.23). To illuminate the oil flow, a bank of LEDs was sunk into a milled out section behind the oil way. The oil flow shows as a silhouette, in effect this could be regarded as dark field illumination. The small rectangular area milled out of the block behind the central oil way was of sufficient size to accommodate a bank of 12 LEDs in a 3 × 4 array. The LEDs were mounted on a panel of printed circuit material with electric contacts. This assembly was screwed over the milled out section of the perspex block with the LEDs in the recess. An opaque strip a little wider than the oil way was centred between the LEDs and the oilway. This completed the lighting effect of dark ground illumination. The specification of LEDs used were for a high luminance type, with an intensity of 45 mcd, a peak wavelength of 583 nm and a voltage range of 0.4–2.3 V. With this arrangement a lens aperture of *f*/5.6 was possible. Ambient light conditions were adequate for the camera covering the engine rpm instrument.

The video recorder was set up inside the control room with a video monitor working at normal room temperature. A number of engine starts were made over a period of several days, some were starts at ambient temperature, others were done in the cold

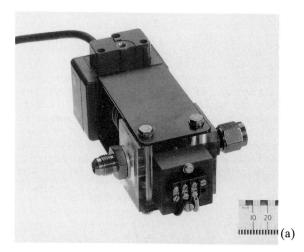

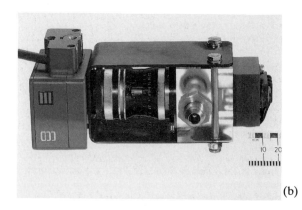

Figure 22.23 Two views of the camera and oil flow unit. (a) Three-quarter top view looking at the LED lighting block and the Perspex oil block. (b) Side view of the CCD camera, lens Perspex block with oil union and LED lighting block.

environment hangar at various temperatures down to −40°C. Time of day, date and trials conditions were recorded verbally at the start of each test on the audio track.

The cameras functioned well at these temperatures although the manufacturer's handbook recommended a minimum working temperature of −10°C. Analysis of the results was purely visual using the video still frame facility of the playback machine. The oil flow was very visible on the video image and it could easily be defined between a smooth continuous oil flow to a series of bubbles at the start of the flow. This was related to a direct readout of the rpm which was clearly shown on the superimposed image, while time was counted from the audio tone and reference to the burnt-in video time code at the engine start and to the continuous flow of oil. Time could also be related to the number of frames in the sequence, there being 25 frames per second (fps) which is 40 ms to each frame (Figure 22.24).

22.4.3 Trampling of an aircraft arrester wire

To facilitate very short landings of military aircraft on ships and on short runways or during emergencies an arrester wire system is used. The tensioned arrester wire is stretched across and supported just above the runway. On landing, an aircraft, which is fitted with a trailing hook from its tail, will engage with the wire to arrest the aircraft and shorten its landing distance. But when an aircraft is taxied onto the runway, positioning for take-off or after landing, it is often necessary to cross the arrester wire

('trampling'). This can be a hazard to the aircraft as the wire consists of a heavy cable with doughnut shaped rubber spacers at regular intervals along its length to provide the cable with sufficient ground clearance to assist hook engagement. Problems occur when an aircraft crosses the wire, since the wire can bounce up and damage the underside of the aircraft. High speed cameras were used to record the bounce of the arrester wire at different taxying speeds of the aircraft. Measurements were made from the recorded images to determine the height of wire bounce. Three high speed cameras were set up, consisting of two film cameras and one high speed video camera.

The high speed video camera, running at 200 pps, was placed on the edge of the runway looking along the wire. This viewpoint was used to assess the safety of the aircraft after each progressively faster run. A high speed film camera also looked along the wire, but on the opposite edge of the runway, and the other film camera was located about 70 m along the edge of the runway looking back towards the arrester wire so as to obtain as near as possible a frontal view of the aircraft (see Figure 22.18).

This trial was carried out in good daylight conditions, as good quality sharp pictures were required to enable measurement of the wire at its top position of bounce, although the wire in this position is at its slowest as the wire is changing direction at this point. The film cameras chosen were of the intermittent type to produce the sharpest pictures. The choice was a Photosonics 1PL camera which has a continuously variable framing rate selectable up to 500 pps and a variable sector shutter. The film stock chosen was Ektachrome 400 as the analysis system required direct reversal colour film.

The high speed video camera had a fixed framing rate of 200 pps, but had a variable shutter. Note that there is a quality restriction here, because as the shutter speed is made faster (shorter exposure), depending on the available light on the subject, the video gain on the camera has to be increased. This results in a grainy appearance to the image and a loss in resolution. It was possible to relate the sensor speed to a film speed, which for practical purposes was determined as being equivalent to 200 ISO.

The high speed video system used was a NAC 200 camera. The system also incorporates a computer based analysis program as an optional extra. Runs were performed with various aircraft at progressively increasing speeds up to landing speeds of the particular aircraft on test (Figure 22.25); in this example two video cameras were used. Film analysis was carried out using a NAC analyser and video analysis was done using a personal computer (PC) and MOVIAS software. Figure 22.26 shows a printout from the computer analysis.

Figure 22.24 Print from a video frame showing oil flow overlaid by engine rpm with date and time below. The round blobs are the ends of drilled holes for the LEDs. The holes became a bonus as they changed in optical shape from apparent oval to round when the oil way was filled with oil. The streaking appearance is air in the oil as the oil way was filling.

Figure 22.25 Printout from the screen of a NAC high speed video system as used with a two camera arrangement for aircraft arrester wire bounce measurement with the MOVIAS video analysis program.

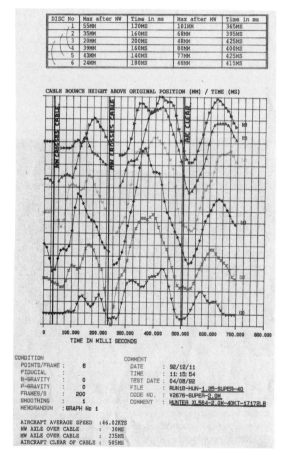

Figure 22.26 Typical computer printout of data retrieved using the MOVIAS video analysis system during trials of aircraft arrester wire bounce.

22.4.4 Helicopter rotor blade icing trials

The operation of helicopters in very cold climates entails a risk of ice formation on the rotor blades. Apart from the obvious safety hazard, ice accretion on the rotor blades affects the helicopter's performance and puts severe limitations on operational use. A system was required to monitor the build-up of ice and to measure its thickness, then relate this to performance and weather conditions to provide assessment of the aircraft's flying limitations. It was also required to monitor the effectiveness of de-icing methods such as heated blades and blade construction materials.

Two separate camera systems were developed, one mounted externally on the rotor head, the other mounted on the tail fuselage. These camera systems were first installed on a Westland Wessex (four bladed) helicopter (Figure 22.27), and subsequently on a dual rotor (three bladed) Boeing Vertol Chinook. For simplicity the development of the Wessex helicopter camera installation is described,

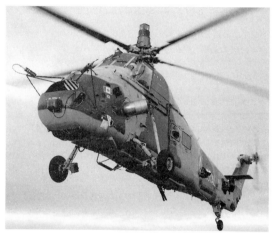

Figure 22.27 Wessex helicopter with rotor head camera and tail camera. Also fitted is a video camera in front of the engine intake with an onboard monitor for aircrew observation of icing during flight.

but installation on other helicopters was similar, with appropriate changes as required by blade configurations. The tail camera was not installed in the Chinook.

It was considered necessary to have a camera looking down the rotor blades to record ice formations during flight. This had never been attempted before so a system had to be developed. The surface of all the blades needed to be recorded, although it was thought that the ice build-up would be uniform on all four blades, but shedding of the ice from each blade may not be even, and could cause an imbalance of the rotor blade assembly. The object of the

photography was to record the effectiveness of the de-icing system and the pattern of ice shedding.

To view all four blades, it was necessary to mount a camera on the rotor head, and design a four sided beam splitter fitted to the front of the camera lens. The camera had to be of a type that had been accepted for aircraft use and would operate in the harsh environment of vibration and cold. Another consideration was picture format and size. Each blade was recorded in a quarter of the frame area and, therefore, the larger the format the greater the size of each image, which made for ease of analysis with greater resolution. Film capacity was important as is was not possible to change film magazines in flight. Sampling rate was not so important as the ice build-up would be comparatively slow. The shedding of ice is more rapid, but could be anticipated to some degree during the operation of the de-icing sequence of the heating elements incorporated in the blades. The chosen camera was a 70 mm Vinten F95 air camera, as this model was available and was designed and proved for use in flight. This camera has a focal plane shutter with a slit of variable width, which provides shutter speeds up to an equivalent of 1/2000 s, which was considered adequate for the rotor head camera.

The camera mounted on the rotor head rotates with the rotor blades (Figure 22.28), so the blades were in effect stationary with respect to the camera, but the ice shedding was quite fast. It was required to have evidence of the size of the ice being shed, so coloured square sectors were painted on the blades in yellow and white, and also the area of the heater mats was coloured red, contrasting with the natural black colour of the blades. When aligning the camera an allowance had to be made for the angle of 'coning' of the blades, caused by the blades bowing as they take up the weight of the aircraft.

A second system was developed to record the leading edge of each blade. It was required to have a head-on view of the whole blade. To achieve this a camera was mounted on the rear fuselage looking forward and angled upward. Each blade was photographed as it passed a point in the field of view of the camera. The camera chosen for this system was again the Vinten 70 mm F95 type.

The rotor head camera used a modified lens system consisting of a Mamiya 55 mm Sekor lens with a pyramid shaped, four sided image splitter. The pyramid block was accurately machined from aluminium. The four sides were angled at approximately 35° and fitted with surface silvered mirrors. The final angle of the mirrors was adjusted by the use of shims. The top point of the pyramid was cut off to give a flat platform about 25 mm square, on which was mounted a digital frame counter. A suitable supplementary lens was fitted in front of the counter to bring it into focus at this short distance to the camera lens. The camera was mounted on its back with the beam splitting optical system, each mirror flat looking down each rotor blade. The whole camera and optical assembly was rigidly mounted into one unit and enclosed in a cylindrical case, with optical flat windows opposite each mirror (Figure 22.29). The whole unit was then mounted on to the rotor head. Power and controls to the camera were supplied from the aircraft though a system of electrical slip rings.

Figure 22.29 Rotor head camera assembly with cover removed.

The fuselage mounted camera (Figure 22.30) was fitted to the rear port side of the fuselage, looking forward and up towards the rotor blades. A high power, short duration electronic flash was mounted near the camera to illuminate each rotor blade as it came into the field view of the lens. The aim was to record each rotor blade as it came into the frame. The camera was triggered by a radar pulse from a specially designed radar transmitter receiver unit

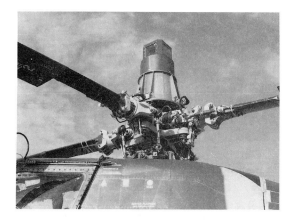

Figure 22.28 Camera in place on Wessex helicopter rotor head.

Figure 22.30 Wessex helicopter with tail mounted camera and flash head.

Figure 22.31 Single frame taken in flight from Wessex rotor head camera. Ice can be seen on the leading edges of the blades.

fitted in the tail of the aircraft. The rotor blades were numbered 1 to 4, with number 3 designated as the master blade that was fitted with a magnetic marker contact which was picked up by a marker sensor on the aircraft, which was at 180° to the radar unit. This marker sensor was used as a timing mark to calculate the delay from the radar trigger to the camera to ensure that a blade was in the field of the camera when it was triggered. It was so arranged that once the magnetic marker was struck, the next blade to pass over the radar unit was number 1. Therefore it was possible to select which blades to photograph and also when to start a sequence by varying the delay times taking into account the rotor speeds. Incorporated into the camera control box was a variable delay unit which could be adjusted to select the blade to start the recording sequence. There were also selection switches to choose which blades were to be photographed.

A sequence can be any number of photographs from 1 to 4 with an automatic or manual time between sequences of 2–60 s (60 s in automatic mode). A four picture sequence (Figure 22.31) has a shortest re-set time of 3 s due to the re-charge time of the capacitors in the electronic flash. The flash is triggered and synchronized to the camera by a microswitch within the camera actuated by the shutter blind. The roller blind focal plane shutter in the camera was modified by making the exposure slit very narrow to produce very short exposures. The slit opening was reduced to 0.5 mm, which produced equivalent exposure times of 1/50 000 s (20 μs). The film travel was geared to move a third of its normal frame length, as only a narrow picture was required of just the rotor blade. This conserved film by allowing three times as many pictures per magazine load and effectively gave a faster film advance cycle, as a shorter length of film was moved.

Many flights were made using these camera systems, both during the coldest weeks in the UK and in Canada, flying in very cold climatic conditions and in cloud to obtain the icing conditions required. Similar tests were carried out on helicopters of the Sea King and Chinook types (Figure 22.32). The film stock used was Ektachrome 400 which often had to be push processed to 1600 EI.

The size of the ice formation areas on the calibrated and colour coded blades was obtained by measurements made directly from the film transparencies by means of a travelling microscope.

Figure 22.32 Two consecutive frames of the same blade taken in flight with the tail mounted camera.

Acknowledgements

These two camera systems produced some most extraordinary photographs of helicopter icing conditions, a result of team effort at A&AEE, Boscombe Down, Salisbury, Wiltshire. The camera development work was done by Mr Ben Dunckley (deceased) assisted by a dedicated team of photographers, J. Williams, R. Barker, G. Beavers and J. Maxwell, supported by the Drawing Office, Machine Workshops and Electronics Laboratory, Technical Services Division. All were driven by a very enthusiastic and demanding Engineer and Trials Officer, Mr Barry Perks (deceased). The whole camera system has subsequently been assigned to Westland Helicopters Ltd.

Grateful thanks are due to the Defence Test and Evaluation Organization (DTEO), Boscombe Down, the Chief Photographer David Langhurst and his able staff for their help and co-operation in providing the photographs. (Now under the new management structure of DTEO they are able to accept tasks from non-Government companies and can offer a photographic, film and video service which they were previously only allowed to offer to Ministry of Defence (MoD) customers.) Thanks also to The Superintendent of the Engineering Division and his Engineers for their co-operation.

(Boscombe Down, Salisbury, Wiltshire is the address of the Ministry of Defence's aircraft and avionics test centre, formerly known as A&AEE, the Aircraft and Armament Experimental Establishment, now the Defence Test and Evaluation Organization.)

Bibliography

Camera Time Code Generators. International IMC Ltd, Wellington Street, Thame, Oxfordshire OX9 3BU, UK

Parker, I. (1984) Chinook's trial by ice. *Flight International* **125**, no. 3912, 1160–1163

Systron Donner Timing Reference Book (Part no. 101341) Systron Donner Corporation, 935 Detroit Avenue, Concord, CA 94518, USA

23 High speed holography

Roberto G. Racca

23.1 Introduction to the technique of holography

Holography is an optical method that allows a *wavefront* of light to be stored on a photosensitive medium and subsequently reconstructed. The wavefront may be represented as a complex quantity, having at any point in space an amplitude and a phase. Photographic emulsions, being sensitive to irradiance, can only record the real amplitude of the light, whilst the phase information is irrevocably lost. The holographic process expands the capabilities of the photographic medium by combining the wavefront to be recorded with a plane wave from the same coherent source, and storing the resulting interference pattern in a high-resolution emulsion. The *reference wave* effectively encodes in the stored pattern the local phase information of the object wavefront as well as its amplitude. In the reconstruction process, a plane wave with the same orientation and wavelength as the original reference wave is used to illuminate the developed emulsion. The pattern stored in the emulsion spatially modulates the reconstruction wave so that the resulting light is a replica of the two waves originally interfering when the hologram was recorded. The object wave is therefore restituted in its entirety when the hologram is reconstructed.

The first holograms (Gabor, 1949) were recorded with collinear beams using monochromatic light of very short coherence length, and had the disadvantage of having to be viewed by staring directly into the reconstructing beam. The holographic technique truly came of age with the discovery of the laser and the invention of *off-axis holography* (Leith and Upatnieks, 1962, 1963, 1964), in which the reference beam impinges on the film from a different direction than the object wave. The reconstructed wavefront is then angularly separated from the reconstructing beam and can be observed without difficulty. This is by far the most commonly used kind of holography, and forms the basis for numerous variations. The more strikingly visual characteristic of a reconstructed off-axis hologram is generally the fact that the image retains all the spatial properties of the original scene such as the ability to focus on different planes and to change the point of observation within a certain angle of acceptance. Other unique properties of the reconstructed image, although less apparent, are at the core of several applications of holography and make it an irreplaceable tool in the arsenal of optical methods available for technical and scientific analysis.

The choice of adopting holography over much simpler photographic techniques in high-speed applications may be dictated by various of factors. The three-dimensional nature of the phenomenon under study may warrant the use of a method capable of fully recording spatial information and, unlike stereoscopic photography, providing true reconstruction of parallax and deferred focusing on chosen planes. More importantly, holography's ability fully to record an optical wavefront in both amplitude and phase opens up a number of applications where this technique can be used to reveal even minute changes in a subject over a time interval. The technique of *holographic interferometry* is perhaps the most widely used holography-based tool in high-speed work over a wide range of applications, and deserves to be covered in some detail in the following section.

23.2 Holographic interferometry

Through the use of off-axis holography, it is possible to produce images overlaid by a pattern of interference fringes that reveal changes in the state of the object being holographed. These changes may consist of deformation, displacement or rotation in the case of an opaque, diffusely reflecting object, or variations in thickness or refractive index in the case of a transparent object. The advent of this technique has brought about an unprecedented ease of visualization for physical phenomena such as the interaction of shock waves (Takayama, 1983).

Holographic interferometry is achieved by recording holographically the wavefront of light from the object at a given time and comparing it interferometrically with either the direct wavefront from the object at a later time or a holographic recording of it. The interferometric comparison simply consists of reconstructing the hologram or holograms in such a way that the two wavefronts are in perfect spatial registration and observing or photographing the

combined wave. A major advantage of holographic interferometry over conventional (Mach–Zehnder) interferometry is that the reference arm and the test arm are spatially coincident but temporally separated, so that path length differences are only introduced by the time-varying phenomenon under study and not by characteristics of the optical equipment.

There are many variations in the technique of holographic interferometry, which are described extensively in a classic book by Vest (1979). In two-exposure holographic interferometry, two successive recordings of the same object are made on the same film or plate, so that upon reconstruction the wavefronts corresponding to the two exposures interfere with each other and reveal changes in optical path length as a pattern of fringes. The two exposures usually record a reference condition and an altered state due to some physical phenomenon. For some studies it may be useful to record two different phases of an evolving phenomenon, in which case the interferogram shows the change between them (*differential holographic interferometry*). The method known as *real-time holographic interferometry* is also used in some specialized applications, and yields itself to the study of time-varying phenomena, as we shall see in the next section. In this technique, a single hologram of the undisturbed subject is exposed, developed and replaced in the exact position where it was recorded (or even developed *in situ*). The original reference beam then works as a reconstruction beam and creates a replica of the object wave under baseline conditions. During the phenomenon, the direct beam from the optical system and the reconstructed object beam from the hologram interact with each other to give a real-time interferogram which can be recorded using conventional photographic methods. Aside from the technical complexity of precisely re-positioning the processed holographic plate or developing it in place, a limitation of real-time holographic interferometry based on standard silver halide medium is the requirement that the reference exposure be taken several minutes before the phenomenon (the processing time of the plate). While this is not a problem for applications involving relatively stable baseline conditions, it precludes the use of the technique in the case of high speed phenomena in which the reference exposure must be taken very shortly before the phenomenon itself in order to avoid extraneous changes in the baseline field. More recent developments of holography have looked at alternative recording media requiring little or no processing time, thus eliminating a major hurdle in the implementation of real-time holographic interferometry. Still, silver halide remains to date the most widespread medium for holographic work.

An important parameter in the recording of holograms is the ratio of reference beam to object beam brightness, which affects the *diffraction efficiency* for reconstruction. The non-linear response characteristics of the emulsion make it virtually impossible to establish a clear-cut value that will give best results under all circumstances. Reference beam/object beam ratios of 3 : 1 to 10 : 1 are often suggested in order to keep the modulation within the linear part of the response curve. For holographic interferometry, in which the ultimate motive is to produce interference fringes of high visibility in the reconstructed image, a reference beam/object beam ratio of 1 : 1 is recommended (Vest, 1979) on the basis of experimental evidence, although the ratio can be higher if other conditions dictate it.

23.3 Time-resolved holography

23.3.1 Objectives

Holography, and in particular holographic interferometry, has assumed a position of importance as a tool for the study of a variety of physical phenomena such as compressible flows, but it still widely lacks one feature that most other methods can offer: the ability to record rapid sequences of images in order to follow the evolution of a phenomenon in time. One way to achieve *time-resolved recordings* is a hybrid method based on real-time holographic interferometry. As previously mentioned, the interference pattern arising from the interaction of a real-time object beam and a reconstructed hologram may be recorded using conventional photography. It is therefore possible to use high speed cinematography to capture a time-resolved view of the evolving phenomenon as visualized by the changing fringe pattern. This is not, strictly speaking, a true high speed holographic recording, but rather a conventional cinematographic recording of events made visible through the unique properties of holography. There are many applications, however, where there is a real need to record in rapid succession actual holograms of the event in order to take advantage of the wealth of information obtainable from a reconstructed hologram, be it three-dimensional visualization or phase restitution. The challenge of recording holographic sequences at the rate of hundreds or thousands of frames per second has been addressed in a variety of ways, but all the different approaches fall into one of two categories of techniques, distinguished by how the individual holograms are kept separate from each other so that they are individually retrievable.

23.4 Hologram multiplexing techniques

23.4.1 Spatial multiplexing

The majority of existing implementations of time-resolved holographic systems adopt in one form or another the technique of *spatial multiplexing*, whereby each hologram is recorded on a separate area of film by successive laser pulses. Spatial multiplexing does not rely on optical properties unique to the holographic recording process: ordinary cinematography is nothing but a non-holographic form of this technique. The recording of each hologram on a fresh area of photographic emulsion may be achieved by deflecting the light, by moving the film, or by a combination of the two methods.

The major challenge of the first approach is to make the object beam and the reference beam coincide at the film plane. However, if the object is diffusely illuminated the object wave may be allowed to fall on the entire surface of the film, whilst the reference beam illuminates different areas at different times. Gates *et al.* (1968, 1970) demonstrated a method in which a scatter plate was used to transilluminate the scene diffusely while a portion of the light was transmitted without scattering through the plate and formed the reference beam. Time-resolved sequences were obtained by illuminating different areas of the scatter plate through a rotating prism or nutating ('nodding') mirror so that the reference beam projection on the film moved with time. A modified version of their original scanning method (Hall *et al.*, 1970) selected the illuminated area on the scatter plate by means of an aperture in a rotating disc placed in front of a wide beam. The second method relaxed the need for extremely short exposure times by effectively eliminating the motion of the beam during exposure. By synchronizing the laser pulsing with the angular position of the scanning device, those authors were able to obtain time-resolved sequences of interferograms by exposing each image twice over two separate sweeps. More complex rotating masks have been used by workers such as Dubovik *et al.* (1977) to generate differential interferograms. Carlsson *et al.* (1991) used a slitted rotating mask to shine the reference beam on a different area of film at each laser pulse, but circumvented the problem of exactly superimposing pairs of exposures for holographic interferometry by removing the slit and recording the reference exposure over the entire surface of the film with a single laser pulse. Feldman (1970) presented a spatial multiplexing system using a solid-state acousto-optical deflector to redirect the light to different areas of film. For the holography of transparent subjects, he used an arrangement that concurrently displaced both object and reference beams to the same spot on the emulsion in order to minimize dispersion of object light. Thomas *et al.* (1972) used three separate lasers to implement a high-speed multiplexing system. The light from each laser was divided into a reference beam that reached a photographic plate and an object beam that traversed the phenomenon along a path common to all the lasers. The common object beam path was then split into three branches that illuminated all the plates, the two additional object beams giving incoherent exposures that did not significantly affect the hologram. Optical delay lines that generate sets of spatially and temporally separated light pulses have been used by Ehrlich *et al.* (1993) to record spatially multiplexed sequences at extremely short intervals.

Systems achieving spatial multiplexing by displacing the film have the potential for recording very long sequences of frames. A reel of film in a conventional movie camera transport may be used in applications requiring an extended run length at moderate framing rates (Decker, 1982; Smigielski *et al.*, 1985). For high speed holographic cinematography, a rapidly rotating holographic plate or a film mounted on the circumference of a spinning drum have been used. Hentschel and Lauterborn (1985) combined this technique with an acousto-optical beam deflection system to increase the multiplexing rate further by recording quadruplets of frames in a direction perpendicular to the film motion. This composite system achieved framing rates up to 300 kHz and series lengths up to about 4000 images. For holographic interferometric applications, however, a method relying on film displacement would not be suitable because of the great difficulty of exactly repositioning the moving medium over successive sweeps in order to overlay the two required exposures.

A remarkable technique that, although strictly a form of spatial multiplexing, falls into a class of its own is *light-in-flight recording* by holography (Abramson, 1983). This elegant method, which allows the direct visualization of the fastest imaginable phenomenon – the motion of light itself – is strikingly simple to implement. The optical set-up is identical to that for a standard hologram, with the object beam and reference beam both reaching the entire photographic plate. The reference beam is oriented at a rather shallow (nearly glancing) angle of incidence, and the optical path lengths are carefully adjusted so that the reference wavefront travels across the plate synchronously with the arrival of the same wavefront from the subject. If the recording light consists of a narrow, picosecond light pulse, the reference beam travelling across the plate acts as an ultra-fast curtain shutter, thus recording an extremely high speed movie of the subject which can then be played back by scanning the viewpoint across the processed plate illuminated by the reconstruction beam. Clearly the only event worthy of

observation by such a method is the displacement of light itself over the field of view, which in Abramson's paper provides an exceptional view of the behaviour of the light front as it passes through various optical components (Figure 23.1). An additional elegant turn on the technique is the ability to perform light-in-flight recording without resorting to a picosecond pulsed laser, using instead a continuous-wave laser with very short coherence length so that the locus over which the object and reference beams interfere to record a hologram is again very narrow.

23.4.2 Spatial frequency multiplexing

There is a second method of recording sequences of individually reconstructible holograms, taking advantage of a unique property of the hologram formation process. The interference pattern that is recorded on the holographic film may be regarded, in direct analogy with communications theory, as the result of a regular set of 'carrier' fringes recorded by the reference wave that are variously modulated by the object wave. The 'carrier' fringes have a unique spatial frequency that is determined by the wavelength of the recording light and the angle of incidence of the wavefront on the film. The analogy with communications theory may be carried further. In the same way that communications signals having different carrier frequencies can be freely mixed and still remain separable, holograms with different 'carrier' spatial frequencies can be superimposed without losing individuality. This is the underlying principle of *spatial frequency multiplexing*. By having the reference beam fall on the film from a different direction for each exposure, recordings of the object beam may be overlaid on the same area of emulsion and subsequently reconstructed individually. The selection is achieved by shining the reconstruction beam at the same angle as the reference beam used in the desired exposure. This hologram multiplexing technique offers several advantages. The object beam, whether diffused or not, does not need to be repositioned in any way for different exposures. The size of the holograms is not restricted by the need to crowd spatially separated recordings in a given area of emulsion as with most spatial multiplexing schemes. Observation and photography of the reconstructed holograms is simple because the film and the eye or camera may be placed in a fixed position and only the reconstruction beam reoriented to select a given image. There are, however, some intrinsic limitations to the spatial frequency multiplexing technique that will be outlined later.

Spatial frequency multiplexing has been used by several workers as a method for recording fast holographic sequences of a small number of images. It is interesting to note the use in early work of a somewhat different but related technique in which the reference beam was stationary and the object beam was imaged from different directions onto the same area of film (Gates *et al.*, 1968) or both beams were stationary and the film was spun about the reference beam axis (Paques and Smigielski, 1965; Smigielski and Hirth, 1970). A single reconstruction beam would then generate angularly separated images propagating from a common pupil. Lowe (1970) first presented a hologram camera that implemented spatial frequency multiplexing as defined earlier in this section. A rapidly rotating mirror shone the reference beam sequentially onto a series of fixed mirrors that reflected it onto a single area of film, on which the object beam also impinged. The pulses of the laser system were synchronized with the angular position of the spinning mirror by means of a continuous tracer light beam reflected off the latter and a system of photomultipliers positioned in correspondence with the fixed mirrors.

There are intrinsic drawbacks associated with the mechanical scanning of the reference beam, most notably the difficulty of exactly registering two successive exposures for holographic interferometry and the loss of image quality due to time smear (Racca and Dewey, 1989), a consequence of the slight angular motion of the reference beam over the duration of a laser pulse. Most of the later implementations of spatial frequency multiplexed holography have been based on various forms of non-mechanical scanning of the reference beam. A multiplexing configuration involving multiple laser sources was presented by Yamamoto (1989), who described different designs for merging the laser outputs into a single object beam with high efficiency. This approach, although capable of high framing rates, is clearly impractical for recording more than a very small number of images. Solid-state spatial frequency multiplexing systems using a single, multiply pulsed laser and selectable reference beam paths have been used by various workers (Hinsch and Bader, 1974; Lauterborn and Ebeling, 1977; Yamamoto, 1989). In these systems acousto-optic deflectors, devices that alter their light refracting characteristics under the influence of frequency-modulated ultrasonic waves, were used either as beam steering devices or as switchable beam splitters to exclusively select one of several paths. Racca and Dewey (1990) implemented a solid-state spatial frequency multiplexing system by subdividing the reference beam into a number of co-existing and angularly separated branches, each individually shuttered by a high-speed liquid crystal shutter. This arrangement allowed the reference exposure for holographic interferometry (Figure 23.2) to be impressed on all frames simultaneously with a single laser pulse by opening all shutters at once just before the occurrence of the phenomenon. Optical delay lines that generate sets of spatially and

temporally separated light pulses have also been used to record spatial frequency multiplexed sequences of interferograms at extremely short intervals (Bush and Charatis, 1982).

Spatial frequency multiplexed holography has some limitations that do not exist, or are substantially less pronounced, in spatially multiplexed holography. Primarily, only a portion of the dynamic range of the photographic emulsion is available to record each of the overlaid holograms, resulting in a degradation of the reconstruction efficiency proportional to the number of images. With careful optimization of the exposure levels and beam intensity ratios, however, sequences of several images of good quality can be obtained. Royer and Smigielski (1970) indicate a practical limit of about 10 images for spatial frequency multiplexing on standard holographic film. The use of thicker emulsions or even fully three-dimensional recording media such as photosensitive crystals can substantially extend the recording range of this method. Also, the loss in reconstruction brightness associated with the substantial darkening of the multiply exposed film can in many cases be alleviated by bleaching the hologram, a simple chemical process performed after developing whereby the darkened silver halide is eliminated so that only the varying thickness of the exposed emulsion modulates the phase of the reconstructing beam. Another limitation has to do with the viewing acceptance angle for individual images. Because the resolving parameter between exposures is the angular orientation of the reference beam, at the reconstruction stage there is a limit to the viewing angle for a given frame beyond which the adjacent frame starts becoming visible. This is so because there is a geometrical reciprocity between the angle of observation and the angle of incidence of the reconstruction beam. If parallax relationships in the image are an important analysis parameter, it may be possible to minimize this drawback by scanning the reference beam in a plane perpendicular to the desired principal plane of observation.

References

Abramson, N. (1983) Light-in-flight recording: high-speed holographic motion pictures of ultrafast phenomena. *Appl. Opt.* **22**, 215–232

Bush, G. E. and Charatis, G. (1982) Multiframe holographic shadowgraphy and interferometry of target plasmas. *Proc. SPIE* **348**, 650–657

Carlsson, T. E., Nilsson, B., Gustafsson, J. and Abramson, N. (1991) Practical system for time-resolved holographic interferometry. *Opt. Eng.* **30**, 1017–1022

Decker, A. J. (1982) Holographic cinematography of time-varying reflecting and time-varying phase objects using a Nd.YAG laser. *Opt. Lett.* **7**, 122–123

Dubovik, A. S., Filenko, Yu. I., Ginzburg, V. M. and

Ushakov, L. S. (1977) Cineholography investigation methods of high-speed events. *Proc. SPIE* **97**, 127–129

Ehrlich, M. J., Steckenrider, J. S. and Wagner, J. W. (1993) A new system for high speed time-resolved holography of transient events. *Proc. SPIE* **1801**, 372–379

Feldman, M. (1970) High-speed photographic and holographic techniques using acoustic light deflection. In *Proc. 9th Int. Congress on High Speed Photography* (Hyzer, W. G. and Chace, W. G., eds), pp. 16–20. Society of Motion Picture and Television Engineers

Gabor, D. (1949) Microscopy by reconstructed wavefronts. *Proc. R. Soc. London, Ser. A* **197**, 454–487

a

Figure 23.1 An example of a light-in-flight recording by holography. (Reproduced with permission from Abramson, 1983.) (a) A spherical wavefront from an argon laser enters at the left, illuminating a white-painted flat object surface at an oblique angle. The lower left end of a tilted mirror has just been reached by the light. (b) The wavefront has reached the middle of the mirror and a portion of it is being reflected in the mirror upward and to the left. (c) The reflected portion of the wavefront is fully separating from the main wavefront which has just passed the mirror. (d) The two components of the light have separated completely, the reflected light leaving a black hole in the spherical wavefront. (e) The main wavefront exits to the right, shadowed by some optical components.

b

c

d

e

a

b

c

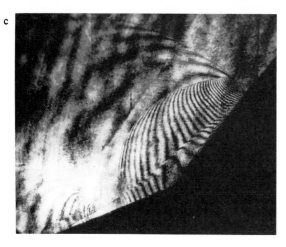

Figure 23.2 An example of time-resolved holographic interferometric recording of a planar shock wave reflecting off a double wedge (Racca and Dewey, 1990). The fringes underneath the curved reflected shock fronts follow lines of constant density in the gas. The three images were recorded at 150 μs intervals, the reference (empty field) exposure having been impressed simultaneously on all three frames 150 μs before the beginning of the sequence.

Gates, J. W. C., Hall, R. G. N. and Ross, I. N. (1968) Repetitive *Q*-switched laser light sources for interferometry and holography. In *High Speed Photography – Proc. 8th Int. Congress on High Speed Photography* (Nilsson, N. R. and Hagberg, L., eds), pp. 299–303. Wiley, New York

Gates, J. W. C., Hall, R. G. N. and Ross, I. N. (1970) High-speed holographic recording of transilluminated events. In *Proc. 9th Int. Congress on High Speed Photography* (Hyzer, W. G. and Chace, W. G., eds), pp. 4–10. Society of Motion Picture and Television Engineers

Hall, R. G. N., Gates, J. W. C. and Ross, I. N. (1970) Recording rapid sequences of holograms. *J. Phys. E: Sci. Instrum.* **3**, 789–791

Hentschel, W. and Lauterborn, W. (1985) High speed holographic movie camera. *Opt. Eng.* **24**, 687–691

Hinsch, K. and Bader, F. (1974) Acousto-optic modulators as switchable beam-splitters in high-speed holography. *Opt. Commun.* **12**, 51–55

Lauterborn, W. and Ebeling, K.-J. (1977). High-speed holocinematography of cavitation bubbles. *Proc. SPIE* **97**, 96–103

Leith, E. N. and Upatnieks, J. (1962) Reconstructed wavefronts and communication theory. *J. Opt. Soc. Am.* **52**, 1123–1130

Leith, E. N. and Upatnieks, J. (1963) Wavefront reconstruction with continuous-tone objects. *J. Opt. Soc. Am.* **53**, 1377–1130

Leith, E. N. and Upatnieks, J. (1964) Wavefront reconstruction with diffused illumination and three-dimensional objects. *J. Opt. Soc. Am.* **54**, 1295–1301

Lowe, M. A. (1970). A rotating mirror hologram camera. In *Proc. 9th Int. Congress on High Speed Photography* (Hyzer, W. G. and Chace, W. G., eds), pp. 25–29. Society of Motion Picture and Television Engineers

Paques, H. and Smigielski, P. (1965) Cinéholographie. *C.R. Acad. Sci., Paris* **260**, 6562

Racca, R. G. and Dewey, J. M. (1989) Time smear effects in spatial frequency multiplexed holography. *Appl. Opt.* **28**, 3652–3656

Racca, R. G. and Dewey, J. M. (1990) High speed time-resolved holographic interferometer using solid-state shutters. *Opt. Laser Technol.* **22**, 199–204

Royer, H. and Smigielski, P. (1970) Expositions multiples sur un hologramme. Qualité des images restituées: applications. *Opt. Acta* **17**, 97–105

Smigielski, P. and Hirth, A. (1970) New holographic studies of high-speed phenomena. In *Proc. 9th Int. Congress on High Speed Photography* (Hyzer, W. G. and Chace, W. G., eds), pp. 321–326. Society of Motion Picture and Television Engineers

Smigielski, P., Fagot, H. and Albe, F. (1985) Holographic cinematography with the help of a pulsed YAG laser. *Proc. SPIE* **491**, 750–754

Takayama, K. (1983) Applications of holographic interferometry to shock wave research. *Proc. SPIE* **398**, 174–180

Thomas, K. S., Harder, C. R., Quinn, W. E. and Siemon, R. E. (1972) Helical field experiments on a three-meter theta pinch. *Phys. Fluids* **15**, 1658–1666

Vest, C. M. (1979) *Holographic Interferometry.* Wiley, New York

Yamamoto, Y. (1989). Multi-frame pulse holography system. *Proc. SPIE* **1032**, 587–594

24 Measurement techniques in detonics

Claude Cavailler

24.1 Introduction

Laboratories concerned with detonics make daily use of metrology diagnostics concerned with the physics of shocks in solids. This particular specialism is only some 50 years old, but a considerable amount of progress has been achieved, as reviewed comprehensively by Al'tshuler *et al.* (1968), Graham (1977), de Gliniasty (1984) and Cavailler (1990). Only an overview of the subject can be given here.

The strong link between measurement techniques and the theoretical modelling of experiences must first be emphasized. It is important to remember that experiments deal with shock waves propagating at velocities of several kilometres per second, with transient states existing for only a few microseconds or even nanoseconds and with dynamic pressures ranging from some 10^5 Pa up to some 10^5 MPa.

It is clear, then, that any knowledge of what happens is strongly dependent on experiment. There is total dependence on the information obtained from the various sensors that have been developed. Because of space limitations, discussion is restricted here first to some qualitative diagnostics for spatial observation of detonic phenomena versus time and then to some quantitative diagnostics such as determining the chronometry of events from measurements by optic, electronic, opto-electronic or radiographic methods, followed by the detection of material densities or boundaries by radiography.

Other topics which have been the subject of previous wide publication that will not be considered here include measurements of continuous stress versus time (Graham *et al.*, 1965; Charest, 1973; Graham and Reeds, 1978; Chartagnac and Perez, 1980; Perez, 1980; Vantine *et al.*, 1980; Guillamot *et al.*, 1981; Bauer, 1983; Bouchu and Lefebvre, 1986; Cavailler, 1990; Cavailler *et al.*, 1990; Chartagnac *et al.*, 1991) and velocimetry of free surfaces from measurements by interferometry (Durand and Laharrague, 1970; Barker and Hollenbah, 1972; Gidon *et al.*, 1985; Gidon and Behar, 1986, 1988; Steinmetz, 1986; CEA, 1987; McMillan *et al.*, 1988; Mercier *et al.*, 1989; Cavailler, 1990; Mercier and Behar, 1991).

24.2 Spatial observation of phenomena versus time

This experimental technique was the first to be used because of its simplicity. Essentially, the subject or phenomena are recorded using a high speed camera of either the framing rotating mirror or opto-electronic type with mirrors and optics. Figure 24.1 shows a framing mirror camera of the CI4 type. Light enters the objective lens at the left, which is a zoom lens of focal length 700–1200 mm, then passes through a mechanical shutter and reflects off a beryllium mirror driven by a high speed turbine (maximum speed 9000 rev s^{-1}). The rotating mirror sweeps the light across a series of 25 relay lenses which project images onto 35 mm film in the focal (film) plane. Figure 24.2 illustrates a CI4 rotating mirror framing camera set up to record the expansion of a 3 mm thick steel cylinder surrounding a 15 mm diameter cylindrical length of high explosive that is initiated by a detonator. The duration of

Figure 24.1 High speed CI4 rotating mirror framing camera.

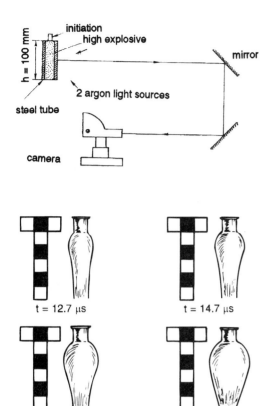

t = 12.7 μs

t = 14.7 μs

t = 128.6 μs

t = 23.5 μs

Figure 24.2 The explosive expansion of a steel cylinder recorded using CI4 framing rotating mirror camera.

recording is only 10 ms. Such framing cameras are still widely used on detonic sites today because, even though interpretation of the images obtained is sometimes difficult, nothing can replace a good image of a phenomenon.

The performances of a range of different framing rotating mirror cameras are detailed in Table 24.1.

All these cameras have been developed by the Commissariat à l'Energie Atomique (CEA) and the Laboratoire Central de l'Armement (LCA laboratory) ETCA 16 bis av. Prieur de la Côte d'or, 94114 Arcueil, France). Their features have been explained in detail over the last 20 years, particularly during the *8th* and the *9th Congresses on High Speed Photography* (Wetzel, 1970; Baluteau, 1972; Wetzel *et al.*, 1972).

The CI6 type camera is the fastest French made rotating mirror framing camera, with an exposure time of 60 ns and a 95 ns interval between two serial frames, but the image size is only 9.5 × 17.5 mm.

As an alternative system, the model TSN 506 I electronic framing camera was produced by Thomson CSF (Division Systèmes Electroniques, Strategic Systems and Nuclear Activities Department) using an image tube manufactured by Philips. From one to six images can be formed on a 50 mm diameter phosphor screen deposited on a fibre optic plate. The performance of the TSN 506 I camera has been described by Hammer and Imhoff (1988). However, as pointed out above, the phenomena of interest can be very fast and reach velocities up to several kilometres per second. In such cases, even the capabilities of the CI6 camera are not sufficient to study a surface state or a set-up singularity (due to problems of dynamic blur). For this reason, a new technique has been developed. The *instantaneous image* (II) technique consists of recording a single image frame by illuminating the scene with a pulsed YAG laser. The laser source is a *Q*-switched Nd.YAG laser using a single mode oscillator, a pre-amplifier, a 16 mm diameter amplifier and a KDP crystal. The available energy is of the order of 1 J at a wavelength of 1.06 μm and 200 mJ at 532 nm for a 10 ns pulse duration. A large amount of work has been done to minimize non-uniformity of the delivered light and to eliminate speckle defects (Cavailler, 1990; Croso *et al.*, 1991).

The II technique can be used to determine dynamic material properties by using an expanding ring technique. A rod of explosive material that is

Table 24.1 Performance characteristics of high speed rotating mirror and electronic tube framing cameras

Camera type	No. of frames	Film format (mm)	Resolution (μm)	Gain (W/W)	Shortest exposure time (ns)	Time between two frames (μs)	Total recording time (μs)
CI4	25	35	40	< 1	140	0.435	10.44
CI5	50	35	40	< 1	80	0.220	10.7
CI6	120	70	40	< 1	60	0.095	11.1
CIAS	25	70	40	< 1	200	0.700	16.7
TSN 506 I	1	1 image (25 mm diameter) 3 images (16 x 19 mm) 6 images (8 x 23 mm)	60	›20	50 ns to 10 μs	0.150– 30	

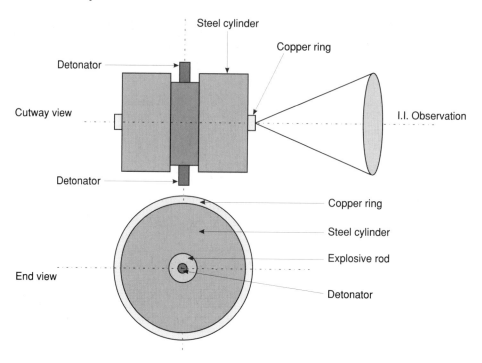

Figure 24.3 Arrangement of the components for the expanding ring technique used to observe dynamic material properties.

initiated by two detonators (one on each end) is confined by a steel cylinder surrounded by a copper ring (Figure 24.3). After detonation, the shock wave is transmitted through the cylinder to the ring, thus giving it a radial velocity. This expansion can be observed with the II technique, the images obtained showing more detail than those obtained using a rotating mirror framing camera (Figure 24.4).

Figure 24.4 Examples of dynamic records obtained from tests made using the expanding ring technique with a copper ring. Left, using a rotating mirror framing camera; right, using the instantaneous image technique with a pulsed laser.

Figure 24.5 Stereoscopic records of the expansion of a copper ring.

The high resolution of II observations is very helpful in understanding material strength at high strain rates. In addition, stereoscopic records (Figure 24.5) can be obtained by using two mirrors set at an angle of 10° to one another. Fractures in the ring can then be visualized in three dimensions and studied more precisely. When velocity measurements are required, the II technique can either be combined with Doppler laser interferometry (DLI), which gives the velocity of one point versus time, or with the instantaneous velocity field (IVF) technique, performed using the same laser (Cavailler, 1990).

For applications that require a shorter exposure duration per frame (down to a few nanoseconds) it is possible to couple a double proximity focused microchannel plate (MCP) image intensifier of 18 mm diameter to the YAG laser (Croso *et al.*, 1991). In this example, the resolution of the image is reduced to a few line pairs per millimetre, but the experiment may benefit from the 500–1000 W/W gain of the intensifier. Full details of this system are given in Yates (1983) and Yates *et al.* (1984).

24.3 Chronometry of events

24.3.1 Electrical sensors

When the study of shock waves began, now some 50 years ago, only electrical sensors were available for instrumentation. The electrical signals were recorded by a multichronometer to an accuracy of 1–10 ns according to the shock strength. It is interesting to note that such sensors are still much used

today (Al'tshuler *et al.*, 1968; Gathers *et al.*, 1983) even though far more precise techniques such as DLI (Durand and Laharrague, 1970) have been developed. The reason for this is that at high velocities the precision of electrical sensors is as good as DLI (de Gliniasty, 1984).

When it is possible, it might be convenient to work with streak cameras. In this case the phenomenon to be observed is relayed onto the streak camera slit so that one dimension of the phenomenon is then analysed with respect to time. An accuracy of ±5 ns is obtained for a sweep speed of 20 mm µs⁻¹ (Cavailler, 1990).

Opto-electronic streak cameras can achieve the same type of measurement, especially with the fastest phenomena where maximum sensitivity is required, but the resolution will be poorer and the accuracy will be reduced (±10 ns for a sweep speed of 5 mm µs⁻¹).

24.3.2 Optical fibre systems

Optical fibres can be used to transmit optical information obtained in the study of multiple dimensional phenomena by means of a one-dimensional opto-electronic streak camera. The first optical fibre probe sensor was developed in China (Shifa, 1988). A large amount of work has been also been carried out at the Lawrence Livermore National Laboratory (LLNL) (Shaw *et al.*, 1976), when the air gap at the fibre top was replaced by a xenon filled microballoon in order to record the delivered signal on a rotating mirror streak camera.

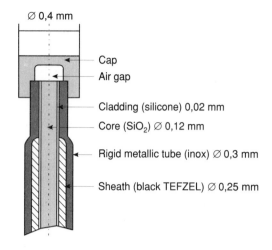

Figure 24.6 Construction of an optical sensor probe.

Figure 24.6 shows the principle of an optical probe as developed by the CEA in 1975 (Gauthier and Bouchu, 1978). The optical signal delivered by this probe is a flash of light produced by ionization under shock compression of the air gap at the top of the pin. This light signal is recorded by a TSN 506 photonic chronometer (Figure 24.7). This instrument uses 54 input fibres coupled in line to the streak tube of the Thomson-CSF streak camera. The optical signals, recorded at a writing speed of 5 mm μs^{-1} or greater if needed, can be read to an absolute accuracy of ± 10 ns (Bouchu and Lefebvre, 1986).

24.3.3 Radiographic techniques

The time course of events can be recorded using radiographic techniques. In France, one testing facility, the Polygone d'Experimentation de Mor-onvilliers is equipped with two sites where radiographic methods are used for chronometric measurements of events involving shaped charge jets and to follow the temporal evolution of detonics phenomena.

The test site that is mainly devoted to the study of shaped charges and self-forging fragment charges is equipped with two 450 kV flash X-ray sources. X-rays are generated by applying a high voltage to an X-ray tube, a technique that dates from 1938 (Steenbeck, 1938) and was largely developed at the Institut Franco Allemand de Recherches de Saint-Louis (Thomer, 1961; Jamet and Thomer, 1976).

Upon the discharge of a Marx generator, a voltage of up to 450 kV and a high current are applied to the X-ray tube to produce an X-ray pulse of 25 ns duration and a 20 mR dose level at 1 m distance. Figure 24.8 shows a typical experimental set-up designed to study the flight characteristics of shaped jets with a path of some metres. The X-ray tubes are housed in a heavily reinforced metal housing (right-hand side in Figure 24.8) located 3 m from the jet trajectory. The tubes are operated from Marx generators located 10 m away in a concrete bunker complex under the firing site. A slit in the lead plate protecting each tube allows a 1.2 m recording of the jet in flight. When the slits are tilted at 15°, the X-ray sources illuminate the same radiographic film housed in a cassette positioned close to the jet fragments at a distance of 0.3 m. The military steel plates of 2 m thickness to be perforated by the shaped charge jet can be clearly seen in the middle of Figure 24.8.

Figure 24.9 shows the two images of the same shaped charge jet head recorded by two flashes with a time interval of 5 μs. The chronometry of each fragment can be achieved very precisely, as shown in

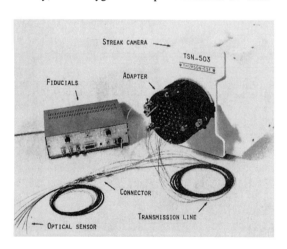

Figure 24.7 A TSN 503 photonic chronometer (streak camera).

Figure 24.8 Experimental set-up and generators for the radiographic chronometry of shaped charge jets.

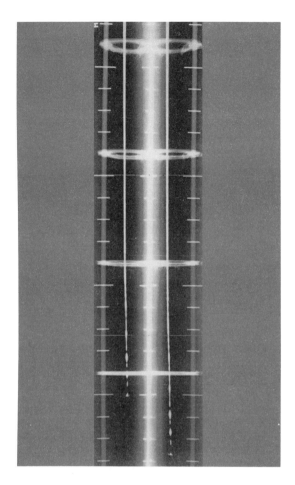

Figure 24.9 Results of flash radiography of shaped charge fragmentation using two 450 kV X-ray tubes.

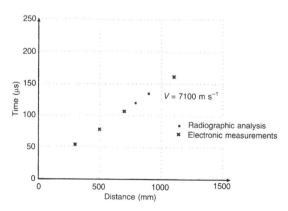

Figure 24.10 The chronometry obtained by a double pulse X-ray flash technique of a jet fragment from a shaped head charge. A velocity of 7100 m^{-1} is obtained which agrees well with electronic measurements shown for comparison.

Figure 24.10 where the two data points for the velocity of jet head fragments obtained by radiographic analysis are in good agreement with electronic measurements obtained using metallic grids positioned along the jet path. The jet velocity is found to be 7100 m s^{-1}. These measurements can be refined further by orthogonal optical observations, which were developed in order to discriminate between the velocity vector components (Held, 1986).

Another test facility has been developed since 1983 around an electron beam accelerator known as ARTEMIS. This set-up provides three radiographs at timed intervals of a single explosive experiment. This capability required the development of high-speed electro-optical cameras capable of recording the three images. The performance and capabilities of ARTEMIS have been detailed by Hauducoeur and Buchet (1981) and by Hauducoeur *et al.* (1984), and will only be summarized here. The ARTEMIS linear accelerator is a travelling wave device with four high frequency sections which increase the electron beam energy up to a maximum 80 MeV. This beam is then focused onto a 2 mm thick tungsten target in order to generate X-ray photons. The accelerator is able to produce X-ray flashes within a 15 µs time window and with an interval of at least 1 µs between two successive flashes. Each X-ray pulse is of 45 ns duration and a dose level of 30 rad at 1 m.

A plastic scintillator (sold under the French trademark ALTUSTIPE) converts the radiographic image into visible light which is then relayed through optical paths and divided into three channels each equipped with double proximity focused MCP image intensifiers of 40 mm diameter which are gated to act as fast operating shutters with a gate-open time (framing time) of 500 ns. This cineradiography system gives three successive images of an explosively driven experiment. The ARTEMIS accelerator is shown in Figure 24.11.

As an example of the high speed cineradiography possible with this facility at CEA, Vaujours, a typical set-up involving a cylindrical implosion study

Figure 24.11 The ARTEMIS linear accelerator.

was performed in order to investigate Rayleigh–Taylor instability in imploding systems (Hauducoeur and Nicolas, 1991; LeGrand, 1991). The pyrotechnic arrangement was a light plastic medium surrounded by a metallic cylinder with different sinusoidal defects accelerated by high explosive initiated by four detonators (Figure 24.12). The radiographic observation was made along the axis of this cylinder. The three successive flashes within 15 μs enabled the temporal evolution of the original defect edge to be followed, as shown in two successive images (Figure 24.13), and compared with numerical simulation results. The instabilities of the interface would hardly be visible by optical recording in such a set-up because of detonation products. X-ray flash radiography is the essential technique to use in such cases because it gives images of good contrast both of heavy materials that are X-ray opaque and of transparent lighter media.

24.4 Flash radiography as a quantitative tool

Flash radiography allows the observation of rapidly moving flows or objects without disturbing the main event. This technique can be an important tool in explosively driven experiments when the physicist is then able to fully deconvolute film densities to obtain the actual masses and positions of large objects containing dense materials of high atomic numbers.

The precision that can be obtained by this technique is, of course, dependent on many parameters

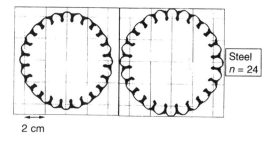

Figure 24.13 Two successive images of a Rayleigh–Taylor instability study recorded using the ARTEMIS linear accelerator.

including the performance of the X-ray source, the experimental set-up with its different arrangements of collimators and shieldings, and the X-ray detection of the X-rays and subsequent image analyses.

24.4.1 The X-ray source

For the high density materials used in experimental work, a suitable X-ray source must have the following characteristics:

- A small source size in order to minimize geometric blur.
- A high output dose level in order to operate in the linear region of the detector response.
- An X-ray spectrum suited to the total absorption characteristics of the high mass density materials being radiographed.

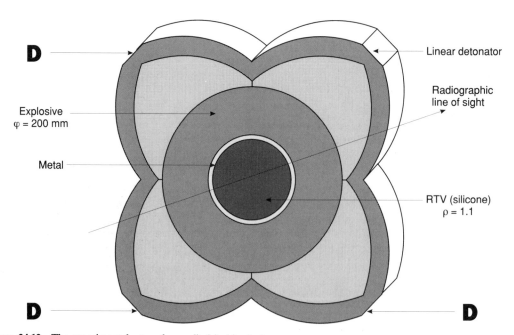

Figure 24.12 The experimental set-up for a cylindrical implosion.

- A short exposure duration of the X-ray flash (pulse) in order to decrease dynamic blur in the image, e.g. an edge travelling at 2 km s⁻¹ moves 0.2 mm during a 100 ns exposure.

To take into account these different parameters, a function called the *factor of merit* (*F*) characterizing each machine has been defined by Martin (1978), where

$$F = gDd^{-2} \qquad (24.1)$$

where *D* is the dose level (in rads) at 1 m, *d* is the source size diameter (in millimetres), and *g* is the radiation efficiency as a function of the incidence angle and energy of the electron beam used to produce the X-rays, together with the absorption coefficient of the target material interacting with the beam.

Within the CEA, the GREC generator, built by Physics International in 1974, is the principal tool for flash radiography experiments (D'a Champney and Spence, 1975). The principles of the machine and details of its performance are given by D'a Champney *et al.* (1981), Buchet *et al.* (1983) and Guix *et al.* (1984).

The Marx generator in this machine is illustrated in Figure 24.14. A total of 160 capacitors are charged simultaneously in parallel with two ±51 kV power supplies and are then discharged in series through 80 spark gaps. All these components are immersed in 525 m³ of oil. This *Marx generator* discharges into an oil insulated co-axial Blumlein pulse forming network and the output of the *Blumlein network* is coupled to a field emission diode through an oil vacuum insulator stalk. The generator is able to deliver 6–7 MV into the diode, which has an effective impedance of 60 Ω. The full width at half maximum of the power pulse is of the order of 25 ns. Since 1975 a series of experiments has been undertaken to upgrade the performance of this machine. The latest configuration of the GREC gives a spot size of 14 mm as a uniform disc, and a dose level of the order of 3.5 Gy at 1 m. The factor of merit of the GREC is therefore of the order of 1.8 × 10⁻² Gy mm⁻². The GREC generator is illustrated in Figure 24.15.

24.4.2 Implementation of experiments

The design of an experiment involving high explosives must minimize scattered radiation, especially when maximum material areal masses are of the order of 200 g cm⁻² (uranium equivalent) or more (Gauthier and Guix, 1982; Mueller, 1984; Neal, 1984).

The image of interest is formed by the differential attenuation of the primary beam by the experimental object (Burq and Vibert, 1990). At the multimegavolt energies needed to penetrate thick objects, there is a strong flux of high energy secondary radiation that can overwhelm the primary beam. Therefore when one wishes to obtain by radiographic techniques quantitative data on areal masses, the aims are:

- To reduce the dynamic range of the information presented to the detector (which is a film cassette in most situations) and restore the original scene in a post-exposure process.
- To reduce the magnitude of the scattered radiation reaching the detector (Mueller, 1984).

Figure 24.14 The Marx generator system of the GREC system for flash radiography.

Figure 24.15 The GREC flash X-ray generator.

The first results were obtained in Vaujours (Gauthier and Guix, 1982) with the development in the late 1970s of a multi-aperture collimator. Measurements of areal masses up to 180 g cm^{-2} have been achieved with this type of collimator, which reduces secondary radiation just before the film cassette. Another uranium collimator set at the front end of the GREC building and which collimates the X-ray source has also improved the capability of the GREC to measure high areal masses.

More recently, a graded collimation method has been developed (Mueller, 1984; Gerstenmayer *et al.*, 1992). Good quantitative data have been obtained with such a device because of its efficiency against scattered radiation.

The use of high explosives in experiments requires the placing of pyrotechnic shielding between the X-ray source and the object and between the object and the recording radiographic film, which is 0.3–1 m from the object. These shieldings absorb some of the available dose level, typically a 25–30 g cm^{-2} loss of equivalent uranium areal mass, or a factor of 4 on the dose level. The total thickness of the pyrotechnic shielding has to be matched to the mass of explosive for each experiment.

24.4.3 X-ray detection using film and intensifying screens

Intensifying screens and X-ray film materials have been the first choice for use in detectors for hydro-shots because of their large dimensions (30 × 40 cm) and good resolution. Initially, variations on medical or fast industrial screens were developed for flash X-ray radiography. The radiographic characteristics of various film–screen combinations have been investigated, notably by Bryant and co-workers (Bryant, 1976, 1995; Bryant *et al.*, 1978; Bryant and Lucero, 1984) and Pierret (1994).

The detection of low X-ray fluences up to 10 MeV requires an increase in the capabilities of radiographic detection, and much effort has been expended to optimize combinations of intensifying screens, film material and photographic processing.

Energy transfer in intensifying screens has been studied by numerical simulations (Franco and Julia, 1991). This parametric study of the energy transfer in an intensifying screen was done by means of a Monte-Carlo type coding of the interaction of ionizing radiation with matter. Photoelectric, Compton and pair production effects were taken into account to optimize the detection cells (layers).

The recording cassette containing the film and intensifying screens as used for hydro-shots consists of a stack of 14 cells (layers) (Figure 24.16). It consists of five cells having metallic screens in front, which are less sensitive but give good resolution. The metallic screens convert X-rays into electrons which form a latent image on the photographic film. The nine following cells are composed of a stack of metallic screens (tantalum or lead, 200 μm thick), intensifying screens (calcium tungstate (CaWO$_4$)), X-ray film with a double emulsion (XAR type) and another intensifying screen. The intensifying screen consists of a base, a reflective layer, a fluorescent layer and a protective layer. When an X-ray beam

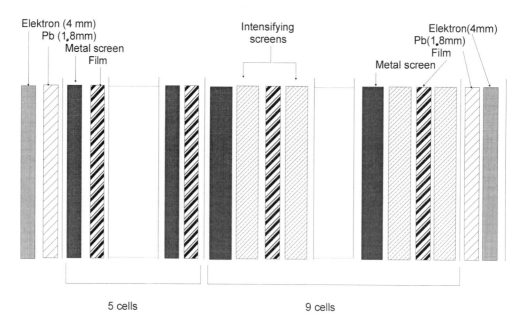

Figure 24.16 X-ray detection using a recording cassette with a stack of 14 cells (layers).

interacts with a metal screen, free electrons are produced which lose their energy to the intensifying screen, producing visible photons that in turn produce an image on the film. The X-ray film is suitably sensitized to the wavelength of the visible photons. The latter nine cells give poorer resolution but are much more sensitive than the previous five cells. Typically with a detection threshold of 2–4 mrad at 5 MeV and a spatial resolution of 0.3 mm^{-1} for an X-ray energy of 10 MeV, a modulation contrast of 50% is achieved (Pierret, 1994). In recent years much effort has been expended on increasing film sensitivity (Franco, 1991; Jesne and Julia, 1992; Julia and Jesne, 1992; Jesne *et al.*, 1993).

The last part of the analysis work to obtain a full deconvolution of the recorded film densities and to give access to the final numerical results comprises; image analysis and processing, these techniques are not discussed here.

24.4.4 X-ray detection with new detector systems

New systems of detection are under active development and these and their performance will become more familiar in the near future. For example, a detector has been developed based on an MCP image intensifier tube. It consists of a proximity focused tube with a useful diameter of 60 mm that can provide both gain and X-ray photon conversion

over a range from 50 keV up to several megaelectron-volts, depending on the thickness of the metallic photocathode. The image intensifier, made by the Philips company, is constructed of five component parts (Figure 24.17).

The input window is a thin titanium foil of thickness 0.2 mm, which also forms the wall of the vacuum chamber. The absorption of X-rays through this foil is considered negligible. A gold photocathode 100 μm thick provides the electron to photon conversion. It is supported by another thin foil of titanium in contact with the input side of an MCP. The thickness and the nature of the photocathode plate are found to be the best compromise to fulfil the opposing requirements encountered at the several megaelectron-volt level to obtain simultaneously a high quantum efficiency and a high spatial resolution.

The zero distance between the photocathode and the MCP input was chosen to increase the spatial resolution of the system. The MCP amplifies the emitted photoelectron image. The diameter of a channel is 40 μm, while the useful diameter and length of the plate are 60 and 16 mm, respectively. For a length/diameter ratio of 400 for each channel, the electron gain is of the order of 2×10^3 for a voltage of 900 V across the plate.

The amplified photoelectron image is proximity focused onto a fluorescent screen in order to be converted into a visible image. This phosphor screen

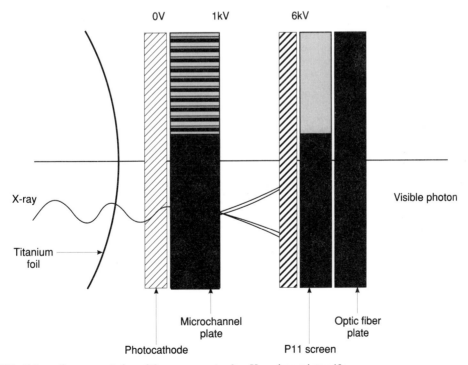

Figure 24.17 Schematic representation of the components of an X-ray image intensifier.

is of the P11 type, with blue emission of peak wavelength 460 nm and a short persistence (phosphor decay time less than 100 μs). These spectral properties are well matched to both film and television detection for a fast image transfer. The highest value of the applied voltage and the narrowest spacing distance are determined by the maximum potential difference that the P11 screen and MCP can withstand without sparking or removal of layers of phosphor. A potential difference ≤6 kV and a separation distance of 1 mm were eventually found suitable. The fibre optics output window provides an excellent flat display for the output image, is well suited for detection purposes and eliminates the need for additional coupling lenses with their associated drastic loss of photons.

The characteristics of this image intensifier for hard X-rays have been measured at its maximum gain for incoming radiation of 1 MeV energy. The response is linear over a dynamic range of 50 between an incoming dose of 100 μrad and 50 mrad. It is possible to resolve spatial frequencies up to 2 lp mm^{-1}. The *signal to noise ratio* (SNR) is more or less proportional to the incoming quantum fluence and the *detective quantum efficiency* (DQE) is about 0.2%. The sensitivity of the device and the dynamic range recorded can be adjusted according to the gain of the MCP. At maximum gain it operates in the range where a combination of MR 800 + CURIX RP2 screen film system is inoperative (Gex *et al.*, 1987; Veaux *et al.*, 1989, 1991). This device is particularly useful in the flash radiography of heavy materials and high explosive experiments, when it can be configured to operate in the high energy X-ray range of 1–10 MeV.

This review of techniques may give the impression that in flash radiography everything has been achieved from an experimental point of view, but this is far from the truth. A fuller understanding of detonics work will come from improvements in X-ray sources, blast protection systems, the geometry of experimental configurations, the detection of X-rays and progress in image detection and analysis. Further progress in high speed photography techniques will improve the experimental techniques and design suited to the requirements of physicists.

Acknowledgements

The advice of R. Guix and J. G. Lefebre and the technical assistance of S. Voltz in the preparation of this chapter is gratefully acknowledged.

References

Al'tshuler, L. V. *et al.* (1968) The effect of electron structure on the compressibility of metals at high pressure. *Sov. Phys. Usp.* **26**, no. 6, 1115–1120

Baluteau, J. M. (1972) Nouvelle caméra ultra-rapide à hautes performances. *Nouv. Rev. Opt. Appl.* **3**, no. 1, 11

Barker, L. M. and Hollenbah, R. E. (1972) Laser interferometer for measuring high velocities of any reflecting surface. *J. Appl. Phys.* **43**, 4669

Bauer, F. (1983) PVF2 polymers: ferroelectric polarization and piezoelectric properties under dynamic pressure and shock wave action. *Ferroelectrics* **49**, 231–240.

Bouchu, M. and Lefebvre, J. (1986) Airgap sensor and associated experimental arrangement. *Proc. SPIE* **648**, 237–251

Bryant, L. E. (1976) *Flash Radiographic Techniques – Exposure, Recording, Triggering and Film Protection. Conference.* LA-UR, Houston, TX

Bryant, L. E. (1995) Film/screen study for flash X-ray application. Issued as an enclosure to multiple addresses, limited distribution letter, 4 June 1995

Bryant, L. E. and Lucero, J. P. (1984) *Film/Screen Study for Flash X-rays.* Los Alamos National Laboratory

Bryant, L. E., Lucero, J. P. and Espejo, R. P. (1978) *X-Ray Film/Intensifying Screen Study for Flash Radiography.* Technical Note. Hewlett Packard, McMinville Division

Buchet, J., Guix, R., Vernier, G. *et al.* (1983) Augmentation des performances radiographiques de l'accélérateur GREC par utilisation d'interrupteurs à plasma et d'une ligne de 150 ohm. In *High Power Beams*, pp. 285–289

Burq, C. and Vibert, P. (1990) Approximation du rayonnement diffusé compton. *Proc. SPIE* **1346**, 517

Cavailler, C. (1990) The evolution of high speed photography and photonics techniques in detonic experiments. In *Proc. 19th Int. Congress on High Speed Photography and Photonics.* (Garfield, B. and Rendell, J. eds). Society of Photo-Optical Instrumentation Engineers, Bellingham, NY

Cavailler, C., Bouchu, M. and Delaval, M. (1990) Measurements of dynamic pressure by PVF2 gauges. *Ferroelectricity Conference*, Urbana, IL

CEA (1987), *Patent deposit number 87 00659* (Jan. 1987). License BM Industrie, 7 rue du Bois Chaland, ZI du bois Chaland, Lisses, France.

Charest, J. A. (1973) EG and G Report, DNA 3101 F

Chartagnac, P. F. and Perez, M. (1980) Shock loading and unloading behaviour of carbon piezoresistive gauges up to 5 GPa. *Rev. Sci. Instrum.* **41**, 46

Chartagnac, P. *et al.* (1991) Dynamic behaviour of PVF2 gauges in the 0–600 kilobars range. *ARA Conference*, San Diego, CA, October 1990

Croso, H., Cavailler, C., Mercier, P. *et al.* (1991) New optical instantaneous laser technique in detonic experiments. *Proc. SPIE* **1539**, 257–265

D'a Champney, P. and Spence, P. W. (1975) *IEEE. Trans. Nucl. Sci.* **22**, no. 3

D'a Champney, P. A., Spence, P. W., Wang, M., *et al.* (1981) Electron and ion beam research and technology. In *4th Int. Topical Conference on High Power*, Palaiseau, France, pp. 435–441

de Gliniasty, M. (1984) Metrology and dynamic behaviour of solids. *J. Phys. Coll. C8* **45**(suppl. 11)

Durand, M. and Laharrague, P. (1970) System of velocity measurements of a projectile using a Fabry Perot interferometer. In *Proc. 9th Int. Congress on High Speed Photography and Photonics, Denver, USA*, pp. 105–111. Society of Photo-Optical Instrumentation Engineers, Bellingham, NY

Franco, P. (1991) Etude du dépôt d'énergie dans les écrans renforçateurs par simulation numérique. *Proc. SPIE* **1539**

Franco, P. and Julia, F. (1991) Energy deposition study in the intensifying screens by numerical simulations. *Proc. SPIE* **1539**, 237

Gathers, G. R. *et al.* (1983) *Shock Waves in Condensed Matter*, pp. 89–90. Elsevier Science, Amsterdam

Gauthier, J. P. and Bouchu, M. (eds) (1978) *Proc. 13th Int. Congress on High Speed Photography and Photonics, Tokyo.* Society of Photo-Optical Instrumentation Engineers, Bellingham, NY

Gauthier, J. P. and Guix, R. (1982) Measurements of very high masses per unit area in a flash X-ray experiment calibration problems. *Proc. SPIE* **348**, 747–751

Gerstenmayer, J. L., Nicolaizeau, M. and Vibert, P. (1992) Collimateur graduel multitrou et tomographie quantitative. International symposium on optical and optoelectronic applied science and engineering. *Proc. SPIE.* **1757**, 1–7

Gex, J. P., Chapron, P. and Bizeuil, C. (1987) Tube convertisseur d'image pour X-durs et applications à la détonique. In *Congrès International de Pyrotechnique*, June 1987. Juan les Pins, France

Gidon, S. and Behar, G. (1986) Instantaneous velocity field measurements. Application to shock wave studies. *Appl. Opt.* **25**, 1429

Gidon, S. and Behar, G. (1988) Multiple line laser doppler velocimetry. *Appl. Opt.* **27**, no. 11, 2315–2319

Gidon, S., Garcin, G. and Behar, G. (1985) Doppler laser interferometry with light transmission by two optical fibers. *Proc. SPIE* **491**, 894

Graham, R. A. (1977) Hypervelocity impact phenomena: unique experimental and modelling techniques. In *High Pressure Science and Technology 6th Airapt International Conference.* (Timmerhaus, K. D. and Barker, M. S., eds), pp. 567–576. Society of Photo-Optical Instrumentation Engineers, Bellingham, NY

Graham, R. A. and Reeds, R. P. (1978) Selected papers on piezoelectricity and impulsive 'pressure' measurements. In *Sandia National Laboratories Report no. 1911*, p. 219

Graham, R. A. *et al.* (1965) Courant piezoelectrique provenant du quartz charge par choc une jauge de contrainte pour les durees inferieures a la μs. *J. Appl. Phys.* **36**, 1775

Guillamot, J. Y. *et al.* (1981) *Premier Symposium sur les Jauges et Matériaux Piézorésistifs*, 29–30 Septembre 1981. CEA, ADERA, CNRS, Arcachron

Guix, R., Biero, H., Buchet, J. *et al.* (1984) High energy flash x-ray generator: GREC, new performances. *Proc. SPIE* **491**, 144–152

Hammer, E. and Imhoff, C. (1988) Enhanced Thomson TSN 506 electronic camera performances through new image converter tubes. *Proc. SPIE* **981**, 41–54

Hauducoeur, A. and Buchet, J. (1981) Facility for cineradiography at high energy: the ARTEMIS programme. *Proc. SPIE* **312**, 257–261

Hauducoeur, A. and Nicolas, P. (1991) Apport de la cinéradiographie dans l'étude du comportement dynamique des matériaux. *J. Phys. IV: Coll. C3*, **1**(suppl. III), 387–394

Hauducoeur, A., Buchet, J., Nicolas, P. *et al.* (1984) ARTEMIS facility for cineradiography at high energy. *Proc. SPIE* **491**, 153–158

Held, M. (1986) The orthogonal synchro-streak technique as a diagnostic tool, particularly for shaped charge jets. *Propellants, Explosives, Pyrotechnics* **11**, 170–175

Jamet, F. and Thomer, I. G. (1976) *Flash Radiography.* Elsevier, Amsterdam

Jesne, P. and Julia, F. (1992) Amélioration de la détection du bas flux X par développement poussé. *45th Annual Conference IST, East Rutherford, USA* [oral presentation]

Jesne, P., Vibert, P. and Heilman, C. (1993) Improving low ray fluencies detection by optimizing film environment before development. In *Proc. 46th Annual Conference IST*, pp. 1–31

Julia, F. and Jesne, P. (1992) Détection des rayons X: évaluation des performances du système d'imagerie. *45th Annual Conference IST, East Rutherford, USA* [oral presentation]

Legrand, M. (1991) Interface instabilities in a cylindrical implosion. *Rev. Sci. Tech. Direction Appl. Militaires*, **2**, 27–40

Martin, J. C. (1978) *Possible Machines for use in a New Large Flash Radiographic Installation.* SSWA, AWRE, Aldermaston, UK

McMillan, C. F., Goosman, D. R. *et al.* (1988) Velocimetry of fast surfaces using Fabry Perot interferometry. *Rev. Sci. Instrum.* **59**, no. 1

Mercier, P. and Behar, H. (1991) Instantaneous velocity field. In *Conference on Lasers and Electro-optics QELS.91*, Baltimore, MA, pp. 1–13

Mercier, P. *et al.* (1989) Interferometry doppler avec un laser multiraies. In *3éme Symposium HDP La Grande Motte*, France, pp. 323–332

Mueller, K. H. (1984) Collimation techniques for dense object flash radiography. *Proc. SPIE* **491**, 130–139

Neal, T. R. (1984) Flash radiography as a quantitative tool. *Proc. SPIE* **491**, 113–129

Perez, M. (1980) Etalonnage en compression par choc et en détente de jauges piézorésistives entre 0 et 200 kilobars. Centre d'Etudes de Gramat

Pierret, O. (1994) Etude de la Détection X sur Film en Radiographie Éclair à bas Niveau de Fluence dans le Domaine 1 à 20 MeV. Ingenior memory CNAM, September 1994

Shaw, L. L. *et al.* (1976) Nanosecond hydrodynamics diagnostics using fiber optic probes and a streaking camera. In *Proc. 12th Int. Congress on High Speed Photography and Photonics, Toronto, Canada*, pp. 1–7. Society of Photo-Optical Instrumentation Engineers, Bellingham, NY

Shifa, W. U. (1988) High speed optical measurement techniques in explosion physic experiments. *Proc. SPIE* **1032**, 1–53

Steenbek, M. (1938) Uber ein verfahren zur erzeugung intensiver Röntgenlichtblitze. In *Procede de Production d'Eclairs de Rayons X Intenses,* vol. 17, pp. 1–18. Siemens Werken

Steinmetz, L. (1986) New laser amplifier improves doppler interferometry. *Energy Technol. Rev.* **Feb.**, 1–7

Thomer, G. (1961) *Mesures de l'Émission Totale et de la Variation de l'Intensité des Éclairs de Rayons X.* Note technique. ISL T 7/61

Vantine, H. C., Erickson, L. M. and Janzen, J. A. (1980) Hysteresis, corrected calibration of manganin under shock loading. *J. Appl Phys.* **51**, no. 4, 1957–1962

Veaux, J., Cavailler, C., Gex, J. P., *et al.* (1989) Tube convertisseur d'image fonctionnant dans le domaine X-durs et application en détonique. In *Congrès HDP, La Grande Motte, France,* pp. 315–322

Veaux, J., Cavailler, C., Gex, J. P. *et al.* (1991) Hard X-ray detector with a MCP image intensifier working in the 100 keV to 1 MeV X-ray range. *Rev. Sci. Instrum.* **62**, no. 6, 1562–1567

Wetzel, M. (1970) Visualization and measurement of dynamic deformations of rotating mirrors. In *Proc. 9th Int. Congress on High Speed Photography, Denver, Colorado,* pp. 135–141. Society of Photo-Optical Instrumentation Engineers, Bellingham, NY

Wetzel, M., Devaux, P. and Pujol, J. (1968) Récents développements des matériels de cinématographie ultra-rapide en France. In *Proc. 8th Int. Congress on High Speed Photography, Stockholm, Sweden,* pp. 492–496. Society of Photo-Optical Instrumentation Engineers, Bellingham, NY

Yates, G. J. (1983) Nanosecond image shuttering studies at LANL. *IEEE 1983 Nuclear Science Symposium, San Francisco, CA*

Yates, G. J. *et al.* (1984) Nanosecond optical shutters. In *Proc. 16th Int. Congress on High Speed Photography and Photonics, Strasbourg, France,* pp. 44–55. Society of Photo-Optical Instrumentation Engineers, Bellingham, NY

25 Cameras and control systems in motor transport research

F. Schreppers

25.1 Introduction

High speed cine cameras have a long history of application to studies in the field of motor transport research. Two particular groups of automotive engineers have used high speed cameras since the 1930s. The first and largest group is concerned with vehicle and traffic safety, while the second group use high speed cameras to aid the design and improvement of components for motor vehicles. This chapter takes a closer look at the use and control of high speed cameras in vehicle and traffic safety research.

Safety research using techniques of controlled vehicle crash tests and propelled sled tests originated in 1937, when the automotive and allied industries, through the Automobile Manufacturers Association in the USA, organized the Automotive Safety Foundation to improve traffic safety, and together with other concerns, stimulated accident research to reduce the high traffic accident fatalities rate of the mid-1930s.

The first crash tests were conducted by General Motors in 1938, but it was not until after World War II that the initiative to protect occupants in traffic accidents really started to gain momentum. The results of such crash tests have been reported regularly since the end of the 1940s, including 44 tests in the USA alone between 1950 and 1957. Also, in Europe, since the beginning of the 1960s, accident research has gained greater importance and crash tests have become a necessity.

For the first crash tests only a single high speed camera was used, but by 1957 as many as 13 cameras recorded the event. Originally, crash tests took place around noon to make use of the full illumination intensity of sunlight. The roof of a test car was cut off to allow a view inside the car by a stationary camera positioned above the collision point. There were no cameras on board the vehicle as suitably *ruggedized* cameras were not then available.

In 1960, General Motors produced an initial design for a *crash decelerator sled*, which was first installed at the medical centre of Wayne State University, and by 1963 the first series of tests with the sled took place. By this time, the first ruggedized high speed cameras were available, such as the Photo Sonics 1B and Stalex MS-16A types. The first batch of 12 Stalex cameras were delivered to the Saab motor company in Sweden in 1960. By the end of the 1960s, crash and sled testing were routine in the automotive industries in many countries of the world.

25.2 Cameras for crash and sled tests

In the early days of crash tests, rotating prism types of high speed cine cameras were used, such as the Kodak and Fastax designs. These cameras were designed principally for laboratory use and were not suited to industrial environments. Being relatively bulky and heavy in weight, they were not ideal for the recording of crash tests.

Nowadays, two different types of high speed cine camera are necessary in connection with crash and sled testing, being suitable for both stationary and on-board use. Ruggedized cameras designed for use actually in the test vehicle can withstand high *g* forces and the severe vibrations that occur during crash and sled testing. In practice, such ruggedized cameras are often also used for stationary applications. This reduces the number of different camera types used in a test and so simplifies setting up, while allowing an easier exchange of cameras and reducing the number of different accessory items needed. A list of representative cameras currently in use is given in Table 25.1.

It is believed that over 2000 high speed cine cameras are now in operation worldwide for crash and sled testing. It is also known that certain cameras have been in use for more than 25 years and still produce pictures of acceptable quality. There has been no notable progress in the last 10 years in the basic design of high speed cameras of the rotating prism type. However, many incremental improvements have been achieved by the use of contemporary technology and materials, so modern cameras are considerably more reliable than those

Table 25.1 Camera types used in car safety testing by crash and sled methods

Camera	Film capacity		Type
	(m)	*(feet)*	
On-board cameras			
Fastax	30	100	Rotating prism
Photo Sonics IB	30	100	Rotating prism
Stalex	30	100	Rotating prism
Stationary cameras			
Drumcam	1	3	Rotating prism
Fastax	120	400	Rotating prism
Hycam	120	400	Rotating prism
Locam	60/120	200/400	Intermittent
Milliken	120	400	Intermittent
E-10	120	400	Rotating prism
Photec	120	400	Rotating prism
Photo Sonics 1PL	60/120	200/400	Intermittent

used originally, but all improvements are in details, there being no change to the basic operation.

25.3 Camera control equipment

By comparison with camera design, a retrospective overview of camera control equipment shows that new technology has had significant influence in its design, resulting in better and more sophisticated systems. Full advantage has been taken of progress in electronics and computer control techniques.

The camera control equipment used about 1960 was very bulky, very heavy and is now considered very primitive, but it worked! As a representative of that time we can take the so-called Goose control (Figure 25.1), which weighed 27 kg (59 lb), with dimensions of 50 × 33 × 26 cm (20 × 13 × 10 inch).

The next generation of camera control equipment available was the WG series designed by the Weinberger company of Switzerland, with production starting in 1961. The concept of this equipment was based on a controlled power supply and a separate *programmer* for initiation of events (Figure 25.2). Novel features included with the power supply were an integrated *time marker generator* and switching devices for the illumination sources used. The programmer used an *electronic counter* to initiate a *pre-event* followed by two additional events after the start of a Fastax or Hycam camera and, if needed, could also limit camera run time. Either the percentage of film length or run time (in milliseconds) could be selected. This two-part controller was not light in weight either, the parts weighing 37 kg (81 lb) and 19 kg (42 lb), respectively, and with dimensions of 54 × 35 × 33 cm (21 × 14 × 13 inch), respectively.

In 1966, Red Lake Laboratories Inc. introduced a new Hycam camera with integrated electronic servo control, giving a whole range of new possibilities. This was followed in 1968 by the Weinberger company with their newly designed Unit-series system, which used a modular concept offering many features (Figure 25.3).

The success of the Unit-series systems can be measured from the fact that they have been in production for more than 20 years in many different versions and combinations for a range of applications. A novel feature of this system was a high quality servo control and power supply for many

Figure 25.1 The Goose control unit for Wollensak Fastax cameras.

Figure 25.3 Weinberger Unit-series camera control unit.

made it possible to design the next generation of camera control equipment, such as the Weinberger Micropro system, incorporating most of the features of the previous Unit-series but with many additional control and safety functions.

The necessity for these additional functions resulted from the need for additional reliability and safety in the use of high speed cameras for crash and sled testing. The number of cameras used for particular tests was increasing as was the annual number of crash tests carried out. The camera control system was now capable of many of the functions once reliant upon the camera and its operator, substantially reducing the risk of failure and increasing cost effectiveness.

All the camera control equipment discussed so far is for stationary or static use only as it cannot normally withstand the high *g* forces occurring during crash or sled testing. For on-board use, since 1970 the Weinberger company has made suitably ruggedized camera control equipment available for Stalex cameras (Figure 25.4). The so-called *Speed Adapter* is direct current (DC) powered and includes a servo control, a time marker generator and auxiliary circuits, while being both small and relatively light in weight.

As the need for increased reliability and safety became increasingly important, the Weinberger speed

Figure 25.2 Weinberger two part camera control unit: (a) power supply unit. (b) programmer unit.

different types of high speed camera including the Automax, Fastax, Hycam, Hytax, Locam, Milliken, Photo Sonics and Stalex designs. Even today a large number of these units are still in use. During this long period of use, there was significant progress in the technology of electronic control systems which

Figure 25.4 Weinberger camera control unit CCS-1 for Stalex cameras.

Adapter SA-3 design of control unit was produced, featuring an integrated interface (Figure 25.5). This Speed Adapter isable to interface with the same Multiple Camera Controller as used in the Micropro control system range for stationary camera use (Figures 25.6 and 25.7). The ability to control both on-board and stationary cameras by one central system now represents the state of the art in this technology (Figure 25.8).

Figure 25.6 Weinberger type PP-1 programmer unit for event control.

Figure 25.7 Weinberger type CS-20 multiple camera control unit.

25.4 Control systems for crash test facilities

Previously, most of the automobile and allied companies involved in testing designed their own systems for centralized camera control, specially adapted to individual needs and budgets. Very often such systems and projects are designed and manufactured by the company itself. Increasingly, however, external engineering services are also used for such projects, and so altogether quite a number of different installations are in use worldwide.

Quite often, the central control system just takes care of the camera system and may only have basic or simple interaction with the other specialities, technologies or measurement systems involved in

Figure 25.5 Weinberger camera speed adapter units for Stalex 16 mm cameras: top, type SA-2b; bottom, type SA-3.

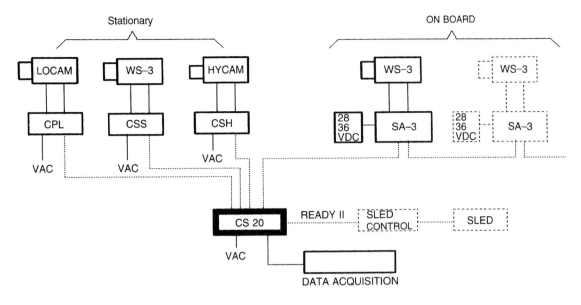

Figure 25.8 Configuration of the components of a recording system using a multiple camera control unit (Weinberger CS-20).

the testing of cars and their components (Figure 25.9). The other technologies involved include those for:

- Data acquisition.
- Propulsion systems.
- Lighting equipment.
- Safety of the test site.

Obviously, the next logical step was to combine these roles in a single integrated control system.

25.5 Advanced camera control systems

A contemporary camera control system of advanced design allows the integration of all the cameras used and their control equipment in a sophisticated test system controlled by a single computer, as for example the Weinberger ACCOS system (Figure 25.10).

25.5.1 Configuration

The usual configuration of an advanced camera control system such as the ACCOS consists of basic components that can be extended with various options. A basic system configuration consists of:

- An electronic control unit for each individual camera used with the system.
- Camera identification circuits installed in each individual camera.
- Distribution terminals.
- Camera control cabinet.
- Camera control software.
- A personal computer (PC) and printer for data input and output.
- Light barrier to trigger the system.
- Umbilical cable connection between camera electronic control units and distribution terminals for on-board cameras.
- Cable connections between camera electronic control units and distribution terminals for stationary cameras.
- Data cable link between distribution terminal and camera control cabinet.
- Data cable link between camera control cabinet and PC.

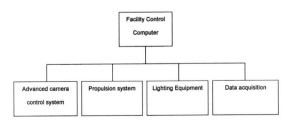

Figure 25.9 Computer control of systems and data acquisition.

This basic system can be extended with the following options:

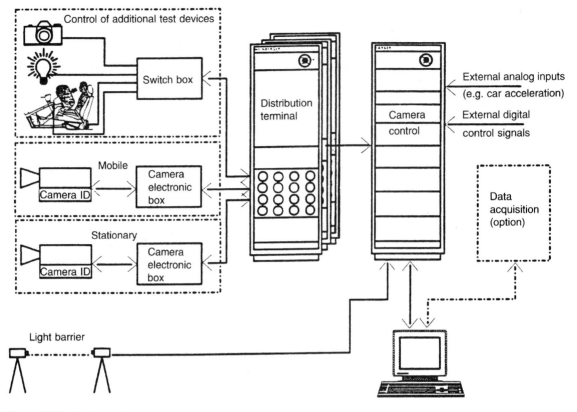

Figure 25.10 Configuration of the Weinberger ACCOS advanced camera control system.

- Switch box, e.g. for airbag initiation or seat belt pre-tensionings.
- Interfaces for FDDI, Interbus S, LAN, etc.
- Input/outputs for external analogue and digital data and status information.
- Software for camera data acquisition and speed curve analysis.

25.5.2 Camera control unit

Ruggedized camera electronic control units are available for cameras of the Locam or Stalex type for on-board applications (Figure 25.11). This camera electronic control unit is the *interface* between the camera and the distribution terminal.

All the necessary set-ups for an automatic test run are performed by this electronic control unit which operates the camera according to a programmed set-up. The programmable parameters are:

- Film framing rate.
- Camera start delay.
- Camera running time.
- Camera test function.
- Control of internal DC/DC converters.

In order to be controllable, an *interface* and a *camera identification logic* are also installed. For emergency situations a *manual start mode* is available. If need be, the camera electronic control unit can also be used as a *stand-alone unit*. Each camera needs its own separate electronic control unit.

25.5.3 Distribution terminal

The camera electronic control boxes are connected to a *distribution terminal* (Figure 25.12). Depending on the test configuration, either four, eight or sixteen cameras may be connected to a single distribution terminal. The distribution terminal consists of an isolated power supply for each of the cameras, a *'watchdog' function* for the primary and secondary power supplies as well as a *test function* for all power supply fuses. The state of the power supply voltages is transmitted to the camera control unit. This guarantees that no test can be initiated if a power supply is faulty. The distribution terminal also has a manual start circuit for simultaneous operation of all the connected cameras.

Figure 25.11 Weinberger camera control units: top, type SA-10 for Stalex cameras; bottom, type PA-10 for Locam cameras.

25.5.4 Camera control

The camera control unit (Figure 25.13) has access to all signals from the cameras, test facilities and light barriers. Up to three distribution terminals with up to 48 cameras may be connected to the camera control unit. In addition, it is possible to connect either two pairs of light barriers or four single light barriers. Galvanically isolated digital inputs can be used to acquire additional signals from the test site, as for example the control of safety facilities.

To permit easy interfacing with the *facility control computer*, the camera control unit has the following digital control lines:

- Test enable (output signal).
- Check run of the camera (input signal).

Figure 25.12 Distribution terminal.

- Crash trigger (T_0) (input signal).
- Camera start (input signal).

These signals can vary depending on whether the camera control unit is being used either for crash tests or for component tests. The camera control unit can be equipped with a *data acquisition unit* that is used to store the start-up characteristics of all cameras in a 2 Mbyte memory. At the end of the test all start-up characteristics are transferred to the control PC. As an option the data acquisition unit may also be equipped with analogue inputs. In this case, acquisition of additional signals from the test site is possible, e.g. to obtain the acceleration of the propulsion system. At the moment of impact (T_0) the camera control unit initiates a time marker signal with a frequency of 1 kHz. This time marker signal is transferred to the cameras in order to generate precise time information concerning the moment of impact (T_0) on the film.

25.5.5 Software control

The whole system is controlled by a *personal computer* (PC), and is able to control crash tests as well

Figure 25.13 Camera control unit.

as component tests. The software incorporated in the PC can perform the following tasks:

- Camera, lens and support device management.
- Configuration of the system.
- Selection of cameras, lenses and support devices for optimization of test results.
- Automatic check of all cameras that are used during the test.
- Automatic control while testing.
- Determination of the start-up characteristics of all cameras.
- Automatic update of the start-up characteristics that are stored in the database.
- Optional analysis of the start-up characteristics.

The software uses a menu driven and easy to learn user-friendly interface. There are separate programs for all the above functions. During the test run all functions can be accessed either separately or from within a batch procedure, which means that no more operator inputs are required in the batch mode.

25.6 Control system capabilities

25.6.1 Crash tests

When using the ACCOS system for crash tests (Figure 25.14) the operator first enters all necessary

camera set-up parameters for the test to the host software program. For every camera to be used, these parameters include choice of lens and the defined test site, as well as the framing rate for filming and camera run time. Next, all the set-ups are loaded into the camera control unit and the status of all cameras is checked. Then a short check run is carried out for all cameras at a low framing rate. At the end of these check routines additional digital inputs may also be checked before the crash test is started. Only if all checks are positive can the start of the crash test run be initiated. The propulsion system may now be started. After the test vehicle has passed the light barrier with the desired velocity, the camera control initiates a starting signal for the cameras. The camera electronic boxes then start the attached cameras after applying the corresponding delays chosen. At the moment of impact the camera control starts to generate a 1 kHz time marker signal. This signal is transferred to the cameras to generate time markers on the film. The cameras are then switched off automatically after the required time or at the end of the film.

25.6.2 Component tests

All necessary set-ups for the test of a vehicle component (Figure 25.15) are also carried out by the camera software and then down-loaded into the camera control unit. All cameras are then checked by a short run at a low framing rate. At the end of these tests additional digital inputs may be checked. Only if everything is working correctly can the start of the test be initiated. The facility control computer does not start the cameras directly. It sends the start signal to the camera control unit which supplies a start signal to the test facility after all cameras are running at their defined framing rate. At the moment of the impact (T_0), the camera control starts to generate a 1 kHz time marker signal. This signal is transferred to the cameras to generate time markers on the film. The cameras are switched off automatically after the defined run time or at the end of the film.

25.7 Conclusions

The use of high speed cine cameras in crash and sled tests is a necessity for the automobile industry. To reduce the workload of the test engineers and eliminate as far as possible all sources of error, the use of an advanced control system is advantageous. Such a control system takes over most of the routine handling and control functions. Also important is the possibility of integrating the camera equipment into the automatic test routines of the other technologies involved in crash or component tests.

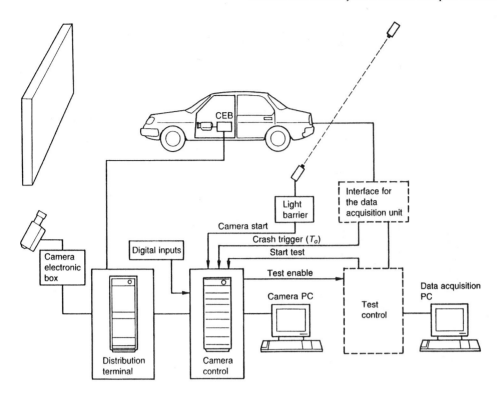

Figure 25.14 Set-up for a vehicle crash test.

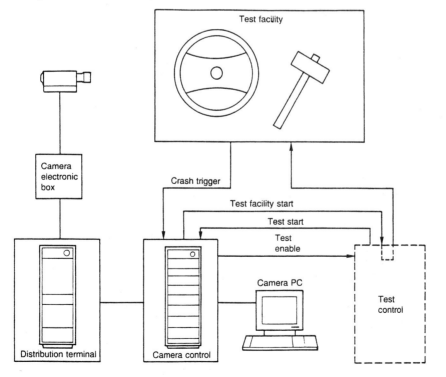

Figure 25.15 Set-up for vehicle components test.

26 Combustion processes in engines

Desmond E. Winterbone, D. A. Yates and Eric Clough

Reciprocating engines have been producing the power to help us sustain our lifestyles for over a century. There has been continuous development of these engines, leading to increased specific power output, reduced fuel consumption and improved emissions performance during this period. The original internal combustion engine developed by Otto, the Otto–Langen engine, was significantly different to current engines and was extremely noisy in operation. The next engine Otto designed was similar to today's engines and was called 'the silent engine' because it was so much quieter. Otto claimed this reduction in noise had been obtained by careful consideration of the airflow in the cylinder. He built a rig consisting of a glass cylinder liner and a manually operated piston to examine this. The flow was made visible by blowing cigarette smoke into the inlet port. Hence, the first flow visualization was done on engines in the 1880s, many decades before high speed photography.

The majority of research and development work on engines is performed using the gross parameters (e.g. power output, specific fuel consumption, exhaust temperature) as indicators of the combustion process. More detailed examination of engine performance can be achieved by the use of pressure transducers in the cylinder, and intake and exhaust manifolds. This approach enables the rate at which the fuel burns to be evaluated, and this is an indication of the manner in which the fuel is being burned in the cylinder. However, none of these techniques gives a detailed knowledge of the mechanism by which combustion takes place; the only way to achieve this is by looking inside the cylinder.

A major benefit of photography compared with other techniques is that it can be used to provide information over the whole field of view at any instant in time. It is also possible to achieve high framing rates, which means that a large amount of information can be obtained on a single engine cycle. Other techniques are often limited to providing point measurements, and data have to be built up by summing data over many cycles. Photographic data are 'stored' in analogue form on the film medium, and can then be digitized many times to allow different analysis techniques to be applied. The disadvantages of film are that: it is not an easy medium to work with because of the delay between shooting the film and processing it; displaying the film is relatively tedious; the image is qualitative and analogue, and must be digitized before it can be analysed quantitatively; and, in certain cases, the film must be calibrated.

This chapter:

- Defines the problems of photography in engines.
- Describes the current situation in respect of film and video-imaging.
- Describes various techniques for imaging engine processes.
- Describes combustion in spark-ignition engines.
- Describes combustion in diesel engines.

The major part of the chapter relates to combustion in diesel engines because this is where the authors have focused their attention over the last 5 years.

26.1 Definition of the problem

Internal combustion engines produce their power output by burning a fuel (usually a hydrocarbon) inside a combustion chamber. Such engines operate over a wide range of speeds, the maximum speed being dependent on the size of the engine. A typical petrol engine for a car will run at an idling speed of about 600–800 revolutions per minute (rpm) and produce its maximum power at well in excess of 5000 rpm. A modern Formula 1 racing engine will have a peak speed of around 15 000 rpm. Diesel engines tend to run at lower speeds and an automotive diesel might have a maximum speed of 4500 rpm. A 4000 kW diesel engine being used for ship propulsion, with a bore approaching 300 mm diameter, might run at a maximum speed of 1000 rpm. In all these engines it is desirable to complete combustion in about 50° crankangle (°CA) rotation; hence, the combustion duration in terms of time reduces with increasing engine speed. Table 26.1 shows the variation in the time per crankangle step for a number of speeds, and also the camera framing rate to achieve photographs every 1°CA. It can be seen that once the engine speed reaches 5000 rpm

Table 26.1 Framing rates to achieve pictures every 1°CA

Engine speed (rpm)	Time per °CA (ms)	Framing rate for one frame per °CA
1000	0.1667	6000
2000	0.0833	12 000
3000	0.0556	18 000
5000	0.0333	30 000
10 000	0.0167	60 000

the framing rate is right at the limit of modern techniques even for photographs every 1°CA.

Gaining optical access to the combustion chamber of an engine is not an easy task. The walls of the combustion chamber are formed by the cylinder head, the liner and the piston. The cylinder head is usually manufactured from cast iron or an aluminium alloy and contains water passages for cooling and gas flow passages for passing air into and out of the cylinder. It will also contain a spark plug (petrol) or fuel injector (diesel) and two, three, four or even five valves. Hence, it can be seen that the cylinder head of a typical engine has very limited access for optical equipment. The cylinder liner is

manufactured from cast iron, and mounted in a cast iron or aluminium cylinder block. It provides the bearing surface for the piston and piston rings, and this limits the possibility of cutting optical windows in its surfaces. In the case of the diesel engine, which usually has a combustion chamber machined in the piston, windows in the cylinder liner do not provide good optical access into the combustion region. The piston is a reciprocating component, connected to the engine crankshaft by a connecting rod, and might be shaped on its upper surface to form the combustion chamber. If optical access is to be gained to the combustion chamber it is necessary to enter the chamber through one of these components.

A method of obtaining optical access without major modification to the engine components is to use an *endoscope* (or borescope). This is a system of lenses mounted in a tube which enables a 'fish-eye' view to be obtained. Karimi *et al.* (1989) have reported combustion experiments performed on a diesel engine using an endoscope developed by AVL (see Werlberger and Cartellieri, 1987). The results gave excellent images of the fuel injection and combustion processes, and the only shortcoming is the image distortion caused by the optical system.

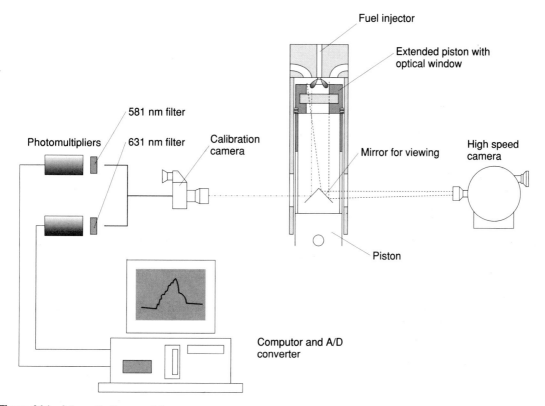

Figure 26.1 Schematic diagram of the arrangement for taking photographs through the piston of a direct injection diesel engine.

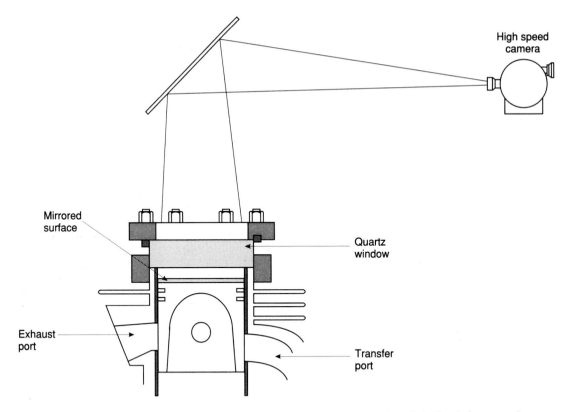

Figure 26.2 Schematic diagram of the arrangement for taking photographs through the cylinder head of a two-stroke spark-ignition engine.

Figures 26.1 and 26.2 show two approaches used for obtaining direct photographs of combustion from realistic engine cylinders. The most popular method for obtaining combustion photographs from internal combustion engines is referred to as the Bowditch (1961) system; this is shown in Figure 26.1 (Winterbone *et al.*, 1994). It is commonly used on four-stroke engines, which usually have the valves located in the cylinder head, and enables realistic gas flows to be maintained in the engine cylinder. This approach consists of extending the cylinder liner to allow an extended piston to be mounted on the original piston/connecting rod arrangement. Optical access to the combustion chamber can be obtained by a system of mirrors through a quartz window at the base of the extended piston. The extended piston and mirror arrangement for a Ricardo Hydra direct injection diesel engine are shown in Figure 26.3. The optical access achieved using this piston is shown in Figure 26.4. In this engine the bowl diameter and volume have been maintained the same as that of the original engine, but the bottom of the bowl is planar. This arrangement limits the optical distortion which occurs when viewing the contents of the combustion chamber, but it also interferes with the air–fuel mixing pro-

cess. A further disadvantage of this approach is that it is not possible to see the combustion and fuel–air mixing that occurs outside the piston bowl when the piston descends and the rich mixture expands to fill the cylinder. Ricardo and Hempson (1972) describe combustion photography undertaken at Ricardo Consulting Engineers at the end of the 1950s, and state that windows of quartz or Perspex (Plexi-glass) may be used. They explain that the life of Perspex is limited and that the temperatures of the components have to be kept lower than with quartz. Falcus *et al.* (1983) used Perspex in a Bowditch arrangement on a medium-speed two-stroke engine, and shaped the piston bowl. Some of the latest photographs at UMIST on a high speed diesel engine have also been obtained using a Perspex combustion chamber bowl, and these are reported in Section 26.5. The great advantages of Perspex are that it is easily machined and cheap, and hence complex piston bowls can be manufactured. A piston crown made of perspex is shown in Figure 26.5, and it can be seen that this has a transparent portion outside the bowl, enabling the fluid to be seen as it enters the 'squish' region.

The approach shown in Figure 26.2 has been adopted in a number of engines used for more fundamental studies of combustion in engines (e.g.

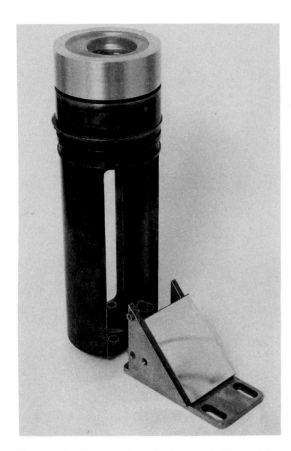

Figure 26.3 Components of the rig shown in Figure 26.1: Bowditch system.

Alcock and Scott, 1962; Scott, 1969; Konig and Sheppard, 1990; Konig *et al.*, 1990). The rig is, in this case, based on a two-stroke engine in which the air and exhaust enter and leave the cylinder through ports in the liner. It can be seen that this arrangement gives a very good view of the whole of the top of the piston, but it usually requires a plane cylinder head, and some compromise on the combustion chamber geometry. Another method of achieving restricted access through the cylinder head has been used by Falcus *et al.* (1983). This consists of removing one of the exhaust valves from a four-valve cylinder head, and photographing down through the port. Taylor (1967) adopted a slightly different approach to obtain access through the cylinder head of a medium speed diesel engine. While access through the cylinder head can provide information which is not available from the Bowditch approach, it usually has a restricted field of view when used on four-stroke engines. In an attempt to overcome these restrictions it is intended, at UMIST, to obtain simultaneous access through both the cylinder head and the piston for some future experiments. The

design of an optical access cylinder head by Rao (1995) is shown in Figure 26.6: this has been manufactured in the workshops at UMIST.

Heywood and co-workers at MIT have used an engine with square cylinder cross-section, constructed from quartz, to photograph combustion events through the walls of the liner (Gatowski *et al.*, 1984). This 'engine' was able to perform all the processes of a four-stroke spark-ignition engine, including combustion. A similar engine has been used at Daimler Benz (Weller *et al.*, 1994). The plane quartz cylinder walls make it possible to view across the whole 'diameter' of the cylinder in a vertical plane. While the combustion chamber is not completely realistic it is very easy to gain optical access for photography and illumination. Such an arrangement is useful for the investigation of the development of the flame from the initial spark right through to the turbulent flame. Yamane *et al.* (1994) have described an interesting technique for taking photographs across a diameter of an engine cylinder by means of a prism and a window in the cylinder head. Winklhofer *et al.* (1995) have described the use of a range of optical techniques to investigate the growth of flames in a spark-ignition engine.

A further factor which should be taken into account when attempting to photograph combustion in diesel engines is that it takes place in two phases. The first phase is the period when fuel is injected into the cylinder, and the mixing of the air and fuel occurs: this period is not self-illuminated and requires an external source of light. The second phase is the period after combustion has commenced, when the soot cloud radiates light and makes the 'combustion' visible. Combustion in a spark ignition engine does not follow the same pattern. The fuel and air are usually pre-mixed prior to being supplied to the cylinder, and hence there is no necessity to view the fuel injection process at this time. Some petrol engines do exist in which the fuel is injected directly into the cylinder, but these are a minority; the study of these engines would benefit from illumination of the injection process. The combustion phase in a petrol engine is self-illuminating, but if the mixture has more air than required to burn the fuel (this is referred to as a *weak mixture*) the light intensity is very weak and it is difficult to see the flame. These problems can be overcome by using additives which will emit radiation in the visible waveband, or by use of an image intensifying camera.

26.2 Brief history of combustion photography in engines

One of the earliest reports of combustion photography in a spark-ignition engine was made in 1931 by Withrow and Boyd, and this was followed in 1936

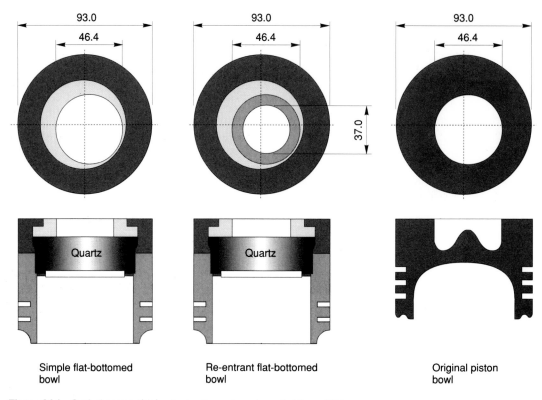

Simple flat-bottomed
bowl

Re-entrant flat-bottomed
bowl

Original piston
bowl

Figure 26.4 Optical access obtained using the system shown in Figure 26.3.

Figure 26.5 Perspex piston crown with optical access into clearance volume.

by a paper by Withrow and Rassweiler on 'knock' in engines. Early studies in a diesel engine were reported in 1932 by Rothrock, but the most well-known papers are those by Alcock and Scott (1962) and Scott (1969). All these studies were based on photographing the combustion through the piston. At this time the concept of computer based image processing did not exist and the photographs obtained were used to give a qualitative insight into combustion phenomena. However, while Alcock and Scott admitted that direct measurement of air motion was very difficult (at that time), they also said that gas movement after the evaporation of the fuel could be inferred from the movement of visible flame clusters. It was commented that: '... flame movement may be due to air movement or to flame propagation along already formed mixture. It is thus a doubtful measure of air movement in the early stages of combustion when propagation is occurring, but more trustworthy later when all the fuel is alight'. This comment is significant because it hints at the techniques that were introduced later.

Shadowgraphy and schlieren techniques have been applied to engines to obtain more information about the non-visible aspects of combustion, and these have enabled density gradients (or gradients in refractive indices) to be observed. Lyn and Valdaminis (1962) report the application of the

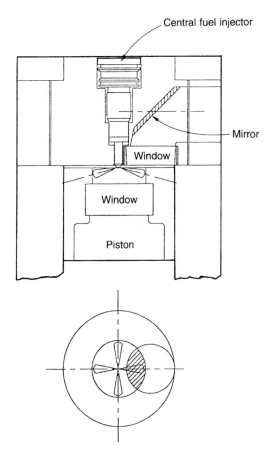

Figure 26.6 Cylinder head manufactured to give optical access in a high speed diesel engine.

distribution by the two-colour method, and the velocities of the gases in the chamber to be evaluated by cross-correlation techniques. The use of the laser has also enabled other techniques to be developed, For example, *laser induced incandescence* (LII) can be used to evaluate the soot distribution throughout a plane in the combustion chamber, and *laser induced fluorescence* (LIF) can be used to show the distribution of 'fuel' prior to combustion. In addition, laser sheets have enabled *particle image velocimetry* (PIV) or *particle tracking velocimetry* (PTV) to be used for estimating flow velocities prior to combustion.

26.3 Imaging techniques

The choice of imaging method is currently in a state of flux. Imaging based on the use of photographic film has not made significant advances over the last few decades, but that based on video has developed tremendously. The situation in respect of techniques needs continuous review before deciding on which medium to use. An attempt at assessing the strengths of each technique is given in Table 26.2.

Table 26.2 Comparison of features of imaging systems

Parameter	*Film*	*Video*	*High speed video*
Resolution	++	+	−
Framing rate	++	−	++
Continuous frames	+	+	−
Exposure time	+	−	++
End use:			
Electronic	−	++	++
Viewing	++	+	−
Ease of use	−	++	+

++, Very good; +, good; −, poor.

schlieren technique to a diesel engine, and Taylor (1967) describes similar work on a medium speed diesel engine. Early work was also done on spark-ignition engines using these approaches.

The next major advance was made when combustion photographs could be used for quantitative studies, and this became possible with the development of frame-grabbing techniques and image processing software in the 1970s and 1980s. The development of pulsed lasers for illumination of the processes occurring in the cylinder, be they the interaction of fuel jets with the combustion chamber wall, the evaluation of flows by holography, or the observation of flame fronts by interferometer techniques, also heightened interest in the use of photography for engine research. Recent years have seen a tremendous increase in the amount of work being performed on engines using combustion photography based either on film or video images.

The application of the computer for image processing has enabled photographs of flame in diesel engines to be analysed for temperature and soot

At present, high speed video cameras are limited to less than 512 × 512 pixels, which significantly restricts their resolution compared to film. Arcoumanis *et al.* (1995) report the use of a Kodak Ektapro HS solid state motion analyser (Model 4540) imaging system which was used at 128 × 128 pixels to image a piston bowl of 41 mm diameter at a rate of up to 13 500 pps. They claimed a spatial resolution of 0.04 mm² (equivalent to a linear dimension of 0.2 mm). If this picture were taken using 16 mm film the resolution would be approximately 600 lines, which is equivalent to 1200 pixels, over the same distance, giving a linear dimension of 0.04 mm. Hence, it can be seen that cine film has a resolution which is almost an order of magnitude better than the video image. To achieve the same resolution as film will require charge coupled device (CCD) arrays of more than 500 × 1000 pixels.

Arcoumanis *et al.* (1995) recorded the images from this CCD camera on a S-VHS recorder and then digitized them later using a frame grabber. In addition to using a high speed CCD camera, they also used a Proxitronic HF-1 camera with a framing rate of 25 Hz and a resolution of 800×590 pixels to take high resolution photographs of combustion once per cycle. Hicks *et al.* (1994) used an intensified CCD camera (Digital Pixel) with a resolution of 1152×770 pixels and a dynamic range of 4096 grey levels to 'photograph' the turbulent flames in a spark ignition engine. This was used with an exposure time of 4 μs, but the repetition rate was not stated. However, they also used a high speed camera at 10 000 pps to resolve the flame development within a single cycle, so there were presumably limitations on framing rate or storage capacity in the case of the video system. Hence, there is still a compromise to be made in the use of video imaging between speed and resolution. At present, film does not require such a large compromise and is the better medium for achieving high resolution, high speed photographs in engines. This situation will probably change in the near future.

A further advantage of film at present is that it is possible to record a large number of consecutive images at a high framing rate. This is important in engine research because of the variability between cycles. The cyclic variability of the petrol engine is very obvious even from an examination of gross parameters such as cylinder pressure, and this reflects the significant differences in the development of flame from cycle to cycle. If the combustion process in a spark-ignition engine is to be examined, it is essential that all the image information is coherent and from the same cycle. Images from different cycles might be useful for the study of cyclic variation but they are not helpful for the analysis of the physical combustion processes. The gross parameters defining combustion in a diesel engine do not exhibit the cyclic variation found in a spark-ignition engine, i.e. the pressure versus crank-angle diagrams do not vary greatly from cycle to cycle, and it might be thought that photographs obtained on different cycles can be used to examine the combustion process in the engine. However, detailed observation of the injection processes in the engine show that the actual fuel injection can vary significantly from cycle to cycle due to the manner in which the injection needle lifts. Also, the points of initiation of combustion are not invariant. So if it is intended to use photographs to examine the interaction between injection and ignition it is essential they all come from the same cycle. After combustion is well under way the processes show much less cyclic variability than those in a spark-ignition engine.

Film has a number of disadvantages which include:

- Processing time.
- Sensitivity to processing.
- Difficulty of analysing images to obtain quantitative data.

All of these negative points make video-imaging directly onto computer storage the attractive method for the future, since it gives instant playback, is not sensitive to any processing technique and can be used directly in image processing.

26.3.1 Direct photography

Direct photography is based on obtaining images in the visible spectrum, and the image bears a direct relation to what would be seen with the naked eye. This technique is useful if the phenomena under consideration are self-illuminating or reflect light. A great advantage of such images is that they can be used qualitatively to see what is happening in the combustion chamber; they relate directly to the experience of the viewer and can be readily interpreted. Disadvantages are that they do not contain a great deal of quantitative information, and often it is not possible to define at exactly what depth the images are being generated. If it is possible to illuminate the image by a light sheet, then information can be obtained on a plane in the field of view.

26.3.2 Shadowgraphy or schlieren techniques

Shadowgraphy can be used to improve the resolution of a non-luminous, transparent image in which changes of density are present. It is then possible to see flame fronts in petrol engines, and regions of evaporation in diesel engine sprays. A similar result can be obtained by the use of schlieren photography. Both these techniques may be used with ordinary or laser light, but the latter greatly improves the sharpness of the images. A schematic diagram showing the optical arrangement for laser schlieren photography from a two-stroke engine, as reported by Hicks *et al.* (1994), is shown in Figure 26.7. In this system the light passes through the field under examination twice, because it is reflected off the piston surface. ACE (1992) reports a similar method of doing schlieren in a direct injection diesel engine, except that in this case the light is reflected off a mirror attached to the cylinder head, and optical access is achieved through the piston with a similar arrangement to that shown in Figure 26.1.

26.3.3 Photography in the non-visible spectrum

Combustion processes emit radiation throughout the spectrum, and are not limited to the visible range. It is possible to obtain images in the infrared

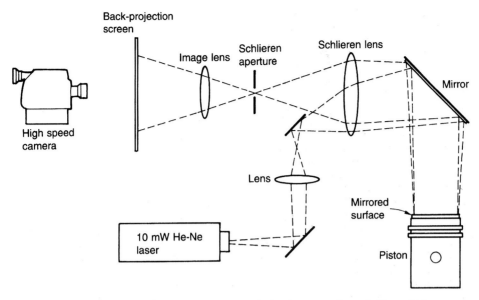

Figure 26.7 Optical arrangement to obtain schlieren photographs for the system shown in Figure 26.2.

wavelength region. Clasen *et al.* (1995) describe the use of such a technique to examine the processes occurring in a diesel engine just after the fuel has been injected. The infrared imaging system consisted of cryogenically cooled Pt–Si imagers. The authors state that the infrared images, which were tuned to the emission lines of water (2.47 and 3.43 μm), bear little resemblance to those obtained in the visible spectrum, and they believe that they indicate the pre-flame reactions that occur before the flame becomes visible.

26.3.4 Holography

Laser holography has been used to obtain images of the flow in the cylinder of a diesel engine just prior to injection and combustion (Dent *et al.*, 1977; and Lakshiminarayan and Dent, 1983; ACE, 1992).

26.3.5 Particle image and particle tracking velocimetry

Particle image (PIV) and particle tracking (PTV) velocimetry are both methods for obtaining velocities of flow in a plane in the field of view. PIV relies on the seeding of the flow to make it visible to the camera, and then a double-exposure photograph is taken by illuminating the field twice, in quick succession, by means of a short-duration flash source. PTV is a similar technique, except in this case more than two images are taken and the laser flash is coded to indicate direction. Early work with PIV in a motored engine is described by Reuss *et al.* (1989), and the use of the same technique in a fired engine is

reported by Reuss *et al.* (1990). Shack and Reynolds (1991) report the use of PTV in an axisymmetric motored engine, while Neusser *et al.* (1995) describe the use of PTV to measure the flow field in spark-ignition engines. The latter describe the measurement of flow in a typical four-valve arrangement, and compare the variation of flow velocities in the cylinder with the change in combustion. Reeves *et al.* (1994) describe the use of PIV to show barrel swirl in a four-valve optical engine, and refer to a method of reducing optical distortion when photographing through a circular cylinder liner. Since PIV and PTV have not been widely applied to fired engines, they will not be discussed again.

26.3.6 Laser-based imaging techniques

Laser based imaging techniques such as laser induced incandescence (LII) or laser induced fluorescence (LIF) can be used to image carbon and fuels, respectively, in the engine cylinder. Both of these techniques require laser excitation of the particles in the flow. The techniques are rather specialized and somewhat removed from normal photographic activities; they will not be discussed further in this chapter, but more information can be found in Fansler *et al.* (1995) and Dec and Espey (1995).

26.4 Combustion photography in spark-ignition (petrol) engines

The spark-ignition engine is a homogeneous charge engine, which means that the fuel and air are well

mixed in the engine cylinder prior to combustion. In chemical terms, the mixture is in a metastable state and is ready to burn if a small perturbation is applied; this is brought about by the spark.

Combustion in a spark-ignition engine is caused by a spark igniting a small flame kernel in the spark gap. This kernel grows as a laminar flame until it reaches a certain critical size, when it becomes turbulent and the flame speed increases. This detail of the flame initiation and propagation processes is known because of combustion photography, either by direct photographs, image intensified photographs, or schlieren or interferometry techniques. A major problem with photographing combustion in spark-ignition engines is that the flame is not very luminous. The luminosity of a flame is related to the radiating particles or gases inside the flame, and gases radiate at their own particular wavelengths. In the case of the pre-mixed flame of a spark-ignition engine, radiating particles (those containing solid hydrocarbons) only occur when the air–fuel mixture is rich, i.e. when there is insufficient air to bring about complete combustion of the fuel (this is referred to as a *rich mixture*). It is possible to improve the luminosity of the flame by adding particles to the fuel, and copper oleate has been used by experimenters. Most engines being constructed nowadays operate at the stoichiometric (chemically correct) air–fuel ratio over a large part of their operating regime, and there are attempts to develop lean-burn engines; under these conditions the luminosity of the flames is very low. In these circumstances it is useful to consider using image intensified photography, although this has the disadvantage of converting the coloured image to monochrome with a concomitant small loss of information.

A mechanism for overcoming the limitations of direct photography of combustion is to view a non-luminous feature of the process. This can be achieved by interferometry or schlieren techniques, which basically measure the changes in density of the mixture in the combustion chamber as combustion occurs. These techniques are discussed below.

26.4.1 Initiation of combustion in spark-ignition engines

Photographs of the initiation of combustion in the spark gap have been taken by Douaud (see Heywood, 1988, and Gatowski *et al.*, 1984). Heywood and Pischinger (1990) describe how these photographs can be analysed to assess flame growth and the rate of heat transfer from the flame kernel region. Douaud used shadowgraphy to obtain his photographs at an engine speed of 1100 rpm with about 40 µs between frames. These showed the passage of the spark between the electrodes of the spark plug, and then the development of a laminar flame kernel (it can be seen to be laminar by the smoothness of its surface). Gatowski *et al.* (1984) used schlieren photography to look at the growth of the 'flame' in the spark gap at engine speeds between 740 and 1400 rpm; the initial flame growing from the spark is shown in Figure 26.8. However, the flame development varies from cycle to cycle, as shown by Witze (1982) (Figure 26.9). The latter effect is caused by the turbulence in the flow in the vicinity of the spark gap, and can have a large effect on the variation of combustion between cycles. This cyclic variation is an important limitation on the performance of spark-ignition engines. First, as air–fuel ratios become leaner the tendency of the flame to be extinguished increases (i.e. the engine misfires) and this sets a limit to running the engine at weak mixtures. Secondly, the cyclic variation causes the emissions from the engine to be increased at any particular operating condition. Hence, high speed photography of the spark and flame initiation process has significantly increased knowledge about these important phases of combustion. The use of these techniques to investigate the initiation of the flame in stratified charge engines will enable the fuel consumption and emissions of engines to be reduced in the future.

26.4.2 Early stages of combustion

The flame kernel generated in the spark gap expands initially as a laminar flame, at the laminar flame speed of the mixture, and this has been shown by Gatowski *et al.* (1984). However, once the flame kernel has grown to a size where it is influenced by the turbulence its surface becomes distorted (Figure 26.10) and the flame becomes turbulent. Heywood and co-workers (MIT) have obtained many photographs of combustion from their square cross-section engine, by means of shadowgraphy or schlieren, which show how the laminar flame becomes turbulent, and these photographs explain why engines can operate over a broad range of speed: the turbulence enhances the flame speed in such a manner that the total combustion period shortens in time, but remains almost constant in terms of crankangle. Hancock *et al.* (1990) show photographs of flames in the early stages of combustion in a lean-burn engine, obtained using an image intensified Imacon camera. They describe an image processing technique that resolves effects during the initial stages of combustion that have a significant influence on the gross cycle parameters.

26.4.3 Turbulent flames

Witze (1982) gives photographs of various flames developing in a spark ignition engine obtained using laser shadowgraphy. These were obtained through a transparent cylinder head and clearly showed that

Plate 1

Plate 2

Plate 3

1 Assassin bug *(Rhinocoris)*
2 Bush cricket *(Phaneroptera)*
3 Grasshopper (blue-winged) *(Oedipoda)*
4 Plant bug *(Leptotema)*

Plate 4

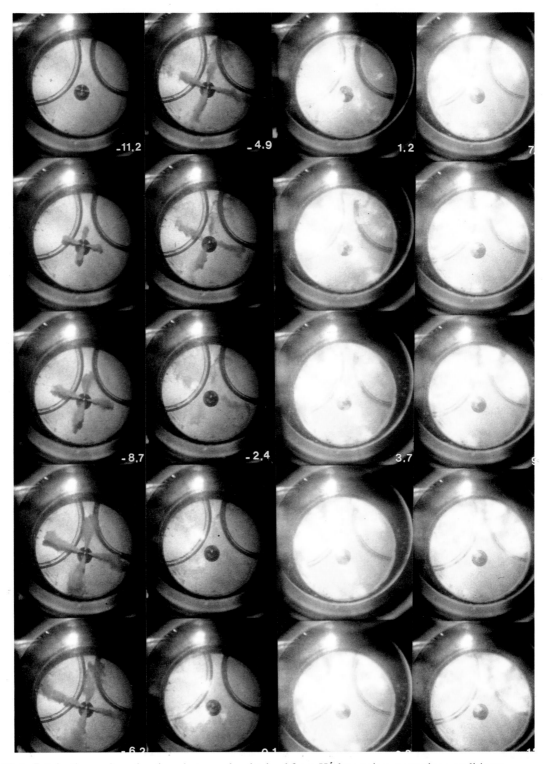

Plate 5 Injection and combustion photographs obtained from Hydra engine: operating conditions: 2000 rev/min; 4 bar bmep; high swirl.

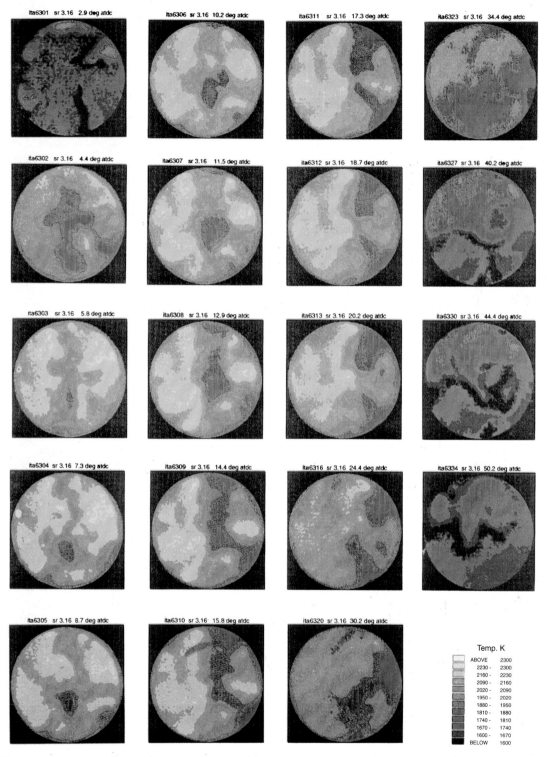

Plate 6 Temperature distribution in combustion chamber at swirl ratio of 3.16.

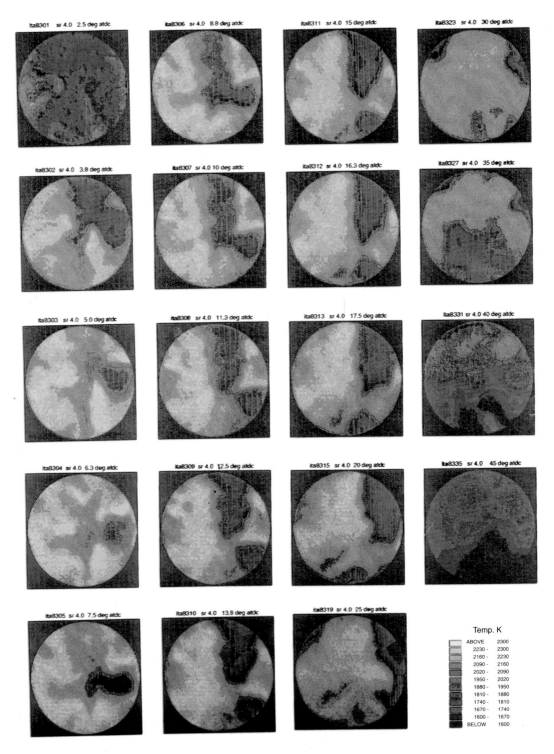

Plate 7 Temperature distribution in a combustion chamber at a swirl ratio of 4.0.

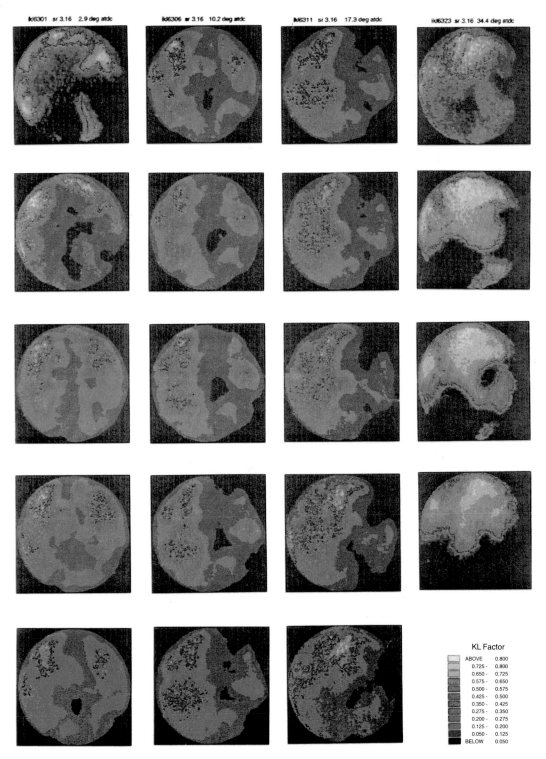

Plate 8 Distribution of carbon in the combustion chamber (as indicated by the KL factor) at a swirl ratio of 3.16.

Plate 9 Flame photographs showing combustion knock.
(a) False colour Image at 6.4 degrees ATDC.
(b) False colour image at 7.3 degrees ATDC.

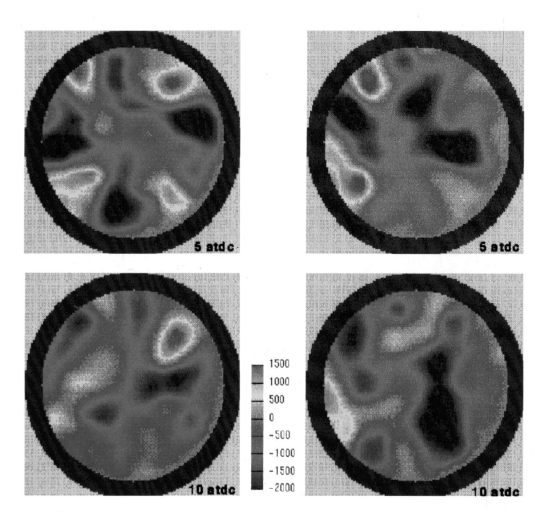

Plate 10 Vorticity generated by the fuel injection process at a swirl ratio of 2.8.

Plate 11 Vorticity generated by the fuel injection process at a swirl ratio of 4.0.

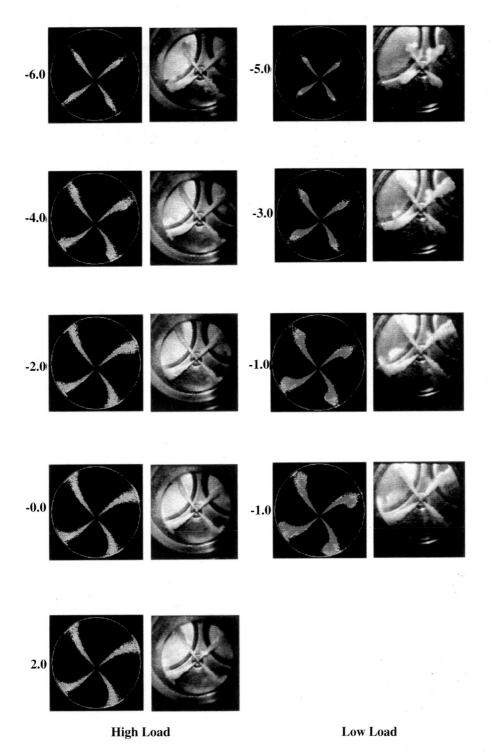

High Load **Low Load**

Plate 12 Comparison between prediction and photographs of fuel sprays.

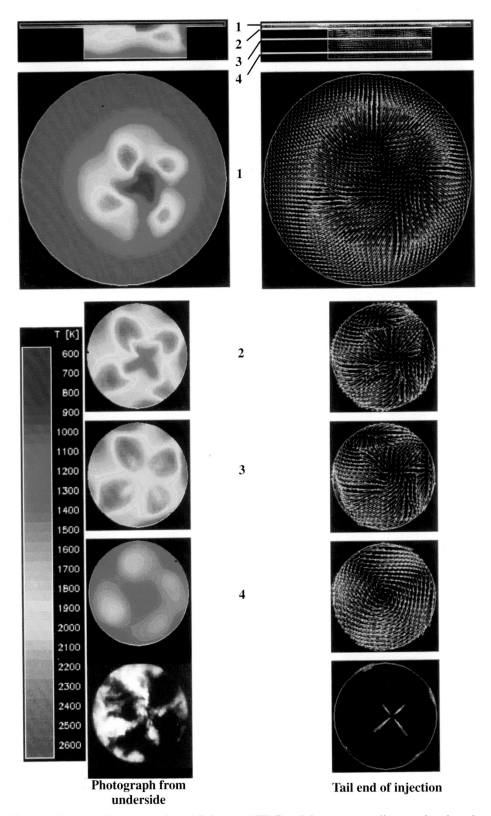

Photograph from underside

Tail end of injection

Plate 13 Sample output from the code at 4.0 degrees ATDC and the corresponding combustion photograph.

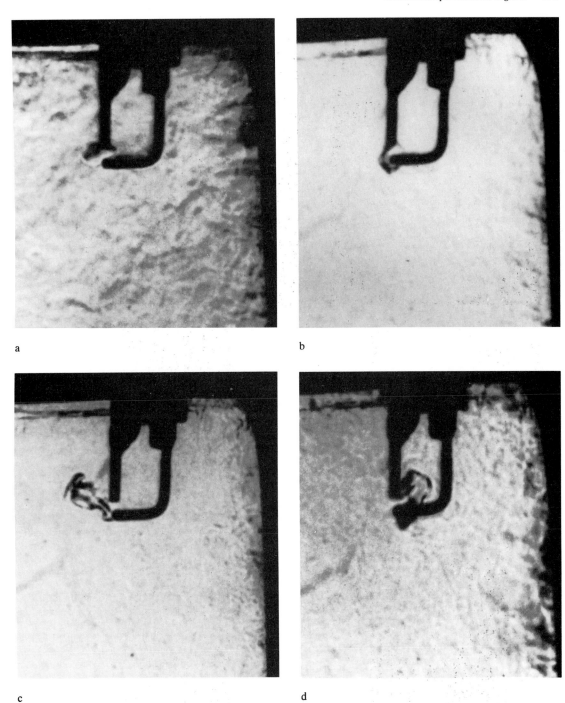

a

b

c

d

Figure 26.8 Initial flame kernel in a spark-ignition engine.

the basic flame, in the absence of ordered flow in the combustion chamber, grew spherically from the spark-plug gap (Figure 26.12). Witz also showed how the flame front was wrinkled by the turbulence generated by the flow in the chamber and by the flame propagation. Heywood and co-workers (MIT) have used the square engine to examine various features of flame propagation, and confirm the

standard | breakdown | surface-gap
(t = 0.84 ms, 7 deg CA) | (t = 0.4 ms, 3.3 deg CA) | (t = 0.4 ms, 3.3 deg CA)

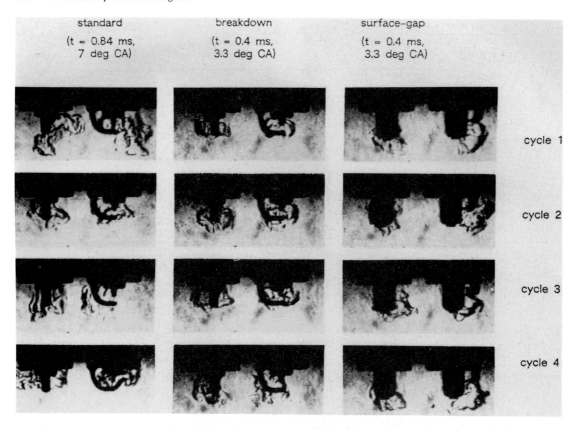

cycle 1

cycle 2

cycle 3

cycle 4

Figure 26.9 Variation of the flame growing from the spark gap in different cycles.

importance of turbulence in spark-ignition engine combustion. It has been possible using this photographic evidence to demonstrate many of the salient features of combustion in these engines, and to relate the combustion processes in the engine to the fundamentals of combustion investigated in combustion bombs or other rigs.

Recent work by Sheppard and co-workers at University of Leeds has shown how combustion photography can be used to obtain quantitative data about combustion in spark-ignition engines. Hicks *et al.* (1994) have described the application of laser sheet imaging and high speed photography for examining the turbulent flame development and structure, and the onset of knock in an engine rig similar to that shown in Figures 26.2 and 26.7. Such an arrangement gives excellent optical access, but the flow patterns in the rig are not truly representative of those in a real engine. However, using this rig it is possible to undertake quite fundamental studies of combustion in an engine which has compression and expansion. This experiment used high speed photography with a Photec camera operating at 10 000 pps, in which TiO_2 particles were illuminated by a light sheet from a copper vapour laser. The

photographs were obtained on Ilford HP5 black and white film: this does not lose much information because there are few data available from the colour of a flame (in the visible wavelengths) in a spark-ignition engine. The flame contour was obtained by tracing around a digitized image (512×512 pixel, 256 grey levels) using a mouse; automated location of the flame boundary by image processing techniques was not successful because of large variations in the illumination of the film. In the same paper, the authors report using a 1152×770 pixel intensified CCD camera in conjunction with a Spectron SL800 Nd.YAG laser to obtain images at four planes in the combustion chamber. They also used two Nd.YAG lasers at different wavelengths (532 and 355 nm) to obtain two sequential sheet images with variable time intervals between them. Figure 26.13 shows some of the flame images obtained using the high speed camera. The flame is highly wrinkled and turbulent; digitized images from the flame are shown in Figure 26.14. These images can give quantitative data about the flame structure, including the 'wrinkle factor', the fractal dimension and other data characteristic of flames in engines. This information is extremely useful because it enables:

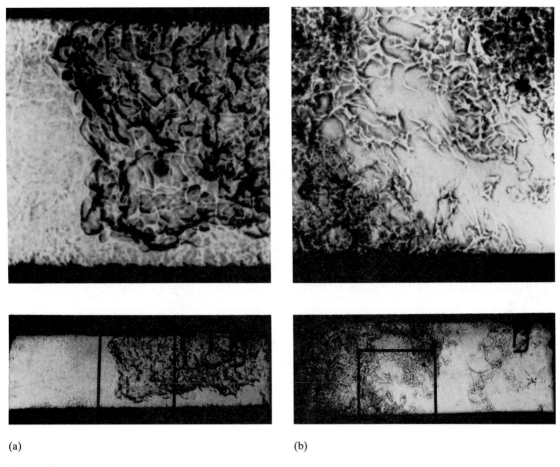

(a) (b)

Figure 26.10 Early stages of combustion in a spark-ignition engine.

- A relationship between laminar and turbulent flame speeds to be established.
- The tendency of the flame to be extinguished due to flame stretch (misfire) to be examined.

An understanding of the fundamentals of combustion in spark-ignition engines will enable lean-burn, low emission engines with good driveability to be built.

26.4.4 Abnormal combustion

Two major forms of abnormal combustion occur in spark-ignition engines. The first has been introduced previously, and is the misfire that occurs at the initiation of combustion. The second is the spontaneous explosion of the pre-mixed charge which occurs at the end of the combustion process – commonly called *knock*. A number of papers report studies of knock by means of combustion photography. As early as 1936, Withrow and Rassweiler

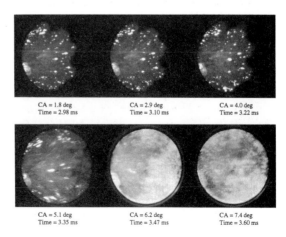

Figure 26.11

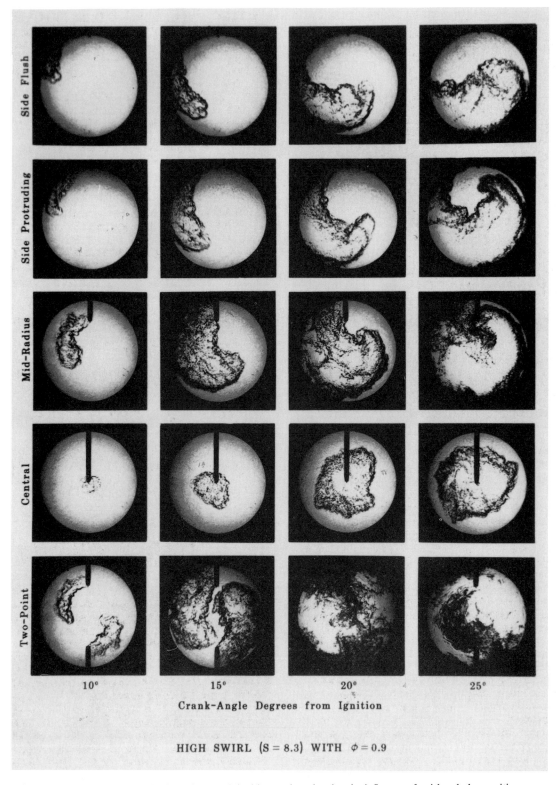

Figure 26.12 Growth of the flame in a spark ignition engine, showing the influence of swirl and plug position.

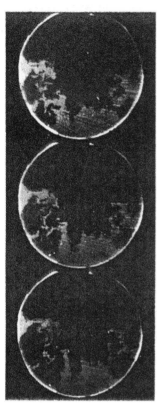

14.5 ms elapsed
time from ignition

15.5 ms elapsed
time from ignition

16.5 ms elapsed
time from ignition

Figure 26.13 Turbulent flame in a spark-ignition engine: photographed by laser sheet.

showed the difference between combustion cycles with and without knock. Nakagawa *et al.* (1984) show by means of schlieren photography the detonation that occurs in knocking combustion due to the spontaneous combustion of the end-gas in the cylinder. Cuttler and Girgis (1988) used a Cinemax image intensifier in conjunction with a high speed camera to obtain photographs at 8000 pps of combustion and knock in a number of different combustion chamber arrangements. The image intensifier increased the light intensity by the equivalent of 12 stops (+12 EV), and enabled the flame to be photographed.

Figure 26.11 shows photographs of combustion with strong knock, obtained by Pan and Sheppard (1994) in an engine with a layout similar to that shown in Figure 26.2. The flame development can be clearly seen, and the flame progresses across the combustion chamber in an approximately 'circular' flame front centred on the spark plug until 4.0° after top dead centre (atdc). The gas motion in the chamber is shown by the white particles (ground pepper), and the velocities are similar to the flame

speed. Between 4.0° and 5.1° atdc detonation occurs and the flame engulfs the chamber; at the same time the gas velocities increase significantly, and a rapid pressure rise occurs. This uncontrolled combustion is known as 'knock' because of the characteristic noise which is heard from the engine.

The study of knock has become more important with 'lead' (tetraethyl lead) being removed from petrol for environmental reasons. The knock resistance, related to the *octane number*, of fuels is now achieved by changing the hydrocarbon compounds found in the fuels. Some of the hydrocarbons being introduced might themselves be health hazards.

26.4.5 Conclusions on combustion in spark-ignition engines

Combustion photography in spark-ignition engines has enabled the following conclusions to be drawn about combustion processes:

- Cyclic variation in the combustion process is caused by the interaction of turbulence with the initial spark.
- The mechanism by which the flame develops from laminar to turbulent.
- The main flame propagation is by a spherical flame front propagating at the turbulent flame speed.
- 'Knock' occurs in the end gas due to spontaneous combustion.

This identification of the underlying processes of combustion has enabled computer models of engine cycles to be developed, and these have been valuable in designing more efficient and less polluting spark-ignition engines.

26.5 Combustion photography in compression-ignition (diesel) engines

The diesel engine is a heterogeneous charge engine, which means that the fuel and air are not well mixed in the engine cylinder prior to combustion. In chemical terms, the separation of the air and the fuel means that the whole mixture cannot spontaneously ignite, but when evaporation of the liquid fuel has taken place there will be local zones of prepared mixture that can burn. It is necessary for the fuel to mix with the air before it can burn, and the rate of combustion in a diesel engine is controlled by the rate of mixing. The concept of a flame is not as valid in this form of engine as in the spark-ignition engine.

Diesel engines can be subdivided into two different groups: direct and indirect injection engines. Indirect injection engines are widely used as the

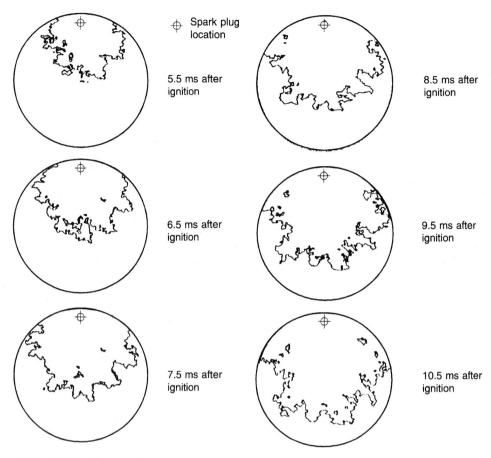

Figure 26.14 'Digitized' images of flames similar to those shown in Figure 26.12.

power plant for small vehicles, and can usually operate at a higher maximum speed than similar sized direct injection engines. In an indirect injection engine the fuel is injected into a small pre-chamber which is connected to the main combustion chamber by a small throat. The airflow in the pre-chamber usually rotates as a forced vortex and this enables a relatively simple injection nozzle to be used, usually with a single injection hole. Some combustion photography has been done in engines of this type (Alcock and Scott, 1962; Allan and Khan, 1970; Lange and Spindler, 1979; Browne *et al.*, 1986). The major emphasis of combustion research in diesel engines is now focused on the direct injection diesel engine which offers the potential of significantly better fuel consumption than other forms of power plant for vehicles. This section concentrates on direct injection diesel engines.

Direct injection diesel engines can be considered to fall into two, indistinct, categories: quiescent chamber engines and engines with swirl. Quiescent diesel engines are those in which there is no attempt to achieve ordered motion of the charge in the cylinder. This means that the mixing of the fuel and the air in these engines must be brought about purely by the momentum of the fuel during the injection process. Quiescent combustion systems are used on slower speed engines, say below 1000 rpm, where there is sufficient time to allow for the air and fuel to mix by this mechanism. In high speed engines, say above 2000 rpm, the rate of mixing brought about by the fuel jets is too slow for the mixing and combustion to take place during the expansion stroke. The rate of mixing in the combustion chamber can be enhanced by applying an ordered swirl motion to the air as it enters the cylinder; this swirl will then strip fuel off the jet and produce a combustible mixture on the downwind side of the jet. There is an interaction between the pressure at which the fuel is injected, the number of holes in the injection nozzle and the amount of swirl required to obtain satisfactory combustion. The optimum combination of these parameters is usually achieved by development work on an engine.

In addition to the use of swirl, the design of the injection system can have a major effect on the

performance of the engine. There are various types of fuel injection nozzle and each has its own characteristics. Some of these will be demonstrated by examples later in this chapter.

After combustion has been initiated the burning region is self-illuminating because the combustion process consists of pyrolysis of the fuel droplets, which results in high temperature carbon particles being present in the flame. These particles radiate as 'grey' bodies and hence emit light in the visible spectrum (the colour indicating the temperature). By the time the combustion process is well under way it is unnecessary to illuminate the cylinder, but during the initial few degrees after ignition it is useful to have some external illumination because the fuel jets and the combustion process co-exist.

26.5.1 A high-speed direct injection diesel engine

This section concentrates on the work on combustion photography in high speed, direct injection diesel engines performed at UMIST; this is because of the amount of data available on combustion in this engine. Cross-reference is made to the work of others to place the results in context. Much of the following is based on Winterbone *et al.* (1994) and Sun *et al.* (1996).

26.5.1.1 Hydra single cylinder research engine

The Hydra single cylinder research engine was developed specifically for this project, and a similar one is installed at Imperial College, University of London (see Arcoumanis *et al.*, 1991a, b). The geometry of the engine combustion chamber is based on an early version of the Ford York direct injection diesel engine, but the conventional fuel injection system has been replaced by a high pressure unit injector. The engine can be run in two forms: as a conventional engine, or with a photographic adaptation that allows the combustion chamber to be viewed through the base of the piston bowl.

The specification of the engine is summarized in Table 26.3, and diagrams of the piston bowl arrange-

Table 26.3 Engine specification

Engine	Ricardo Hydra single-cylinder
Photographic system	Bowditch system: photography through piston bowl
Bore	93.67 mm
Stroke	90.54 mm
Compression ratio	16.75
Rated speed	
Normal	4000 rpm
Photographic	3600 rpm
Variable swirl mechanism	SR = 2× to 4× engine speed

ments are shown in Figures 26.4 and 26.5. The engine arrangement has been described in detail in Winterbone *et al.* (1994) and Rao *et al.* (1992a, b, 1993).

A high pressure unit injector system was fitted to the engine. This was equipped with an electronic control system which enabled the fuel injection timing and fuelling rate to be controlled to a high degree of repeatability. A description of the fuel injection system is given in Rao *et al.* (1992a) and Frankl *et al.* (1989).

The engine was run in its normal mode during an extensive series of tests to measure its gross performance parameters, such as power output, torque, fuel consumption and levels of emissions. These results have been reported in Rao *et al.* (1992a, b, 1993), and Gomes and Yates (1992), where the gross parameters and emissions levels have been examined as a function of a range of input parameters, including engine speed, load, fuel injection timing and swirl.

The engine has been operated in the photographic mode at engine speeds of up to 3000 rpm, which is the fastest reported for an engine with photography through the piston. These tests have focused on the fuel injection and combustion phases of the engine processes, but information on the flows in the cylinder prior to combustion has been obtained on a similar engine by Arcoumanis *et al.* (1988, 1990, 1991a) with laser Doppler anemometry (LDA). The fuel injection phase of the engine process requires illumination, and this has been achieved in this case by means of a high intensity copper vapour laser.

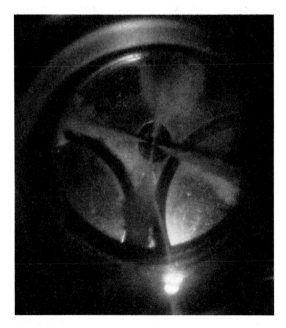

Figure 26.15

The full specification of the laser is given in Table 26.4, where it can be seen that the pulse power, width and repetition frequency enable exceptionally good illumination to be achieved. The short pulse width (around 10 ns) is sufficient to 'freeze' the jet motion (see Section 26.5.2), which enables a sharp image of the jets to be obtained. This work has been reported by Rao *et al.* (1992a, b, 1993, 1995).

Table 26.4 Specification of a copper vapour laser

Laser	Oxford Lasers CU15-A copper vapour laser
Wavelengths	510.6/578.2
Average power (W)	15
Pulse width (ns)	10–40
Peak power (kW)	70
Pulse repetition frequency (kHz)	3–20
Beam diameter (mm)	25

The combustion images were photographed using a high speed camera capable of recording images over a number of consecutive combustion cycles. This latter requirement has restricted the speed of the camera that can be used, but it is essential to ensure that the combustion cycles are repeatable, and representative of 'steady' conditions. The camera specification, along with that of the photographic films is given in Table 26.5.

Figure 26.16

Figure 26.17

In the original series of tests using the photographic rig, a total of 45 films were shot with a success rate of around 70%. This work was performed using colour reversal film, covering a range of speeds from 1000 to 3000 rpm, with swirl ratios of 2.8–4.0, film speeds of 10 000–20 000 pps, and a number of nozzle hole arrangements, injecting into open and re-entrant bowls. The swirl ratio (SR) is the ratio of the nominal angular velocity of the forced vortex in the combustion chamber to the engine speed. It changes during the engine cycle as the charge is compressed into and expands out of the combustion bowl. It was found that the photographs of the first cycle were not representative of the operating conditions due to the characteristics of the injection system after it was initially switched to injection mode: for this reason, only the second and subsequent cycles were analysed. It was possible to photograph about seven consecutive cycles of operation before the window in the piston became obscured by condensed products of combustion.

26.5.2 Illumination of the fuel-injection process

The fuel injection process plays a crucial role in the combustion in a diesel engine, especially in a direct injection engine, because it governs the way in which the fuel and air mix to form the combustible mixture. Hence, a good knowledge of injection is

Table 26.5 Specification of a high speed camera and film

High speed camera	*Hadland Photec*
Full frame	10 000 pps
Objective lens	80 mm focal length, *f*/2.7
Half-frame	20 000 pps
Objective lens	45 mm focal length, *f*/2.7
Film	
Initial tests	
Kodak Ektachrome VNF 7251 polyester based colour reversal film	
Length	135 m (450 foot)
Useful length	60 m (200 foot)
Two-colour tests	
Fuji 125 (125 ISO) colour negative film	
Length	30 m (100 foot)
Useful length	15 m (45 foot)
Eastman Kodak 7296 (500 ISO) colour negative film	
Length	120 m (400 foot)
Useful length	45 m (150 foot)

vital if the subsequent combustion is to be understood: this is even more true if the purpose of the project is to examine the production of emissions (oxides of nitrogen (NO_x), carbon monoxide and particulates).

The combustion process in a diesel engine starts when liquid fuel is injected into the combustion chamber through a fuel-injection nozzle. In the direct injection diesel engine the nozzle contains a number of small holes through which the fuel is injected and atomizes into a jet of droplets that entrains the air into which the fuel evaporates to make a combustible mixture. The temperature and pressure of the air inside the combustion chamber are such that the fuel–air mixture can spontaneously ignite at any site when the conditions are right. Hence, this is a major difference from the spark- ignition engine, where the point of ignition is well defined in space and time, and singular. In a diesel engine the point of ignition can change with operating conditions, and there can be multiple ignition sites. Also, the instant of ignition in a diesel engine is not well defined but is controlled by the rate of fuel evaporation and the chemical processes that prepare the fuel for combustion. After combustion has been initiated, there is rapid combustion until the already mixed fuel and air are consumed (referred to as the *pre-mixed period*) and after that the rate of combustion is controlled by the rate at which the fuel and air mix (referred to as the *diffusion burning period*).

The fuel is injected into the cylinder of the engine through a nozzle which will contain upwards of four holes. In a high speed, direct injection engine the diameter of these holes might be less than 0.2 mm and the injection pressure might exceed 10^8 N m^{-2} (1000 bar). This results in the tip velocity of the jet being up to 200 m s^{-1} (see Arcoumanis *et al.*, 1990; and Rao *et al.*, 1992a). The time taken for the fuel jet to travel from the nozzle to the wall of the piston bowl for the engine shown in Figure 26.3 is about 0.25 ms at 3000

rpm: this time might rise to about 0.75 ms at 1000 rpm. Hence, to obtain sufficient detail of the spray development (say 10 frames) requires a camera framing rate of 40 000 pps. Such a rate is not achievable from a camera which will record the whole combustion process (say 60° CA), and some compromises must be made. In reality, rates of up to 20 000 pps are achievable using film, and hence about five frames would be obtained between the start of injection and impingement. This also means that the jet travels 20% of its total travel in the time between consecutive frames, and possibly as much as 10% of that distance during the exposure period. If continuous lighting is used then blurred or distorted photographs will result, depending on the shutter specification. The use of a copper vapour laser with an exposure time of about 20 ns removes this problem and the jet motion during the period of illumination is only 0.1% of the total distance – this is negligible and results in extremely sharp photographs (Figure 26.15). Rao *et al.* (1992a) have reported measurements made on fuel injection jets and Figure 26.18 shows the jet periphery (as observed by reflected light) traced from photographs like the one shown in Figure 26.15 Attempts to use pattern- and edge-resolving software were not successful and the diagrams shown in Figure 26.18, like those for the spark-ignition engine shown in Figure 26.14, were traced manually.

Figures 26.15 and 26.18 show the visible edge of a jet which is reflecting laser light. They give no information on the manner in which the fuel is evaporating into the air. Figure 26.15 shows that, after impinging on the wall of the piston bowl, the fuel jet spreads along the bowl, and this also enhances the mixing process. Since this engine has a high swirl ratio the fuel jets are swept around the chamber in a clockwise direction. Figure 26.16 shows the injection pattern from a nozzle with five holes. Obviously, in this case each fuel jet has a

Figure 26.18 Periphery of fuel jets obtained by tracing photographs similar to the one shown in Figure 26.15.

Iiyama *et al.* (1992) attempted to overcome this problem by fitting a guide at the end of the needle. Figure 26.17 shows the injection pattern from a two-stage injection system, in which the needle opens the injection holes in two 'steps'. The aim here is to reduce the amount of fuel injected initially, in order to control noise and the production of NO_x, and then to inject the majority of the fuel into an existing combustion zone. Unfortunately, the mechanical arrangement in this injector is not symmetrical and the needle has biased to one side of the nozzle, resulting in most of the fuel coming from three holes. This causes very poor utilization of the air in the combustion chamber and the smoke emission of the engine is high. Rao *et al.* (1992) have also reported an investigation which was performed on this rig to investigate the effect of injector fouling on combustion. It was found that, while there was no clear influence of the fouling on the fuel jets, the subsequent combustion was significantly more erratic with fouled injectors.

While photography enables the fuel injection process to be observed in some detail, it is still necessary to get more information about this process, which is central to the whole combustion process in direct injection diesel engines. The following requirements need to be addressed:

- Higher framing speeds to obtain better temporal resolution on the jets.
- Larger magnifications to obtain better spatial resolution.
- Methods of obtaining information close to the nozzle exit in order to understand better the jet break-up mechanism in the engine itself.
- Techniques to visualize the evaporation mechanism and the fuel–air mixture preparation.
- Methods of sectioning the fuel jets in order to obtain two-dimensional tomographic images.

26.5.2.1 Synchronization of illumination

Early experiments were conducted using a copper vapour laser (see Table 26.4) to illuminate the whole of the engine cycle, from the start of injection until the end of the film: the synchronization is depicted by Series 1 in Figure 26.19. This approach was adopted because of difficulties in synchronizing the camera and laser due to the high starting currents required by both devices: once synchronized and started, it was best to let them continue running. The photographs obtained in Series 1 gave excellent pictures of the injection process at up to 20 000 pps and enabled some analysis of injection to be done. They also showed the combustion phase quite clearly, although it was bathed in a green light. It was only when the films were analysed to evaluate temperature and 'soot' values that it was found that the high intensity light from the laser was interfering with the spectroscopic analysis of the films. This

smaller sector of the air in the combustion chamber associated with it, and hence the mixing process should be less critical. However, if the swirl ratio is too high it is possible for the individual jets to interfere with each other and cause regions that are too rich for complete combustion and will generate soot.

A noticeable feature in both Figures 26.15 and 26.16 is that the jets are not all the same shape; some are long and thin, while others are fluffy and do not penetrate well. This is probably caused by the mechanical construction of the nozzle (referred to as a 'VCO' nozzle) in which the needle that controls injection might obstruct flow to certain holes.

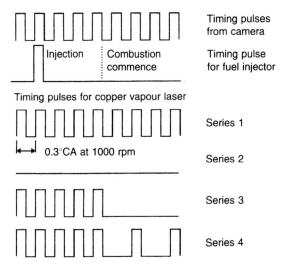

Timing pulses from camera

Timing pulse for fuel injector

Timing pulses for copper vapour laser

0.3°CA at 1000 rpm — Series 1

Series 2

Series 3

Series 4

Figure 26.19 Methods of synchronizing the laser for diesel engine combustion photography.

required that a series of films for spectroscopic analysis for temperature and 'soot' (Series 2) was taken without any illumination by the laser. These photographs had the advantage of showing combustion without any interference from the laser light, but did not show the preceding injection; it was not possible to relate the injection and combustion phases.

Ways of overcoming this problem are:

- To take two sets of photographs on successive cycles; one showing the injection phase by illumination, and the other the combustion phase when the laser is switched off. This has the disadvantage of not showing the injection and combustion phases on the same cycle. It had been seen, during Series 1, that the fuel injection processes were not very repeatable, and that the jet trajectories varied significantly between cycles. Hence, any attempt to relate the injection processes to the subsequent combustion is fraught with problems. The advantage of this technique is that it only requires the laser to be switched on and off once.
- To use the laser to illuminate the first part of the injection and combustion process, and then switch it off until the next cycle, as shown in Series 3. This technique enables the important early stages of the injection process to be illuminated, and the period after combustion has commenced to be self-illuminated. It has the advantage that the laser is only switched on and off once per cycle. The disadvantage of the technique is that it is not possible to see the fuel jet after switching off the laser, and hence the interaction of the fuel and the combustion cannot be assessed.

- The final approach considered is to illuminate alternate frames of the high-speed photographs. The synchronization diagram for this is shown as Series 4 in Figure 26.19. This technique is an extension of the Series 3 one, and consists of leaving the laser on until combustion has commenced, and then flashing it on only alternate frames of the photograph. Hence the frames show, alternately, injection–combustion–injection, etc. Once combustion is well established, and the fuel is fully vaporized, the laser can be switched off altogether. This means that it is possible to see images of injection and combustion right through the initial phases of combustion. If the photographs are taken at 20 000 pps, at an engine speed of 1000 rpm, then there are images of injection and combustion available with 0.6° CA intervals, with a skewing of only 0.3° CA between each set of pictures. In this way it is possible to follow the initiation and build up of combustion in the cylinder during the same cycle.

26.5.3 Examples of photographs of combustion

Examples of photographs obtained from the Hydra engine are shown in Plate 5 and Figure 26.20. These photographs are images of the contents of the cylinder. If the photographs were illuminated by the laser then the images are those visible by the light reflected from them, and after ignition the self-illuminated features are also present. If the photographs have been taken with the laser switched off then they contain information from the self-illuminated region of the chamber (i.e. combustion). These photographs were obtained by the arrangement shown in Figure 26.1, and the laser illuminated the image along the same line as the photographs were taken. Hence, the photographs are either 'line integrals' of the information if the image is semi-transparent, or define a zone close to the bottom of the image if it is opaque. The photographs shown here do not contain precise information on the depth at which they were taken, and are not truly two-dimensional representations of what is happening in the combustion chamber. If it was required to obtain two-dimensional images it would be necessary to use light sheets to illuminate the field of view; this approach was discussed in relation to the spark-ignition engine in Section 26.4.3. The use of laser sheets in spark-ignition engines is possible because the pre-mixed flame occurs in the gaseous phase, and the 'combustion' process is transparent and does not radiate strongly in the visible spectrum. Such approaches have been used in studies associated with diesel engine combustion, but there are some difficulties in applying them in an actual engine cylinder. The reasons for this are:

Figure 26.20. ▲

Figure 26.21 ▶

- The combustion chamber in a direct injection diesel engine is in the bowl of the piston, so the light has to pass through the piston material as well as the liner.
- The fuel jets are non-transparent over much of their length.
- The combustion process radiates strongly in the visible spectrum.

Laser sheets have been used extensively to study the jets of fuel produced by diesel engine nozzles, both in quiescent bombs and in wind tunnels. This approach has produced information on the way in which the fuel atomizes when it leaves the nozzle, but a major problem is that the jets are relatively dense and it is often not possible to obtain information very close to the hole exit where many important processes that influence the jet structure occur. Laser sheets have also been used to produce soot images by means of LII, when the laser beam causes the soot in the plane of the light, produced during the combustion process, to burn instantaneously and radiate strongly.

Figure 26.21 shows images of fuel injection and the initial combustion obtained using alternate illumination. The first sites of combustion are clearly

visible when the laser is off, and these can be related to the fuel jets. It can be seen that combustion always occurs downwind of the jet; this would be expected from consideration of the flow processes around the jet since it is where the fuel–air ratio approaches stoichiometry. As the load on the engine is increased, i.e. more fuel is injected, the point of initial combustion moves towards the wall of the combustion chamber, and this shows how the interaction with the piston bowl is essential to achieve satisfactory mixing in current direct injection diesel engines.

The initial combustion period described above is a rapid phase of combustion, when the fuel and air which have mixed before ignition occurs burns rapidly; this is often referred to as the *pre-mixed* phase of combustion (although this has a specific meaning in terms of energy release, and might not apply exactly to this period). The pre-mixed combustion period has a large influence on the production of NO_x and noise, and attempts are made to control this period by use of two-stage injectors, etc.

After the pre-mixed fuel and air have burned, the combustion process is controlled by the rate of preparation of the mixture, i.e. the rate at which the fuel evaporates into the surrounding air to produce a combustible mixture. This phase is clearly visible in combustion photographs because it produces, and consumes, incandescent particles of pyrolysed fuel; these emit the light which gives the combustion the characteristic red-yellow colour.

Plates 14 and 15 show typical flame sequences from a diesel engine cylinder. The flame engulfs the chamber, making good use of the air available, and ultimately is extinguished as the fuel is finally consumed. Plate 16, which is a flame sequence from the injection process shown in Plate 12, shows how the utilization of air in this case is extremely bad, with combustion being restricted to part of the combustion chamber. This injection system produces a lot of smoke simply because the fuel is not able to reach the air in which it can burn.

26.5.4 Application of image processing to photographs

Plate 5 and Figures 26.20 and 26.21 give a qualitative impression of the combustion process in the engine. The colours indicate different temperatures, and show that the cylinder contents are not at a uniform temperature. However, it is not possible from visual observation to assess the levels of the temperatures, only to identify hot and cold regions. If the photographs are projected by a cine projector the motion of the contents of the cylinder is obvious, and an impression of the velocities can be obtained. However, again, it is not possible to provide quantitative data simply by viewing the images.

The use of modern image processing techniques enables much more quantitative information to be obtained from these photographic images. Two such techniques are described below.

26.5.4.1 Two-colour measurement of temperature and 'soot'

The measurement of temperature by the two-colour method was originally proposed by Hottel and Broughton (1932), who used it to estimate the temperatures of furnaces. The first application of the approach to engines was by Uyehara *et al.* (1946), and this was followed by the work of a group of researchers at the Tokyo Institute of Technology, led by Matsuoka and Kamimoto (Matsui *et al.*, 1979, 1982). The use of the technique has expanded over recent years and a number of papers reporting the use of the method have appeared (Petersen and Wu, 1986; Quoc *et al.*, 1991; Anon., 1992; Arcoumanis *et al.*, 1995). A full description and the mathematical basis of the technique are given by Gomes and Yates (1993) and Winterbone *et al.* (1994).

The two-colour method is based on the emission properties of the carbon formed in the flame inside the combustion chamber. The basis of the method is to measure the light intensity from the incandescent carbon in the combustion chamber at two wavelengths on the emission spectrum, in this case chosen as 581 and 631 nm to avoid interference from the emission wavelengths of carbon dioxide, water vapour and combustion radicals. The small size of the particles should result in their temperature being close to the gas temperature. The objective is to obtain a measurement of the temperature of the combustion products over the whole field of view through the base of the piston. The easiest way to achieve this would be by analysis of combustion films, but the drawback here is the difficulty of ensuring the colour balance of the film, both during exposure (when the window will be getting dirty) and during processing (when development might change the colours).

Both of these potential problems can be overcome by performing a 'live' measurement of the temperature at one point in the cylinder, while taking high speed combustion photographs over the whole field of view. The photographs can then be analysed later, and calibrated using the data from one point. To do this it is necessary to have visual access to the cylinder through two independent paths; a suitable system is shown schematically in Figure 26.1. The light received by the calibration camera falls on an optical fibre mounted on the focal plane of the camera body. This optical fibre is divided into two sections and the light is then directed via filters of the chosen wavelengths onto two photomultipliers. The signals from these photomultipliers are fed to a PC through an analogue to digital converter (ADC), with an acquisition rate of 400 kHz.

It is also possible to use the two-colour method to obtain information about the amount of soot in the

combustion chamber. A factor called *KL* is a direct outcome of the method, where *K* is the absorption coefficient and *L* is the path length through the soot cloud. In this engine, where the piston bowl has a flat bottom, the path length is the same over the whole of the field of view at any particular crankangle. Hence the variation in the value of the *KL* factor is a direct measure of the variation of *K* over the combustion chamber: *K* will be directly related to the amount of soot in the line of sight. In this way it is possible to locate the regions of the combustion chamber where soot is generated or burned up.

High speed photographs of combustion in the Hydra engine were taken at three inlet swirl ratios (SR = 2.8, 3.16 and 4.0, which covers the extremes of the swirl mechanism) for an engine speed of 1000 rpm with the express purpose of assessing the power of these techniques to identify various features of flow in the combustion bowl. A camera speed of around 10 000 pps is quite adequate for an engine speed of 1000 rpm, and gives a resolution of about 0.75° CA between frames.

Plates 6 and 7 show two-dimensional temperature distributions measured using the two-colour method at swirl ratios of 3.16 and 4.00, respectively. The photographs were obtained at a load of approximately 4×10^5 Nm^{-2} (4 bar) bmep, with all operating conditions beside the swirl ratio maintained, as far as possible, constant. The temperature field has been split into 12 zones, with a minimum temperature zone of 1600 K and a maximum one of 2300 K. This covers the temperature range of interest in diesel engine combustion.

First, it is useful to interpret the significance of the photographs. They were obtained by photographing through the base of the piston, as shown in Figure 26.1. The effect of this is that the photographs are a two-dimensional image through the *depth* of the piston bowl, and the temperature will be a line 'average' through the combustion zone. The effect of this is that any stratification through the depth of the bowl will not be resolved on the film, and the maximum temperatures will be underestimated. It is not possible to assess the effect of the averaging that occurs by this technique, but the measured temperatures are not unreasonably far from the adiabatic flame temperatures that will be achieved in some regions of the combustion chamber.

The injection timing was maintained at 9° before top dead centre (btdc), and there was a period of ignition delay before either a luminous zone became apparent, or the pressure versus crankangle diagram showed combustion was occurring. Significant combustion had occurred by about 3° atdc, and this is the first frame shown in the figures. The fuel jets do not start to burn simultaneously, and ignition occurs preferentially in two of the jets. The ignition starts on the downwind side of the jet centre line and is enhanced by the deflection of the fuel jet off the

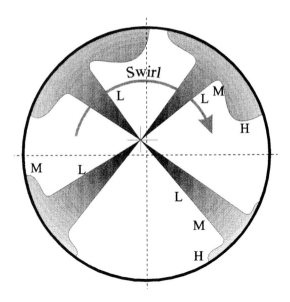

Figure 26.22 Points of initiation of combustion at different swirl ratios: L, low; M, medium; H, high.

combustion bowl wall. The points of combustion initiation at all three swirl ratios are shown in Figure 26.22. After combustion has started the charge is consumed by the process.

As the combustion period develops the burning zone spreads throughout the chamber, and high temperatures are reached in some regions: it is here that the NO$_x$ is formed. Comparison of Plates 6 and 7, which differ only in the swirl ratio, shows that the pre-mixed combustion period is more significant and the diffusion combustion is more rapid at the higher swirl ratio.

Plate 20 was obtained from the same combustion photograph as Plate 8, but in this case it was processed to show the variation of *KL* throughout the combustion bowl. High values of *KL* indicate where the largest concentration of soot occurs. This interpretation is aided with this particular combustion chamber because the depth is constant over the whole field of view: more care is required when interpreting similar results from a chamber of varying depth. It is interesting that the soot appears to form in regions close to the wall of the piston bowl. This suggests that, while wall impingement is a mechanism for enhancing the mixing of the fuel and air, it is also somewhat deleterious because it exacerbates the production of soot.

These results from combustion photography show the following:

- The combustion inside this engine is not uniform, and reflects the non-axisymmetric layout of the combustion chamber.
- The above results in significant variations in the temperature levels reached in the vicinity of the

different jets, and produces higher NO$_x$ levels than would be necessary to achieve the same performance if the chamber was axisymmetric (because NO$_x$ production is an exponential function of temperature).

- The levels of soot produced by different fuel jets are not the same, and an axisymmetric layout would improve the fuel utilization at the same performance level.
- The combustion process is strongly affected by swirl, and high swirl reduces soot formation but increases NO$_x$ formation at the speed considered.
- The impacting of the fuel jets on the wall of the piston bowl plays an important part in the mixing process, but too much impingement increases soot formation.
- It is possible to play off the NO$_x$ and soot emissions by varying the swirl ratio, and there should be an optimum swirl ratio for meeting the emissions legislation. It might be necessary to vary the level of swirl with engine speed and load.

26.5.4.2 Cross-correlation technique for the evaluation of gas velocities after combustion

As stated previously, a significant amount of work has been done on the evaluation of gas velocities in engine cylinders prior to combustion. This has been done, in the main, using LDA (Arcoumanis *et al.* 1988, 1991a, b; Tindal *et al.*, 1989; Murakami *et al.*, 1990), although some recent work has used particle image velocimetry (PIV) (Reuss *et al.*, 1989, 1990). Both these techniques require seeding of the flow, and rely on the light reflected from the seeding particles, e.g. silicone oils or titanium dioxide. Once combustion occurs, the background light intensity in the combustion chamber swamps any light reflected from the seeding, even if it is not burned, and the methods can no longer be applied.

The cross-correlation technique described here has been used by Shioji *et al.* (1989), Yamaguchi *et al.* (1990) and the group at the Advanced Combustion Engineering Institute (ACE, 1992) and relies on the light emitted by the incandescent particles in the combustion chamber. This has the advantage that the flow does not require seeding, and that the method will work after combustion has commenced. A disadvantage is that it is not possible to be precise about the 'plane' in which the velocity is being evaluated.

The basis of the technique is to identify features of the combustion photographs in one frame and to locate those features in the next frame. The distance moved by the features between the frames is directly related to the velocity of the gas in that region of the combustion chamber. The velocity can be evaluated by dividing the distance moved by the time between consecutive frames of the film. Features of the combustion photographs can be identified by 'capturing' the image in a computer by means of a CCD camera, in a similar manner to that described above. It is then possible to superimpose a window on the image and store the pixel arrangement defined by that window. If the image in the window maintains its pattern between two frames, i.e. it does not distort or dilate, then it should be possible to locate a region in the next frame which has a cross-correlation coefficient of unity with the original image. The theory for the method is given by Winterbone *et al.* (1993) and Sun *et al.* (1996). In reality, the regions do change between frames and it is never possible to get an exact correlation. In this case the problem becomes one of locating the position which gives the maximum cross-correlation coefficient: this is done by moving the original window over the next frame of the photograph and examining the contours of cross-correlation coefficient to locate the peak value. The first attempt at applying the technique to the UMIST project is reported by Winterbone *et al.* (1993), and a recent paper by Sun *et al.* (1996) explains in detail how the results can be processed to obtain the velocity fields reported here. It is shown that the predictions can be improved if it is assumed that the gas undergoes rotational as well as translational movement, and that interpolation techniques can be used to replace spurious vectors.

The combustion images are complex, as shown in Plate 21 which depicts two frames, separated by 1.4° CA, grabbed by the CCD camera. (These are not actually consecutive frames, and in this case there would be another frame between the two shown. The cross-correlation is performed on consecutive frames.) The CCD camera used was a monochrome device, and converted the colour image into a monochrome one with 256 grey levels. The diagrams in Plate 9 have been arbitrarily coloured to enhance the contrast. The movement of features is not obvious from these still images, although some distinct features can be seen, and yet the human eye can readily detect the general motion by viewing the moving picture – hence, the information on motion must be contained in the images. The method adopted is to break the first image into cells and attempt to cross-correlate these with regions in the second image, as described by Sun *et al.* (1996).

The camera speed used in these experiments resulted in a time of about 0.13 ms between consecutive images, which gives a resolution of about 0.75° CA at an engine speed of 1000 rpm. The cell size was chosen as 6 × 6 mm. This is a compromise: too small a cell size means that there are insufficient features in the cell to obtain a good cross-correlation coefficient, while too large a size reduces the ability of the technique to resolve details in the flow. The velocities were calculated at grid points distributed evenly over the combustion chamber, with a grid spacing of 1.5 mm; a boundary of 2.5 mm was left unprocessed at the edge of the piston bowl. This spacing, which resulted in overlapping of the tracking cells, gave

about 750 grid points over the combustion chamber area (i.e. 32 grid points along each diameter).

An early attempt to calculate the flow field in this engine using this method (Winterbone *et al.*, 1993) showed a field with a significant number of incorrect vectors. These maps were improved by 'manually' setting a threshold on the amplitude of size of a vector in relation to its nearest neighbours, and also by 'manually' removing vectors whose direction deviated significantly from their nearest neighbours.

In addition, vectors with low cross-correlation coefficients were discarded because the confidence in these vectors was low. Usually, about 15% of the original vectors were removed in this process, and this resulted in a relatively sparse vector field. Methods of refining the vector field are described by Sun *et al.* (1996), and the reader is referred to that paper for further details. The effect of refining is shown in Figure 26.23. The four diagrams show the effect of the individual processes on the raw data.

Figure 26.23 Vector refinement processes. (a) Initial map obtained from image processing. (b) The map in (a) after removal of spurious vectors; cut-off cross-correlation coefficient 0.7. (c) Field after interpolation of vectors in (b). (d) Field after smoothing of vectors in (c).

The flow field in Figure 26.23(d) is better defined than it is in Figure 26.23(a) and, while it might appear to be significantly different from its predecessors, careful examination shows that the features in Figure 26.23(a) have simply been clarified. The general vortex structure which is apparent in Figure 26.23(a) has been maintained, and the dominant velocity vectors already in Figure 26.23(a) have remained in Figure 26.23(d). The centre of the 'vortex' is already off-set in Figure 26.23(a), and this has now been clarified by the refining process. The minor features of the flow evident in Figure 26.23(a) have been refined and are now more pronounced. It will be shown later that the 'squareness' of the flow indicates the interaction of the fuel injection process and the intrinsic forced vortex characteristic of the underlying flow process.

A selection of the CCD images and the velocity fields for a swirl ratio of 2.8 is shown in Figure 26.24, for the period from 5° to 25° atdc firing. The diagrams contain only half the calculated vectors to improve their clarity; the interpolation and smoothing were performed using all the vectors available. The fuel injection process commenced at 9° btdc, and finished at 2° atdc, hence it was complete by the time the first calculation of the vector field is shown at 5° atdc. Figure 26.24 shows that the velocity field is predominantly a forced vortex, and this is in agreement with the observations of Zhang *et al.* (1994) who applied PIV to a motored engine with a bowl-in-piston combustion chamber. However, the flow at 5° atdc is quite disrupted, and there are regions that exhibit strong radial flow. It will be shown that this is due to the momentum of the fuel jets. As the cycle continues the flow becomes better ordered and approaches a vortex structure by about 15° atdc. Sun *et al.* (1996) show that the flow at a swirl ratio of 4 is much more dominated by the swirl vortex, and even at 5° atdc the general swirl motion is obvious.

The centre of the vortex can be located in many of the velocity fields and it can be seen that it is not in the centre of the bowl, or the centre of the cylinder. The vortex centre also appears to move in an irregular manner, and this is in agreement with the observations of Arcoumanis *et al.* (1987), who measured the velocities in a similar engine during the compression stroke, i.e. before combustion, by LDV. This suggests that the flow pattern generated during induction and compression is carried over into the combustion and expansion periods.

26.5.5 Vorticity

Individual packets of the fluid can have both translational and rotational motion. The net rate of rotation (or average angular velocity) of a fluid element is defined as vorticity. Randomly distributed and fluctuating vorticity can be regarded as a fundamental characteristic of turbulence (Tennekes and Lumley, 1972).

The two-dimensional velocity data available in the vector maps allow the out-of-plane (axial) component of vorticity to be determined. The out-of-plane vorticity distributions at swirl ratios of 2.8 and 4.0 are shown in Plates 10 and 11, respectively. The red areas represent positive vorticity (counterclockwise circulation) and the blue ones represent negative vorticity, with the intensity (as defined by the scale) varying linearly with the vorticity magnitude. The blue ring denotes the unprocessed area near the wall of the combustion chamber. The corresponding velocity map for Plate 10 is given in Figure 26.24. The counterrotating vortices are a combination of the vortices caused by the fuel injection process and the swirl.

As noted above, only large scale vorticity is resolved by this technique, but the effect of fuel injection, which finished a number of crankangle degrees previously, is still clearly visible. The fuel injection process generates strong vortex motion as the air in the combustion chamber is entrained in the jets which flow radially across the combustion chamber. These vortices are enhanced near the combustion chamber wall as the jets impinge on the piston and are deflected circumferentially. Plates 10 and 11 show four vortex pairs, and these are associated with the four jets from the injector nozzle. Chang (1993) reported the effects of fuel jet impingement obtained from a rig; he showed the generation of the vortices caused by the jet–wall interaction. The vortex flow is the main mechanism by which air is entrained in the fuel jets and it assists the break-up of the fuel jets and promotes the mixing of fuel and air. The manner of the vorticity formation also shows the influence of high injection pressure on the diesel combustion.

At the high swirl setting the vortices spread over a larger area, and this demonstrates that the swirling motion has significant influence on the transport and distribution of the fuel–air mixture and the fuel burning in the initial combustion stage.

26.6 Conclusions from combustion photography

- The flow in the combustion chamber is dominated by a forced vortex during the combustion stage, but the flow pattern is very complicated and some secondary vortices exist.
- The velocities in the combustion chamber bowl increase as the swirl setting is increased on the variable swirl mechanism. There is a decay in swirl during the combustion period and this is more significant at high swirl.
- The vorticity distribution is not uniform in the combustion chamber. Strong vortices are generated by the fuel injection around the impingement region in the initial stages of combustion.
- The dissipation rate of the vortices is low at high swirl ratio during the combustion period.

26.7 Preliminary predictions of the flow in the engine

One use of the results obtained from photographic studies is to support computer simulation of the processes in the engine. Some preliminary calculations have been performed on the simulation of the flow and combustion in the cylinder of the Hydra photographic engine using a proprietary computer code called KIVA (Amsden *et al.*, 1989; Finlay, 1995). Plate 12 shows the agreement between the fuel jets calculated using the KIVA3 code and those measured on the engine. A prediction of the combustion in the engine obtained from KIVA3 is shown in Plate 13. It can be seen that the underlying

processes that were made visible by photography and image processing are replicated by the KIVA3 code. Computer codes have attained a high level of accuracy in evaluating the gas flows in engines prior to combustion, and the next great challenge is to be able to calculate the combustion process. Photography of combustion in engines provides information on the way in which the luminous combustion progresses in the cylinder, and is a useful source of data on combustion. As the models become more refined it will be necessary to obtain more detailed data on the manner in which the combustion takes place, and then more sophisticated approaches such as LII and LIF will be needed.

Figure 26.24 Vector field in a combustion chamber at a swirl ratio of 2.80. *(cont. on page 387.)*

26.8　Overall conclusions

Photography of combustion in engines has greatly increased our understanding of the underlying physical mechanisms by which fuel and air burn to produce both power and emissions. The way in which turbulence in the cylinder interacts with the laminar flame to increase the flame speed of a spark-ignition engine is fundamental to designing high speed engines. The effect of turbulence on flames in weak mixtures can also be observed, and this provides the route to designing engines which will operate without misfiring.

Photography of diesel engine combustion has given a better understanding of the way in which the fuel jet entrains air to make a combustible mixture.

Location of the points of ignition enables the mechanisms of combustion to be better understood.

The application of computer techniques takes combustion photography from a qualitative technique to one which provides quantitative data on the processes involved. In the spark-ignition engine, it is possible to evaluate flame speeds from photographs and to assess the effects of turbulence on the flame structure. In the diesel engine, an estimate of the temperature of the 'flame' in the combustion process can be obtained, as well as the flow patterns in the combustion chamber after combustion. Laser sheet methods will result in tomographic data becoming available, and this will enhance the quality of the information.

The data obtained from combustion photographs

11.5 atdc

20atdc

c　　　　　15 atdc

d　　　　　25 atdc

can be used to improve computer models of engine combustion, and this will enable the design process to be shortened, and better engines to be designed without the need for extensive development.

Acknowledgements

The results presented from the UMIST activity are the product of work by a team, including the technicians, students and experimental officers. The contributions of Roger Pruce, Jim Kirk, Bob Pick, Hugh Frost, K. K. Rao, Paulo Gomes, Sun Jin-hui and Shekkar Zambare must be acknowledged. The Engineering and Physical Sciences Research Council (EPSRC) supported the underlying infrastructure of the project, and numerous funding bodies supported the students. Some of the work was sponsored by industry, and this support is also gratefully acknowledged.

References

Note: A reference quoted as: *SAE 000000* refers to the paper numbering scheme used by the Society of Automotive Engineers (SAE).

Alcock, J. F. and Scott, W. M. (1962) Some more light on diesel combustion. *Proc. Inst. Mech. Engrs (Auto Div.)* **5**, 179–191

Allan, A. B. and Khan, A. (1970) Investigation of combustion phenomena in a swirl chamber compression-ignition engine using schlieren techniques. *SAE 700500*

Amsden, A. A., O'Rourke, P. J. and Butler, T. D. (1989) *KIVA2: A Computer Program for Chemically Reactive Flows with Sprays*. Los Alamos Laboratory

Anon. (1992) *ACE's Spray and Combustion Photo Review*. Advanced Combustion Engineering Institute, Tsukuba, Japan, Sep. 1992 [A summary of papers published by ACE personnel, and containing excellent colour photographs]

Arcoumanis, C. *et al.* (1987) Swirl centre precession in engine flows. *SAE 870370*

Arcoumanis, C., Vafidis, C. and Whitelaw, J. H. (1988) LDA measurements in piston bowls of motored diesel engines. In *Laser Anemometry in Fluid Mechanics*. Ladoan-Instituto Superior Tecnico, Lisbon

Arcoumanis, C., Cossali, E., Paal, G. and Whitelaw, J. H. (1990) Transient characteristics of multi-hole diesel sprays. *SAE 900480*

Arcoumanis, C., Hadjiapostolou, A. and Whitelaw, J. H. (1991a) Flow and combustion in a Hydra direct-injection diesel engine. *SAE 910177*

Arcoumanis, C., Hadjiapostolou, C. and Whitelaw, J. H. (1991b) Measurements of the flow in a Ricardo Hydra DI diesel engine. In *Proc. of the Institution of Mechanical Engineers Conference on Internal Combustion Engine Research in UK Universities, Colleges, and Polytechnics*, London, 1991, pp. 113–122, Paper C433/019

Arcoumanis, C., Bae, C., Nagwaney, A. and Whitelaw, J. H. (1995) Effect of EGR on combustion development in a 1.9 l diesel optical engine. *SAE 950850* [also in *Diesel Engine Combustion Proc.* **SP-1092**, 169–194

Bowditch, F. W. (1961) A new tool for combustion research – a quartz piston engine. *Trans. SAE* **69**, 17–23

Browne, K. R., Partridge, I. M. and Greeves, G. (1986) Fuel property effects on fuel/air mixing in an experimental diesel engine. *SAE 860223*

Chang, J.-C. (1993) Diesel spray characteristics and spray-wall heat transfer. Ph.D. thesis, University of London, London, UK

Clasen, E., Campbell, S. and Rhee, K. T. (1995) Spectral IR images of direct injection diesel engine combustion by high pressure fuel injection, *SAE 950605*. In *Diesel Engine Combustion Processes*, SP-1092

Cuttler, D. H. and Girgis, N. S. (1988) Photography of combustion during knocking cycles in disc and compact chambers. *SAE 880195*

Dec, J. E. and Espey, C. (1995) Ignition and early soot formation in a DI diesel engine using multiple 2-D imaging diagnostics, *SAE 950456*. In *Engine Combustion and Flow Diagnostics, SAE Publication SP-1090*

Dent, J. C., Keightley, J. H. and De Boer, C. D. (1977) The application of interferometry to air–fuel ratio measurement in quiescent chamber diesel engines. *SAE 770825*

Falcus, M., Clough, E., Whitehouse, N. D. and Nowell, E. (1983) Photographic studies of diesel combustion in a quiescent combustion chamber. *SAE 831292*

Fansler, T. D., French, D. T. and Drake, M. C. (1995) Fuel distributions in a firing direct-injection spark-ignition engine using laser-induced fluorescence imaging, *SAE 950110*. In *Engine Combustion and Flow Diagnostics, SAE Publication SP-1090*

Finlay, M. (1995) *KIVA3*, Los Alamos Laboratory

Frankl, G., Barker, B. G. and Timms, C. T. (1989) Electronic fuel injectors – revisited. *SAE 891001*

Gatowski, J. A., Heywood, J. B. and Deleplace, C. (1984) Flame photographs in a spark ignition engine. *Combustion Flame* **56**, 71–81

Gomes, P. C. F. and Yates, D. A. (1992) The influence of some engine operating parameters on particulate emissions. *SAE 922222*

Gomes, P. C. F. and Yates, D. A. (1993) Diesel engine temperatures and soot particle densities measured by the two-colour method. In *Proc. Inst. Mech. Eng. Conf. C465–029. Experimental and Predictive Methods in Engine Research and Development*, Birmingham, UK, November 1993

Hancock, M. S., Belmont, M. R., Buckingham, D. J. (1990) Development of an image capture and analysis technique for the investigation of the very early stages of combustion in a lean-burn engine and the detection of a novel early combustion phase which correlates with subsequent cycle quality. *Proc. IMechE., Part D: Trans-*

port Eng. **204**, no. 2, 125–132

Heywood, J. B. (1988) *Internal Combustion Engine Fundamentals*. McGraw-Hill, New York

Heywood, J. B. and Pischinger, S. (1990) How heat losses to the spark plug electrodes affect flame kernel development in an SI engine, *SAE 900021*

Hicks, R. A., Lawes, M., Sheppard, C. G. W. and Whittaker, B. J. (1994) Multiple laser sheet imaging investigation of turbulent flame structure in a spark-ignition engine. *SAE 941992*

Hottel, H. C. and Broughton, F. P. (1932) Determination of true temperature and total radiation from luminous gas flames. *Ind. Eng. Chem.* **4**, no. 2, 166–175

Iiyama, A., Matsumoto, Y., Kawamoto, K. and Ohishi, T. (1992) Spray formation improvement of VCO nozzle for DI diesel smoke reduction. *IMechE Seminar on Diesel Fuel Injection Systems*, Solihull

Karimi, E. R. *et al.* (1989) High-speed photography of fuel spray and combustion events in a production diesel engine and a combustion bomb. *Proc. Institution of Mechanical Engineers Conference C372/01*

Konig, G. and Sheppard, C. G. W. (1990) End gas auto-ignition and knock in a spark ignition engine. *SAE 902135*

Konig, G., Maly, R., Bradley, D., Lau, A. K. C. and Sheppard, C. G. W. (1990) Role of exothermic centres of knock initiation and knock damage. *SAE 902136*

Lakshiminarayan, P. A. and Dent, J. C. (1983) Interferometric studies of vaporising and combusting sprays. *SAE 830244*

Lange, K. and Spindler, W. (1970) Investigation of local mixture strength and flame propagation with aided and unaided ignition. *Conference on Combustion in Diesel Engines, Proc. IMechE*, 7–9 April 1970, Paper 11

Lyn, W. T. and Valdaminis, E. (1962) The application of high-speed schlieren photography to diesel combustion research. *J. Photogr. Sci.* **10**, 74–82

Male, T. (1949) Photography at 500 000 frames per second of combustion and detonation in a reciprocating engine. In *Proc. 3rd Symposium on Combustion, Flame and Explosion Phenomena*, p. 721. Combustion Institute, Pittsburgh, PA

Matsui, Y., Kamimoto, T. and Matsuoka, S. (1979) A study on the time and space resolved measurement of flame temperature and soot concentration in a DI diesel engine by the two-colour method. *SAE 790491*

Matsui, Y., Kamimoto, T. and Matsuoka, S. (1982) Formation and oxidation processes of soot particulates in a DI diesel engine – an experimental study via the two-colour method. *SAE 820464*

Murakami, A., Sakimoto, M., Arai, M. and Hiroyasu, H. (1990) Measurement of turbulent flow in the combustion chamber of a DI diesel engine. *SAE 900061*, Detroit, MI

Nakagawa, Y., Takagi, Y., Itoh, T. and Iijima, T. (1984) Laser shadowgraphic analysis of knocking in SI engine. *SAE 845001*

Neusser, H.-J., Spiegel, L. and Ganser, J. (1995) Particle tracking velocimetry – a powerful tool to shape the in-cylinder flow of modern multi-valve engine concepts.

SAE 950102 [Also in *Engine Combustion and Flow Diagnostics*, SAE publication SP-1090, Detroit, MI]

Pan, J. and Sheppard, C. G. W. (1994) A theoretical and experimental study of the modes of end gas auto-ignition leading to knock in SI engines. *SAE 942060*, Baltimore, OH

Petersen, R. C. and Wu, K. (1986) The effect of operating conditions on flame temperature in a diesel engine. *SAE 861565. Trans. SAE* **6**, 869–883

Quoc, H. X., Vignon, J. and Brun, M. (1991) A new approach to the two-colour method for determining local instantaneous soot concentration and temperature in a DI diesel combustion chamber. *SAE 910736*

Rao, K. K. (1995) Spray, combustion and emissions studies in high-speed DI diesel engines. Ph.D. Thesis, UMIST, Manchester, UK

Rao, K. K., Winterbone, D. E. and Clough, E. (1992a) Laser illuminated photographic studies of the spray and combustion phenomena in a small high speed DI diesel engine. *SAE paper 922203*, San Francisco, CA

Rao, K. K., Winterbone, D. E. and Clough, E. (1992b) Combustion and emission studies in high-speed DI diesel engines. In *IMechE Conference Proceedings C448/070, Combustion in Engines*

Rao, K. K., Winterbone, D. E. and Clough, E. (1993) Influence of swirl on high pressure injection in a Hydra diesel engine. *SAE 930978.* Detroit, MI

Reeves, M., Garner, C. P., Dent, J. C. and Halliwell, N. A. (1994) Study of barrel-swirl in a four-valve optical IC engine using particle image velocimetry. In *JSME – COMODIA-94, Yokohama*, pp. 429–435

Reuss, D. L., Adrian, R. J., Landreth, C. C., French, D. T. and Fansler, T. D. (1989) Instantaneous planar measurements of velocity and large-scale vorticity and strain-rate in an engine using particle-image velocimetry. *SAE 890616*

Reuss, D. L., Bardsley, M., Felton, P. G., Landreth, C. C. and Adrian, R. J. (1990) Velocity, vorticity and strain-rate ahead of a flame measured in an engine using particle-image velocimetry. *SAE 900053*

Ricardo, H. R. and Hempson, J. G. G. (1972) *The High-speed Internal Combustion Engine*, 5th edn. Blackie, London

Rothrock, A. M. (1932) *The NACA Apparatus for Studying the Formation and Combustion of Fuel Sprays and the Results of Preliminary Tests*. US National Advisory Committee for Aeronautics, Technical Report 429

Scott, W. M. (1969) Looking in to diesel combustion. *SAE J.* **78**, SP-345

Shack, D. H. and Reynolds, W. C. (1991) Application of particle tracking velocimetry to the cyclic variability of the pre-combustion flow field in a motored axisymmetric engine. In International Congress & Exposition. Detroit, Michigan, USA, 25 February–1 March 1991. *SAE Technical Paper Series. 910475*

Shioji, M., Kimoto, T., Okamoto, M. and Ikegami, M. (1989) An analysis of diesel flame by picture processing. *J. Soc. Mech. Eng., Ser. II* **32**, no. 3

Sun, J.-H., Yates, D. A. and Winterbone, D. E. (1996)

Measurement of the flow field in a diesel engine combustion chamber after combustion by cross-correlation of high-speed photographs. *Exp. in Fluids* in press

Taylor, D. H. C. (1967) The analysis of fuel spray penetration and distribution in a medium-speed diesel engine using optical techniques. Ph.D. thesis, University of Loughborough, Loughborough, UK

Tennekes, H. and Lumley, J. L. (1972) *A First Course in Turbulence*. MIT Press, Cambridge, MA

Tindal, M. J., Suen, K. O. and Yianneskis, M. (1989) The variation of flow pattern in a diesel engine cylinder with speed. *SAE 890791*

Uyehara, O. A., Myers, P. S., Watson, K. M. and Wilson, L. A. (1946) Flame temperature measurements in internal combustion engines. *Trans. ASME* **Jan.**, 17–30

Weller, H. G., Uslu, S., Gosman, A. D., Herweg, R. and Maly, R. R. (1994) Prediction of combustion in homogeneous spark-ignition engines. In *JSME – COMODIA-94, Yokohama*, pp. 163–169

Werlberger, P. and Cartiellieri, W. P. (1987) Fuel injection and combustion phenomena in a high-speed DI engine observed by means of endoscopic high-speed photography. *SAE 870097*

Winklhofer, E., Fuchs, H. and Fraidl, G. K. (1995) Optical research engines – tools in gasoline engine development? *Proc. Inst. Mech. Engrs, Part D* **209**, 281–287

Winterbone, D. E., Clough, E., Rao, K. K., Richards, P. and Williams, D. (1992) The effect of DI nozzle fouling on fuel spray characteristics. *SAE paper 922232*, San Francisco, CA

Winterbone, D. E., Sun, J.-H. and Yates, D. A. (1993) A study of diesel engine flame movement by using the cross-correlation method. *SAE paper 930979*, Detroit, MI

Winterbone, D. E., Yates, D. A., Clough, E., Rao, K. K., Gomes, P. and Sun, J.-H. (1994) Combustion in high-speed direct injection diesel engines – a comprehensive study. *Proc. Inst. Mech. Engnrs Part C* **208**, 223–240

Withrow, L, and Boyd, T. A. (1931) Photographic flame studies in the gasoline engine. *Ind. Eng. Chem.* **May**

Withrow, L. and Rassweiler, G. M. (1936) Slow-motion shows knocking and non-knocking explosions. *SAE J.* **39**, no. 2, 297–303, 312

Witze, P. O, (1982) The effect of spark location on combustion in a variable swirl engine. *SAE 820044* [*SAE Trans.* **91**]

Yamaguchi, I., Nakahiro, T., Komori, M. and Kobayashi, S. (1990) An image analysis of high-speed combustion photographs for DI diesel engine with high pressure fuel injection. *SAE paper 901577*

Yamane, K., Ikegami, M. and Shioji, M. (1994) Fuel injection pressure and nozzle orifice diameter in direct-injection diesel engines. In *JSME – COMODIA-94, Yokohama*, pp 225–230

Zhang, L., Ueda, T., Takatsuki, T. and Yokota, K. (1994) A study of the cycle-to-cycle variation of in-cylinder flow on a motored engine. In *The Third International Symposium on Diagnostics and Modelling of Combustion in Internal Combustion Engines*

Index